American Impressionism

Impressionist Picture of a Garden

Give me sunlight, cupped in a paintbrush,
And smear the red of peonies
Over my garden.
Splash blue upon it,
The hard blue of Canterbury bells,
Paling through larkspur
Into heliotrope,
To wash away among forget-me-nots.
Dip red again to mix a purple,
And lay on pointed flares of lilacs against bright green.
Streak yellow for nasturtiums and marsh marigolds
And flame it up to orange for my lilies.
Now dot it so—and so—along an edge
Of Iceland poppies.
Swirl it a bit, and faintly,

That is honeysuckle.
Now put a band of brutal, bleeding crimson,
And tail it off to pink, to give the roses.
And while you're loaded up with pink,
Just blotch about that bed of phlox.
Fill up with cobalt and dash in a sky
As hot and heavy as you can make it;
Then tree-green pulled up into that
Gives a fine jolt of color.
Strain it out,
And melt your twigs into the cobalt sky.
Toss on some Chinese white to flash the clouds,
And trust the sunlight you've got in your paint.
There is the picture.

Amy Lowell

Preface

PUBLISHED IN 1984, *American Impressionism*, was a response to the growing interest among collectors, scholars, and dealers in the work produced, beginning in the 1880s, by American painters reflecting the artistic phenomenon of Impressionism, which had evolved in France during the previous decade. American artists' exploration of the new aesthetic was fueled by the eagerness of collectors in the United States to acquire paintings by those French artists, Claude Monet especially. The revival of interest in American Impressionism, in turn, surfaced first around 1960 among a group of prescient collectors of great aesthetic discernment, Rita and Dan Fraad and Margaret and Ray Horowitz in particular. In response to their enthusiasm, and that generated by other collectors inspired by the Fraads and the Horowitzes, commercial establishments in New York, Boston, and Philadelphia began to investigate and gather works by the American masters of Impressionism. This activity stimulated scholars such as Donelson Hoopes in 1972, and Richard Boyle in 1974, to produce the first substantial publications on American Impressionism. Museums, too, began to single out American Impressionism for notice; both the National Gallery of Art in Washington, and the Metropolitan Museum of Art in New York mounted exhibitions on this subject in 1973, the latter devoted to the Horowitz collection.

That was then, and this is now. It has been seventeen years since the appearance of the first edition of *American Impressionism*, and there is no sign of any diminishment of interest. On the contrary, exhibitions devoted to this art seem to appear not every year but every month. The Horowitz collection, enriched by another twenty-five years of collecting, was recently shown at the National Gallery. The number of publications on aspects of American Impressionism has expanded exponentially. The market for paintings by artists such as Mary Cassatt, Childe Hassam, John Twachtman, Theodore Robinson, and a score of others has driven prices into the seven-figure range. In fact, the "market problem" today is not how or where to sell such works but how to locate examples by these and countless other artists of the movement.

Of course, there have been tremendous developments over the last seventeen years: the reputations of hundreds of American Impressionist painters have been disinterred. There have been scores of investigations of the work of regional artists and art colonies throughout the nation, generally manifested in exhibitions. Time and increased study has yielded a considerably more authoritative alignment of this phase of American art not only with French painting but with that produced elsewhere in Europe, in Canada, and even by Asian artists. Even so, *American Impressionism* appears to have pretty well stood the test of time. This new edition, therefore, is meant to recognize several needs. Since the demand has remained constant after numerous printings, the book is once more made available. An additional chapter affords discussion of the preferred themes among our Impressionists, a subject contemplated seventeen years ago but not then addressed. And in-depth consideration is given to those developments of the last decade and a half, outlined above. American Impressionism and, hopefully, *American Impressionism* will offer satisfaction and pleasure to the twenty-first century.

William H. Gerdts
PROFESSOR EMERITUS OF THE
CITY UNIVERSITY OF NEW YORK

William H. Gerdts

American Impressionism

ABBEVILLE PRESS PUBLISHERS

NEW YORK · LONDON

For Ray and Margaret Horowitz,
leaders of American Impressionism,
and for Abbie, again and always.

The expanded chapters are specially
dedicated to Ronald G. Pisano,
a great art historian and a good friend.

Editors: Nancy Grubb and Jeanne D'Andrea
Designer: Howard Morris
Picture Editor: Dana Cole
Production Manager: Louise Kurtz

FRONT COVER: William Merritt Chase,
The Fairy Tale (major portion), 1892. See plate 145.

BACK COVER: Childe Hassam,
Allies Day, May 1917, 1917. See plate 399.

PAGE 2: John Leslie Breck, *Garden at Giverny*,
c. 1887. Oil on canvas, 18 x 22 in. Private collection.

FRONTISPIECE: Frederick Frieseke. *Woman in a Garden*,
c. 1912. Oil on canvas, 31 x 26 1/2 in. Terra Museum of
American Art, Evanston, Illinois; Daniel J. Terra Collection.

"Impressionist Picture of a Garden" from *Pictures of the*
Floating World by Amy Lowell. Copyright 1919 by Amy Lowell;
copyright renewed 1947 by Ada A. Russell.
Reprinted by permission of Houghton Mifflin Company.

First edition, 1984
Second edition, 2001
10 9 8 7 6 5 4 3 2 1

Library of Congress Cataloging-in-Publication Data
Gerdts, William H.
 American impressionism / William H. Gerdts.—2ND ed.
 p. cm.
 Includes bibliographical references and index.
 ISBN 0-7892-0737-0 (alk. paper)
Impressionism (Art)—United States. 2. Painting, American—19TH century. I. Title.

ND210.5.I4 G474 2001
759.13—dc21 2001022419

Contents

I

PRELUDE, TO 1886

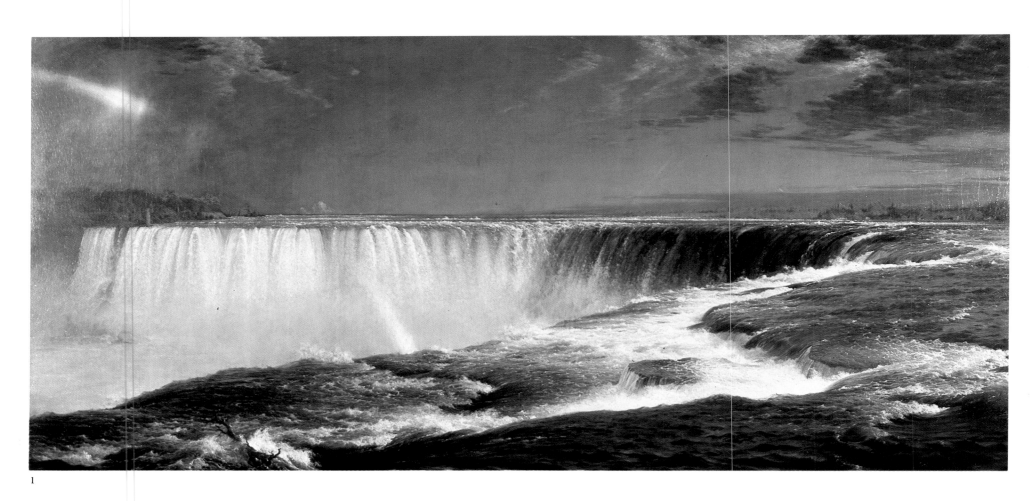

1

1 Nature and American Art: Color, Light, and Transience

CAPTURING THE GLORIES AND INTRICACIES OF nature was the primary goal in American art for much of the nineteenth century, supplanting traditional academic doctrines and the supremacy of classical prototypes. Naturalism had been born in Europe, but the allegiance to nature may have been more complete in America, with its lack of an academic artistic tradition. When Impressionism later penetrated this country, its modernism ironically coincided with another new gain for American artists—their first truly cosmopolitan academic training. At the same time the traditional milieu that offered this training was gradually disintegrating in Europe. One of the distinctive features of American Impressionism was the way in which it reconciled Impressionist and academic practices.

"Nature" in the narrower sense of "landscape" had an intense appeal for Americans in the nineteenth century, although that appeal developed slowly. Few landscapes are known from the eighteenth century (and none from the seventeenth), and the occasional European landscapes that were imported represented the security and tradition of the Old World rather than the dangers or mysteries of the New. Only as civilization progressed and the hostility of the wilderness became a distant memory did nature begin to be seen by Americans as a "New Eden," a blessing from the deity and a reflection of Holy Scripture, rather than a hazard or a curse. This new attitude of the early nineteenth century swiftly found interpreters.[1] The greatest was Thomas Cole, who portrayed the beauty and sublimity of the American wilderness. His best efforts were devoted to elaborate historical and allegorical landscapes, often in series such as his 1836 *Course of Empire* (plate 2) and *Voyage of Life* (1840). In these ambitious scenes nature was the conduit for romantic expressions of man's temporality and insignificance in the face of God's omnipotence. Cole subscribed not only to the continued belief in the supremacy of history painting but also to the tenaciously held academic principle that compositions—created by the artist's imagination—were superior to pictures that mechanically transcribed nature.

While that principle held sway, there was little interest in the carefully observed effects of nature, in light and color and atmosphere. Early nineteenth-century landscape painting in America, as in Europe, evinced a far greater regard for the majestic, for formidable mountains with towering peaks, dense forests, massive cliffs and chasms. But gradually the emphasis changed; indeed, the history of

"What comparison is there between the garden landscapes of England or France and the noble scenery of the Hudson, or the wild witchery of some of our unpolluted lakes and streams? One is man's nature, the other—God's."

The Literary World, May 15, 1847, p. 348.

1. FREDERIC EDWIN CHURCH (1826–1900). *Niagara Falls*, 1857. Oil on canvas, 42½ x 90½ in. The Corcoran Gallery of Art, Washington, D.C.; Museum purchase.

landscape painting during the nineteenth century can be viewed as a shift from the solid and substantial to the ephemeral, from forests and mountains to light and atmosphere, from the timelessness of classical art to the transience of Impressionism.

Names and definitions of art movements are always controversial, and this is true of both the earliest native art movement in this country, the Hudson River School, and its more recently identified offshoot, Luminism. The aesthetic of the Hudson River School seems to encompass two basically dissimilar approaches. The art of Thomas Doughty and Thomas Cole was anthropocentric, with nature manipulated to express a dialogue between man and his Maker, as in Cole's *Course of Empire*. The so-called second generation of Hudson River School artists—what I see as the real Hudson River School—was quite different. Whether in the more humble, contained paintings of Asher B. Durand or the exotic panoramas of Frederic Church and Albert Bierstadt, these artists recorded their subjects with respect, even reverence, for the deity's creativeness.

For those artists known as Luminists—participants in a movement that began in the mid-1840s, reached its apogee from 1855 to 1865, and declined in the 1870s—reverence for nature was as profound as it was for the "mainstream" Hudson River School artists. Sanford Gifford, John F. Kensett, Fitz Hugh Lane, and Martin Johnson Heade are the primary painters now identified with Luminism, but almost every landscape master working from about 1845 to 1875 investigated to some extent the effects of atmosphere as colored light.[2]

Luminism obviously refers to an emphasis on the effects of light, and it is not coincidental that the term *Luminists* was first applied not to mid-century artists like Gifford but to the American Impressionists. Historians now see Luminism as an almost worldwide aesthetic at mid-century, shared by American artists with colleagues particularly in northern European countries such as Denmark and Russia. This concern with light and its effects, however, was especially strong in the United States, and although it was engendered by very different motivations from those that introduced Impressionism, Luminism as an expression of light was a precursor of the later movement.

Another facet of Impressionism that fascinated American artists was color, and, although there is little in our painting that compares with the work of Delacroix, American art was often seen by both natives and others as primarily coloristic. In the early nineteenth century American artists and patrons responded with tremendous enthusiasm to the portraiture of Sir Thomas Lawrence and the revolutionary genre painting of David Wilkie, both imbued with the vigorous chromaticism and bravura brushwork associated with Romantic art, while French art remained identified with Neoclassical drawing, modeling, and design.

Color remained a primary concern of American critics throughout the century, whether a painter was admired or condemned. This emphasis was underscored by the opening in New York of the Düsseldorf Gallery in April 1849. Art training and production in Düsseldorf, Germany, was recognized here and in Europe as the acme of professional achievement, and many talented young Americans studied there from the late 1830s through the 1850s. The Düsseldorf Gallery allowed a comprehensive evaluation of those artistic achievements, and, despite the anxieties engendered by nationalist predilections and the rivalry of competitive art organizations in New York, the gallery's ongoing exhibition was well received during the 1850s. Yet the Düsseldorf paintings were viewed, correctly, as hard and mechanical, expertly drawn but especially deficient in color—in invidious comparison to American art.

From the first, American landscapists were concerned with creating a palpable atmosphere. This concern seems to have been based more on recognizing the power of art to achieve a warm and agreeable result than on any perception of uniquely American qualities. The seventeenth-century French painter Claude Lorrain was considered the great master of atmosphere in landscape. Working in

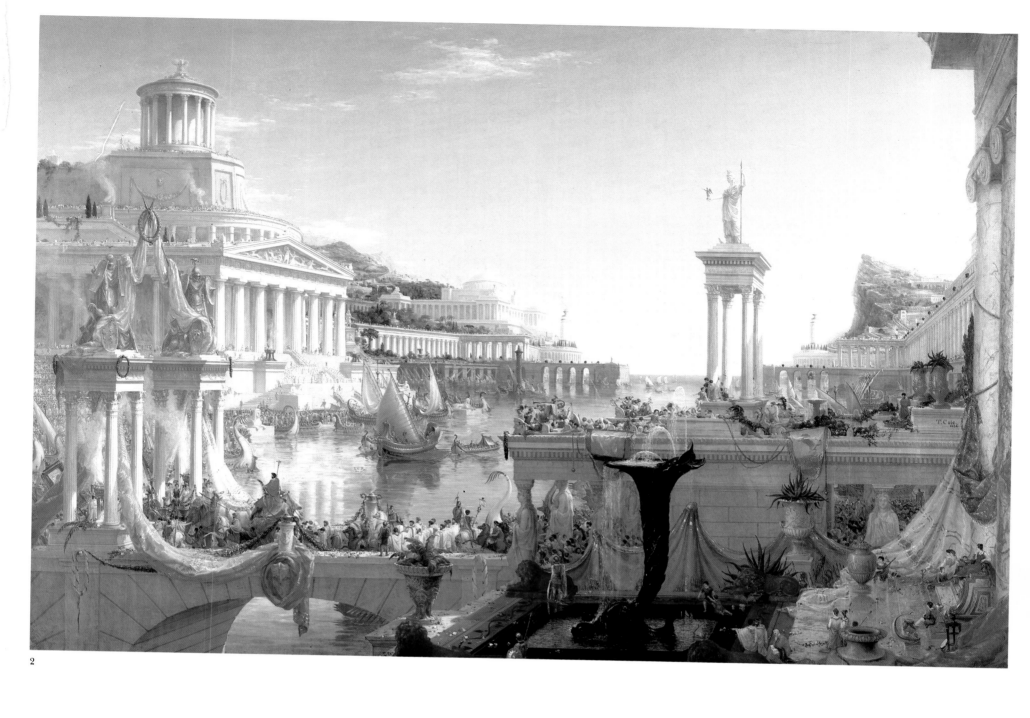

2

Italy, Claude was not only the spiritual mentor of successive American landscape painters but the subject of the first American essay on landscape painting.[3] The anonymous writer of 1796 suggested that no artist had ever surpassed Claude, since he had exhausted all the varieties of landscape experience. Nonetheless, the next several generations of Americans tried to rival him or at least pay homage to his invention. This was true of Thomas Cole and of Cole's even more famous contemporary, Washington Allston. Numerous other mid-nineteenth-century American landscapists, including some of the Luminists, learned from Claude. Gifford, for example, was not only the most Claudian in composition and overall conception but also the painter who amplified the master's conception of a warm, pervasive, hazy light. Like Claude, Gifford seems to have fully developed this atmospheric concern in Italy, in his *Lake Nemi* of 1856–57 (plate 3), but quickly domesticated it in his American landscapes and in those painted later in Europe, the Near East, and North Africa.

Gifford's art was within the Hudson River School aesthetic; George Inness's developed from that aesthetic and in reaction to it. He was the primary American landscapist to respond to the more personal moods of nature, as did the French Barbizon artists—Jean Baptiste Corot, Théodore Rousseau, and others—and his painting marks the high point of the American counterpart. While Inness voiced

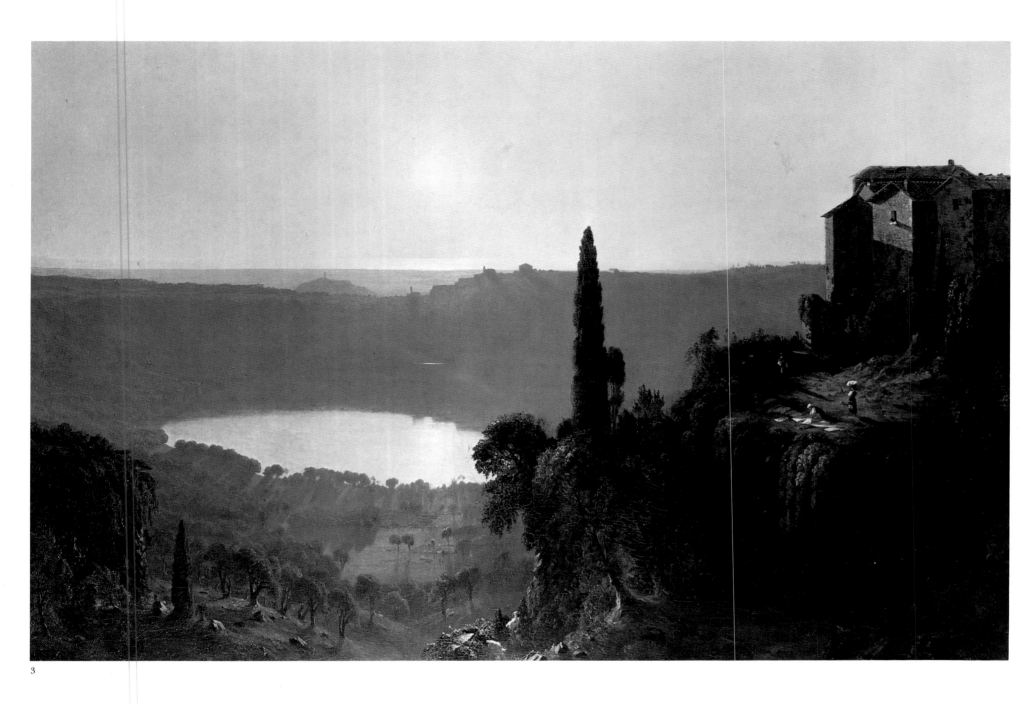

3

3. SANFORD GIFFORD (1823–1880). *Lake Nemi*, 1856–57. Oil
on canvas, 39⅝ x 60⅜ in. The Toledo Museum of Art;
Gift of Florence Scott Libbey.

4. GEORGE INNESS (1825–1894). *The Trout Brook*, 1891. Oil
on canvas, 30 x 45 in. The Newark Museum; Purchase,
The Members Fund, 1965.

an antipathy toward Impressionism, his art shared with it an overriding concern
for creating a palpable atmosphere, one that united all forms of nature within it
and drew forth an empathetic response from the viewer.[4] The work of Inness's
later years can be seen as the beginning of Tonalist landscape. Tonalism was a
movement that flourished in America from about 1880 to about 1915, devoted
primarily to landscape painting and related to late Barbizon manifestations in
France and the United States. The artists who practiced it were most concerned
with poetic evocations of nostalgia and reverie, accomplished either by the domi-
nation of one color—especially gray, gold, or blue—over all others or by the
emphasis on a colored atmosphere or mist through which forms were perceived,
often dimly, and which produced an evenness of hue throughout.

Much art is made to embody permanence, timelessness: portraiture records an
individual for the ages, landscape insures the memory of a place, and historical
pictures memorialize great and valorous deeds. Yet these very works, established
as icons, embody their opposites; for the portrait stops time as time cannot be
stopped, and later appearance gives lie to the durability of the image. In American

landscape, temporality was a concern from the first. Early in their careers Asher B. Durand, Jasper Cropsey, and William Sontag followed Cole in a devotion to landscape and to painted allegories of the passage of time, but at mid-century such serial presentations merged with naturalistic landscapes, sometimes related to identifiable geographic locations. Depicting the seasons in individual works increasingly occupied American landscapists: Cropsey specialized in autumnal pictures and George Durrie in winter scenes. Concerns for time of year, time of day became ever more prominent, as did paintings of autumn and twilight hours. In fact, the popularity of Impressionist pictures can be seen partly as a reaction to the close tonality and faint gloom so popular in these dusky scenes.

While light, color, atmosphere, and transience are among the primary formal concerns of Impressionism, they did not spring full-blown into American art at the end of the 1880s, nor were they a wholesale importation. They had informed the strategies of our earlier landscape painters, however different their motivations. But in seeking out an aesthetic continuum in the art of the Hudson River School, the Luminists, and the Barbizon-oriented landscapists, we must not obscure the fact that Impressionism represented a radical break with the past. It bespoke a new alignment in our art conditioned by the experiences of younger American painters abroad in the post–Civil War years.

4

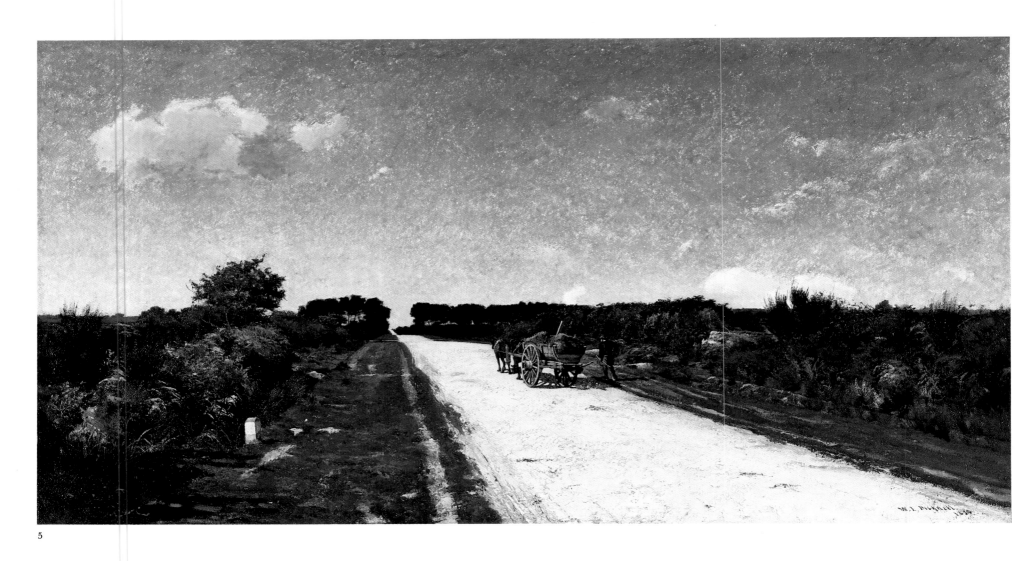

5

2 Glare: An Alternative Aesthetic

THE MANIPULATION OF LIGHT to intensify pictorial impact had been a concern of Western artists for over two hundred years before Claude Monet and his colleagues began to develop Impressionism. But intensifying the experience of light did not necessarily lead to formal dissolution. The American Luminists, for example, chose a delicate balance wherein solid forms continued to appear solid even when seen through a heightened colored atmosphere, a balance so fragile that Luminism itself was dissolved by the more powerful aesthetics that followed.

One of these was the "glare aesthetic," which can be traced back at least as far as the mid-eighteenth century and even earlier.[1] Glare reminds us that Impressionism was not the only approach to light in the late nineteenth century and also that the effective alternatives were diametrically opposed to its light-dissolving strategies. For artists concerned with glare, light reinforced form. The concept of glare demands a surface that reflects brightly, and the most effective is a well-defined strong architectural plane. A suggestion of this is found as early as the seventeenth century in architectural pictures and cityscapes by Dutch specialists such as Gerrit Berckheyde. The intense effects of chiaroscuro, of contrasting planes of brilliantly reflective pavement and architectural walls, and equally strong dark planes of shadow, was adopted a century later by Antonio Canaletto in Venice. The planar surfaces of architecture remained mainstays of glare painting, and this dependence on architecture may well have made the style too limited and led to its abandonment.[2]

The glare aesthetic spread throughout Europe in the 1850s, and the light and color planes became increasingly strong. A major example is *The Pretty Baa Lambs* of 1852 by the English Pre-Raphaelite artist Ford Madox Brown, painted outdoors in the intense heat and light of midsummer. This work has often been named a precursor of Impressionism, not only for its brilliant chromaticism and abandonment of dark neutral tones but also because it was done outside. But with its hard outlines, sharply defined forms, intense shadows, and solid modeling, with no suggestion of loose brushwork or divisionist dissolution, this painting is decidedly *not* Impressionist.

American painters working within the glare aesthetic almost never participated in the Impressionist movement, though inevitably there was some overlap. One such painter was Winslow Homer. Homer's several depictions of croquet

5. WILLIAM LAMB PICKNELL (1853–1897). *Road to Concarneau*, 1880. Oil on canvas, 42⅜ x 79¾ in. The Corcoran Gallery of Art, Washington, D.C.; Museum purchase, 1899.

players of the mid-1860s defined the forms as broad, flat planes of strong local color; and *An Adirondack Lake* of 1870 (plate 6) is conceived in bands of light and shade, with forms pressed against the picture plane, although illusionistic recession is emphasized through various pictorial devices. This Adirondack picture is unusual within the glare aesthetic because it is backlit, which puts the guide in sharp, shadowy contrast to the brightly lit lake and sky. In a number of later farm scenes of the '70s, Homer adopted a more usual treatment of light, as in *Rustics* of 1874. Here the farmhouse wall is parallel to the picture plane, blocking any view into the distance; all the action of the scene is played against that wall, an intensely colored reflective surface and a strong spatial marker. Eighteen seventy-four witnessed the first full expression of the French Impressionist aesthetic, but Homer's *Rustics* is totally *non*-Impressionist. Homer and his French contemporaries shared the wish to record full sunlight and to create brighter, more colorful natural effects, yielding to increased interest in outdoor phenomena; but he achieved these goals by intensifying rather than eliminating tonal contrasts.

Defined drawing and concern with form are part of the overall insistence on control that made the glare aesthetic more appealing to academic artists than Impressionism in the 1870s. While Homer was not academically trained, his

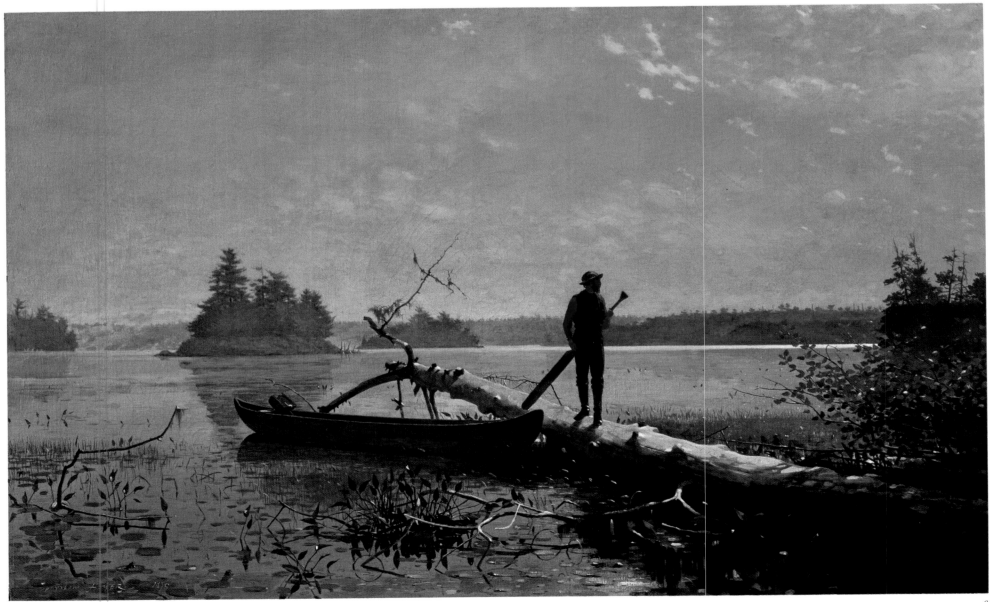

6

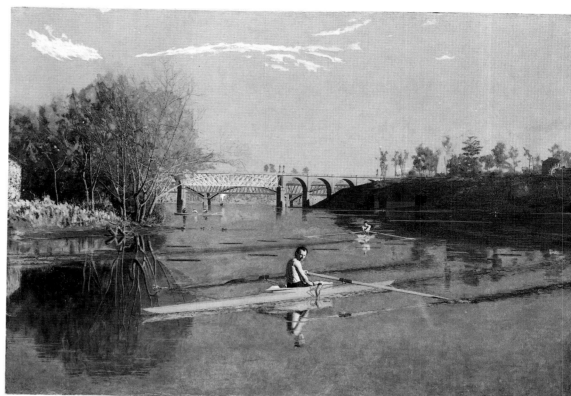

contemporary Thomas Eakins most surely was, having studied in France in the late 1860s with Jean Léon Gérôme and Léon Bonnat. Gérôme particularly, in some of his Orientalist pictures of the '60s, depicted figural activities against reflective planar surfaces, a lesson Eakins applied to his first major figural work, *Street Scene in Seville* of 1870. That June, Eakins left Europe for Philadelphia and the next year began the series of sculling and boating pictures of his early maturity. In these works—above all, his 1871 *Max Schmitt in a Single Scull* (plate 8)—Eakins further explored the glare aesthetic. The composition opens onto a broad panorama of the Schuylkill River landscape, with intense light sharply silhouetting the scullers on the river against the plane of the barely disturbed river. In the distance loom several bridges: their clearly defined structures are an understated triumph of modern engineering, and their architectural expanses reinforce the picture's compositional breadth. Eakins utilizes them as thin, flat architectural planes to reflect light and to create arched patterns that act as geometric dividers between water and sky. *Max Schmitt in a Single Scull* is the most famous of Eakins's many outdoor paintings of the 1870s in the glare manner, very different from his dark portraits and genre subjects of the time. The difference between the two in the use of light is conditioned not only by contrasting environments but by different attitudes toward figure and landscape painting. American Impressionists, like Eakins, would be far more concerned with light and color in outdoor scenes than in figure painting, where their academic training was paramount.

The masterpiece of American painting within the glare aesthetic was painted in France by William Lamb Picknell: *Road to Concarneau* of 1880 (plate 5). One of literally thousands of Americans to study in Paris, Picknell became a pupil of Gérôme a decade after Eakins. He was one of dozens of American artists attracted to the Brittany village of Pont-Aven from 1876 on, an artists' colony started by his countryman Robert Wylie. There, near the port of Concarneau, Picknell's masterpiece was conceived. *Road to Concarneau* was awarded an honorable mention in the Paris Salon of 1880, and its effects of glaring light were specifically com-

6. WINSLOW HOMER (1836–1910). *An Adirondack Lake*, 1870. Oil on canvas, 24¼ x 38¼ in. Henry Art Gallery, University of Washington, Seattle; Horace C. Henry Collection.

7. JEAN LÉON GÉRÔME (1824–1904). *Excursion of the Harem*, 1869. Oil on canvas, 47½ x 70 in. The Chrysler Museum, Norfolk, Virginia; Gift of Walter P. Chrysler, Jr.

8. THOMAS EAKINS (1844–1916). *Max Schmitt in a Single Scull*, 1871. Oil on canvas, 32¼ x 46¼ in. The Metropolitan Museum of Art, New York; Purchase, Alfred N. Punnett Fund and Gift of George D. Pratt, 1934.

9. FRANK DUVENECK (1848–1916). *Italian Courtyard*, 1886. Oil on canvas, 22¼ x 33³⁄₁₆ in. Cincinnati Art Museum; Gift of Frank Duveneck.

10. JOHN TWACHTMAN (1853–1902). *Venice, The Grand Canal*, 1878. Oil on canvas, 10¾ x 16 in. Private collection.

11. JOHN TWACHTMAN. *Arques-la-Bataille*, 1885. Oil on canvas, 60 x 78⅞ in. The Metropolitan Museum of Art, New York; Purchase, Morris K. Jesup Fund, 1968.

12. CHILDE HASSAM (1854–1935). *The Little Pond, Appledore*, 1890. Oil on canvas, 16½ x 22 in. Daniel P. Grossman Gallery, New York.

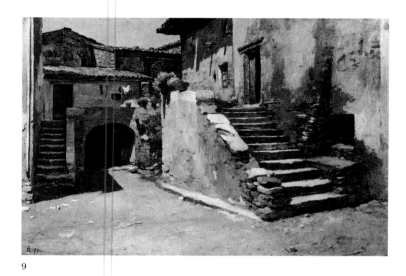

9

10

mended in the French press.[3] Picknell allied the strong, hot tonal light to a symmetrical landscape of plunging orthogonals that carry the eye deep into space, a device much utilized at the time and particularly identified with Giuseppe de Nittis, Gustave Caillebotte, and Vincent van Gogh. The rapid spatial plunge may derive from contemporary landscape photographs, and the flat, light-filled roadway described in one basic tone may also be a device adopted from early photography.[4]

Munich-trained artists such as Frank Duveneck also depicted flat light planes in architectural settings, as in his *Italian Courtyard* of 1886 (plate 9). Duveneck had been the leader of the Americans who studied in Munich and had gathered around him a group known as the "Duveneck Boys," artists who studied and painted with him in Polling, Bavaria, and accompanied him to Florence and Venice. In Italy during the 1880s Duveneck painted a number of works that seem to soak up sunlight, and one senses an almost conscious reaction against his vivid black studio painting of a decade earlier in Munich—as if he were trying to throw off his Germanic training and succumb to the Mediterranean ambience. In *Italian Courtyard*, Duveneck enjoyed the broken stonework and variegated surfaces of crumbling walls but subordinated them to the brightly lit, geometric surfaces that contrasted with their own strong shadows and silhouettes.

Blondness and even whiteness were very important to this light- and color-conscious generation. Americans as well as Europeans were aware of the work of Gustav Robert Kirchhoff and Robert Bunsen, Heidelberg professors whose discoveries in spectrum analysis were made public in 1860. Ultimately the Impressionists dissolved white light into its spectral components on the surface of the canvas, but immediately before Impressionism was adopted by American painters a concern already existed for rendering white itself. A writer in *Art Amateur* in 1886 said, "The conquest of white is a problem every painter yearns to solve. It is regarded as the highest technical achievement to render white textures in high light and temperate shade with approximate truth."[5] This concern also was recognized by the artist-writer Otto Stark, one of the fascinating group of Hoosier Impressionists who appeared in the 1890s (see chapter 8). Stark published an article in 1895 called "The Evolution of Impressionism."[6] Academically trained and a convert to Impressionism, he was not a disinterested commentator; his arguments on the development of Impressionism are simplistic but nevertheless warrant attention.

Stark viewed the evolution of color in Western art at the end of the nineteenth century in four stages. Given that he covered only the period from the Philadelphia Centennial of 1876 to the 1893 World's Columbian Exposition in Chicago, his stages necessarily overlap, yet Stark's chronology and his perceptions of attitudinal changes toward light and color were not inaccurate. The first stage after the Centennial was that of "the Munich manner," which emphasized blackness and brownness; this black manner was transported to bright, sunlit Venice by Duveneck and several of his Boys, such as John Twachtman (see plate 10). Stark recognized next "the gray movement"—a protest against the black manner—which originated in France, where "a more rigid method of drawing was sought after." The gray movement was a consequence of working outdoors, and he summed up its results as pictures beautiful in repose, harmonious in tone; good in values, in a monotonous sense, but lacking in light and color (see plate 11). Yet, Stark noted that these landscape artists working outdoors inevitably were attracted by pure sunlight and thus brought about the next stage, "the white movement," the "high key" in painting, which he defined as striving to identify painting as light, as near white as the palette allowed. Stark recalled "walking through exhibitions where a large percentage of canvases looked like white-washed fences, the paint being plastered on in a manner which reminded one of mortar put on with the trowel of a stone mason." Undoubtedly he was referring to works such as Picknell's *Road to Concarneau* and other paintings within the glare

aesthetic. Yet for Stark the Impressionist, this was still "not sunlight." Rather, he saw the white movement as only a preliminary stage that culminated in the fourth stage of light and color investigation, which was Impressionism (see plate 12). But he was wrong. The glare aesthetic was actually an alternative approach to the study of natural phenomena, which acknowledged the need for order and control implicit in the aesthetic credo of the academic system. The implications and achievements of the glare aesthetic were international, and while it did not survive the triumph of Impressionism it must be recognized as a significant development of late nineteenth-century art. And in such works as Childe Hassam's *Grand Prix Day* of 1887 (plate 100), it was not incompatible with Impressionism itself.

11

12

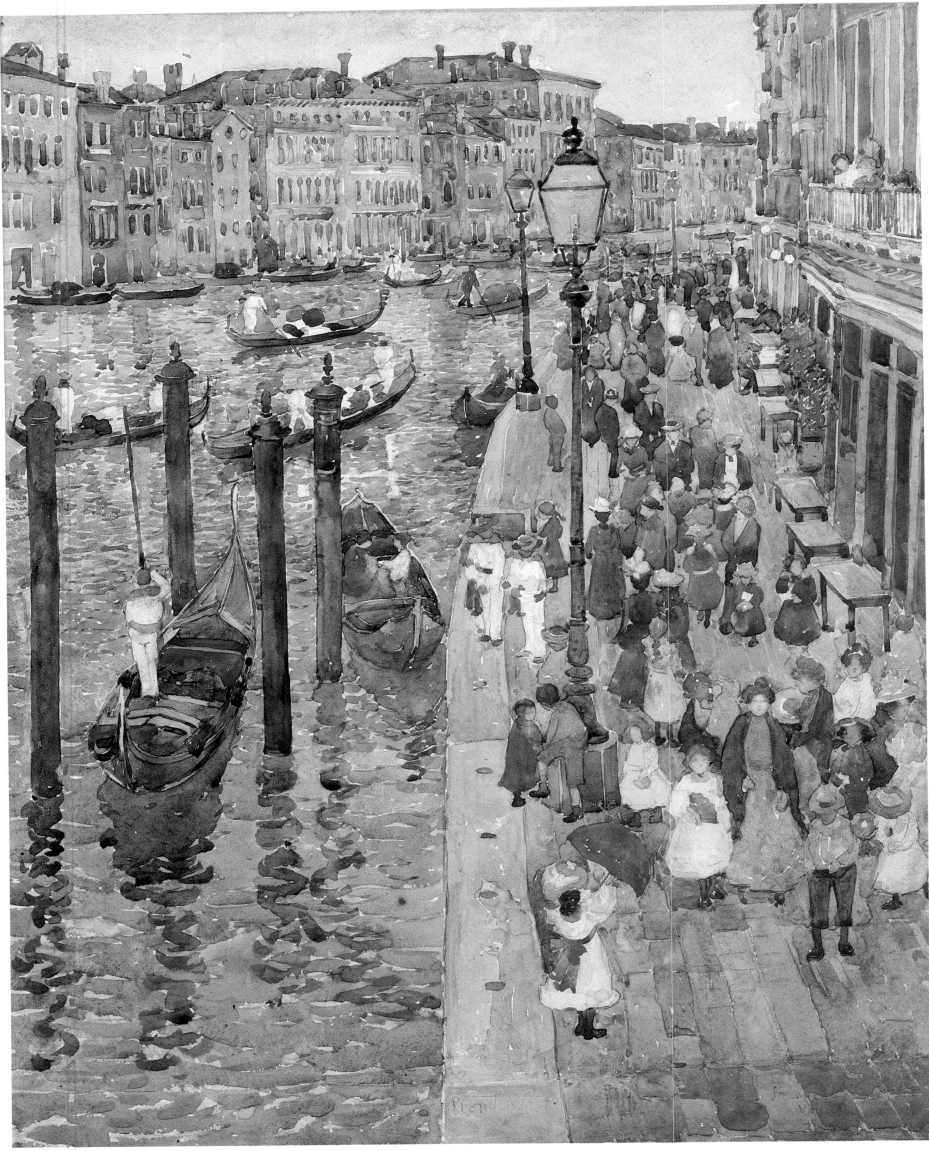

3 Americans Abroad after the Civil War

ROM FRANCE, Impressionism spread to almost every nation of the world, and the United States was especially receptive to it. One reason for this positive response can be found in the new cosmopolitanism that pervaded American culture after the Civil War.[1]

In the early nineteenth century almost all major and many minor American artists had traveled abroad to view the Old Masters and when possible to study in European academies; a few also sought European patronage. This pattern continued in the 1840s and '50s, although a rising voice of nationalism echoed William Cullen Bryant's warning to Thomas Cole as he was about to depart for Europe in 1829: "keep that earlier, wilder image bright."[2] At mid-century, artists were encouraged to explore Europe, but only as a prelude to creating a distinctive American art at home; some writers even advised against European travel and training, and certainly against depicting European subjects. If America was a New Eden, then the American artist should find the bounty of this New World sufficient for his brush.

The endearing naïveté of this concept of American superiority was slowly eroding even before the Civil War as Americans making the Grand Tour became increasingly aware of European achievements. Most often their ultimate destination was Italy, where they were comforted by the presence of large colonies of American expatriate artists in both Florence and Rome and where Americans were praised for their superiority over Italian artists. In the 1840s European art began to be imported by enterprising dealers and institutions, particularly in New York. The French dealer Goupil set up a New York branch in 1848, and the next year John Godfrey Boker established the Düsseldorf Gallery of contemporary German art, which remained an active force for over a decade. The French paintings imported by Goupil, especially those of the renowned academic masters Paul Delaroche, Horace Vernet, Ary Scheffer, and a little later Jean Léon Gérôme, were praised in the American press, while the merits of the Düsseldorf School were more contested, even though many American artists trained in that city. The 1850s and '60s also witnessed large exhibitions of foreign art, especially the major show of contemporary British painting in 1857–58 in New York, Philadelphia, and Boston, which featured the controversial Pre-Raphaelites, and the numerous shows of French and Belgian art imported by the European dealers Ernest Gambart and Alfred Cadart.[3]

13. MAURICE PRENDERGAST (1861–1924). *The Grand Canal, Venice*, 1898–99. Watercolor on paper, 17⅜ x 13¾ in. Terra Museum of American Art, Evanston, Illinois; Daniel J. Terra Collection.

How severe an impact the Civil War had on American culture is debatable. On the one hand, relatively little American art dealt directly with the great conflict, except for illustrations in the pictorial newspapers. On the other hand, some of the older optimism about America's uniqueness and invincibility had been shattered, though it is questionable whether this in itself was significant in leading artists, critics, and patrons to the cosmopolitanism that dominated the post–Civil War decades.

More and more Americans threw off the nationalistic mantle and joined Europeans in seeking common goals and common pictorial expression. This era has become recognized as the American Renaissance, a welcome term that offers a context for cultural analysis. There was, indeed, some emulation of Italian Renaissance forms, and, like fifteenth- and sixteenth-century Italy, America witnessed a renaissance in the widespread promotion of the arts. But above all it was a renaissance in the sophistication of the professional art establishment. During this era numerous civic museums were founded; art dealers proliferated, most of them in European painting, sculpture, and *objets de vertu*; and many an American Maecenas appeared, primarily as collectors of European art. A professional art press was established, with journals such as *Art Amateur*, *Art Interchange*, the *Studio*, *Modern Art*, and many other shorter-lived periodicals featuring the writings of professional critics such as Clarence Cook, Mariana van Rensselaer, Montague Marks, Roger Riordan, William C. Brownell, and others. Artists established numerous organizations to further their interests and to work toward a complete integration of the arts, exploring decorative arts, book design, and architectural enterprises that incorporated painting and sculpture.

In order to compete qualitatively with their European colleagues and to share the patronage directed toward them, American artists sought professional instruction in the same schools that trained Europeans. What had been an occasional presence in art schools such as London's Royal Academy and, more prominently, the Düsseldorf Kunstakademie, became a deluge in the post–Civil War years. A few Americans still studied in London, and one or two, such as Gari Melchers, still sought training in Düsseldorf, but increasingly they went to Munich and even more to Paris. Parisian training was not new for Americans, of course; John Vanderlyn had studied there at the end of the eighteenth century, and in the early nineteenth century George Peter Alexander Healy, for example, had studied with the Baron Gros. Thomas Couture, a French student of Gros, began to take on American pupils in 1846 when William Morris Hunt went to him, and Couture continued to teach Americans throughout his lifetime. Hunt returned to America with French teaching principles that he imparted to his pupils in Newport and Boston and with an aesthetic amalgam of Couture and Jean François Millet that had an impact on art collecting in Boston. While French training may have affected dozens of American artists at mid-century, it shaped thousands of them from the mid-1860s on.[4] At the Ecole des Beaux-Arts they could work gratis with eminent French academicians; or they might pay to train at the independent ateliers such as Julian's, Colarossi's, and others, which admitted women students (the Ecole did not); or they might supplement their training with private lessons from major artists of the French establishment, including some who also taught at the Ecole or the independent ateliers.

These Americans recognized Paris as the center of the art world—for training, exhibition, and patronage. The exhibition was above all the yearly Salon, where thousands of artists competed for chances to display major works. The catalog proudly announced their affiliation with one or another French master, who might himself be a juror for the show and prejudicial toward his students. After a work was accepted into the Salon, the fledgling artist could hope for a desirable hanging location instead of being "skied" out of sight; could hope for a complimentary review in the Parisian press or even in reviews that sometimes appeared in America; and, perhaps most important, could hope to sell the work to one of the

rich American collectors who often preferred to acquire art abroad. Less likely was French or other European patronage, though American works were occasionally purchased by the French government for the national collection. Some Americans found it most convenient and satisfying to remain in France, even after their years of training, exhibiting their specialized subject matter year after year in the Salon and sending works for exhibition to England and America. Others returned home after winning accolades at the Salon, though they rarely found enough patronage in America to make a living and usually resorted to a combination of painting, illustrating, and teaching. Their efforts in this last category eventually reproduced the French academic training system in the numerous art schools in the States.

Oriental and peasant subjects were two of the most popular categories to be seen each year in the Salon, which also encompassed historical and religious painting, portraiture, land-, sea-, and cityscapes, various forms of still life, and other themes as well. The academic training at the Ecole and the ateliers, however, was directed primarily toward the figure—delineating its outer form, understanding its inner structure, and creating multifigural compositions in correctly constructed environments. American students in Paris, like their European confreres, spent years mastering the figure. Thus when they were exposed to more advanced art, such as paintings by Manet, they were initially loath to simplify and distort form or to abandon the spatial relationships they had struggled to learn. What has wrongheadedly been described as a peculiarly American devotion to reality was actually the preservation of an academic mastery of form that these artists were the first Americans to achieve. The cost of that achievement was far too great to be abandoned easily.

But training in landscape painting was something else. French academic masters, such as Gérôme, painted very beautiful and characteristically well-structured landscapes, and most utilized landscape settings with some frequency. However, although the landscape study was part of the academic tradition, instruction in landscape was quite negligible in the late nineteenth century. Artists of the period seem to have learned to paint landscapes by going outside, setting up easels, and painting what they saw, perhaps with some advice from artists such as the surviving Barbizon masters. Thus the approach to landscape was neither as ingrained nor as

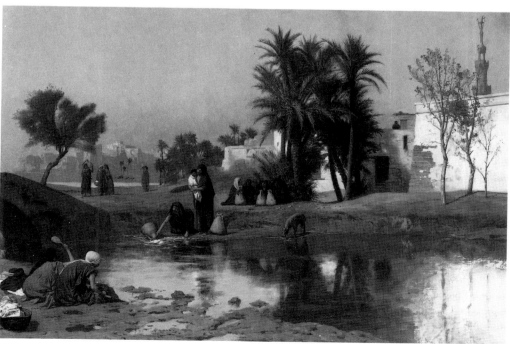

14. JEAN LÉON GÉRÔME (1824–1904). *Medinet-el-Fayoum, Upper Egypt*, c. 1903. Oil on canvas, 26½ x 39½ in. Sterling and Francine Clark Institute, Williamstown, Massachusetts.

14

formalized as the approach to the figure, so that many American artists in France could react spontaneously to nature and investigate Impressionist landscape advances. This led to what now seems an almost schizophrenic aesthetic for some Americans: solidly structured, monochromatic figure painting and brilliantly prismatic landscapes painted with amazing dash and vigor, the former created in the artists' Paris studios, the latter on summer holidays in the countryside.

This dual aesthetic also accounts for the great popularity of Jules Bastien-Lepage. Among the French masters of the 1870s and early '80s, just as Impressionism first arose, Bastien-Lepage and his art represented a proper balance of academic tradition and modern concepts. Beyond his personal magnetism and his sympathetic reception to Americans, such as J. Alden Weir, was the greater appeal of his art. Fashioned around advanced ideas of unidealized naturalism, it was devoted to monumental images of the downtrodden peasant. Bastien-Lepage's

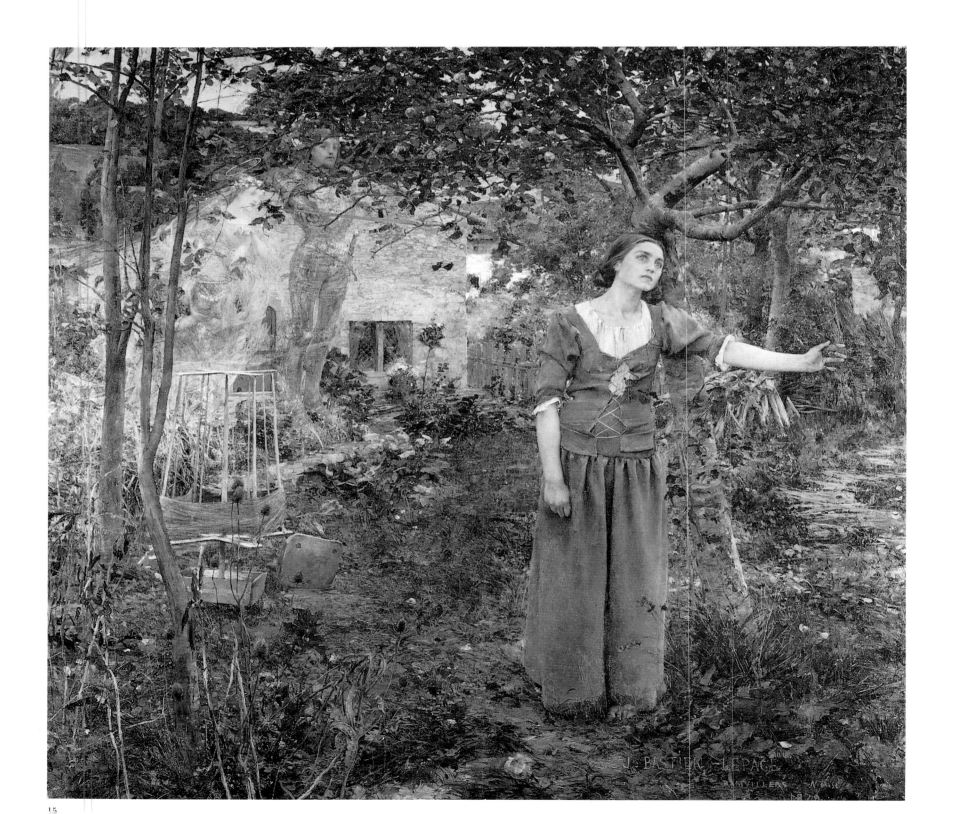

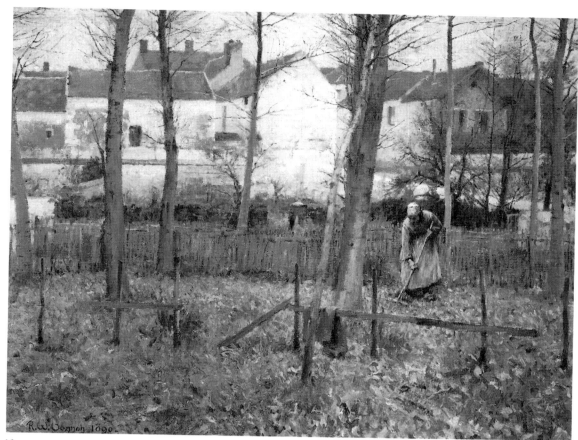

16

figures were solidly constructed but in no way formulaic, and, while his space was carefully defined, he utilized the modern devices of a high horizon and plunging perspective. He was modern, too, in posing his subjects naturally, outdoors, in one overall illumination. As with space, so with technique: he represented a compromise between academic finish and blatant painterliness.

Bastien-Lepage's painting began to attract American critical attention beginning with his contributions to the Paris Salon, reviewed in the *Art Journal* in the late 1870s. But he attracted much more serious American interest with his most famous picture, *Joan of Arc* (plate 15), shown in the Salon of 1880. It was acquired the next year by the American collector Erwin Davis, acting on the advice of Weir, and exhibited in New York at the Society of American Artists and the Metropolitan Museum of Art. Though the picture was not universally lauded in America, its display at the Society gave it the stamp of modernism and at the Metropolitan the approval of authority. Two years later, in 1883, Bastien-Lepage was reportedly coming to Boston to paint portraits, and the *Boston Herald* featured an interview with him in which he predicted the creation of an original and unconventional school of painting in America, since its artists were unfettered by tradition.[5] Bastien-Lepage never made the journey; he died the following year, much mourned by his American disciples.

Although Bastien-Lepage was not an Impressionist, he was a most influential figure in the development of late nineteenth-century painting. Perhaps this is as true for American art as for French, because he offered American artists a solution to the dilemma of academic training versus modernist experimentation within an ideological format that held social meaning. While no American painter seems to have emulated Bastien as completely as some of his Scottish and Scandinavian colleagues and followers, his aesthetic is recognizable in diverse works of Weir, Robert Vonnoh, Edward Simmons, and other American Impressionists.

15. JULES BASTIEN-LEPAGE (1848–1884). *Joan of Arc*, 1879. Oil on canvas, 100 x 110 in. The Metropolitan Museum of Art, New York; Gift of Erwin Davis, 1889.

16. ROBERT VONNOH (1858–1933). *November*, 1890. Oil on canvas, 32 x 39⅜ in. Pennsylvania Academy of the Fine Arts, Philadelphia; Temple Fund Purchase.

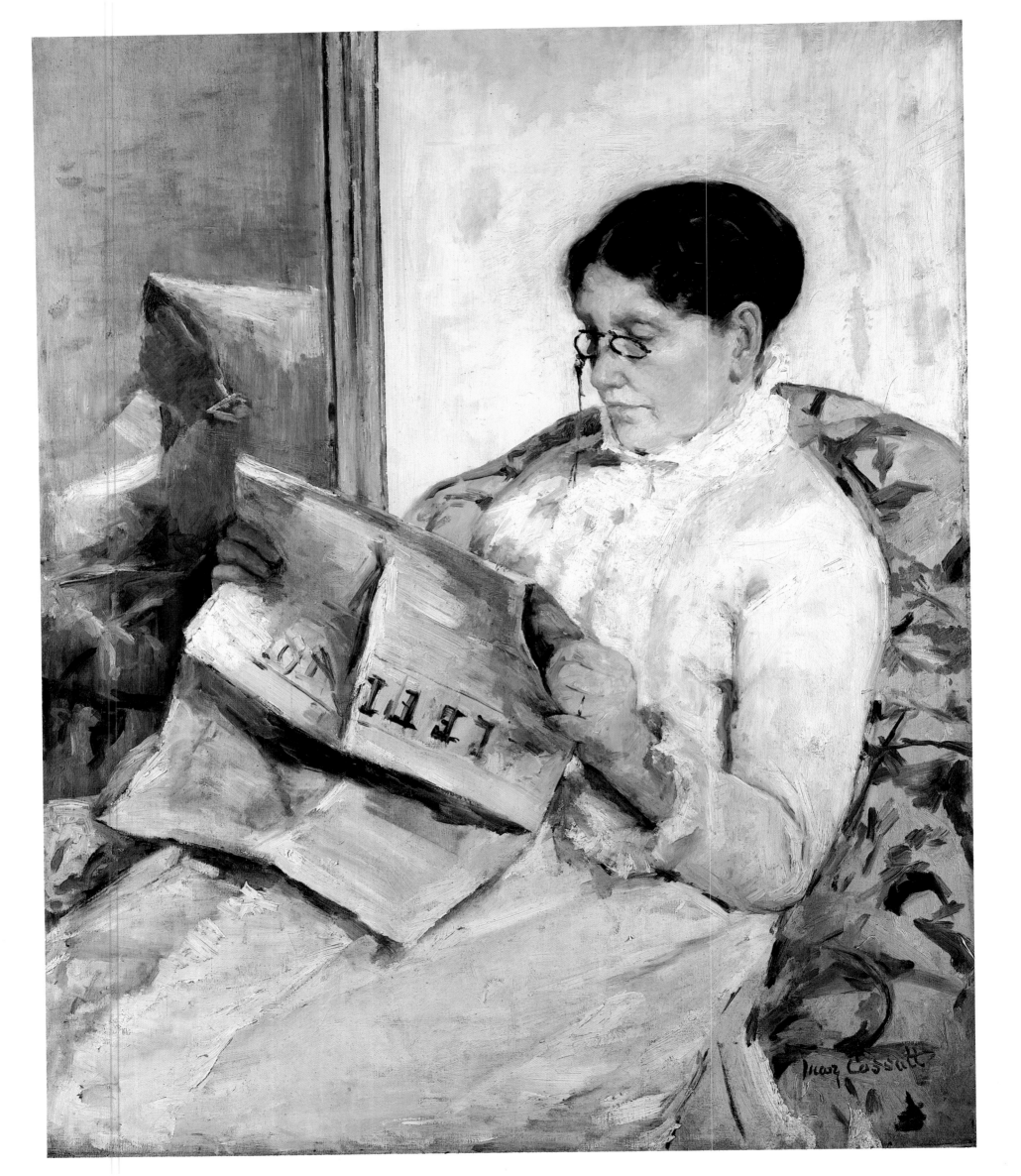

4 Americans and Impressionism, at Home and Abroad

Perceptions and Misperceptions

ALTHOUGH THE TERM *Impressionism* was subject to many interpretations in America, especially in its earliest usage, American artists and critics gradually came to understand its salient characteristics.[1] The Impressionists, both the French originators of the style and their American followers, used, to varying extents, pure, prismatic colors unmixed on the palette and laid directly on the canvas. Under close analysis each hue is separately visible; at a distance they fuse on the retina to give the illusion of flickering light and vibrating atmosphere, qualities abetted by replacing firm outlines and smooth surfaces with thick impastoes. The intense colorism is heightened by abolishing neutral tones and the blacks and grays used for shadows. These effects, antithetical to academic practice, deny conventional illusionism with its attendant suggestion of three-dimensional modeling. The subject matter of Impressionism is often casual, everyday life, captured with an immediacy enhanced by transient effects of light and atmosphere. This immediacy was emphasized by means of new compositional devices: plunging perspective, cropping of forms (rather than traditional closed and balanced compositions), asymmetrical juxtapositions of crowded forms and emptiness—all devices taken from the newly appreciated arts of photography and of the Orient. The alliance between Impressionism and these new and exotic art forms further underscored the separation between Impressionism and academic art.

French Impressionism can be documented from its first group exhibition in Paris in 1874 at the studio of the photographer Nadar. The artists called themselves the *Société anonyme des artistes peintres, sculpteurs, graveurs, etc...*, but the critic Louis Leroy affixed the name subsequently accepted in an article entitled "Exhibition of the Impressionists" published in the April 25 issue of *Charivari*; the term was derived from the title of Claude Monet's 1872 port scene *Impression—Sunrise*. The group held seven more exhibitions, through 1886, although the composition of its membership as well as its aesthetic changed considerably over the twelve-year span, and none of the fifty-five artists whose work appeared in one or more exhibitions participated in every show. Strangely, although thousands of American artists were studying in Paris during these years, they seemed for the most part uninterested in the new movement and in its public exhibitions, particularly the earlier ones.

One of the first American painters to look closely at French Impressionist

17. MARY CASSATT (1844–1926). *Reading "Le Figaro,"* 1878. Oil on canvas, 39¾ x 32 in. Private collection.

painting was the master landscapist George Inness, and his comments are incisive though hardly sympathetic. In all likelihood, Inness saw paintings by the Impressionists when, returning from an extended stay in Italy, he spent a year in Paris beginning in spring 1874. By 1879, when his first article about it appeared in the American edition of the *Art Journal*, he was obviously familiar with French Impressionism, and yet the only example that he might have seen in America was a single Degas pastel. After condemning Pre-Raphaelitism for its material concerns, Inness went on to say:

> Impressionism has now become a watchword, and represents the opposite extreme to pre-Raphaelitism. It arises from the same skeptical scientific tendency to ignore the reality of the unseen. The mistake in each case is the same, namely, that the material is the real. It was supposed by the founders of the Impressionist school that the aesthetic sense could be satisfied by what the eye is impressed with. The Paris Impressionists a few years ago had so nearly succeeded in expressing their idea of truth, that only flat surfaces, the bounds of which represented, at some points, defined forms, appeared on their canvases. Everything was flat. But God's truth is only made more evident by such error....[2]

To evaluate Inness's diatribe against Impressionism, one must be aware not only of his basic belief in the spiritual interpretation of landscape, and reality itself, informed by his Swedenborgian religiosity, but also of the new classicism that had developed in his art during his latest Italian sojourn. (Swedenborgians viewed the world as a material reflection of the more fluid, everchanging spiritual hereafter.) *The Monk* of 1873 (plate 18) exemplifies this new classicism, and its traditional principles of structure and harmony seem diametrically opposed to Impressionism's sketchy spontaneity.

Inness's antipathy to Impressionism continued and became almost a cornerstone of his aesthetic. This is obvious, for instance, in his now famous letter to the important writer and critic George Hitchcock, who solicited information from Inness in 1884 for a catalog of his painting at the American Art Galleries in New York. In his reply, written from Goochland, Virginia, Inness stated:

> Just as I have fought Pre-Raphaelitism I fight what I consider the error of what is called impressionism.... While Pre-Raphaelitism is like a measure worm trying to compass the infinite circumference, impressionism is the sloth enrapt in its own eternal dullness. Angularity, rotundity involving solidity, air and light involving transparency, space and colour involving distances, these constitute the appearances which the creative mind produces to the individualized eye and which the organized mind endorses as reality. A representation which ignores any one of these elements is weak in its subjective and lacking in its objective force and so far fails as giving a true impression of nature.[3]

Even at the end of his life Inness continued to rail against Impressionism.[4] Despite his vehement denouncements of the aesthetic, later historians have noted that the increased colorism and the atmospheric dissolution of his work of the 1880s and '90s is related to the new art form, although its spiritual content is very different.

While Inness bluntly expressed his negative response to the work of Monet and his associates, American critical evaluation of the movement was confounded by indecision as to exactly what Impressionism was. American critics began to notice the French movement by 1876, when Henry James reviewed the second Impressionist exhibition for the *New York Tribune*. He found the work "decidedly interesting" but nevertheless preferred the "good old rules which decree that beauty is beauty and ugliness, ugliness...for the young contributors to the exhibition of which I speak are partisans of unadorned reality and absolute foes to arrangement, embellishment, selection.... None of the members show signs of possessing first-rate talent, and indeed the 'Impressionist' doctrines strike me as incompatible, in such an artist's mind, with the existence of first-rate talent."[5] A year later, in the *Nation*, James gave a negative review to some of Whistler's Nocturnes, Arrange-

"*I am seventy years of age, and the whole study of my life has been to find out what it is that is in myself. . . . Now there has sprung up a new school, a mere passing fad, called Impressionism, the followers of which pretend to study from nature and paint it as it is. All these sorts of things I am down on. I will have nothing to do with them. They are shams.*"

George Inness, 1894. Quoted in George Inness, Jr., *Life, Art, and Letters of George Inness*, p. 168.

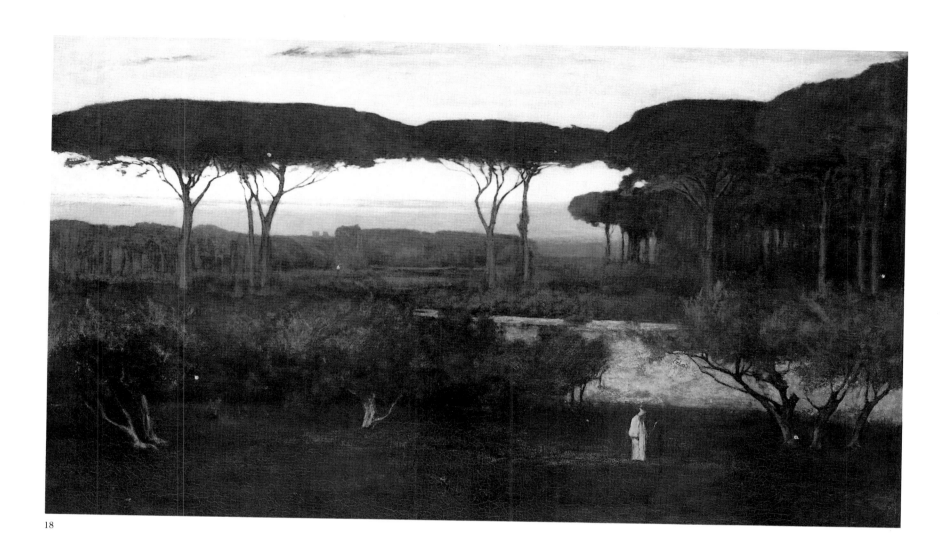

18

"*We cannot in fact understand the purpose of the new school. It is founded neither on the laws of Nature nor the dictates of common sense. We can see in it only the uneasy striving after notoriety of a restless vanity, that prefers celebrity for ill doing rather than an unnoted persistence in the paths of true Art. . . . [The Impressionist exhibition] was worth seeing for the same reason that one would go to see an exhibition of pictures painted by the lunatics of an insane asylum. . . .*"

American Register, May 17, 1879, p. 4.

ments, and Harmonies exhibited at the Grosvenor Gallery, stating: "Mr. Whistler, it is known, is an 'impressionist'; one of his nocturnes is his impression of Mr. Henry Irving, and another his impression of Miss Ellen Terry. It may be good to be an impressionist; but I should say on this evidence that it were really better to be an expressionist."[6] The American critic William C. Brownell wrote more positively about the impressionistic qualities of Whistler's work in an important article in *Scribner's Monthly* for August 1879.[7] Whistler, however, with his belief in art for art's sake and his emphasis upon a muted, misty palette, was far more a Tonalist, as defined earlier, than an Impressionist.

Confusion over what constituted Impressionism seems to have increased in the early 1880s. Lucy Hooper, the strongly conservative Paris critic for the *Art Journal*, correctly identified the aesthetic and its practitioners when, in 1880, she noted:

> The Impressionists have opened an exhibition at No. 1 Rue des Pyramides; but the most celebrated of the group, M. Manet, has not seen fit to join his forces to those of his brethren and sisters, and has gotten up, like M. de Nittis, an exhibition of his own on the Boulevard des Italiens. Of M. Manet it must be said that he is less mad than the other maniacs of impressionism . . . he is not to be judged by the same standard as are those who have joined the ranks of the impressionists merely because it is easier to dash off an unnatural daub, defying all the rules of perspective and colouring, than it is to paint an accurate and carefully-finished picture.[8]

When American critics of this time acknowledged Impressionist qualities in the work of native artists they obviously misunderstood Impressionism even as the

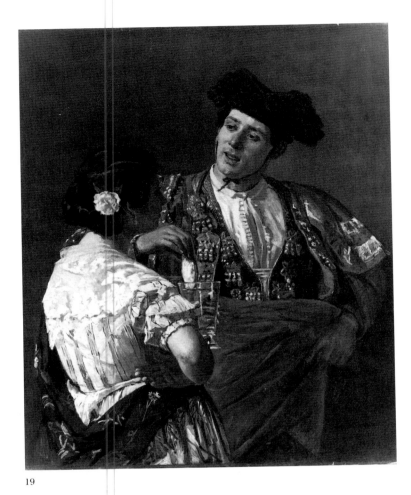

19

term came more and more into more general usage. Thus a writer in *Lippincott's Magazine* for April 1881, reviewing the New York Water-Color Exhibition, wrote: "Frank 'impressionism,' indeed, is characteristic now of many of our cleverest men. Mr. Winslow Homer led this list this year, perhaps, and his rivals were Mr. Blum and Mr. Currier, who are both impressionists, though of very different kinds."[9] J. Frank Currier was hardly an artist concerned with dissolution of light into prismatic color but rather a Munich-trained painter whose canvases emphasized neutral tones and rich blacks laid on with slashing brushwork. And indeed these hallmarks of the advanced Munich style seem to have become identified as "Impressionism" by critics in the United States. This was discussed at length, again negatively, in the short-lived magazine the *Studio and Musical Review*, beginning with two articles on February 26, 1881. One of these, by Munich artist and critic Frederick Pecht, was even entitled "The Impressionists under Heavy Fire. Attacked in Their Own Stronghold by a German Master," while a second, "The Impressionists," noted that "Impressionism, as a serious school of art, has spent its force in America."

That this "Munich version" of Impressionism was associated with the new Society of American Artists—established in New York in 1878—was made abundantly clear in two reviews in April of that year by Archibald Gordon of the fourth annual exhibition of the Society, entitled, "The Impressionist Painters" and "The Impressionists."[10] Reading Gordon, one can understand what was condemned as "impressionism" in the early '80s: especially patchy daubing of paint (William Bunce's *Venezia*), enigmatic meaning and "chromatic atrocity" (Albert Pinkham Ryder's *In Splendor Rare the Moon*), "bad drawing and smart tricks" (William Merritt Chase's *Interior of a Studio*), crudeness and materiality (William Dannat's *Spanish Gypsy*), and generally sketchy, careless, conventional treatment, and false perspective, anatomy, and color. Gordon also links this interpretation of Munich-based Impressionism to French art, but to the painting of Bastien-Lepage rather than to Manet or Monet. He most condemned Bastien-Lepage's *Joan of Arc* (plate 15), which had been lent to this exhibition of otherwise American works: "No picture of them all deserves heartier reprobation than this example of impudent and pretentious materialism."

It is difficult to determine how long this critical misconception of Impressionism held in America. In a sense it can be viewed as the adoption by conservative writers of *Impressionism* as a term of opprobrium applied to the radical Munich aesthetic, however inaccurately. But even as the Munich style became more acceptable, and examples began to appear at the more traditional National Academy of Design, the term was still applied though no longer in condemnation. Thus in Charles Kurtz's *National Academy Notes* of 1883, Bunce's *A Sail in Gray* and John Twachtman's *Marine* were objectively characterized, with no hint of deprecation, as "examples of the impressionist school."[11]

French Impressionist painting would not be correctly identified in America until it was seen in large numbers. Similarly, American artists were rather haphazardly deemed "Impressionists" until the aesthetic was wholeheartedly adopted by native artists, and this occurred only in the late 1880s, with one exception. That exception was Mary Cassatt, and even in her case there is some confusion regarding the appearance of her work in America during the crucial decades of the 1870s and '80s.

Mary Cassatt

It is ironic that the artist who is arguably the greatest of the American Impressionists can be considered both "American" and "Impressionist" only in a qualified sense. Certainly she was American born and bred, and maintained the allegiance throughout her life, though at a distance.[12] Nevertheless, Cassatt's role in the adoption and development of Impressionism in America is relatively marginal, attributable more to her personal influence on American collectors than to the

impact of her work. While some of her paintings undeniably fall under the rubric of Impressionism, these works seldom, if ever, were among her relatively few pictures that came to America in the late nineteenth century.

Mary Stevenson Cassatt was a member of a wealthy, socially prominent Pennsylvania family; though born in Allegheny City in the western part of the state, she grew up in Philadelphia. There she began her artistic studies in 1860 at the Pennsylvania Academy of the Fine Arts, but, in retrospect at least, she did not find that training agreeable, and in 1866 she became part of the first group of post–Civil War artists to seek professional training in Paris, as did Thomas Eakins and other Philadelphia painters. Unable to enter the Ecole des Beaux-Arts because of its proscription against women students, she took private lessons with Gérôme and quite possibly she enjoyed some training with Couture at Villiers-le-Bel.[13] She also attended classes at the atelier of Charles Chaplin, a fashionable painter of women. The Franco-Prussian War forced Cassatt to return to America, but she eagerly hurried back to Europe in 1871. She spent most of 1872 in Parma, studying with Carlo Raimondi, investigating the Old Masters, and painting two commissioned copies. In Italy she developed a lifelong admiration for a number of

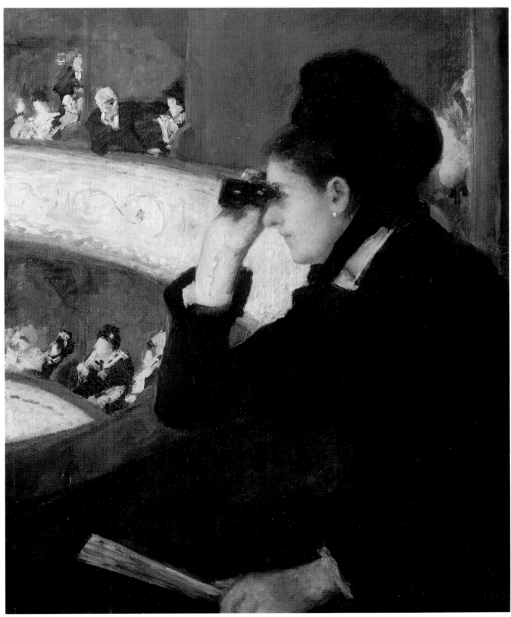

19. MARY CASSATT. *Torero and Young Girl*, 1873. Oil on canvas, 39¾ x 33½ in. Sterling and Francine Clark Institute, Williamstown, Massachusetts.

20. MARY CASSATT. *At the Opera*, 1880. Oil on canvas, 31½ x 25½ in. Museum of Fine Arts, Boston; Charles Henry Hayden Fund.

20

sixteenth-century masters, above all Correggio and Parmigianino, but it is specious, I think, to connect her enthusiasm for them with her later concentration on the mother and child, the modern Madonna.

A decisive break occurred in Cassatt's career when she visited Spain in October 1872. Like many artists of her generation, she was attracted to the painting of Velázquez; she admired the work of Murillo as well. Cassatt moved from Madrid to Seville, where she did a number of paintings of contemporary Spanish life, in the style not of the Old Masters, but of the greatest contemporary interpreter of Spanish subjects, Edouard Manet. The finest of these, her *Torero and Young Girl* of 1873 (plate 19), is exceptionally strong figure painting, and while the sure treatment of the two interacting forms reveals her academic mastery, the lack of ideality and the sense of the momentary ally her with the painters of modern life. The color is rich, dark, and dramatic, and the surface of the painting is vivid with the *alla prima* handling of the medium. Perhaps most important for Cassatt was her insistence on meshing the figures in space, the girl inclining toward the left, and the torero leaning slightly to the right and behind her.

This painting and its companions were taken to Paris by Cassatt in the spring of 1873 and in a sense announced the debut of the mature artist. *Torero and Young Girl* was shown at the Salon, and even more surprising, three of these pictures were exhibited late that year at the fourth Cincinnati Industrial Exhibition. Considering their modernity, so unusual in American art at the time, it is strange that no notice seems to have been taken of the works; instead the critics concentrated on the sentimental German pictures in the show. In 1874 *Torero and Young Girl* was one of two Cassatt paintings shown at the National Academy of Design; there, too, it was ignored by the critics except for the writer in the *Nation*, who perceptively acknowledged that a new force was at large: "The Spanish subjects of Miss Cassatt are remarkable, and have a most cruel blighting effect on those that we remember from Mr. George Hall, our own familiar guide among the scenes of Spain...."[14] Cassatt's Spanish pictures were powerful works in a modern vein, but not at all Impressionist, though in her *Torero and Young Girl* the fascination with colored patterns in the woman's blouse and the bullfighter's flamboyant costume presage a concern that strongly surfaced again in the early 1890s in works such as *The Bath* (plate 28). Monumental figure painting in which anecdote, even when present, was understated, would almost certainly have seemed suspect at the National Academy of Design, but it was very much in keeping with the aesthetics of the Society of American Artists, and it is not surprising that they invited Cassatt to exhibit with them. She did, but only once, in their second annual exhibition in 1879. Although she had begun her long association with Degas two years before and had begun to exhibit with the Impressionists in 1879, the works she sent to New York were in her older, more conservative mode—Manet rather than Degas, if you will. She showed two paintings there, the more significant being the great picture of her mother, *Reading "Le Figaro"* of 1878 (plate 17). It is a strong, objective likeness, brilliant in the handling of almost totally neutral tints and in carving out space with the scoop of the patterned chair purposefully set at an angle for greater three-dimensional force. At the left she placed a mirror—her first use of a device that would continue to be associated with Cassatt and with her mentor, Degas—to underscore the "reality" of the figure's surroundings by presenting the viewer with its painted reflection. The mirror is cut off, like a photographic snapshot, which again stamps the work as "modern."

The New York critics took notice of Cassatt's painting, but only Susan Carter in the *Art Journal* gave it an extended review, perceptively acknowledging the basic naturalism that was the key to Cassatt's modern style: "It is pleasant to see how well an ordinary person dressed in an ordinary way can be made to look."[15] Cassatt was included in a seminal discussion of advanced American painting by William C. Brownell that appeared in *Scribner's Monthly* in 1881 and that was developed around the artists of the Society. Brownell reproduced Cassatt's *At the Opera* of

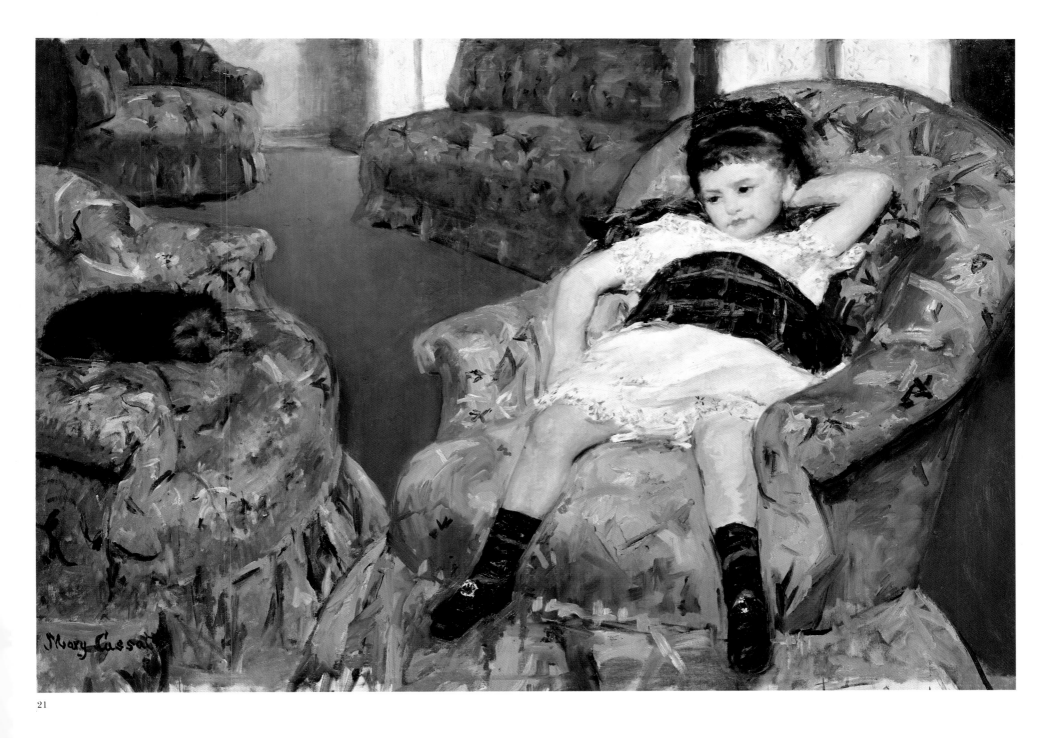

21

1880 (plate 20) and referred to it as an example of the "better sort of Impressionism," but this monochromatic rendering of a strongly silhouetted woman in black is not Impressionist at all. It is, however, an example of Cassatt's art as New York knew it, through reproduction, in the 1870s.[16]

As early as 1874 Cassatt's work had attracted Degas's attention when he saw it at the Salon. The following year she persuaded her good friend Louisine Elder (later Louisine Havemeyer) to purchase Degas's *A Ballet* (now *Ballet Rehearsal*) of 1874 (plate 40). Exhibited in New York in 1878, it may well have been the first authentically Impressionist picture to be seen in America. Meanwhile, Cassatt had been rejected by the Salon jury in 1877, and her great picture *Little Girl in a Blue Armchair* (plate 21) had been refused by the American section of the 1878 Exposition Universelle in Paris; her *Head of a Woman*, which *was* accepted and shown, seems to have been universally ignored. Once Cassatt began to show with the Impressionists in 1879 she never again sent her work to the Salon, denouncing the concept of the juried exhibition.

The ungainly pose of the young girl in *Little Girl in a Blue Armchair*, which may have been a critical factor in the picture's rejection, embodies her commitment to the realist basis of the Impressionist aesthetic and, more specifically, to the figural

21. MARY CASSATT. *Little Girl in a Blue Armchair*, 1878. Oil on canvas, 35¼ x 51⅛ in. National Gallery of Art, Washington, D.C.; Mr. and Mrs. Paul Mellon Collection.

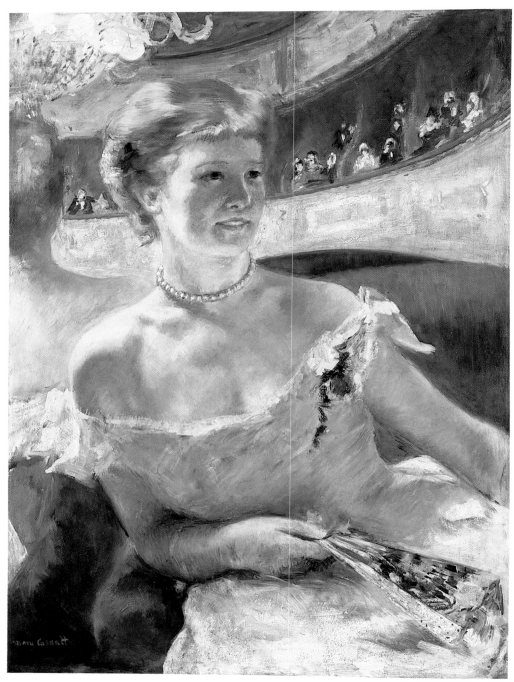

22

style of Degas himself. The child was the daughter of a friend of Degas, and Degas, in fact, worked on the picture. Louisine Havemeyer recalled a letter from Cassatt: "How well I remember, nearly forty years ago, seeing for the first time Degas' pastels in the window of a picture dealer on the Boulevard Haussmann. I used to go and flatten my nose against that window and absorb all I could of his art. It changed my life. I saw art then as I wanted to see it."[17] Yet it must be emphasized that Cassatt was never Degas's pupil. What she gained from Degas was a controlled spontaneity, a disciplined freedom of paint application, and a devotion to contemporary subject matter portrayed in an objective, candid manner. *Control* is the key word here, and that control was applied to the figure—rarely to landscape or even landscape settings, for Cassatt's figures were usually set indoors and in even illumination. Her color assumed a higher key and a fuller chromatic range, but one can refer to Cassatt as a "full" Impressionist only during the years she

exhibited with the Impressionists, 1879–86, and even then not in all her works.

One of Cassatt's most colorful and Impressionist pictures, and arguably her most beautiful painting, is *Lydia in a Loge, Wearing a Pearl Necklace* of 1879 (plate 22), shown that year in the fourth Impressionist exhibition. Her sister, Lydia, is depicted in soft reflected illumination from a chandelier, visible in the background mirror in which Lydia's back and the range of boxes also appear—the background, then, is a reflected "illusion" rather than the real space of the theater. There is no middle ground, only Lydia up front and the distant row of boxes; yet that distance is actually in the immediate foreground because it is a reflection—the result is a very sophisticated spatial ambiguity, highly original for Cassatt and yet derived from the imagery of Manet and Degas. The theater is prominent in Cassatt's art of this period, as in Degas's, but this picture seems incredibly advanced for any American artist, including the Cassatt of just a year or two earlier. Yet her somber and monochromatic *At the Opera* was painted the year *after* this picture—Cassatt followed no consistent direction away from neutral tones into the full range of the spectrum.

Lydia in a Loge may also be the first truly Impressionist painting by an American to be so recognized and discussed—and condemned, which is not surprising given the early date—in the American critical press. A reviewer for the *New York Times* noted the Impressionist show on April 27 and was at least perceptive enough to group Cassatt with Degas: "I am sorry for Mary Cassatt; she is a Philadelphian, and has had her place in the Salon—a great triumph for a woman and a foreigner; but why has she thus gone astray! Her 'Lady in an Opera-box' is a nasty representation of a dirty-faced female, in variegated raiment, who in real life, would never have been admitted in any decent society until she had washed her face and shoulders, while the background looks as though painted with the yolk of an egg."[18]

The sparkling coloration of this ravishing painting celebrates, in a sense, not only Cassatt's productivity of this period but also her personal satisfaction. Cassatt was extremely close to her parents and her sister, who came to live with her in 1877. For the next five years the artist was able to bask in the congenial atmosphere of familial warmth and membership in a professional band of innovative

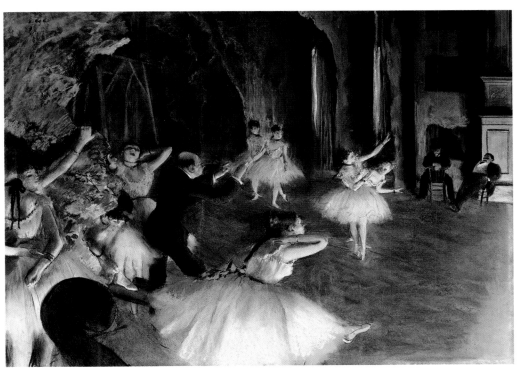

22. MARY CASSATT. *Lydia in a Loge, Wearing a Pearl Necklace*, 1879. Oil on canvas, 31⅝ x 23 in. Philadelphia Museum of Art; Bequest of Charlotte Dorrance Wright.

23. EDGAR DEGAS (1834–1917). *The Rehearsal on the Stage*, c. 1874–78. Pastel over brush and ink drawing on paper, 21 x 28½ in. The Metropolitan Museum of Art, New York; The H. O. Havemeyer Collection.

23

artists. During this period, when her work was most strongly Impressionist, her most frequent model was her sister. After Lydia died in 1882 Cassatt was much saddened, and something of the rich radiance of Impressionism was lost in her work, though it remained essentially coloristic. The emphasis on depicting children, with or without adults, increased markedly soon after Lydia's death, as if the object of Cassatt's pictorial affection was necessarily replaced by another theme, less personal but broader in range. Even so, her treatment of children and childhood remained as sympathetically objective as her renditions of her sister had been. There was never sentimentality in her work.

Lydia was not Cassatt's inevitable model even between 1879 and 1882, and some of her most beautiful *and* Impressionist pictures depict other subjects. While something of Renoir's elegance informs her painting at this time, Degas's influence remains paramount, despite certain thematic dissimilarities. Cassatt painted mostly women and children, separately and together—sophisticated young women, women of fashion, women in upper-class dwellings or at the theater. Unlike Degas's dancers, the latter are patrons of the theater, not performers, and although Cassatt's subjects wear modish costumes and hats, they are never milliners. Her models look like, and usually were, women with at least some social pretensions; she did not paint models per se. Like Degas, Cassatt was more comfortable creating strongly structured forms—certainly part of her academic heritage—in interior settings with controlled illumination, particularly about 1880. One could probably find a correlation between her increasing emphasis on firm drawing and strong outlines from the mid-'80s on and her greater tendency to set subjects outdoors—as though one compensated for the other.

In Cassatt's superb *Cup of Tea* of about 1880 (plate 24), Lydia is shown with a cup momentarily poised at her mouth, a casual, almost snapshotlike gesture that could exist only for a few seconds. Yet no picture by the artist is more carefully calculated; the cup's saucer is held just below it in the absolute center of the painting, a small but strong horizontal element of stability. Likewise, the artist manipulates the large forms of the two simply garbed women against a riot of patterns—the large floral shapes of the sofa on which they sit and the strong vertical design of the wallpaper behind. Both women are left of center, asymmetrically balanced against the open space between the tea set and the distant fireplace casually cut off at the right. This asymmetry of form and balance of solids and voids is an Oriental strategy that was often adopted by Degas.

A number of Cassatt's paintings of Lydia from 1880 show her outdoors; perhaps the most colorful is *Lydia Crocheting in the Garden at Marly* (plate 25). Cassatt had taken a villa at Marly-le-Roi that summer, next to the villa of Edouard Manet, and the coloristic strength relates to Manet's outdoor garden pictures of the time. Often Cassatt depicts Lydia quietly engaged in solitary activities—crocheting, reading, working at a tapestry frame. Susan, an unidentified model for much of Cassatt's work at this time, may have been related to her longtime faithful maid and attendant, Mathilde Valet, and may have begun to pose as Lydia became increasingly ill. Probably Cassatt's finest painting of her is *Susan with Dog on a Balcony* of 1883 (plate 26), in which the strongly modeled figure complements Cassatt's interpretation of bright sunlight and casts shadows onto the bright blues, pinks, and other hues. Colors *are* brilliant, but form is emphatically *not* dissolved. The placement of the subject on a balcony parallels the exploration of this device by other Impressionists, above all Gustave Caillebotte. The balcony setting allowed artists like Caillebotte to work with a combination of ambiguities—indoor-outdoor settings and an on-high, plunging vantage point. While the ambience suggests Cassatt's awareness of this strategy, her use of it is limited. She instead explores the more traditional contrast of the thin, geometrically rigid black iron supports to the rounded, swelling forms of the figure, which is further set off by the angles of the wall and doorway. Significantly, the distant background architecture is also summarized in sharply angled brushstrokes.

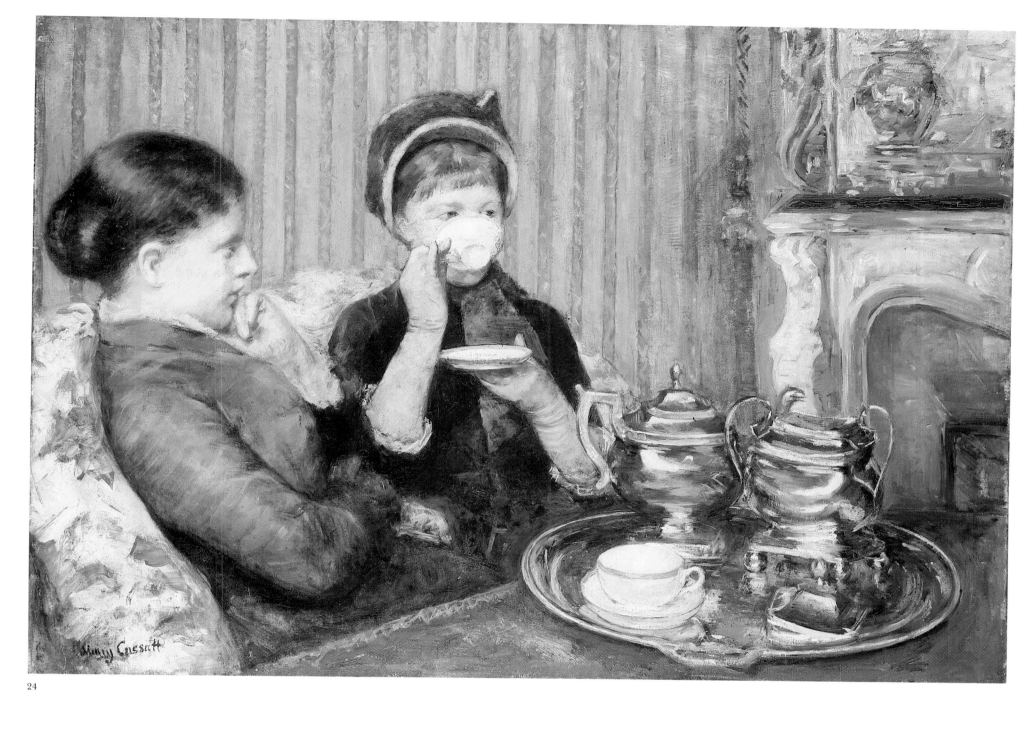

24

The maternal theme is the one, of course, that has been most associated with Cassatt, and the first full-length monograph on her, published in 1913 by Achille Segard, was called *Mary Cassatt, Un Peintre des enfants et des mères*.[19] Since such an identification doubly endangered the artist, both in suggesting a narrow artistic vision and a potential for sentimentality, more recent writers have tended to downplay the significance of this theme, sometimes suggesting that it was only a later development in her art. This theme, however, gave her biographers the irresistible opportunity to relate her fascination with children and mothers to her own unmarried and childless state.

Children emerged as a major subject as early as *Little Girl in a Blue Armchair* of 1878, and Cassatt began to explore the maternal theme by 1880; one of the first of those major efforts is her *Mother About to Wash Her Sleepy Child* (plate 27), shown that year in the fifth Impressionist exhibition. The same aesthetic principles of her nonmaternal subjects govern these works: concern with a balance of solid modeling, rich paint qualities, and coloristic exploration; powerful draftsmanship and an interest in contrasting patterns; an interpretation at once momentary and objective; and a heritage from naturalism that insured completely convincing images. Some recent writers on Cassatt have identified her pictures of mothers and

24. MARY CASSATT. *Cup of Tea*, c. 1880. Oil on canvas, 25½ x 36½ in. Museum of Fine Arts, Boston.

children as modern Madonnas, but it seems that she firmly insisted on removing religious overtones and very deliberately shunned the traditional; more convincing is the recent interpretation of Cassatt as an artist who devoted her talents primarily to exploring the experiences of her class and sex.[20] A natural modernity seems uppermost in her conception, and she often averts the face of her adult, if only partially, to avoid formality. Interestingly, the critics seldom allied Cassatt or her work with American contemporaries, even those who shared certain stylistic or thematic preferences. Rather, she was consigned to the French artistic camp and frequently compared to Berthe Morisot, who also painted domestic themes in a modified Impressionist manner. Cassatt was usually deemed the more powerful of the two.[21]

By the mid-1880s many French Impressionist painters had begun to move away from the dissolution of form into light and color, recognizing what had been lost in abandoning traditional structure. Cassatt, too, sought to reinvest her work with a greater sense of design, though she had never forsaken it to the extent that Monet and Renoir had, for instance. This was not a sudden change, and loose, free brushwork reappeared often in her work; but by 1890 strong, sharply outlined, more emphatic patterning predominated. This is best seen in *The Bath* of about 1892, the first item in the catalog of her important exhibition at Durand-Ruel in Paris in 1893, two years after her first show there and the first with a significant complement of her painting. The maternal theme dominates but only very generally; a woman, traditionally identified as "a mother," is busy washing the feet of an infant and both seem engrossed in the activity—or perhaps in the water temperature; in any event, the spiritual is totally absent. But that is the subject of the picture; what really interests the artist is the integrated design of the two figures silhouetted against a series of contrasting patterns: the bold olive, purple, and white stripes of the woman's dress play against the diamond pattern of the rug and the different flower patterns on wallpaper and chest behind, while the curvilinear shapes of bath bowl and water pitcher strongly contrast with the dominant stripes. Also striking is Cassatt's adoption of a high viewpoint, looking down on the scene and flattening the figures against the cut-off forms of wall, chest, and rug.

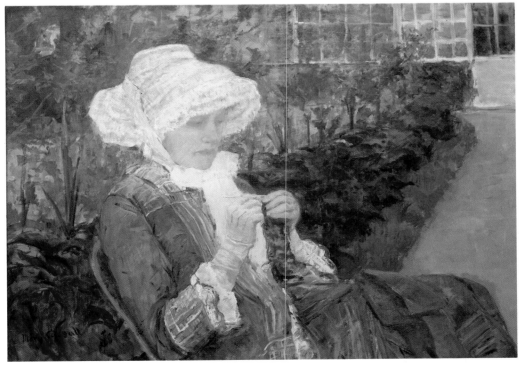

25

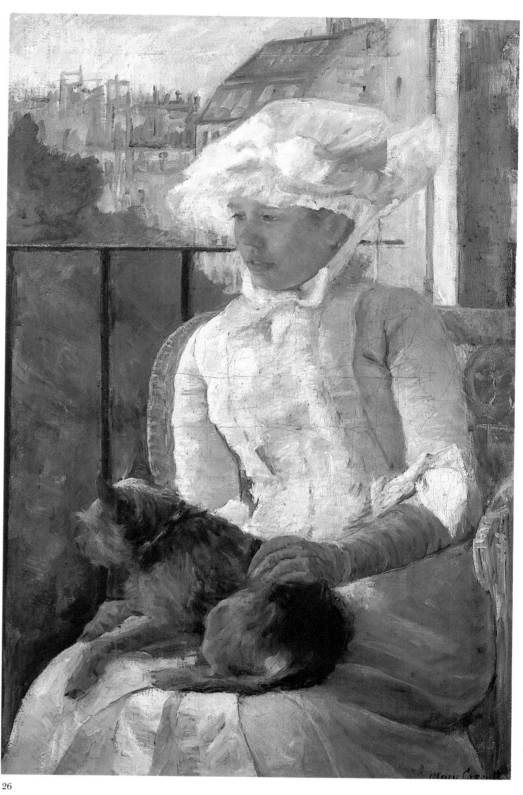

26

Not only the primary viewpoint but its variations are arbitrary—artificial rather than naturalistic design. Thus the pitcher is seen more straight on, which flattens it more completely, while figures and bowl are more compressed when viewed from above.

The changes in Cassatt's art about 1890 resulted in part from her intensifying response to Japanese art. In that year she and Degas visited an exhibition of Japanese art, and its impress is most clearly seen in the magnificent set of intaglio prints she made the next year. With marked success she tried to reproduce the

effects of the Japanese woodblock with a complicated process combining drypoint, soft-ground etching, and aquatint. The new concern with flat color areas, compressed space, and strong linear design was diametrically opposed to orthodox Impressionism. Such qualities and their derivation from Japanese art were discussed, along with Cassatt's indifference to conventional canons of beauty, when her prints were first shown at the Wunderlich gallery in New York in late 1891. One critic said, "The artist has plainly found in this every-day subject abundant opportunity for experiment with simplicity of line and largeness of mass, and has relied with faith on the power of her art to make her work interesting...."[22]

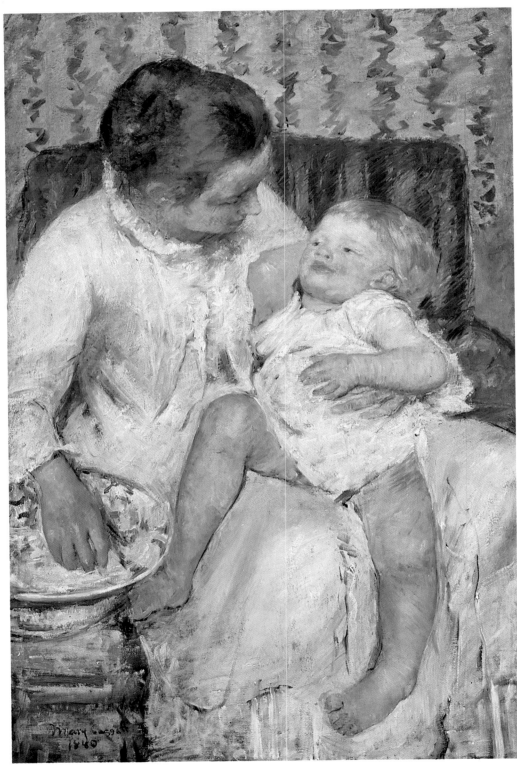

27. MARY CASSATT. *Mother About to Wash Her Sleepy Child*, 1880. Oil on canvas, 39½ x 25¾ in. Los Angeles County Museum of Art; Mrs. Fred Hathaway Bixby Bequest.

28. MARY CASSATT. *The Bath*, c. 1891–92. Oil on canvas, 39 x 26 in. The Art Institute of Chicago; The Robert A. Waller Fund.

27

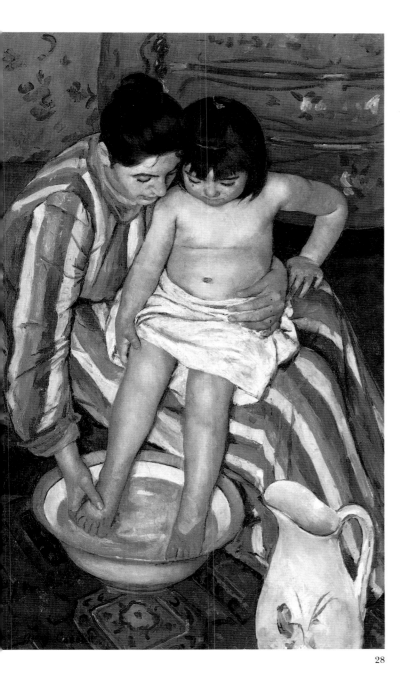

28

Cassatt's 1893 exhibition in Paris was a major one, including significant works as early as *Lydia in a Loge* of 1879. American critics again mentioned her lack of concern for conventional beauty; the writer in the *Collector*, for instance, admired the "...curious charm about her pictures, in spite of her deliberate adherence to the ugly, for she follows the craze of the day that no longer paints ugly as well as pretty models, but scorns beauty and seeks out uncomeliness. The charm can, I imagine, be traced to the fact that she is really a very gifted woman, doing what she does in a fashion which only a gifted painter could." But this critic also noted, with regret, the change that had come over her work: "For my part I liked Miss Cassatt better when she was more of an impressionist, ten years or so ago, and less of an extremist."[23]

The same renewed concern with linear design, flattened forms, and compressed space also appeared in contemporary mural painting. The anti-illusionistic approach of Puvis de Chavannes was the most renowned example and one that had great ramifications in the mural movement in America. Cassatt created a giant, fifty-foot mural, *Modern Woman*, for the 1893 World's Columbian Exposition in Chicago; the companion mural, *Primitive Woman*, was painted by her colleague and fellow expatriate Mary Fairchild MacMonnies. Unfortunately, Cassatt's mural disappeared shortly after the close of the Exposition and may well no longer exist. It is known today, however, not only from photographs but also from several paintings of the period of women picking fruit, which echo the central portion of her allegorical mural, *Young Women Plucking the Fruits of Knowledge and Science*. Cassatt's several easel paintings of the subject continue the more structured design of the early '90s, and this naturally carried over into her mural. Figures are casually disposed in all of these works, but the symbolic overtones of a modern Eden are readily apparent in the lushness of their orchard setting, a setting she used for several other subjects of the period. In the latest of her orchard paintings, *Baby Reaching for an Apple* of 1893 (plate 29), Cassatt seems most explicit in her rejection of traditional iconography, returning the mother and child to pick the apple of life in a garden of fulfillment. Reviewing the related mural in preparation the previous year, Mariana van Rensselaer had noted that there was "...to be no serpent in this nineteenth century Eden.... For today the forbidden fruit is no longer forbidden."[24]

Cassatt painted her mural in France and never saw the work installed in the Woman's Building at the Exposition. She made her first visit back to America in 1898–99 and then another in 1904 but otherwise remained in Europe, frequently traveling with the Henry Havemeyers and helping them to collect Old Master and contemporary paintings. Her final trip home was in 1908–9, but by then her eyesight was beginning to fail and her later art varies in quality. Some works of the early 1900s are surprisingly bold and sure; others exhibit weakness in drawing and roughness in color, suggesting the growing physical deterioration that resulted in total blindness by the mid-teens. Cassatt was more consistently successful in later years when working with pastel, a medium she had begun to explore in the 1870s and with which she seems to have reached a high point by the mid-'90s. *In the Garden* of 1893 (plate 30) is one of the most richly colored and beautiful of all her works, combining strong drawing and vivid coloration with a decorative patterning that some critics attribute to the influence of Persian miniatures. Certainly the graphic, broken nature of the medium, used also by Degas, who influenced her pastel technique, allowed and in some ways even demanded a continuation of the Impressionist techniques she had to a degree abandoned in oils.

In the Garden was one of a carefully selected group shown by Durand-Ruel in New York in 1895. This was the first time a large number of her works, beginning with her Spanish pictures, had been shown in her native country, except for the significant group of prints exhibited by Wunderlich four years earlier. American critical reaction was mixed; the writer in the *Collector* expressed reservations: "That I do not agree with Miss Cassatt in viewing the antithesis of merely pretty

29. MARY CASSATT. *Baby Reaching for an Apple*, 1893. Oil on canvas, 39½ x 25¼ in. Virginia Museum of Fine Arts, Richmond.

30. MARY CASSATT. *In the Garden*, 1893. Pastel on paper, 28¾ x 23⅝ in. The Baltimore Museum of Art; Cone Collection, formed by Dr. Claribel Cone and Miss Etta Cone of Baltimore.

"As to Matisse, one has only to see his early work to understand him. His pictures were extremely feeble in execution and very commonplace in vision. As he is intelligent he saw that real excellence, which would bring him consideration, was not for him on that line. He shut himself up for years and evolved these things; he knew that in the present anarchical state of things—not only in the art world but everywhere—he would achieve notoriety —and he has. Of course all this has only 'un temps'; it will die out. Only really good work survives."

Mary Cassatt to Ellen Mary Cassatt, March 26, 1913 [?]. Quoted in Nancy Mowll Mathews, ed., *Cassatt and Her Circle: Selected Letters*, p. 310.

29

art as the only cogent protest against artificiality and conventionalism, is because I believe that while beauty of form and grace of line are to be found in nature, they are to be preferred to coarser and less lovely themes. But I like to look at Miss Cassatt's works all the same, for those individual qualities which no defects or weaknesses of the motives to which they are applied can hide."[25]

The exhibition occasioned the first article by an American author devoted to Cassatt and her work, written by William Walton and published in *Scribner's Magazine* in March 1896. Walton was extremely discerning in his analysis of Cassatt's art up to the mid-'90s; on her pictures of maternal themes he noted:

> In all of them may be felt that directness and vigor of presentation which has caused this lady to be claimed by the Impressionists; but hers is scarcely impressionistic painting as generally understood, vague as is that term. In all of them may be felt a certain sentiment, or charm, or poetry—something much more than mere good painting. The feeling of nature, of summer air and space, of the charm of green apple orchards, or parks, and, very frequently, the mystery of mother love and the pulchritude of the Baby. But seldom indeed has that inefficient but most valuable of potentates been more carefully studied and faithfully rendered, in many of his various moods, and in his relations with the mother that bore him or the nurse that tends him.[26]

Cassatt's painting gradually came to be seen more often in America, but its impact seems to have been minimal. Younger Americans such as George Biddle who occasionally visited the elderly expatriate as she withdrew more and more into the solitude of blindness found her increasingly embittered and ever more violently opposed to the new movements that succeeded Impressionism in the early twentieth century.[27]

Finish versus the Sketch

As we have seen, a serious confusion arose in the 1870s about the definition of Impressionism. It became identified with a freedom of execution—a "sketchiness"—alien to American art lovers and critics. This negative response was not unique to Americans; Manet's exploitation of the technical process of painting in works such as his *Olympia* of 1863 had been almost as offensive to French viewers as the indecency of his subject. It wasn't the idea of *creating* sketches that seemed radical when they were first seen by the public; it was *exhibiting* them that fostered confusion, debate, and contempt. A work of art to be examined, admired, sold, and acquired was expected to have a high degree of "finish," a completeness in terms of careful drawing and smooth surface that required the elimination of all, or almost all, signs of the technical process of painting.

Thus critical dismay and anger were provoked when sketches began to appear regularly in American public exhibitions during the late 1870s. This reaction was bluntly stated by a writer in *Appleton's*, who invoked Raphael and Titian to elucidate the true meaning and purpose of finish, and then asked:

> What new dogma is this, then, that so long as color is heaped on in a vigorous manner, a picture must be accepted as complete, however crude and raw it may seem, however absolute is the evidence that the artist stopped before he had done?... The sketches of almost every artist show indications of skill; the beginnings of art, it has been well said, are always easy; it is only when sketches are developed into pictures that the full resources of the artist, his limitations, as well as his resources, are made known. Many a sketch indicates breadth, freedom, ease, virility; but the difficulty is, how to carry these qualities to their legitimate end... brought to that state of completeness that the methods and processes of the work are hidden, so that one who looks at it sees textures, not paint, force by virtue of completeness and not by ruggedness, things and not guesses at things.[28]

This was in 1878, a crucial year in the controversy over sketchiness versus finish, the year of the first exhibition of the Society of American Artists. The

31. JAMES ABBOTT MCNEILL WHISTLER (1834–1903). *Nocturne in Black and Gold—The Falling Rocket*, c. 1874. Oil on oak panel, 23¾ x 18⅜ in. The Detroit Institute of Arts; Gift of Dexter M. Ferry, Jr.

32. JAMES ABBOTT MCNEILL WHISTLER. *Canal, San Canciano, Venice*, c. 1880. Pastel on tinted brown paper, 11¼ x 6½ in. The Westmoreland Museum of Art, Greensburg, Pennsylvania; The William A. Coulter Fund.

31

"Of late there has been not a little of amazing jargon in regard to and in behalf of uncompleted pictures. There is no doubt an ignorant notion prevalent that smoothness and polish are the crowning qualities of a 'finished' picture, and it is right enough that instructed criticism should denounce this form of emasculated prettiness. But the critics who rush to the extreme of preferred rudeness and slap-dash to that true finish which completes and helps to render perfect, commit as absurd an error of judgement as those they condemn."

Appleton's Journal, August 1878, p. 185.

exhibition provoked a good deal of critical flak, largely because "sketches," per se, appeared in it as they never had at the National Academy of Design. The writer in the *Nation*, for instance, warned the artists to be less addicted to dragging their "impressions" into the show and calling them "pictures." The reviewer in the art magazine the *Aldine* complained, "Many of these were mere sketches or studies which should not be seen outside of the studio, unless it is the object of the society to simply show what the younger artists of the day are striving to accomplish."[29] But the power of such Old Guard reaction was far outweighed by the support of the newly established professional critical establishment, including Richard Watson Gilder and William C. Brownell of *Scribner's Monthly*, Clarence Cook of the *New York Tribune*, and Sylvester Koehler, editor of the *American Art Review*. Indeed, one might postulate that the demise of the older *Aldine* magazine after 1879 in the wake of competition from the new art periodicals *Art Interchange* (founded in 1878), and the *Art Amateur* and *American Art Review* (both begun in 1879) resulted

46

32

at least in part from its intransigence in the face of change. Cook hailed the new Society for ushering in a revolution, and Koehler, who reviewed American developments in his *American Art* of 1886, subtitled his coverage of the Society's first decade "The Promise." Brownell's series of articles on "The Younger Painters of America," in *Scribner's Monthly* of 1880–81, summed up the recent achievements; American art, he wrote, finally had lost its characterlessness: "We are beginning to paint as others paint."[30] The cosmopolitanism of early Society exhibitions was emphasized by critics such as the reviewer for the *Nation*, who pointed out that both Munich and Paris were represented. Critics also noted that Munich dominated at first, offering a "looser, bolder, broader brushwork," but by 1892 its impact had seriously declined, and even the "most prominent graduates of Munich have departed wholly or in large degree from their old methods."[31]

This was noted by Charles De Kay, the important art writer who six years earlier had written an article called "Whistler, the Head of the Impressionists,"[32] although Whistler himself was far more a Tonalist painter and the promulgator of art for art's sake. While he was a painter of vast significance for American as well as European art, his relationship to the development of American Impressionism was only tangential. It lay principally in his contact with certain American artists beginning late in 1879, in Venice, where Whistler had journeyed with a commission from London's Fine Arts Society to do a series of etchings of the city. He also produced there a large number of pastels, as well as a few Venetian Nocturnes in oil. Among the first Americans he met was Theodore Robinson, but, more important, he developed a rapport with Frank Duveneck and his Duveneck Boys, fresh from Munich; two of them, Otto Bacher and Harper Pennington, wrote engaging accounts of their association with the great expatriate.[33] Whistler's involvement with pastel was essential for the development of that medium in America during the 1880s, which immediately followed his contact with the Americans in Venice in 1880–81 and the highly favorable reviews of his Venice pastels in America as well as England, when these were shown at the London Fine Arts Society in March 1881. The ensuing interest in pastel in this country can be documented by a number of articles.[34]

In winter 1882–83, or possibly that spring, a group of younger New York artists, all just back from Europe, formed an organization referred to as the Pastel Club but officially called the Society of Painters in Pastel.[35] Their first exhibition opened in March 1884, with sixteen artists showing sixty-four works at Moore Gallery in New York. Mariana van Rensselaer noted Whistler's influence in these works[36] and, indeed, the president of the Club, Robert Blum, had known Whistler in Venice. The exhibition was exceedingly well received, and the *Magazine of Art* prophesied correctly that the show would result "in a pastel craze."[37] It seems likely that its success contributed significantly to the increasingly enthusiastic acceptance of Impressionism in America, for pastel painting introduced richness of color and "rapid sketching and the making of short-hand memoranda" noted by the *Magazine of Art* critic, qualities that would soon be seen in Impressionist oil painting. Indeed, one critic of the exhibition noted in the *Art Interchange*: "'Impressionism' is here seen at its sanest and best, and those who are susceptible to the charms of cleverness and dash can find much to delight them...."[38]

Despite this critical success, the Club's second show did not take place until four years later, in 1888. In part this resulted from lack of financial success and in part from the peregrinations of some of the leading members, Blum and Charles Ulrich, who traveled abroad extensively. When the second exhibition finally was held, it was, significantly, at the Wunderlich gallery, where Whistler's work had first been regularly exhibited in New York. Noticeably fewer of the more "finished" pastels were shown. Ulrich and Edwin Blashfield were missing, and the new exhibitors included artists like John Twachtman, who was working in the distinctly sketchy style of Whistler and Robert Blum and was soon to be associated with American Impressionism. Indeed, the critic for the *Magazine of Art* wrote, "Ameri-

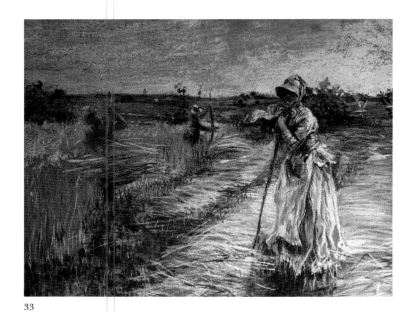

33

34

can pastel is based on French work of the radical sort and impressions are preferred to elaborate composition," and noted, "'Whistlerism' is a powerful element in American pastel work."[39] The third exhibition, in 1889 at Wheeler's Gallery, added Theodore Robinson, whose *Rainy Day in Venice* was noted by the critic of *Art Amateur* "as an agreeable bit of Impressionism."[40] The fourth exhibition, in 1890, was again at Wunderlich (which had shown a group of Whistler's pastels the previous year); it included three works by Childe Hassam, which were characterized by the writer in *Art Amateur* as very Parisian and similar to the work of de Nittis. He noted, too, that Robinson and now also Robert Reid represented the Impressionists.[41]

The Pastel Club held only these four exhibitions and they were consistently well regarded. Perhaps its disappearance can be partly attributed to the continued travels of its founder and president, Robert Blum, who was in Japan and had not participated in the 1890 exhibition.[42] More significant, the Club seems to have been absorbed into other art organizations, notably the American Water Color Society and, even more, the New York Watercolor Club, founded in 1890. Reviews of their exhibitions state that pastels were a large part of the work shown. It is equally meaningful that aesthetic distinctions among the media were being erased. Not only were artists working in "mixed media" but critics often commented that many oils had a chalky, pastel look and that watercolors especially resembled pastels, particularly in the use of thick opaque gouaches in a high color key.

The pastel medium served to introduce many aspects of Impressionism into America, and each of the Club's exhibitions showed an expanded awareness of the new aesthetic as well as increased participation by artists of established or imminent Impressionist persuasion. Although Whistler himself was not an Impressionist, and although initial confusion among critics about his relationship to the movement had obscured their general understanding of the aesthetic, he did significantly influence its evolution in America through the medium of pastel.

French Impressionism Comes to America

The earliest Impressionist-related French artist to garner serious American attention was Edouard Manet, and the earliest American critic to consider his work was Lucy Hooper, the Paris correspondent for the *Art Journal*. A British periodical that was arguably the most significant of the nineteenth century, the *Art Journal* began its American edition in 1875, and that year Lucy Hooper wrote an article for it on Manet's *Argenteuil*, shown in the Paris Salon that April. Condemning it as a "daub," she described the woman's costume as a series of violent streaks, and termed the whole thing dreadful, though admitting that some artists and critics admired the work.[43]

Manet was the subject of a study in *Appleton's* in September 1878,[44] and the following year his work was first seen in America. *Execution of Maximilian* (plate 39) was brought here in November 1879 by Mme. Emilie Ambré of "Colonel" James Henry Mapleson's Italian Opera Company and shown at the Clarendon Hotel in New York and the Studio Building in Boston. The New York critics were surprisingly positive, admiring the splashes of paint and the picture's power and originality. The comments centered as much on its political overtones as on its aesthetic, and Manet was identified as a primary figure in the naturalist movement, allied with his literary colleague Emile Zola.[45] In the 1880s Manet's work was seen increasingly in America, and by the end of the decade his *Child with a Sword* (1860) and *Woman with a Parrot* (1866), acquired in 1881 by the collector Erwin Davis with the help of his advisor, J. Alden Weir, had entered the collection of the Metropolitan Museum of Art. But it must be noted that these were early works by Manet, certainly not fully Impressionist pictures, and it was paintings such as these that gained him increasing admiration. Even so, American reception of Manet was not universally favorable; when his *Entombment* (1864) was shown in the Foreign

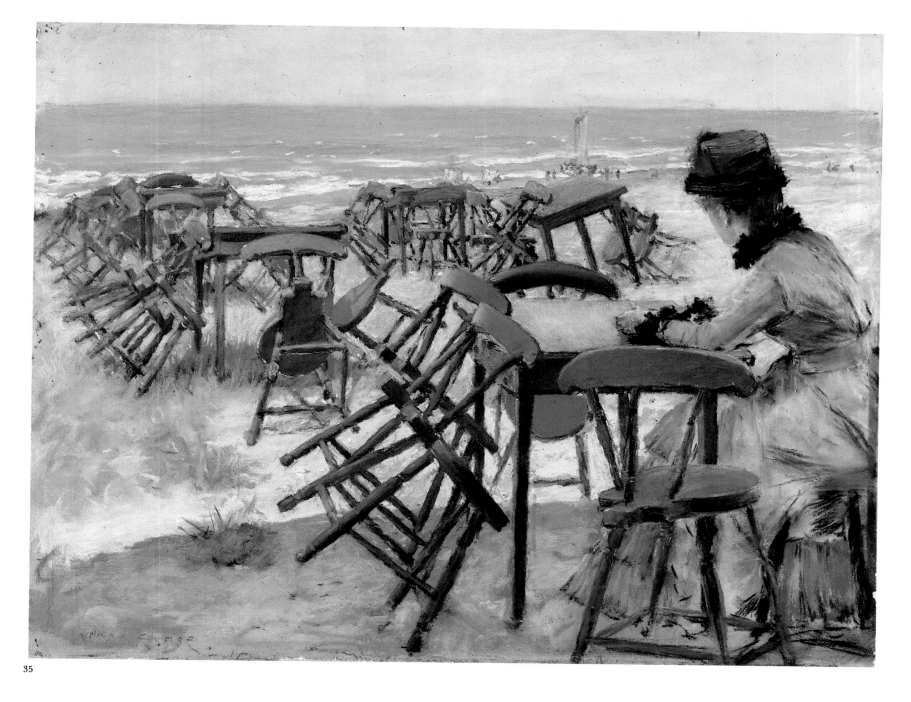

35

Exhibition in Boston, in 1883, William Howe Downes found it "a ghastly and revolting vision of death in its most material and brutal aspect."[46] The following year Theodore Child reviewed the Manet memorial exhibition in Paris, concluding that "there are, out of the immense number of pictures exhibited, very, very few in whose company a man of well-balanced mind and refined taste would care to live...."[47]

Child was to modify his judgment of Manet subsequently, but meanwhile, Impressionism in its purest aspects was becoming far more familiar in America. Manet's *Maximilian* was not the earliest French Impressionist picture seen in this country. In all probability, that distinction is enjoyed by Degas's *A Ballet* (now *Ballet Rehearsal*) (plate 40), a gouache and pastel that Mary Cassatt had advised Louisine Elder to purchase in 1875 and that was exhibited in New York in 1878 at the American Water Color Society. While John Moran, in the *Art Journal*, found the *motif* "unworthy," he deemed the picture "noteworthy" and "exceedingly striking and realistic," recognizing Degas as a leader of the French Impressionists.[48] The critic in the *Century* was more enthusiastic. He, too, recognized Degas as one of the strongest Impressionists; the picture "though light, and in parts vague, in touch" was "the assured work of a man who can, if he wishes, draw with the sharpness and firmness of Holbein."[49]

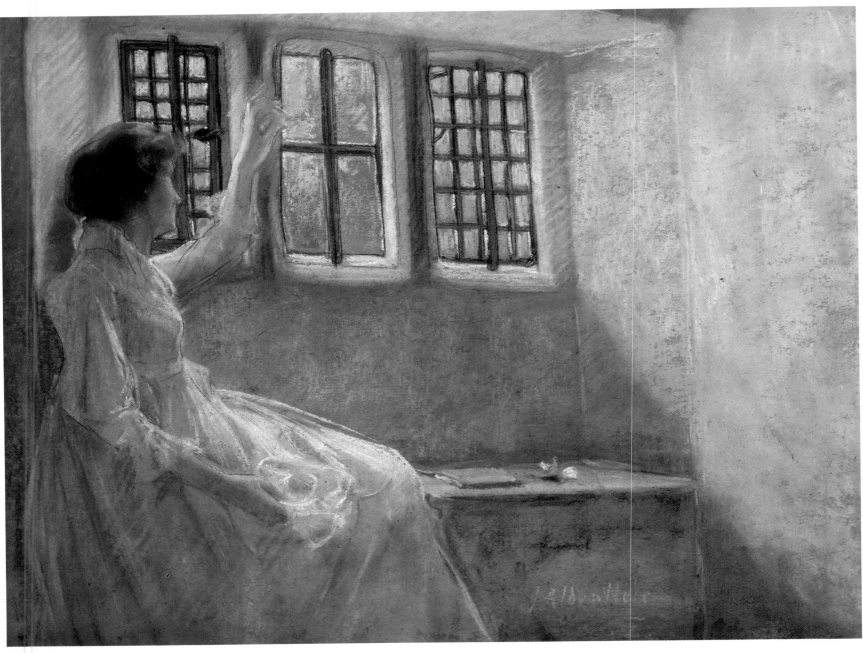

36

36. J. ALDÉN WEIR (1852–1919). *The Windowseat*, 1889. Pastel and pencil on paper, 13¼ x 17½ in. Private collection.

37. CLAUDE MONET (1840–1926). *The Artist's Garden at Argenteuil*, 1872. Oil on canvas, 24 x 28½ in. The Art Institute of Chicago; Mr. and Mrs. M. A. Ryerson Collection.

38. JOHN TWACHTMAN (1853–1902). *Haystacks at Edge of Woods*, 1890s. Pastel on paper, 9 x 12½ in. National Museum of American Art, Smithsonian Institution, Washington, D.C.; Gift of John Gellatly.

In the years immediately following this first showing of an Impressionist picture in America, the public gradually became more aware of the new movement. The first full-scale analysis of Impressionism in an American periodical was written by L. Lejeune and published in *Lippincott's Magazine* in December 1879, but though it attempted to be objective, it was basically critical toward the preponderance of violet tones and the preference for the sketch. Most of all it criticized the lack of concern for locating "the soul behind the material scene." Lejeune called Manet "the high priest of Impressionism."[50]

It was not until 1883 that a full complement of Impressionist art appeared in America. That fall Boston witnessed two very distinct exhibitions, the important American show at the New England Manufacturers' Institute featuring much contemporary painting and accompanied by a superlative catalog, and a show mounted by the Foreign Exhibition Association of arts and manufacturers from abroad, which resulted from a projected Boston World's Fair planned for 1881 but abandoned. About half the oil paintings in the second exhibition were French, and many of them were Impressionist works, sent by the dealer Paul Durand-Ruel. Manet's *Entombment*, reproduced in the catalog, elicited the condemnation of Downes previously quoted, but the exhibition also included six works by Pissarro, four by Renoir (including his famous *Breakfast at Bougival*), four by Sisley, and

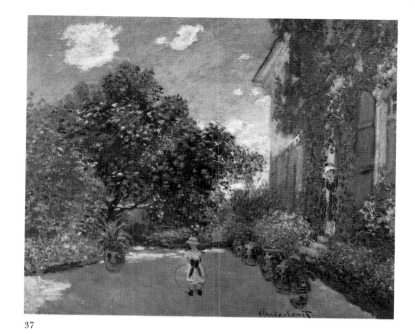

37

38

three by Monet (including one of his Argenteuil garden). Thus for the first time the American public had an opportunity to view a full representation of the new aesthetic. The critical response was curious; the writer in the *Art Interchange* reproved the bad drawing and curious coloring but found a freshness and piquancy that gave the works charm. A more conservative critic writing for the "Monthly Record of American Art" in the American edition of the *Magazine of Art* identified a strong appeal to literary interest and condemned the "contempt of drawing, impossible color, and childish, puttering handling."[51]

Late that same year New York enjoyed the Pedestal Fund Art Loan Exhibition, organized to raise money to construct a base for the Statue of Liberty. The painting display was supervised by J. Carroll Beckwith, but the guiding spirit was William Merritt Chase. Chase had led J. Alden Weir to Manet in the first place, when Weir was pursuing acquisitions for Erwin Davis, and Chase arranged a substantial loan of works from Davis for the exhibition, including two paintings by Manet. These received the place of honor in the show, and Chase was castigated by the critics for giving such work emphasis at the expense of more traditional and popular French masters; but, as the writer in the *Art Interchange* recognized, neither of Manet's paintings was Impressionist. Degas's *The Ballet*, also owned by Davis, was certainly the most advanced picture in the exhibition. Mariana van Rensselaer called it a "superb bit of brush-work" and praised Chase and Beckwith for their first-rate selections and for including Manet and Degas against the wishes of more populist forces. The writer in the *Art Amateur* mentioned these French painters and concluded that "all the good painting of the men who will come into notice during the next ten years will be tinged with impressionism."[52] He was not mistaken.

Concern in America with the new art movement remained relatively dormant until summer 1885, when James F. Sutton of the American Art Association invited Durand-Ruel to organize an exhibition of Impressionist paintings for New York. The opportunity must have seemed a godsend to Durand-Ruel, who recalled American enthusiasm for the Barbizon paintings he had previously handled, and he probably saw the possibility of recouping his fortunes after recent financial difficulties. Approximately 290 paintings arrived in New York on March 23, 1886, and the exhibition opened on April 10. The controversial show was so popular that it was transferred to the National Academy of Design, where it reopened on May 25. The show was almost totally Impressionist. The few non-Impressionist, more academic works were carefully placed at the entrance to lead the visitor gently into the installation. Once there, however, the viewer found twenty-three canvases by Degas, seventeen by Manet, fifteen by Sisley, seven by Morisot, thirty-eight by Renoir, forty-two by Pissarro, and forty-eight by Monet. Strangely, none by Cassatt were sent from abroad, but her brother, Alexander, lent two of her pictures to the National Academy. Though the catalog did not distinguish among media, the show was entitled a *Special Exhibition of Works in Oil and Pastel by The Impressionists of Paris*, underscoring the significance of the pastel medium. The critical reaction to the exhibition was extensive, and from 1886 Impressionism continued to receive great attention from the press, both newspaper and periodical; the latter included general magazines as well as the growing number of specialized art publications. The newspapers, such as the *New York Herald* and the *New York Times*, tended to reject Impressionism. The art magazines clearly betrayed their conservative or liberal leanings. The *Magazine of Art* quoted its own negative review of the Boston Foreign Exhibition of three years earlier, after a reference to the disagreeable task of reviewing the 1886 show. This attitude was only slightly amended with the additions made at the National Academy; the writer stated that the "quality has been raised somewhat by loans from New York collections and a couple of works by Mary Cassatt." The writer in *Art Age* commented at great length about the show as "Communism incarnate," tracing the heritage of Impressionism back to Gustave Courbet.[53] The writer in

39

the *Art Interchange* made a better attempt to understand the purposes and techniques of the Impressionists but concluded with a generally negative reaction. Roger Riordan, one of the more perceptive modernist writers, adopted a more historical approach in the *Art Amateur*; he viewed Monet as heir to Turner, and Pissarro to Millet. Riordan was lukewarm about most of the Impressionists, but he often singled out specific works in a very positive manner, such as Manet's *The Beggar* and his *Battle of the Alabama and Kearsarge* (1864), and tended to be most favorably inclined toward Renoir.[54] The most perceptive review, and the most positive one in an art magazine, was in Clarence Cook's *Studio*. Cook found in the show

> more than a simple pleasure, it is exhilarating delight to find ourselves for once in a collection of pictures, and of French pictures too! in which not a single one of the black band appears.... Allow for all exaggerations, deduct for all the crudeness, and vain shooting at the sun, what every one must feel is here, is the work of men delighting in the exercise of their art, not working at a task for the sake of boiling the pot, nor weaving rhymes at a penny a line, but singing as they paint, and facing the new world with the leaping wine of discovery in their veins.[55]

Except for Cook, the most receptive critics of the 1886 show were the writers for general periodicals. Some of them, too, were uncomprehending; the writer in the *Nation* referred to Impressionist paintings as "magnificent insanities," and Edward Garczynski in the *Forum* repeatedly referred to them as monstrosities. But the writer in the *Critic* distinguished between the tenderness and grace of Impressionism reserved for landscape and the hard brutality of naked truth in the figure painting, concluding that "New York has never seen a more interesting exhibition than this." And Luther Hamilton, writing in the new periodical *Cosmopolitan*, called the show refreshing and unique, a protest against the commonplace, and "one of the most important artistic events that ever took place in this country...."[56] The most analytic and well-rounded review was written by Mariana van Rensselaer, and it appeared in two issues of the weekly *Independent*. After acknowledging the materialism, the lack of modeling and outlines, the disregard of conventional beauty, the seeming crudeness and carelessness in drawing and coloring, she went on to trace the heritage of Impressionism and to investigate the specific characteristics of work by individual members of the group. She concluded:

> Eccentric, willful, audacious, even affected, though many of them may seem at first sight; easy as it is to say that they are mere *poseurs*, bound to force public attention at whatever cost, mere *frondeurs*, dissatisfied with art as it existed before them, simply because it *did* exist before them, such seeing and saying is as false as facile. Some of them at certain times may indeed lay themselves open to the charge of loving eccentricity and exaggeration for their own sakes; but, as a rule, considered as a whole, and much more if judged by their best results, they prove their sincerity, and prove that it is served by technical skill of a high order. Whatever the public may think about the exhibition, I am sure that every artist will have found in it many things which have not only delighted his eye but given him fresh and valuable hints, and sensibly widened his idea of his pictorial performance.[57]

And what of the success of Durand-Ruel's venture? While some collectors already owned Impressionist works—Alexander Cassatt, Louisine Elder Havemeyer, and Erwin Davis—and while some of the paintings sold were not Impressionist, Durand-Ruel nevertheless is reported to have earned $40,000. This exhibition marked the beginning of serious interest in collecting Impressionist art. Durand-Ruel's success, however, was viewed with hostility by the New York commercial world. The American Art Association had assumed the role of an educational institution, which allowed the collection to enter this country as a nonprofit enterprise; but Durand-Ruel's success was so great that his New York

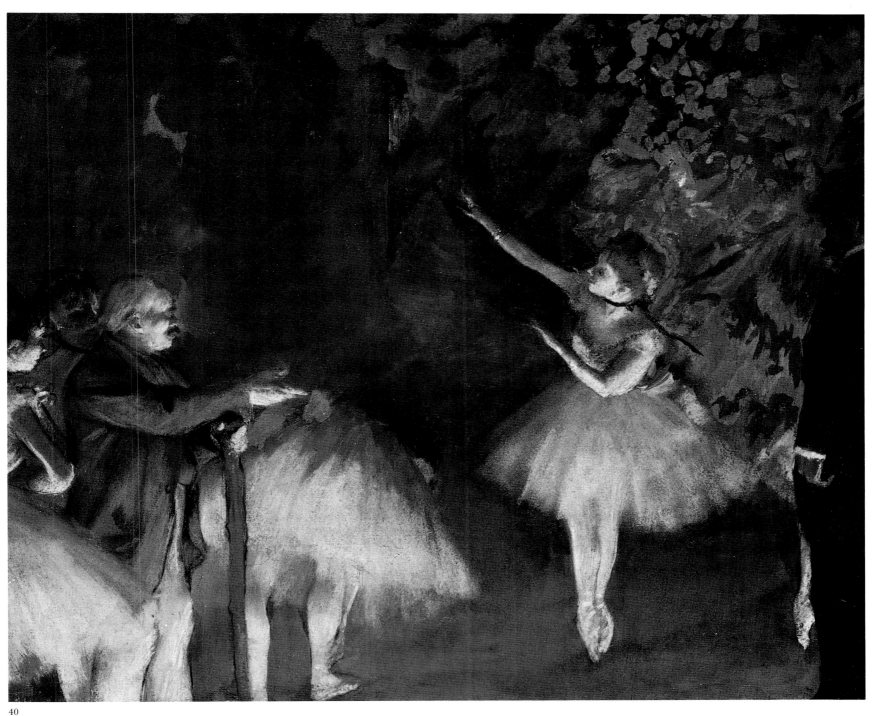

40

39. EDOUARD MANET (1832–1883). *The Execution of Maximilian*, 1868. Oil on canvas, 79¼ x 119¾ in. Städtische Kunsthalle Mannheim.

40. EDGAR DEGAS. *Ballet Rehearsal*, 1874. Gouache and pastel on paper, 21¾ x 26¾ in. Nelson-Atkins Museum of Art, Kansas City, Missouri; Acquired through the Kenneth A. and Helen F. Spencer Foundation acquisitions fund.

competitors successfully put an injunction on sales when he attempted to hold another exhibition at the National Academy of Design in 1887. In any case, this second exhibition was much more traditional; not only were the contemporary paintings more conservative but there were works of historical significance such as Delacroix's *Death of Sardanapalus* (1827). And while Manet, Sisley, Monet, and Pissarro were included, the star of this show was Puvis de Chavannes, seen in force here for the first time.

Eighteen eighty-six was a key year for America in coming to terms with Impressionism. Until then, the aesthetic had been misunderstood, a radical departure from time-honored, unquestioned standards. American artists, collectors, and critics might voice preferences for the overtly academic, the more suggestive and poetic, or even the more avant-garde and sketchy; but draftsmanship, tone, and careful values were normative, and the rumored existence of more radical art was not to be taken seriously. Now, with the enormous impact of the Durand-Ruel exhibition of 1886, American art would never be the same.

II

RISING PERCEPTIONS

1886 – 1893

41

5 Giverny: The First Generation

The Men of 1887

ON MAY 1, 1883, Claude Monet moved from Vetheuil to Giverny, where he would remain for the rest of his career. There he painted many of his most famous canvases, such as his series of haystacks, which have come to exemplify French Impressionism. Monet's move was motivated less by the charms of the little town than by the exigencies of the moment, for he faced eviction from a rented house in Vetheuil. In search of another dwelling, he explored farther down the Seine until he came upon Giverny. [1]

Though Monet did not take pupils, advising those who came to him to seek inspiration directly from nature, more and more artists sought him out, to his increasing dismay. Over the decades painters who sought fame by association continued to visit and even reside in Giverny, peppering their biographies with references to ties with the French master that one suspects are often much exaggerated. It is difficult to document the precise nature of the personal or professional relationship that such painters might have had with Monet. One must speculate also on the interrelationships among the young artists who congregated in Giverny; for all the magnetic force that Monet exerted, the interaction of these artists was probably as important as Monet's own presence. Although the Americans constituted the largest contingent of foreign painters in Giverny, there were also others, from England to eastern Europe, working there. Other major French avant-garde painters also visited Giverny—Paul Cézanne, for example, painted there in 1894—and one might ask if such activity affected the American artists.

For all that is known about American artists in Giverny,[2] from the mid-1880s well into this century, a surprising amount is *not* known. Particularly significant is the first American presence in Giverny: Who arrived first, and when? The problem is not a lack of candidates but rather whose account to believe. Discussions of the American introduction to Giverny date back as far as the late nineteenth century, and recent historians and biographers have offered numerous alternatives, but almost all of them conflict to some degree, and none is completely consistent with known facts or dated pictures.

The earliest candidate is Willard Metcalf, who later developed into a significant Impressionist landscape painter. He came from Boston, where he studied with the important traditional landscapist George Loring Brown. Metcalf started his career as a figure painter and illustrator, producing striking pictures for a series

41. THEODORE ROBINSON (1852–1896). *The Wedding March*, 1892. Oil on canvas, 22 x 26 in. Terra Museum of American Art, Evanston, Illinois; Daniel J. Terra Collection.

42

of articles on the Zuni Indians published in *Century* magazine in 1882–83. He then went abroad to study at the Académie Julian. During his free summers Metcalf explored the popular artists' colonies that had grown up in the French countryside during the 1860s and '70s. He went to Pont-Aven in Brittany in 1884 and was particularly productive in Grèz, where his beautiful *Sunset at Grèz* of 1885 (plate 43) shows the impact of the French tradition, established by Bastien-Lepage, of painting peasant life outdoors. Metcalf's unsentimental depiction of a child at her daily chores is tied to firm figural and spatial construction. The specific foreground plant forms and the spatial planes soaring to a high horizon that completely envelops the figure are hallmarks of Bastien-Lepage's art, but the sunset glow that permeates the forms is distinct to Metcalf and suggests the coloristic emphasis of his Impressionist maturity a decade later. Metcalf also painted in Walberswick, England, but his present biographer puts him in Giverny, attempting to meet Monet, by May 1885. He supposedly returned that summer, was invited to lunch with the artist, and spent the afternoon painting in the garden with Monet's stepdaughter, Blanche Hoschedé-Monet, who was also an Impressionist painter.[3] The same account postulates an association formed in Giverny in 1885 with Theodore Robinson. It links Metcalf's early activity in Giverny with a 1948 report by Monet's descendant Pierre Toulgouat that Monet's painter friend Ferdinand Deconchy visited Giverny in 1885, accompanied by Robinson. Robinson was to become the most famous American Givernois, but his work before 1888 is imperfectly known and none suggests the impact of Monet. The Toulgouat report also contradicts others that place Robinson's first visit to Giverny in 1887.[4]

One of the earliest accounts of the American discovery of Giverny was published on March 8, 1895, in the *Boston Evening Transcript*. It was written by Edward Breck, brother of the painter John Leslie Breck, who recalled that he was

> ...the only layman of the little band of artists who first went thither in 1887. In the early summer of that year Louis Ritter, of gentle memory, and his friend, Willard Metcalf, visited their fellow painter [Paul] Coquand at the chateau of Fourge in

42. WILLARD METCALF (1858–1925). *Goose Girl*, 1884. Oil on canvas, 18 x 24 in. Private collection.

43. WILLARD METCALF. *Sunset at Grèz*, 1885. Oil on canvas, 34 x 43⅝ in. Hirshhorn Museum and Sculpture Garden, Smithsonian Institution, Washington, D.C.

44. LOUIS RITTER (1854–1892). *Barley Field, Giverny*, 1887. Oil on canvas, 24 x 39¾ in. Jeffrey R. Brown.

43

44

Eure, the proprietor of which a lucky marriage had enabled him to become. Leaving Fourge, Ritter and Metcalf strolled along through the valley that grew more and more beautiful as it neared the Seine. At the little village of Giverny on the Epte, within an hour's walk from Vernon and the Seine, the transcendent loveliness of the country cast a spell over them and they wrote their friends in Paris that Paradise was found and only wanting to be enjoyed. The invitation was answered by Theodore Robinson, Theodore Wendel, Blair Bruce and John Leslie Breck, who, with the present writer and his mother, formed the American colony that year, and are the "simon pure" original "Givernyites."[5]

For Ritter, a talented Cincinnati painter, the Giverny period was no more than an interlude. John Leslie Breck and Theodore Wendel are more significant to the development of American Impressionism and will be discussed later; William Blair Bruce, a close friend of Theodore Robinson, was a Canadian and thus is omitted from the account of this group by "Greta," the pseudonymous Boston contributor to the *Art Amateur*, who wrote in October 1887: "Quite an American colony has gathered, I am told, at Giverny, seventy miles from Paris on the Seine, the home of Claude Monet, including our Louis Ritter, W. L. Metcalf, Theodore Wendel, John Breck and Theodore Robinson of New York. A few pictures just received from these men show that they have got the blue-green color of Monet's impressionism and 'got it bad.' "[6] The Boston origins or connections of this group were significant; only Robinson was identified as a New Yorker, and the rest—Metcalf, Ritter, Breck, and Wendel—all had exhibited in Boston and most of them were to bring Impressionism back to that city, which earlier had been the center for Barbizon landscape in this country.

Curiously, Edward Breck's account of the American discovery of Giverny did not mention Monet; it was a "chance" discovery based on the town's own charms, not on the presence of a master. A year later this was emphatically restated by Dawson Dawson-Watson, another American artist at Giverny, who recorded that in June 1888 John Leslie Breck told him of his previous summer there: Breck, Robinson, Blair Bruce, Wendel, and a painter named Taylor, in deciding where to spend the summer, picked at random a station from a list at the Gare Saint Lazare in Paris and lighted upon Pont de l'Arche. En route they changed trains at Vernon and, agreeing on the loveliness of a place that they saw on the Seine, vowed to return there if Pont de l'Arche had nothing to offer. It did not, and they returned to the unknown community, Giverny.[7]

Neither Monet nor Ritter figures in this account, but rather an artist named Taylor, the most shadowy of all the early Americans there. This was Henry Fitch Taylor, who in 1913 was instrumental in organizing the Armory Show in New York; at that time he turned his back on Impressionism and devoted his talents to radical new strategies in painting and sculpture. Almost nothing is known today of Taylor's early involvement with Impressionism, except his rapid synthesis of the experience. He had returned to New York in 1888 and a review of the fifth Prize Fund Exhibition at the American Art Galleries in New York in April 1889 describes several of his landscapes as "Claude Monet and Pissarro without the shadow of an apology."[8] His one work at the National Academy in 1889 seems to have gone unnoticed. But his *Souvenir of Barbizon* and *Souvenir of Giverny*, shown that year at the Society of American Artists, were likened to the work of Pissarro (interestingly, *not* Monet) and he was identified with Robinson and Wendel as part of the strong Impressionist contingent.[9] Two years later he became a member of the Society, but he did not participate after 1895 and then almost dropped from view for about twenty years.

One further reshuffling of the basic Giverny group of 1887 can be found in Blair Bruce's recently published letters. Robinson is mentioned particularly, because he and Blair Bruce had been in Barbizon earlier in 1887. Metcalf, Wendel, and *both* Ritter and Taylor also are mentioned, but not John Leslie Breck.[10] In sum, there seem to have been at least six American artists painting in Giverny that

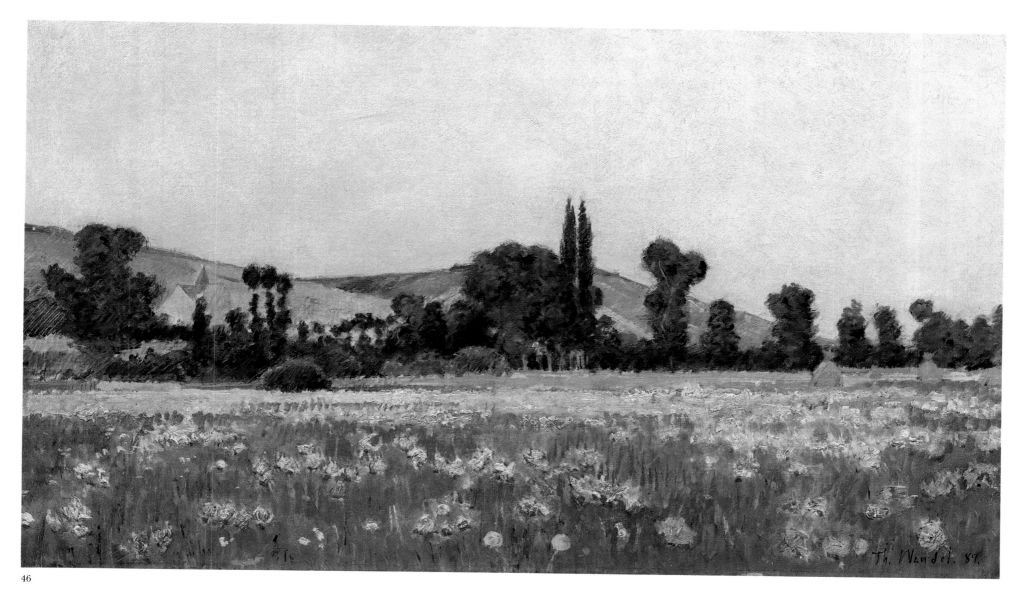

46

45. THEODORE WENDEL (1857–1932). *Girl Fishing by a Stream, Giverny*, c. 1887. Oil on canvas, 16¼ x 19¾ in. Vose Galleries of Boston.

46. THEODORE WENDEL. *Flowering Fields, Giverny*, 1889. Oil on canvas, 12½ x 21½ in. Private collection.

summer plus the Canadian Blair Bruce. Even this, however, is not the end of the story, nor of the confusion. One of these original "Givernyites," the Ohioan Theodore Wendel, had followed the Midwestern path to Munich and become one of the Duveneck Boys before returning to paint in New England. He went again to Europe in the mid-'80s, this time to the Académie Julian in 1886. Wendel was certainly painting in Giverny in 1887, but the confusion derives from his *Girl with Turkeys, Giverny*, dated 1886, which suggests an even earlier visit.[11]

However romanticized the stories of discovering Giverny might be, it seems unlikely that Monet's presence there was unknown; rather, his absence from these accounts suggests a typical American assertion of independence, after the fact. In the late 1880s the art of these painters developed toward greater freedom and colorism, toward greater modernity, a development that almost surely would have occurred whether they painted in the shadow of Monet or not.

Metcalf's painting at Giverny took on neither a prismatic coloration nor any suggestion of divisionist dissolution of form. Most of his known works from about 1886 to 1888 are landscapes painted in rich masses of contrasting greens; they are more concerned with vibrant sunlight and shadow and are looser and freer than his figures in outdoor settings, such as his *Sunset at Grèz*. Metcalf's preference for pure landscape over figure-oriented work may be a result of his associations in Giverny, but his *Ten Cent Breakfast* of 1887 (plate 49), annotated "Giverny," is a very structured, rather tightly painted, academically arranged group portrait of a rural *vie de Bohème*. The figures are identified as Robinson seated in the back, Robert Louis Stevenson at the right, John Twachtman seated at the left, and a standing figure is conjecturally identified with a host of other artists.[12]

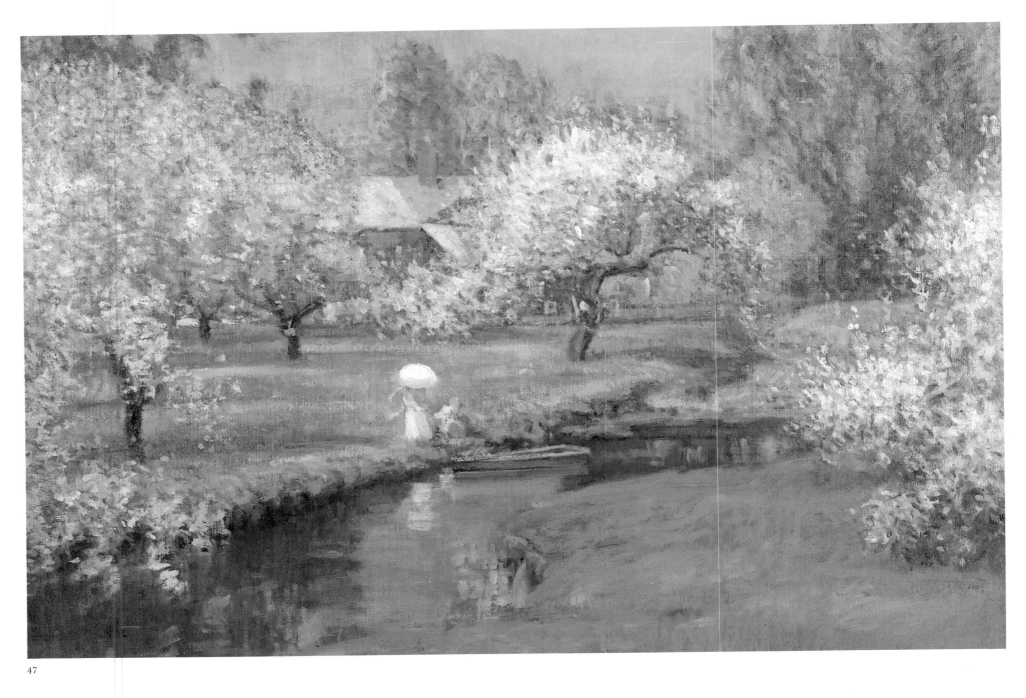

47

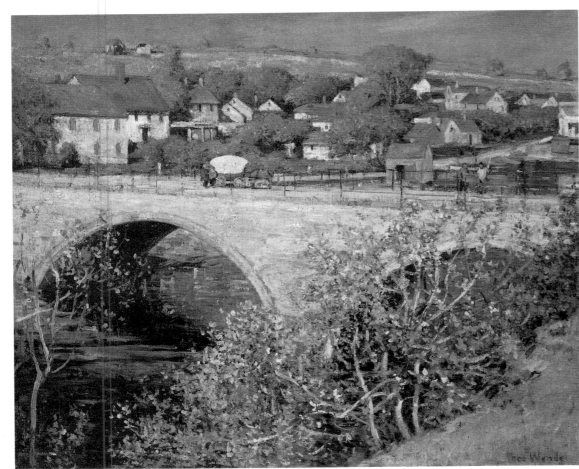

48

In fall 1887 Metcalf traveled to Tunis, and the intense colors and Mediterranean light of North Africa may have stimulated the increasing luminosity and colorism in his art more than his contact with Monet, though his pictures from the trip have the flat, reflected light and strong drawing associated with the glare aesthetic. Metcalf returned to France and to Giverny but was back in America in 1889. His work of the next seven years is exceedingly little known, so that it is difficult to discern his transition to the Impressionism of pictures such as his *Gloucester Harbor* of 1895 (plate 185), with its similarity to the orthodox American Impressionist landscapes of Childe Hassam.

Wendel, like Metcalf, returned to America in 1889 and the two held concurrent exhibitions in Boston that year. Critics noted the modernity of both artists but distinguished between the rich greens and intense light of Metcalf's work and Wendel's adherence to Impressionism, particularly in the heightened colorism and use of purple shadows.[13] Wendel's art seems to have developed gradually yet quickly in this direction. His *Girl Fishing by a Stream* (plate 45), done about 1887 in Giverny, certainly exhibits brighter effects of light and a broader color range than his work of the previous year, but even in the scintillating light patterns through the trees it suggests a combination of Tonalist and Impressionist effects. The forms of the natural surroundings or the figures that often populate Wendel's landscapes are strongly generalized into broad tonal masses and are realized in painterly textures.

One critic in 1891, after reviewing a show of Gérôme-inspired canvases by Frederic Bridgman, said of Wendel: "He, too, is an imitator, however. If Bridgman is Gérôme and water, Wendel is Monet and jam. But the new things that Monet and his imitators have to say, the colors and qualities which they constrain us to see by exaggerating them out of all proportion to facts are, at least, more entertaining than the weary old Gérômisms."[14] He concluded that "Mr. Wendel comes the nearest of the Bostonian Impressionists to handling the Monet style with effect." Wendel continued to exploit Impressionist color in his paintings of Gloucester and Ipswich, and he came to be regarded more as a devoted interpreter of the New England scene than as a stylistic innovator, though he remained faithful to the new aesthetic he had pioneered.[15]

47. THEODORE WENDEL. *Lady with a Parasol by a Stream*, 1889. Oil on canvas, 20 x 30 in. Dr. John McDonough.

48. THEODORE WENDEL. *Bridge at Ipswich*, 1908. Oil on canvas, 24½ x 30 in. Museum of Fine Arts, Boston; Gift of Daniel S. Wendel and purchase, Alfred Gordon Tompkins Fund.

49. WILLARD METCALF (1858–1925). *Ten Cent Breakfast*, 1887. Oil on canvas, 15¹⁄₁₆ x 22 in. The Denver Art Museum; T. Edward and Tullah Hanley Collection.

49

50

51

52

The year after Wendel was named the foremost Boston artist working in the style of Monet, his fellow Givernois, John Leslie Breck, was given the same honor. Breck, too, studied in Munich and then went to Antwerp; he was in America in 1883, at the Académie Julian in 1886, and in Giverny the next summer. There, he not only fell under Monet's influence but became romantically involved with Blanche Hoschedé-Monet; this was one of several involvements between Monet's stepdaughters and American artists. In Breck's case, Monet intervened, and the disappointed suitor left Giverny in 1890.[16]

Breck's French landscapes are the richest in color and the most scintillating of the American's works. He also explored the active facture and to some degree the broken brushwork of Impressionism. His *River Epte* of about 1887 (plate 51) is a subtly colored recording of the gentle stream, utilizing pure, unblended pigment; but he downplays the rich chromatic display to emphasize the effect of moving water (this was a favorite view undertaken by almost all the "men of 1887"). In contrast, several garden pictures of the period blaze with color. It may have been a group of these works that was shown in the Boston home of the artist Lilla Cabot Perry in the late 1880s; there they were viewed by local artists and the writer Hamlin Garland, who commented on the "vivid canvases by a man named Breck, [which] so widened the influence of the new school.... I recall seeing the paintings set on the floor and propped against the wall, each with its flare of primitive colors—reds, blues, and yellows, presenting 'Impressionism', the latest word from Paris."[17]

Breck was back in Boston by October 1890, and his disappointment at the unsuccessful courtship of Blanche Hoschedé-Monet seems to have been swiftly assuaged by his engagement to a Miss Plummer. A Breck exhibition in November at Boston's St. Botolph Club, which became the major center for showing avant-garde art in that city, provoked a storm of reaction in both Boston and in New York. Boston criticism ran the gamut from genuine admiration to charges of

50. JOHN LESLIE BRECK (1860–1899). *Rock Garden at Giverny*, c. 1887. Oil on canvas, 18 x 22 in. Private collection.

51. JOHN LESLIE BRECK. *The River Epte*, c. 1887. Oil on canvas, 24 x 43¾ in. Berry-Hill Galleries, New York.

52. JOHN LESLIE BRECK. *View of Ipswich Bay*, 1898. Oil on canvas, 18 x 22 in. Berry-Hill Galleries, New York.

53

54

amateurism and slovenly brushwork.[18] Most of the pictures were scenes of Giverny, some painted in Monet's garden; there were also views in Essex County and a painting of Niagara Falls. Breck subsequently spent time in California and wintered in 1891–92 in Kent, England, showing with the New English Art Club; but Boston remained his home, and he continued to exhibit at the St. Botolph Club. A memorial show was held for him there in 1899, but by that time the leadership of Boston Impressionism had been assumed by Edmund Tarbell, and a distinct school of Impressionist figure painting was in formation.

Theodore Robinson

The most significant of the American Givernois was Theodore Robinson. Though he died quite young, his work received far more critical notice in America than that of other artists during Impressionism's crucial formative years there; thus his influence was much greater than, say, Breck's or Wendel's. Most important, his painting was stronger, more varied, and at its best perhaps more beautiful than that of many of his contemporaries.[19]

Robinson was born in Irasburg, Vermont, an area he returned to at the end of his career. He studied first in Chicago and then in 1874 at the National Academy of Design and the newly founded Art Students League. Two years later he was in Paris studying with Carolus-Duran and then with Gérôme. From the former he may have gained a predilection for a rich, painterly technique, while Gérôme would have instilled in him the primacy of sound draftsmanship; integrating these two directions remained a problem for Robinson throughout his career. At this

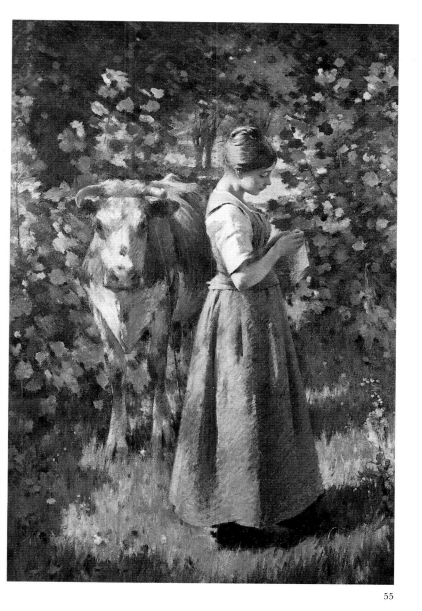

55

time, he seems not to have been concerned with or perhaps aware of the radical aesthetic of Impressionism. In the late 1870s and '80s, he summered at Grèz, where he would have known the brothers Birge and Alexander Harrison, Willard Metcalf, and especially Will Low among the Americans, as well as artists from many other nations. Grèz seems to have been important for Robinson, as it was for many others, because the communal activities reinforced their eagerness to work outdoors. Their art was often concerned with rural landscape or peasants, interpreted with a combination of academicism and sensitivity to outdoor light.[20]

Robinson's career proceeded unexceptionally: he first exhibited at the Paris Salon in 1877; he was represented in the first inaugural show of the progressive Society of American Artists in 1878; and he returned home late in 1879, after a visit to Venice, where he met Whistler. His *Girl with the Dog* (plate 53) seems to represent his manner of the early 1880s: solid figure drawing of a child informally posed outdoors in the evening, in a grayish luminosity characteristic of the plein-airism of Bastien-Lepage and his followers. Robinson was back in France in 1884 and for eight years resided there, though he returned frequently to America. He was an effective force in American art exhibitions, and his presence was strongly felt.

Robinson's eight years abroad may be divided into his pre-Impressionist and Impressionist years. Pictures such as the beautifully rendered *Apprentice Blacksmith* of 1886 (plate 54) are still strong, tonal works; set in well-defined interiors, they depict craftsmen and time-honored trades, a theme favored in this period by figure painters on both sides of the Atlantic.

Robinson's friendship with Monet may have begun in 1886 or 1887, if not before, but in 1888 he moved next door to Monet and lived there until 1892; unlike most Americans who visited Giverny, he became an intimate of the French artist. Robinson's art of the period displays a conversion to the Impressionist aesthetic, a conversion subject to certain qualifications. He never adopted Monet's

53. THEODORE ROBINSON (1852–1896). *The Girl with the Dog*, early 1880s. Oil on canvas, 19¼ x 13¼ in. Cincinnati Art Museum; Gift of Mrs. A. M. Adler.

54. THEODORE ROBINSON. *Apprentice Blacksmith*, 1886. Oil on canvas, 60⅛ x 50 in. Timken Museum of Art, San Diego, California; The Putnam Foundation.

55. THEODORE ROBINSON. *La Vachère*, 1888. Oil on canvas, 86¾ x 61½ in. The Baltimore Museum of Art; Given in Memory of Joseph Katz by his children.

56. THEODORE ROBINSON. *In the Garden*, c. 1889. Oil on canvas, 18 x 22 in. The Westmoreland Museum of Art, Greensburg, Pennsylvania; The William A. Coulter Fund.

56

techniques and theories as completely, say, as his friend, Blair Bruce, or some other American Givernois, such as Lilla Cabot Perry. A full conversion, had Robinson sought it, was hampered by his training and predilections—an admiration for native realists such as Winslow Homer and Thomas Eakins as well as his academic education. A respect for strong drawing and tonal values remained with Robinson throughout his career. He had also developed a real and continuing concern for the theme of the peasant and his milieu, which required academic strategies that Robinson could not, or would not, discard. Finally, one must not overlook the way in which Robinson's art developed during his four years in Giverny: although his paintings of 1888 might be expected to be less avant-garde than those of 1892, he did not follow a straight path to Impressionism; in fact,

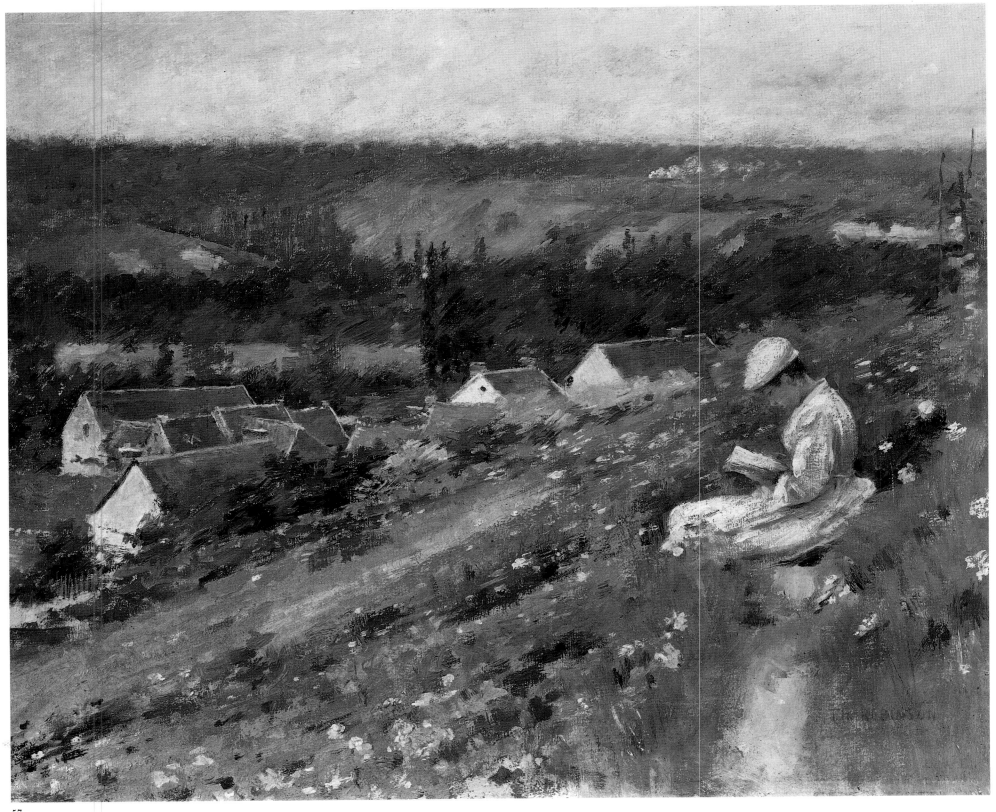

58

59

vacillation and hesitancy seem to characterize his progress.

The most monumental of Robinson's early Impressionist works is *La Vachère* of 1888 (plate 55), a full-length image of a peasant girl painted for the Salon of 1889. Robinson's primary concern is with the sunlight flickering through the leaves and over the surfaces of figure and animal, all broadly rendered in freely applied paint. Form is only generally indicated and the girl is a poetic, contemplative image; no stress is placed on her duties or hardships. There is spontaneity and a fascination with the momentary quality of the illumination. Yet the drawing of the figure and animal is still extremely careful; color areas are filled in, while the foreground and the leaves are undefined in outline. Shadows are relatively deep and opaque, and the picture space is extremely shallow and carefully controlled. Even the block letters of the signature suggest limited space and the flatness of the picture plane, a favorite device of the school of Bastien-Lepage. Such a monumental image was rare for Robinson; he was more at ease with smaller works, a tendency that he came to decry.

Robinson's painting *Day Dreams,* of 1889, exhibits softer planar transitions and the integration of figure with surroundings through looser brushwork, particularly in the merging of skirt and ground plane. The composition of *Day Dreams* also is more gently dynamic than that of *La Vachère* with its resolute uprights. *Day Dreams* is composed of a series of arcs curving along a diagonal, firmly anchored by the figure and the tree to her left. One of the most structured of Robinson's peasant pictures is *In the Garden* of about 1889 (plate 56), and it is particularly noteworthy that the garden is a useful one, a kitchen garden where vegetables grow. Just as Robinson's figural subjects in Giverny are associated with the earth, so his garden is a source of sustenance, unlike the decorative garden that was to become a major theme for the next generation of American Impressionists.

The landscape itself, painted outdoors around Giverny, was the other theme to occupy Robinson. One of his earliest and finest landscapes in an Impressionist manner was *The Valley of Arconville* of about 1888 (plate 57). The houses of the village and his model Marie reading on a hillside are simply though crisply

57. THEODORE ROBINSON. *The Valley of Arconville*, c. 1888. Oil on canvas, 18 x 21⅞ in. The Art Institute of Chicago; Friends of American Art Collection.

58. THEODORE ROBINSON. *Winter Landscape*, 1889. Oil on canvas, 18¼ x 22 in. Terra Museum of American Art, Evanston, Illinois; Daniel J. Terra Collection.

59. THEODORE ROBINSON. *Bird's Eye View of Giverny, France,* 1889. Oil on canvas, 25¾ x 32 in. The Metropolitan Museum of Art, New York; Gift of George A. Hearn.

60

61

rendered; the landscape is more freely brushed, but structure is crucial. As Blair Bruce did in some of his Giverny landscapes of this time, Robinson emphasizes a series of parallel diagonals from upper right to lower left, while planes of grasses and earth in a foreground dotted with wildflowers are repeated in the flat planes and strongly outlined rooftops of houses in the valley. These gradually assume a more horizontal axis and are repeated in the ranges of trees and hills in the distance, then even out to a sharp, unbroken horizon that is near the top of the picture plane, so that the composition lines seem to radiate from a half-open fan, held together at the upper right. The narrow color range is limited primarily to shades of green with some light earth tones and touches of pale lavenders. In many works, such as Robinson's *Bird's Eye View of Giverny, France* of 1889 (plate 59), the colors became more intense, but the chromatic range remained limited and the compositional structure pronounced. Spontaneity resided in the touch, in the application of paint, but not in an immediate reaction to the scene itself.

Works like these soon were seen back in America, and they branded Robinson as an adherent, even a leader, of avant-garde Impressionism. In 1888 he exhibited only one work at the Society of American Artists, a now-unlocated *Flight into Egypt*. In contrast, the following year he exhibited seven, most of them landscapes judging by their titles, including *The Valley of Arconville*. All the critics noted his adoption of Impressionism, of the color and compositions of Monet and Degas.[21] Robinson showed only two pictures in 1890, the *Bird's Eye View of Giverny, France* and *Winter Landscape* (plate 58), which won the Webb Prize for the best landscape by an artist under thirty-five. Though the exhibition was dominated by John Singer Sargent's *La Carmencita*, Impressionist-related paintings prevailed in the landscape section, and Robinson was cited by the critic in the *Nation* as "the best of them all.... Mr. Robinson was an intelligent artist before he was an impressionist, and remains an intelligent artist now that impressionism claims him for its own. His 'Winter Landscape,' No. 151, to which the Webb prize has been awarded by the jury, has great distinction of color, and is a picture much beloved of his brother artists. His 'Birdseye View,' No. 152, with its clustered cottages seen in steep

60. THEODORE ROBINSON. *Two Girls in a Boat*, c. 1890. Photograph gridded in pencil, 3 ¹/₂ x 4 ¹/₂ in. Private collection.

61. THEODORE ROBINSON. *Two in a Boat*, 1891. Oil on canvas board, 9 ³/₈ x 13 ⁵/₈ in. The Phillips Collection, Washington, D.C.

62. THEODORE ROBINSON. *La Débâcle*, 1892. Oil on canvas, 18 x 22 in. Scripps College, Claremont, California; Gift of General and Mrs. Edward Clinton Young, 1946.

perspective, is most interesting in drawing, though a trifle flat and chalky in its attempt at color on a high key."[22] This may be the first time an American Impressionist work was commended by a juried prize. In 1892 Robinson received a second award, the Society's Shaw Prize given to the best figure painting, for *In the Sun*. Robinson's decision to include a major figure composition certainly must have stemmed, in part, from a hope of winning a second prize in another category. A study of the critical reviews of the Society in the late 1880s and early '90s suggests that Impressionism penetrated the landscape category first, and figure painting by 1891 and 1892, after the critics recognized the conversion to the style.

In the Sun was one of several notable figural canvases that Robinson created during the early '90s with the aid of photographs; *Two in a Boat* (plate 61) is

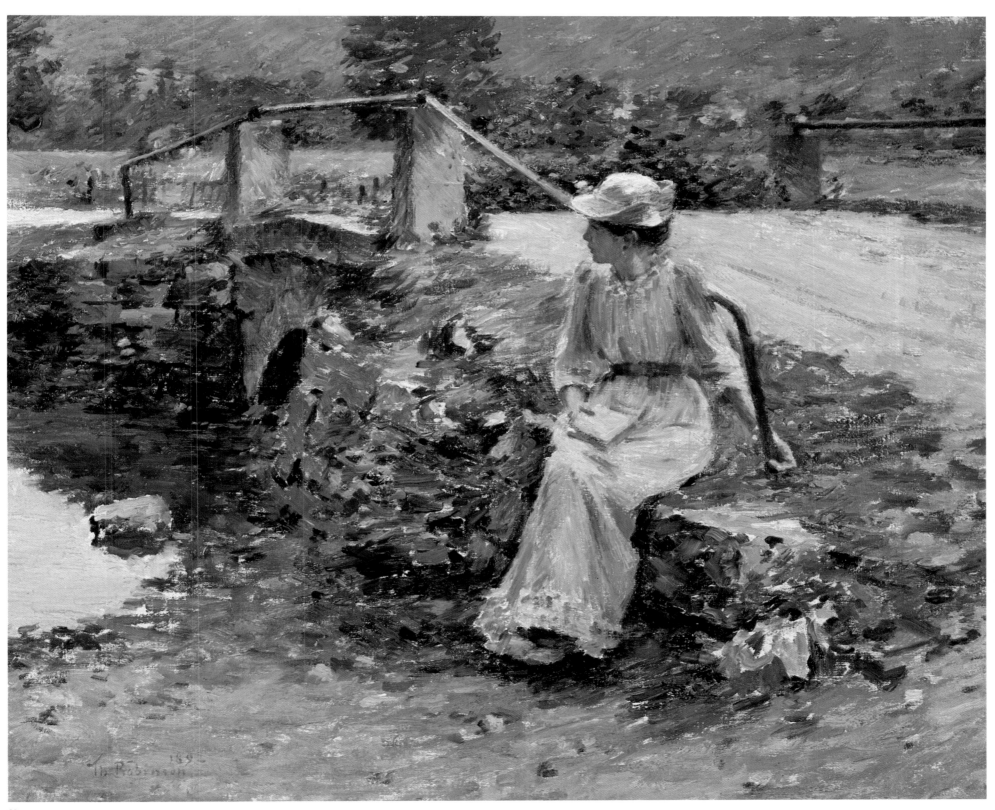

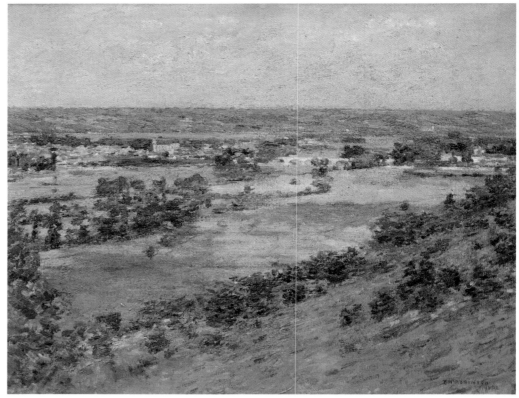

63

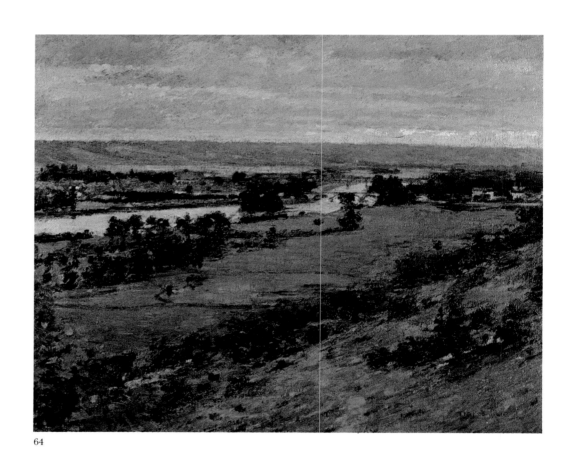

64

63. THEODORE ROBINSON. *Valley of the Seine*, 1892. Oil on canvas, 25 x 32½ in. Addison Gallery of American Art, Phillips Academy, Andover, Massachusetts.

64. THEODORE ROBINSON. *Valley of the Seine*, 1892. Oil on canvas, 26 x 32 in. Maier Museum of Art, Randolph-Macon Woman's College, Lynchburg, Virginia; Gift of Francis M. Weld, 1945.

65. CLAUDE MONET (1840–1926). *Rouen Cathedral, The Façade in Sunlight*, 1894. Oil on canvas, 41¹³/₁₆ x 29 in. Sterling and Francine Clark Institute, Williamstown, Massachusetts.

66. THEODORE ROBINSON. *Valley of the Seine from Giverny Heights*, 1892. Oil on canvas, 25⅞ x 32⅛ in. The Corcoran Gallery of Art, Washington, D.C.; Museum purchase, 1900.

another and one of the finest.[23] The photographs he used sometimes utilized the blurring effects of brilliant sunlight, but they also allowed him to maintain a constancy of pose and reduced the cost of models, which he always used as well. *Two in a Boat*, almost surely posed on the Seine or the Epte, maintains the strong diagonal composition Robinson favored in figure painting and the close coloristic tonalities, in this case a blue-to-violet range. He eliminated one of the boats in the

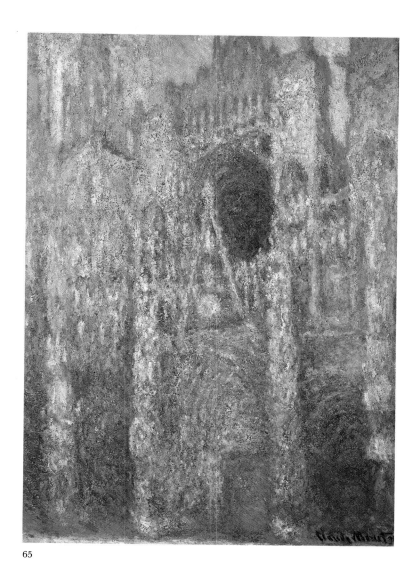

65

original photograph, creating a less cluttered composition and giving the two girls in the forward boat greater clarity and focus. Despite the self-conscious composition, the sketchy, thin paint handling and the untouched areas of canvas suggest an increased freedom and assurance in his art by 1891.

Some of Robinson's works of 1892, his last year in France, such as *La Débâcle* (plate 62), are among the most Impressionist and most beautiful of his career. (The title refers not to any impending disaster but to Zola's novel published that year, which Marie holds.) The rich purples of the figure's dress contrast with the broadly applied trees and to the vivid yellow book in her lap, though Robinson maintains a careful harmony of purple tones. And even in 1892, the figure—no longer a peasant woman—is carefully drawn and, like the bridge in the background, has a specific form and structure.

Standing, seated, or lying down, Robinson's figures are most often contemplative. The most important exception is *The Wedding March*, also of 1892 (plate 41), one of his most fascinating works. The painting commemorates the marriage of the American painter Theodore Butler to Suzanne Hoschedé-Monet, one of the great painter's stepdaughters. Robinson began the picture two weeks after the July 20 wedding. The couple saunters down the village street in glowing sunlight, the broad roadway a plane of light and a foil for the dark-suited men, while the light penetrates Suzanne's enveloping veil. The spontaneity of Robinson's brushwork —long, thin strokes for the figure, and short, thick daubs of greens, yellows, and earth colors for the surrounding landscape—echoes the forceful stride of the figures. This was the artist's only "historic" picture.

The Wedding March testifies to Robinson's enduring closeness to Monet and his family. Monet continued to critique works Robinson showed him, and Robinson adopted some of Monet's subjects. The high point of this interchange occurred in 1892, when Monet asked Robinson's opinion on some of his first views of Rouen Cathedral, which Monet had begun in late February or March of that year. In view of Robinson's dependence on academic procedures, it is not surprising that he

"A great day—the marriage of Butler & Mlle. Suzanne. Everybody nearly at the church—the peasants—many almost unrecognizable. . . . The wedding party in full dress—ceremony first at the mairie then at the church. Monet entering first with Suzanne. Then Butler. . . . Frequent showers. Champagne and gaiety—a pretty blonde . . . running, Dyce and Courtland & Butler flirting with and kissing her. . . ."

Theodore Robinson, diary entry, July 20, 1892. Frick Art Reference Library, New York.

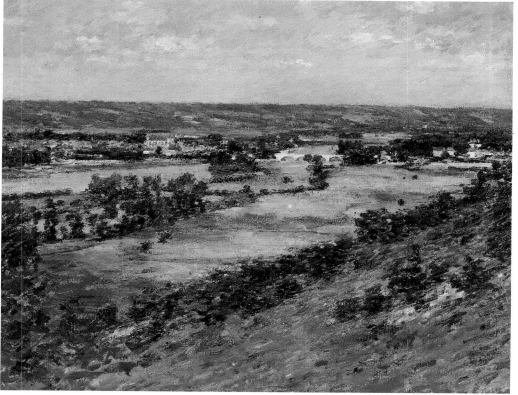

66

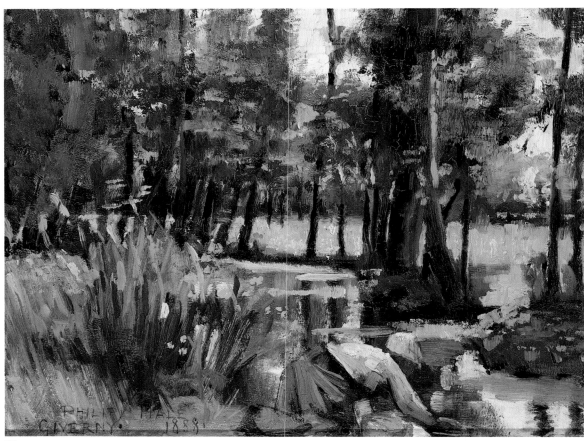

67

admired the pictures for their maintenance of "construction and solidity."[24] Robinson, in turn, began a group of paintings modeled not on Monet's style but on the principles of his serial depictions of haystacks, poplars, and the cathedral. Robinson's three-part series the *Valley of the Seine* (plates 63, 64, 66), which he called *Vue de Vernon* in his diary, was done outdoors in summer, while Monet's Rouen Cathedral pictures were done from a hotel window at a less convenient time of year. Robinson's series is a small one, compared with Monet's dozens of pictures of the cathedral, but it was the closest that he, or any American painter at that time, had come to certain basic tenets of Impressionism.

Robinson's three pictures show the valley of the Seine and the town of Vernon in bright sunlight, in sunlight with floating shadows, and on an overcast gray day. In his diary he noted his intent to include the "Vernon Cathedral and parts of bridge, etc.," perhaps a further tribute to Monet's Cathedral series, though Robinson's cathedral is tiny within the panoramic vastness. Monet's series analyzed specific forms under specific atmospheric conditions at specific times of day and year. Robinson avoided such exactitude, concentrating on the entire landscape at one time of year and perhaps even one time of day, but under varying conditions of light and atmosphere. He showed the paintings to Monet, who admired the gray version most, just as Robinson had favored the Rouen Cathedral under overcast skies. The three pictures were never exhibited together in Robinson's lifetime, although he showed one of the sunlit views at the Society in 1893. Robinson's outstanding selections that year included *La Débâcle*, and the reviewer in the *Critic* noted: "In about half of the landscapes the now familiar Impressionist recipe is followed with more or less success. Mr. Theodore Robinson's six contributions, in all of which the landscape is of more account than the figures, are easily the best of this class. Mr. Robinson no longer paints like a bold adventurer, but like a man who has found a range of subjects, a scheme of color and a mode of handling that

suit him, and who is happy in exploiting his new possessions. He is much less of a colorist and much more careful of detail than his master, Monet...."[25]

Robinson was now back in America; he had left France the previous December and was never to return. Separated from the artistic inspiration of Giverny, Robinson vacillated between an impulse toward greater spontaneity and firm adherence to academic standards that he felt needed constant reinforcement; but certain conclusions made by twentieth-century historians about his return to a native realism now seem untenable. Robinson continued to uphold the new Impressionist aesthetic until his premature death in 1896.

The Americans who had gone to Giverny in 1887 were soon joined by others. In 1888 Philip Leslie Hale was there, and by the following summer he had begun to leave his dark, tonal, Spanish-influenced style for one richly colored and sun filled. He was to become one of the most advanced Boston figure painters working in an Impressionist manner, and surely his exposure to the work of Monet and of his fellow American practitioners must have influenced his future art; Hale's art and career will be discussed later (see chapter 9). Theodore Earl Butler also came to Giverny with his friend and colleague Theodore Robinson, after study at the Art Students League in New York and then at the Académie Julian, the Atelier Colarossi, and the Grande Chaumière in Paris. Of all these early Americans in Giverny, only Butler, whose wedding to Suzanne Hoschedé-Monet was commemorated by Robinson, remained there permanently, working in an Impressionist manner derived from Monet's and painting many of the same subjects. Gradually, Butler's work took on more Post-Impressionist, even Expressionist, overtones. Suzanne died in 1899, and one year later Butler married another sister, Marthe, who had cared for the children of Suzanne and Theodore during the former's illness. Well into the twentieth century he continued to act as a conduit for Americans in Giverny.[26]

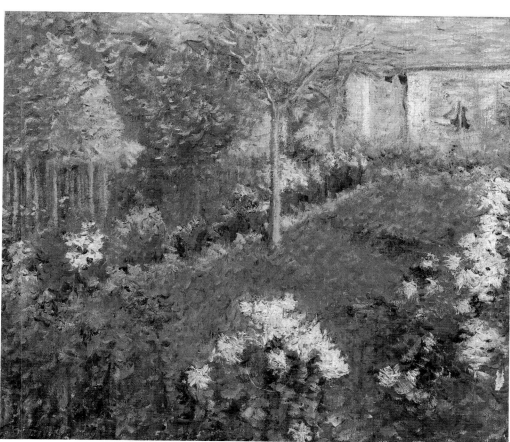

67. PHILIP LESLIE HALE (1865–1931). *Giverny*, 1888. Oil on canvas, 10 x 13 in. Herbert M. and Beverly Gelfand.

68. THEODORE BUTLER (1876–1937). *Un Jardin, Maison Baptiste*, 1895. Oil on canvas, 21⅛ x 25¾ in. The Metropolitan Museum of Art, New York; Gift of Mr. and Mrs. Raymond J. Horowitz, 1976.

68

John Singer Sargent

The most famous American artist to visit Giverny in 1887—indeed, the most famous *ever* to visit Giverny—was John Singer Sargent, who may have been there in 1888, but more likely in 1887. Impressionism appears to have been his primary concern for only a short while. He was trained in France, and the same painterly instincts inculcated by Carolus-Duran led not only to his better-known Grand Manner portraiture, but also underlay his Impressionist work.[27] At least in oil painting, Sargent was primarily a portraitist, as was his French master. Yet figure and subject pictures fascinated him from the first, and his earliest success was his 1878 *Oyster Gatherers of Cancale* (plate 70), his second work exhibited at the Paris Salon and a tour de force painting of glittering sunlight. The peasant subject by that time was traditional in French art—Sargent's innovation was the coastal setting. He deliberately negated the peasants' grueling toil with sparkling color and scintillating brushwork.

In his search for pictorial means to present outdoor scenes, Sargent continued to investigate contemporary modes, painting tonal twilight views of the Luxembourg Gardens. But only after the controversy over his exhibition of *Madame X* at the Salon in 1884 and his consequent move to England, did he veer toward a modified Impressionism. Yet his first calling remained portraiture, and the impetus for his Impressionist involvement was his 1884 *Garden Study of the Vickers Children* (plate 72).[28] The children are portrayed in flat color areas of strong tonal contrast, Manet for reference, perhaps, but not at all Impressionistic. The picture was important, beyond its intrinsic merits, as the immediate precursor to *Carnation, Lily, Lily, Rose* (plate 73), one of Sargent's most significant subject paintings and one conceived within the Impressionist methodology. It was painted in Broadway in the west of England during the summers of 1885 and 1886 when Sargent stayed with his good friend and fellow expatriate, Frank Millet.[29] The models for *Carnation, Lily, Lily, Rose* were Millet's daughter Kate in 1885 and the children of English illustrator Frederick Barnard in 1886, but unlike the *Vickers Children* it is not a portrait. Sargent wanted to project a mood of restrained gaiety and youthful joy and to capture the colors and light of a summer evening with

69

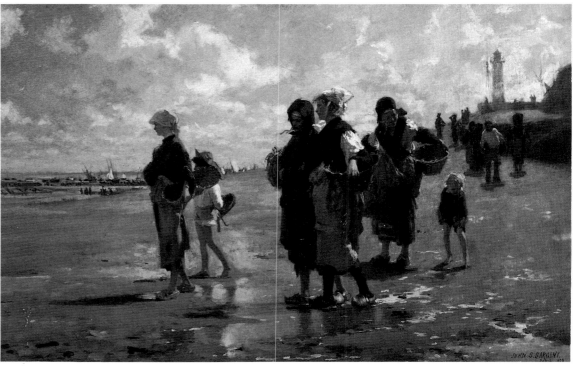

70

71

young girls in glistening white among lilies and Japanese lanterns. The colors are far more variegated than in the *Vickers Children* and some areas are quite freely painted in a somewhat divisionist technique; furthermore, Sargent worked on the picture for only a very brief period in the early evening, to maintain a constant quality of light. The painting was enthusiastically received at the Royal Academy in 1887, though more for its sentiment than its avant-garde aesthetic. It was well known in America, too, and emulated by the Midwestern painter Luther van Gorder in a canvas of 1895. For mid-1880s England it was a daring picture, but its Impressionism was modified and its chromaticism cautious; its light was of evening, rather than the glare of midday. The girls are carefully delineated, a selective Impressionism, with the setting more loosely treated. Sargent's pure landscapes painted among the lilies in Millet's garden are less self-conscious; they reveal better the extent of his daring in regard to light, color, and painterliness and they justify more clearly the reference to him as the "archapostle of the dab and spot school."[30]

By the mid-1880s French Impressionism was well known to Sargent, who would have seen Monet's work as early as 1874 at the first Impressionist exhibition and knew Monet personally by 1876. In 1887 Sargent acquired Monet's *Rock at Tréport* and the two painters began a firm friendship. Sargent visited Monet in Giverny, probably in 1887, and portrayed the French artist painting in the woods outside of town (see plate 75). Not surprisingly, this picture is far more fluid than *Carnation, Lily, Lily, Rose*, evoking a more immediate impression of a scene less premeditated; its forms are broken and generalized, its figures, ground plane, and forest setting are treated evenly. Yet even painting alongside Monet, Sargent did not adopt the French artist's full color range, and neutral tones still prevail.

Sargent's summer painting at Calcot on the Thames in 1888 and at Fladbury in 1889 brought him as close as he would come to the full adoption of Impressionism. Works like *A Backwater, Calcot Mill near Reading* (plate 74) depict figures and boats along the quiet waterway, sometimes enmeshed in vegetation that is rendered in spiky, quill-like brushstrokes, which became a hallmark of Sargent's Impressionist

69. JOHN SINGER SARGENT in his Paris studio, 1885.

70. JOHN SINGER SARGENT (1856–1925). *Oyster Gatherers of Cancale*, 1878. Oil on canvas, 31⅛ x 48½ in. The Corcoran Gallery of Art, Washington, D.C.; Museum purchase, 1917.

71. JOHN SINGER SARGENT. *Millet's Garden*, 1886. Oil on canvas, 27 x 35 in. Private collection.

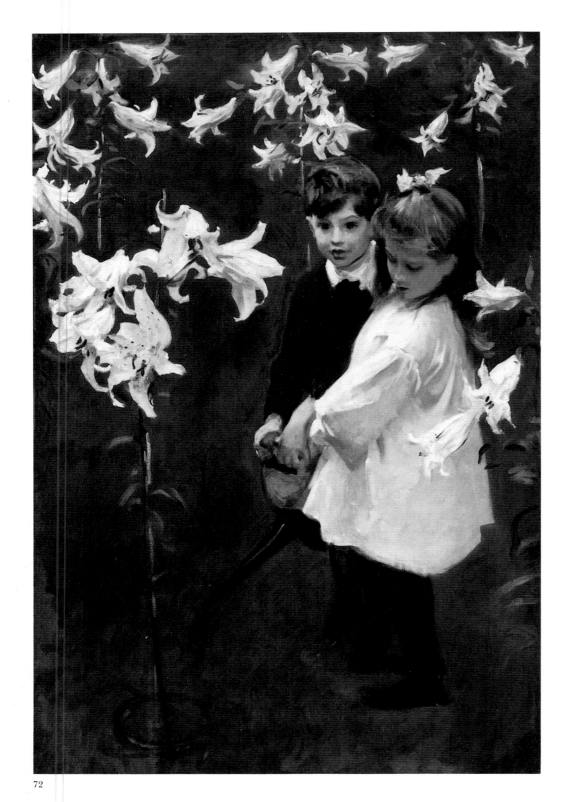

72

72. JOHN SINGER SARGENT. *Garden Study of the Vickers Children*, 1884. Oil on canvas, 54³/₁₆ x 35⅞ in. Flint Institute of Arts; Gift of Viola E. Gray Charitable Trust.

73. JOHN SINGER SARGENT. *Carnation, Lily, Lily, Rose*, 1885–86. Oil on canvas, 68½ x 60½ in. The Tate Gallery, London.

technique. His most fully Impressionist works probably are those depicting his sister Violet, walking with a parasol, drenched in sunlight (see plate 77); they are paintings in which he has eliminated all neutral tones and adopted a rich range of color. They would seem to derive from Monet's pictures of women with parasols on a hilltop at Giverny, but a comparison of these works is instructive. Monet presents a worm's-eye view of figures against the sunlight and the sky, almost absorbed into the light and space of the heavens; Sargent's view is from above, his figures firmly grounded in the more controlled light of late afternoon or early evening. In pictures such as *Boating Party at Calcot Mill* (plate 79), the figures are still more fully delineated than the background, characteristic of a number of works painted in 1889 at Fladbury, including the masterpiece of that summer, *Paul Helleu Sketching with His Wife* (plate 80). Sargent's design here is bold and innovative. His friend, the artist Helleu, is seen from above on a strong diagonal

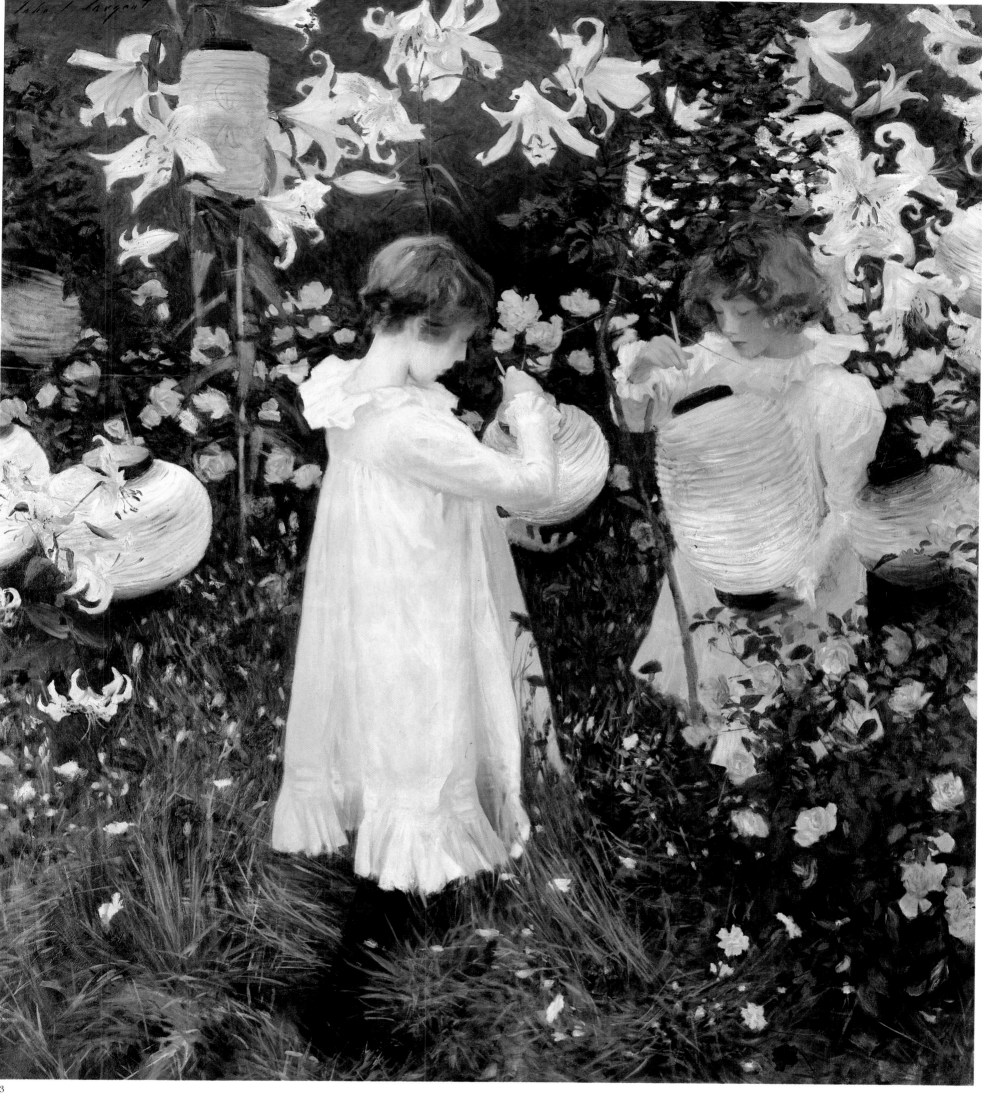

73

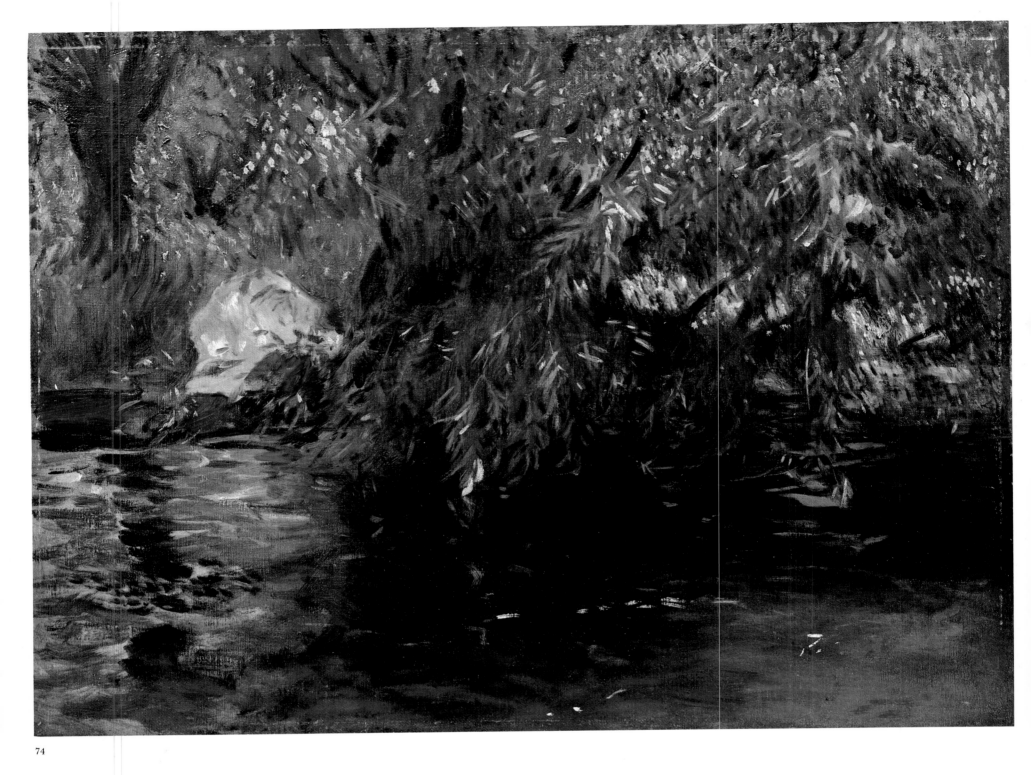

74

74. JOHN SINGER SARGENT. *A Backwater, Calcot Mill near Reading*, 1888. Oil on canvas, 20⁹⁄₁₆ x 27 in. The Baltimore Museum of Art; Gift of J. Gilman D'Arcy Paul.

75. JOHN SINGER SARGENT. *Claude Monet at the Edge of a Wood*, c. 1887. Oil on canvas, 21¼ x 25½ in. The Tate Gallery, London.

76. CLAUDE MONET. *Woman on a Hill*, 1886. Oil on canvas, 51⁹⁄₁₆ x 34⅝ in. Jeu de Paume, Musée du Louvre, Paris.

77. JOHN SINGER SARGENT. *A Morning Walk*, c. 1888. Oil on canvas, 26⅜ x 19¾ in. The Ormond Family.

axis, paralleled by the sweep of thick grass on the bank of the stream and the canoe to his right, while his wife lies quietly at an angle, parallel, in turn, to the canvas on which Helleu works. The grasses are loosely rendered, but the figures are soundly drawn and reflect Sargent's training under Carolus-Duran. Indeed, Helleu's pose even recalls that of Carolus-Duran in Sargent's great portrait of his teacher painted ten years earlier.

Late in 1889 Sargent returned to America and to more portraits. In 1890 his major commission for the murals in the Boston Public Library effectively turned his art to new directions and brought an end to his overt involvement with Impressionism. But Impressionist qualities survived or were revived in many of the broadly rendered and vividly colored watercolors he painted during holidays or summers early in this century—Alpine landscapes or rich nature studies, such as his *Gourds* of about 1908 (plate 78). Among his oil paintings, the spirit of Impressionism surfaced most completely in another picture of fellow artists painting out-doors, *The Sketchers* of 1914 (plate 82). The models are his friends Jane and

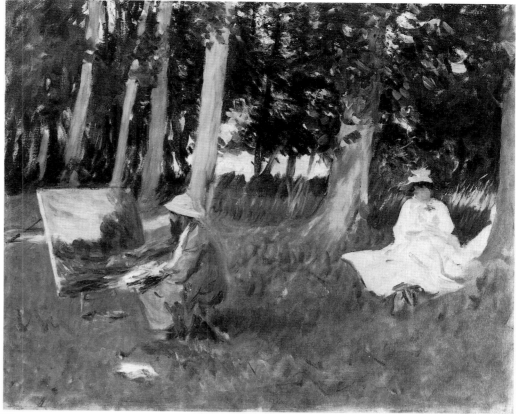

75

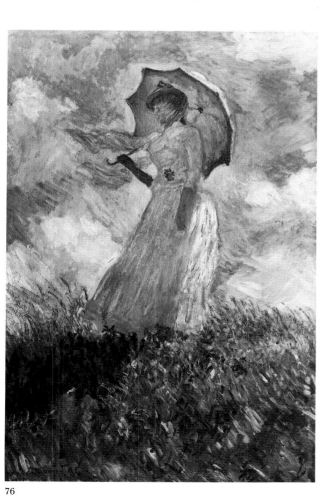

76

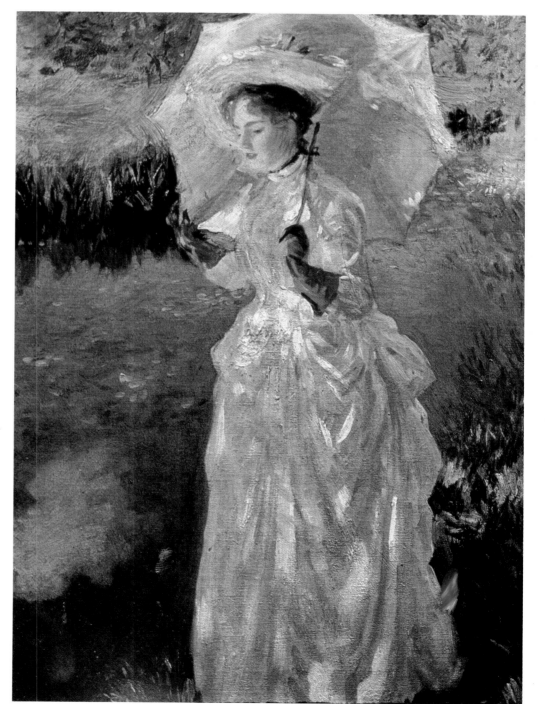

77

81

78

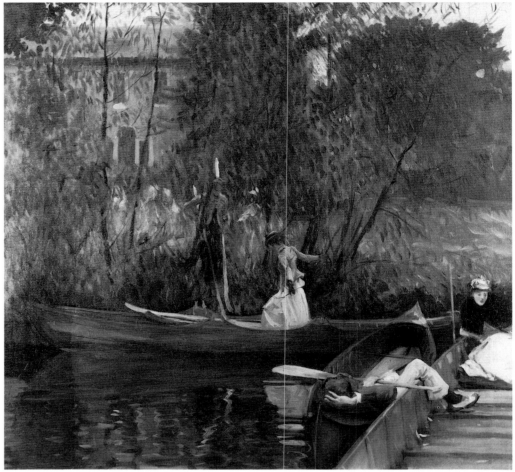

79

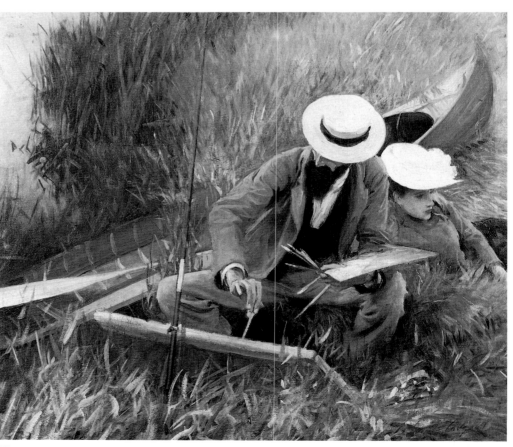

78. JOHN SINGER SARGENT. *Gourds*, c. 1905–8. Watercolor on paper, 13¹³⁄₁₆ x 17⅞ in. The Brooklyn Museum; Special Subscription Fund.

79. JOHN SINGER SARGENT. *A Boating Party*, 1889. Oil on canvas, 34⅝ x 36⅜ in. Museum of Art, Rhode Island School of Design, Providence; Gift of Mrs. Houghton P. Metcalf in memory of her husband, Houghton P. Metcalf.

80. JOHN SINGER SARGENT. *Paul Helleu Sketching with His Wife*, 1889. Oil on canvas, 26⅛ x 32⅛ in. The Brooklyn Museum; Museum Collection Fund.

81. JOHN SINGER SARGENT. *Dennis Miller Bunker Painting at Calcot*, c. 1888. Oil on canvas, 26¾ x 25 in. Terra Museum of American Art, Evanston, Illinois; Daniel J. Terra Collection.

82. JOHN SINGER SARGENT. *The Sketchers*, 1914. Oil on canvas, 22 x 28 in. Virginia Museum of Fine Arts, Richmond; Museum purchase, The Glasgow Fund.

83. DENNIS MILLER BUNKER (1861–1890).

80

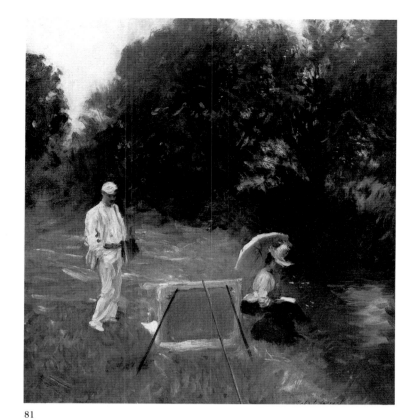

81

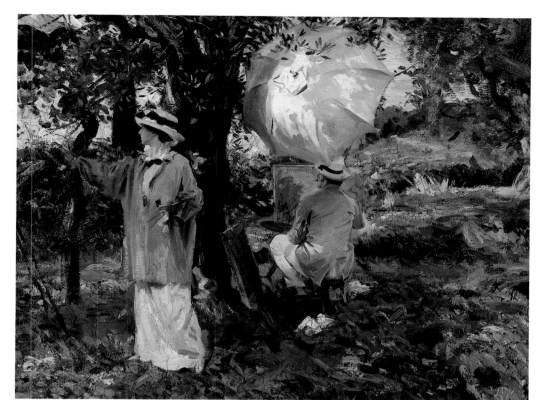

82

"I expect to be off in the country in a few days. Sargent
has found a charming place near Reading . . . willows,
boats—and I hope pretty girls—. . . I don't know just how
you are going to see J.S.S. He may be going to Paris but
you know how hard it is to tell where he'll go. . . .
The youngest Miss Sargent is awfully pretty—charming.
What if I should fall in love with her? Dreadful thought,
but I'm sure to—I see it coming—It is at moments like
these that I feel most keenly the absence of your restraining
hand."

 Dennis Miller Bunker to Isabella Stewart Gardner, June 25,
 1888. Isabella Stewart Gardner Museum Correspondence,
 Archives of American Art.

83

Wilfred de Glehn (Jane was one of the Emmet sisters, a family of New York artists).
In *The Sketchers*, Sargent was less concerned with the systematized methodology of
Impressionism than he had been before, now using its vigorous brushwork and
bright colorism simply to suggest informality and animation.[31]

Dennis Miller Bunker

Twenty-five years earlier, in the summer of 1888,[32] Sargent had painted the
young Boston artist Dennis Miller Bunker at Calcot. Bunker had met Sargent the
previous winter through his patron, Mrs. Jack Gardner. At Calcot, Sargent por-
trayed Bunker standing away from his own painting on an easel, while Violet
Sargent sits to the right along a tree-shaded stream (see plate 81). The picture is
painted with an engaging technical spontaneity. While the paint application is very
free, the color range is subdued; blacks and browns abound in the landscape and
even in Violet's skirt.

 Bunker had studied with William Merritt Chase at the Art Students League in
the late 1870s and later in Paris with Gérôme and at the Académie Julian.
Returning to Boston, he began to teach at the newly founded Cowles School. His
attractive tonal landscapes and his strong, academic portraiture made him a
mainstay of the Boston art scene. Bunker's subsequent figure painting continued
to prove his sensitive mastery of academic principles. His summer work of 1889
and 1890, done in Medfield, Massachusetts, demonstrates that he had thoroughly
learned the lessons Sargent taught him at Calcot. The suggestion of the informal,
even the uncomposed, radiates from Bunker's brilliant *Wild Asters* of 1889 (plate
86). The color is bright and rich, though tempered by a Tonalist preference for a
dominant hue. In *Wild Asters* the horizon is eliminated completely; in other
landscapes of these years, Bunker raised it high, which flattens the picture as the
eye moves back rapidly in space, a flowing movement reinforced by the strong,
single, curving diagonal axis of the stream that bisects the picture. The foliage
repeats Sargent's quill-like strokes, or, in Bunker's case, "fishhooks," as his col-
league Edmund Tarbell called them. *Wild Asters* was seen in New York in the 1890
exhibition of the Society of American Artists; the writer for the *Critic* found that
Bunker had "led a stream from some dye-shop through the flowery banks of a
milliner's window."[33]

84

84. DENNIS MILLER BUNKER. *On the Banks of the Oise*, 1883. Oil on canvas, 26 x 36 in. Berry-Hill Galleries, New York.

85. DENNIS MILLER BUNKER. *Brittany Town, Morning*, 1884. Oil on canvas, 14 x 28 in. Mr. and Mrs. Ralph Spencer.

86. DENNIS MILLER BUNKER. *Wild Asters*, 1889. Oil on canvas, 25 x 30 in. Mr. and Mrs. Jared I. Edwards.

87. DENNIS MILLER BUNKER. *Chrysanthemums*, 1888. Oil on canvas, 35⁷⁄₁₆ x 47⁵⁄₈ in. Isabella Stewart Gardner Museum, Boston.

85

If Bunker's Impressionism was disturbing in New York, it was even more radical in Boston, where he had introduced it as early as 1888 in the brilliant *Chrysanthemums* (plate 87), set in Mrs. Gardner's Brookline greenhouse. The most vibrant painting Bunker had yet created, it made very evident his adoption of Sargent's loose, long, spiky brushstrokes. With its deep plunge directly back into space, its brilliant color, free paint application, and loose composition, this work differs in every way from Bunker's earlier tonal and academically structured landscapes of the French countryside, such as his *Brittany Town, Morning* of 1884 (plate 85).

Bunker's Impressionist pictures and those sent from France by John Leslie Breck were among the earliest native Impressionist works seen in Boston in the late 1880s. In 1890 Sargent, back in America, renewed his friendship with Bunker and attended his Boston wedding. That fall Bunker left for New York and three months later died there of influenza. A memorial show of his paintings held the following February at the St. Botolph Club was one of a series of Impressionist

landscape exhibitions in Boston in the early 1890s of work by Breck, Wendel, Metcalf, and others. But Bunker's impact, because of his limited Impressionist production and his early death, was less sustained than that of the other landscapists or the Boston figure painters who were beginning to dominate the art scene.

Bunker was an extremely engaging figure, admired not only by wealthy Boston patrons but also by his fellow artists. Hamlin Garland, who resided in Boston in the late 1880s, noted that when he visited the Bunker memorial exhibition he "understood something of the struggle which he had undergone in changing from 'the school of mud' to the school of the open air, and the use of primary colors."[34] Garland also wrote that Bunker had become aware of Impressionism when he viewed a group of Breck's canvases in the studio of their friend Lilla Cabot Perry.

Lilla Cabot Perry

Perry had studied with Bunker, along with Robert Vonnoh, at the Cowles School before going to Paris to study at the Julian and Colarossi academies. In 1889 she went for the first time to Giverny, where she established an enduring friendship with Monet;[35] of all the Americans at Giverny in the late 1880s, she subscribed most completely to his aesthetic. During the next two decades, Perry spent half of her summers in Giverny. Her pictures, such as *Haystacks, Giverny* of about 1896 (plate 89), apply the divisionist technique and full color range of orthodox Impressionism to a typical Monet subject. Perry's *Giverny Hillside* (plate 90), though relatively less structured than Monet's paintings, recalls not only his work in general but, in particular, his *Poppy Field near Giverny* (plate 88). The latter was shown in New York the following year and was singled out in Cecilia De Silver Michael's important pamphlet on the show as the work best exemplifying Monet's theory of triangulation.[36]

Mrs. Michael's discourse is important because it concerns itself with an underlying geometric structure in Monet's work, countering the charges of formlessness. She described his canvas as the interior of a geometric solid, with the poppy field a parallelogram, and noted: "It is significant that in one of Monet's highest expressions of thought the unbending principles of geometric form are the most clearly discernible. It may be claiming too much to say that mathematical principles are the basis of all truth, but that the two are nearly related must be acknowledged."[37] And further, she saw in this underlying structure the meaning and message of Monet's art: "an interminable depth" is achieved, from which a "sense of solemnity steals over the observer. He is brought most terribly near the source and origin of things.... Here is the beginning of life's course. Unconscious of what is back of the hill, the soul is absorbed by the immediate; though she may step forward, through the gay-flowered field, onward to her future, the past is locked in mystery. Nature throws no obstacle to her progress; there is no warning hand to hold the soul from running to her own destruction; and the indifference of nature to suffering or happiness is terrible to contemplate."[38] If Mrs. Michael's interpretation of Monet is a radical one and difficult to accept, it was well received and even translated into French.

In 1898 Perry's husband, the noted writer and educator Thomas Sergeant Perry, accepted the chair in English literature at a college in Tokyo, where the couple spent three years. Lilla Cabot Perry introduced full Impressionism into Japan, in works such as *Japan* of 1900 (plate 92). But, as with so many Americans, the concern for color and light and the dissolution of form applied only to Perry's landscapes; in her figure paintings, whether done in France, Japan, or Boston, she maintained a firm academic stance, with accurate drawing and well-modeled forms created through strong tonal contrasts.

Throughout her career, Perry was an effective force in the Boston art world, and she exhibited actively with the Guild of Boston Artists in the 1910s and '20s. After her first summer in Giverny in 1889, she brought back an Etretat view by Monet, one of his first pictures to be seen in Boston, and one admired by few

88. CLAUDE MONET. *Poppy Field near Giverny*, 1885. Oil on canvas, 26¾ x 33 in. Museum of Fine Arts, Boston; Juliana Cheney Edwards Collection, Bequest of Robert Edwards in memory of his mother.

89. LILLA CABOT PERRY (c. 1848–1933). *Haystacks, Giverny*, c. 1896. Oil on canvas, 25¾ x 32 in. Warren Snyder Collection.

90. LILLA CABOT PERRY. *Giverny Hillside*, n.d. Oil on canvas, 18 x 22 in. Blake and Barbara Tartt.

88

89

90

viewers, excepting her brother-in-law, John La Farge. A few years later she lectured on Monet for the Boston Art Students Association, and late in her life, in March 1927, she published the article "Reminiscences of Claude Monet from 1889 to 1909." She was not the first artist to write about a friendship with Monet, nor the first American to describe a visit to him at Giverny. Theodore Robinson published an article on him in September 1892, just before leaving France for good; among the illustrations were an 1890 full-length drawing of Monet by Robinson and a painting he did of Monet's house.[39] In 1897 Anna Seaton-Schmidt published an article about an afternoon visit with Monet the previous July, during which he said, "When I first came to Giverny I was quite alone, the little village was unspoiled. Now, so many artists, students, flock here, I have often thought of moving away...." And then Seaton-Schmidt noted that "his eyes rested lovingly on his beautiful home, a real home that has grown up about him, and we did not wonder that he has found it hard to leave."[40] The critic and

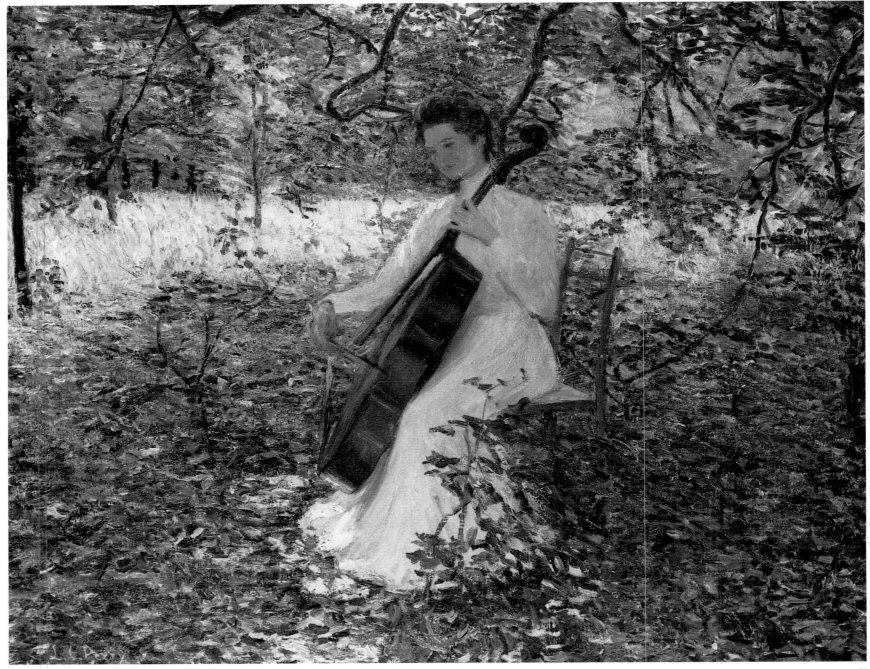

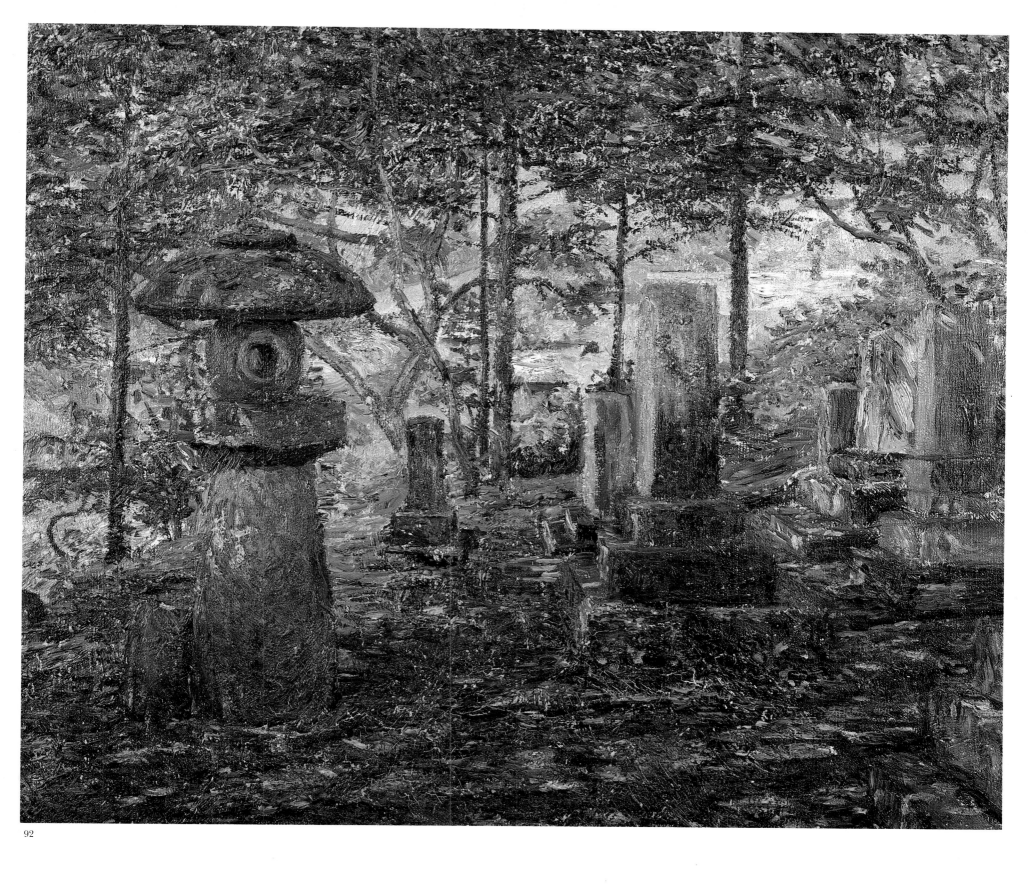

92

91. LILLA CABOT PERRY. *The Violincellist*, n.d. Oil on canvas, 21 x 25 in. Private collection.

92. LILLA CABOT PERRY. *Japan*, 1900. Oil on canvas, 17¾ x 21¾ in. Coggins Collection of American Art.

writer Walter Pach published an article "At the Studio of Claude Monet" in 1908, based on a visit he made to try to bring Monet to America. Monet and Pach discussed Sargent, Chase, Robert Henri, and Winslow Homer, whose work Monet knew from an example at the Musée du Luxembourg, and especially Whistler, whom Monet had known personally. Although Monet expressed a desire to visit America, he was not attracted by its pictorial possibilities and decided against the journey.[41] But of all these accounts, it was Perry's "Reminiscences," written immediately after Monet's death in 1926, that offered the fullest recollection of the painter by an American and the warmest tribute to the French Impressionist who so profoundly affected American art.

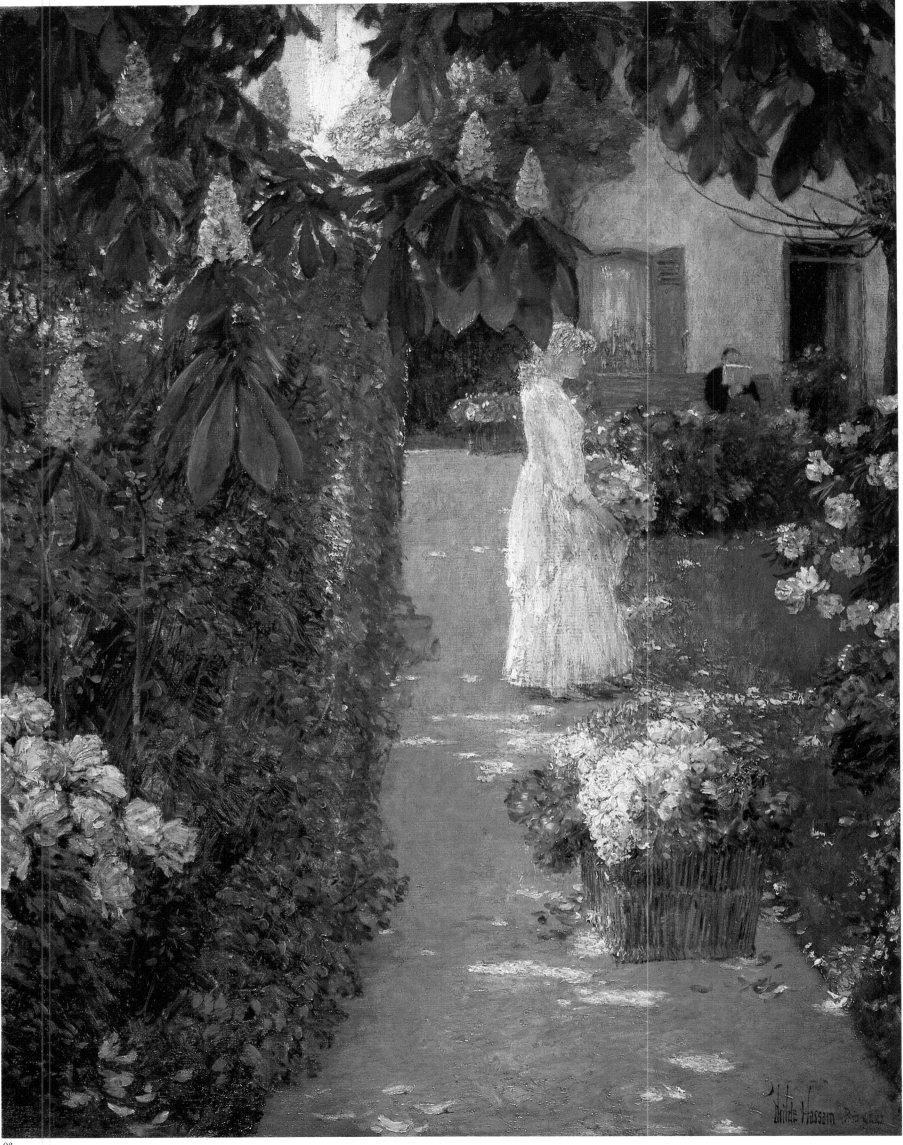

6 The Early Masters

Childe Hassam

B<small>Y THE EARLY</small> 1900s Albert Gallatin, one of the most perceptive American art writers of the time, could state unequivocably that "Childe Hassam is beyond any doubt the greatest exponent of Impressionism in America."[1] Like Robinson and other early Americans involved in the movement, Hassam had begun his career unaware of the new style, beyond some works of Johan Barthold Jongkind shown to him in Boston by William Morris Hunt in the late 1870s. And even after his conversion to Impressionism in France about 1887 or 1888, his art was noticed only gradually. In the early 1890s the torchbearers of Impressionism were Theodore Robinson and others now little recalled.

Today most critics and historians would agree that Hassam was the American painter most completely Impressionist, and they would also concur with Gallatin's criteria for defining *American* Impressionism and Hassam's involvement with it: "for the scientific aspect of Impressionism, for the theories of pure Impressionism, and for the employment of only the colors of the spectrum, Hassam seldom gives a thought." Instead, Gallatin continued: "Momentary effects produced by sunlight is usually his theme, it is true, and equally true is it that he paints by placing his colors in juxtaposition, in order to attain effects to be seen at a distance."[2]

While the outline of Hassam's career is well known, and many of his works quite familiar, the specifics of his development are still somewhat hazy. Estimations of his career have been oversimplified by imposing a consistency dear to art historians, but often irrelevant to the artists themselves.[3] Current interest in Hassam's Impressionism should not blind us to his pre-Impressionist achievements, nor to those of several major figures in American Impressionism. Very few of its pioneers started with Impressionism, since it was not an indigenous art; rather, they adapted it to or adopted it in place of an aesthetic that often had already yielded handsome results. This is true of J. Alden Weir's tremendously beautiful, dark, dramatic still lifes of the 1880s; John Twachtman's adaptations of Whistler; and even work by some of the regional artists such as Theodore Steele, whose Munich-derived landscapes of the 1880s may be among his finest. This is also true of Childe Hassam's Tonalist urban scenes.

Much is still to be learned about Hassam's early paintings, which are just beginning to emerge in any quantity. Born in Dorchester, Massachusetts, Hassam began his career as an illustrator for newspapers and magazines and, from 1883

93. CHILDE HASSAM (1859–1935). *Gathering Flowers in a French Garden*, 1888. Oil on canvas, 28 x 21⅝ in. Worcester Art Museum; Theodore T. and Mary G. Ellis Collection.

on, for books. Like his paintings, the book illustrations are of high quality both before and after his conversion to Impressionism, and a thorough study of them is needed.[4] Specific information on Hassam's training as a painter is scarce: in the late 1870s he took evening classes at the Boston Art Club, drawing lessons with William Rimmer at the Lowell Institute, and is believed to have studied with Ignaz Gaugengigl, a Bavarian artist who immigrated to Boston in 1879. Gaugengigl, a specialist in tightly painted, miniaturist figure compositions, had been a pupil of Wilhelm von Diez, the enormously popular German master at the Munich Royal Academy.[5] Boston received Gaugengigl enthusiastically, and although Hassam never became proficient in that tradition, the precise drawing of figures in his oils may result from this training.

Hassam's earliest paintings were done in watercolor, a technique that had recently become popular in America as a suitable medium for finished works of art. Hassam also began to teach watercolor painting, though his pupils seem to have been gifted amateurs rather than serious professionals; still, one of these was Jane Hunt, the sister of the doyen of Boston painting, William Morris Hunt, and another was Celia Thaxter, with whom Hassam would develop a long-lasting friendship significant to his art. In July 1883 the *Studio* magazine reported that Hassam had gone abroad for several months with his good friend the painter and illustrator Edmund Garrett. Hassam went to Great Britain, France, Italy, and Spain, dividing his time between the study of earlier masters and painting watercolors of foreign scenes.[6]

Hassam's earlier watercolors had been in the British tradition of colored drawings, more topographical and pre-Turneresque with rather tightly delineated figural and landscape forms that recall his training as an illustrator and possibly Gaugengigl's influence. His watercolors such as the 1883 *Beach at Dunkirk* (plate 94), while still linear, suggest a fascination with creating deep spatial movement through the use of plunging perspectival lines; this remained part of his art throughout his career. Bright sunlight is also a concern here, pictorialized in the glare aesthetic device of using broad planes as foils to the sharply drawn figures.

Returning to Boston in late 1883, Hassam exhibited sixty-seven watercolors in his first one-man show at Williams & Everett Gallery. While they seem to have been well received, and he maintained an interest in watercolor throughout his

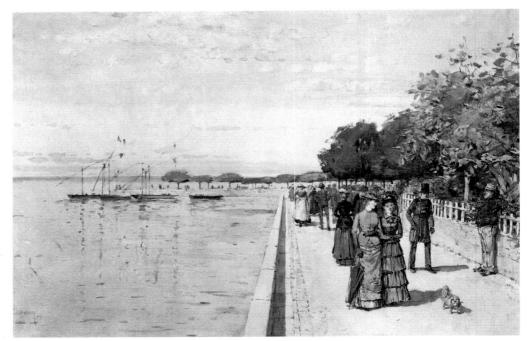

94. CHILDE HASSAM. *Beach at Dunkirk*, 1883. Watercolor on paper, 17½ x 26½ in. The Metropolitan Museum of Art, New York; Gift of Mr. Arthur G. Altschul, 1971.

95. CHILDE HASSAM. *Old House, Dorchester*, 1884. Oil on canvas, 16 x 26 in. U.S. Steel Corporation, Pittsburgh, Pennsylvania.

96. CHILDE HASSAM. *Barnyard*, 1885. Oil on canvas, 30 x 41½ in. Coe-Kerr Gallery, New York.

94

95

96

career, he apparently concluded that he would pursue the more ambitious oil medium. The dominant painter in Boston had been the Barbizon-oriented William Morris Hunt, and next door to Hassam in his Tremont Street studio was George Fuller, the Barbizon-inspired figure painter whom Hunt had championed. Thus it is not surprising that some of Hassam's oils of the mid-'80s, such as *Barnyard* (plate 96), are monumental rural scenes of American farm life, native equivalents to the European peasant theme favored by Jean François Millet. This may have been the picture shown at the Boston Paint and Clay Club in 1886 and described in the *Art Interchange* as "a haying scene, strong and exquisitely graded in tone and feeling."[7] Hassam was an active member of that club, which seems to have been more modern than the Boston Art Club.

Rural labor was not a long-lived pictorial interest for Hassam, although similar themes appear occasionally in his Impressionist work. More enduring was his concern for buildings and the urban scene. His *Old House, Dorchester* (plate 95)

looks forward many years, in subject if not style, to Hassam's cottage paintings of his later years in East Hampton, Long Island; but his major interest in the mid-'80s was Boston street scenes, views along Columbus Avenue or the Commons in evening light or rain.[8] In them Hassam adapted the close Tonalist values of Fuller's work or the late landscapes of George Inness to interpretations of the urban scene, carefully integrating the activities of the city's inhabitants and the movement of their vehicles. *Rainy Day, Columbus Avenue, Boston* of 1885 (plate 97) is perhaps the outstanding example of Hassam's early Tonalism; its high horizon plunges the viewer precipitously back into space, while the major vehicles and figures move inexorably forward. The broad expanse of pavement glistens with rain, and acts as a foil for the dark figures and carriages—a kind of Tonalist equivalent of the flat planes in glare paintings that more often reflect intense sunlight.

Such paintings are masterpieces of their kind and prove that Hassam needed no further training in composition and perspective. When he returned to Paris in 1886, it was probably to try to master the figure. Hassam enrolled at the Académie Julian, studying figure painting with Gustave Boulanger and Jules Lefebvre. Unlike his first trip to Paris, when he apparently evidenced no interest in Impressionism, this time it had a strong impact upon his art, though the precise source of that impact is not recorded. Before his trip Hassam may well have seen Durand-Ruel's great Impressionist show in New York.

There are significant changes in Hassam's paintings of 1887, notably in *Une Averse, rue Bonaparte* (plate 98). Its subject is almost a Parisian equivalent of his

97

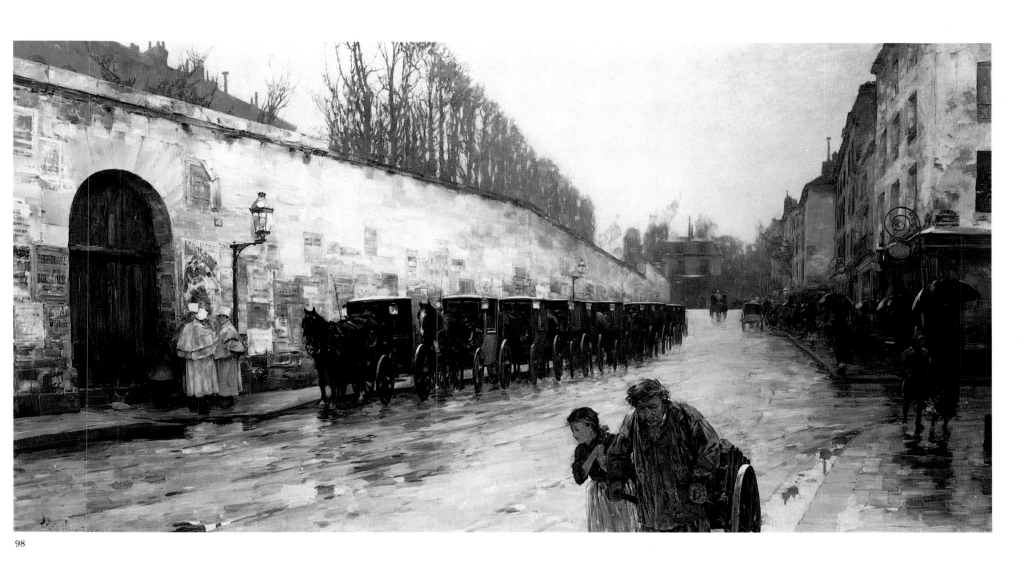

98

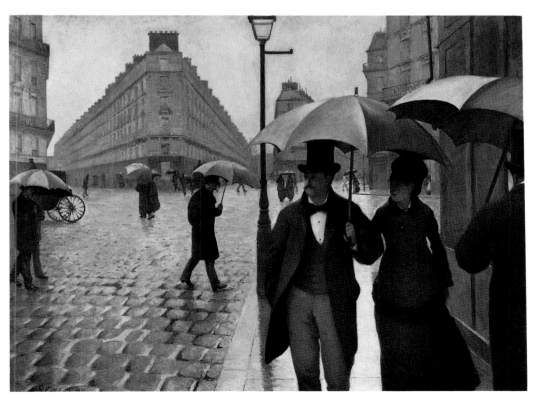

97. CHILDE HASSAM. *Rainy Day, Columbus Avenue, Boston*, 1885. Oil on canvas, 26⅛ x 48 in. The Toledo Museum of Art; Gift of Florence Scott Libbey.

98. CHILDE HASSAM. *Une Averse, rue Bonaparte*, 1887. Oil on canvas, 40¼ x 77¼ in. Hirschl and Adler Galleries, New York.

99. GUSTAVE CAILLEBOTTE (1848–1894). *Paris, A Rainy Day (Intersection of the Rue de Turin and Rue de Moscow)*, 1877. Oil on canvas, 83½ x 108¾ in. The Art Institute of Chicago; Charles H. and Mary S. Worcester Fund.

99

Columbus Avenue picture of 1885—a strong perspectival plunge back into space in a rain-swept urban view—but here Hassam's colors are lighter and more diverse, the brushwork looser and the forms more broken, and the planes of pavement and wall scintillate with pigment facture as much as with reflections of water and light. But as Hassam's art moved in a more modernist direction, he remained faithful to the urban scene portrayed under overcast skies, the theme that would first win him critical recognition.

Later in 1887 Hassam painted *Grand Prix Day* (plate 100), another very specific city view, but this time in the full radiance of bright sunlight. He has moved much closer to Impressionism, too, in the flecked brushwork and rich, intense colorism of the scene; the moody melancholy of earlier urban scenes is replaced by the joyousness that characterized so much Impressionist art. Yet one must beware of tracing a direct course for Hassam from Tonalism to Impressionism or of characterizing his work of these years as wavering between them. Rather, Hassam seems to have chosen to work in whatever manner best suited his purpose and his interpretation. *Grand Prix Day*, for example, is a compendium of several aesthetics: the broken brushwork in the avenue of trees and the sky in true Impressionist technique; the strong plane of the street reflecting the sunlight and silhouetting the figures and the carriages in the glare aesthetic; and carriages and horses in the academic manner. Impressionist, glare, and academic in one canvas may seem art historically inconsistent, but Hassam was concerned not with consistency but with effective painting.

During the Parisian years, Hassam's scenes of the city and its inhabitants were painted at different times of the day and in all kinds of weather. In summer, Hassam and his wife, Maude, went to Villiers-le-Bel, outside Paris, and there he painted a number of brightly colored garden scenes in which women, sometimes his wife, were shown among the flowers and identified with them as images of loveliness. Such paintings as his 1888 *Gathering Flowers in a French Garden* (plate 93) suggest a similarity to Monet's series of garden pictures done in Vetheuil in 1881, one of which was in the 1886 Durand-Ruel exhibition in New York. Hassam does not seem, however, to have met Monet nor to have visited Giverny. His painting is more insistent than Monet's in its geometric grid for the forms, almost as though he had taken Mrs. Michael's analysis of Monet's compositions to heart; his colors are darker and more restricted in range, so that the white dress stands out more strongly against the rich reds and greens of the flower garden that seems to envelop and protect the figure. Here he has adopted a traditional Impressionist subject that he would explore, exploit even, back home.

The Hassams returned to America after three years abroad, arriving in October 1889. Hassam had shown his work in Paris, at the Salon and the Exposition Universelle of 1889; he had also continued to exhibit in Boston, with several shows at Noyes, Cobb & Co. One held in March 1889 was greeted with much enthusiasm for both the "jewell-like yet harmonious color" of flowers and trees, and "Hassam's favorite rainy street scenes, with wet pavement giving blurred reflections of hurrying figures...."[9] But he left Boston for a New York studio and quickly involved himself in the active art life of the city.

Hassam showed in the last exhibition of the Society of Painters in Pastel in 1890 and was instrumental in founding the New York Watercolor Club that year. But oil painting remained his main interest, and he became perhaps *the* major interpreter of New York in that period. *Washington Arch, Spring* of 1890 (plate 102) reveals Hassam at the height of his powers, reveling in the bright spring sunshine and capturing the activity of strollers, streetcleaners, and horse-drawn cabs. Hassam's involvement with the city was inexhaustible; he caught its many moods in every season, from numerous vantage points at different times of day and in varied weather. Hassam exhibited more actively with the Society of American Artists in the early 1890s than with the more conservative National Academy, but he was better known for his themes than for his advanced aesthetic. While one critic

"I believe the man who will go down to posterity is the man who paints his own time and the scenes of every-day life around him. . . . I sketch these things because I believe them to be aesthetic and fitting subjects for pictures. There is nothing so interesting to me as people. I am never tired of observing them in every-day life, as they hurry through the streets on business or saunter down the promenade on pleasure."

Childe Hassam, quoted in A. E. Ives, "Mr. Childe Hassam on Painting Street Scenes," *Art Amateur*, October 1892, pp. 116–17.

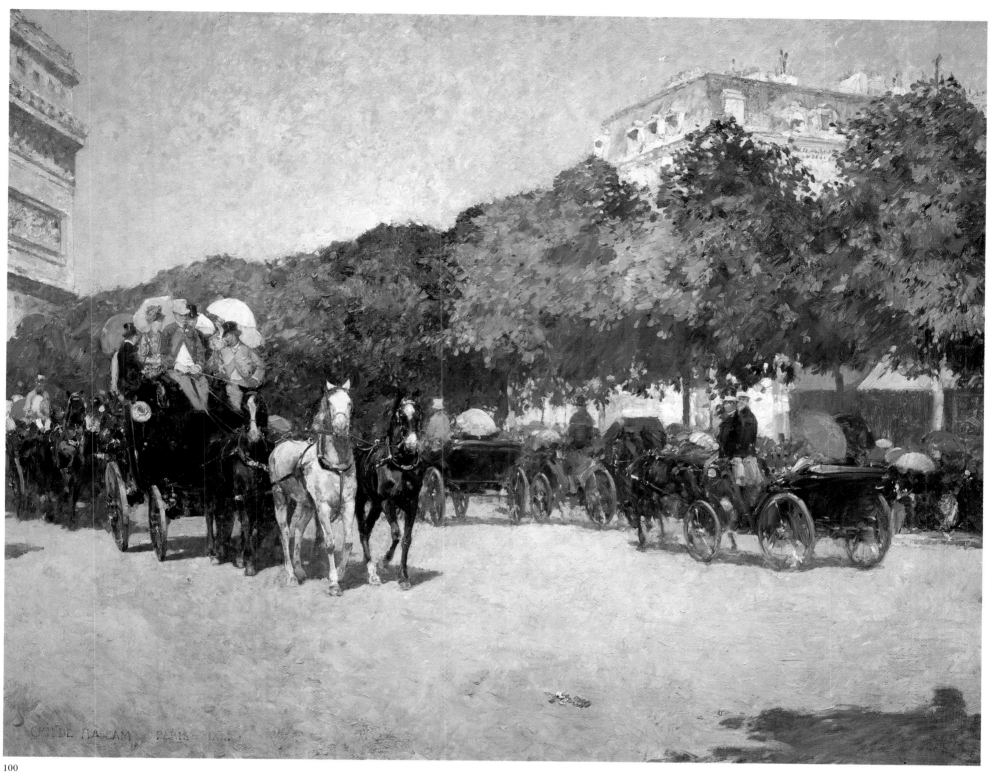

100

100. CHILDE HASSAM. *Grand Prix Day*, 1887. Oil on canvas, 24 x 31 in. Museum of Fine Arts, Boston; Ernest Wadsworth Longfellow Fund.

advised Hassam to "come in out of the rain,"[10] others spoke of him as "a brilliant painter, a sort of Watteau of the Boulevards, with unlimited sparkle and gaiety, movement and animation. He suggests a crowd well; he gives you the color of the streets and the tone of the city."[11] In one of the earliest important articles on Hassam, an interview called "Mr. Childe Hassam on Painting Street Scenes," which appeared in the *Art Amateur* of October 1892, Hassam discussed his emphasis on color, on the dominance of blue in his atmosphere, rather than the "'molasses and bitumen school' of more traditional painting." He also spoke of his preference for painting the city life around him, because it offered "aesthetic and

fitting subjects for pictures.'' He recalled that Gérôme told his pupils to "go into the street and see how people walk," and he reminisced about Boston's Columbus Avenue: "The street was all paved in asphalt, and I used to think it very pretty when it was wet and shining, and caught the reflections of passing people and vehicles.''[12] A year later Hassam brilliantly illustrated an article on Fifth Avenue by Mariana van Rensselaer for the *Century* magazine of November 1893.[13]

Many of Hassam's urban views of the 1890s and early 1900s are scenes of Union Square; his studio at 95 Fifth Avenue was not far from the square, which he portrayed in all seasons, creating a particularly large number of winter scenes such as *Winter in Union Square* of 1890 (plate 104). Hassam, in such works, shows a fascination with the city in the snow: figures, cabs, and trolleys are seen as specks against the falling, blanketing white, and he favors the purple and lavender tones that were becoming the hallmark of Impressionism. The urban activity is vividly conveyed through the vigorous, unevenly applied strokes and the strong diagonals of carriages and trees that zigzag across Union Square. Such bird's-eye views of the city from a studio window suggest a derivation from similar views by Pissarro and Monet, but *Winter in Union Square* and other paintings like it were done before the French Impressionists had turned to this theme in full force. *Winter in Union Square* is most like some of Monet's 1873 views into the boulevard des Capuchines (see plate 103), and Hassam might have seen one of these in the major Monet and Rodin exhibitions held in Paris in late June 1889.

Although today we may view Hassam as the most completely Impressionist in the French sense, it is surprising that his contemporaries in the first generation of American Impressionists working at home viewed him differently. It may be that his preoccupation with urban scenes was so strong that his work seemed removed from that of Monet, Pissarro, and Renoir, whose relatively few city subjects were unknown in America. That Theodore Robinson, rather than Hassam, stood for Impressionism in New York in the early 1890s was made abundantly clear in the

101

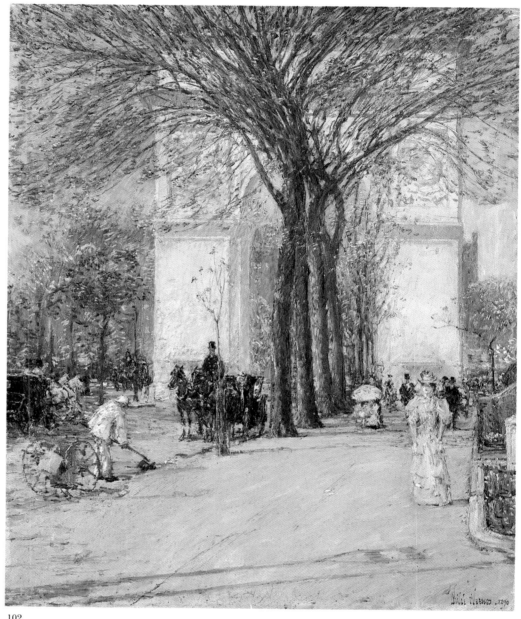

102

review of the National Academy of Design annual in the *Art Amateur* of January 1891. The critic wrote:

> Mr. Hassam is an Impressionist in the sense that he tries to communicate the impression made on him by a particular scene to those who look at his pictures. Theodore Robinson is also an Impressionist in the same sense; yet he is the only one of the two to whom the term will generally be applied. The reason is that his technique is the more novel, and to frequenters of picture exhibitions will suggest that of Monet, Pissarro and a majority of other French Impressionists. They have found it to suit their aims and their abilities to paint in oils as they would make a single study in pastels. Over a more or less careful drawing they place a mosaic of small touches of pure color, depending on distance to make them blend and harmonize.[14]

By this time, however, Hassam had begun laying down that "mosaic of small touches of pure color" in the Appledore paintings that are arguably the most beautiful of his entire career. About 1884, before his decisive European sojourn, Hassam had begun to spend time during the summers on Appledore, among the

101. CHILDE HASSAM. *Vase of Roses*, 1890. Oil on canvas, 20 x 24¼ in. The Baltimore Museum of Art; The Helen and Abram Eisenberg Collection.

102. CHILDE HASSAM. *Washington Arch, Spring*, 1890. Oil on canvas, 26 x 21½ in. The Phillips Collection, Washington, D.C.

103. CLAUDE MONET (1840–1926). *Boulevard des Capuchines, Paris (Les Grands Boulevards)*, 1873–74. Oil on canvas, 31¼ x 23¼ in. The Nelson-Atkins Museum of Art, Kansas City, Missouri; Acquired through the Kenneth and Helen Spencer Foundation acquisitions fund.

104. CHILDE HASSAM. *Winter in Union Square*, 1890. Oil on canvas, 18¼ x 18 in. The Metropolitan Museum of Art, New York; Gift of Miss Ethelyn McKinney, 1943, in memory of her brother, Glenn Ford McKinney.

105. CHILDE HASSAM. *Celia Thaxter's Garden, Isles of Shoals, Maine*, 1890. Oil on canvas, 17½ x 21 in. Private collection.

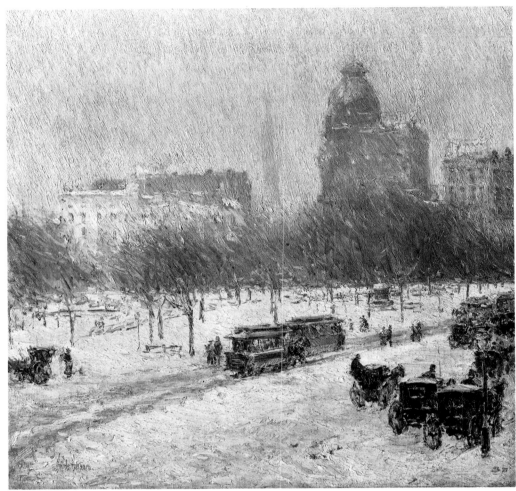

104

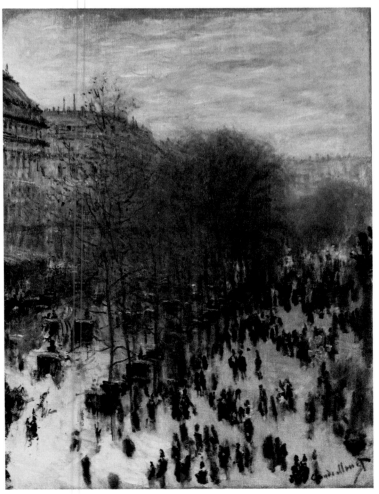

103

Isles of Shoals off the coasts of New Hampshire and Maine, at the home of his pupil Celia Thaxter.[15] Thaxter was a poet and essayist whose informal artistic and literary salon during the summers on Appledore attracted such respected painters as Arthur Quartley, J. Appleton Brown, Hassam's friend Ross Turner, and earlier, Ellen Robbins and William Morris Hunt (Hunt drowned at Appledore in 1879). Hassam was the most notable artist to work on Appledore, and the island offered him special inspiration that derived from the location and configuration of the islands and from Celia Thaxter's renowned garden. Creating and cultivating a garden in the rocky soil of Appledore was an exhilarating challenge to Thaxter, who celebrated her flowers in prose and poetry; Hassam was to do the same in oil, pastel, and watercolor. He singled out the garden's poppies, the same flowers featured in so many of Monet's canvases. In Hassam's Appledore pictures they blaze among the green foliage, against the white rocks and the clear blue skies, with the flecked, broken brushwork and full chromaticism of Impressionism. Thaxter's was a "natural," informal garden, and Hassam emphasized the wild freedom of pure nature that suggests the joyous release he must have felt while summering on Appledore. Though he continued to visit the island for several decades, his finest paintings of the colorful garden were done between the summer of 1890, after his return from abroad, and the summer of 1894, when Thaxter died.

Oils such as Hassam's *Celia Thaxter's Garden, Isles of Shoals, Maine* of 1890 (plate 105) again seem to reflect, although less classically, the geometric compositional underpinnings that Mrs. Michael had discovered in Monet's work. But Hassam also imbued the island scenes with a specific sense of place, as well as with the

bright sunlight and clear atmosphere of the New England summer. Most of his paintings of the Appledore garden are without figures, but his 1892 painting of Celia (plate 106) is one of his best-rendered figures: she towers over the climbing blooms and yet looks down humbly upon her fragile creations, in an image that is portrait, landscape, and still life.

New York became aware of Hassam's Appledore garden imagery when he began exhibiting his summer work at the Society of American Artists, showing *Isles of Shoals, June* and *Midsummer* in 1891, *Midsummer Morning* in 1892, and *An Island Garden* in 1893. Some critics thought they suffered from "a brilliancy sometimes obtained at a loss of harmony and refinement. A striking example of this is Mr. Childe Hassam's study, a 'Midsummer Morning' in Celia Thaxter's garden of poppies in the Isles of Shoals. Here, no doubt, were reds and greens, blue sea and white rocks, to 'tax the resources of a painter's palette,' as the novelists say. But it is hard to believe that the general effect was as crude as in the painting."[16]

That garden was also the stimulus for Hassam's beautiful series of watercolors, such as the *Home of the Hummingbird* of 1893 (plate 108), used to illustrate

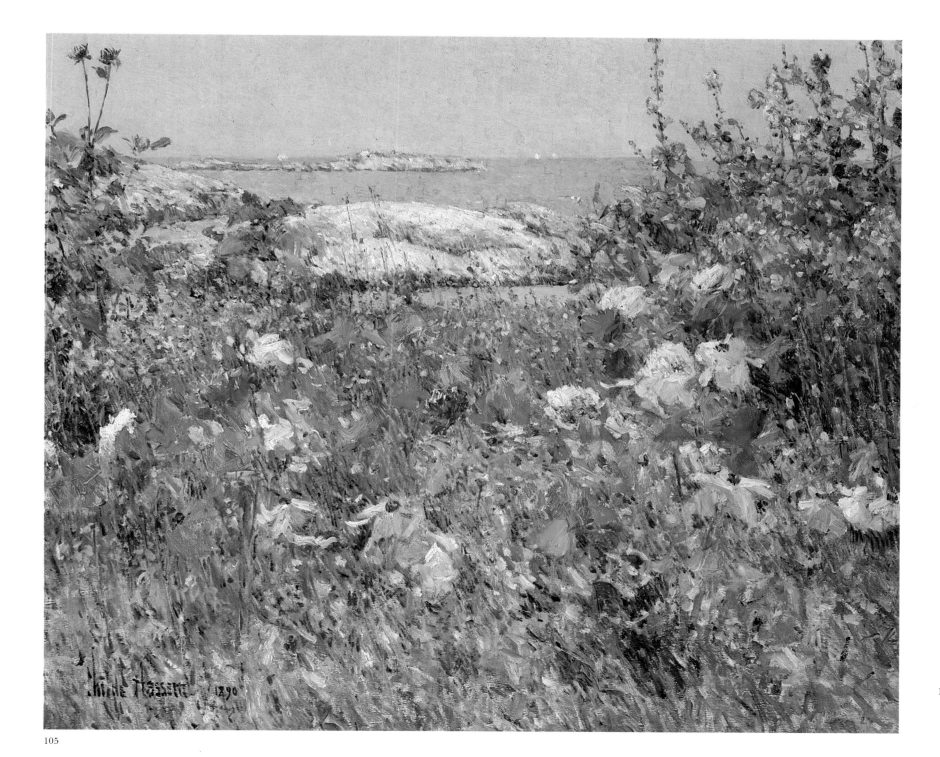

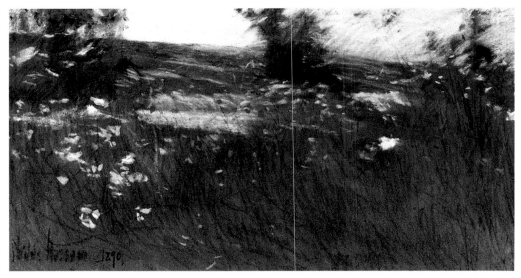

107

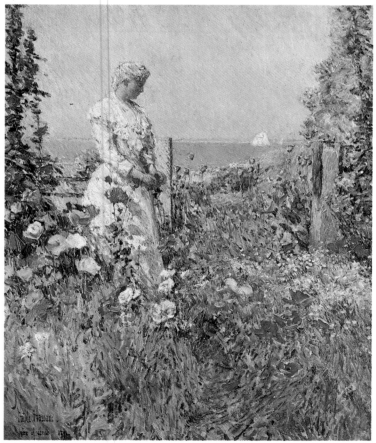

Thaxter's last book, *An Island Garden*, published just before her death.[17] Twenty-two of Hassam's watercolors are reproduced as headpieces and illustrations, and they demonstrate his brilliant virtuosity in the medium: his manipulation of vividly colored wet washes and his rendering of the flowers in the landscape with naturalism and great vitality. Earlier, in 1892, Hassam had provided Impressionist watercolors for William Dean Howells's *Venetian Life*, but those for *An Island Garden* are his richest and most colorful excursions into this genre.

Hassam and Thaxter's friendship and collaboration were celebrated in his marvelous oil *The Room of Flowers* (plate 109), painted in 1894. Though the figure is a younger woman than Celia, the painting is a memorial to her, to her environment, and to her commitment to art, emphasized in the wealth of pictures on the walls. The casualness of summer life at Appledore is charmingly presented in the informal arrangement of chairs, pillows, and other furniture, all bathed in the warm sunlight flowing through the windows, a jumble of elements in which the reclining lady in pink is almost lost. Indeed, one Parisian journalist felt that the picture should have been entitled "Cherchez la Femme."[18] Most vivid are the myriad bouquets of the title. Thaxter was quoted as saying: "Yes, I plant my garden to pick, not for show. They are just to supply my vases in this room."[19] And Candace Wheeler, though contemptuous of the informality of the garden, wrote: "But in the house! I have never anywhere seen such realized possibilities of color! The fine harmonic sense of the woman and artist and poet thrilled through these long chords of color, and filled the room with an atmosphere which made it seem like living in a rainbow."[20] Hassam vividly caught that "rainbow" in his finest hour. Although he was one of the most versatile and expressive American Impressionists, and his originality would continue for at least a quarter-century after Thaxter's death, Hassam never surpassed the art born of this rich association on Appledore in the early 1890s.

Theodore Robinson and Childe Hassam were among the first American "converts" to Impressionism and justifiably have remained highly regarded as its major proponents. Usually grouped with them as the predominant figures of the first generation of American Impressionists are J. Alden Weir and John Twachtman, but such an assessment is open to interpretation—more so, perhaps, in the case of Weir than of Twachtman. In some ways the work of Weir and Twachtman is quite similar, and they exhibited together in several important shows. Moreover, they were close friends, and their personal and professional lives frequently interconnected.

106

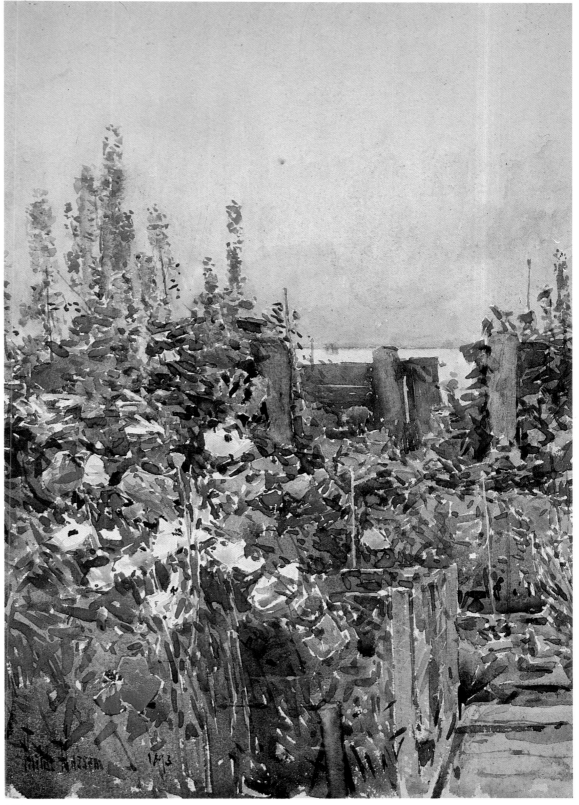

108

106. CHILDE HASSAM. *Celia Thaxter in Her Garden*, 1892. Oil
on canvas, 22⅛ x 18⁵⁄₁₆ in. National Museum of American
Art, Smithsonian Institution, Washington, D.C.; Gift of
John Gellatly.

107. CHILDE HASSAM. *Poppies, Isles of Shoals*, 1890. Pastel on
paper, 7¼ x 13¾ in. Mr. and Mrs. Raymond J. Horowitz.

108. CHILDE HASSAM. *Home of the Hummingbird*, 1893. Water-
color on paper, 14 x 10 in. Mr. and Mrs. Arthur G. Altschul.

Neither painter's art displays the orthodox Impressionism derived from
French practice that can be seen in Hassam's art. Weir's later landscapes are closer
to that aesthetic than Twachtman's very original Impressionism, but Weir's style is
a modification, too, and developed somewhat later than Twachtman's. Their
distinct developments may result from a number of factors. Weir's background
provided him with the more solid, traditional artistic grounding, not only in studio
training but in theoretical concerns for the meaning and purposes of art. Perhaps
because of that, Weir remained, above all, a figure painter, even though land-
scapes eventually occupied much of his attention and through them he expressed
his Impressionist inclinations.

103

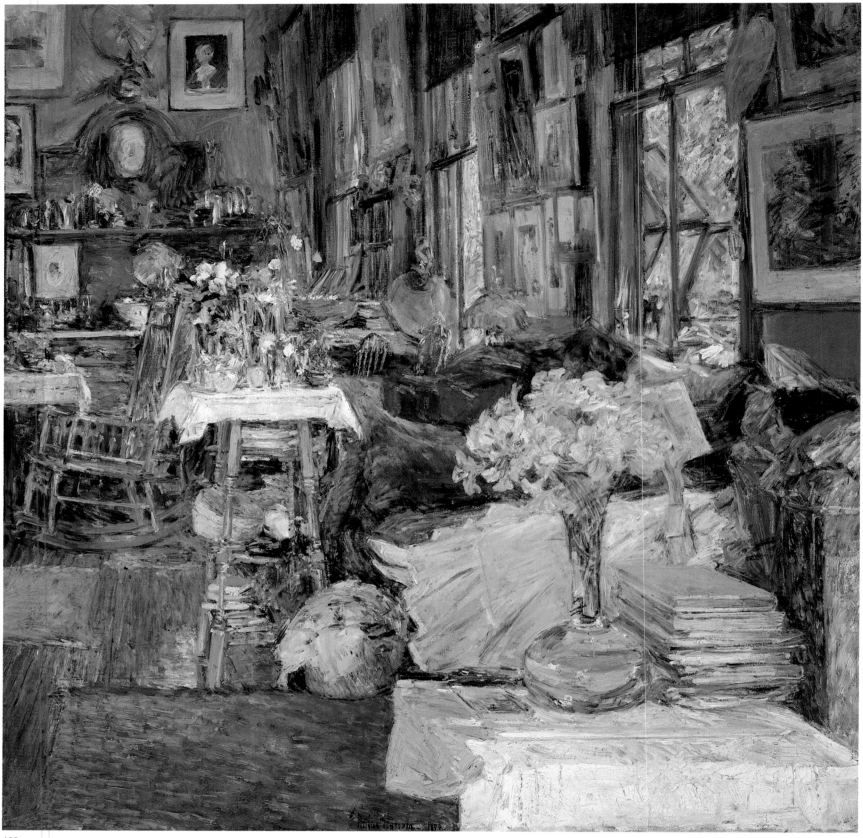

109

109. CHILDE HASSAM. *The Room of Flowers*, 1894. Oil on canvas, 34 x 34 in. Mr. and Mrs. Arthur G. Altschul.

110. J. ALDEN WEIR (1852–1919). *Study of a Male Nude Leaning on a Staff*, 1876. Oil on canvas, 31½ x 25½ in. Yale University Art Gallery, New Haven, Connecticut; Gift of Julian Alden Weir.

111. J. ALDEN WEIR. *House in Brittany*, 1875. Oil on canvas, 29¾ x 32⅝ in. Private collection.

110

111

J. Alden Weir

Weir was born and grew up in West Point, New York, where his father, Robert Weir, was professor of drawing; both Julian and his brother, John Ferguson Weir, adopted art as a profession.[21] After three years of study at the National Academy of Design, Julian enrolled at the Ecole des Beaux-Arts in 1873 and worked with the great French academician Jean Léon Gérôme. Such training could only have strengthened his conviction about the primacy of the figure; he learned to draw the figure well and became adept at the structural modeling of form in light and dark. Weir's very finished *Study of a Male Nude Leaning on a Staff* (plate 110), is among the finest known by an American art student of the period and testifies to the soundness of Gérôme's training. Weir was extremely aware both of contemporary developments in art and of the interest shared by his colleagues in certain Old Masters; he was particularly attracted to artists such as Frans Hals and Hans Holbein.

Weir early formed a close friendship with Jules Bastien-Lepage, and he remained his closest American friend until the French master's early death in 1884. Almost surely under his influence, Weir began to modify his art, concerning himself more with outdoor light and still more with outdoor subjects and depictions of peasant life. Bastien-Lepage hardly needed to supply this impulse, as many Americans spent their summers or even longer periods in rural Brittany, painting the landscape and the peasants. Weir was no exception, as his darkly painted, strongly constructed *House in Brittany* of 1875 (plate 111) demonstrates.

This was "modern art" for Weir and many others at the time. He knew the work of Manet and the new group of Impressionists, but he was incensed by their radical departure from tradition:

> I went across the river the other day to see an exhibition of the work of a new school which call themselves "Impressionalists." I never in my life saw more horrible things. I understand they are mostly rich, which accounts for so much talk. They do not observe drawing nor form but give you an impression of what they call nature. It was worse than the Chamber of Horrors. I was there about a quarter of an hour and left with a head ache, but I told the man exactly what I thought. One franc entree. I was mad for two or three days, not only having paid the money but for the demoralizing effect it must have on many....[22]

In 1877 Weir returned to New York via London, where he established a friendship with Whistler, although he deplored Whistler's lack of finish and found his paintings only "commencements." Yet Whistler's art seems to have influenced Weir's portraits and figure paintings of the 1880s; one critic referred to his "customary sad harmony of black and gray."[23] His *Against the Window* of 1884 (plate 114), with its dark tonalities and strong silhouetted figure parallel to the picture plane, suggests a direct indebtedness to Whistler's famous portrait of his mother, shown in New York only two years earlier.

Weir arrived home in 1877 just in time for the founding of the Society of American Artists, which came to represent the progressive painting and sculpture of the younger, European-trained artists. He quickly became a major figure in the Society and was recognized critically as one of the more vital younger men. By the 1880s Weir had become a rallying point for the progressive young artists of his day, a role he maintained all his life. He also advised American collectors such as Erwin Davis, whom he encouraged to acquire Bastien-Lepage's *Joan of Arc* and Manet's *Woman with a Parrot* and *Boy with a Sword*. These were significant modern works, and Manet's connection with the Impressionists was recognized, but they are early pictures, suggesting Spanish influence and far removed from Impressionism. They are, in fact, not totally dissimilar from Weir's own art of that time.

Much of Weir's creative activity during these years was also given over to dark, hushed still-life painting, particularly of flowers—especially roses—combined with objects of art of great beauty.[24] While they may be among the loveliest American

112

still lifes of the period, they are antithetical to Impressionism. Weir's palette gradually lightened in some of his paintings of the 1880s, such as his portrait of his sister, Carrie, of 1882 (plate 113). The introspective figure holds a bunch of roses and is seated next to a typical Weir still life; a festoon of flowers hangs on the wall behind. In the darker *Against the Window* he also balanced a central figure with a goblet containing flowers to the left. His model was Anna Baker, whom Weir had married in 1883.

During the 1880s Weir took up summer residence in rural Connecticut, which must account to some degree for his turn to landscape subjects and also for his gradual involvement with Impressionism. His association with Twachtman, with whom he had traveled to Holland as early as 1881, also became stronger, and the two men often exhibited together, as they did in the second exhibition of the Society of Painters in Pastel in 1888. The pastel medium, so significant for the development of Impressionism, was one that Weir responded to enthusiastically. Yet, although his palette was lightened as a result of using pastel, there seems to have been no suggestion of Impressionism in his work shown in Weir and Twachtman's two-artist exhibition at the Fifth Avenue Art Galleries in February 1889, prior to their successful auction sale at Ortgies & Co. Weir's paintings were considered more diverse, for he showed still lifes and figures, but most were scenes of rural Connecticut. Some were likened to those by Courbet, but overall they seem to have clung to the spirit of Bastien-Lepage.[25]

Weir's first significant one-man show was held at the Blakeslee Gallery in January 1891 of pictures done the year before. All the critics noted that he had gone over completely to Impressionism. The writer in the *Collector* found the landscapes reflective of Sisley and the figures of Pissarro, rather than of Monet; by and large the critics praised the work for "being the first successful attempts in their manner (except Mr. Theodore Robinson's) by an American painter" in the bluish tones, the "rude style of handling," and the extreme inattention to detail. Another writer, in the *Art Amateur*, noted that "Mr. Weir is the first among Americans to use impressionistic methods and licenses successfully. He really obtains that atmospheric quality, that out-of-doors look which a considerable number of his French comrades have attained from the start."[26]

Weir and Twachtman had the opportunity to be compared with their French contemporaries in a four-man show in 1893 at the American Art Galleries that included the paintings of Monet and Albert Besnard. By then, however, not only were Weir and Twachtman completely, if not entirely accurately, identified with the Impressionists, but Impressionism itself had become an accepted if still controversial form. Some critics of the American Art Galleries show found the American pictures less intense, less barbaric, and more silvery than the French ones, as well as more concerned with realistic, rather than artistic truth—for Weir, still the heritage of Bastien-Lepage.[27] For others, the hesitancy in comparison to full-blown Impressionism seemed undesirable. Alfred Trumble, the editor of the *Collector* and no friend of Impressionism, indicated:

> When you turn around among the Weir and Twachtman pictures, you seem to be looking at Monet, at Sisley, at Bastien-Lepage, through a fog, which washes out the force and substance and leaves the shadow. The mannerisms are all here. But the virile power is not. It is the ghost of something else, a mere imitation.... The two Frenchmen downstairs do things in their own way. It may be a good way, or a bad one, as we choose to estimate it, or a mistaken one. But at any rate it is their way.[28]

That year Weir began to paint the thread factories of Willimantic, Connecticut, in a series of about six pictures made between 1893 and 1897. These works can be identified as Impressionist, even though strong geometric structures anchor the compositions, for they are interpreted in a bright, sunlit atmosphere with variegated tones, and the paint is laid on in an increasingly loose manner. The first of these factory landscapes marks the start of Julian's true progression in the early 1890s into Impressionism. Its full achievement began in the mid-90s.

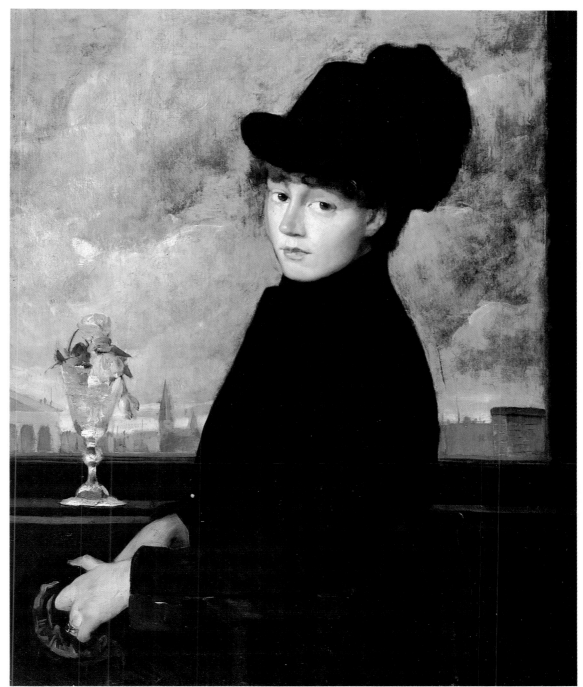

114

113

112. J. ALDEN WEIR. *Roses*, c. 1884. Oil on canvas, 35½ x
24¾ in. The Phillips Collection, Washington, D.C.

113. J. ALDEN WEIR. *Flora (Carrie Mansfield Weir)*, 1882. Oil
on canvas, 44 x 34 in. Brigham Young University Art
Museum, Provo, Utah.

114. J. ALDEN WEIR. *Against the Window*, 1884. Oil on can-
vas, 36⅛ x 29½ in. Private collection.

John Twachtman

The involvement of Weir and Twachtman with Impressionism is roughly equivalent, but John Twachtman is probably the more original of the two. He remained the most consistently admired of all the major Impressionist painters until the denunciation of Impressionism in America in the wake of more avant-garde developments in the teens and the twenties.[29] This admiration resulted, in part, from the fact that Twachtman's mature painting aligned more easily than most Impressionist work with the growing concern with abstraction and from being championed by leading American artist-critics of a later generation such as Marsden Hartley, who called him a "super-fine artist of sensibility and distinction."[30]

Twachtman was particularly close to Robinson as well as to Weir, although his background and training were quite different from theirs. Twachtman was born in Cincinnati and, like a great many artists from the Midwest, he began his European studies in Munich, rather than Paris, after studying locally at the McMicken School of Design (1871–75). He was fortunate to be at McMicken during Frank Duveneck's brief tenure in 1874, and in 1875 Twachtman accompanied Duveneck back to Munich and enrolled in the Royal Academy. Twachtman joined the Duveneck Boys and traveled to Venice with Duveneck and William Merritt Chase in 1877; but his father's death the following year brought him back to Cincinnati. Between 1878 and 1883 Twachtman moved among American and European cities: Cincinnati, New York, teaching with Duveneck in Florence in 1880, traveling in Holland and Belgium with Weir in 1881.

The late 1870s were exciting years for European-trained American artists in New York because the Society of American Artists' first exhibition in 1878 successfully challenged the supremacy of the somewhat stultified National Academy. Twachtman exhibited with the Society from the first, but his Venetian scenes, shown in 1878, like his subsequent scenes around Cincinnati and New York harbor, are a far cry from Impressionism. Instead they are in the manner of the more progressive Munich painting of the '70s: dramatic tonal contrasts with rich, deep blacks applied with bravura paint handling and sometimes choppy, jagged brushstrokes.[31]

115

"You do not know how tempting every opportunity is to me, and how I long to go in quest of fame and fortune. Why should it be either and why can't happiness be complete without either or both? No! My star shines brighter and I see greater possibilities. In my mind I have finer pictures than ever before. Ten thousand pictures come and go every day and those are the only complete pictures painted, pictures that shall never be polluted by paint or canvas."

John Twachtman to J. Alden Weir, 1880. Quoted in Richard Boyle, *American Impressionism*, p. 164.

116

117

115. JOHN TWACHTMAN (1853–1902).

116. JOHN TWACHTMAN. *Coast Scene*, 1879. Oil on canvas, 22 x 36 in. Reading Public Museum and Art Gallery, Reading, Pennsylvania.

117. JOHN TWACHTMAN. *New York, Harbor*, c. 1879. Oil on canvas, 8¹⁵⁄₁₆ x 12¹⁄₁₆ in. Cincinnati Art Museum; Bequest of Mr. and Mrs. Walter J. Wichgar.

118. JOHN TWACHTMAN. *Spring*, n.d. Pastel on paper, 14 x 11 in. The Phillips Collection, Washington, D.C.

118

119

119. JOHN TWACHTMAN. *Cabbage Patch*, probably 1897–98.
Oil on canvas, 25 x 25 in. Helen Hyman.

120. JOHN TWACHTMAN. *Icebound*, 1888–89. Oil on canvas,
25½ x 30½ in. The Art Institute of Chicago; Friends of
American Art Collection.

In 1882 Twachtman determined that he had carried the Munich manner about as far as he could, a decision undoubtedly influenced by his trip to the Low Countries the previous year. There he had met Anton Mauve, the leader of the Hague School of Painters, and Weir's close friend, Jules Bastien-Lepage. In a letter written to Weir in 1885, Twachtman tempered his admiration for Bastien-Lepage's art: "…he seldom went beyond the modern realism which, to me, consists too much in the representation of things."[32] Nonetheless, between 1883 and 1885 Twachtman studied at the Académie Julian and painted in the French countryside at Honfleur and Arques-la-Bataille. Some critics feel that the works from this time are the finest of Twachtman's career; in their even gray light and soft, subtle gray-green tonalities, they suggest the influence of Bastien-Lepage and even a kinship with the Hague School. But true to his stated aesthetics, Twachtman replaced the banalities of "the representation of things" with a tremendous sense of near-abstract design and a flattened space that suggest the impact of Oriental art. Twachtman's painting would always be associated with Chinese and Japanese art,[33] which he may have experienced directly, or through contemporary French painting such as that of Puvis de Chavannes, or through the art of Whistler, which critics later often related to Twachtman's.

Perhaps the most paradoxical aspect of Twachtman's career is that, although he was the only major American Impressionist to study in both Munich and Paris, he was also by far the least concerned with the focus of academic training, the figure. Twachtman did paint a few figure pictures, but they are atypical and not especially well realized; certainly he did not evince the serious concern for the

figure that might be expected. Even though his growing artistic connections with the young, advanced American painters in Paris gave him contact with figure specialists such as Robert Reid, Frank Benson, and Edmund Tarbell, he himself remained committed to landscape. Such a commitment must have seemed sanctioned when one of his European works, *Windmills*, won the Webb Prize in 1888 at the Society of American Artists.

In winter 1885 Twachtman rejoined Duveneck in Italy, this time in Venice, and grew close to another American, Robert Blum. Blum had been one of the prime organizers of the Society of Painters in Pastel (see chapter 4), and their friendship naturally helped direct Twachtman's art toward the medium, which he had recently adopted in Holland. He continued to explore pastel after his return

121

112

122

121. JOHN TWACHTMAN. *End of Winter*, 1890s. Oil on canvas, 22 x 30⅛ in. National Museum of American Art, Smithsonian Institution, Washington, D.C.; Gift of William T. Evans.

122. JOHN TWACHTMAN. *Meadow Flowers*, 1890s. Oil on canvas, 33¹⁄₁₆ x 22¹⁄₁₆ in. The Brooklyn Museum; Polhemus Fund.

from Europe in 1886. Twachtman and Weir began to exhibit with the Painters in Pastel at its second exhibition, in 1888. There Twachtman's aesthetic association with Whistler seemed particularly noticeable in the sketchy suggestiveness of his chalk application to the toned paper that constitutes the major color in his fragile, exquisite landscapes. Twachtman's pastels are "bits" of nature in which the artist avoided the picturesque.

Once back in the United States, Twachtman lived near Weir in southern Connecticut. That summer of 1886 Twachtman was in Greenwich and in September was renting at the Holley House in Cos Cob, which later served many other American Impressionists. In 1887 he rented at Branchville, and in 1890 he purchased a farm on Round Hill Road in Greenwich. There many of his best-known works were created: the views of Horse Neck Falls and the Hemlock Pool. Twachtman, however, had already begun painting these scenes by autumn 1888, the crucial period in his development as an Impressionist: his painting in 1887 is still related to the style he had developed in France, but by the winter of 1888–89 his Impressionist manner had emerged.[34]

In June 1889 Twachtman exhibited his *Icebound* (plate 120) at the Art Institute of Chicago, a work painted the previous winter of the falls and Hemlock Pool in Greenwich. It is a key work of the finest quality that signals his turn to his own very personal Impressionism. Twachtman adopted a lighter and sometimes higher color range, a looser brushstroke, and a concern for light and especially atmosphere, which allies his painting with the Impressionist aesthetic, but he seldom adopted the broken brushstroke of orthodox Impressionism or the full chromaticism of Monet or Hassam. In *Icebound* he had already adopted the thick, almost gritty paint surfaces of his mature art of the 1890s, and the sinuous outlines separating the snowy banks from the water foretell the rhythms of turn-of-the-century Art Nouveau. Snowy, icy winter scenes would become favored by Twachtman, but unlike the seasonal concerns of Monet and other Impressionists, his response was subjective and not involved with recording natural phenomena.

The critics recognized this when Twachtman had a one-man show at the Wunderlich gallery in March 1891. Twachtman's stylistic change after 1890 was noted, as Weir's had been; both Twachtman's involvement with Impressionism and his idiosyncratic adaptation of it were recognized. A writer in the *Critic* referred to Twachtman's audience: "Even if they have learned to swallow their dose of impressionism, it will profit them nothing; for this painter's best qualities are purely personal." Among the oils he singled out two snow scenes that "will make the fortunes of the collectors who are wise enough to buy them."[35] The writer in the *Art Amateur* emphasized that "few painters, out of Japan, have ever been more given to abstracting the quaint essence of a scene and ignoring all that a vulgar realist would think it necessary to include."[36] But Clarence Cook in the *Studio* expressed the deepest sympathy for Twachtman's new art, finding poetry especially in his winter pieces. In comparing these to Walter Launt Palmer's photographic winter scenes he said, "Twachtman's work strikes for some of us a deeper, tenderer note; it charms in spite of argument, and when they talk of his incompleteness, we answer that we like Twachtman's half loaf better than some other people's whole ones."[37]

Yet, unlike his profitable auction in 1889 at the Ortgies gallery, Twachtman's exhibition of Impressionist work did not sell well. The public seemed confused by its elusiveness and perhaps also by the prosaic subject matter, though not by his style. Often he painted temporal or coloristic variations on the same subject, with full sunlight being relatively rare. Twachtman remained more concerned with "bits" of landscape, shunning the panoramic view. His "bits" occasionally included close-up views of flowers—delicate meadow flowers or more dramatic and aggressive tiger lilies—paintings that one writer on his 1891 show described as "like dreams of flowers."[38] The sources of Twachtman's Impressionism, beyond the conjunction of his own development with the growing general awareness of

the style by about 1890, remain unclear, but a significant catalyst was surely Theodore Robinson. Their friendship, which began in Paris, was furthered on Robinson's visits to America in the late 1880s and early '90s and deepened after he returned to stay in 1892. Robinson and other Impressionists, such as Henry Fitch Taylor, visited with Twachtman in Greenwich or stayed for relatively long sessions at the Holley House in Cos Cob. These frequent contacts with Robinson may have helped direct Twachtman's art and must have reinforced his Impressionism during these crucial years.

The Boston Impressionists

Although Weir and Twachtman are primarily associated with the development of Impressionism in New York, most of their works were painted in Connecticut and they had considerable influence on local Impressionist developments in that state, above all in Cos Cob—the "Cos Cob Clapboard School," as Childe Hassam referred to it.[39] The other major center for the early development of Impressionism in this country was Boston. Though the core group of Boston Impressionists has been identified for some time, the pervasiveness of the new aesthetic in that city around 1890 is a phenomenon that scholarship is just now recognizing, and the complexity of its origin and development in Boston still requires study.[40] Already noted was the return to Boston of a number of young artists, such as Theodore Wendel and John Leslie Breck, after sojourns in Giverny and the critical reaction to their exhibitions (see chapter 5). But Boston also spawned an extremely important group of figure painters who adopted the new aesthetic, and ultimately both their art and their influence proved more significant. While there was undoubtedly some overlap in activities and some interchange among the artists, it is intriguing to speculate why the figure artists became so much more important and why Boston Impressionism became exclusively identified with them. One explanation may lie in the traditional dominance of the figure over landscape. Then, too, the figure painters stayed on longer, while Breck died young and Wendel retreated from the scene to Ipswich. Perhaps most important, the figure artists proselytized and the landscape painters did not: Edmund Tarbell, Frank Benson, Joseph De Camp, William Paxton, and Philip Leslie Hale were all excellent teachers, and Hale, especially, was also an influential writer on art.

The leader of the Boston figural Impressionists was Tarbell, and the group was referred to early on as "The Tarbellites," a term coined somewhat invidiously by the critic Sadakichi Hartmann in March 1897.[41] Tarbell was born in West Groton, Massachusetts, and, after working at the Forbes lithography firm in Boston, attended the Boston Museum School under the eminent German artist Otto Grundmann, a Belgian-trained expatriate who was an important if neglected personality in the history of late nineteenth-century American art education.[42] Tarbell went to Paris in summer 1884 to study at the Académie Julian and traveled to Germany and Italy as well, visiting Venice in 1886 before returning that year to Boston.

At the Boston Museum School, Tarbell first met Frank Benson, and they maintained a lifetime association, teaching and exhibiting together in their maturity. Benson had left to study abroad earlier, in October 1883, traveling via New York to Liverpool, London, and Paris. Like many American artists, he spent some time in Brittany, summering in 1884 in Concarneau; moving on to London in November 1884, he exhibited at the Royal Academy before returning to America in late spring 1885. He returned to Salem, but took a position the next year teaching art in Portland, Maine, and then rejoined Tarbell in Boston in 1889, when both of them accepted appointments at the Boston Museum School, where they served until 1912.

Both Tarbell and Benson began to assume positions of the greatest significance in the Boston art world about 1889, resulting in part from their roles as influential teachers. Impressionist landscapes were just beginning to be seen in Boston;

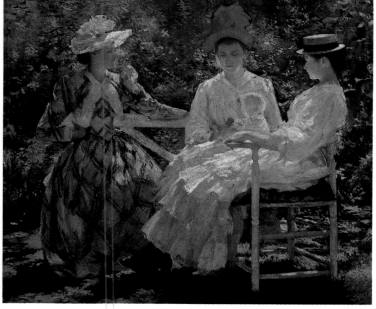

123

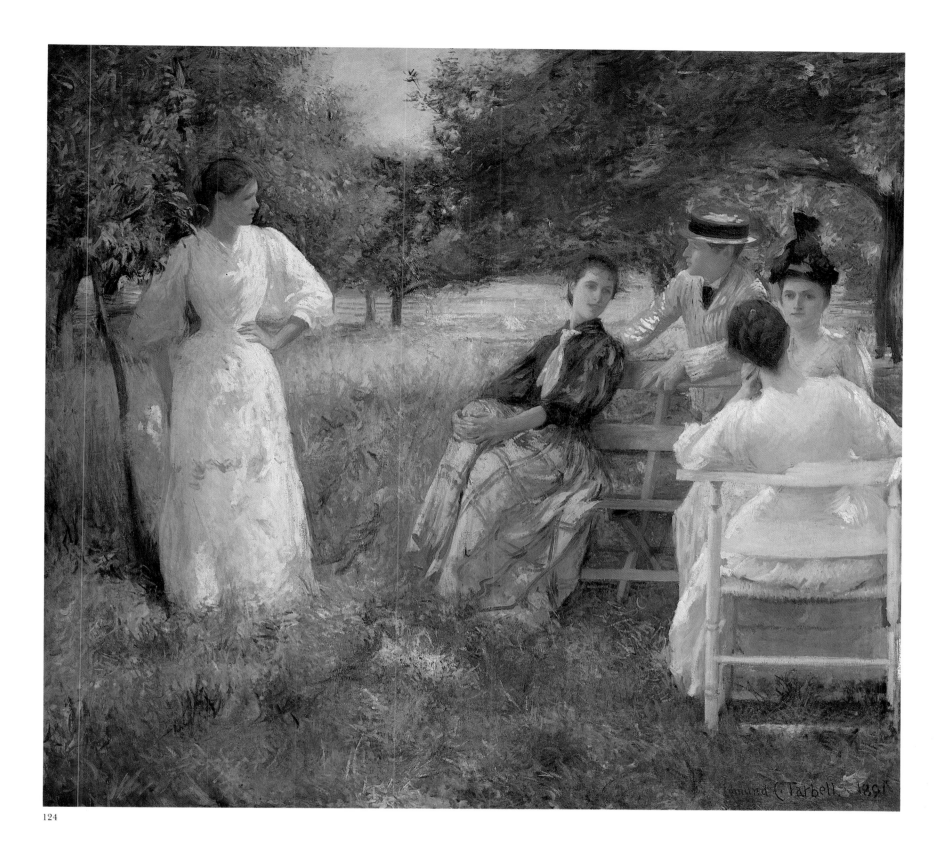

124

123. EDMUND TARBELL (1862–1938). *Three Sisters—A Study in June Sunlight*, 1890. Oil on canvas, 35⅛ x 40⅛ in. Milwaukee Art Museum; Gift of Mrs. Montgomery Sears.

124. EDMUND TARBELL. *In the Orchard*, 1891. Oil on canvas, 60½ x 65 in. Herbert M. and Beverly Gelfand.

Wendel and Willard Metcalf had one-man shows that year and Lilla Cabot Perry came home with a Monet landscape. Breck's work was also seen in the city in the late 1880s, and Dennis Bunker began to produce his Impressionist-related landscapes in 1889. Certainly such circumstances must account in part for Tarbell's turn to Impressionism in 1890, when he produced his *Three Sisters—A Study in June Sunlight* (plate 123). Tarbell's Impressionism is concerned with rich, full summer sunlight, but it is built around the figure—more specifically, around lovely, languorous young women—at ease, dressed in and surrounded by a full range of

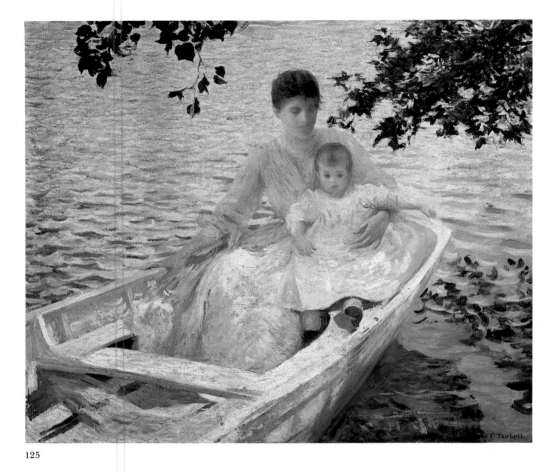

125

126

125. EDMUND TARBELL. *Mother and Child in a Boat*, 1892.
Oil on canvas, 30 x 35 in. Museum of Fine Arts, Boston;
Bequest of David P. Kimball in memory of his wife, Clara
Bertram Kimball.

126. FRANK BENSON (1862–1951). *Girl in a Red Shawl*, 1890.
Oil on canvas, 32¼ x 32¼ in. Museum of Fine Arts, Boston;
Bequest of David P. Kimball in memory of his wife, Clara
Bertram Kimball.

127. PHILIP LESLIE HALE (1865–1931). *Girls in Sunlight*, c.
1892. Oil on canvas, 29 x 39 in. Museum of Fine Arts,
Boston; Gift of Lillian Westcott Hale.

128. LILLIAN WESTCOTT HALE (1881–1963). *L'Edition de
Luxe*, 1910. Pastel on paper, 23 x 15⅛ in. Museum of Fine
Arts, Boston; Gift of Miss Mary C. Wheelwright.

127

luscious colors, complete with the signature purple shadows of Impressionism. The figure painting is sure and careful, the composition soundly structured. In mood as well as theme, Tarbell's *Three Sisters* suggests Renoir more than Monet, if a French counterpart is sought.

In its Impressionist chromaticism the *Three Sisters* was quite an advanced painting for an American artist, but its fame was overshadowed by Tarbell's *In the Orchard* (plate 124) of the following year, a larger work with five figures in a less confined landscape setting. Theodore Robinson, in Boston in March 1892, noted that he saw the picture in the collection of the city's leading art patron, Mrs. Montgomery Sears;[43] after it was exhibited at the St. Botolph Club in 1891 and in New York in 1892, the picture was shown at the Columbian Exposition in Chicago in 1893. This work, perhaps more than any other, established Tarbell as a commanding figure among American moderns of the period. With its structured form and brilliant light and color *Mother and Child in a Boat* of 1892 (plate 125) reinforced his elevated position, while its subject matter helped identify the link between the Boston Impressionists and the upper-class elite.

The ability of Tarbell and his colleagues to remain adventurous as artists yet socially and institutionally "safe" within the art world is reflected in their relationships with the major New York art organizations. Although their identity in terms of residence, teaching, patronage, and even exhibitions remained firmly tied to Boston, New York artistic and critical exposure was crucial. Tarbell, for instance, exhibited a portrait with the Society of American Artists in 1887 that won him membership in that organization, and Frank Benson began to show with them the following year. Yet both artists also exhibited with the more conservative National Academy of Design, and it was there that Tarbell began to show his more radical pictures: the *Three Sisters* in 1891 and *In the Orchard* in 1892; the latter, especially, was triumphantly received in the press. The writer in the *Studio* noted that the picture carried the exhibition's honors, and the writer in the *Art Amateur* called the work "the most successful painting in the new manner.... The effect of open air and real afternoon sunshine is unmistakably there. The figures, too, are animated, their poses natural and varied, the grouping interesting." Royal Cortissoz pointed out in the new, Montreal-based *Arcadia* magazine that Tarbell had "emulated Claude Monet without being either strained or obviously imitative."[44] One of the most interesting discussions of Tarbell's art at the time is found in the series of dialogues on contemporary artists between the artists George Torrey and William Henry Howe published in the *Art Interchange* in 1894. While Howe said that the *Three Sisters* "make you squint and blink, they are so saturated with sunbeams," he judged *In the Orchard* "the best picture of its class that I have seen.... It is natural, easy, gay, and a charming effect of color and light."[45]

By the early 1890s Tarbell and Benson often were paired by the critics, an identification undoubtedly stimulated by their two-artist show in 1891 at the St. Botolph Club. Their aesthetic also seems to have been shared by Joseph De Camp, who had begun to teach at the Boston Museum School in 1885 and who was numbered among the "Tarbellites" (De Camp is discussed at greater length in chapter 10). In his article "The Tarbellites," Sadakichi Hartmann admired the technical prowess of these artists but faulted them for their "mania for posing in sunlight," and their "clever brushwork and paint, and beneath the canvas nothing to satisfy the soul." Hartmann found particularly "that one can never be sure which of them painted this or that picture. This year de Camp exhibits a picture that seems to be technically a facsimile of Benson's picture of last year, and next year Benson will come forth with a canvas that will look like a Tarbell of several years ago. Individuality is deemed unnecessary...."[46]

What is strange about the charge, particularly with regard to Tarbell and Benson, is that while their work can indeed be compared, they developed in rather opposite directions. When Tarbell's colorful outdoor scenes of figures in sunlight first emerged, Benson was concentrating on indoor figures in very muted light and

129

130

somewhat muted color. Tarbell later moved indoors and concentrated on figures directly inspired by seventeenth-century Dutch models, above all Vermeer, just as Benson turned to outdoor paintings of young women and children in light colors and brilliant sunlight, beyond even Tarbell's bright chromaticism of a decade earlier. Benson's indoor scenes in the crucial years of the early 1890s, exemplified by his *Girl in a Red Shawl* of 1890 (plate 126), were even somewhat Whistlerian and closer to (though more prosaic than) the idealized portraits and figures of his good friend Abbott Thayer than to the Impressionist experimentation of Tarbell. In fact, Hartmann implicitly differentiated two distinct artistic concerns when he described a hypothetical Tarbellite exhibition, introducing the typical "lamp and firelight effects, and an occasional lawn fête." But Tarbell was the artist of those outdoor lawn fêtes, and Benson was the one painting the subtle, warm illumination of lamp and firelight. After exhibiting the *Girl in a Red Shawl* at the National Academy in 1890, Benson showed a *Twilight* in 1891, *By Firelight* in 1892, *Lamplight* in 1893, and another *Firelight* in 1894 (many of these are unlocated today). *Lamplight* brought him his most significant early recognition, the first prize of $500 offered by the Boston firm of Jordan, Marsh & Co. at their newly established gallery in 1894.[47]

One of the most interesting and most undervalued Boston figure painters of the early 1890s was Philip Leslie Hale.[48] In 1889 his *Old Bird Fancier* (now *The Ornithologist*) made a sensation at the Salon of the Champs de Mars; the figure is solidly constructed and there is only a hint of luminosity in the garden view. But that summer Hale began to create bright, Impressionist works. After a trip to Spain in April 1890, he returned briefly to America and for the next three years journeyed regularly between New England and France. Hale developed much of his quite radical Impressionism at the home of his aunt, Susan Hale, at Matunuck, Rhode Island, where in summer 1891 he posed models in diaphanous costumes outdoors to obtain the effect of vibrant sunlight; by 1895 he wrote to his close friend and fellow painter William Howard Hart, who remained in France, that he

129. ROBERT VONNOH (1858–1933). *Companion of the Studio*, 1888. Oil on canvas, 51½ x 36¼ in. Pennsylvania Academy of the Fine Arts, Philadelphia; Temple Fund Purchase.

130. ROBERT VONNOH. *Winter Sun and Shadow*, 1890. Oil on canvas, 18⅛ x 24⅛ in. North Carolina Museum of Art, Raleigh.

131. ROBERT VONNOH. *Poppies*, 1888. Oil on canvas, 13 x 18 in. Indianapolis Museum of Art; James E. Roberts Fund.

was "très Impressioniste" but that he was working hard on his drawing. Of his painting he said, "I'm trying to pitch them a little lower than my Giverny things but higher than my last year's work."[49]

Like that of his Boston colleagues, Hale's subject matter consisted primarily of lovely white-clad young women in brightly lit gardens, but his works of the 1890s—with titles such as *Girls in Sunlight* (plate 127), *Glare of Sunlight*, *Flash of Summer*, or *Study of Sunlight*—subject his figures to far greater dissolution than do those of his fellow painters. In the following decade, however, after a notable one-man show at Durand-Ruel in New York in 1899, Hale's art took on increasingly academic characteristics, with harder and firmer drawing, more detail, and more overt sentiment. This seems to have occurred about the time he married his much younger student, the able artist Lillian Westcott Hale, and perhaps her extremely sensitive figure drawing renewed his commitment to academic procedures and ideals, though his own involvement in the teaching of drawing must also have been a factor. Of all the Boston Impressionists, Hale was the most involved as a writer, critic, and historian: he was the Paris critic for the short-lived but enterprising magazine *Arcadia* in 1892–93; wrote articles on French Impressionist

131

132

painters such as Degas and Raffaëlli; and, finally, served the Boston *Herald* as art critic for many years.[50]

American artists working in France were exposed to the Impressionist theories and practice at the art colonies that many joined during the summer. Giverny, with Monet's presence, was obviously the most conducive to the transmission of the aesthetic. In rural France there were other popular art centers such as Barbizon; Pont-Aven and Concarneau in Brittany; Auvers; Ecouen; and the group of villages near the Forest of Fontainebleau: Cernay, Marlotte, Montigny, and particularly Grèz.[51] Grèz was especially popular with artists from 1875 into the 1890s, but the dominant aesthetic there was more that of Bastien-Lepage, as practiced particularly by Scottish, Scandinavian, and American painters. And by the time this aesthetic was replaced by the more advanced styles of Impressionism and Post-Impressionism, the artists had gravitated from Grèz to learn in the shadow of Monet at Giverny, of Gauguin at Pont-Aven, or at home.

The important exception was Robert Vonnoh, a Boston artist of major significance. Unlike Tarbell, Benson, Hale, and others, he did not maintain an allegiance to the city.[52] Vonnoh studied at the Massachusetts Normal Art School in 1875 and then went to the Académie Julian in 1880. He returned to Boston in 1883, where he taught at the Cowles School in 1884 and at the Boston Museum School in 1885. In 1886 Vonnoh married and the couple honeymooned briefly in Grèz; the

following year they were back in France, and, after brief study at the Julian, they returned to Grèz, this time for an extended stay; by 1888 Vonnoh was producing landscapes and nature studies that revealed a new direction.

Vonnoh's painting of the time expresses particularly well the aesthetic dichotomy of many American Impressionists. Flower studies painted outdoors, such as his *Poppies* of 1888 (plate 131), are almost Fauvist in their raw brilliance; they immerse the spectator directly in the rich, chromatic blooms, and the paint is laid on freely and broadly with wide brushes or a palette knife. But his *Companion of the Studio* (plate 129) of the same year, a portrait of a fellow Julian student, John C. Pinhey of Montreal, is a solid, three-dimensional likeness, conceived entirely in neutral tones, though a fluid, painterly technique is seen here as well.

Vonnoh's conversion to Impressionism was not a result of his increasing interest in landscapes, for the prevailing landscape mode at Grèz was far less experimental. He does seem to have formed a friendship with the Irish artist Roderick O'Conor, who arrived in Grèz about 1884 and by 1886 was painting landscapes in bright, unmixed hues and thick impastoes. By the end of the decade O'Conor had come into contact with Vincent van Gogh, and after 1890 deserted Grèz to join the group around Gauguin in Pont-Aven, continually developing an expressive aesthetic based on coloristic intensity.[53] O'Conor's Impressionist period, though relatively brief, had an impact on Vonnoh's style that is seen at its most intense in the flower studies or in some of the small, brilliantly prismatic landscape studies. In Vonnoh's larger, more finished outdoor scenes, spontaneity is sacrificed to structure. This is especially true of his masterwork of the period, the large *Coquelicots (Poppies)* (plate 134) completed c. 1890, for which the poppy paintings were studies; but even here the color is bright and the paint surface is richly impastoed. Vonnoh's work in Grèz explored light and color in all seasons. *Winter Sun and Shadow* (plate 130), *Springtime in France* (plate 133), *Summer Landscape* (plate 132), and *November* (plate 16) display a complete color and tonal range, though often paint is broadly applied and unmixed, juxtaposing the lavenders, violets, and purples of Impressionism. Vonnoh wrote, "I gradually came to realize the value of first impression and the necessity of correct value, pure color and higher key, resulting in my soon becoming a devoted disciple of the new movement in painting."[54]

By the spring of 1891 Vonnoh was back in Boston, yet another convert to Impressionism, and in November he received a one-man show at the Williams & Everett Gallery, mostly of paintings done in France during the previous two years. In the catalog Vonnoh stated: "In all cases he has worked with a definite purpose to interpret as directly and simply as possible the truths of Nature, not in a literal sense, but solely with reference to color sentiment and artistic impression."[55]

Vonnoh's stay in Boston was brief, for in fall 1891 he began to teach at the Pennsylvania Academy of the Fine Arts and a year later moved to Philadelphia. Increasingly, his time was divided between teaching and painting, especially portraits, though his landscapes continued to be well represented in exhibitions.[56] Lucy Monroe, the astute art writer for Chicago news in the *Critic*, wrote about his landscapes in 1894: "He is one of the men who indicate the direction in which American art is advancing beyond the French. It is acquiring a finer perception of the significance of things, a warmer sympathy with life, a keener spirituality. Mr. Vonnoh has learned what he could from the impressionists, but he has learned more from nature itself...."[57] And Susan Ketcham, reviewing his one-man show at Durand-Ruel in 1896, summed up Vonnoh's achievements, especially in regard to *Coquelicots*: "His landscapes are interesting per se and also as showing the development of impressionism. Looking closely, one sees the artist's joy in pure color, the fun he has had in using big brushes and the palette knife, in putting paint on direct from the tube, in 'loading,' in scraping down. His work is spontaneous, vital.... The picture which crowns the collection is the 'Poppy Field.' All who have seen in France or Italy the superb fields of yellow grain ablaze with poppies, fragile

133

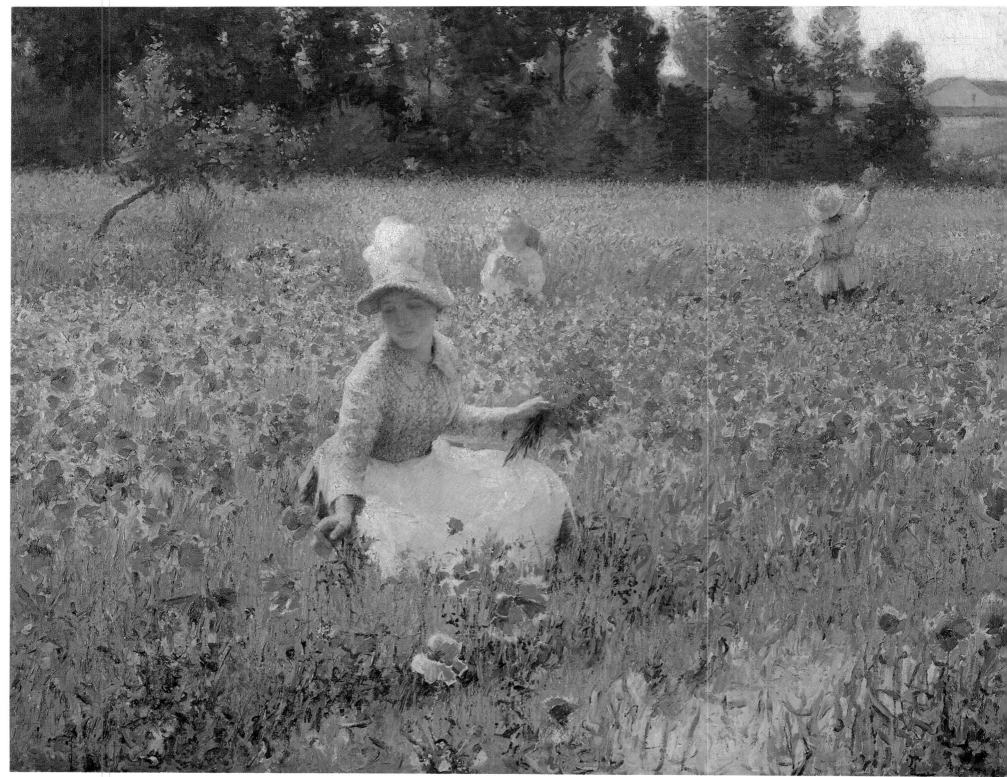

and flickering like flames in the slightest suspicion of a breeze, will enjoy this counterfeit presentment."[58]

In 1899 Vonnoh married his second wife, the sculptor Bessie Potter, and painted a number of garden landscapes, some of which included her. Rich in color, these paintings suggest the brilliant innovation of his Grèz scenes, but his later landscape painting was generally more timid. In the development of American Impressionism, Vonnoh was significant as both teacher and painter. He first taught portraiture at the Pennsylvania Academy, but his instruction proved so popular that in 1892 he took on two life classes for men and women; among his first students were Robert Henri, William Glackens, and Maxfield Parrish. While Vonnoh maintained the academic commitment, he obviously encouraged the Impressionist aesthetic. As one student put it, "I studied with Vonnoh in Philadelphia last winter, and he not only discarded black but all the siennas and the ochres."[59] In 1893 a reviewer in the *Art Amateur* complained about "this purple whirligig of so-called impressionism" at the Academy's show of student work.[60]

It is undoubtedly more than speculation to suggest that Robert Henri's brief but brilliant involvement with Impressionism was stimulated by his contact with Vonnoh. Henri had studied at the Académie Julian, but he praised Monet's exhibition of the Haystack series at Durand-Ruel in 1891; after studying with Vonnoh he was labeled an Impressionist in the manner of Monet at the Pennsylvania Academy.[61] Henri spent the summers of 1892 and 1893 on the coast of New Jersey, in Atlantic City and Avalon, rendering figures in the landscape, particularly women seated among the dunes. As Vonnoh had taught, the draftsmanship of the figures is sure, but the colored paints are applied in the broken, brilliant tones of orthodox Impressionism. Henri's involvement with the style was short-lived, and on his return to Paris he soon turned to Whistlerian figure painting and dark, moody scenes. In 1897 Sadakichi Hartmann recalled Henri's Impressionism, speaking admiringly of his "beach scenes, perspective views of piers and stretches of sand, empty or crowded by a variegated throng, always under the blazing sun—that look like caskets of jewels, or out of door effects à la Monticelli."[62]

134. ROBERT VONNOH. *Coquelicots (Poppies), "In Flanders Field,"* c. 1890. Oil on canvas, 58 x 104 in. The Butler Institute of American Art, Youngstown, Ohio.

135. ROBERT HENRI (1865–1929). *Girl Seated by the Sea,* 1893. Oil on canvas, 18 x 24 in. Mr. and Mrs. Raymond J. Horowitz.

135

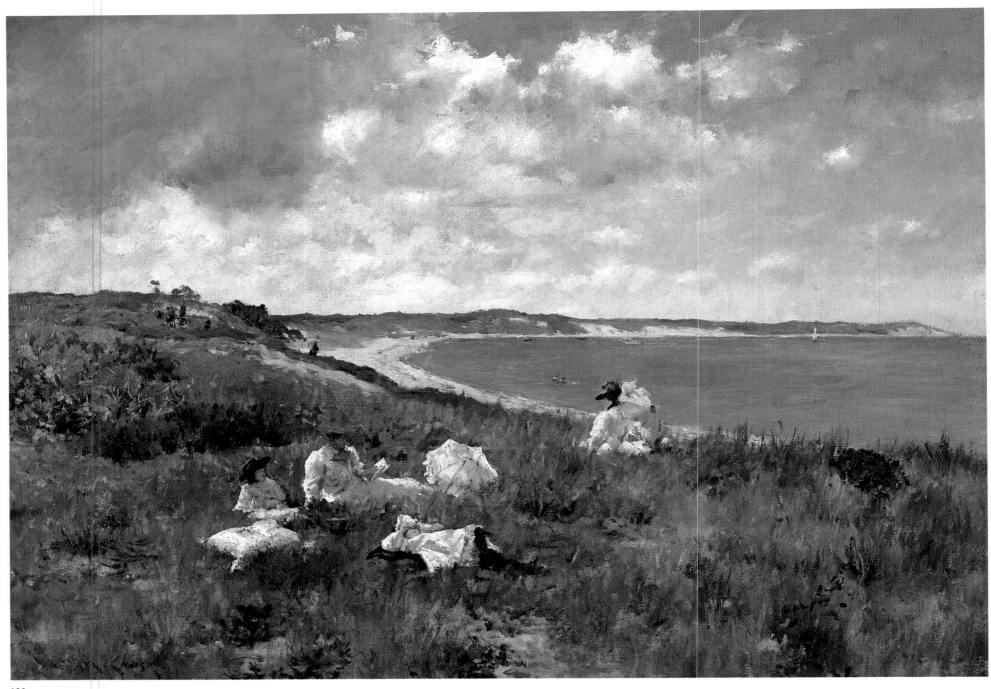

136

7 Widening Exposure

Critical Commentary

THE IMPRESSIONIST AESTHETIC was a major, perhaps *the* major, issue among magazine writers on contemporary art in the decade after Durand-Ruel's exhibition of 1886. This topic was not limited, of course, to periodicals, but the newspaper critics were necessarily most concerned with immediately reviewing the increasing number of Impressionist works in major exhibitions (some of that criticism has already been quoted here in discussions of major painters such as Hassam and Robinson). The periodical writers often reviewed the shows with more comprehensive understanding of the state of the arts, and several also discussed the phenomenon of Impressionism per se. Some of the more cosmopolitan in outlook, such as Theodore Child, Cecilia Waern, and Roger Riordan, were encouraging, even enthusiastic; others, who espoused a more traditional and nationalist perspective, such as Alfred Trumble and William Howe Downes, were not.

The 1886 exhibition was a watershed event. It not only presented a triumphant display of Impressionism that garnered great critical notoriety but it also informed public, critics, and artists about the nature of the movement. Critical writing on Impressionism in the United States from 1886 to the Columbian Exposition in 1893 was at first moderate and then became more conservative. While responses to Impressionism were constantly on the increase, until about 1889 it remained a moderately controversial issue, partly because Impressionism was still considered a foreign phenomenon. The most intelligent and perceptive of the moderate observers was Theodore Child, a major critic who periodically resided in France and wrote on artistic trends in Paris. His "Note on Impressionist Painting," published in *Harper's Magazine* in January 1887, was a careful analysis of the techniques and innovations of Impressionism that tried to differentiate among its leading painters; he noted, for instance, Pissarro's "tendency to see blue everywhere" and "that the truncated composition was invented by M. Degas, the greatest of the Impressionists...." Child, however, concluded that Impressionism's greatest contribution was its war against bituminous color and hard abstract outlines, rather than the actual achievements of the artists, for "If you proclaim Claude Monet and Renoir to be masters in the art of painting, you must have thrown overboard forever Velásquez, Rembrandt, and Titian."[1]

As Impressionist-tinged work slowly began to be seen in America, painted by Americans, the controversy quickened, and conservatives found their strongest

136. WILLIAM MERRITT CHASE (1849–1916). *Idle Hours*, 1894. Oil on canvas, 25½ x 35½ in. Amon Carter Museum, Fort Worth, Texas.

voice in Alfred Trumble, editor in 1889 of the new magazine the *Collector*. He was one of the great champions of George Inness, and his memorial articles in the *Collector* were later published as the first book on the great landscape painter.[2] Trumble upheld Barbizon tonal and spiritual values, sharing Inness's disdain for both the aesthetic and the materialist concerns of Impressionism. He lamented in the *Collector* of November 1889 that "The battle which was once waged over the merits of impressionistic art in France seems likely to be transferred to this country."[3] At this point, however, the *Collector* maintained a positive attitude toward Impressionism, calling Manet a great painter, Pissarro a good one, Sisley of lighter caliber, and Monet "incomparably the greatest of Impressionists." The movement was faulted only because it had "induced a number of incapable and insincere men—failures on the conventional lines of art—to adopt, or rather, to imitate their methods."

During the next two years American exhibitions generously represented Impressionism, not by French artists but by American followers—or, as Trumble might have called them, imitators. When he took up the cudgels against Impressionism in December 1891, the former moderation was abandoned. Considering a work by Monet, Trumble wrote:

> This is a strong picture, your mentor tells you. In one sense it is; but there is none of the strength of nature in it. Its power is the power of the paint pot. Nature never painted anything in such colors and with such a hand. . . . This fellow seizes on the mildest forms of nature—forms in which these softer influences really abound—the quiet village street, the slumbering pool, the mist-enshrouded glory of a sunset harvest field, and tears all grace and beauty from it, covers it with furious splotches, rips it into iron lines and jigs it into saw edges, carves it with knives and mangles it in white lead and chrome yellow, which pass for light with him.[4]

Trumble's distaste was echoed by William Howe Downes, a leading art historian and critic in Boston and a champion of the naturalism of Winslow Homer. In "Impressionism in Painting," published in the *New England Magazine* in July 1892, Downes recalled the Durand-Ruel show of 1886 and, even earlier, the Foreign Exhibition of 1883 in Boston, where Manet, Pissarro, Monet, Renoir, and Sisley had first been seen by an American audience. While Manet enjoyed some respect in Downes's eyes, ". . . these others, whatever else they might be, were no painters. . . . The first impression made by the works of Pissaro [sic], Monet, Renoir, and Sisley was that their mannerisms outweighed whatever merits they might possess; and a further acquaintance with those works leads to no different conclusion. In other words, the worth of what they have to say, be it greater or less, is utterly obscured by their way of saying it. That their methods of execution have any value as such is a claim which has never been established in practice."[5] What may really have bothered Downes most was that "Very soon a considerable number of American artists began to manifest marked symptoms of sympathy for the purple mania and a tendency to the noisy effects which the Impressionists produce in their mistaken attempts at brilliancy. Of course the imitators exaggerate the faults of their models. . . . Impressionism is a fashion, —a fad, and, like all fashions, it will run its course. . . . "[6]

By 1892, however, not all critics were hostile to the new movement. One of the most intelligent and sympathetic was Cecilia Waern, who published "Some Notes on French Impressionism" in the *Atlantic Monthly*. She said, "Impressionism, like most new things, great or small, is at present more discussed than understood." Approaching the movement scientifically, she noted its aim to achieve a unity of impression through a study of the laws of optical effects, and, while "All this may seem to deal with the form, and not the spirit of art," she concluded that "so impressionism does, in a grand, enthusiastic, undaunted way that is full of noble promise for the future of art."[7]

Waern knew her recent art history. She cited "Renoir's splendid renderings of

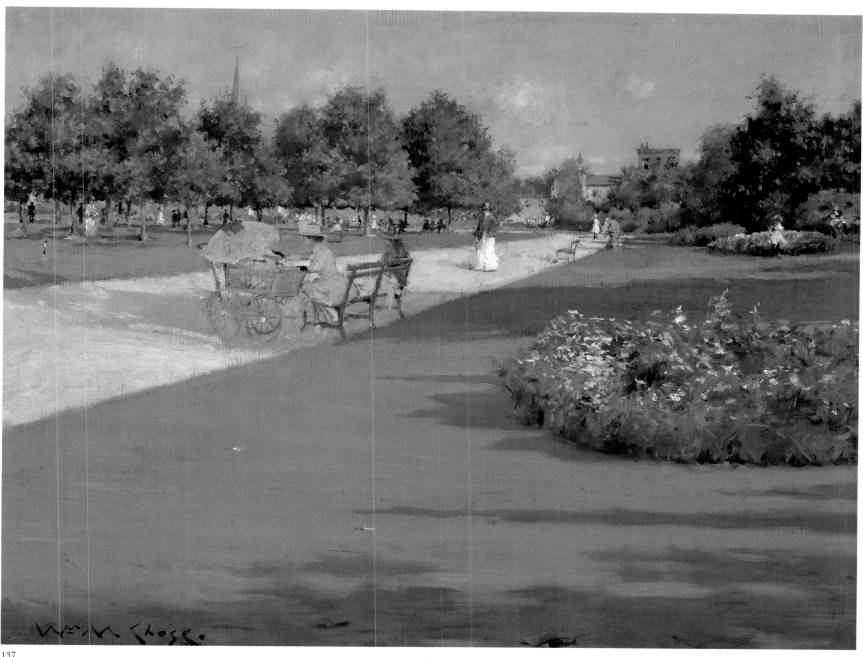

137

137. WILLIAM MERRITT CHASE. *Prospect Park, Brooklyn*, n.d. Oil on canvas, 17⅜ x 22⅜ in. Colby College Museum of Art, Waterville, Maine; Gift of the Misses Adeline F. and Caroline R. Wing.

intense southern sunlight and color," "Sisley's delicate luminous spring days," and "Pissarro's bright, gleaming, sparkling sunlight," while asking: "And who can resist Claude Monet? M. Monet is an acknowledged master now, and it is not necessary to sing his praises; yet I cannot help dwelling on two points: the universality of his genius as a landscape painter, and the eminently poetical qualities of his mind." She offered complete contradiction to Downes's condemnation, finding "Monet is a poet; everything he touches in his inspired moments seems to give out its inmost tone of beauty. He is a born colorist, enthusiastic and inspiring. But above all, he is an artist...."[8] Though Waern did not discuss the American adherents to the new movement, it was she who took the young Bernard Berenson to Theodore Robinson's studio in November 1894.

Critical controversy came to a head later in 1892 in the *Art Amateur*. In November and December, a writer identified only as "W.H.W." published "What Is Impressionism?" a two-part article damning the movement as no more than a glaring novelty primed by the enthusiasm of picture dealers. The author was

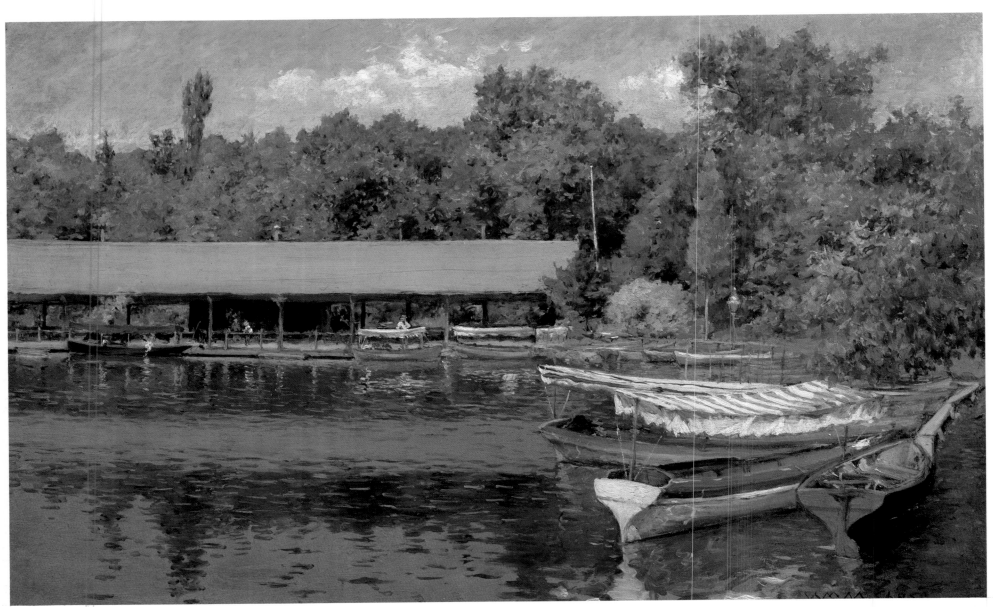

distressed "to observe how in Paris and London and New York impressionism is in evidence among the younger men, and a prismatic glamour is to be seen in every direction.... As regards Messrs. Monet, Pissarro and Sisley, whose paintings have lately been, so to speak, forced down the throat of the amiable American public, anything more slovenly, unmannered, and false we do not remember to have seen."[9]

This time a rebuttal appeared, entitled "From Another Point of View," written by "R.R." (almost surely the art writer and sometime painter who occasionally contributed to the *Art Amateur*, Roger Riordan). R.R. emphasized that the "movement has become universal. There are German, English, American Impressionists, as well as French." He applauded the individuality of Monet and Pissarro, of Weir and Hassam, and traced the evolution of Impressionism from the naturalness of the rough sketch painted out of doors, with its suggestiveness and its occasional high color key, acknowledging that such an approach must involve a loss of imitation and refinement in modeling. But he concluded: "We are not called upon to reject the masters of academic drawing like Lefebvre because we find something to admire in the unacademic drawings of Degas or Renoir. To come nearer home, we can enjoy at the same time the grace and refinement of Mr. Henry O. Walker's work and the sparkle and animation of Mr. Theodore Robinson's."[10]

Surely it was the flourishing of Impressionism among American painters that inspired Trumble in the *Collector* of May 1893 to react so vehemently against the

American Art Galleries' exhibition of work by Monet, Albert Besnard, Twachtman, and Weir. For Trumble it was a double affront signaling the establishment of French Impressionism in America and its adoption by respected young Americans. He recalled:

> When M. Durand-Ruel made his first attempt to plant these new flowers in the soil of American aestheticism, no task seemed more hopeless. Yet behold, today! The criticism which once derided them, denying them even the undeniable good there is in them, now is blind to the undeniable bad.... I have allowed them what I conceive to be good in their art, and have denied that it is either great art or the art of the future.... The great weakness of this school, if one may call it a school, is that it is simply and solely materialistic. It shows you something but it suggests nothing. No matter how much it may interest, it does not touch you.[11]

Outdoor Teaching

The continued reaction against Impressionism by such distinguished writers as Trumble attests to its growing dominance in contemporary American art. Another factor sometimes overlooked is the dissemination of Impressionism through outdoor study. While not all outdoor painting concentrated on landscape—and even when landscape was emphasized it was not necessarily Impressionist—the establishment of schools to teach outdoor landscape painting did coincide with the growing adoption of Impressionism by American artists, and they in turn transmitted it to their students. Outdoor teaching was a new phenomenon. Although earlier students had been encouraged to make studies directly from nature, traditional academic instruction, in drawing and painting, was concerned primarily with the mastery of perspective, the human figure, and ultimately the creation of figure compositions.[12] This was perhaps even more true of the early art schools in the United States than in the more established ones in Europe.[13] Landscape painting nevertheless began to be tremendously significant in American art in the second quarter of the nineteenth century, and it remained so. Artists and their students drew their subjects directly from nature, however thoroughly they might rework them into effective "compositions"; but they did just that—they *drew*. Only in the 1840s did landscapists begin to paint rather than draw from nature, and this

138. WILLIAM MERRITT CHASE. *Boat House, Prospect Park*, c. 1897. Oil on panel, 10¼ x 16 in. Margaret Newhouse.

139. WILLIAM MERRITT CHASE. *A City Park*, c. 1888. Oil on canvas, 13⅝ x 19⅝ in. The Art Institute of Chicago; John J. Ireland bequest.

139

did not become common for another generation. As painters began to respond to landscape, they naturally explored desirable terrains, and gradually favorite painting grounds were selected and colonies formed. The White Mountains in New Hampshire, for instance, began to attract painters like Thomas Cole as early as the late 1820s, and by the 1850s artists swarmed to the area of Mount Washington and the Conway Meadows, often painting side by side. Lake George, New York, was another favorite painting ground, as were several spots in the Catskills.

In Europe there were favorite rural retreats and colonies frequented by artists in almost every country; some painters visited these locales regularly in summer, when the academies were closed, and sometimes established artists lived in them more or less permanently. The most famous of these was Barbizon, in France, but there were many others. Barbizon attracted American artists such as William Babcock and, more significantly, William Morris Hunt, who moved there about 1853. Pont-Aven in Brittany appealed to a large number of American artists as well as painters from other nations; Robert Wylie of Philadelphia was there by 1866, attracting many other Americans before his untimely death in 1877. William Lamb Picknell arrived in 1876, as did H. Bolton Jones and Francis Jones of Baltimore. (In the 1880s Picknell and Bolton Jones developed an Americanized version of Pont-Aven on the North Shore of Massachusetts at Annisquam.[14])

Disciplined by their French academic training, American artists painted together in the New England landscape during the summer, and outdoor teaching classes soon began to develop. There is no documentation of the first outdoor class; it is more significant that the phenomenon expanded on a large scale. In the summer of 1890, for example, Joseph De Camp taught twenty or more women at Annisquam, while nearby in Ipswich, Arthur Wesley Dow had a class; and in Swampscott, Charles Woodbury, the seascapist, taught a dozen pupils. East Gloucester was even more active that summer. Rhode Holmes Nicholls had a dozen pupils in watercolor of landscapes, while Frank Duveneck's class from Boston painted landscapes outdoors and also worked at times from the human figure. On Duveneck's absence for a week, his former pupil the Impressionist Theodore Wendel took over: "...a young artist, who is studying deeply into the mysteries of light upon color. No browns and blacks enter into his scheme of painting."[15]

John Twachtman's 1889 summer class at Newport, Rhode Island, was small, but it may have been what sparked the outdoor teaching movement. While at Newport, Twachtman learned of his appointment to teach that fall at the Art Students League in New York, and with the security of that position, he purchased a house in Greenwich, Connecticut, which became his permanent residence. He commuted to New York two days a week to teach; he enjoyed neither the city nor the tedious drill of his League classes, but he felt them essential to training students. In the summer at Cos Cob, adjoining Greenwich, Twachtman taught outdoor painting classes with great enthusiasm; some of his students had worked with him at the League. One of the earliest was Ernest Lawson, and a classmate noted, "Ernest Lawson was the leading member of the class...for from the first he got hold of things, and painted canvases made of color and filled with light and air."[16]

J. Alden Weir joined Twachtman in teaching summer classes at Cos Cob in 1892. The school continued until the end of the century.[17] Twachtman's teaching, in contrast to his League instruction, was totally removed from the academic. He was, in fact, called "the first teacher to bring the theories and methods of Impressionism before art students in this country."[18] Impressionism was indeed at the heart of his teaching at Cos Cob:

When I first left the German academies I knew nothing of the open air methods. We had been taught to use bitumen for shadows, and accordingly we saw them that color. The theory as advanced by impressionists and actually discovered only about fifty years ago is this: Sunlight is warm, the shadows partaking of the blue of the sky become cold. It was a grand discovery, but now we must go farther, do away with

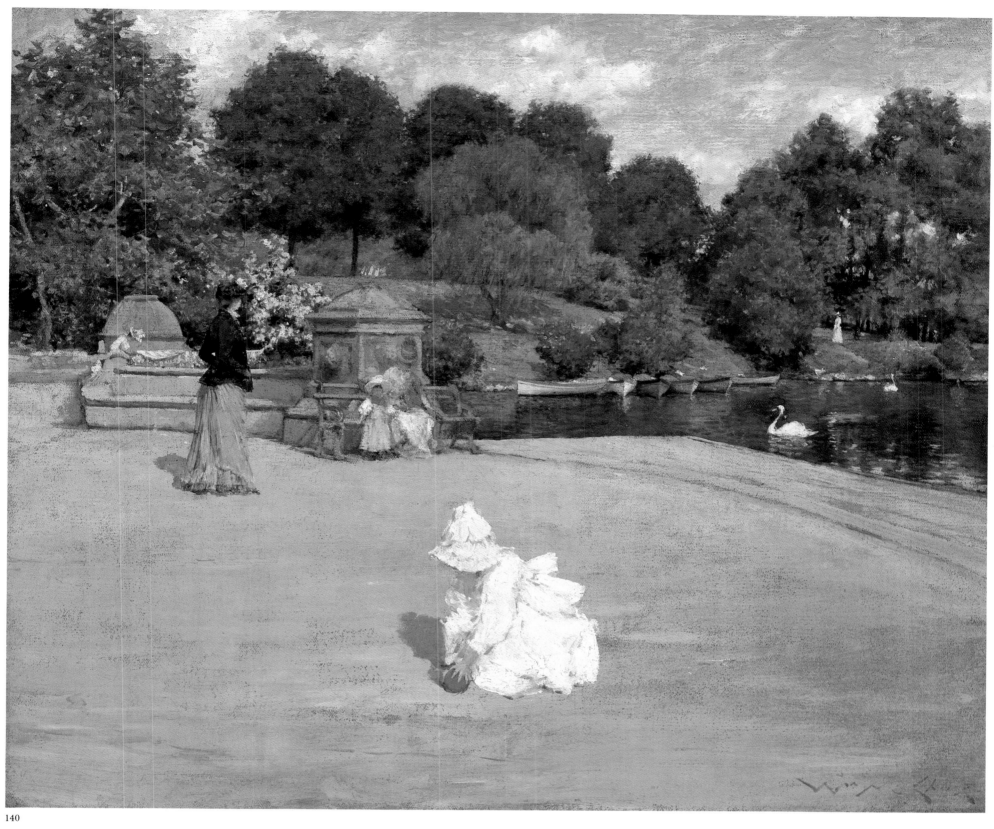

140

the everlasting purple shadow and study color as we find it.... If you naturally get things too cold, study flowers where warmth is concentrated. Monet walks in his garden and looks at the hearts of his flowers until his eyes are saturated with the color.... Mix colors less on your palette, more on the canvas, or you will brush all the life out of them. Do you know you can mix red, blue and yellow together until you have only mud color?"[19]

Though formalized outdoor teaching seems to have been initiated about 1889 or 1890 by Impressionist-inspired Americans recently trained in Europe, further investigation may well document an earlier precedent. The several volumes of Sylvester Koehler's *United States Art Directory and Year-Book* of 1883 and 1884 list no

summer art schools among the extensively documented educational institutions, but Ernest Knaufft—a drawing teacher, writer on drawing instruction, and editor of the new magazine the *Art Student*—wrote in 1893 that he had held a summer class for seven years at Chautauqua, New York.[20] And, in an article of 1900 on William Merritt Chase, Knaufft stated that it was Chase who made the summer outdoor painting school significant, by founding a school in 1891 in the Shinnecock Hills on Long Island. Shinnecock's importance for outdoor teaching lay in its longevity, in the completeness of Chase's pedagogical program, and in the professional status assumed by so many of its students, as well as in making Chase preeminent in the American art world.

Although Shinnecock became the best known, similar summer art schools proliferated throughout the country. The *Magazine of Art* reported in summer 1892 that the Impressionist painter Robert Reid was teaching in the Farmington Valley near East Hartford, Connecticut. Also mentioned was a summer school that had operated for some years at Round Lake, New York, with instruction that season by Otto Toaspern. William Baer had taught there from 1888 to 1891 and before him Benjamin Fitz (the summer program there still awaits clarification[21]). In 1893 Baer returned from Europe and took over Ernest Knaufft's summer classes at Chautauqua. The following year Irving Wiles taught at Silver Lake, New York, and Charles A. Vanderhoof, an instructor at the Cooper Union in New York, conducted summer classes in illustration, etching, and sketching from nature.[22]

Theodore Robinson became involved in summer teaching during the last few years of his life. In summer 1893 he taught a class for the Brooklyn Art School at Napanoch, New York, near the Delaware and Hudson Canal. The hot weather, his asthma, and his own artistic uncertainty made teaching unpleasant for him, and yet he seems to have enjoyed working with some of the young women students and to have inspired them to "sketch 'from nature' instead of from the wooden and plaster substitutes offered at art schools," as one delightful, and delightfully illustrated, newspaper description put it. "Mr. Robinson consented, after a good deal of entreaty, to be the guide of these would-be impressionists.... In spite of being a devoted artist, Mr. Robinson is fortunately gifted with a sense of humor which will carry him through the summer."[23] The other factor that "carried him through the summer" was the opportunity to do some of his own work—some of the best painting of his American years. The following summer he taught the class again, but this time at Evelyn College in Princeton, New Jersey. Though students were fewer than the previous year, the landscape was also less inspiring, and he produced little satisfactory work.[24]

On the proliferation of summer art schools the *Magazine of Art* reported in 1892: "The students in the Pittsburgh Art School have for the third time migrated from the sooty city to the village of Scalp Level on the Alleghanies, where they have occupied for some weeks the residence of a Mr. Veil without let or charge...."[25] For a generation Scalp Level had been the favorite outdoor painting ground for professional artists in the Pittsburgh area. In 1894 summer schools were also announced in Cincinnati and Minneapolis.[26] The impact of these schools and their results were being recognized. That year the *Art Interchange* acknowledged:

> A decade ago such schools were unknown.... That these Summer schools have exerted a powerful influence on the character of our painting will be seen by any one who studies the exhibitions.... We no longer have any doubt that the modern eye has been developed to see color, movement, light and atmosphere unknown and undreamed of in Kensett's day. Painting has become almost a thing of science; in fact, there is danger of its being carried so far in that direction as to lose its spirit. But out of this enlarged vision and abler technique, which is directly traceable to the teachings of the Summer schools, will come the geniuses of the next period in our art.[27]

141. THEODORE ROBINSON (left) painting outdoors.

142. WILLIAM MERRITT CHASE. *The Open-Air Breakfast,* c. 1888. Oil on canvas, 37⁷⁄₁₆ x 56¾ in. The Toledo Museum of Art; Gift of Florence Scott Libbey.

William Merritt Chase, Artist and Teacher

Chase can be best discussed as both artist and teacher in this chapter because his own painting coalesced with Impressionism during those fertile years of the 1890s when he was most involved in outdoor summer teaching. His art showed tremendous stylistic variation, and he was susceptible to extremely varied influences and relationships. Born in Indiana, he trained in Indianapolis with Barton Hays before moving to New York in 1869; there he studied at the National Academy of Design.[28] His professional career began with the painting of still lifes in New York and Saint Louis, where he was encouraged by Munich-trained John Mulvaney and patronized by some prominent Saint Louis businessmen. In 1872 Chase entered the Royal Academy in Munich and with Frank Duveneck became one of the most prominent Americans studying there. Chase remained in Munich until 1877, when he joined Duveneck and Twachtman on a trip to Venice; there he received an invitation to teach at the newly formed Art Students League in New York. He came home in 1878, a crucial time for both Chase and American art. He not only began his teaching career but joined the new, avant-garde Society of American

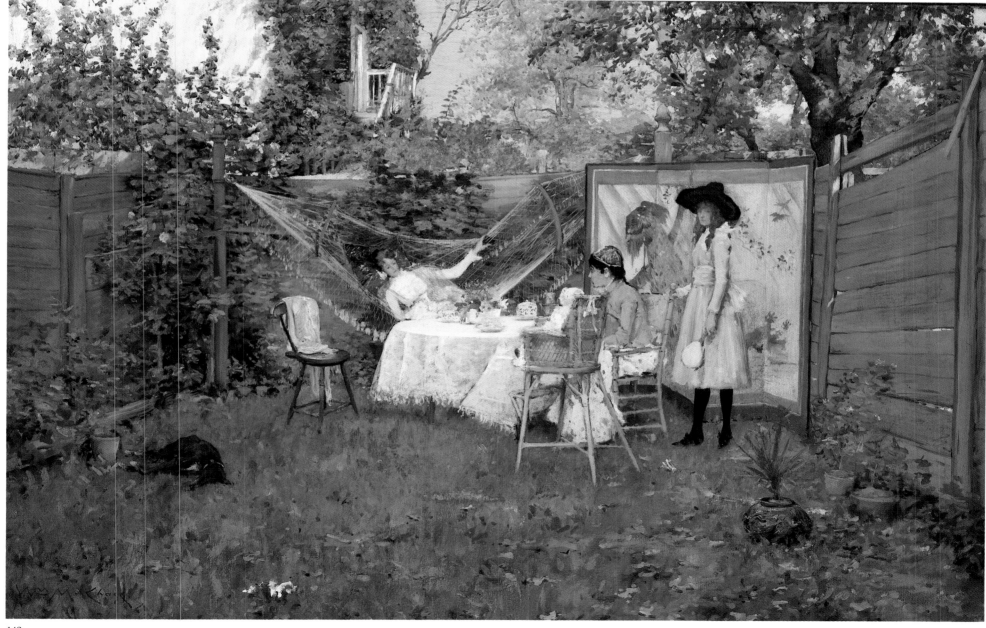

Artists; indeed, Chase's *Ready for the Ride* was the painting most noticed by critics in the Society's first exhibition that year, and it helped to characterize the Society as initially more Munich than Paris oriented.

During the 1880s, as Chase came to admire Manet's work, he gradually abandoned his dark tonal style and began to work in a more colorful, plein-air manner. His involvement with the pastel movement also stimulated the evolution of a freer, more spontaneous manner. But it was in his scenes of Prospect Park in Brooklyn and Central Park in Manhattan that Chase first revealed a sustained commitment to the effects of light and color in a natural setting, related to the concurrent investigations of some of his fellow Americans at Giverny. Several Prospect Park views were seen in Chase's first one-man show at the Boston Arts Club in November 1886. Preceding the pictures sent home from Giverny by John Breck and others, these paintings may be the earliest announcement in Boston of American interest in Impressionism after the Durand-Ruel show in New York the previous spring.

Chase married in 1886, and the couple lived in Brooklyn, where Prospect Park was convenient subject matter. It was also a conscious choice, a bit of nature that Chase could record vividly and fleetingly—an urbanized nature with sparkling figures and evidence of man's cerebral handiwork in the design of Frederick Law Olmsted and Calvert Vaux. The organized planting and the broad paths make a work such as Chase's *Prospect Park, Brooklyn* (plate 137) not unlike Picknell's *Road to Concarneau* (plate 5). The emphatic perspective in Chase's work recalls his answer to a question on the need for perspective study: "About the very best lecture in perspective that I ever had was once when I stood at the back end of a railroad-train and saw a track running to a point away from me—and I never have forgotten it, and I have seemed to see things diminish in the distance so ever since."[29]

Chase was a realist, and so considered himself. Even in the next decade, when he more closely embraced Impressionist techniques, it was because they were useful to him in realizing his perceptions of reality, not because he was subscribing to an aesthetic. This was true of his Brooklyn park scenes, judged in 1889 by Kenyon Cox as "far and away the best things Mr. Chase has yet done. . . . Crisp, fresh, gay, filled with light and air and color and the glitter of water and dancing of boats, or the brightness of green grass in sunshine, and the blue depths of shade upon gravel-walks, brilliant with flowers and the dainty costumes of women and children, they are perfection in their way. . . ."[30]

By 1889 Chase was painting Central Park. He exhibited a number of these pictures in his special showing at the Inter-State Industrial Exposition in Chicago that year, and the acclaim was greater because Chase was able to find poetry and romance in familiar bits of landscape. In 1891 the important critic Charles De Kay observed: "The distinction of being the artistic interpreter of Central Park, and of Prospect Park, Brooklyn, has come to Mr. Chase very naturally, and without special forethought on his part. He has been painting in Central Park for some years, and he worked in Prospect Park, Brooklyn, until the vulgar abuse of a man who is still retained in its management forced him to leave that fine Park unexplained. . . ."[31] Some of these Central Park scenes, such as his *Terrace at the Mall* (c. 1887–91), are more vibrant in light and color than the slightly more linear Brooklyn pictures, and the use of "glare-aesthetic" planes of reflected light is even more pronounced. All the park scenes are small, but Chase realized his plein-air manner on a large scale in *The Open-Air Breakfast* (plate 142), painted about 1888. It is a scene of his family in their Brooklyn backyard and a brilliant portrayal of informal leisure.

For all his later years on Long Island, Chase was essentially an urban artist, whether in his great work space in the Tenth Street Studio Building or in the parks and backyards of Brooklyn and Manhattan. He was also an important teacher at the Art Students League from 1878 to 1895; ultimately, he became the single

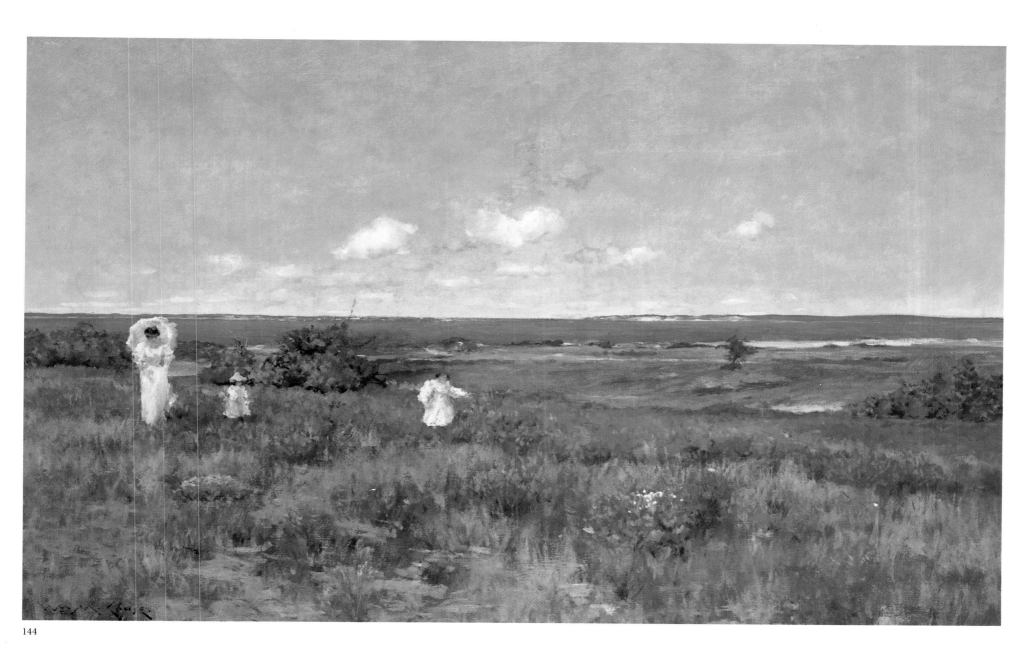

144

most important teacher of his generation, perhaps in all of American art education. In 1896 he opened his own school in New York, later renamed the New York School of Art, and taught briefly in Brooklyn and Chicago.

The genesis of Chase's outdoor teaching lay partly in the enthusiasm of Mrs. William Hoyt for the art and methodology of the plein-air painters. In 1890 she invited Chase to Southampton, Long Island, to discuss the founding of a summer school, and the following year the Shinnecock Summer Art School began operation. Chase carried on for twelve seasons, and the school was tremendously popular, successful, and famous. Articles describing the teaching program abounded.[32]

Chase spent Monday and Tuesday each week reviewing his students' work; he was also "at home," three miles from the Art Village where many students stayed, on Sunday and on Monday afternoon. Chase himself taught oil and pastel painting; his pupil Adelaide Gilchrist taught drawing in charcoal for beginners, and Rhoda Nichols, previously at East Gloucester, taught watercolor. In April 1894 an exhibition of Shinnecock student work was held at Sanchez & Co. in New York. A writer in the *Critic* commented that "several of the students are so far advanced that their studies have a positive value as pictures."[33]

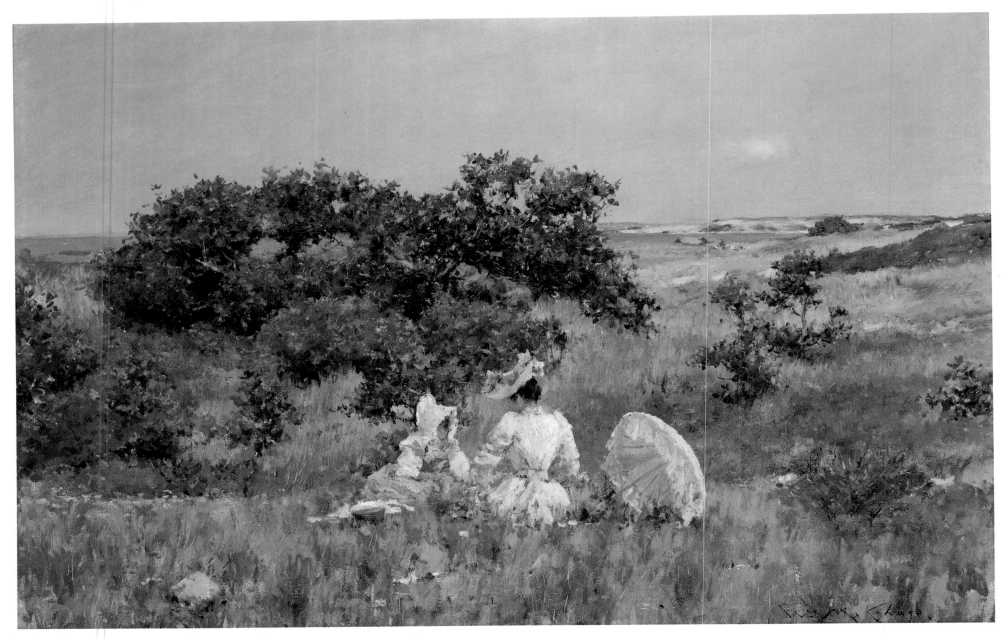

145

145. WILLIAM MERRITT CHASE. *The Fairy Tale*, 1892. Oil on canvas, 16½ x 24½ in. Mr. and Mrs. Raymond J. Horowitz.

146. WILLIAM MERRITT CHASE. *The Orangerie*, c. 1910. Oil on cradled panel, 23½ x 33 in. Private collection.

As summer painting in the open air became a primary influence on late nineteenth- and early twentieth-century American art, it also proved liberating to the artist-instructors themselves; obviously it was advantageous for a painter devoted to outdoor light, sunshine, and color to instruct a class in just that environment. In June 1893 John Gilmer Speed wrote about Chase's previous summer in Shinnecock in "An Artist's Summer Vacation" and noted that "summer vacation is his busiest and his happiest time, and upon the work then done he not infrequently finds his inspiration for the remainder of the year."[34] Speed added that "the advantage of living in such a place is that all an artist has to do is to take out his easel and set it up anywhere, and there in front of him is a lovely picture." Chase did paint the most beautiful landscapes of his career in Shinnecock, sometimes very broadly rendered scenes, like his *Idle Hours* (plate 136), sometimes more detailed and scintillating, like his great *Fairy Tale* of 1892 (plate 145). Speed said of the latter: "Another out-of-door study is that of a lady and child in the grass of a sand hill, with Peconic Bay in the background. This sketch was taken almost in front of Mr. Chase's house, and indeed, nearly all of the summer sketches were made close by."[35]

The lady and child and most of the figures in Chase's Shinnecock paintings are members of his family. The casual joy of the earlier *Open-Air Breakfast* continues now fully immersed in rural summer nature. At times, particularly in the foliage of

The Fairy Tale, the technique is extremely close to orthodox Impressionism; yet, to a degree, Chase is to American Impressionism as Eugène Boudin is to French, both in style and subject.

From 1903 Chase taught summer classes abroad: in Holland in 1903, England in 1904, Spain in 1905, Florence in 1907 and 1909–11, Bruges in 1912, and Venice in 1913. His Florentine landscapes, particularly, often use more conventional Impressionist techniques than his earlier park and Shinnecock pictures; those of Italian olive groves and especially those painted around the orangerie of his Florentine villa show an increased interest in the variegated coloration of flower gardens. Yet the motivation for Chase's art remained the expression of the reality of his subject through the expressivity of his technique.

"Don't hesitate to exaggerate color and light. Don't worry about telling lies. The most tiresome people—and pictures—are the stupidly truthful ones. I really think I prefer a little deviltry."

William Merritt Chase, quoted by Frances Lauderback in "Notes from Talks by William M. Chase, Summer Class, Carmel-by-the-Sea, California," *American Magazine of Art*, September 1917, p. 438.

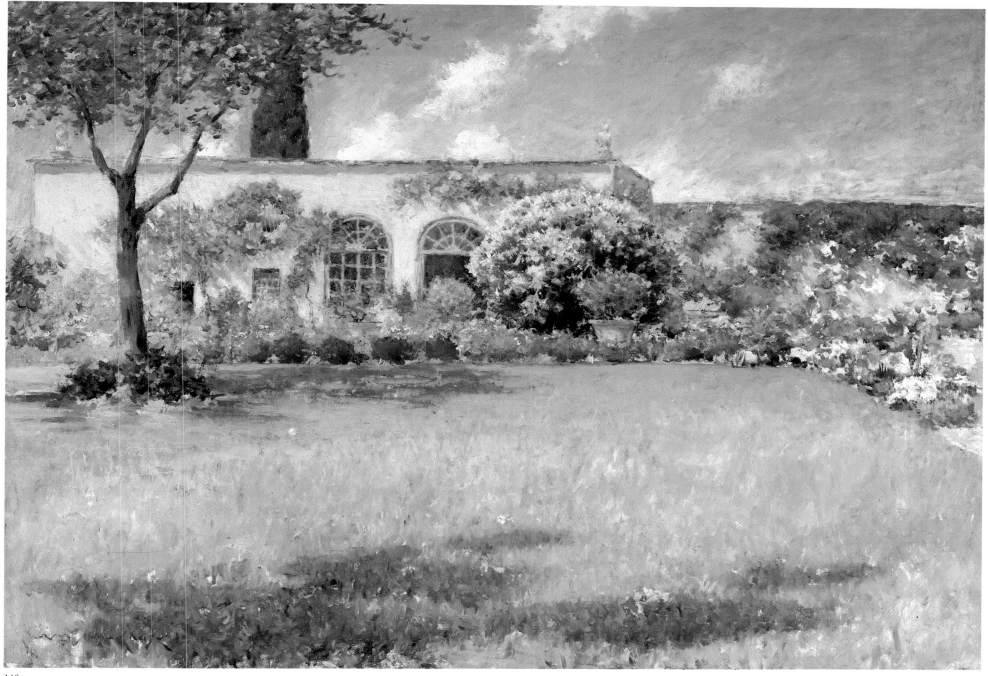

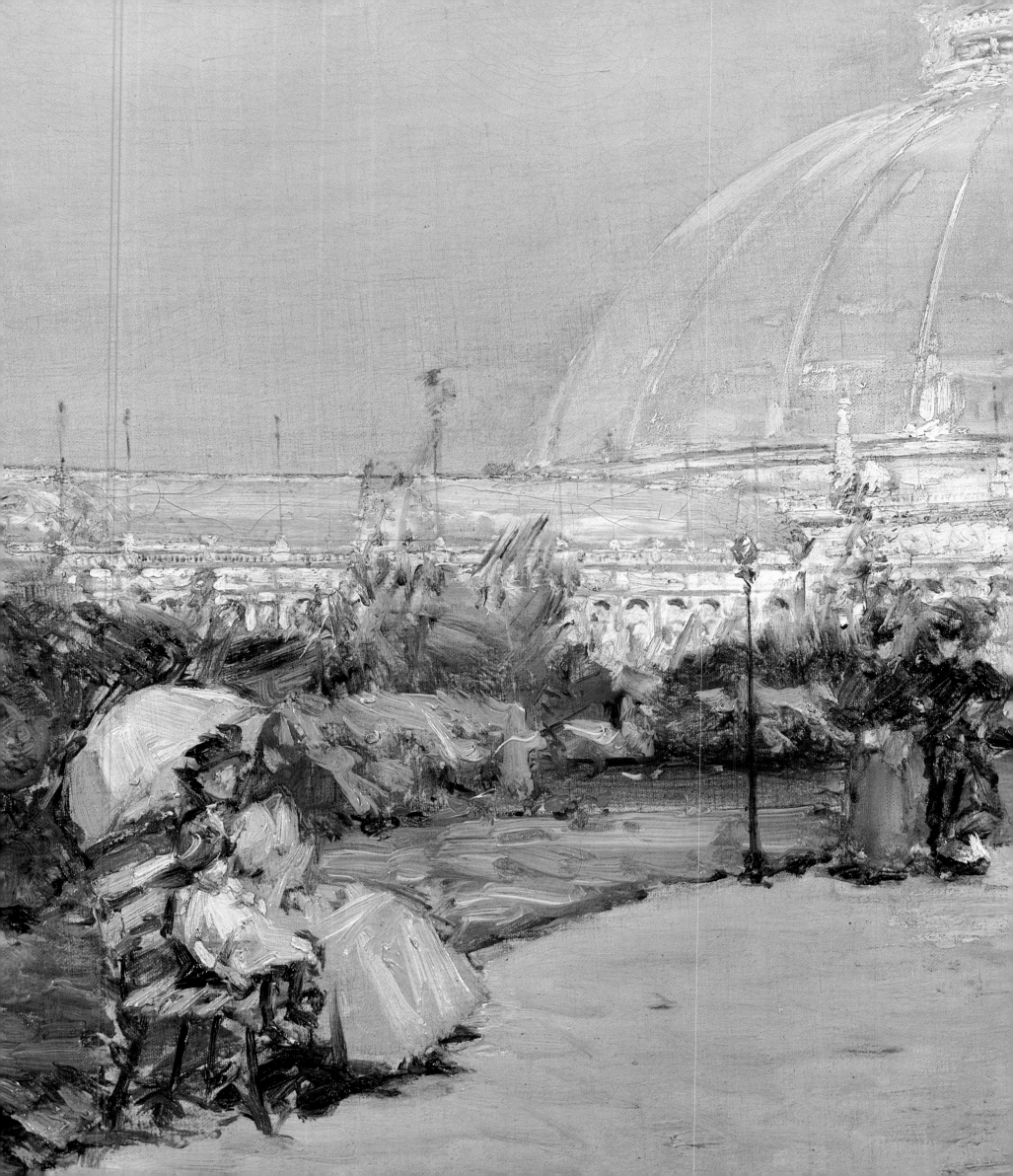

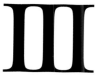

THE YEARS OF TRIUMPH

1893 – 1898

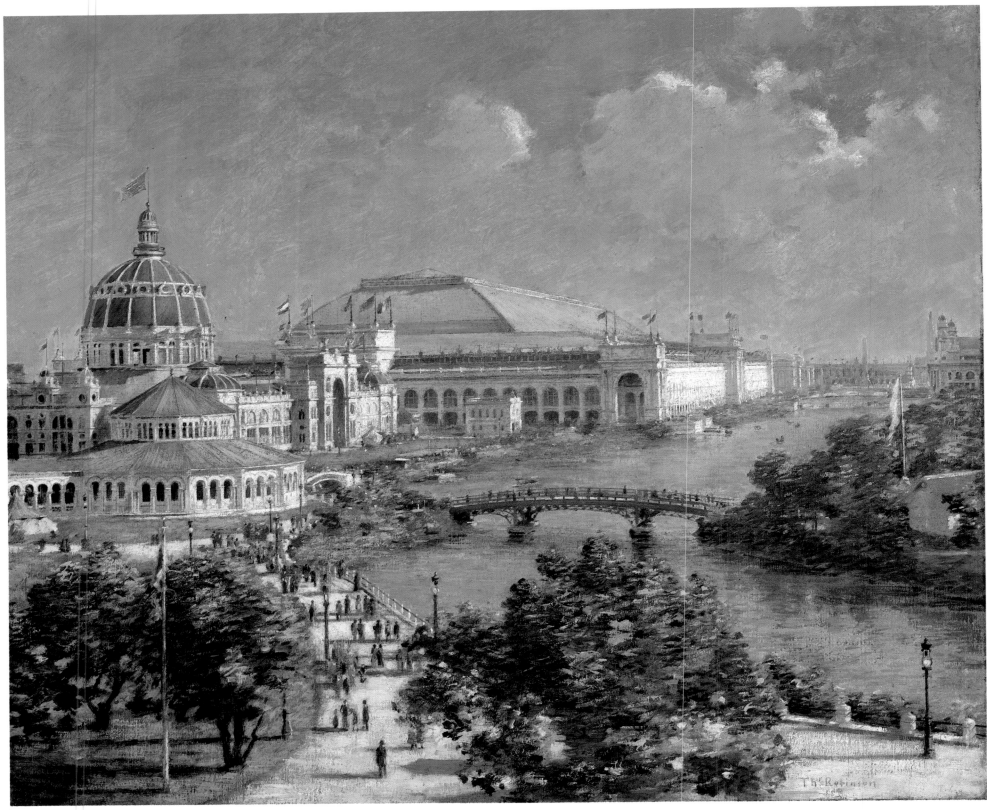

147

8 The World's Columbian Exposition of 1893

THE MAJOR CULTURAL EVENT IN AMERICA during the years of Impressionist development was undoubtedly the World's Columbian Exposition of 1893 in Chicago. It was called "The White City"—an apt name for the dazzling display of Beaux-Arts architecture that encompassed the achievements of the modern world. National contingents vied with one another to establish the quality, variety, and modernity of their painting and sculpture. While some chauvinistic critics, such as the British, insisted that their displays were the finest, and while other groups, particularly the Scandinavians, were universally judged to have made giant strides, most critical attention was drawn to the French and the American displays, and a rivalry of sorts developed as to their quality and profundity. The Americans—the judges who juried the selections and awarded the prizes, the artists, the critics, and the general public—wanted to refute charges made at previous International Expositions that American art was only a pale, somewhat retardataire reflection of French achievement and to prove that American art had come a long way since the Philadelphia Centennial of 1876, the first comprehensive display of world art in this country.[1]

American painters were deeply involved with the Exposition beyond their contributions to the Art Gallery display and their roles as jurors, particularly as painters of the mural decorations of several fair buildings.[2] Perhaps the most fascinating were the paintings by a number of American women for the Woman's Building. The largest and most spectacular of these were the approximately twelve-by-fifty-foot paintings called *Primitive Woman* and *Modern Woman* by Mary Fairchild MacMonnies and Mary Cassatt, respectively, neither of which seems to have survived.[3] A number of the American Impressionists, and some who soon joined their ranks, such as J. Alden Weir and Robert Reid, also painted murals.[4]

Some major triumphs of American Impressionism were on view in the Art Gallery. Among the most noticed were Hassam's *Grand Prix Day* (plate 100), which had marked the beginning of his conversion to the movement; Tarbell's *In the Orchard* (plate 124), his fullest indulgence in the aesthetic; Robinson's *Layette*, done in Giverny in 1892; Benson's more subdued *Girl in a Red Shawl* (plate 126), which won a prize; several of Twachtman's winter scenes; and a large display of Vonnoh's work, including his *November* (plate 16). Yet, while there was a strong display of American Impressionism, it would be easy to overestimate its presence. Given the size of the American exhibit, there were few totally Impressionist pictures. Many

147. THEODORE ROBINSON (1852–1896). *Chicago Columbian Exposition*, 1894. Oil on canvas, 25 x 30 in. Private collection.

artists who had "converted" to Impressionism or had developed a related style chose to show more conservative works or to emphasize the variety of their art rather than its modernity. Vonnoh, for instance, exhibited a good many subdued landscapes and figure pieces, and most of Lilla Cabot Perry's pictures were figure paintings, though this included her very colorful *Petite Angèle*. Chase exhibited several park scenes but no Long Island landscapes, and Hale's only offering was not a sun-drenched garden picture but his *Old Woman Reading*.

While Impressionism by no means dominated the American display, in the official French section it was completely absent, except for several works by Raffaëlli.[5] The French display was traditional, thanks to the presence of Gérôme, Adolphe William Bouguereau, and Léon Bonnat on the jury. The French Impressionists *were* on view at the fair, however, in the *Loan Collection of Foreign Works from Private Galleries in the United States*—125 paintings and sculptures lent by collectors such as the Havemeyers, Alexander Cassatt, Albert Spencer, Frank Thomson, and, of course, the Potter Palmers. The Palmers not only were the major collectors in Chicago, particularly of contemporary art, but also were deeply involved with the Exposition and its art show. Among the works exhibited in the *Loan Collection* were two marines by Manet and his masterwork *Dead Toreador*; several canvases by Degas, including one of ballet dancers and one of race horses; a number of landscapes by Pissarro and one by Sisley; and four pictures by Monet that were singled out by Roger Riordan in the *Art Amateur* because "none of these men have given themselves as singly to the reproduction of the actual effect upon the eye as Claude Monet, who…still works in values, but his strong point is in his extraordinarily vivid color, which is also, when one puts air enough between him and the picture, extraordinarily true in hue."[6] A Renoir figure piece was much admired, too, as both painting and portrait.

Yet again one should not overestimate the impact of these paintings. Not only were they shown apart from the official French section but they constituted only a small segment of the *Loan Collection*. Why, then, can one justifiably speak about the Columbian Exposition as something of a vindication, even a triumph, of Impressionism in America? Because throughout the national displays the new aesthetic of light and color seemed to dominate, to "shine out" in every gallery. Even if the Impressionist paintings were a minority, their vividness commanded attention and, perhaps more important, they exerted a cumulative effect as visitors went from room to room; conversely, it was noted when the impression of light and color was absent from national displays. Critics designated the paintings that partook of this aesthetic "modern," even when they were traditionally composed and their figures rather academically rendered. One finds even the cautious critic John Van Dyke calling the Danish, Norwegian, and Swedish artists "Scandinavian impressionists" and their paintings "almost prismatic in their color brilliancy… something new, this stream of art under the northern lights…every weary wanderer there in Chicago knows how welcome was the Scandinavian section after viewing the other pictures. It was a breath of pure air after the hot-house studio, something unique, something new…."[7]

These Scandinavian paintings seem rather tame today, compared with the work of Tarbell and Hassam, let alone Monet and Renoir. Yet this enthusiasm is relevant, too, for writers on art needed a justification for championing modernism—which meant Impressionism—in a way that would acknowledge a national expression with some independence from French precedents. They found it in Chicago, especially since the official French display did *not* acknowledge the art that was so exciting throughout the fair. And in turn Impressionism found its most enthusiastic champion in the critic, novelist, and short story writer Hamlin Garland.

Garland was living in Boston in the late 1880s when he became associated with a coterie of Boston artists, including the landscape painter John J. Enneking. Through Enneking he came to know Dennis Bunker, and through Bunker he

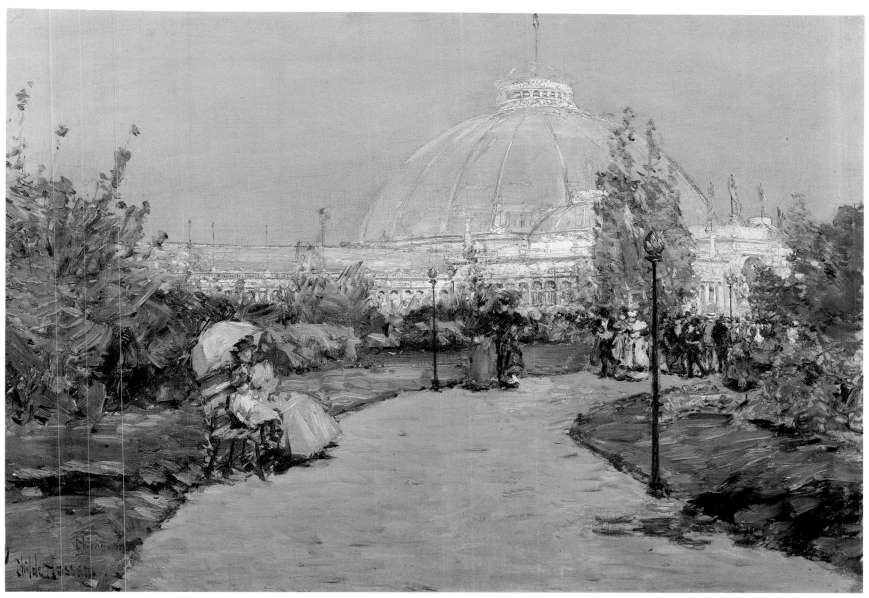

148

148. CHILDE HASSAM (1859–1935). *Crystal Palace, Chicago Exposition*, 1893. Oil on canvas, 18 x 26 in. Mrs. Norman B. Woolworth.

seems to have met Lilla Cabot Perry; at her home he saw some works by John Leslie Breck that she had brought from Giverny, "presenting 'Impressionism,' the latest word from Paris."[8] In the early 1890s, Garland loosened his connections with Boston and traveled frequently back to his native Midwest, often staying in Chicago. He was there in the summer of 1893 and attended the Exposition; he settled there permanently in April 1894. In February 1894 Garland gave a lecture on Impressionism at the home of the banker and art patron Franklin Head; in it he described his reaction to the art at the fair. Published that year in Garland's *Crumbling Idols*, this lecture has been called by John Rewald "probably the first all-out defense of the movement to be written in English." It may not have been first, but it may well have been the most influential.[9] Garland noted:

To-day, as seen in this wonderful collection, impressionism as a principle has affected the younger men of Russia, Norway, Sweden, Denmark, and America as well as the *plein air* school of Giverney [*sic*]. Its presence is put in evidence to the ordinary observer in the prevalence of blue or purple shadows, and by the abundance of dazzling sun-light effects.... This placing of red, blue, and yellow side by side gives a crispness and brilliancy, and a peculiar vibratory quality to sky and earth which is unknown to the old method. And if the observer will forget conventions and will refer the canvas back to nature instead, he will find this to be the true concept.[10]

Garland mentioned specific Scandinavian artists and Americans such as Bunker,

149

Perry, Tarbell, and Benson, defining the typical Impressionist artist as "a buoyant and cheerful painter. He loves the open air, and the mid-day sun." And Garland concluded: "To a man educated in the school of Munich, the pictures, both of the Norwegian and of the Giverney [*sic*] group of Frenchmen and all other pictures with blue and purple shadows, are a shock. They are not merely variants, they are flags of anarchy; they leave no middle ground, apparently. If they are right, then all the rest are wrong. By contrast the old is slain."[11]

Garland's essay struck a nationalist note when he said, "As I write this, I have just come in from a bee-hunt over Wisconsin hills, amid splendors which would make Monet seem low-keyed." His search for indigenous art—much like his attempts during these years to develop a regional literature—led him to participate actively in organizing the Central Art Association in Chicago, and to become its president in March 1894. The Association promoted the arts in the Midwest by sponsoring exhibitions and lectures and publishing a monthly journal, *Arts for America*.[12]

One of the most interesting Association publications was a fall 1894 pamphlet entitled *Impressions on Impressionism*. It recorded a discussion of "The Critical Triumvirate," three thinly disguised figures in the Chicago art world—Garland, the sculptor Lorado Taft, and the conservative landscape painter Charles Francis Browne—about the work in the *Seventh Annual Exhibition of American Paintings*, which opened in late October at the Art Institute of Chicago. One of the first major exhibitions of American art to be seen in Chicago after the Exposition, it reflected the new enthusiasm for Impressionism. Browne was a painter in the Barbizon mode and naturally less receptive to Impressionism than his colleague: his first reaction to the show was a predictable "They've all gone crazy." He asked: "Is a Brittany peasant more to us than everything else? Haven't we out-door subjects in our fields, or our mountains, by our glorious lakes, on the shores of our loud sounding seas? We assuredly have. American art must be developed by the artists in happy sympathy with American surroundings, and supported by a public

149. JOHN J. ENNEKING (1841–1916). *The Brook, North Newry, Maine*, n.d. Oil on canvas, 24⅛ x 30⅛ in. Henry Art Gallery, University of Washington, Seattle; Horace C. Henry Collection.

150. JOHN J. ENNEKING. *Through the Orchard*, c. 1895. Oil on canvas, 24 x 36 in. Private collection.

loving the home things more than imported foreign sentiment.''

Garland continued to champion the Impressionists, especially the Bostonians Tarbell and Benson, but he deplored the lack of American content and echoed Browne's nationalistic sentiments: "What pleases me about the Exposition is that while the principle of impressionism is almost everywhere it is finding individual expression.... There are very few pictures here with Monet's brush-stroke imitated in them. The next step is to do interesting American themes and do it naturally...."[13]

Garland's search for an Americanized response to Impressionism was one to which some Eastern artists such as Robinson were sympathetic; indeed, Garland, who admired Robinson, sent him a copy of *Impressions on Impressionism*. The artist noted in his diary that it was "witty and sensible and suggestive—the sort of thing that ought to do good—I like its freedom from heaviness, dogmatism—and a number of good things are said, *pour et contre*."[14] But by the time Robinson received it on December 18, 1894, Garland had discovered what he was searching for, and within a week or so he was presenting it to Chicago audiences. This was the work of the "Hoosier School."

The "Hoosier School" designation was Garland's. The Hoosier Impressionists

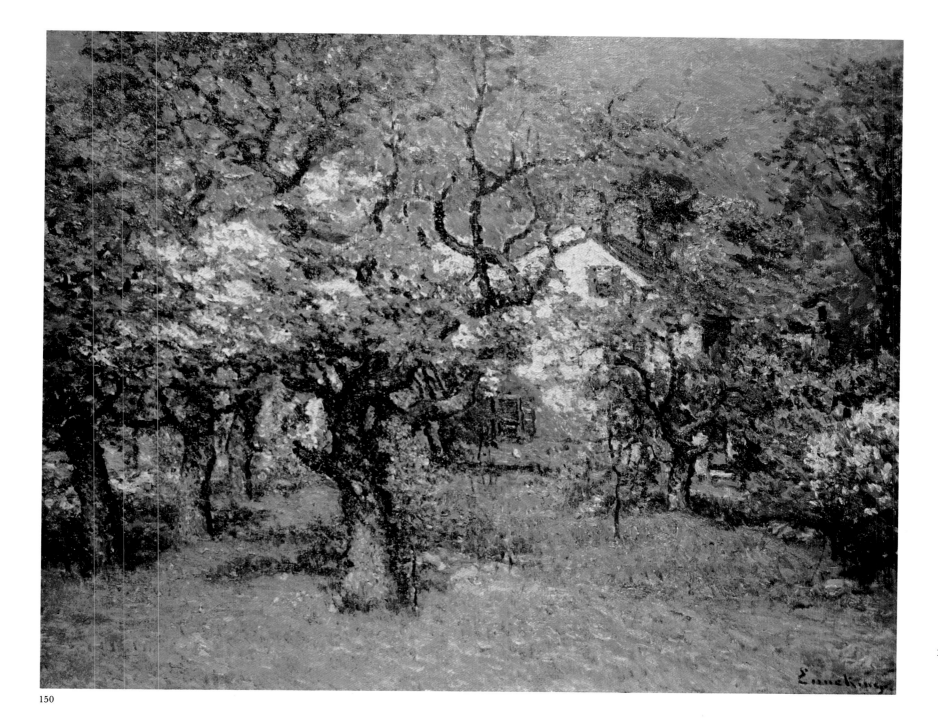

151

152

were the first regional group to work in that aesthetic. While their contribution can be overstated in terms of achievement or significance, they did have historic precedence and were extremely capable painters. They are important, too, because their work corresponds to Garland's call for a nationalized modernism; and as regionalists they offered inspiration to other groups, such as the New Hope painters and the Society of Ozark Painters, some of which still need study.[15]

The Hoosier artists were the first Indiana painters who remained there to work (Chase, for instance, came from Indiana but painted elsewhere) and who achieved a level of professionalism beyond a delightful—or sometimes inspired—provincialism. The core of the Hoosier group—William Forsyth, John Ottis Adams, and particularly Theodore Steele, who was acknowledged as the leading figure among them—studied in the early and mid-1880s in Munich, following the regular curriculum at the Royal Academy and then studying outside Munich, at Schleissheim, with the expatriate American J. Frank Currier.[16] The work of the Hoosiers then consisted of peasant genre pieces and broadly painted, dark tonal landscapes, such as Steele's *Pleasant Run* of 1885 (plate 151), painted in Indianapolis just after his return from Munich. Gradually, during the late 1880s and early '90s, Steele and his colleagues turned to a more colorful, light-filled aesthetic as they explored the Indiana landscape: the valleys of the Whitewater and the Muscatatuck rivers in and around communities such as Vernon and Brookville. Steele's work began to be seen more widely after his return from Germany, when he exhibited with the Society of American Artists in New York in 1886; but the Hoosier painters did not start to attract serious national attention until 1893, when Steele and Forsyth exhibited in the Art Gallery of the Columbian Exposition. Garland first became aware of their work then, and a short notice in the first issue of *Modern Art* mentioned their reception by the jury: "A landscape by Mr. Steele was the only picture that received a number one vote."[17] This may have been Steele's 1892 *On the Muscatatuck*.

The Midwest's emergence as a significant cultural force can be traced directly to the Exposition. Another sign was the appearance, not in Chicago but in

153

146

154

151. THEODORE STEELE (1847–1926). *Pleasant Run*, 1885. Oil on canvas, 19¼ x 32½ in. Indianapolis Museum of Art; Gift of Carl B. Shafer.

152. THEODORE STEELE. *The Bloom of the Grape*, 1894. Oil on canvas, 30⅛ x 40⅛ in. Indianapolis Museum of Art; Bequest of Delavan Smith.

153. THEODORE STEELE. *Whitewater Valley*, 1899. Oil on canvas, 21¹⁵⁄₁₆ x 29 in. Ball State University Art Gallery, Muncie, Indiana; Gift of Mrs. Edmund Burke Ball.

154. THEODORE STEELE. *The Old Mills*, 1903. Oil on canvas, 30 x 45 in. Mr. and Mrs. Clarence W. Long.

Indianapolis, of *Modern Art*; begun in 1893, for its short existence in the 1890s it was the finest, best-designed publication on art in this country. It included frequent articles on Impressionism, many of them by the Hoosier painters: Forsyth reviewed Impressionist work at the Exposition, and both Steele and Otto Stark wrote analyses and histories of the movement.[18] Stark was a Paris- rather than a Munich-trained painter who settled in Indianapolis in 1892. Two years later Steele, Forsyth, Stark, and a self-trained Indianapolis artist named Richard Gruelle held a joint exhibition of summer work at the Denison Hotel in Indianapolis. Hamlin Garland, who had noted the painting of Steele and Forsyth in Chicago the previous year, was in the city to deliver a lecture and was so impressed by their work that he invited them to extend the exhibition to Chicago, at the Central Art Association. Steele persuaded Garland to include several paintings by his Munich comrade John Ottis Adams, and the show opened in Lorado Taft's studio in the Chicago Athenaeum building in late December 1894. Another pamphlet was published by "The Critical Triumvirate" entitled "Five Hoosier Painters."

In the foreword the "Triumvirate" collectively acknowledged: "These men were isolated from their fellow-artists, they were surrounded by apparently the most unpromising material, yet they set themselves to their thankless task right manfully—and this exhibition demonstrates the power of the artist's eye to find floods of color, graceful forms and interesting compositions everywhere." Steele was deemed the most powerful of the group with his *Bloom of the Grape* of 1894 (plate 152), probably his best-known landscape. Garland praised it, and even the conservative Browne found it "fresh in color and free in handling," noting that "These men are conservatively impressionistic, they are not 'wild'...." Taft said they "had selected the better part of impressionism...that one of the great lessons of impressionism has been to teach our painters how to focus attention upon some important feature in a canvas and how to slur and subordinate non-essentials. The extreme impressionist slurs everything."[19]

The Midwestern affiliation of the Hoosier School was also commended. Garland stated: "A group of men like these can transform the color sense of the whole west—or more truly awaken the unconscious color sense. This exhibition can hardly be over-estimated in its effect on our western painters." The Chicago writer for the *Critic*, Harriet Monroe, said that she was "impressed by the sense of

156

155

something new and fine, like the emotion which assailed me at the first view of the Swedish exhibit at the Columbian Exposition. Here is an indigenous art—a group of sincere men modestly and eagerly giving us their own."[20] If the success of the Hoosier School was regional, it was acknowledged nationally. In March 1895 the *Art Amateur* wrote, "Among the Indianapolis painters whose work is making some stir in the West, T. C. Steele is pre-eminent for broad handling, poetic spirit and agreeable color. He is of the impressionist school, and deals in the glorification of the commonplace Indiana landscape."[21]

Though Garland was soon to become more involved in literary matters, he wrote the catalog introduction for the combined exhibition of Chicago's Palette Club and Cosmopolitan Art-Club held in January 1895 at the Art Institute. Adams, Forsyth, Stark, and Steele all exhibited; Forsyth and Steele as members of the Cosmopolitan. Garland wrote: "Monet makes Giverny. Giverny does not make Monet.... The light floods the Kankakee marshes as well as the meadows and willows of Giverny. The Muscatatuck has its subtleties of color as well as L'Orse...." He was undoubtedly referring to Steele's *On the Muscatatuck* and *Afternoon on the Muscatatuck*.[22]

157

After the Columbian Exposition the tide of Impressionism began to flow well beyond the Kankakee and the Muscatatuck, though the Hoosiers remained its most significant reservoir in the Midwest for some time. But writing on the 11th annual exhibition of the Saint Louis Exposition and Music Hall Association in September 1894, the *Art Amateur* said, "The Impressionists are represented at their best," with examples by Manet, Monet, Sisley, Renoir, and Pissarro, whose *Prairie at Eragny* was "one of the most luminous pictures in the exhibition."[23] That year in the California Midwinter Exposition at San Francisco, works by Renoir, Sisley, Pissarro, and especially Monet were shown. *A Field in Giverny* by Monet was seen as "so full of atmosphere and color, that it really dazzles you, and makes you catch your breath," though the critic cautioned, "this work may not be appreciated or understood by the masses."[24]

More native Impressionism flowed through the land via institutional channels, and through these exhibitions as well as others the Hoosier painters gained regional renown.[25] In Saint Louis, Adams and Steele had a two-artist exhibition in 1896; in 1904 their work was included in the Louisiana Purchase Exposition, where Steele's 1903 *The Old Mills* (plate 154) was shown, a work in which his "conservative impressionism" had developed into full-scale adherence.[26] In 1907, in one of the most attractive, unspoiled parts of Indiana, Steele fathered the Brown County School, a later extension of modified Impressionism. It attracted not only Indiana- but particularly Chicago-based painters, who came to summer or even to stay, products of the summer classes of Chicago artist John Vanderpoel in Delavan, Wisconsin. Brown County became one of the most notable regional art centers in America in the early twentieth century.[27] Meanwhile, the older members of the Hoosier School—Steele, Stark, Adams, and Forsyth—continued to garner praise and awards not only in America but abroad. Steele's *Bloom of the Grape* won honorable mention in the Paris Exposition Universelle of 1900, and all four artists were seen in the Exposición Internacional in Buenos Aires in 1910. Steele particularly was fêted with a number of one-man shows; during one held in 1910 by the Art Association of Indianapolis, a critic wrote, "Mr. Steele learned in Europe only a better way of expressing Indiana."[28]

155. JOHN OTTIS ADAMS (1851–1927). *Blue and Gold*, 1904. Oil on canvas, 18 x 28 in. Private collection.

156. OTTO STARK (1859–1926). *The Seiner*, 1900. Oil on canvas, 27 x 22 in. Mr. and Mrs. Clarence W. Long.

157. OTTO STARK. *Suzanne in the Garden*, 1904. Oil on canvas, 36 x 16 in. Eckert Gallery, Westfield, Indiana.

158. JOHN OTTIS ADAMS. *The Ebbing of Day (The Bank)*, 1902. Oil on canvas, 34 1/16 x 47 15/16 in. Ball State University Art Gallery, Muncie, Indiana; Permanent loan from the Frank C. Ball Collection, Ball Brothers Foundation.

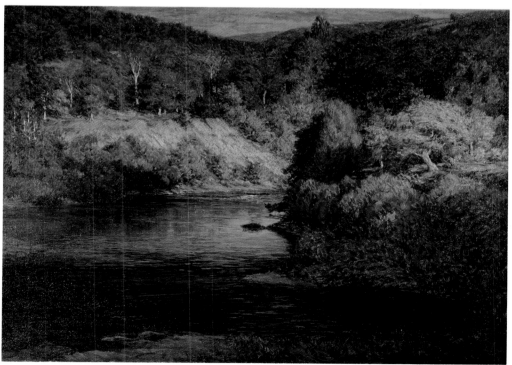

158

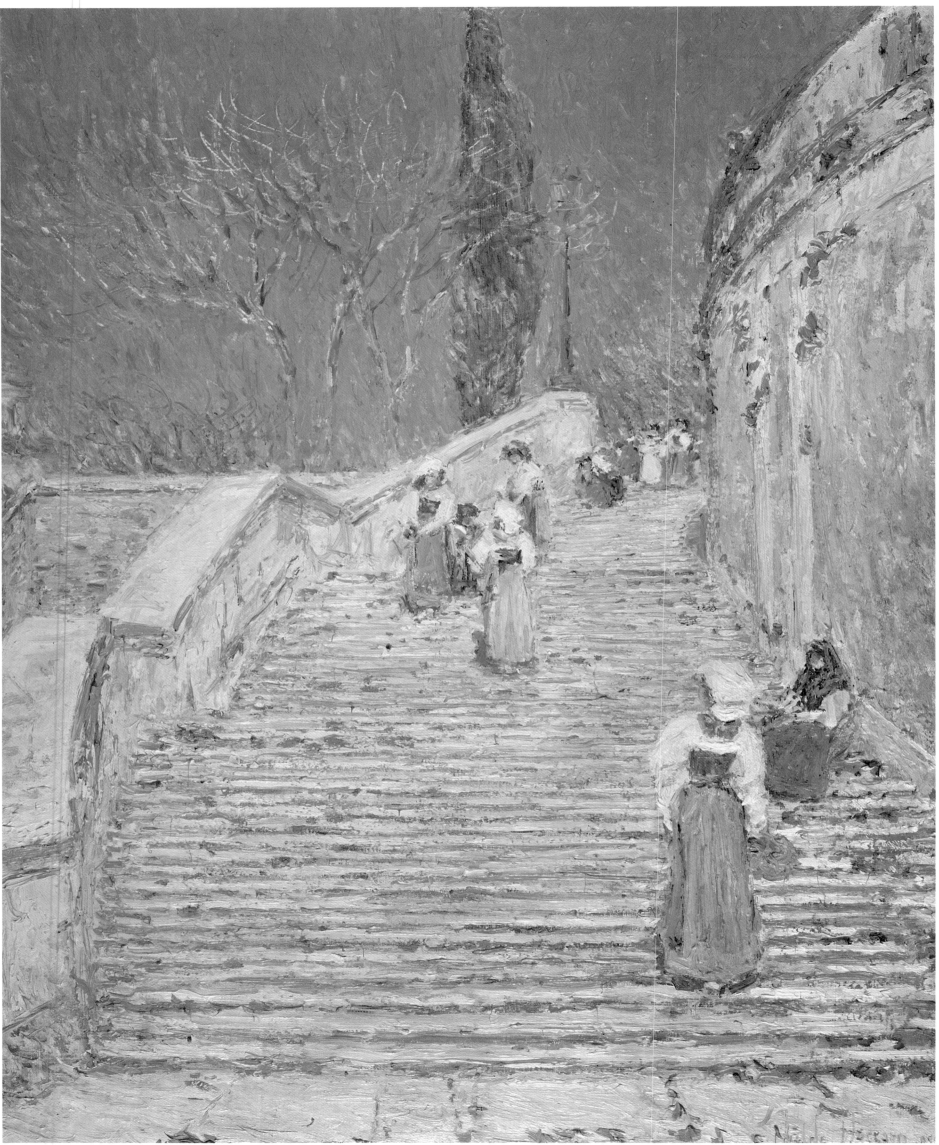

9 The Master Impressionists

THE MID-1890S WAS A TIME OF CONSOLIDATION for American Impressionism. Impressionist and Impressionist-related works appeared more and more often in museums and commercial galleries, and the movement strongly affected the teaching of art; it also began to attract new adherents. Collectors were increasingly favorable to Impressionism and negative criticism was becoming muted except for a few diehards like Alfred Trumble. It was also a time when each major American Impressionist established an individual rapport with the style.

Theodore Robinson

These were Theodore Robinson's last years. He returned to this country in late 1892, then spent the next summer and early autumn at Napanoch, New York, creating some of his most beautiful American paintings. Perhaps the best known is *Port Ben, Delaware and Hudson Canal* (plate 162), one of several canal scenes painted that summer. In it Robinson achieved a clarity of atmosphere and a freshness of color that transcend much of his art. It typifies rural New York and also transmits the French peasant tradition that had earlier occupied his attention. While "work" and "workers" are not his theme, these *are* farm buildings and the canal a working waterway. Indeed, reports on Robinson's summer classes told of the towpath bristling with white umbrellas, teacher and students boarding the boats to be towed from one lock to another, and canalmen even pointing out the "tender purples" and "fresh greens" of the landscape.[1]

Robinson's canvas is carefully structured in a casual symmetry that utilizes a strong geometric underpinning. W. Lewis Fraser, writing about the picture in 1899, questioned whether it should be considered Impressionist, with its sober, dispassionate color scheme and its well-studied composition, which he analyzed skillfully: "With what nice judgment the lines of the canal reach the margin of the foreground just a little to the left of the centre; how admirably, when the eye would naturally tire following up the rigid lines of the artificial waterway, the barn is accented on its left bank, and how admirably the bridge forms the contradicting line just at the right place."[2] When Fraser wrote this the picture was on view at the American Art Galleries, having been rejected by the Metropolitan Museum of Art. After a storm of controversy, Robinson's supporters were somewhat vindicated when the work was acquired in 1900 by the Pennsylvania Academy of the Fine Arts, where he had taught briefly in 1895.

159. CHILDE HASSAM (1859–1935). *Piazza di Spagna, Rome,* 1897. Oil on canvas, 29¼ x 23 in. The Newark Museum; Gift of the Misses Lindsley.

151

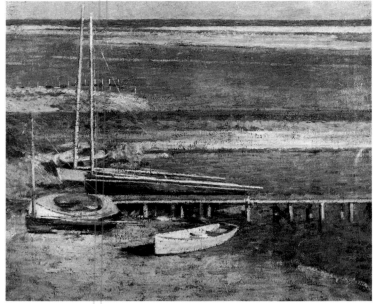

160

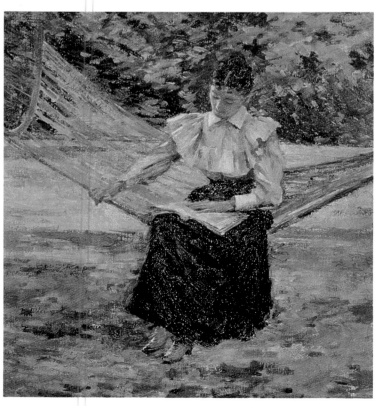

161

Another of Robinson's finest American works is *The White Bridge* (plate 163), painted in October 1893; it is a stronger, more geometric, abstracted composition in which the artist combined the freedom of Impressionism with the broader light-reflecting planes of the glare aesthetic.[3] Robinson had begun to express increasing doubts about his work, but recent critical conclusions that he was renouncing the Impressionist innovations of his French style are not true.[4] Rather, he was unsure that he could reconcile the colorism and painterliness of Impressionism with the traditional aspects of design that he had mastered in Paris. On April 14, 1894, he noted in his diary, "My painting stops too soon and I am too satisfied with the appearance (surface) without going on and giving that special effort of attention." Renewed inspiration came from an interest in Japanese prints, an enthusiasm he shared with Twachtman, Weir, and Taylor.

Although New York remained Robinson's winter base, he was spending much of his time with his fellow Impressionists, in and out of the city. In late February 1894 he visited the Weirs as his old friend was beginning to respond strongly to Impressionism in his own work. In June, Robinson began to go up to Cos Cob, where Twachtman taught and painted, and in July saw some of Twachtman's recent Niagara canvases. Robinson painted a series of marvelous coastal pictures at Cos Cob, including *Low Tide, Riverside Yacht Club* (plate 164) and *Boats at a Landing* (plate 160), which are brilliant in tonality but extremely abstract in design. In these works he demonstrated the combination of vibrant light, good drawing, and austere sobriety that he would prescribe for "the moderns" in his diary entry of November 21.

In July, Robinson went to Princeton to teach his summer class, but he found his canal pictures less interesting than those of the previous summer; even the *Girl in a Hammock* (plate 161), begun that month, he judged banal, except for its pose and color. The painting is the finest of several he did of this subject in his last years. A visit to the Jersey coast at Manasquam left him disappointed: "Perhaps I should live inland—need the inspiration of mountains or at least hill forms." Doubts about his art continued to form in his mind and on New Year's Day, 1895, he resolved to strive "for a little more completeness," castigating himself for relying too much on photographs and for having begun too many things without giving them sufficient time; his work wanted more severe design rather than color, and he reiterated his wish to pattern it after Holbein and the Japanese. Later that month Robinson hung his pictures in a one-man show at the Macbeth Gallery; despite good critical reaction it drew few sales. Shortly afterward, Halsey Ives of the Saint Louis Museum requested from Macbeth a traveling show of Robinson's work, which circulated in the South and Midwest, and was featured in the Cotton States and International Exposition in Atlanta in the fall of 1895. (Ironically, it reached Saint Louis after the artist's death.)

Robinson had continued the "serial" method in his landscapes after his return to America, and even his *Port Ben* exists in three versions, one large and one smaller sunlit one and a smaller, grayer variant. In March and April 1895 he painted three Hudson River canvases in Haverstraw, New York: one in bright sunlight, one in fog, and one with sunlight breaking through the fog. Later that spring Robinson pursued his decision to seek the mountains and returned to his native Vermont. In May he brought a class to Townshend for the summer; the teaching went well, but his panoramic canvases of the West River Valley were less successful. He was irresolute in his search to fuse color and design, painterliness and structure, and this uncertainty became more apparent in these scenes, which were painted at different times of day and may have been motivated by the serial concept. Robinson was more successful on an intimate scale but often considered the smaller works banal. Hamlin Garland confirmed this in conversation with the artist: "I told him candidly that I thought his themes unworthy of the skill and study he had given them."[5]

If Robinson was hard on himself, he was an equally severe judge of his fellow

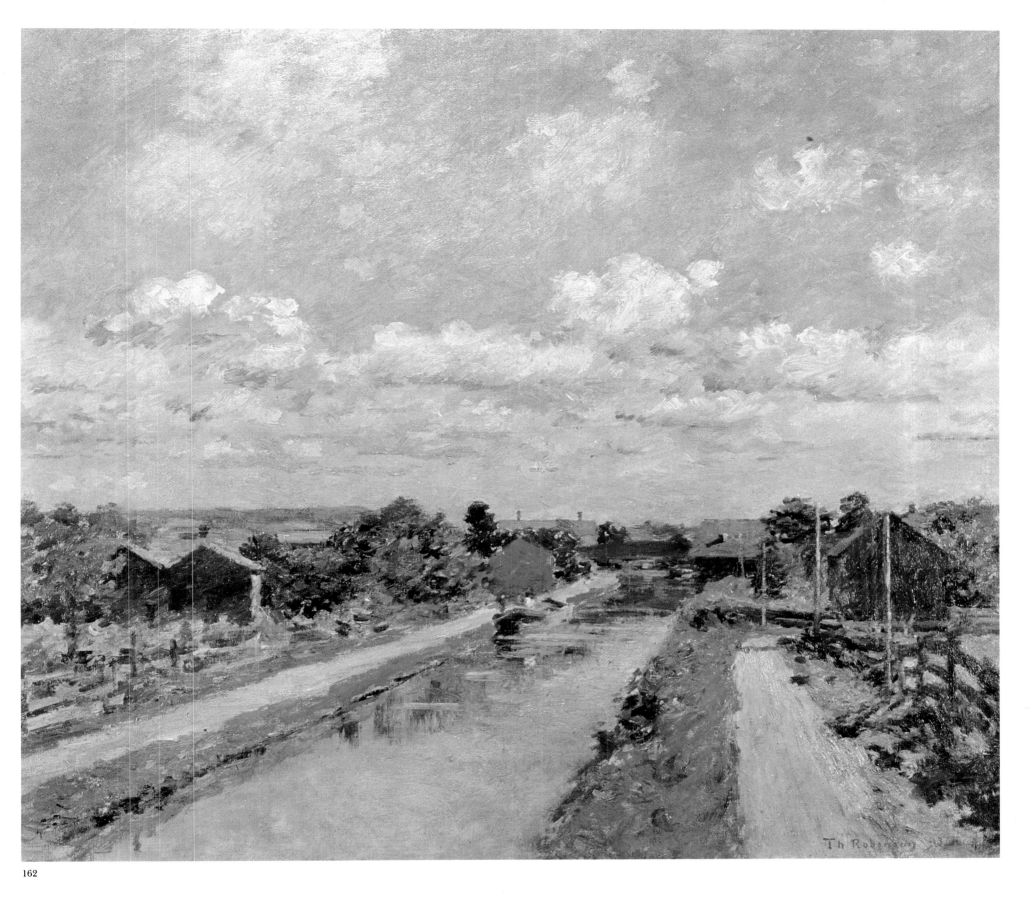

162

Impressionists. He deplored Weir's poor drawing and judged Twachtman's Niagaras too imitative of Monet. Ernest Lawson's French paintings he found wanting in delicacy of vision, and shortly before Robinson died he called Hassam's paintings at the American Art Association "a tinsel sort of art," or, as he wrote Philip Hale, "a skin-deep art."[6] Robinson may have been a better judge of his colleagues' paintings than his own. Though indecision occasionally undermined his work, he created many sensitive paintings and contributed significantly to the development of Impressionism in America.

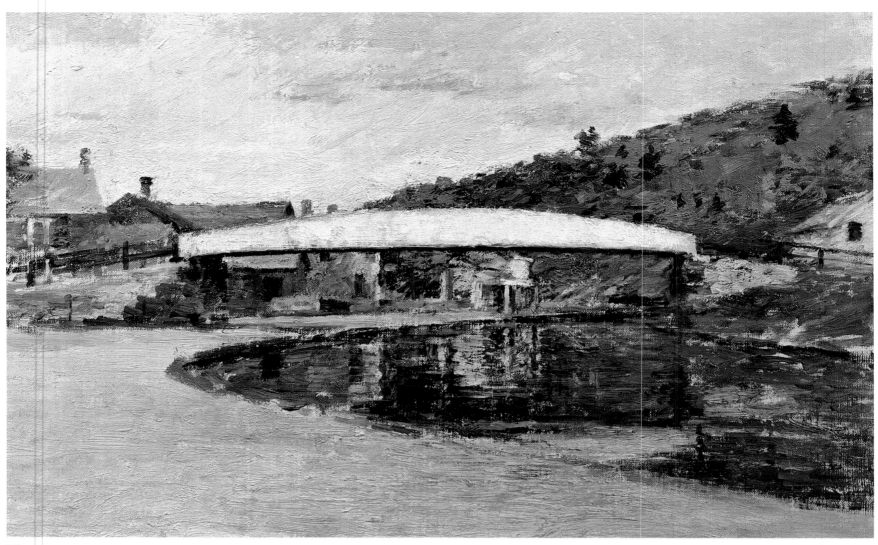

163

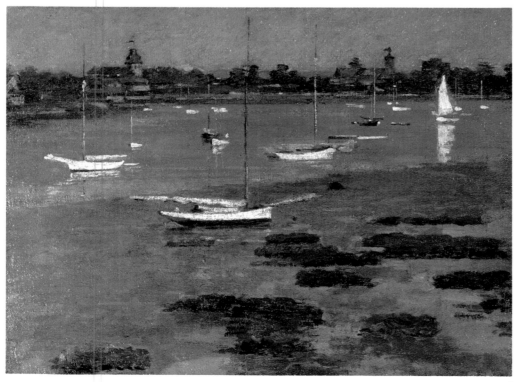

164

163. THEODORE ROBINSON. *The White Bridge*, 1893. Oil on canvas, 15 x 22 in. Mr. and Mrs. Ralph Spencer.

164. THEODORE ROBINSON. *Low Tide, Riverside Yacht Club*, c. 1894. Oil on canvas, 18 x 24 in. Mr. and Mrs. Raymond J. Horowitz.

165. THEODORE ROBINSON. *Union Square in Winter*, 1895. Oil on canvas, 20 x 17 in. New Britain Museum of American Art; Gift of A. W. Stanley Estate.

166. CHILDE HASSAM. *Union Square in Spring*, 1896. Oil on canvas, 21½ x 21 in. Smith College Museum of Art, Northampton, Massachusetts; Purchased 1905.

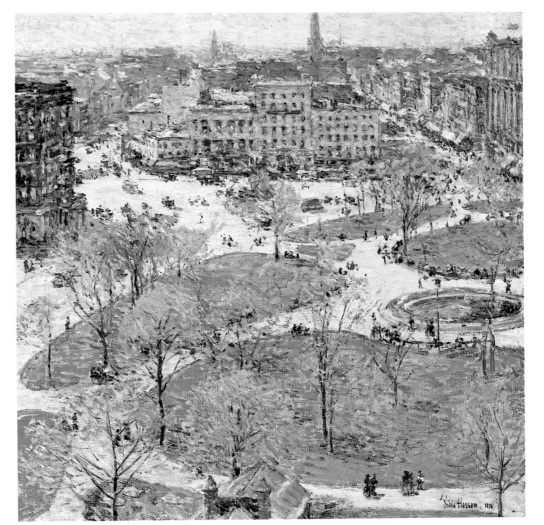

166

Childe Hassam

Childe Hassam continued to consolidate his position during the mid-1890s as one of the foremost and most committed American Impressionists. Despite the variety of subjects he undertook throughout his career and the especially great beauty of his Appledore paintings of the early '90s, his reputation was established primarily as a painter of the city—the city in all seasons and moods. One of the most beautiful of these is *Union Square in Spring* of 1896 (plate 166); the high, panoramic view of this favorite urban scene derived ultimately from the French Impressionists. Hassam responded brilliantly to the contrast between the oasis of soft, curvilinear greenery and the colorful but darker piles of masonry surrounding the square; paths and streets act as flat, sun-reflecting surfaces.

Hassam conveyed the vitality of the great cities he painted with all the colorful beauty of Impressionist art. Yet the exotic was not for him; he painted in Havana for a month in early 1895, and his city views are sun-drenched and color-filled but lacking in poetry. In the Cuban views there is an increased emphasis on the geometry of buildings—walls, rooftops, doors, and windows are conceived in slightly cubic terms, a bit like some of Robinson's earlier views of Giverny, and historical hindsight relates them to Post-Impressionism. While Hassam never renounced the chromaticism or vibrant brushwork of Impressionism, he seemed at times to need structural reinforcement. His 1897 scenes of the Piazza di Spagna in Rome (see plate 159) are richly colorful and the paint is laid on more vividly than ever in thick impastoes, but his formal concerns are abetted by the repeated striations of the steps themselves. In Pont-Aven, Brittany, Hassam continued to explore this structural emphasis in a manner at times even pointillist.[7] His scenes of Paris are among his most exuberant of these European works, less structured and at times almost playful. There Hassam again painted the brightly colored formal

165

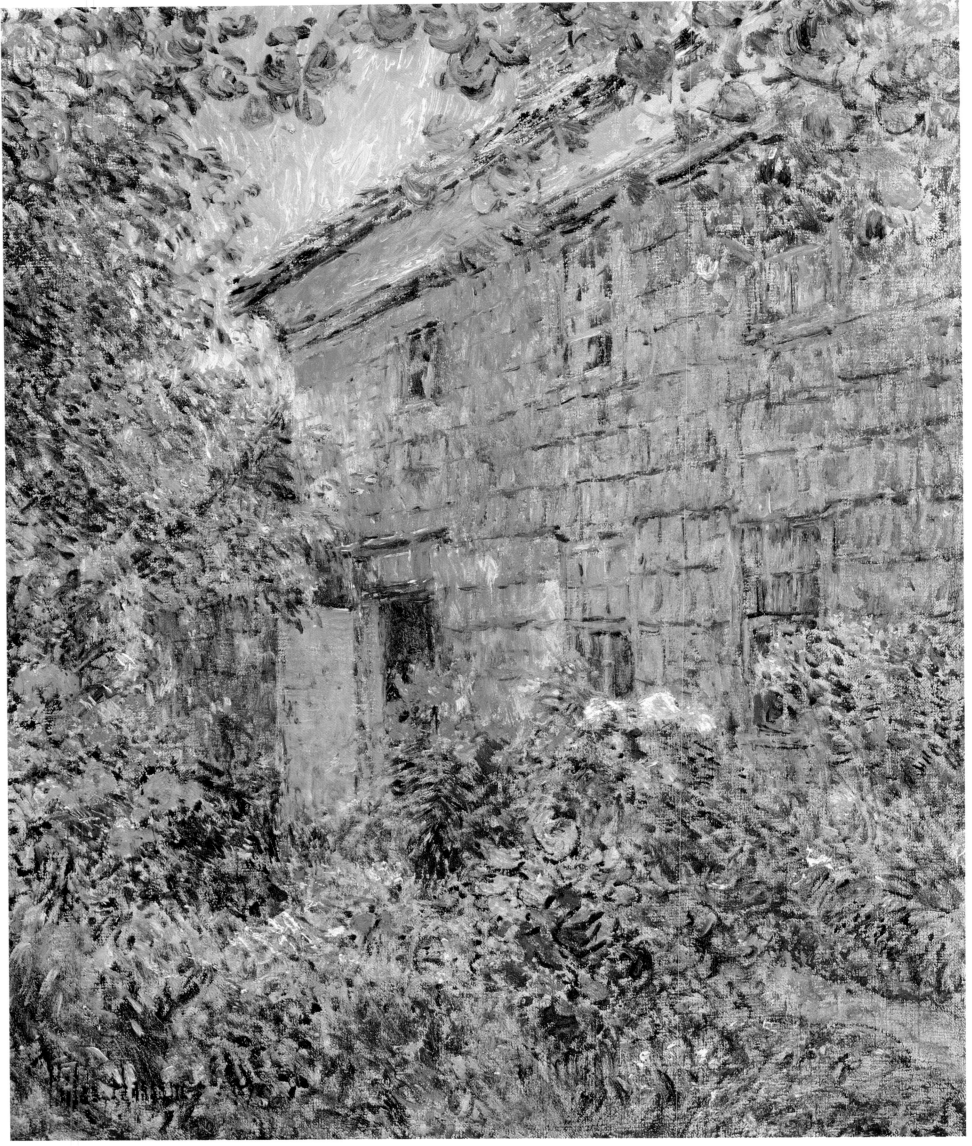

168

gardens of his earlier visit, which had preceded the freer, natural garden pictures on Appledore.

By the time he returned to New York in late 1897, Hassam had won a leading position in the American art world. One of his Cuban pictures received the Webb Prize at the National Academy of Design, and one of his new Paris scenes was to win the Temple Gold Medal at the Pennsylvania Academy in 1899. He had been given a major exhibition and sale at the American Art Association in February 1896, which comprised over two hundred pictures—a scale unprecedented at the time for a living artist. One critic felt that Hassam had forced his color beyond reason but also admitted that the show was the most brilliant and attractive of the season; he was most impressed by the variety of Hassam's art.[8] This diversity persisted throughout the artist's development and remains an underestimated component of his artistic legacy.

John Twachtman

Twachtman was not only happiest on his Greenwich property or in nearby Cos Cob, but there he painted the great majority of his finest works. His overall development is fairly easy to trace, from his powerfully brushed Munich-influenced pictures of the late 1870s and early '80s, through the more subtly tonal French works of the mid '80s, and finally his personal Impressionist development from about 1889 to the end of his life, with a new vigor appearing in his last few years. But a specific chronology within these periods is difficult to detect: his subjects are similar, and he almost never dated his paintings. Thus a documented exhibition of a painting entitled *Waterfall*, for example, offers little help in identifying which of his dozens of waterfall pictures that might be. For the remainder of the '90s, after participating in the 1893 show with Weir, Monet, and Besnard,

167. CHILDE HASSAM. *Old House and Garden, East Hampton, Long Island*, 1898. Oil on canvas, 24¹⁄₁₆ x 20 in. Henry Art Gallery, University of Washington, Seattle; Horace C. Henry Collection.

168. JOHN TWACHTMAN (1853–1902). *My House*, 1890s. Oil on canvas, 30⅛ x 25 in. Yale University Art Gallery, New Haven, Connecticut; Gift of John Twachtman.

169

170

*"Tonight is full moon, a cloudy sky to make it mysterious
and a fog to increase mystery. Just imagine how suggestive
things are. I feel more and more contented with the iso-
lation of country life. To be isolated is a fine thing and we
are then nearer to nature. I can see how necessary it is
to live always in the country—at all seasons of the year.*

*We must have snow and lots of it. Never is nature
more lovely than when it is snowing. Everything is so
quiet and the whole earth seems wrapped in a mantle. . . .
All nature is hushed to silence. . . ."*

John Twachtman to J. Alden Weir, December 16, 1891.
Quoted in Dorothy Weir Young, *The Life and Letters of J. Alden
Weir*, pp. 189–90.

169. JOHN TWACHTMAN. *White Bridge*, c. 1900. Oil on can-
vas, 30 x 25 in. Memorial Gallery of the University of
Rochester; Gift of Mrs. James Sibley Watson.

170. JOHN TWACHTMAN. *Old Holley House*, 1890s. Oil on
canvas, 25¹⁄₁₆ x 25⅛ in. Cincinnati Art Museum; John J.
Emery Fund.

Twachtman exhibited much less actively—another aspect of consolidation. The
style and subject matter of his art, as well as his personal and professional life, were
finally established.

Twachtman's favorite subjects were views of the Holley House, views of his
own house in different seasons, scenes on his property, including Horseneck
Brook, the Blue Brook waterfall, and his garden, which he gradually elaborated
with structures such as the white bridge that he featured in several of his finest
works. Though Twachtman seems never to have met Monet, this devotion to
personal surroundings at different seasons suggests the French artist's concerns
and methodologies. But Twachtman's work was never as analytical as Monet's—
far more important was his emotional response to the familiar landscape—and
though he might repeat the same subject, Twachtman basically did not think in
series. It is increasingly apparent that Monet's work, too, projects his own psycho-
logical state much more than has been acknowledged. Twachtman's, however, is
far more subjective, expressing his intimate search for the poetry inherent in his
own private landscape—for the sentiment and soul that some critics, such as
Trumble, found so sadly lacking in most Impressionist art.

Twachtman's methodology was less orthodox than that of any major Ameri-
can Impressionist in the 1890s. His approach to landscape was nonanalytical and
nonnaturalistic, and he usually avoided the systematic division of color into sepa-
rate components, though his is still a coloristic art. Among Twachtman's winter
subjects, the great *Old Holley House* (plate 170) interprets the snowy blanket on
buildings, trees, and foreground in bright blues and violets, while his spring scenes
are vivid with greenery. His paint became thick, even gritty, unlike the thin washes
of his French period, an effect heightened by his procedure of drying canvases out
in the sun.

Twachtman increasingly simplified his compositions and preferred a narrow
landscape range—close-ups rather than panoramic views. His designs are often
pushed close to the surface of the canvas, an effect reinforced by his extremely
high horizons—some compositions are horizonless—and his preference for a
square canvas, which tends to negate illusionistic depth. His paintings are quiet,
and winter was his favorite season: "All nature is hushed to silence," he wrote
Weir.[9] His gently flowing brooks are far more successful than his occasional
roaring torrents. This evocation and understatement have been recognized by
many critics who saw in Twachtman's art a strong relationship to the Oriental,
and, indeed, by the early 1890s, he was an enthusiast of Japanese art, as were
Robinson and Weir.[10] Twachtman's sense of abstract design also has an affinity
with the Orient. This is especially true of the evocative *Sailing in the Mist* (plate
172): a single figure in a small boat, its dark hull balanced by the flamelike white
sail, is set in a gentle blue-lavender sea with no land, no horizon, no point of
reference. It is, typically, undated, and one craves to know both where and when
he painted it.[11]

Invited by Charles Carey of Buffalo to do a series on Niagara Falls in 1894,
Twachtman undertook a very different subject. Waterfalls are common enough in
his art, but they are usually private and secluded, even poetic, with titles such as
The Rainbow's Source (plate 174). Niagara had been painted by almost every
American landscapist. Some sought the picturesque, more sought grandeur, al-
most all attempted to feature the falls' panoramic breadth; Twachtman opted for
views from below the falls, bringing the viewer straight into the spot where the
water hits the rocks with great force, a force interpreted in rainbow colors and
streaking brushstrokes. Twachtman's Niagaras were admired by many writers on
his work, and Charles De Kay applauded his avoidance of the panoramic: "All is
fluid, all motion, all color."[12]

Eliot Clark recognized that Twachtman's forte was the intimate not the grand,
and commended him for overlaying the elemental power of nature with veils of
mist and evanescent hues of color. For Clark, a former pupil of Twachtman, "the

172

171

173

174

171. JOHN TWACHTMAN. *Emerald Pool*, c. 1895. Oil on canvas, 25¼ x 30¼ in. Wadsworth Atheneum, Hartford, Connecticut; Bequest of George A. Gay by exchange and the Ella Gallup Sumner and Mary Catlin Sumner Collection.

172. JOHN TWACHTMAN. *Sailing in the Mist*, c. 1895. Oil on canvas, 30½ x 30½ in. Pennsylvania Academy of the Fine Arts, Philadelphia; Temple Fund Purchase.

173. JOHN TWACHTMAN. *Niagara Falls*, c. 1894. Oil on canvas, 30 x 30 in. Mr. and Mrs. Raymond J. Horowitz.

174. JOHN TWACHTMAN. *The Rainbow's Source*, 1890s. Oil on canvas, 34⅛ x 24½ in. The St. Louis Art Museum.

pictures of Niagara are happier'' than those he painted the next year at Yellowstone on commission from Major W. A. Wadsworth of Buffalo.[13] And, in fact, the more panoramic Yellowstone scenes are among Twachtman's least successful. To quote Clark: "He failed to humanize the Yellowstone, or to bring to it that human emotion which might do so, but he brought back some splendid bits of color from its opalescent pools and radiant waterfalls."[14] And indeed, his several views painted there of the Emerald Pool are marvelous jewels of color set into sinuous arabesques of outline that suggest the contemporary Art Nouveau aesthetic (see plate 171).

J. Alden Weir

For Twachtman's close friend J. Alden Weir, 1893 through 1897 was also a period of reassessment. Weir embraced Impressionism later than many colleagues, but in

175

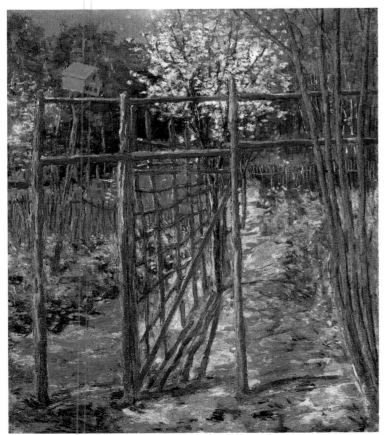

176

an equally personal way. There had been earlier signs of this direction in his works shown at the Society of American Artists in 1892, greeted in the press as "New-Impressionist handiwork" with "spinach-like texture" and a "mist of green that suggests miasma." These qualities found in his figure painting aroused more ire than did his landscapes,[15] and Weir turned more to landscape painting and figures in landscapes in the early '90s. *The Gray Trellis* of 1891 (plate 176) begins to assume a rough, broken Impressionist brushwork, though the color is extremely subdued and a sense of structure predominates. Although a garden picture, it presents none of the profusion of flowers or immersion in light and bright color associated with such Impressionist subjects.

Even more than Twachtman, Weir found his subject matter at his door: almost all of his figures and landscapes of the '90s were painted near his Branchville or Wyndham home or in the surrounding Connecticut hills. The death of his wife, Anna, early in 1892, was a tremendous blow to him, only somewhat alleviated by his teaching. That summer he painted his mural for the Manufacturers and Liberal Arts Building at the Columbian Exposition in Chicago. Late in 1893 new happiness came to him when he married Anna's sister, Ella Baker, and that year he turned much more fully to Impressionism.

177

One factor in this change was Weir's series of about six paintings of the thread factories in Willimantic, Connecticut. The series, however, and its evolving commitment to Impressionism, developed very gradually. The first of these canvases, shown at the Society of American Artists in 1894, was seen by the critics as a rejection of Weir's previous experimental manner. The *Art Amateur* critic commended him for having "conveyed a sense of space in the broken and undulating foreground that he could hardly have attained in the spotty manner of certain of his recent paintings"; the writer in the *Critic* praised his work, too, stating that Weir "apparently satisfied himself that he can work to better purpose in his old manner than in the luminarist way."[16]

Weir's new interest in light, in freer brushwork, and broader color range suggests the influence of his good friend Robinson, who admired one of the factory pictures in 1894 for being "modern, yet curiously medieval."[17] Weir's interest in the industrial landscape is noteworthy, reminiscent of two paintings that his brother, John Ferguson Weir, had made of the foundry in Cold Spring, New York, in the 1860s; they remain not only his most famous works but milestones in the American depiction of industry. But unlike the almost demonic sublimity of his

175. J. ALDEN WEIR, *Lengthening Shadows*, 1887. Oil on canvas, 21 x 25 in. (approx.). Private collection.

176. J. ALDEN WEIR. *The Gray Trellis*, 1891. Oil on canvas, 26 x 21½ in. George D. J. Griffin.

177. J. ALDEN WEIR.

178. J. ALDEN WEIR. *The Laundry, Branchville*, c. 1894. Oil on canvas, 30⅛ x 25¼ in. Private collection.

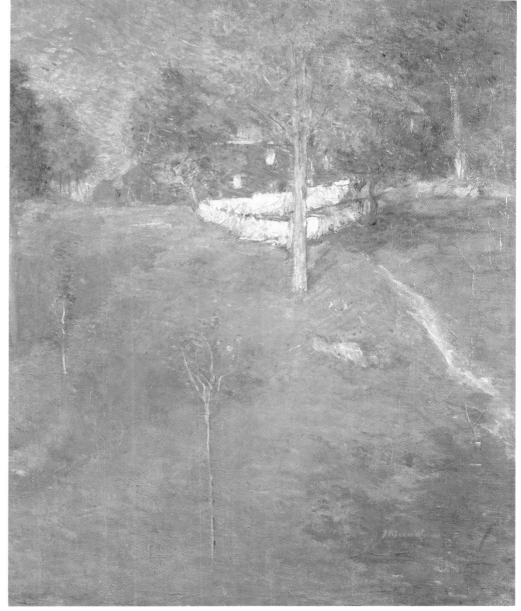

178

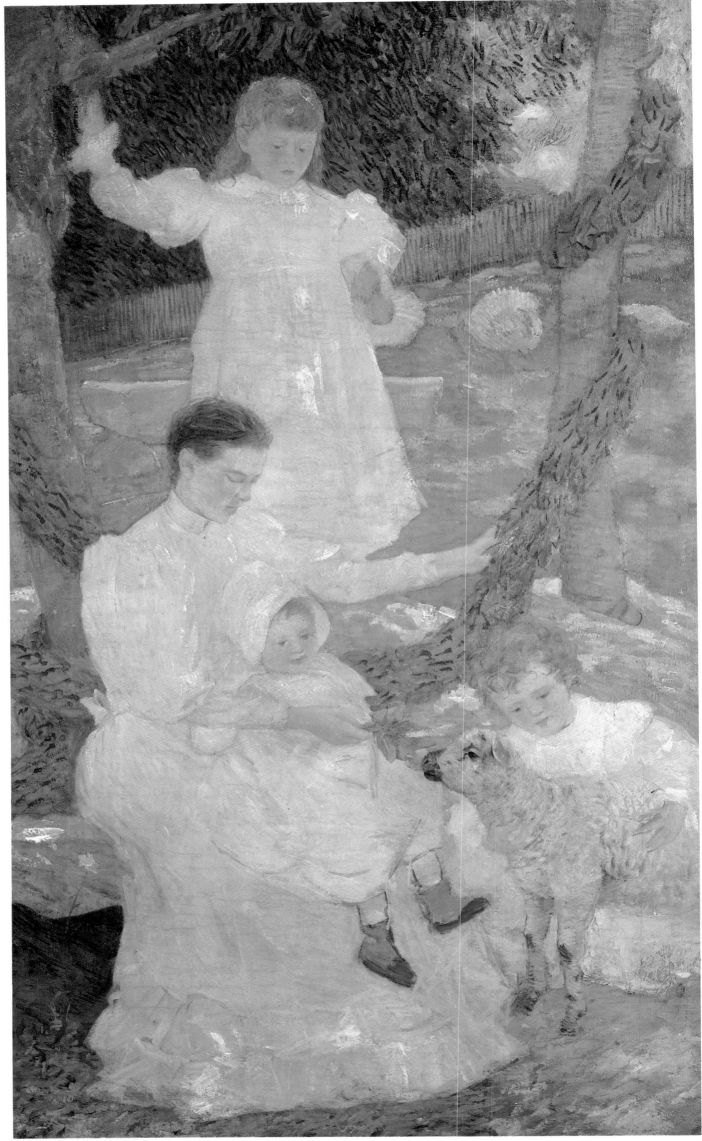

179

179. J. ALDEN WEIR. *In the Dooryard*, probably 1894. Oil on canvas, 80⅛ x 47⅛ in. © Copyright 1983, Charles Burlingham, Jr.

180. J. ALDEN WEIR. *Midday Rest in New England*, 1897. Oil on canvas, 40 x 50½ in. Pennsylvania Academy of the Fine Arts, Philadelphia; Gift of J. G. Rosengarten, Isaac Clothier, Robert Ogden, Dr. Francis Lewis, Edward B. Coates.

181. J. ALDEN WEIR. *Factory Village*, 1897. Oil on canvas, 29 x 38 in. © Copyright 1983, Cora Weir Burlingham.

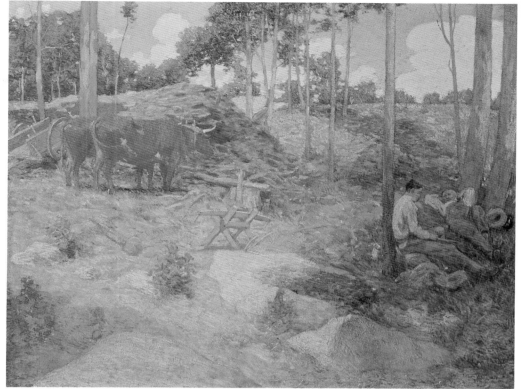

180

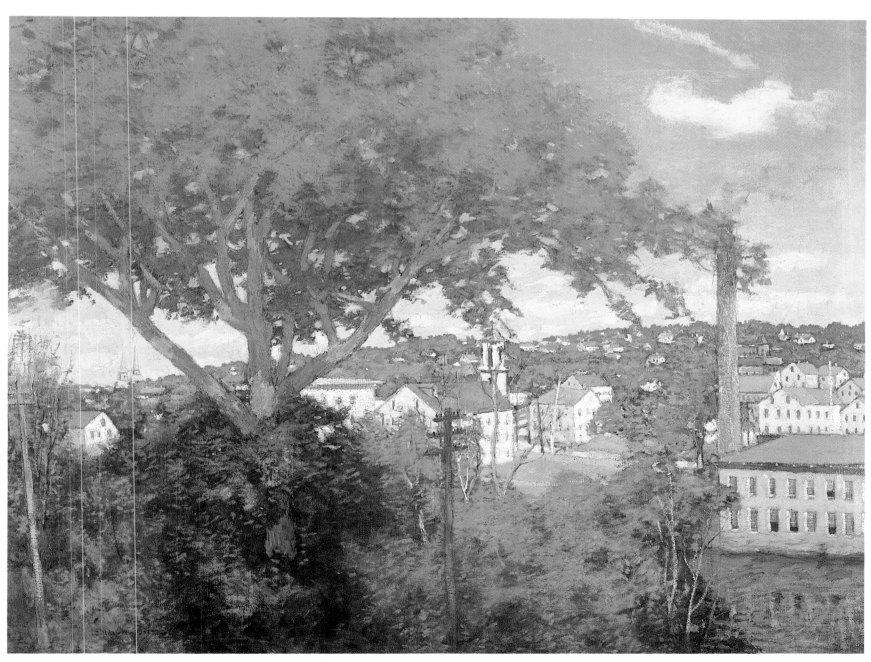

181

182

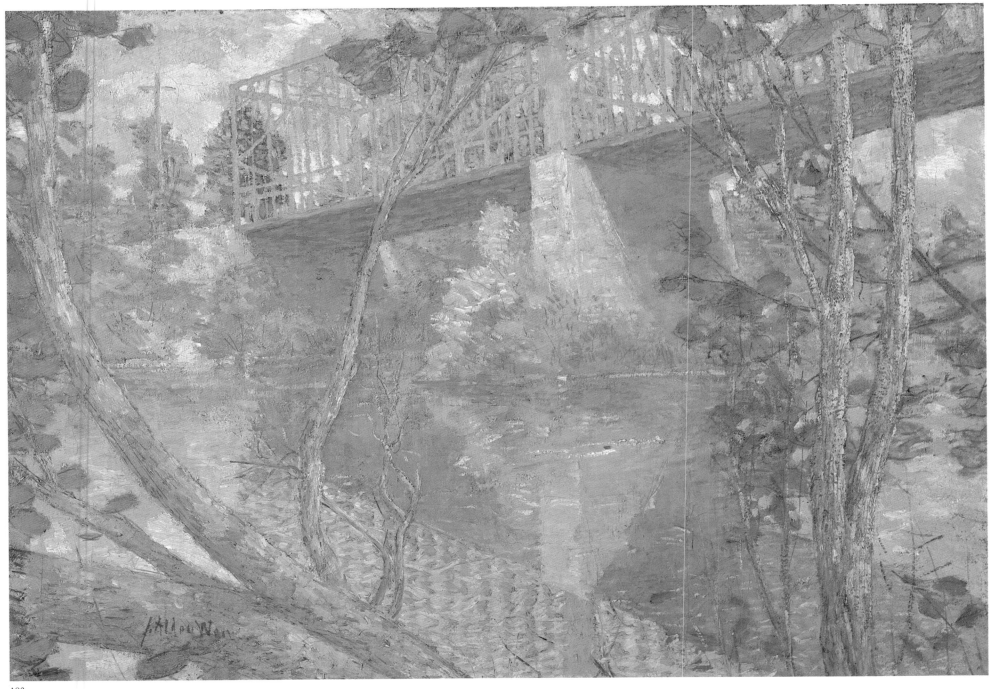

183

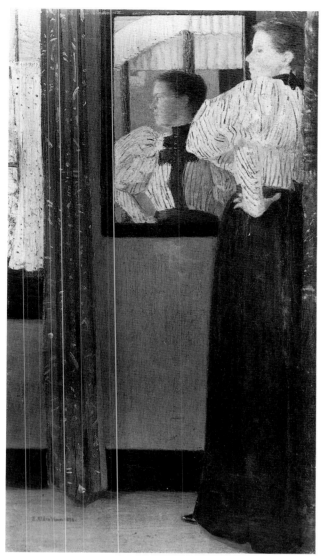

184

brother's canvases, Julian rendered his scenes with tranquil harmony: factories nestle in the bed of nature and the machine is at ease in the garden. The last of the series, *Factory Village* of 1897 (plate 181), uses Impressionist brushwork sparingly, and the color range is still "tonal": while oranges and greens are juxtaposed, the predominant variations are *within* a single hue—green.

For all the gentleness of Weir's painting, there are often covert allusions to a work ethic. This asserts itself, in part, through the modernity of his subjects: factories or even home scenes, such as *The Laundry, Branchville* of 1894 (plate 178), or a garden picture in which a bare trellis suggests farm work more than the leisure of flowers. In farming pictures such as *Lengthening Shadows* of 1887 (plate 175), Weir frequently emphasized the rockiness of the Connecticut countryside, along with undulating contours and rich sunlight, to convey the difficulties of agriculture there. *In Midday Rest in New England* of 1897 (plate 180), one of the best known, both workers and animals are at ease, in a quiet scene set within a typical, irregular "hard" landscape. But the heavy shapes of the animals and the sharp, upright tree trunks leave no doubt that these figures toil; for all the broken brushwork and the soft, pastellike colors, the tight contours reinforce the heaviness of the forms and recall Weir's closeness to Bastien-Lepage.

Obweebetuck (plate 182), of the mid-'90s, is one of Weir's finest Wyndham landscapes; the mountain of the title rises in the distance, behind a scene of leisure painted in Weir's pastel tones. Stronger is the most famous of his landscapes—*The Red Bridge* of 1895 (plate 183). Saddened by the loss of an earlier bridge, Weir was inspired to paint the unadorned, functional span that replaced it. The strong pattern of the bridge and its reflection in the water contrast with the curvilinear, foliate greens that are both pastel and tonal variations of a single hue. The striking forcefulness of Weir's design in this painting pays homage to Japanese aesthetics.[18] About 1893 Weir, Twachtman, and Robinson had begun an enthusiastic study of Japanese aesthetics and techniques, producing a series of works in the Japanese manner. Weir also began to collect Japanese prints and visit exhibitions of Japanese art, probably including the one at the Columbian Exposition and another at the Boston Museum in autumn 1893. By 1894 paintings such as *The Laundry, Branchville* showed the impact of this study in the high horizon and two-dimensional decorative effect. But *The Red Bridge* of a year later demonstrates a much more complete absorption of the manner: the high horizon, the assertive geometry of the composition, and especially the dominant diagonals suggest its derivation from Japanese art. Weir cuts off forms that are on unrelated planes—the high bridge in the middle distance and the looping tree branch at lower left— a device found in many Japanese prints. Despite the vibrancy of Weir's Impressionist brushwork, the forms are strong and simplified, and space is flattened into a decorative scheme.

Weir's increased interest in landscape meant fewer figure pieces; Impressionism is much more evident in those set outdoors. One of the most fascinating of his indoor paintings is *Reflections in a Mirror* of 1896 (plate 184). At first the clear forms and precise outlines suggest a renewed academic emphasis, and when the picture was shown at the National Academy in 1898 a critic wrote: "that the rough texture which some of these painters affect...is not necessary, is shown in Mr. Weir's very interesting 'Figure with Head reflected in Mirror,' which is smoothly painted and quite refined in line, yet equal to the pictures mentioned above in atmospheric quality."[19] This painting is, in fact, very modern. The cropping, the asymmetrical design, the emphatic geometry, and the flat color areas are still part of the Japanese heritage. The sharply profiled figure and the shimmering dark curtain are obvious references to Whistler. The vivid textile patterns and the utilization of the mirror suggest a conscious emulation of Degas, of Cassatt, or both. By the late 1890s Weir had assimilated the many modern strands of Impressionism.

182. J. ALDEN WEIR. *Obweebetuck*, mid-1890s. Oil on canvas, 19½ x 23¼ in. © Copyright 1983, Cora Weir Burlingham.

183. J. ALDEN WEIR. *The Red Bridge*, 1895. Oil on canvas, 24¼ x 33¾ in. The Metropolitan Museum of Art, New York; Gift of Mrs. John A. Rutherford, 1914.

184. J. ALDEN WEIR. *Reflections in a Mirror*, 1896. Oil on canvas, 24¼ x 13⅝ in. Museum of Art, Rhode Island School of Design, Providence, Rhode Island.

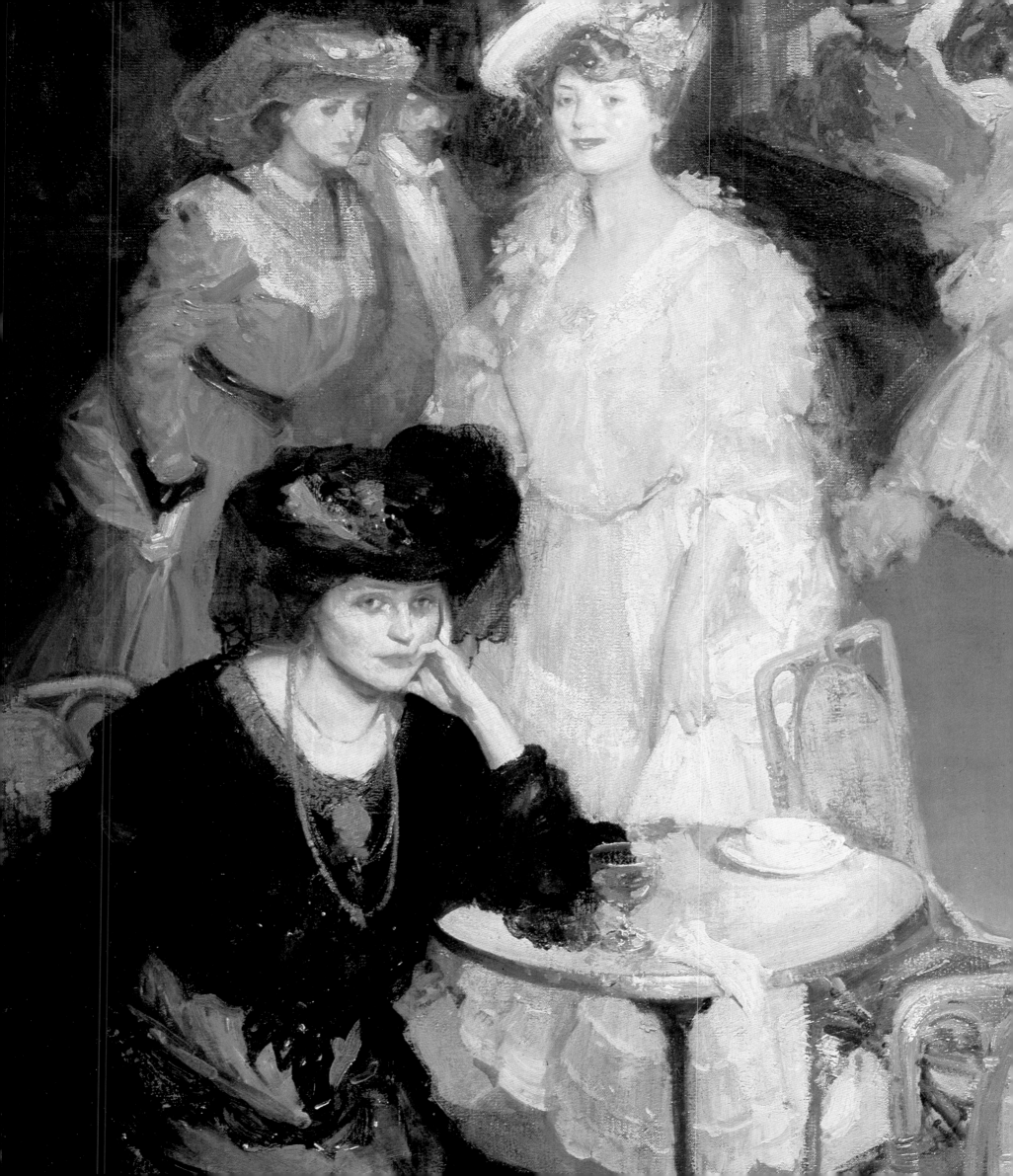

IV

THE IMPRESSIONIST
ESTABLISHMENT

1898–1915

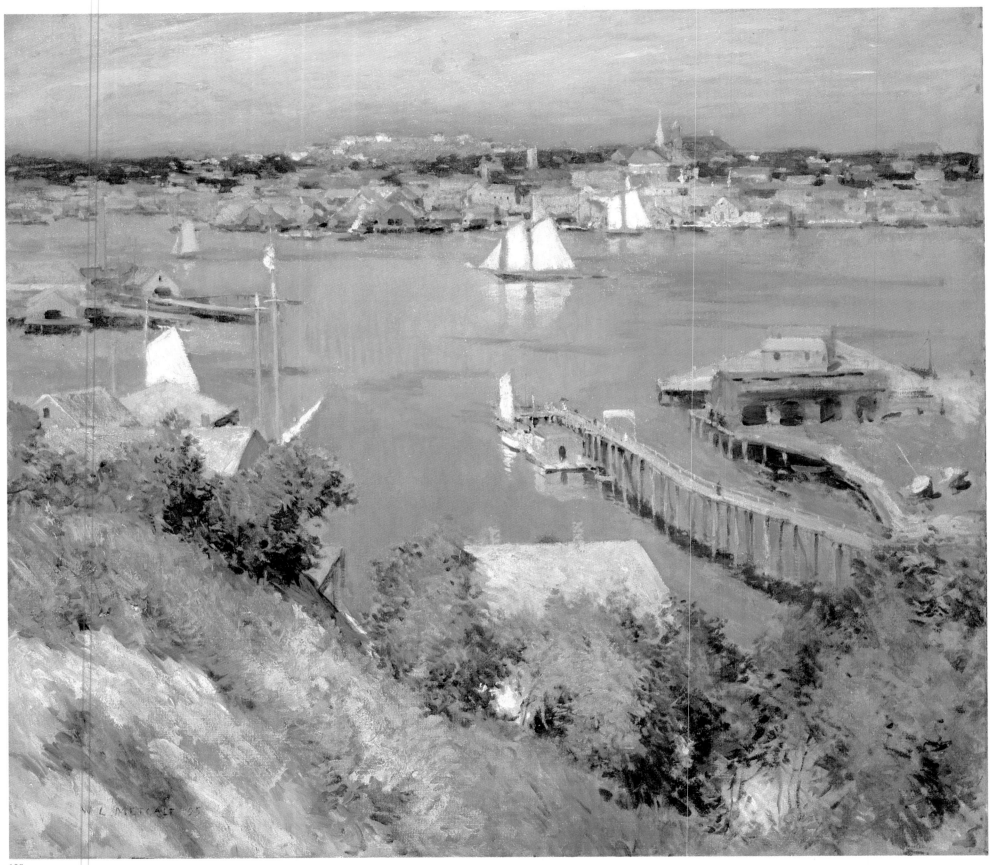

10 The Ten American Painters

ON MARCH 31, 1898, the first exhibition of the "Ten" was held at Durand-Ruel in New York. The Ten American Painters was a very loosely knit organization that came to be regarded in its own time as well as in art historical perspective as a kind of academy of American Impressionism.[1] This is not incorrect, for most of its members were committed to an Impressionist aesthetic, a commitment that remained generally stable, though some of the group's members later became seriously involved with formal portraiture.

The Ten was so called because of its ten artist members who exhibited together in 1898, and there were ten members throughout the organization's twenty-year lifetime: Childe Hassam, J. Alden Weir, John Twachtman, Willard Metcalf, Edmund Tarbell, Frank Benson, Joseph De Camp, Thomas Dewing, Edward Simmons, and Robert Reid. When Twachtman died in 1902 his place was taken by William Merritt Chase. The group exhibited annually in New York, usually at the Durand-Ruel or Montross gallery, and often the shows traveled to the St. Botolph Club in Boston. When the Ten was first constituted on December 17, 1897, each member signed an agreement to exhibit at every annual show and to add new members only by unanimous consent.[2] The first condition was not met—the Ten held quite a few exhibitions in which one or another member did not participate, but the shows were exclusively of the group. They were not invitational, nor did they ever include outside artists, even though many American painters were far more "Impressionist" than Dewing or Simmons, for instance. The group held emphatically to the second part of its agreement; there were never fewer than ten members, except between Twachtman's death and Chase's election, and there were never more.

There was nothing magic in the number ten, however. Had Theodore Robinson still been alive when the group was formed, he almost certainly would have been included. Two other artists had, in fact, been invited to join: Winslow Homer and Abbott Thayer. Homer was sympathetic but refused, and Thayer at first was tempted but finally withdrew his candidacy. It is interesting to speculate on the nature of the Ten—or the "Twelve"—had these two men been included, since its Impressionist inclinations would have been significantly muted. This is important because it underscores the primary motivation for the Ten. It was *not* established to provide a safe harbor for Impressionism but because of growing dissatisfaction

185. WILLARD METCALF (1858–1925). *Gloucester Harbor*, 1895. Oil on canvas, 26 x 28¾ in. Mead Art Museum, Amherst College, Amherst, Massachusetts; Gift of George D. Pratt.

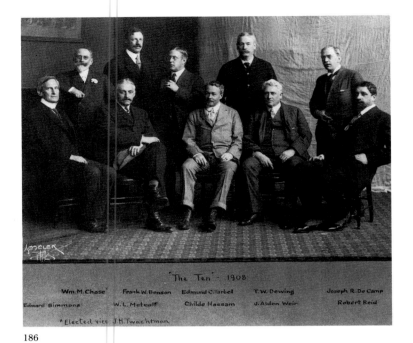

The Ten - 1908

Wm. M. Chase Frank W. Benson Edmund C.Tarbell T. W. Dewing Joseph R. De Camp
Edward Simmons W. L. Metcalf Childe Hassam J. Alden Weir Robert Reid
*Elected vice J.H.Twachtman

1889

Wm. Allen Sullivant Robt Reid Robt Van Bastwick Willard Metcalf Hubari Da
Sam Isham Harry W. Watrous Carlton Chapman

with dominant art organizations, especially the Society of American Artists. The Society had been formed in 1877 by younger painters opposed to the conservative policies of the National Academy of Design; the Ten was formed twenty years later because a similar fate seemed to have befallen the Society. Indeed, every member of the Ten was also a member of the Society. The day they signed a membership agreement with the one, they also signed a withdrawal notice from the other.[3]

Yet there were crucial differences between the two "secessions." The Ten had no officers and minimum concern for administration. More important, all of its members were established artists: some had won significant prizes, all were well known among critics and art lovers, and some, though not all, were quite successful. They did not bring youthful zeal to the Ten as the young moderns had to the Society; they were not artists with a cause, beyond their own satisfaction. Some critics of their first exhibitions expected greater militancy; but historical perspective in general has been correctly moderate in assessing the Ten in terms either of "modernity" or of "Impressionism." They were far more concerned with showing their paintings under optimum conditions and with public reaction than with pioneering.[4] The Ten had only one purpose: to provide an exhibition base so that their works might be seen comfortably, harmoniously, and selectively. Simmons summed this up in his charming autobiography: "We left the society as a protest, not believing that an art show should be like a child's bouquet—all higgledy-piggledy with all the flowers that can be picked."[5] Among the Ten, there was dissatisfaction about the Society's exhibitions on three counts: the great disparity in quality, the vast number of works, and the tremendous variety of styles.

It was probably inevitable that the Society, even with the continued existence of the older National Academy, would become increasingly conservative and not surprising that it finally merged with the Academy in 1906. The Society was originally constituted when the younger artists had just come back (or were not yet back) from sophisticated European training and were imbued with cosmopolitan precepts of subject and style, while the Academy espoused nativist concepts and traditions. As time went on, the Academy inevitably began to absorb some of the European-trained artists; and after ten years or so, the Society was itself divided into those painters of a more classical bent, to whom academic training was uppermost or total, and those who, while not rejecting that training, were more concerned with nonacademic and thus nontraditional matters. Impressionist-related artists were naturally among the latter. The critics writing on the Society's exhibitions did note the changing predominance of the Tonalist and the Impressionist aesthetics. In 1886 the *Art Interchange* marked an "undue affection for greys," but in 1888 the attitude of the magazine changed to approval, in that "grey and melancholy days are preferred to garrish [sic] sunny ones, and twilight and moonlights are in high favor."[6] Impressionism reared its head boldly in 1889 and 1890, but in 1891 both the *Art Interchange* and the *Art Amateur* found more twilight and night scenes and *less* Impressionism. After that, Impressionism developed in earnest.[7]

A study of the exhibition records of the Ten's members in the years just prior to their first showing in March 1898 confirms their growing alienation from the Society. In 1894 the ten painters showed a total of twenty-three pictures and, in 1895, twenty-nine. But the following year, 1896, this was down to twenty, and in 1897, only seven—that year most of the ten painters, in fact, did not exhibit at all. They were plainly dissatisfied, and the conservative National Academy offered them no alternative; during those years one or another of the Ten showed a picture or two at the Academy, totaling no more than six or seven each year. Beyond these dry statistics is the recognition that these painters seemed increasingly to rate the Society and the Academy as fairly equal. Tarbell tended to show his more spectacular pictures at the Academy rather than at the Society, beginning with his *Three Sisters* in 1891 and *In the Orchard* the following year; Twachtman exhibited some of his most radically modern works at the Academy, including one

188

186. The Ten.

187. Sherwood Studio Party.

188. FRANK BENSON (1862–1951). *Lady Trying on a Hat*, 1904. Oil on canvas, 40¼ x 32 in. Museum of Art, Rhode Island School of Design, Providence, Rhode Island; Gift of Walter Callender, Henry D. Sharpe, Howard L. Chase, William Gammell, and Isaac C. Bates.

of the Niagaras in 1894 and *The White Bridge* in 1897; and Weir's masterpiece, *The Red Bridge*, was shown there in 1896. No doubt each artist had his reasons for choosing a certain outlet for each picture, considering questions of style, prospective patronage, opportunities for favorable critical reception, and even matters of timing, transportation, and the like, but it remains true that the differentiation between the two art organizations was shrinking. Art critics also acknowledged the heterogeneous nature of the Society's exhibitions in the mid-'90s, while singling out the growing presence of the Impressionist contingent. Among the movements represented in 1895 the writer in the *Art Amateur* cited "the noble phalanx of Impressionists, or Luminarists, whichever title suits them."[8] In 1896 the writer in that magazine was visibly annoyed: "Those of our younger painters who follow more or less closely Mr. Claude Monet and the French Luminarists have had things pretty much their own way." The writer in the *Critic* that year also noted that the works at the Society were "almost without exception in that very high key of color which until recently was seldom attempted except by Mr. Claude Monet and his fellow luminarists."[9] When the more committed Impressionists decided to exhibit little or nothing in 1897, many of the still conservative critics were clearly

189. JOSEPH DE CAMP (1858–1923). *Gloucester*, 1900. Oil on canvas, 20 x 24 1/16 in. Cincinnati Art Museum; Gift of Frank Duveneck.

190. JOSEPH DE CAMP. *Woman Drying Her Hair*, 1899. Oil on canvas, 36⅛ x 36⅛ in. Cincinnati Art Museum; Mary Dexter Fund.

191. THOMAS DEWING (1851–1938). *The Days*, 1887. Oil on canvas, 43³⁄₁₆ x 72 in. Wadsworth Atheneum, Hartford, Connecticut; Gift from the Estates of Louise Cheney and Anne Cheney.

192. THOMAS DEWING. *Morning Glories*, n.d. Oil on canvas on three wood panels, 64½ x 72 in. overall. Museum of Art, Carnegie Institute, Pittsburgh; Acquired through the generosity of the Sarah Mellon Scaife Family, 1973.

190

189

satisfied. The writer in Alfred Trumble's *Collector*—probably Trumble himself—noted that the show was "an improvement over that of last year in that not so much of the frantic puzzles of the ultra-impressionists is there to bewilder the unregenerate gallery trotter...." and the *Art Interchange* critic wrote, "As a whole the display is more rational, more serious than usual; rabid impressionism and clownish tricks of the palette are noticeably absent from the galleries...."[10]

With the defection of the Ten artists in 1898, the critics noted the change in the Society's show. The writer in the *Critic* observed, "The paucity of work of a decorative character, and the lowered tone of color...may both be due to the absence from the exhibition of the ten artists who withdrew a few weeks ago from the Society." The critic in the *Art Interchange* found the defection salubrious: "The withdrawal of the wing of extremists seems to have had the effect of rendering the ensemble more sane and inspiring, more restful and homogeneous."[11] He also cited the large percentage of portraits, and, indeed, portrait and figure painting, bastions of academic expression, were increasingly dominant at the Society. Nonfigurative alternatives were further reduced in 1899 when another schism developed with the formation of the Society of Landscape Painters. The critic in the *Art Amateur* noted, "The practical secession of a number of landscapists to form the new Society of Landscape Painters may account for the comparatively small display made in that department of art."[12] This new Society, far shorter-lived than the Ten, consisted of painters who were basically Barbizon- or Tonalist-oriented, but it was undoubtedly inspired by the secession of the Ten and by the goal of a harmonious exhibition. It contributed further to the dominance of the Society by

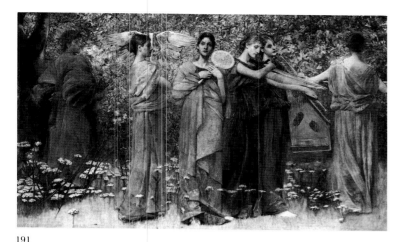

191

academic figure painters such as Will Low, George de Forest Brush, and, above all, Kenyon Cox.

According to Childe Hassam's reminiscences, written decades later, he conceived the Ten one winter evening on his way down Seventh Avenue, going from his studio on Fifty-seventh Street to Weir's house on Twelfth Street. Hassam acknowledged that Weir took to the idea immediately and that they in turn enlisted Twachtman. They invited Thayer and the Boston artists Tarbell, Benson, and De Camp; next were added Metcalf, Dewing, Simmons, and Reid. On January 8 a meeting was held, reported in the *New York Times* the next day (under the heading "Eleven Painters Secede," the eleventh being Thayer). Weir was quoted on their dissatisfaction with the huge Society exhibitions and the preference of the new group for small annual shows by artists of compatible tastes.[13] In the subsequent letter of withdrawal from the Society, written and received on January 12, the secessionists noted the inability of the Society to maintain a high level of art; this immediately impelled the Society to call a special meeting at which the seriousness of the defection was recognized.

For a while dissension in the art world bordered on acrimony. Kenyon Cox, vice-president of the Society, emphasized that "while most of the gentlemen belong to the impressionistic wing of the Society they cannot say that they have not been well treated. At least five of them have taken prizes," and he also noted that until recently they had controlled the juries, had their work favorably hung, and generally had run the affairs of the Society.[14] Tarbell countered with the charge that the membership of the Society had recently been augmented by men of mediocre ability who had voted themselves into positions of power on the Committee of Awards. Joseph De Camp echoed these sentiments, charging that such mediocre artists would never have been admitted in the early days of the Society and that their presence had negated the honor of membership in the Society and allowed commercialism to infiltrate it. He added that the secession had been planned for three years earlier—perhaps after the exhibition of 1896.[15] Even the name of the Ten caused discussion. Some critics saw an arrogance in any group that designated itself "*The* Ten American Painters." But that was neither its intention nor its name. The artists had never called themselves "The Ten," according to Simmons, because they had originally hoped to be twelve. The catalog cover for their first show was adorned with a simple Roman "X," and above it was the designation "The First Exhibition/Ten American Painters." Inevitably the press seized on the descriptive title as the organization's name.

From the first, exhibitions of the Ten were well received. The critic in the *Art Amateur* observed a pleasing harmony and the emergence of each man's individuality.[16] Hassam later believed that their smallness was part of their success.[17] Almost surely a chief reason for the positive reception, at least of the first two or three shows, was the installation itself. Each artist chose the works he would show and often eliminated those that seemed to clash with paintings by the other artists. The gallery space was divided into ten equal areas, and each artist hung his area to its best advantage. The first show included two to eight works by each of the painters; Weir showed the most, eight paintings, including his *Factory Village* (plate 181). Wall colors were changed if necessary to harmonize with the paintings, which were hung sparely in the Oriental manner pioneered by Whistler over a decade earlier, at the Fine Arts Society in London, but novel even now in New York.

The second exhibition at Durand-Ruel in 1899 was even more exotic: cocoa matting was placed on the floor and thin white cheesecloth stretched over the red walls, held in place by dull gilt moldings. Critics described the environment as a hazy dream that enhanced the effect of works painted as if with perfumes. But not all critics felt that secession should continue, and they objected to the imposition of a fifty-cent fee to see twenty-three pictures by nine painters (Metcalf was absent that year). The paucity of works engendered serious criticism and the conclusion

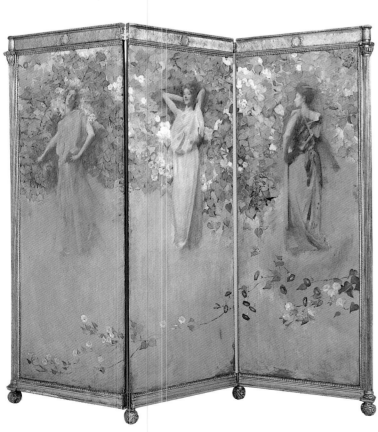

192

that the painters had made little special effort to select their displays. Joseph De Camp was excepted, particularly for his life-size study of a nude—*Woman Drying Her Hair* (plate 190)—which was admired as much for its abstract beauty of expression as for its rendering of lifelike form. Hassam, too, showed some studies of the nude, and critics contrasted this with the absence of nudes from the Society shows.[18]

Exhibitions of the Ten continued to be small and select, usually no more than thirty paintings, shown in New York and occasionally also in Boston at the St. Botolph Club. Some of the artists, especially Weir and Benson, seem to have supplied more significant and innovative paintings than others. Simmons was probably the least constant and least well represented, and in 1901 his work was absent altogether. In his autobiography he mentions that some friction developed within the group because his murals tended to be larger than the other works and that this restricted his showing; finally, he said, "To save controversy, we left the hanging to the dealer, and he placed those which sold the best in the choice parts of the room and the others elsewhere."[19]

In 1905 only eight of the Ten exhibited; though Chase had replaced the deceased Twachtman, neither he nor Simmons was represented. Ironically, the largest showing of the Ten was not in New York but at the Pennsylvania Academy of the Fine Arts in 1908; almost a hundred works were on view. An introduction by John Trask described the show as a tenth-anniversary celebration that offered the first opportunity for complete study of the group's accomplishment. By the next decade, however, time began to weaken the significance and impact of the group. A reviewer in *International Studio* in 1913 recognized the cause of the decline when, after applauding their yearly celebration of "the joy of vernal sunshine, the summering beauty of surfaces," he commented:

> A generation has however passed since these ideas were new to the world of artistic expression, yet still the members of The Ten are apparently content with their original programme. Scant change has marked their production from season to season. There has been a decided tendency toward the interchange of ideas among themselves, but during this entire interval little or nothing has come from without.... Quite frankly, these men move within too restricted a circle. They are not responsive enough to external influences. In certain instances they are positively unsympathetic, not to say hostile, to the more recent manifestations of contemporary endeavor, and this attitude has not been devoid of influence upon their development.[20]

In 1917 the Ten celebrated their twentieth anniversary with an exceptionally large show of about fifty works at the Montross Gallery. Chase had died in 1916 but his fish still life was deemed the finest painting in the exhibition; Benson and Tarbell, who seemed to resemble each other too much, were found to be caught up in mere technique.[21] The final exhibition of the Ten was not in the regular series but a special showing in winter 1917–18 at the Corcoran Gallery in Washington, D.C., where Tarbell was principal of the museum school. Indeed, the review in the *Washington Star* treated the show as a retrospective, acknowledging that the Ten had "exerted a strong and beneficent influence upon the development of American art."[22]

The painting of Benson and Tarbell had been likened almost from the start of their careers, and Weir and Twachtman often were considered together. Yet the surprising diversity among these artists, even in their first show of 1898, represented a modern, if not a radical, stance. These four, along with Hassam, were the best established Impressionists. Willard Metcalf, having returned from France via a brief but productive visit to Tunis, became reinvolved with illustration, and the art literature of the 1890s dealt primarily with this role. He also assumed Will Low's job as instructor of the women's classes in drawing after the antique at the Cooper Institute. As an easel painter he was active in the first half of the decade

193

193. THOMAS DEWING. *The White Birch*, c. 1896–99. Oil on canvas, 42 x 53⅞ in. Washington University Gallery of Art, St. Louis.

194. THOMAS DEWING. *Recitation*, 1891. Oil on canvas, 30 x 55 in. The Detroit Institute of Arts; Purchase, picture fund.

195. THOMAS DEWING. *The Hermit Thrush*, c. 1893. Oil on canvas, 34¾ x 46⅛ in. National Museum of American Art, Smithsonian Institution, Washington, D.C.; Gift of John Gellatly.

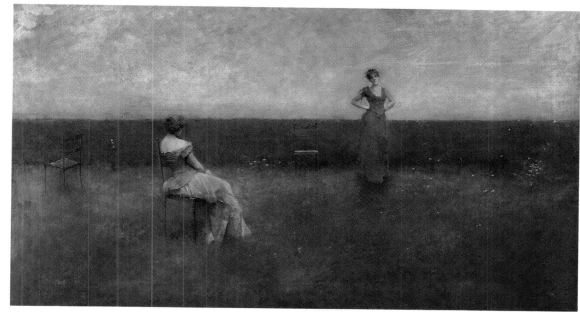

194

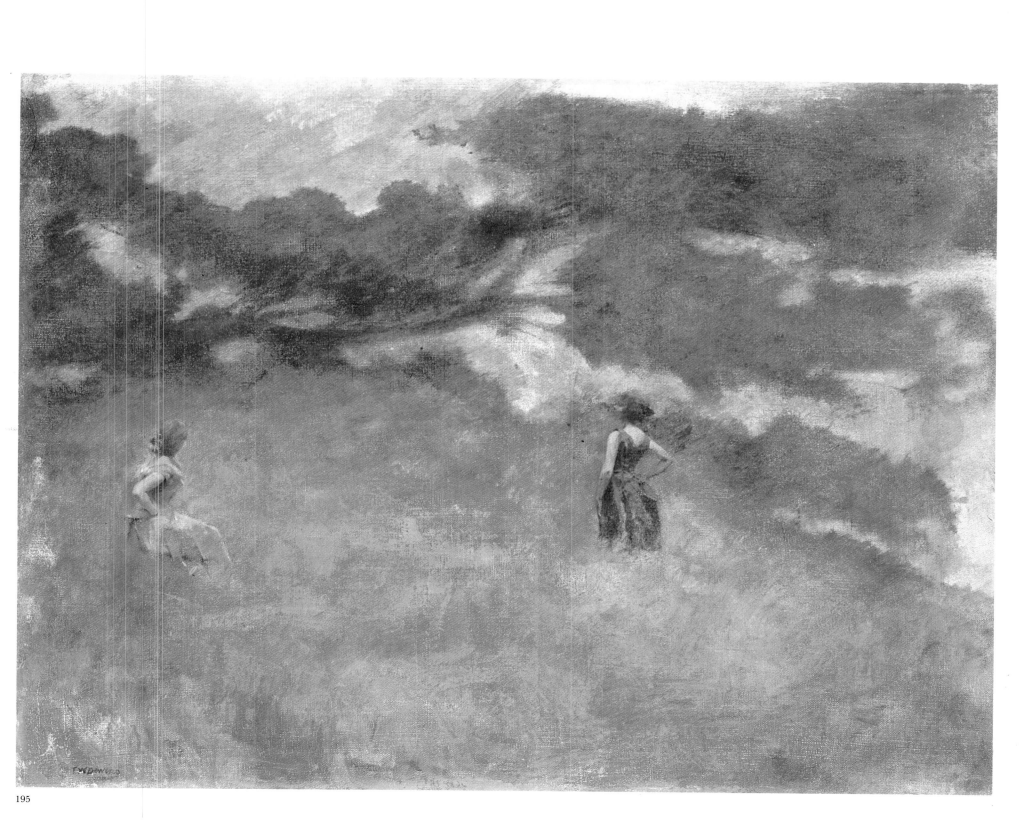

195

196. THOMAS DEWING. *Reclining Nude*, n.d. Pastel on brown paper, 6⅞ x 10 in. Private collection.

197. THOMAS DEWING. *The Necklace*, 1907. Oil on wood, 20 x 15¾ in. National Museum of American Art, Smithsonian Institution, Washington, D.C.; Gift of John Gellatly.

196

178

primarily as a portraitist. In 1896 Metcalf showed summer work at the Society of American Artists and won the Webb Prize with *Gloucester Harbour* (plate 185). Its panoramic sweep of New England coastline and its joyous sense of harbor life in Impressionist color and sunlight look forward not only to his own later work but even more to some of Hassam's turn-of-the-century harbor pictures and those of Harriet Lumis.

The art of Joseph De Camp, like that of Metcalf, is well known today only in terms of the work from about 1904 or '05.[23] In De Camp's case this is primarily a result of the tragic loss of his studio holdings in the Harcourt Building fire in Boston in late 1904. De Camp was a Munich- rather than Paris-trained artist from Cincinnati and one of the Duveneck Boys, before he returned to teach at the Boston Museum School in the mid-'80s. For many years he also taught at the Massachusetts Normal Art School; his teaching, his portraiture, and his rather slow, deliberate professional pace may account for a smaller oeuvre than that of many of his colleagues. His best-known paintings of the '90s are poetic renditions of the nude, *Magdalene* and *Woman Drying Her Hair*.[24] They were shown respectively at the first and second exhibitions of the Ten, and the latter seems to have been the success of the show. It had already won the Temple Gold Medal at the Pennsylvania Academy that year (1899) and immediately afterward was sold to the Cincinnati Art Museum. De Camp borrowed it back for the Paris Exposition Universelle of 1900, calling it "the most complete and most representative of my works." If so, it would confirm the fact that De Camp was not yet an Impressionist, even given his membership in the Ten. In its modest pose and poetic expression, De Camp's *Woman Drying Her Hair* is more academic and traditional than Tarbell's well-known *The Venetian Blind* of 1898 (plate 233), from which it seems to derive. Given the loss in his studio fire, it is hard to pinpoint the time and place of De Camp's turn to greater involvement with Impressionist-related aesthetics. It may have begun at least by the summer of 1900, when he seems to have joined Twachtman and Duveneck at Gloucester. There, even Duveneck's work took on a new, exciting colorism.[25]

De Camp and particularly Metcalf became far more integrated within the American Impressionist camp in the decades after the Ten was formed, undoubtedly stimulated by that association. Thomas Dewing and Edward Simmons, by contrast, always remained outside the movement. The oldest of the Ten, Dewing was a well-established painter by 1897 and probably the most securely patronized, by Charles Lang Freer of Detroit.[26] This patronage is an important clue to Dewing's style and appeal, for Freer was one of the nation's major collectors of Oriental art and of American art that seemed to harmonize with his Oriental predilections—the ideal figures of Abbott Thayer, the soft, tonal landscapes of Dwight Tryon, the paintings of Dewing, and above all the art of Whistler.[27]

Dewing was an artist of profound aesthetic sensibility, as well as one of the most exquisite technicians and pictorial poets of the late nineteenth century. Despite his inclusion in the Ten he is only peripheral to our discussion because he was very much *not* an Impressionist. He was, rather, an adherent to Tonalism—in fact, he was *the* Tonalist figure painter.[28] His early work particularly was close to late Pre-Raphaelitism and the art of Albert Moore and Lawrence Alma-Tadema in England. Dewing's masterwork of the late '80s is *The Days* of 1887 (plate 191), but by the early 1890s his figures are painted more softly, often clad in iridescent gowns and posed in mellow light-filled interiors. Dewing joined the Ten because of the spirit of tranquility and harmony that the group projected.[29] Although usually restrained, his color is sometimes enlivened and comes closer to Impressionism. This occurs in several of his multipaneled screens, an accessory extremely popular at the end of the century, reflecting the vogue for things Oriental; Dewing was probably the finest American painter of screens at the time. One of these is his *Morning Glories* (plate 192); although the figures are in a basically abstract, floral setting, the outdoor environment is more related to Impressionism. Dewing

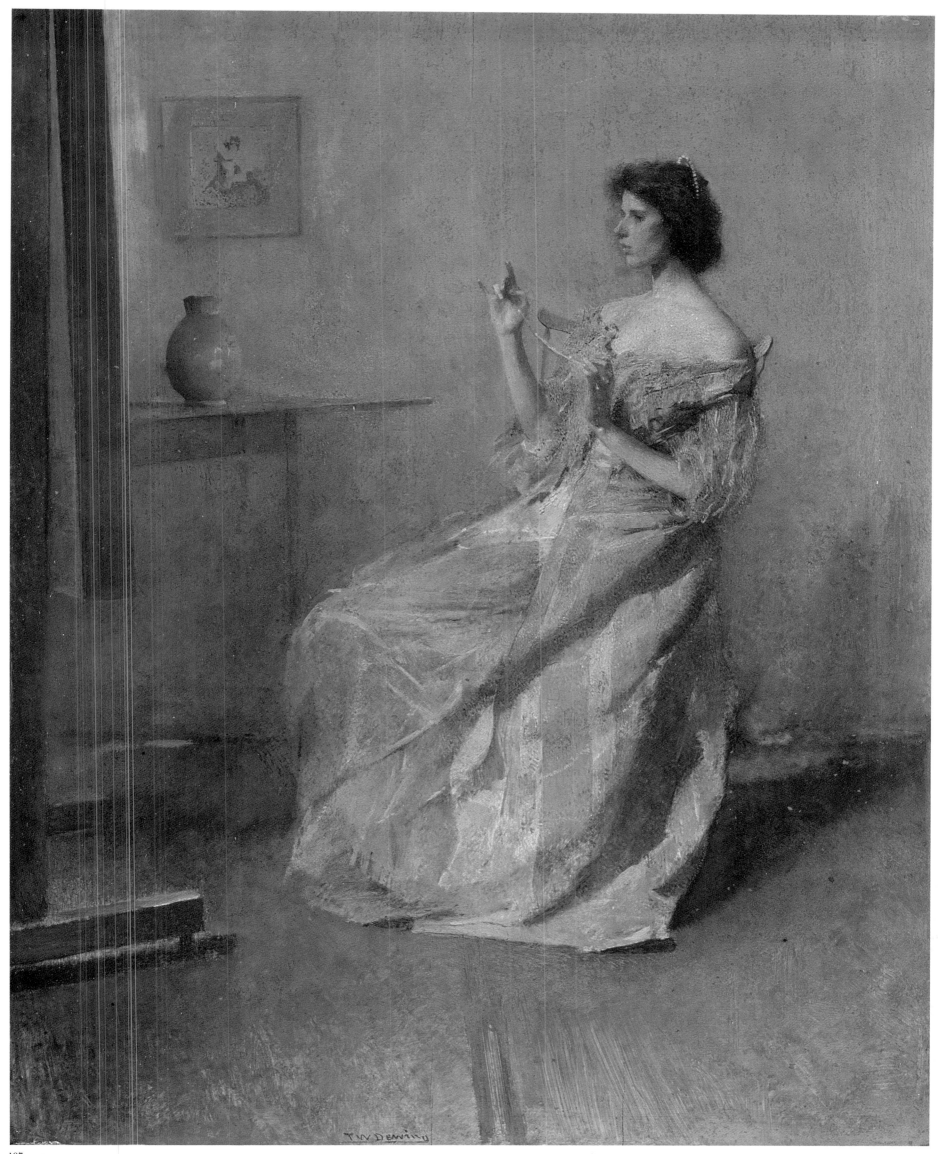

painted many depictions of women in lushly green landscapes, such as his *White Birch* (plate 193) and *The Hermit Thrush* (plate 195), but their settings are also generalized and ambiguous; they are decorative paintings with no interest in the definition of locale. Dewing himself referred to them as "Decorations."[30]

Critics of the time were aware not only of the rarefied beauty of Dewing's work but also of his distinction from his fellow members of the Ten. One of the most perceptive writers on Dewing at the turn of the century was Sadakichi Hartmann. Among the few Americans sensitive to European Symbolism in the 1890s, Hartmann wrote about it in the short-lived magazines that he edited (the *Art Critic*, 1893–94, and *Art News*, 1897); he discussed Dewing several times in periodicals that contained articles on the Rosicrucians, and he found the spirit of the poet Algernon Swinburne in Dewing's paintings.[31]

In his best work Edward Emerson Simmons was even less attuned than Dewing to the Impressionist predilections of the Ten. He had remained abroad for over twelve years before returning to America in 1891. In 1879 he went to Paris where he studied at the Académie Julian and then took up residence at Concarneau in 1881. There he painted successful figure subjects in the manner of Bastien-Lepage, and he was one of the mainstays of the artists' colony. Later that year he moved to the not-dissimilar colony at Saint Ives in Cornwall, where most of the artists were Americans and Simmons the most respected of them.[32] At Saint Ives he began a series of marine paintings that were his most important and best-known

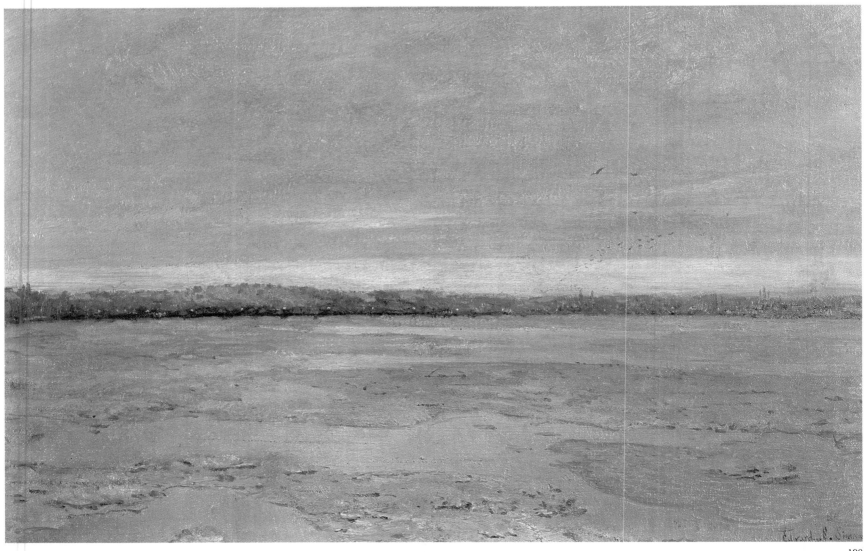

198

199

easel pictures. Simmons exhibited annually at the Society of American Artists from 1888 until he joined the Ten in 1898. The marine paintings elicited less notice than his more powerful peasant figures, but as perceptive a critic as Clarence Cook found *Calm at Evening*, shown in 1892, the best landscape in the exhibition.[33] His *Night, Saint Ives Bay* (plate 199) is probably the work described at length in the *Art Interchange* of 1894 as a "noble marine painting, with a suggestion of calm grandeur."[34] Simmons's pictures of the 1880s are not at all Impressionist; but a few known figure paintings of the '90s, such as *Dressing* of 1893, are painted in a very low-keyed, somewhat divisionist manner. By that time Simmons had embarked on his career as one of the nation's foremost muralists with his work at the Columbian Exposition.

Robert Reid was the member of the Ten who emerged most clearly as an Impressionist, although critics of their exhibitions always considered his work somewhat isolated and special.[35] Reid was a New Englander who studied at the Boston Museum School from 1880 to 1884. During that time he formed associations with Tarbell, Benson, and Metcalf. He was active at the school and edited the *Art Student*, perhaps the most significant of the spate of art school publications that emerged in the 1880s and '90s. In winter 1884 Reid moved to New York to study briefly at the Art Students League; by fall 1885 he was in Paris at the Académie Julian. In the summer he went to Etaples, a Normandy fishing village that became a major art colony for both Frenchmen and foreigners; the former included Albert Besnard, with whom Reid would later be compared. Etaples was bleak and harsh, but that seemed to suit the sad fisherfolk dramas that Reid painted at this time, such as his *Death of the First Born* of 1888 (plate 200) and his *Blessing the Boats*.[36]

Reid returned to New York in 1889, where he kept his studio for the rest of his career. He taught at the Art Students League from 1893 to 1896 and initially showed at both the National Academy and the Society of American Artists; but the Society was his preferred forum until he joined the Ten. He showed *Death of the*

198. EDWARD SIMMONS (1852–1931). *A River in Winter*, n.d. Oil on canvas, 14 x 22¼ in. Graham Williford.

199. EDWARD SIMMONS. *Night, Saint Ives Bay*, n.d. Oil on canvas, 50 x 60 in. Private collection.

200

First Born at the Society in 1889, and for four years he exhibited two pictures there annually; he doubled that number in 1894 and showed six works in 1895, with considerable variety in subject and approach; but, possibly discouraged with the presentation or with critical reaction, he showed only three works in 1896, two the following year, and, of course, none in 1898.

Even in Reid's early works, such as the large-figured, tragic *Death of the First Born*, his palette is soft and glowing. His *Reverie* of 1890 depicts a woman in pink in a tree-covered park setting; broadly and loosely painted, it shows a clear movement toward Impressionism. This has been interpreted as a temporary aberration, probably because Reid's direction was deflected in 1892 by his work on murals for the Columbian Exposition and on the many murals that followed, including those at the Library of Congress and the Appellate Courthouse in New York.[37] Aberration it probably was not, although it is extremely difficult to analyze Reid's development and to determine the date of his conversion to Impressionism, because of the few extant works from the early and mid-'90s. However, in the *Studio* of 1891 a writer who admired Reid's *Summer Sunshine* at the Union League Club lamented, "This is, by far, the best work of his that we have seen; but, nevertheless, we wish we need not count Mr. Reid among the young men who have been bitten by the Impressionist tarantula...." From the time of a notice in the *Critic* about *The Letter*, shown at the Society in 1892, Reid was regularly referred to as an Impressionist and grouped with similar artists.[38] In August 1894

his recently completed *Execution of St. Paul*, made for the Church of the Paulist Fathers in New York, was called "...the first example of its kind—that is, of what is termed for want of a better name impressionistic painting—to find its way into any of our churches or public buildings, while totally devoid of anything approaching religious feeling, shows much cleverness in rendering sunlight and open-air effects."[39] The titles alone of the easel paintings he exhibited at the Society in 1894 suggest his full immersion in Impressionism: *Dog-Day Sunlight*, *Reflections*, and *Crosslights*.[40] Reid's six works shown at the Society in 1895 seem to have completed his linkage with Impressionism. A writer in the *Art Interchange* in May stated, "If you must have prismatics, Mr. Robert Reid seems determined to supply them."[41]

At about this time Reid also began to define his principal theme—attractive young women with flowers—in the first version of his *Fleur-de-Lys* of about 1896 (now lost). *Opal*, a nude variant of this subject, was shown the following year at the Society, and his work again was likened to the painting of Besnard.[42] Thus by the time Reid showed four works with the Ten in 1898, his art had almost fully matured. His paintings tended to be very decorative—modishly gowned and coiffured figures, often with floral attributes, painted in broad, ribbonlike strokes of bright color and with a vivid sense of motion; this movement distinguished Reid's art from that of his colleagues in the eyes of the critics, some of whom were disconcerted by it.[43] *Gladiolas* was also shown with the Ten that first year. It, too, depicts a young woman holding a bunch of flowers; the title suggests a pure still life, and, indeed, the floral element was a very strong part of Reid's conception. Ensuing years saw literally dozens of these pictures: *Apple Blossoms*, *Daffodils*, *Fleur-de-Lys* (plate 201), *Peonies*, *White Lilacs*, *Yellow Flower*, *Azaleas*, *The Canna*, *Pink*

200. ROBERT REID (1862–1929). *Death of the First Born*, 1888. Oil on canvas, 37¼ x 33⅝ in. The Brooklyn Museum; Gift of Mr. and Mrs. Sidney W. Davidson.

201. ROBERT REID. *Fleur-de-Lys*, c. 1899. Oil on canvas, 44⅛ x 42¾ in. The Metropolitan Museum of Art, New York; George A. Hearn Fund, 1907.

201

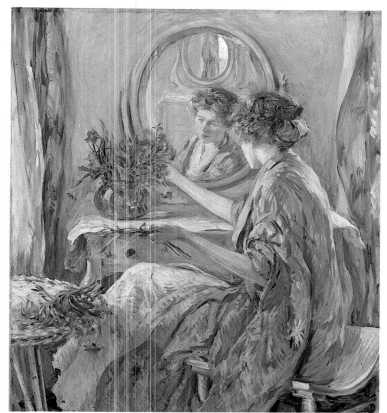

203

204

Carnation, and *Tiger Lilies*. Three of them—*The Canna*, *Azaleas*, and the second version of *Fleur-de-Lys*—represented Reid in the 1899 exhibition of the Ten; the last, referred to in the *Art Interchange* as "bewilderingly rich," is today the most famous of Reid's paintings. Writers emphasized his association of woman with flower and the long tradition of that association; one even commented that Reid "cannot see a girl without seeing flowers, and cannot see flowers without seeing a girl." Another attempted to distinguish variations in mood set by Reid's different flower girls: the gladsomeness of *The Canna*, the wistfulness of *Azaleas*, and the nostalgia in *Fleur-de-Lys*.[44]

Reid's work was considered somewhat out of tune with that of his colleagues in its high pitch of color, and critics welcomed his single exhibitions.[45] From 1901 through 1905 he became involved in mural painting, and he was virtually inactive as an easel painter.[46] Reid returned to his favorite subject matter of young women in outdoor floral settings and dappled sunlight in works such as *Daffodils* of 1906 and *The Brown Veil* of a few years later. These may be slightly more naturalistic than the pictures of the late 1890s; they are also at times more pastel in coloration. But naturalism is not at the heart of Reid's art, and their essential "decorativeness" was not only underscored in the articles written about him but also in his manipulation of forms, colors, and space.[47] Often one tone would dominate and unify a composition: in *The White Parasol* of about 1900 (plate 202) the figure is flattened against the impenetrable background of flowers that unite with the large bouquet she holds, so that the picture plane becomes essentially screenlike.[48]

About 1910 Oriental motifs began to appear in Reid's paintings of figures in kimonos posed against screens in more controlled indoor settings, although these did not wholly supersede his earlier preference for the outdoors. One of the most sensitive descriptions of his art at this time appeared in Sadakichi Hartmann's magazine, the *Stylus*:

> Reid is only an impressionist in his backgrounds and landscapes. In his figures he paints more smoothly, more solidly. This must have been with him an inevitable outcome of experiments, or rather of an intuitive feeling for the adequacy of things. A figure is never seen en pointillist. A figure even at a considerable distance in a twilight atmosphere is still seen in planes and vague outlines. Vibration is there, but a vibration which can be expressed much better *en masse* than in broken up surfaces.... Of late he has become more reticent. Mystic blues, purples, light green and blue greys seem to fascinate him most, and although he still indulges in rich variations, the blue of dreams dominates the arrangement."[49]

Reid continued to paint murals, including those for the Fine Arts Building at the Panama-Pacific Exposition in San Francisco in 1915. Two years later he settled in Colorado Springs and helped found the Broadmoor Art Academy, one of the first in the Rockies. He also became much more involved with portraiture, creating what he termed "portrait impressions" in oil; he quickly indicated only essential forms and features on the neutral buff canvas in the quick, vivacious, sinuous brushstrokes of his earlier Impressionist days.[50]

202. ROBERT REID. *The White Parasol*, c. 1900. Oil on canvas, 36 x 30 in. National Museum of American Art, Smithsonian Institution, Washington, D.C.; Gift of William T. Evans.

203. ROBERT REID. *The Violet Kimono*, 1910. Oil on canvas, 29 x 26¾ in. National Museum of American Art, Smithsonian Institution, Washington, D.C.; Gift of John Gellatly.

204. ROBERT REID. *The Miniature*, c. 1913. Oil on canvas, 30 x 26 in. Detroit Institute of Arts; City of Detroit purchase.

11 The Master Impressionists

Childe Hassam

FOR CHILDE HASSAM THE DECADES after the formation of the Ten were successful years as Impressionism continued to be the dominant aesthetic in America. Yet the all too facile charge that Hassam's art was then fully developed, unchanging, even stagnant—a charge that has prevailed for many years—is simply untrue. These were rich and productive years in which he began fresh interpretations of a tremendous variety of themes.

New York scenes continued to play a large part in Hassam's oeuvre, and some of the most beautiful of his winter pictures were done about 1900; in them, the dominant, cool blue tones filled the blanketing atmosphere. The consummate expression of his involvement with the urban environment may be his 1899 book of illustrations of Paris, London, and New York entitled *Three Cities*.[1] At the same time, he painted several panoramic views of New England towns: Gloucester in 1899, Provincetown in 1900, and Newport in 1901 (see plate 206), summer canvases that alternated with his paintings of Appledore. Hassam had worked in Gloucester as early as 1890, but the paintings of these New England towns at the turn of the century reveal a new mastery. Scintillating Impressionist color and brushwork, particularly in the shimmering plane of the harbor water, are secured by a strong sense of geometry: the cumulative rectilinear forms of the buildings often assume pyramidal shapes, while the strong horizontals and verticals of the full-masted boats are not unlike Robinson's Cos Cob pictures of 1894. Occasionally Hassam adopted the square format—much in use by Twachtman and Metcalf.

These are tremendously serene, optimistic pictures, bathed in limpid summer sunlight. Yet for all their cheerfulness, they are more than just "pretty" town views, happy, carefree coastal scenes. They are affirmations of America and its heritage, above all the heritage of Hassam's own New England. Early twentieth-century writers often referred to him as a Yankee or Puritan painter,[2] unintentionally conjuring up images of folksiness or prim austerity. Rather, Hassam was investigating his own roots and those of his country. Optimistic about the progress of modern art, he considered it compatible with the New England tradition. The brilliant white church spires in the Newport pictures rise up above the horizon; silhouetted against the clear sky, the strong, bright vertical accent unites the busy town and harbor with the heavens and makes direct reference to traditions of religious faith.[3]

205. CHILDE HASSAM (1859–1935). *Sunset at Sea*, 1911. Oil on burlap, 34 x 34 in. Rose Art Gallery, Brandeis University, Waltham, Massachusetts.

206

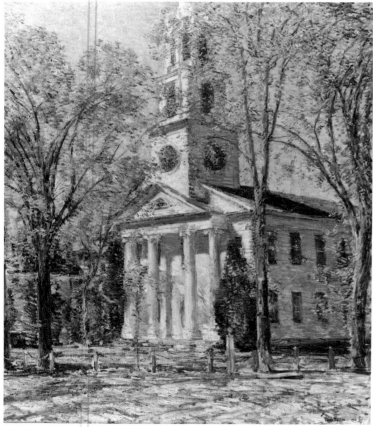

207

Hassam's wanderings through New England began to focus in 1903 with his first stay at Florence Griswold's boarding house in Old Lyme, Connecticut. The art colony that had begun to develop in Old Lyme was shifting its emphasis from Tonalism, introduced there in 1899 by Henry Ward Ranger, to Impressionism. While Ranger remained the main exponent of Tonalism in America, other painters who summered in Old Lyme came under Hassam's influence and turned to Impressionism. Hassam himself painted many landscapes in and around the town, but none as often as the Old Congregational Church. Most known versions, painted between 1903 and 1906, are in a reduced color range of brilliant, reflective white, with golden foliage sparkling in the sunlight and a plane of clear blue sky. Hassam also painted the church in moonlight, softly glowing in the darkening night air, the most formal and symmetrical of these representations. The church at Old Lyme was Hassam's Rouen Cathedral.

Another of Hassam's themes—a serious concern if not a dominant one—was the activity of labor. He painted a number of scenes devoted to shipbuilding in coastal New England; they are close-up, almost intimate views of man's toil and contrast sharply with the panoramic sweep of his harbor scenes of the same towns. One of the earliest is *The Caulker* of 1898 (plate 209), a Gloucester subject; others include *The Rigger's Shop, Provincetown*, and *Building the Schooner, Provincetown*, both of 1900. Man is shown at work, though not under strain. The small town is still there, under bright skies, but Hassam adopts a coarser, rougher, and more varied brushstroke and a stronger chiaroscuro, and the compositions are considerably more dynamic than in his city and village panoramas or his garden scenes.

Hassam carried the theme of labor into some of his New York canvases, and the masterpiece is his 1904 *The Hovel and the Skyscraper* (plate 208). He combined the dramatic brushwork and tonality used in his recent scenes of New England laborers with a typical on-high viewpoint, looking out upon Central Park in winter, with a distant panorama of buildings and the river beyond. The snow-covered foliage in the middle distance is rendered in short, curvilinear strokes and soft ocher tones, contrasting with the long, strong horizontals and verticals of the construction. Several older buildings remain at the right, in contrast to the uncompleted skyscraper. The real contrast, however, is between man's structures and nature, both so monumental that man himself is dwarfed by them.

About 1900 Hassam turned to another theme that periodically occupied his attention for the rest of his career—the nude. A number of these were studio nudes, but most were posed in outdoor settings. They tend to suffer from Hassam's inadequacies in figure drawing. Thus in the more satisfying ones the nudes are seen at a distance, immersed in a forest setting; light flickers over them in Impressionist patterns and the figures are only "piquant accents," as Royal Cortissoz described them.[4] The nudes and the laborers are at opposite ends of the spectrum of Hassam's art. Some of his later nudes are extremely large pictures and recall the mural tradition of Puvis de Chavannes. In 1904 Hassam painted a twelve-foot-long scene of nudes on the New England coast for his good friend Charles Erskine Scott Wood—an art patron in Portland, Oregon—to be installed in Colonel Wood's library. That summer Hassam apparently accompanied the painting to Portland and painted some Oregon landscapes while he was there.[5] Better known, however, are the many landscapes from a second trip in 1908, painted in the Harney and Malheur deserts of eastern Oregon.[6] These were acclaimed at the Montross Gallery the following year; they utilize Impressionist light and flecked brushwork, as in *Golden Afternoon, Oregon* (plate 211), but there is a new sense of decorative pattern and an almost antinaturalistic organization of forms. They are more synthetic works that suggest a relationship with Post-Impressionism and relate to the decorative Impressionist tendencies developing at the time among artists such as Emil Carlsen, Daniel Garber, Carl Krafft, and Lawrence Mazzanovich.[7]

Hassam carried these tendencies toward the decorative and the abstract to a

206. CHILDE HASSAM. *Cat Boats: Newport*, 1901. Oil on canvas, 27 x 29 in. Pennsylvania Academy of the Fine Arts, Philadelphia; Temple Fund Purchase.

207. CHILDE HASSAM. *Church at Old Lyme*, 1906. Oil on canvas, 30⅛ x 25¼ in. The Parrish Art Museum, Southampton, New York; Littlejohn Collection.

208. CHILDE HASSAM. *The Hovel and the Skyscraper*, 1904. Oil on canvas, 34¾ x 31 in. Mr. and Mrs. Meyer P. Potamkin.

209. CHILDE HASSAM. *The Caulker*, 1898. Oil on canvas, 24½ x 20½ in. Cincinnati Art Museum; Howe Fund.

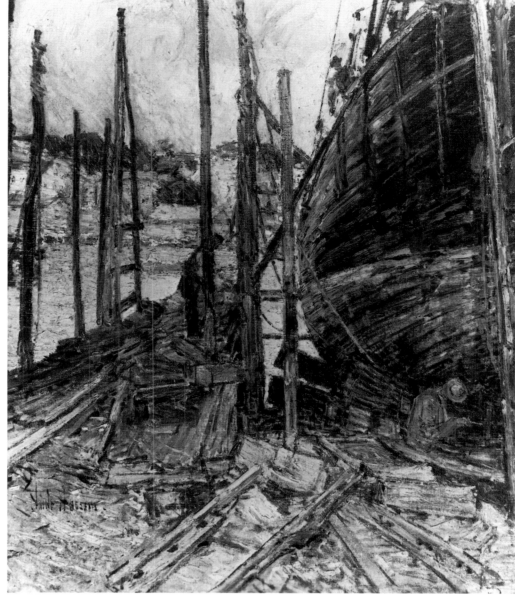

209

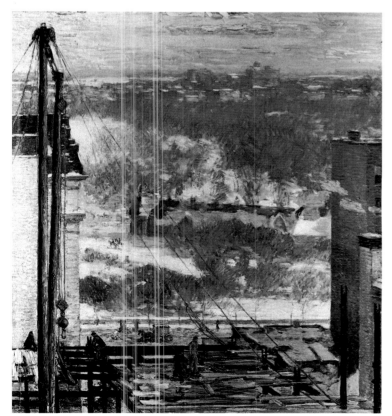

208

brilliant extreme in his 1911 *Sunset at Sea* (plate 205), a square canvas of two unequal planes of flickering color: a reddish purple sky and a flaming yellow sunset reflecting in blue-green water. Except for the single black shape of a tiny boat, the canvas is a totally nonrepresentational field of colorist abstraction. That summer Hassam had returned from his last trip to Europe, a voyage that may have triggered this painting. This is probably one of several sunset views done that summer among the Isles of Shoals, but topographical reference is totally removed.

In works such as this Hassam gave lie to charges of superficiality: even his good friend and patron Colonel Wood had described him as a Kodak.[8] Admittedly such paintings are exceptions, yet Impressionism in general was hardly a poignant form. The spiritual depths of Twachtman's paintings, the earthiness of Robinson's, the personal commitment of Weir's were often missing from Hassam's art. Although Robinson may have correctly designated it as a "tinsel-sort" and "skin-deep," Hassam brought amazing fertility and inventiveness to his painting. This can be seen in his New York Window series. These are often large and compositionally complex pictures of women in interiors. A still life of fruit or flowers usually is placed strategically in relation to the figures, which are silhouetted against win-

189

dows screened by the sheerest curtains, veiling the New York skyline to contrast with the clarity of the indoor forms. Usually the still life is on a highly polished table that reflects the windows beyond, and the mullions create a strong grid for the softer forms and patterns of figures, still lifes, and furnishings. In several of the most splendid of these, such as the 1918 *Tanagra* (plate 213), a Japanese screen contributes to the geometric structure and decoration. Though Hassam projects a mood of contemplative ideality in the Window series, this is underplayed in favor of his continuing Impressionist interest in light. Although the origin of the series has not been pinpointed, it may derive from interiors he would have seen in Paris by Post-Impressionists such as Pierre Bonnard and Edouard Vuillard.[9] The Window series continued into the early 1920s, and at the time these works were thought to be Hassam's most memorable, but until recently they have been among his least recalled.[10]

John Twachtman

John Twachtman had little more than four years to live after the founding of the Ten, but in those years his painting took yet another turn.[11] In 1901 he had a one-man show in New York at Durand-Ruel, which went on to the Cincinnati Art Museum. The exhibition included many paintings done in Gloucester the previous summer. Indeed, his last three summers, 1900 to 1902, were spent in that fishing community, and it was there that Twachtman died.[12] Duveneck was there in 1900 and was joined by Twachtman and De Camp, effecting a reunion among the Cincinnati-Munich trained painters. While both Duveneck and De Camp appear to have moved in the direction of Impressionism at the time, Twachtman, in a sense, reverted to the Munich manner. The work of his last three summers is far more vigorous than that of the previous decade in Greenwich, though if one could decipher Twachtman's progress during the '90s, year by year, one might find a growing tendency toward broader, slashing brushstrokes and away from delicate, evanescent effects. The sinuous, almost Art Nouveau outlines and patterns in the landscape are replaced in the Gloucester paintings by a strong geometry, emphasizing the structural planes and outlines of the wharves and buildings.

210. CHILDE HASSAM.

211. CHILDE HASSAM. *Golden Afternoon, Oregon*, 1908. Oil on canvas, 30¹⁄₁₆ x 40⅜ in. The Metropolitan Museum of Art, New York; Rogers Fund, 1911.

212. JOHN TWACHTMAN (1853–1902). *Waterfront Scene, Gloucester*, c. 1901. Oil on canvas, 16 x 22 in. Mr. and Mrs. Raymond J. Horowitz.

213. CHILDE HASSAM. *Tanagra*, 1918. Oil on canvas, 58¾ x 58¾ in. National Museum of American Art, Smithsonian Institution, Washington, D.C.; Gift of John Gellatly.

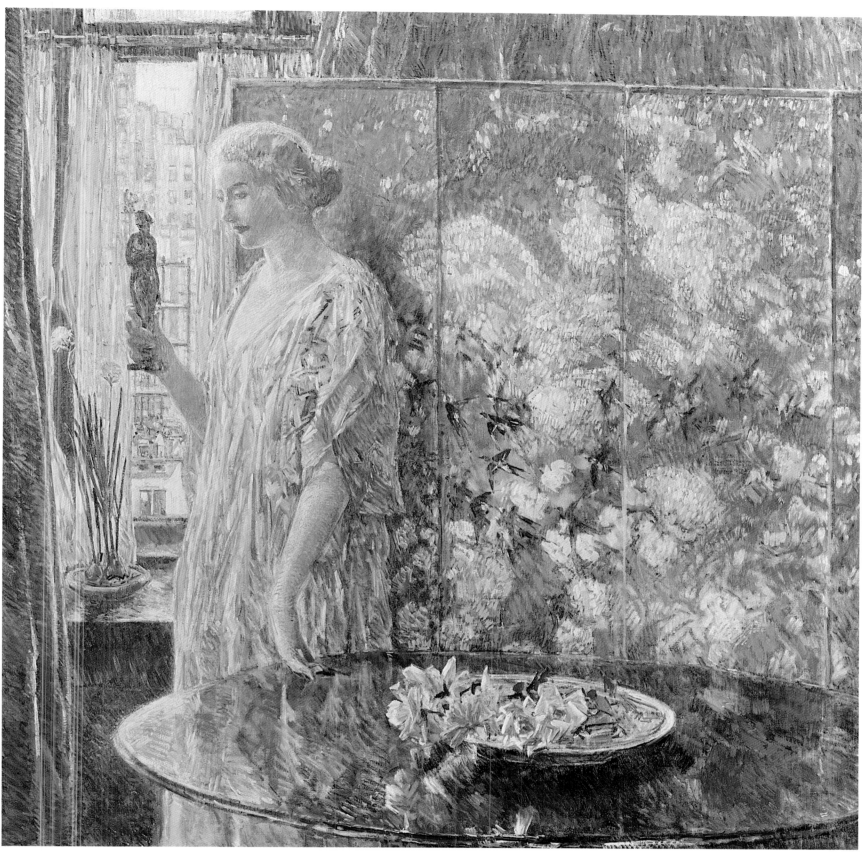

213

Twachtman's *Waterfront Scene, Gloucester* (plate 212) may be one of the 1900 pictures in his exhibition of 1901, or perhaps the *Salt Wharf*, *Grinnel's Wharf*, or *At the Wharf*. His palette became somewhat stronger in his last three years, and he reintroduced the black that had been banished after the Munich and Venice years. Perhaps this partial return to an earlier aesthetic was brought about by the locale, for he was also returning to the vigorous harbor scenes he had essayed much earlier in Venice and New York.

The sophisticated design that Twachtman had developed in the mid-1880s in

214

215

214. JOHN TWACHTMAN. *Harbor View Hotel*, 1902. Oil on canvas, 30 x 30 in. The Nelson-Atkins Museum of Art, Kansas City, Missouri; Nelson Fund.

215. JOHN TWACHTMAN. *Bark and Schooner*, or *Italian Salt Bark*, 1900. Oil on canvas, 25 x 25 in. University of Nebraska Art Galleries, Lincoln.

216. J. ALDEN WEIR (1852–1919). *The Donkey Ride*, 1899–1900. Oil on canvas, 49 x 38 in. © Copyright 1983, Cora Weir Burlingham.

France remained a part of his painting, and his predilection for the square canvas continued. *Italian Salt Bark* (plate 215) is an example, painted in his first summer at Gloucester in 1900. These works shunned the multiple glazes over heavy underpaint that characterize his most typical work of the 1890s and were painted directly, *à premier coup*. This is most evident in his last painting, the unfinished *Harbor View Hotel* (plate 214), of the spot where the artists congregated in East Gloucester. The strong receding diamond shape of the pool contrasts vigorously with the looser darkness of the umbrella-shaped tree that forms a strong vertical central axis, although the two dominant shapes are united by reflections of the green-black foliage in the water below.

J. Alden Weir

Twachtman's death in July 1902 deprived the Ten of one of their best-loved members and must have grieved his long-time colleague J. Alden Weir. By 1899, Weir had enjoyed sufficient security to give up teaching permanently, and that was a particularly rich year for his art. About this time he painted *The Orchid* (plate 217), one of the loveliest of a series of half-length figures of women—the traditional alliance of the beautiful woman and lovely flower. The figure exhibits a return to more academic rendering and is painted in a very subtle, Tonalist key of warm browns, the brushwork only slightly broken. During that period, Weir also did two of the finest of his large, outdoor figures: *The Donkey Ride* (plate 216) and *In the Sun* (plate 218), both depicting his daughters. His color range is somewhat more varied, and his concern with light much more intense, particularly in *In the*

217

218

Sun. Here, too, accurate figure drawing is important, but the compositions are considerably flattened through an allover evenness of illumination, a consistency in paint application, and noticeable brushwork for figures and background. In *The Donkey Ride* figures and animal are pressed close to the picture plane; *In the Sun* exhibits an upward spatial tilt, with the figure moved as far foward as possible. The treatment of light and brushwork creates almost tapestrylike effects, suggesting a kinship with some aspects of later Impressionism and Post-Impressionism; specifically, these effects recall the work of the Swiss-Italian artist Giovanni Segantini.[13]

Weir's landscape style during the first decade of the new century continued his personal interpretation of Impressionism, emphasizing tonal variations within a limited color range. One of the most successful of these is the monumental *Building a Dam, Shetucket* (plate 219), of 1908, in which the mechanical equipment is absorbed within the tree-filled Connecticut hills near Weir's Wyndham home. That absorption is underscored by the consistency of broken Impressionist brushstrokes. *Building a Dam* is bright and sunlit, but some of Weir's later landscapes are twilight and even nighttime scenes, more moody and introspective. Among his most unusual paintings of this later period are two nocturnes, *Queensboro Bridge* of 1910 and *The Plaza: Nocturne* of 1911 (plate 220). Compared with the dramatic urban work of some of the Ashcan School, such as John Sloan, these Whistlerian night scenes may seem retardataire, but they are instead late contributions to the alternative aesthetic of Tonalism, better known in the work of Birge Harrison, who painted Tonalist scenes of New York City skyscrapers.[14]

In general, there is an unquestionable decline in much of Weir's art in the decade before his death in 1918, although he remained an important figure in the official art world. In 1912 he was elected first president of the Association of American Painters and Sculptors, a year before it presented the International Exhibition of Modern Art in New York, better known as the Armory Show. Though undoubtedly chosen for his known tolerance of modernism, he resigned from the Association when it openly opposed the principles of the National Academy of Design, and several years later he became president of that venerable body.

Willard Metcalf

Willard Metcalf became most prominent during the years just after the formation of the Ten, when he turned anew to Impressionism. He spoke of his "renaissance"—a self-consciously grandiose term—that occurred in Boothbay on the Damariscotta River in Maine, where he worked from fall 1903 to November 1904; it is true that both his art and his fortunes enjoyed a radical improvement immediately after this sojourn.[15] In his personal life the most significant event was his ability to refrain from excessive drinking, at least for a time; and in winter 1904–5 he commuted to teach at the Rhode Island School of Design in Providence. The first clear signs of change in Metcalf's painting were evident in his show of twenty-one canvases at the Fishel, Adler, and Schwartz Galleries in New York in February 1905 and in the works he exhibited that year with the Ten. The critic in the *New York Herald* described Metcalf as "a plein-airist, a follower of the Giverny school of French painters, but his work has an originality not often found among American painters influenced by Monet and his followers."[16]

Although Metcalf and Hassam are often considered the principal artists who led the Old Lyme art colony from Tonalism to Impressionism, Metcalf's stay in the community was relatively brief; perhaps the association is based on the quality of the painting he did there and its importance to his own career. Metcalf spent his first summer in Old Lyme in 1905, though he had visited there for a bit on his way to Maine two years earlier.[17] His 1905 *Poppy Garden* (plate 222), possibly painted in the Old Lyme garden of his colleague Clark Voorhees, can be viewed as a direct descendant of Monet's Giverny paintings of poppy fields and, more specifically, of Hassam's garden pictures painted at Appledore a decade earlier. The rich chro-

219

217. J. ALDEN WEIR. *The Orchid*, 1899. Oil on canvas, 24½ x 20 in. Huntington Library and Art Gallery, San Marino, California; Virginia Scott Steele Collection.

218. J. ALDEN WEIR. *In the Sun*, 1899. Oil on canvas, 34 x 26¼ in. Brigham Young University Art Museum, Provo, Utah.

219. J. ALDEN WEIR. *Building a Dam, Shetucket*, 1908. Oil on canvas, 31¼ x 40¼ in. The Cleveland Museum of Art; Purchase from the J. H. Wade Fund.

220. J. ALDEN WEIR. *The Plaza: Nocturne*, 1911. Oil on canvas, 29 x 39½ in. Hirshhorn Museum and Sculpture Garden, Smithsonian Institution, Washington, D.C.

220

221. WILLARD METCALF (1858–1925).

222. WILLARD METCALF. *The Poppy Garden*, 1905. Oil on canvas, 24 x 24 in. Private collection.

223. WILLARD METCALF. *May Night*, 1906. Oil on canvas, 39½ x 36⅜ in. The Corcoran Gallery of Art, Washington, D.C.; Museum purchase, 1907.

224. WILLARD METCALF. *White Veil*, 1909. Oil on canvas, 36 x 36 in. Detroit Institute of Arts; Gift of Charles Willis Ward.

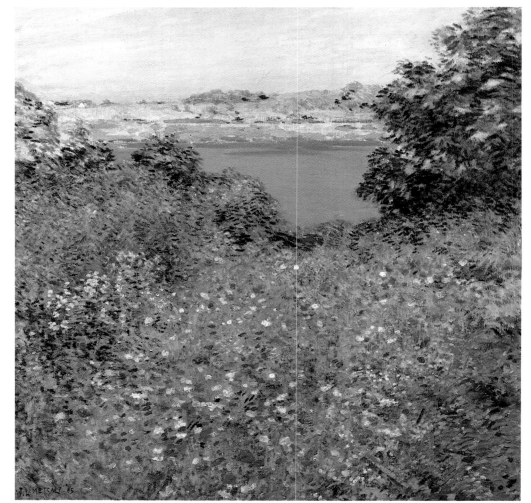

222

221

223

maticism, sparkling light, and broken brushwork recall Hassam at his most Impressionist and suggest that Hassam may have been instrumental in its development. Although Metcalf's late manner may have begun with his earlier Maine paintings, the Old Lyme experience certainly focused its direction. Yet the fact that Metcalf's Gloucester pictures of a decade earlier were already in line with Impressionist directions indicates that his stylistic progress was logical rather than radical.

Even more important for Metcalf's career was *May Night* (plate 223), painted in Old Lyme the following year. It is a night scene depicting the Florence Griswold house where many of the artists boarded, the "art center" of Old Lyme. Its poetic qualities are rare in Metcalf's art, and it was tremendously appreciated; it won the Corcoran Gold Medal and was the highest-priced painting in Metcalf's show in December 1906 at the St. Botolph Club, where most of the canvases were of Old Lyme subjects. Metcalf's work sold well at high prices in that show and subsequently did well in New York. From this time he was an acclaimed master of the Impressionist landscape. *May Night* proved influential not only on his own art, which repeated the soft nocturnal effects in works such as *Benediction* and *White Lilacs*, but also on that by other artists at Old Lyme.

Metcalf developed as a painter of seasonal landscapes. The specific nature of the individual seasons, the colors of the foliage, the quality of the light were emphasized in his art and remarked upon by the critics. Perhaps most attractive are his winter scenes, and critics such as Royal Cortissoz, who had been one of the first to respond to Metcalf's Fishel, Adler, and Schwartz exhibition, felt that he was second only to Twachtman in his responsiveness to winter.[18] Though Metcalf had painted such scenes earlier, he began to concentrate on snow scenes in 1909 and created masterful examples such as *White Veil* (plate 224) and *Icebound* (plate 225). The former is a very unusual work in which the gently falling snow creates the

W. L. METCALF. '09

225

226

"veil" of the title, a kind of scrim that acts as a picture plane through which the grayish purple landscape is seen. This is one of Metcalf's many square paintings, a format said to have been suggested to him by his dealer Albert Milch; despite the fact that he painted more square pictures than any other American artist, he was not the first to do so—Ryder and Twachtman preceded him—nor did he in his traditional compositions display the radical spatial flattening found in Twachtman's or even Hassam's square canvases.

The rapid, broken brushwork of the *White Veil* replicates falling snow, but it is as much a Tonalist as an Impressionist painting in its limited, harmonious coloration, and Metcalf avoids the deep blue shadows and multiple hues that Hassam chose for his snow scenes. In other winter scenes, such as *Icebound* or *Cornish Hills* (plate 227) of 1911 (a particularly impressive year for major works by Metcalf), the color range might be greater but the drawing is firm and the landscape forms dramatically massed, with none of the broken brushwork and flickering patterns of traditional Impressionism. Metcalf's painting is sometimes more Impressionist, sometimes more precise—variations that seem to have little to do with chronology.

Although the decade that began in 1903 with his "renaissance" year in Maine may have been the greatest period of Metcalf's art, he continued to produce brilliant New England scenes until his death in 1925. There is, however, something a bit formulaic about some of the work of his last decade. He continued to use the square format often, as in *Captain Lord House, Kennebunkport, Maine* of about 1920 (plate 226); and in his colorful spring landscapes the brushwork often became even looser and more feathery. The most impressive of his late canvases were painted in northern New England in the colder, more barren months from October to March, works such as *Indian Summer, Vermont* of 1922 (plate 397). In these Metcalf adopted a panoramic view of the rugged hills and mountains, the broad sweep of the valley, and the somewhat sparse foliage; his color is not sweet

227

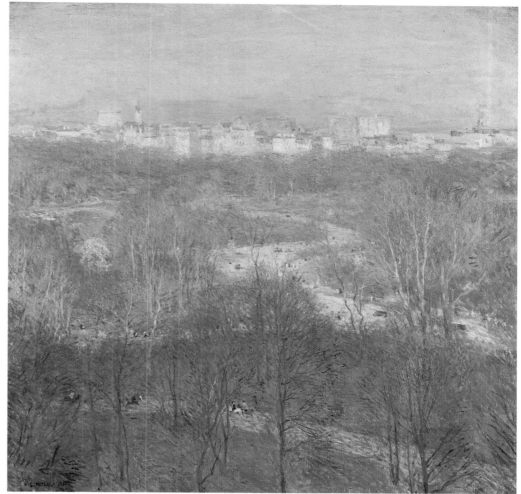

228

225. WILLARD METCALF. *Icebound*, 1909. Oil on canvas, 29 x 26⅛ in. The Art Institute of Chicago; Walter H. Schultze Memorial Collection.

226. WILLARD METCALF. *Captain Lord House, Kennebunkport, Maine*, c. 1920. Oil on canvas, 36 x 36 in. Lyme Historical Society, Florence Griswold Museum, Old Lyme, Connecticut; Gift of Mrs. Henrietta Metcalf.

227. WILLARD METCALF. *Cornish Hills*, 1911. Oil on canvas, 35 x 40 in. Thomas Barwick.

228. WILLARD METCALF. *Early Spring Afternoon, Central Park*, 1911. Oil on canvas, 36⅛ x 36 in. The Brooklyn Museum.

and joyous, but rich and sonorous. The larger forms were interpreted in broader color areas, and he rejected the divisionism of his warmer, more colorful scenes. Elizabeth de Veer, his current biographer, convincingly speculates that in these later years he may have chosen to create so many winter scenes precisely to avoid the divisionist technique. The compositions of the autumn and winter landscapes are somewhat repetitious, built around the zigzagging diagonals of a ribbonlike stream that carries the eye from the foreground into the New England foothills.

Indian Summer, Vermont was painted in Chester, where Metcalf created many of his finest later landscapes; but he ranged throughout New England—painting at Old Lyme and around Guilford, Connecticut; in the Berkshires; along the Housatonic River at Chester; and at another art colony in Cornish, New Hampshire. Metcalf became known as "the poet laureate of the New England hills," yet his celebration went beyond the regional to the national. Of all the American Impressionists, he was most often considered the painter who extolled American nature. Christian Brinton in 1908 observed, "Few American painters are more national in feeling or less influenced by foreign modes or methods than Mr. Willard L. Metcalf,"[19] and in his seminal recognition of the "new" Metcalf in 1905, Cortissoz had spoken of his ability to depict the "truth to the very soul of the American landscape."[20] Cortissoz expanded on this theme in his memorial essay on Metcalf in 1925. Similarly, in that memorial year of 1925 Bernard Teevan spoke of Metcalf as the "finest American painter of New England countryside," and Catherine Beach Ely discussed Metcalf's "thoroughly American temperament" and spoke of his ability to create a "portrait of a scene essentially American."[21] Domesticating an aesthetic that was so obviously foreign and making it something uniquely American was a crucial issue to American critics from about 1900. Almost all American Impressionists were interpreted by their champions as striving to adapt the style, but Metcalf was seen as the truly *American* Impressionist.

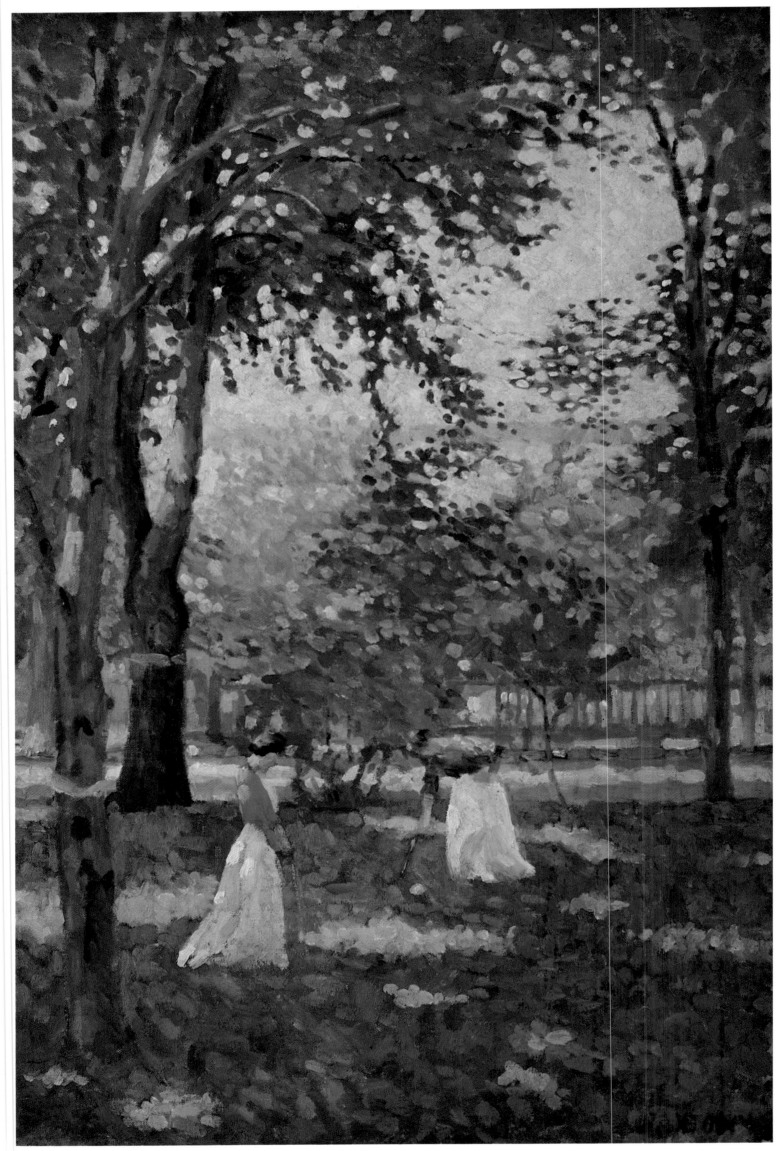

12 Regional Schools

B<small>Y THE BEGINNING OF THIS CENTURY</small> Impressionism in one form or another had become the prevailing aesthetic throughout most of America. Regional "schools" of art arose for the first time, and they were often Impressionist dominated. The interrelationship between the rise of regional professional art and Impressionism is complex. It involves the establishment of art patronage and promotion in urban centers beyond the traditional East; the development of organized outdoor teaching throughout the country; and the formation of a more elaborate national network of sales galleries and exhibitions through which the artists and their works could move easily because of faster modes of transportation.

The Hoosier School and the rise of regional Impressionism in Indiana have already been discussed in relation to the Columbian Exposition (see chapter 8). Two other regional groups in the East are especially significant for the quality of their work and the importance of their artists: the Boston School and the school in Old Lyme, Connecticut. They are distinct in numerous ways. The Old Lyme painters were primarily landscapists; the dominant trend in Boston was toward the figure. Old Lyme developed in the early years of this century; the Boston School had developed its Impressionist emphasis earlier. The Boston figure painters already discussed—Edmund Tarbell, Frank Benson, and Philip Leslie Hale—were among the innovators of their generation, along with contemporaneous landscapists such as John Leslie Breck and Theodore Wendel.

Massachusetts

A number of Boston painters of the 1890s retreated from their all-consuming concern with light and color as the new century developed, and followers began to emulate this more conservative trend. Most significant was the leader of the group, Edmund Tarbell, and the turn from the freer, more experimental direction in his art and that of his colleagues is usually pinpointed to his *Girl Crocheting* of 1904 (plate 231).[1] Tarbell has focused on a single figure, carefully placed in a sparse but elegant interior with fine furniture, antique porcelains, and priceless Old Master paintings on the walls, as well as Tarbell's own copy of Velázquez's portrait of Pope Innocent X. Velázquez may be honored, but the more influential master is Jan Vermeer; his art informed the later work of the Boston School and significantly altered its direction from coloristic Impressionism to a subtler Tonalism.[2] Nuances

229. WILLIAM PAXTON (1869–1941). *The Croquet Players*, c. 1898. Oil on canvas, 32 x 21 in. Private collection, Boston.

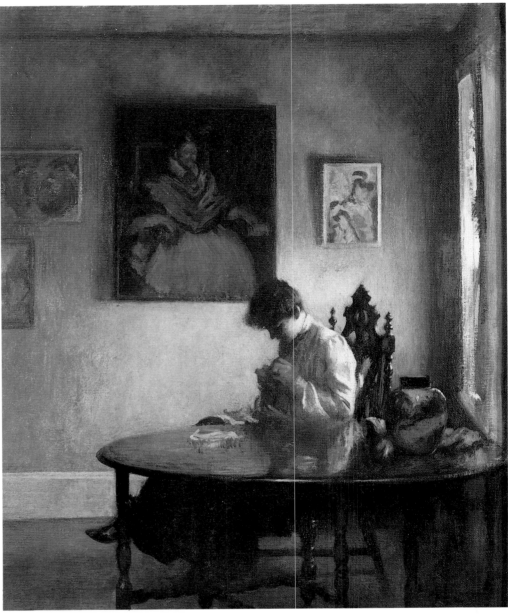

231

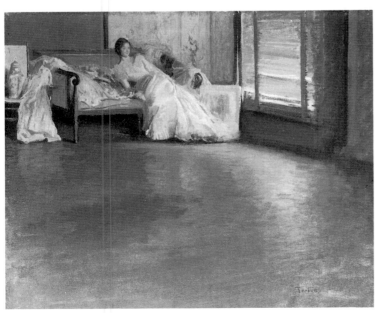

230

of light and atmosphere became Tarbell's primary consideration in pictures such
as *Girl Crocheting* and *Girl Reading* (plate 232) of about 1909; both emulate the
color, light, and even the subject matter of Vermeer, though not his technical
methodology of repeated glazing. Such introspective pictures, which differ the-
matically from earlier works like *Three Sisters* (plate 123) or *In the Orchard* (plate
124), reflect Tarbell's conscious preference for more subdued interpretations.

The Vermeer rediscovery and revival began in France as early as the 1860s;
whether the Boston painters were familiar with Vermeer's work when they re-
turned to Boston from European training is unknown.[3] Tarbell's 1898 *Venetian
Blind* (plate 233) exploits the subtle light filtering through slatted blinds and onto a
discreet nude, his most famous rendering of the nude. His 1899 *Across the Room*
(plate 230) prefigures his Vermeer-derived compositions of the next decade in its
quiet sobriety and the few but elegant furnishings. Again, the low-keyed light is
filtered through blinds, but both pictures are still painted in an almost Impression-
ist manner, and the asymmetrical composition with its expanse of empty floor
bespeaks Degas's influence. Tarbell's turn to interior scenes with more controlled
light prepared the way in Boston for the absorption of Vermeer. The work of the

Dutch artist was introduced through the Vermeer monograph, probably written by Philip Leslie Hale, in the *Masters of Art* series in 1904. Hale expanded this into a major study of the artist published in 1913.[4] By then Hale's own work had retreated from his brilliant summer sunlight garden scenes of the 1890s, in which form was almost totally dissolved, to much more academically drawn figures, though still of attractive young women among flowers. The figures are often more idealized in their classicized gowns and more subdued in their movements, though the color is still rich, as in *The Crimson Rambler* (plate 238). Perhaps the most successful of Hale's later pictures, it was purchased from an annual show by the Pennsylvania Academy in 1909.[5] The major spokesman and historian among the Boston painters, Hale acknowledged Vermeer's impact on their art countless times.

This impact inevitably affected the development of the figure painters—the "Tarbellites"—who joined the Boston School after the turn of the century; this

230. EDMUND TARBELL (1862–1938). *Across the Room*, 1899. Oil on canvas, 25 x 30⅛ in. The Metropolitan Museum of Art, New York; Bequest of Miss Adelaide Milton de Groot, 1967.

231. EDMUND TARBELL. *Girl Crocheting*, 1904. Oil on canvas, 30 x 25 in. Canajoharie Library and Art Gallery, Canajoharie, New York.

232. EDMUND TARBELL. *Girl Reading*, c. 1909. Oil on canvas, 32½ x 28¼ in. Museum of Fine Arts, Boston; Charles Henry Hayden Fund.

233. EDMUND TARBELL. *The Venetian Blind*, 1898. Oil on canvas, 51⅞ x 38⅜ in. Worcester Art Museum.

234

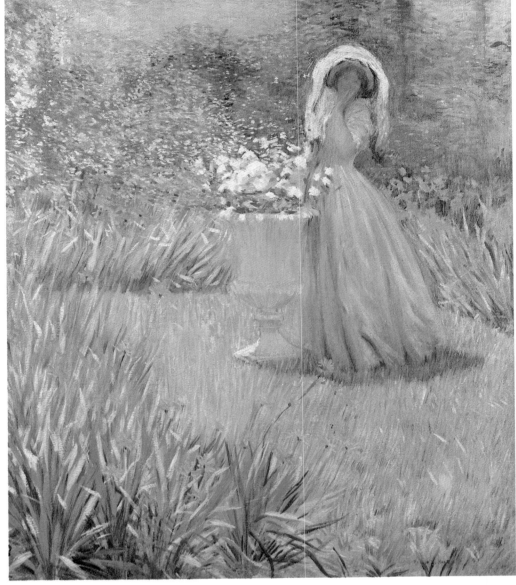

236

235

237

234. EDMUND TARBELL. *Marshall Ferdinand Foch*, 1920. Oil on canvas, 78¹/₁₆ x 78¼ in. National Museum of American Art, Smithsonian Institution, Washington, D.C.; Gift of the National Art Committee.

235. PHILIP LESLIE HALE (1865–1931).

238

236. PHILIP LESLIE HALE. *Walking through the Fields (In the Garden)*, mid-1890s. Oil on canvas, 30 x 25 in. Vose Galleries of Boston.

237. WILLIAM CHURCHILL (1858–1926). *Leisure*, 1910. Oil on canvas, 30⅛ x 25⅛ in. Museum of Fine Arts, Boston; Gift of Gorham Hubbard.

238. PHILIP LESLIE HALE. *The Crimson Rambler*, n.d. Oil on canvas, 25 x 30 in. Pennsylvania Academy of the Fine Arts, Philadelphia; Temple Fund Purchase.

would seem to be true both of established artists, such as Joseph De Camp, and others little known today, such as William Worcester Churchill. As we have seen, De Camp's paintings became Impressionistic only after he began to work with Twachtman, Duveneck, and others in 1900; after that period his primary concern was portraiture. Most notable of the portraits is his great picture of Theodore Roosevelt painted for Roosevelt's Harvard classmates (plate 241). Even this formal portrait suggests Vermeer: the elegant arrangement of forms, the fine furniture, and above all the broad expanse of wall, crossed by a fine atmospheric net of light, which acts as a vast backdrop to silhouette Roosevelt.[6] De Camp's relatively few landscapes, such as *The Little Hotel* of 1903 (plate 239), suggest that there he felt free to indulge in Impressionism, but his figure paintings concentrate on well-

239

241

240

modeled women in interiors. Some wear long gowns or colorful kimonos or veiled hats; a few are more domestic, such as his 1916 *Seamstress* (plate 243). The typical De Camp figure is silhouetted against a window by a broad panel of outdoor light, in contrast to the subtler, modulated interior atmosphere; she sits in a fine eighteenth-century-style chair and works at a well-polished table. *The Blue Cup* of 1909 (plate 244) depicts a lovely young woman whose apron suggests that she is a maid, though she holds the cup to the light to admire its translucence, not to clean it. Elegance of life style and Vermeerian light effects combine as the true subject of the picture, and both focus on the fragile object in the maid's delicate hands. Most often De Camp's female subjects play musical instruments, which, like their elegant dress, are symbols of luxury.

Better documented today than De Camp is his pupil William McGregor Paxton.[7] Born in Baltimore, Paxton grew up in Boston and studied in the late 1880s with Dennis Bunker at the Cowles School; he went on to Paris to work briefly at the Académie Julian and then with Bunker's own master, Jean Léon Gérôme. From Gérôme as well as from Bunker, Paxton derived a solid mastery of form and sure drawing of the figure that never deserted him. When he returned to the Cowles School in 1893, Bunker was dead and De Camp was teaching there. Thus, Paxton's later concentration on elegant interiors with attractive young women seems to derive from De Camp. First, though, he went through a period of

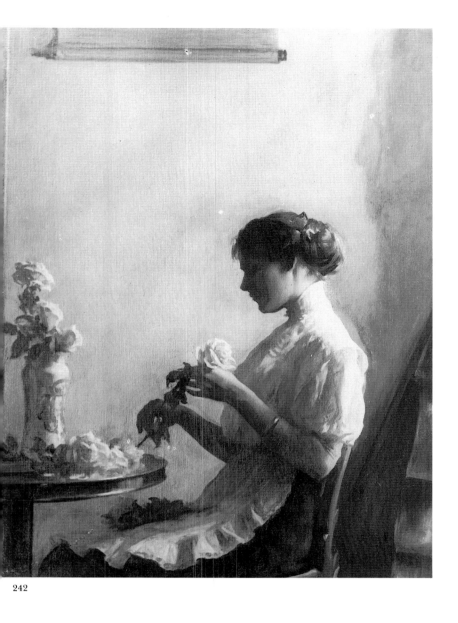

242

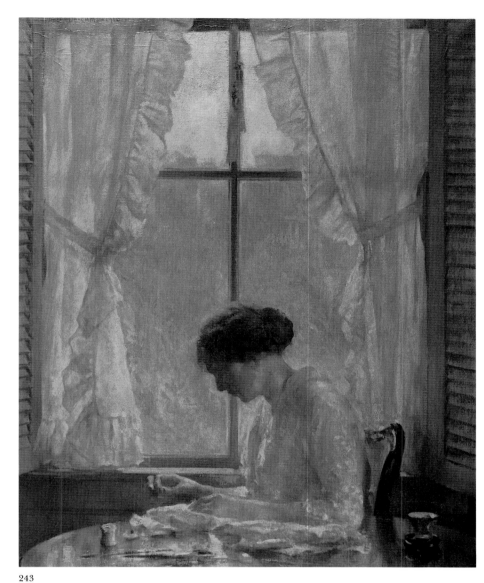

243

239. JOSEPH DE CAMP (1858–1923). *The Little Hotel*, 1903. Oil on canvas, 20 x 24¼ in. Pennsylvania Academy of the Fine Arts, Philadelphia; Temple Fund Purchase.

240. JOSEPH DE CAMP. *The Farewell*, n.d. Oil on canvas, 36 x 21¼ in. Private collection.

241. JOSEPH DE CAMP. *Theodore Roosevelt*, 1908. Oil on canvas, 96 x 66 in. Harvard University Portrait Collection; Gift of the class of 1880.

242. JOSEPH DE CAMP. *Roses*, 1909–10. Oil on canvas, 39 x 32 in. Location unknown.

243. JOSEPH DE CAMP. *The Seamstress*, 1916. Oil on canvas, 36¼ x 28 in. The Corcoran Gallery of Art, Washington, D.C.; Museum purchase, 1916.

244. JOSEPH DE CAMP. *The Blue Cup*, 1909. Oil on canvas, 50½ x 41½ in. Museum of Fine Arts, Boston; Gift of Edwin S. Webster, Laurence J. Webster, and Mrs. Mary S. Sampson in memory of their father, Frank G. Webster.

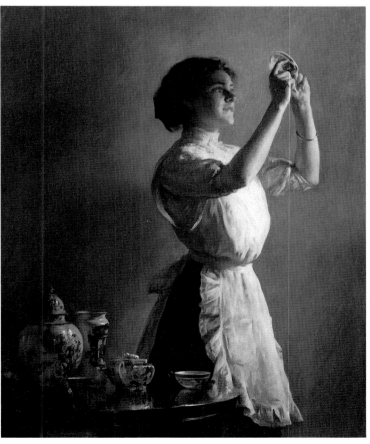

244

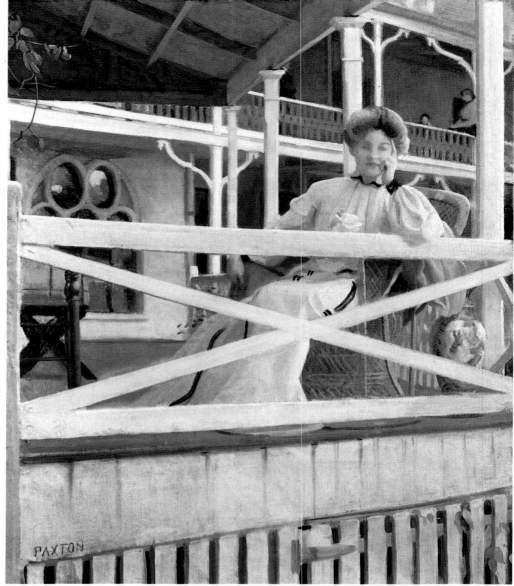

245

245. WILLIAM PAXTON. *The White Veranda*, 1904. Oil on canvas, 30 x 25 in. Mrs. John Cheever.

246. WILLIAM PAXTON. *The Front Parlor*, 1913. Oil on canvas, 27 x 22⅛ in. The St. Louis Art Museum; Bequest by exchange, Cora E. Ludwig and Edward Mallinckrodt.

broadly painted colorful outdoor scenes of refined living, as in *The Croquet Players* of c. 1898 (plate 229). This is truly Impressionist and nearly divisionist in its broken brushwork, as is the masterpiece of his early years, *The White Veranda* of 1904 (plate 245). These pictures suggest a kinship with Tarbell's paintings of about 1890 and Benson's of a decade later, as well as with Philip Hale's paintings of ladies outdoors. *The Croquet Players* is extremely painterly; in *The White Veranda*, painted in Paxton's summer studio in East Gloucester, a strong sense of formal construction reasserts itself. The white veranda beams and rails create a crisscrossing design that sweeps the fore- and middle grounds and frames the central figure, all in blazing, flat sunlight—a latter-day example of the glare aesthetic.

The November 1904 fire in the Harcourt Building destroyed an enormous amount of work by Paxton and De Camp; Paxton alone lost about a hundred canvases. Nonetheless, he continued to work in the summer in Provincetown and East Gloucester. Occasionally he made sunlit depictions of women against the sea and sky, but he concentrated more and more on interior views of upper-class life, peopled usually by a single young woman and more rarely by two.

Paxton's subjects as well as their treatment are close to De Camp's, but his color is often more varied and of higher key, his treatment of light subtler—from rather

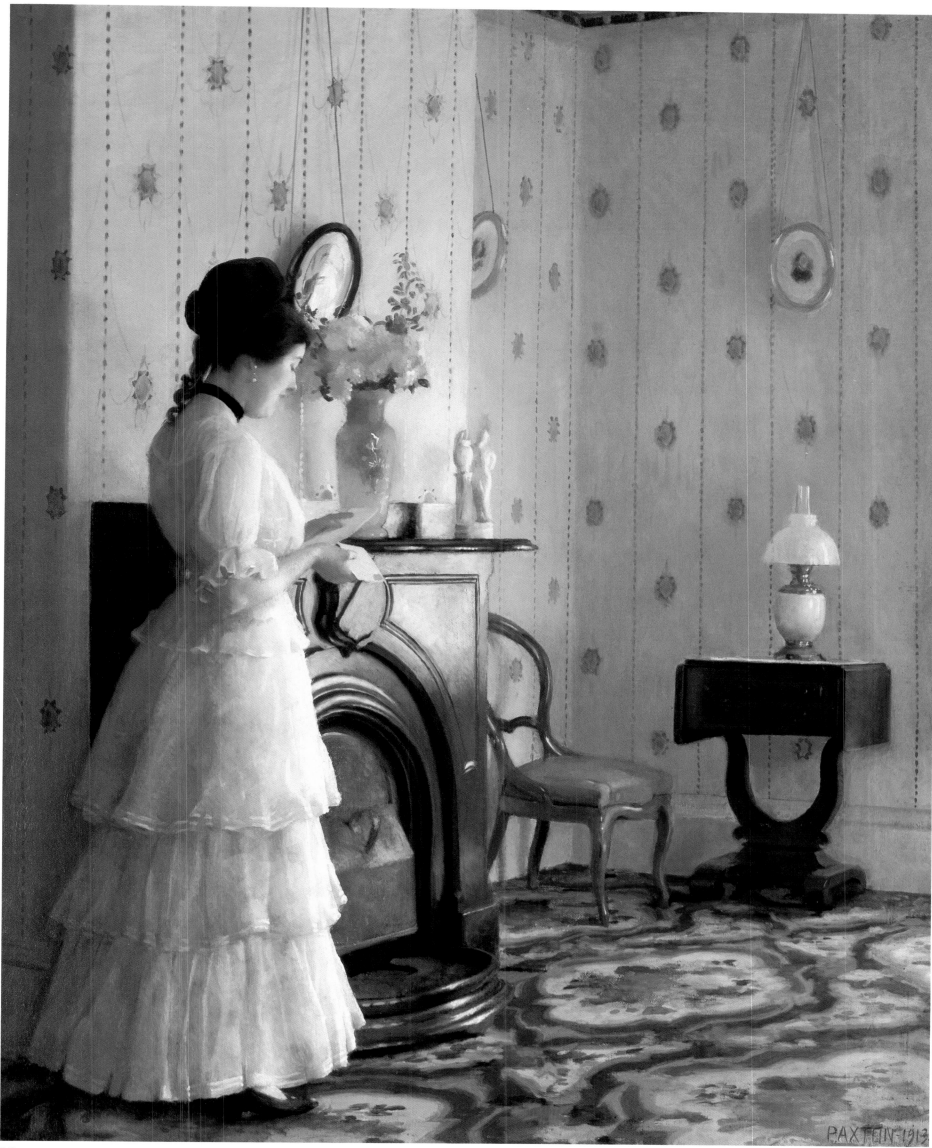

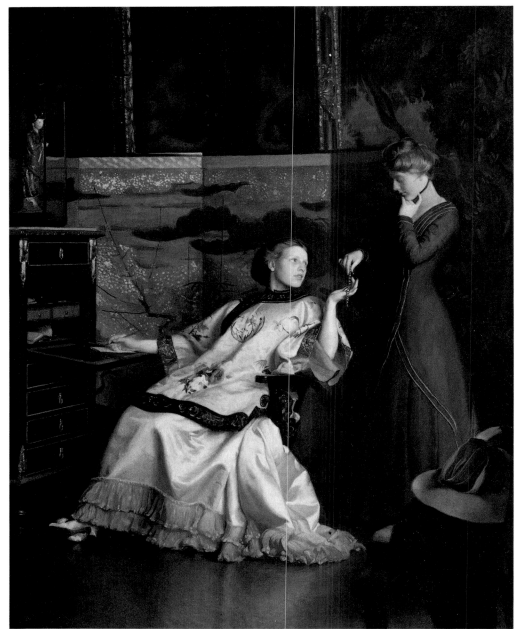

248

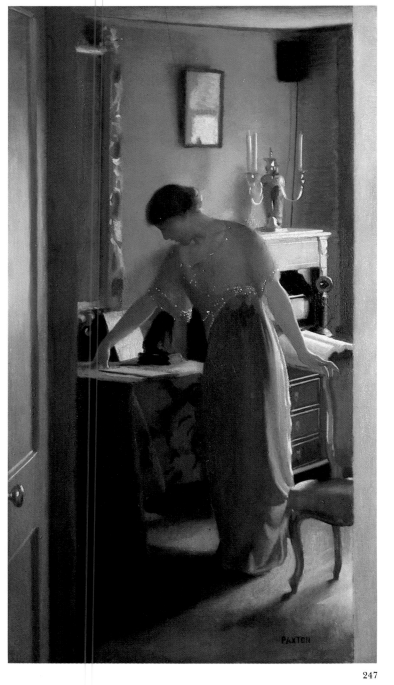

247

dark, shadowy interiors, as in *The Housemaid* of 1910 (plate 249), to brightly lit ones, such as *The Front Parlor* of 1913 (plate 246). The geometry of the rooms is often stressed through doors, pictures on the walls, paneling, and furniture; but windows are seldom represented, and the light sources are only suggested; there are no broad planes of clear light as in a number of De Camp's pictures. Mirrors, however, are not infrequent motifs, though they act as geometric planes rather than as spatial extensions. Objects in these interiors, as in Tarbell's, are often precious Oriental porcelains and the like, and the costumes are exceedingly fine. Both objects and furnishings are richer and more abundant than in Tarbell's paintings, and they reinforce the sense of wealth that characterizes Paxton's art, as does the polish of his style. His painting is usually "harder" than Tarbell's or Benson's, or, of course, Vermeer's. A number of Paxton's works of the mid-1910s —for example, *The Front Parlor* and *The Other Room* (plate 247) of 1916, as well as his *Nude* (plate 250) of the previous year—display a softer, more atmospheric quality, perhaps because his work had been criticized for its porcelainlike surfaces. The paintings of the 1920s and after tend to revert to a greater hardness and more

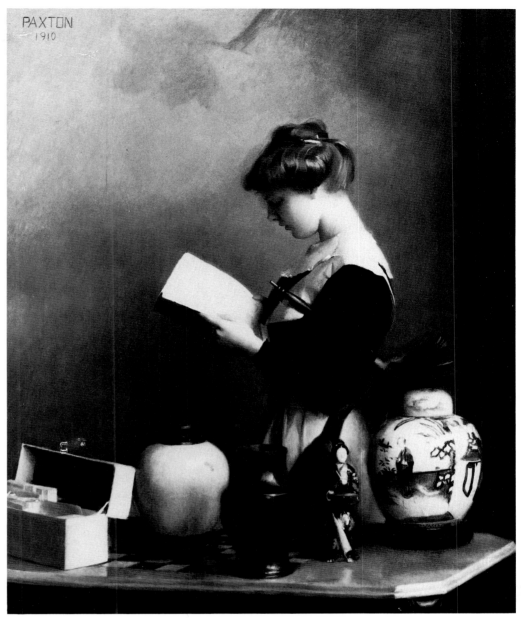

249

247. WILLIAM PAXTON. *The Other Room*, 1916. Oil on canvas, 31½ x 17½ in. El Paso Museum of Art.

248. WILLIAM PAXTON. *The New Necklace*, 1910. Oil on canvas, 35½ x 28½ in. Museum of Fine Arts, Boston; Zoe Oliver Sherman Collection.

249. WILLIAM PAXTON. *The Housemaid*, 1910. Oil on canvas, 30¼ x 25⅛ in. The Corcoran Gallery of Art, Washington, D.C.; Museum purchase, 1916.

250. WILLIAM PAXTON. *Nude*, 1915. Oil on canvas, 24 x 33 in. Museum of Fine Arts, Boston; Charles Henry Hayden Fund.

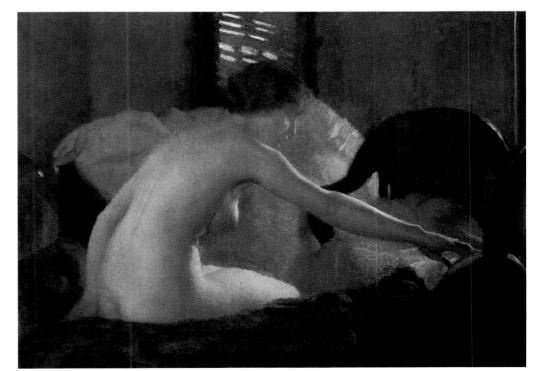

250

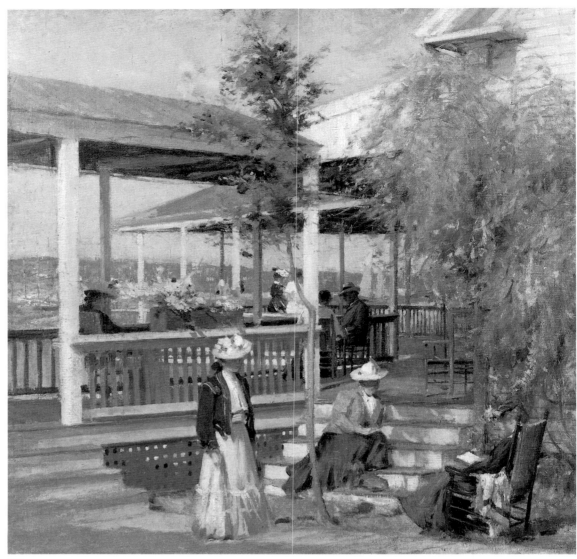

251

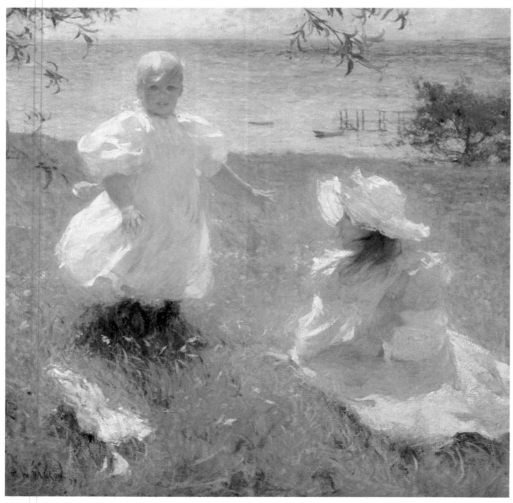

252

253

steely drawing, compared with the sensitivity and subtlety of the previous decade and a half.

As a theme in American Impressionism, the Boston image of woman has been the one most acknowledged and discussed in critical literature, from both an artistic and a sociological point of view. Recent critics have identified the distinctly antifeminist undertones of these images. Bernice Leader has pointed out that these dreaming ladies who while away their time in melancholic reverie conform to a contemporary ideal of womanhood that upholds the social values of a passive domesticity. Dr. Leader goes farther to suggest that the paintings are an implicit criticism of recent feminist gains in turn-of-the-century Boston.[8]

Paxton obviously worshiped the female form, and his 1915 *Nude* is one of the liveliest by an American Impressionist. Yet he, more than any Boston painter, has been said to exemplify this antifeminism. More mature than the models of Tarbell and Benson, Paxton's women do little more than write letters, admire bric-a-brac, and dress well, or, in the rare cases when they congregate, admire costly fabrics or jewelry. The interior screens that double the confinement in paintings such as *The New Necklace* of 1910 (plate 248) and the all-pervasive sense of "no exit" reinforce

251. EDWARD WILBUR DEAN HAMILTON (1864–1943). *Summer at Campobello, New Brunswick*, c. 1890–1900. Oil on academy board, 28 x 28 in. Museum of Fine Arts, Boston; Bequest of Maxim Karolik.

252. FRANK BENSON (1862–1951). *The Sisters*, 1899. Oil on canvas, 40 x 39½ in. IBM Corporation, Armonk, New York.

253. FRANK BENSON.

254. FRANK BENSON. *Child Sewing*, 1897. Oil on canvas, 30¼ x 24 in. National Academy of Design, New York.

254

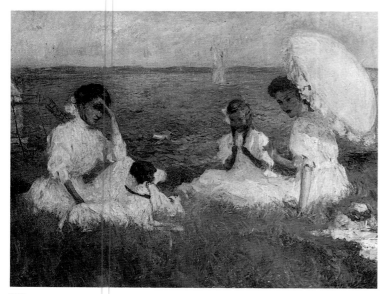

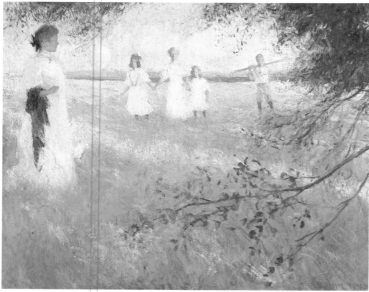

255. FRANK BENSON. *Summer Afternoon*, 1906. Oil on canvas, 30½ x 39½ in. Location unknown.

256. FRANK BENSON. *Evening Light*, 1908. Oil on canvas, 25¼ x 30½ in. Cincinnati Art Museum; Kate Banning Fund.

257. FRANK BENSON. *Sunlight*, 1909. Oil on canvas, 32¼ x 20 in. Indianapolis Museum of Art; John Herron Fund.

their isolation. Paxton's usually hard surfaces, which treat the women and the possessions equally, further suggest that these lovely ladies are so much chattel. The only labor, or real activity, is performed by cooks and maids, who function solely to keep those possessions in good order—animate and inanimate alike.

The outdoor paintings of the Boston artists are fresher in subject and in painterly, light-filled manner, ranging from Tarbell's earlier works to those of the turn of the century by Paxton and even Edward Wilbur Dean Hamilton. The latter's *Summer at Campobello, New Brunswick* of about 1900 (plate 251) seems partly indebted to Paxton's *White Veranda* for its emphasis, though less insistent, on the geometry of architectural structure. Hamilton was once judged a leading member of the Boston Impressionist camp; he was said to have "come in to the fruitage of the violet and yellow era," but to be an Impressionist who "recurs to 'the values'— the one essential test of all true landscapists."[9] Trained at the Ecole des Beaux-Arts, he spent much time in Grèz and Venice; most of his Venetian pictures are unlocated. Particularly well received, they were usually city scenes in brilliant sunlight, while most of the Grèz paintings were evening and night views, or of gray, cold tonality.[10]

About 1900 Frank Benson had begun to emphasize blazing sunlight, bright colors, and pure white in his views of young women and children outdoors. Ironically, as Tarbell moved more and more indoors, Benson took the opposite direction, though neither course was exclusive. In Benson's indoor pictures one can trace a change from emphasis on the figure, as in the 1890 *Girl in a Red Shawl* (plate 126) and the 1897 *Child Sewing* (plate 254), to emphasis on more careful modulations and reflections of light, as in *Lady Trying on a Hat* of 1904 (plate 188). By 1904, however, Benson's focus had shifted to outdoor scenes, particularly of his daughters in bright summer sunlight among sparkling foliage or high on hilltops. The reason for Benson's growing infatuation with brilliant light and color is unclear. Most discussions have centered on explaining what delayed his response to Impressionism, which came later than Tarbell's. They have proposed Benson's teaching activity in Portland, Maine; his residence in Salem, Massachusetts, which placed him outside the more advanced art centers; and, most of all, the influence of Abbott Thayer and his images of ideal womanhood. But, while Benson always acknowledged his respect for Thayer's painting, and both artists were equally removed from outdoor Impressionism in the 1890s, Benson's earlier works simply do not resemble Thayer's—they are too down-to-earth and have already evinced an interest in the subtle illumination of twilight and firelight.

Another possible explanation of Benson's move to Impressionism is his involvement in mural painting, particularly his murals at the Library of Congress completed in 1896; but this argument is somewhat specious, too. Benson's allegorical ladies in the Library are placed outdoors, yet the technique itself is decidedly non-Impressionistic and the figural interpretation quite realistic, nondecorative— unlike the much more decorative Impressionism of Robert Reid. Benson's representations of the Seasons in the Library of Congress do foreshadow the seasonal concerns in his spring and summer canvases, which usually portray his own family in the landscape. Another impetus toward a full Impressionist aesthetic—beyond Benson's own developing interests—was his association with the Ten, for just after its founding he began to concentrate on outdoor subject matter. This was not apparent in the first show of 1898, but the next year a disapproving critic wrote, "Even Mr. Benson appears to us to be losing ground in persistently following the impressionist lure."[11] This referred to Benson's lone entry in the Ten show, the now-unlocated *In the Woods*. That same year he painted *The Sisters* (plate 252), which was not exhibited with the Ten until 1901. This canvas seems to be the true start of Benson's full Impressionism; it was also a work that the critics admired greatly and continued to recall with enthusiasm, comparing it with some of his paintings of the next decade.[12] The two sisters, dressed in sparkling white, sit on the grass in the bright sunlight with a brilliant blue sea beyond. Benson eschews

257

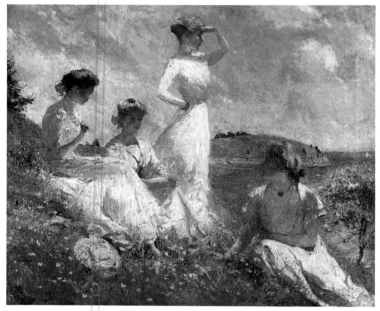

258

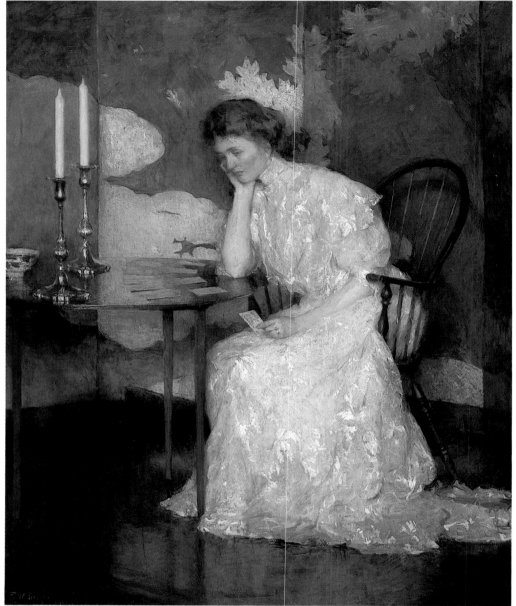

260

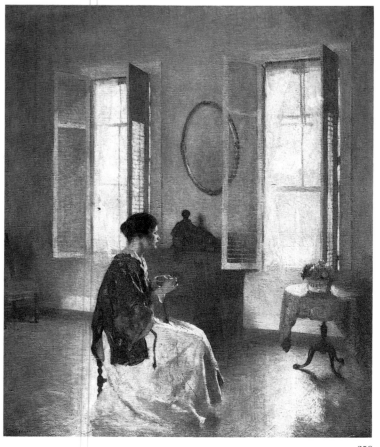

259

poetry, let alone ideality; while the title does not specify that the children are his daughters, they are imbued with an unsentimental familiarity and individuality that identifies a domestic scene.

In 1902 Benson's three paintings in the Ten exhibition—*Summer*, *Summer Sunlight*, and *Eleanor*—expanded these thematic concerns. *Eleanor* represents his favorite daughter-model shading her eyes from the glaring sun. The motif occurs again in *Sunlight* (plate 257), presumably painted in 1909, since the standing young woman in brilliant white reappears in the dated *Summer* of that year. In *Summer Afternoon* of 1906 (plate 255) a young woman again shades her eyes with a hand, while a parasol is held by another; both motifs signal the intense light that reflects from their white garments and from the glaring sea in the distance. *Evening Light* of 1908 (plate 256) presents a more muted variant of Benson's favorite themes— the exploration of light and the depiction of lively, radiant young Americans.

From about 1910 Benson turned to the wildlife and sporting subjects so popular at the time.[13] His domestic pictures also show a retreat from the glaring brilliance of his exteriors and a greater emphasis on a Vermeer-like subtlety, closer to the paintings of Tarbell and the interiors of Hale and De Camp. Some links with

Impressionism can be discerned in the vigorous brushwork and coloristic concerns of the monumental still lifes that Benson produced in his later years (see plate 396); these links are also apparent in his portraits, usually quite formal but often vivid, particularly those of women and children.

Several leading Boston figure painters turned increasingly to portraiture in their later years.[14] Some of them indulged in Impressionism as a summer or holiday activity, even if it was totally absent from their official work. This is certainly true of Boston's leading portraitist at the turn of the century, Frederic Porter Vinton. Vinton's portraits find their ancestry in the work of Velázquez and

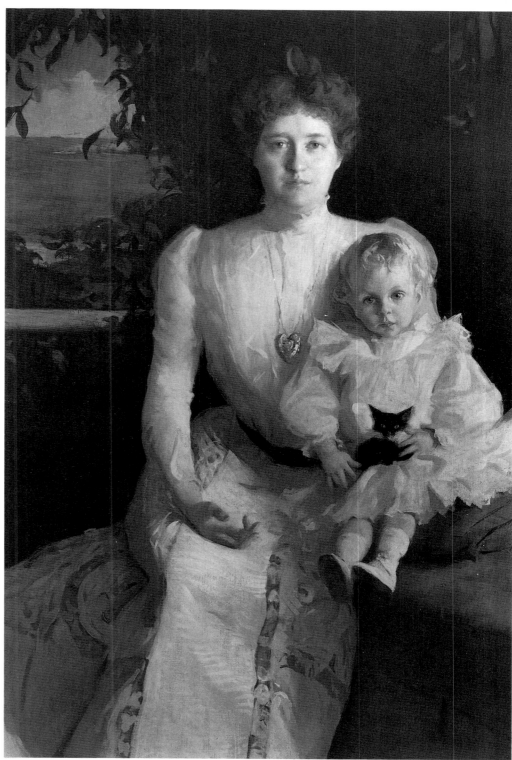

258. FRANK BENSON. *Summer*, 1909. Oil on canvas, 36⅜ x 44⅜ in. Museum of Art, Rhode Island School of Design, Providence, Rhode Island; Bequest of Isaac C. Bates.

259. FRANK BENSON. *Open Window*, 1917. Oil on canvas, 52¼ x 42¼ in. The Corcoran Gallery of Art, Washington, D.C.; Museum purchase, 1919.

260. FRANK BENSON. *Girl Playing Solitaire*, 1909. Oil on canvas, 50½ x 40½ in. Worcester Art Museum.

261. FRANK BENSON. *Mrs. Benjamin Thaw and Her Son, Alexander Blair Thaw III*, 1900. Oil on canvas, 60 x 39½ in. Berry-Hill Galleries, New York.

261

263

262

a more immediate source in the painting of one of his Paris teachers, Léon Bonnat. His landscapes often derived from the Barbizon precepts of Charles François Daubigny, but he was also a friend of Eugène Boudin and owned works by him. Occasionally, as in *La Blanchisseuse* of 1890 (plate 263), Vinton's works take on the broken brushwork and colorism of Impressionism; they also recall that he was a colleague of Sargent and of Sargent's Boston disciple, Dennis Bunker.[15]

A later Boston Impressionist, and one active in the interpretation of the city itself, was Arthur Clifton Goodwin.[16] His friend and mentor was Louis Kronberg, little known today, who depicted ballet dancers in the manner of Degas. Like Degas, Kronberg often worked in pastel, and he taught Goodwin to master this medium. Goodwin's vigorously painted scenes of Boston in both pastel and oil revel in capturing contemporary urban life, and they represent an aesthetic cross between Impressionism and the art of New York's Ashcan School. *On South Boston Pier* (plate 262) is an early Boston picture by Goodwin, a subject he painted in oil and in a pastel of 1904; it is lighter than usual in tonality, with more emphasis on the figure. It is not unlike Maurice Prendergast's contemporaneous work in Boston, and a connection is not improbable. Goodwin moved to New York in 1921, and two years later to a farm in Old Chatham, New York, where he spent the rest of his life, near the Ashcan artist George Luks.

A chapter still to be written on regional American Impressionism is one about the activity on Massachusetts's North Shore at the turn of the century and after, in and near Gloucester, Rockport, and the Cape Ann area. The activity of Hassam, Twachtman, De Camp, and Duveneck in Gloucester has been discussed, and that community remained a center for artists such as John Sloan, Stuart Davis, Marsden Hartley, and Edward Hopper, just as notable painters such as Fitz Hugh Lane and William Morris Hunt had worked there earlier. Nearby Rockport developed somewhat later, and the artists active there came from all over the country and were not, of course, necessarily Impressionist. Lewis Meakin, from Cincinnati, was the finest landscapist there at the turn of the century; he trained in Munich at the same time as the Indianapolis group. Though Meakin's art is much honored in Cincinnati, it still requires study in depth to yield an understanding of his chrono-

262. ARTHUR CLIFTON GOODWIN (1866–?). *On South Boston Pier*, c. 1904. Oil on canvas, 15⅞ x 20 in. The Toledo Museum of Art; Gift of Florence Scott Libbey.

263. FREDERIC PORTER VINTON (1846–1911). *La Blanchisseuse*, 1890. Oil on canvas, 18¼ x 24 in. Museum of Fine Arts, Boston; Gift of Alexander Cochrane.

264. LEWIS MEAKIN (1850–1917). *Salt Marsh, Cape Ann*, 1892. Oil on canvas, 21³⁄₁₆ x 33⅛ in. Cincinnati Art Museum; Gift of the Meakin Estate.

265. HARRIET LUMIS (1870–1953). *Morning in the Harbor*, c. 1918. Oil on canvas, 18 x 22 in. Location unknown.

264

265

266. JULIE MORROW (c. 1882–1979). *Morning Reflections, Rockport*, n.d. Oil on canvas, 30 x 26 in. Cincinnati Art Museum; Gift of the artist.

267. GEORGE NOYES (1864–1954). *The Gorge*, 1910. Oil on canvas, 30½ x 34¼ in. Furman Collection.

268. CHARLES EBERT (1873–1959). *Old Lyme Church*, c. 1923. Oil on canvas, 30 x 36 in. First Congregational Church of Old Lyme.

269. WALTER CLARK (1848–1917). *Noank*, 1900. Oil on canvas, 20 x 30 in. A. Everette James, Jr., J.D., M.D., and family.

270. CHARLES EBERT. *Monhegan Cove*, n.d. Oil on canvas, 25 x 30 in. Lyman Allyn Museum, New London, Connecticut.

267

266

logical development. He wrote, "Each place, like every man one meets, has an individual character."[17] Perhaps this accounts for the more colorful palette and broken brushwork of his New England landscapes, such as his *Salt Marsh, Cape Ann* (plate 264), in contrast to his more Tonalist landscapes done in the Midwest. Meakin often summered in New England, particularly around Gloucester and Camden, Maine. Connecticut-born Harriet Randall Lumis settled in Springfield, Massachusetts, on her marriage in 1892. She studied art there and in 1910–11 worked with Leonard Ochtman at Mianus, Connecticut. Though Ochtman painted in a primarily Tonalist manner, it seems that the Mianus–Cos Cob–Old Lyme environment led Lumis to an Impressionist commitment. She studied further at the Breckenridge Summer School of Art in Gloucester and worked there frequently, producing particularly colorful views of the harbor and the neighboring landscape. Julie Morrow painted on both the North Shore and in Provincetown, in a manner totally committed to Impressionism, as her work in Rockport demonstrates. In 1929 she married Cornelius W. De Forest of Cincinnati and took her rich variant of Impressionism to the Midwest. Among able Impressionist painters who depicted the more rugged interior scenery of New England, George Noyes also awaits study. He was a Boston-based painter who studied and worked in France before returning to interpret New England in an Impressionist manner. Noyes produced coastal paintings, worked in Gloucester, and was one of the first landscapists to paint on Cape Cod. He also created many colorful interpretations of the mountains of New Hampshire and Vermont, such as *The Gorge* of 1910 (plate 267), painted in Manchester, Vermont.

269

"The most talked about art colony in America today is at Old Lyme, Connecticut. . . . One explanation of the remarkable jump Lyme has taken, is that Willard Metcalf sold in three days $8000 worth of Lyme landscapes in the St. Botolph Club last winter. This made Lyme landscapes sound like Standard Oil, and with no less enthusiasm than the gold hunters of '49, the picture makers have chosen Lyme as a place in which to swarm."

"With the Old Lyme Art Colony," *New Haven Journal Courrier,* July 5 (c. 1908?).

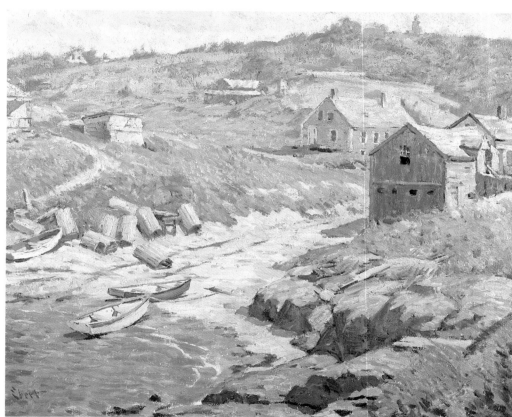
270

268

Connecticut

Impressionism was the dominant aesthetic in a number of Connecticut centers, notably Cos Cob and Old Lyme. While Old Lyme became the most famous Impressionist-oriented art colony in America, Cos Cob developed earlier.[18] Many painters, including Ernest Lawson, studied in Cos Cob during the summer with John Twachtman, who lived nearby in Greenwich. Charles Ebert, who studied first in Cincinnati and then at the Académie Julian, moved to Greenwich in 1900, where he studied with Twachtman. In 1909 Ebert began to summer on Monhegan Island off the coast of Maine, which he interpreted in brilliant color and changing atmosphere.[19] Strangely, the Connecticut Impressionists working on Long Island Sound seldom chose to depict its more placid coastline but preferred

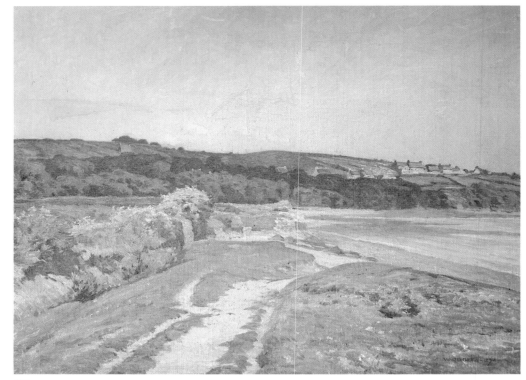

272

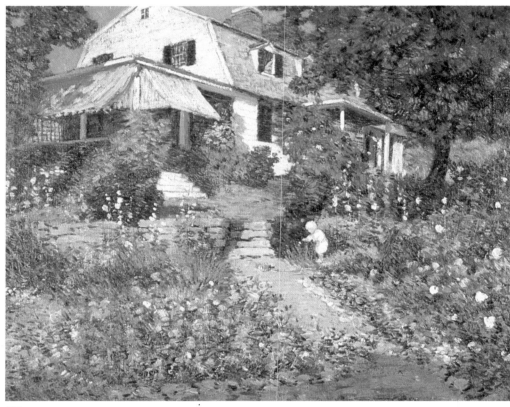

273

271

Massachusetts and Maine. Ebert moved to Old Lyme in 1919 and continued to work in an Impressionist vein. Under Twachtman's influence, Walter Clark, another periodic visitor to Cos Cob, moved away from his earlier Barbizon mode, which had been reinforced by George Inness when the two painters had adjoining New York studios. Clark's *Noank* (plate 269), painted in 1900 when Twachtman's influence on his fellow artists was strongest, depicts a Connecticut coastal community near Mystic that often attracted painters from Cos Cob and Old Lyme.

As an art colony Old Lyme had a particularly interesting history that revolved around Florence Griswold and her stately Georgian mansion on the main street of

274

the village. The Griswolds were an old, distinguished family that had fallen on hard times, and Miss Florence was forced to take in summer boarders.[20] The first artist to arrive was Clark Voorhees, in 1896, on a bicycle exploration of Connecticut before he went off to study at the Académie Julian. In 1899 the Tonal landscapist Henry Ward Ranger, in search of a town that could serve his vision of a Barbizon in America, followed Voorhees's recommendation and found the perfect spot in Old Lyme. The following year he was joined by a host of other Tonalist landscape painters, who like him were working in a rural genre.[21]

The Tonalist sovereignty did not last long, for in 1903 Childe Hassam joined the colony and exhibited in the second annual art show at the Noyes Library late that summer. Hassam was the catalyst that changed the Old Lyme aesthetic from Tonalist to Impressionist, beginning with his brilliantly colored representations of the Old Congregational Church. Ranger soon built a studio farther up the coast at Noank, as other artists of an Impressionist persuasion began to summer in Old Lyme. One of these was Walter Griffin, who joined his friend Hassam by 1904, when both showed in the annual exhibition. Griffin lived in Hartford and spent much time in Farmington, Connecticut—yet another "American Barbizon"—but his work had already adopted the sun-filled hues of Impressionism. His chronology is uncertain, but by 1894 at the end of his first sojourn in France he was painting colorful landscapes such as his *Brittany Coast* (plate 272). Later he adopted an almost Expressionist handling of paint, with wiry brushwork and palette knife, which informs his more distinctive, if less lyrical, landscapes. Willard Metcalf was in Old Lyme briefly in summer 1903 and returned regularly for the next several years beginning in 1905. He painted some of his finest canvases there, including the 1905 *Poppy Garden* (plate 222) and the 1906 *May Night* (plate 223).

Often younger artists working in Old Lyme either developed as Impressionists or turned away from other aesthetics. Both Will Howe Foote and Clark Voorhees started visiting the village regularly in 1901. Voorhees worked at first in a Tonalist manner under the leadership of Ranger but soon went over to Impressionism. While his *Moonlight Mystery* is yet another night view of the Griswold House, *My Garden* (plate 273) of about 1914 explores a favorite Impressionist motif in full

271. HENRY WARD RANGER (1859–1916). *Connecticut Woods*, 1899. Oil on canvas, 28¼ x 36³⁄₁₆ in. National Museum of American Art, Smithsonian Institution, Washington, D.C.; Gift of William T. Evans.

272. WALTER GRIFFIN (1861–1935). *Brittany Coast*, 1894. Oil on canvas, 19¼ x 25½ in. Vose Galleries of Boston.

273. CLARK G. VOORHEES (1871–1933). *My Garden*, c. 1914. Oil on canvas, 28¾ x 36 in. Michael Voorhees, granddaughter of artist.

274. WILL HOWE FOOTE (1874–1965). *A Summer's Night*, c. 1906. Oil on canvas, 34 x 30 in. Lyme Historical Society, Florence Griswold Museum; Gift of the artist.

275. FRANK DUMOND (1865–1951). *Autumn, Grassy Hill*, n.d. Oil on canvas, 10 x 14 in. Nelson C. White.

275

276

chromatic sunlight. Foote seems to have come under the Impressionist influence in France, where he and his friend Frederick Frieseke had studied at the Académie Julian beginning in 1897; and a show of his work held in his native Grand Rapids, Michigan, in 1900 indicates that he had already become a colorist.[22] *A Summer's Night* (plate 274) is almost a paraphrase of Metcalf's *May Night* and was probably painted about the same time; but it is more colorful than Metcalf's picture and Foote worked often in full emulation of Hassam.

In 1902 Foote assisted Frank DuMond at the Lyme Summer School of Art, sponsored by the Art Students League. DuMond had taught at the League for a decade and was one of the most popular and able teachers of the time; his Old Lyme classes soon grew to such proportions that the League was persuaded to move its summer school to Woodstock, New York, after antagonisms developed between the students and the established Old Lyme artists. But DuMond stayed on there teaching privately. His painting, much in need of study, displays a fascinating dichotomy: he created monumental religious canvases in an academic tradition and realistic landscapes in and around Old Lyme that steadily intensified in sun-soaked colorism.[23] Like DuMond, William Chadwick arrived in Old Lyme in 1902; he remained there as a summer visitor through 1910 and a permanent

277

resident from 1915. Perhaps because he was a younger man and entered the professional arena when Impressionism had become a given, he confronted fewer choices and consequently his art appears "easy." It is comfortable and confident in its sunny Impressionism, long on competence and short on originality. But its very imitativeness presents a rather complete panorama of Impressionist styles and motifs. Thus his *On the Porch* of about 1908 (plate 276) is reminiscent of many

278

276. WILLIAM CHADWICK (1879–1962). *On the Porch*, c. 1908. Oil on canvas, 24 x 30 in. Lyme Historical Society, Florence Griswold Museum; Gift of Mrs. Elizabeth Chadwick O'Connell.

277. WILLIAM CHADWICK. *Connecticut River*, n.d. Oil on canvas, 30 x 40 in. Lyman Allyn Museum, New London, Connecticut.

278. WILLIAM CHADWICK. *Orange Bridge*, c. 1915. Oil on canvas, 24 x 30 in. Geist Collection.

279. WILLIAM CHADWICK. *Hamburg Cove*, 1923. Oil on canvas, 36³⁄₁₆ x 40⅛ in. The Museum at the Holyoke Public Library, Holyoke, Massachusetts.

279

280

281

similar, stronger paintings by Hassam, while his *Summer Garden* of about 1916 joyously repeats a theme favored by many Impressionists and also is painted in a manner recalling Hassam's later landscapes. Chadwick's *Orange Bridge* of about 1915 (plate 278) is a less daring paraphrase of Weir's masterwork, *The Red Bridge* (plate 183), and the ubiquitous Old Congregational Church appears again in Chadwick's oeuvre.

The Old Lyme painters were naturally attracted to motifs that seemed distinctive to the town and its surrounding landscape. One especially appealing subject was the flowering laurel, the Connecticut state flower, painted by Hassam and later by Chadwick in his 1923 *Hamburg Cove* (plate 279). But the laurel was even more a specialty of Edward Rook, who settled in Old Lyme in 1903. Rook was one of the most vigorous painters of the colony; he applied broken color in an almost Expressionist manner that recalls the work of Walter Griffin, but without his

282

somewhat schematized mannerisms. The vitality of Rook's brushwork communicates an effect of lively movement; his laurel has a sense of growth, while *Bradbury's Mill, Swirling Water* (plate 280) is appropriately named. Much Impressionist painting is notable for its placidity; Rook's is not.

Among the first artists to arrive in Old Lyme in Hassam's wake, one of the best known today is Guy Wiggins. Wiggins, who seems to have done about as many summer landscapes in Connecticut as winter scenes in New York City, is best known for the latter. He may have begun to paint them in the 1920s, after an unsuccessful attempt to paint a sunny landscape in his New York studio in winter. Wiggins's combination of the bright colors of urban life with flickering snowfall and the city's massive architecture (aided by his own early architectural training) proved tremendously successful. However, the repeated application of this approach to various Manhattan locales produced something akin to potboilers in contrast to the spontaneity of his Old Lyme summer landscapes.

Among the group who came to Old Lyme somewhat later were George Burr and Gregory Smith; both arrived in 1910. Smith was lured there by his colleague from Grand Rapids, Will Howe Foote, but found his basic models in the styles of Hassam and Metcalf. His work is seen at its happiest and most complete in *The Bow Bridge* (plate 283) of about 1912–15, one of the most distinctive and most frequently painted motifs in the village. Burr's *Old Lyme Garden* (plate 284) is yet another example of the floral environment motif so beloved by Impressionist painters. As adherents to the colony multiplied, the impact of its creativity diminished. Hassam stopped exhibiting with the group in 1912, though two years later the Lyme Art Association was formed to erect a permanent gallery. Their goal was not reached until 1921, and by that time the Old Lyme Impressionists had passed their moment of vitality.

Old Lyme was the major art colony on the Connecticut coast, but artists settled in many other communities along the shore: Leonard Ochtman was at Mianus and Ranger at Noank; even farther north, Charles Harold Davis had settled in Mystic in 1892.[24] Davis's artistic transformation was extremely dramatic. In 1880 he

280. EDWARD ROOK. *Bradbury's Mill, Swirling Waters*, c. 1917. Oil on canvas, 30¼ x 38⅝ in. Lyme Historical Society, Florence Griswold Museum; Gift of Mrs. Chauncey B. Garver.

281. EDWARD ROOK (1870–1960). *Laurel*, c. 1905–10. Oil on canvas, 40³⁄₁₆ x 50⅜ in. Private collection.

282. GUY WIGGINS (1883–1962). *Metropolitan Tower*, n.d. Oil on canvas, 34 x 40⅛ in. The Metropolitan Museum of Art, New York; George A. Hearn Fund, 1912.

283. GREGORY SMITH (n.d.). *The Bow Bridge*, 1912–15. Oil on canvas, 36 x 40 in. Gregory Smith.

283

227

285

284

enrolled in the Académie Julian, but soon spent most of his time in the Barbizon region, where he became enamored of the delicate, silvery mists and the soft, warm glow of sunshine. He became one of the finest and most original interpreters of Tonalist landscape in the 1880s, and he returned to America with this artistic approach in 1890. It is not certain exactly when Davis started to abandon the subtleties of Tonalism and venture into Impressionism, but it seems to have occurred about 1894. The Boston critic William Howe Downes began to notice a change in Davis's work in 1892, but he also said, "The tendency towards a more luminous style became noticeable after 1894. Until that time the artist had adhered to the extreme moderation and sobriety of color ... wanting in animation, sparkle and gayety."[25] By 1900 it was recognized that "he came under the spell of sunshine and the influence of the luminists. His brushwork loosens, becomes more and more a marvelous sleight-of-hand. . . ."[26] Davis's style had changed, and so had his subject matter—from the French landscape to that of Connecticut and from a concentration on the land to the sky. His Tonalist skies had been softly glowing planes that silhouetted the low-lying landscapes; his Impressionist skies were brilliant cobalt or ultramarine blue, within which monumental cumulus clouds floated, creating dramatic shapes and vivid color contrasts that endowed the scene

286

with that characteristic Impressionist sense of the momentary. Davis, indeed, published an essay on cloud painting in 1909.[27]

Most artists in Connecticut at the turn of the century and later settled along the coast. J. Alden Weir was the first among the Impressionists to work in the interior of the state. He settled in Branchville after inheriting a large house in Wyndham from his wife's family. Though he taught at Cos Cob, Weir was not associated with any of the local art colonies. Among the many colleagues to visit him in Connecticut was the Danish-born Emil Carlsen, who was considered a major still-life painter in America at this time. Carlsen's growing interest in landscape reinforced the appeal of living in idyllic country surroundings, and in 1905 he purchased a home at Falls Village, deep in the Berkshire foothills of northwestern Connecticut.[28] Like Weir, Carlsen was attracted to the beauties of the rolling hills and interpreted them in soft, pastellike tones. Carlsen's landscape mode, however, is more completely of this century, and it developed in the more decorative, somewhat nonnaturalistic manner that characterized later Impressionism. Often quite large, like many of the more decorative manifestations of Impressionism, many of them create a tapestrylike effect; both distant and foreground areas receive equal luminosity, and forms are similarly defined without atmospheric diminution. Again like Weir, he used light, bright colors, and the scenes project great serenity; but Carlsen avoided Weir's broken brushwork and thick impastoes, preferring thinner paint application.

284. GEORGE B. BURR (1876–1939). *Old Lyme Garden*, n.d. Oil on canvas, 12 x 9 in. Lyme Historical Society, Florence Griswold Museum; Gift of Patricia Burr Bott.

285. CHARLES DAVIS (1856–1933). *Sky*, n.d. Oil on canvas, 36 x 30 in. Lyman Allyn Museum, New London, Connecticut.

286. CHARLES DAVIS. *Evening*, 1886. Oil on canvas, 38⅛ x 57⅞ in. Private collection.

287. EMIL CARLSEN (1853–1932). *Connecticut Hillside*, c. 1920. Oil on canvas, 29¼ x 27⅜ in. The Art Institute of Chicago; Walter H. Schulze Memorial Collection.

287

288

New York

In the neighboring Hudson River Valley were two important art centers at Woodstock and Cragsmoor, outside of Ellenville, which had developed earlier. The genre specialist Edward Lamson Henry had built a house in Cragsmoor about 1884, after visiting in 1879.[29] Frederick Dellenbaugh arrived two years later, and Eliza Greatorex in 1884. Many more came early in this century, at the time that Impressionism was proliferating. One of the painters involved with Impressionism was Charles Courtney Curran. Invited to Cragsmoor by Dellenbaugh in 1903, Curran was immediately charmed by it, and he completed a house there in 1910. Earlier he had done crisply rendered figures of elegant women in panoramic landscapes and more softly rendered fantasy figures of fairylike women among roses, a rare example of American Symbolism. About the time Curran went to Cragsmoor he turned to the theme that would involve him for the rest of his career: beautiful, "modern" young women in bright sunlight, often high on a hill or mountaintop, silhouetted against the brilliant blue sky. They are not unlike Frank Benson's contemporaneous canvases in spirit and aesthetic. Color is rich and Curran, like Benson, achieved a sense of vitality and immediacy; but his figures are far more sharply drawn and clearly outlined, and his surfaces sometimes almost enamellike in contrast to Benson's more broken and varied ones. The clear drawing, slightly stylized forms, and limitless space inject an element of fantasy, a heritage perhaps of his earlier Symbolism.

Helen Turner was invited to Cragsmoor by Curran in 1906, and she too built a house, completed in 1910.[30] There she painted radiant pictures of women in gardens and on porches, surrounded by flowers, in a very individual coloristic manner with the paint almost gritty and laid on thickly and dryly. Curran and Turner were avid gardeners and the garden theme is strong in her work, but the figure almost always predominates. Her 1914 *Girl with Lantern* (plate 289) displays

a mastery of form learned at the Art Students League: a woman in a white dress scintillating with colored shadows holds a brilliant Japanese lantern and is silhouetted against a tapestried background of foliage. Even in the shadows the figure glows with sunlight; the lantern not only refers to colored light but also pays homage to earlier Impressionist paintings, starting with Sargent's *Carnation, Lily, Lily, Rose* (plate 73).

The other major center along the Hudson River was the summer school of the Art Students League, which was transferred to Woodstock from Old Lyme. While Impressionist precepts were acknowledged, it was not the primary aesthetic there. The school flourished under the able leadership of Birge Harrison and then John Carlson: Harrison was one of the most sensitive of American Tonalists, and Carlson opted for a vigorous, slashing approach to landscape. Elsewhere in New York State painting also flourished, and communities of artists formed in urban centers such as Rochester and particularly Buffalo, where Charles Reiffel, Alexis Fournier, and others worked—activity that has yet to be studied by serious scholars.

New Jersey
The leading Impressionist in New Jersey was Edward Dufner, a major instructor at the Buffalo Fine Arts Academy before he resigned in 1908 to teach at the Art

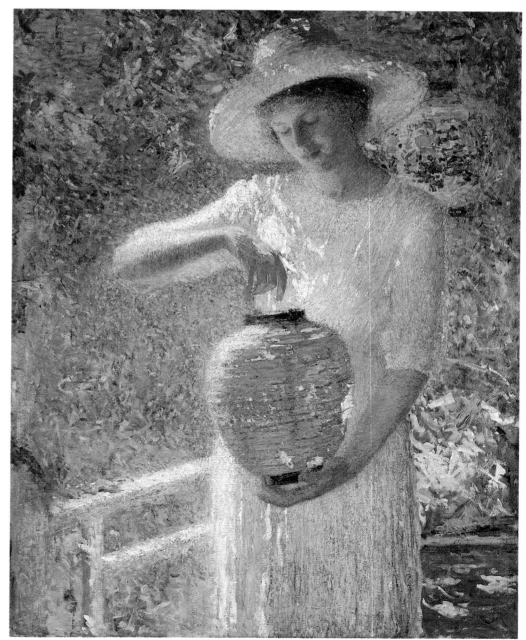

288. CHARLES C. CURRAN (1861–1942). *On the Heights*, 1909. Oil on canvas, 30⅛ x 30⅛ in. The Brooklyn Museum; Gift of George D. Pratt.

289. HELEN TURNER (1858–1958). *Girl with Lantern*, 1914. Oil on canvas, 44 x 34 in. Private collection.

289

Students League. His conversion to Impressionism occurred shortly after his move and is picturesquely documented:

It was not, however, until one day in the spring of 1909, while he was living in Caldwell, N.J., that the complete transformation came. He went forth one sunny morning in May with canvas, paints, and easel in search of a motif for inspiration, and finally settled on the bank of a beautiful lake whose clear, blue water reflecting a sky of brilliant hue, scintillant verdure, and May blossoms, attracted his mood. He proceeded to paint the scene in direct contradistinction to his former low-keyed palette. While deep in his work, some little children came along and after a few moments' hesitation asked the artist if they might watch him while he worked. He smilingly welcomed their company and as they stood in the landscape their bright frocks and rosy cheeks appeared to him to add charm to the scene. He asked them if they would like to be a part of his picture. Delighted, they acquiesced. Presently a group of ducks appeared on the lake as if to complete the joyous composition of perfect springtime, and at the suggestion of the little girls to 'Please put them in the picture,' he added them to his sketch. He called the picture "Joys of Spring" which, the next winter when shown in New York, found an immediate purchaser.[31]

However apocryphal this report, it does describe not only Dufner's first involvement with Impressionism but the joyous nature of his later work. Dubbed the

290. EDWARD DUFNER (1872–1957). *Summer Days*, n.d. Watercolor and gouache on paper, 30¹/₈ x 24¹/₄ in. Private collection.

291. CECILIA BEAUX (1863–1942). *New England Woman (Mrs. Jedediah H. Richards)*, 1895. Oil on canvas, 43 x 24 in. Pennsylvania Academy of the Fine Arts, Philadelphia; Temple Fund Purchase.

292. ROBERT HENRI (1865–1929). *Beach at Atlantic City*, 1893. Oil on canvas, 12 x 17⅞ in. Phoenix Art Museum; Gift of Mr. and Mrs. James Beattie.

290

291

292

"Painter of Sunshine," he depicted a perfect and perpetual springtime: a family lolling serenely in a colorful landscape near a glistening stream in which ducks swim contentedly. Figures are casually but carefully delineated in crisp white garments suffused with purple shadows, while the landscape is depicted in long colored strokes laid side by side and the water with shorter, more curvilinear ones. Dufner early found an attractive, successful, Impressionist formula which he repeated over and over, but always professionally.

Pennsylvania

The history of Impressionism in the third major Eastern metropolis, Philadelphia, has not been studied, but the movement had far less impact there than in New York or Boston, perhaps because of the strong academic tradition translated into native terms by Thomas Eakins at the Pennsylvania Academy and continued by Thomas Anshutz and others. Impressionist painting was first introduced in Academy shows in 1889 when Hassam's *Grand Prix Day* (plate 100) was exhibited, and gradually the modern aesthetic made headway. Only Hassam exhibited in 1890, but the next year in addition to his work both oils and watercolors by Theodore Robinson were shown as well as a painting by Monet. Robert Vonnoh was on the jury in 1892, when the show included a group of Hassam's pastels, some paintings by Tarbell, and four works by Monet. For the rest of the decade the number of Impressionists on the jury and in the exhibitions increased; the high point may have been in 1894 when both Tarbell and Twachtman won Temple Gold Medals. Eighteen hundred ninety-eight saw the Academy's most significant showing of works by Mary Cassatt, the most famous of all Philadelphia Impressionists, who had not exhibited there since 1885, when Alexander Cassatt had lent several portraits. Two of the three major works included in 1898 were Cassatt's great picture *The Bath* (called *The Toilet*) (plate 28) of about 1892 and her 1893 pastel *In the Garden* (plate 30).

What distinguished Philadelphia from Boston and New York in these crucial years of Impressionist development was not the lack of Impressionist works exhibited but the absence of local Impressionist artists. Boston had the Tarbellites and New York had the Hassam-Weir-Twachtman-Robinson group, but there were no Philadelphia Impressionists for at least a decade. Cecilia Beaux exhibited her magnificent *New England Woman* (plate 291) in 1895, which is probably the closest she came to working with Impressionist color, but even this is exceptional in her oeuvre. Vonnoh and Robinson both taught at the Academy during the decade, but Robinson was there only one season, and Vonnoh's impact was felt primarily by Robert Henri, who flirted only briefly with Impressionism, showing several New Jersey coast scenes at the Academy in 1893.

The principal heir to the Impressionist tradition in Philadelphia was Hugh Breckenridge, a student at the Academy in the late 1880s.[32] It is not known whether Vonnoh affected his development before Breckenridge went abroad to study in 1892. After his return to Philadelphia and a post at the Academy, critics noted his growing concern with Impressionism, demonstrated at first in his lamplight figure pieces. In summer 1898 Breckenridge opened the Darby Summer School of Painting in a barn in Darby, Pennsylvania; two years later he moved it to larger quarters at Fort Washington, Pennsylvania, where he named his home "Phloxdale." His landscapes and garden pictures from this decade are among the strongest and best Impressionist works of the period in this country. A writer in 1908 noted that "Mr. Breckenridge evidently is very fond of flowers; there is a considerable number of garden pictures in the collection, and all are fine in composition and color and are extremely decorative in character."[33]

The major "school" of Impressionism in Pennsylvania flourished not in Philadelphia but in the area around New Hope. Its central figure was Edward Redfield, who had been a student at the Pennsylvania Academy with Henri and Breck-

293

*"The Pennsylvania school born in the Academy at
Philadelphia or in the person of Edward W. Redfield is a
very concise expression of the simplicity of our language
and of the prosaic nature of our sight. It is democratic
painting—broad, without subtility, vigorous in language
if not absolutely in heart, blatantly obvious or honest
in feeling. It is an unbiased, which means, inartistic,
record of nature. The painters are a body of plain men to
whom the artistic spirit is a myth, an extravagance or a
frivolity. Back of them is a line of settlers pushed to
rudimentary thought by rudimentary living."*

Guy Pène du Bois, "The Boston Group of Painters: An Essay
on Nationalism in Art," *Arts and Decoration*, October 1915,
p. 457.

294

293. HUGH BRECKENRIDGE (1870–1937). *The Flower Garden*, c. 1906. Oil on canvas, 25 x 30 in. Warren Snyder Collection.

294. WALTER ELMER SCHOFIELD (1867–1944). *The Rapids*, c. 1914. Oil on canvas, 50¼ x 60¼ in. National Museum of American Art, Smithsonian Institution, Washington, D.C.; Bequest of Henry Ward Ranger through the National Academy of Design.

295. EDWARD REDFIELD (1869–1965). *Between Daylight and Darkness*, c. 1909. Oil on canvas, 50 x 56 in. Private collection, New Jersey.

296. EDWARD REDFIELD. *Pennsylvania Mill*, late 1930s. Oil on canvas, 50 x 56 in. Laurent Redfield.

297. EDWARD REDFIELD. *Cedar Hill*, c. 1909. Oil on canvas, 50 x 56 in. Private collection, Hoboken, New Jersey.

enridge in the late 1880s. He returned from study abroad in 1892 and settled in Center Bridge, Pennsylvania, in 1898.[34] There, along the Delaware River, he began to produce the large landscapes, particularly snow scenes dashingly painted in a single session, that became the hallmark not only of his art but of Pennsylvania Impressionism. His broadly painted panoramas influenced numerous fellow painters and were perpetuated in his teaching at the Academy. One might justifi-

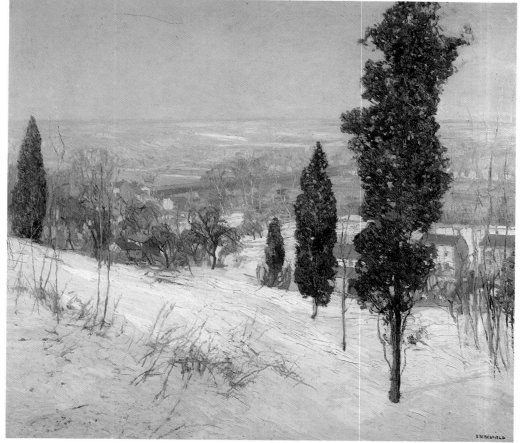

297

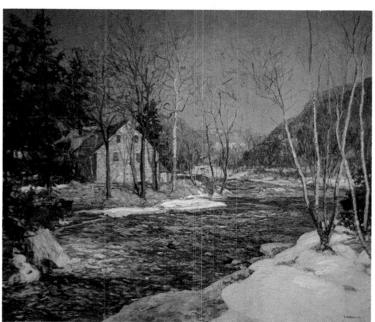

295

296

ably question whether the Pennsylvania School was Impressionist at all, since its aesthetic seems more related to the naturalism of Winslow Homer and the contemporaneous painting of George Bellows, but critics of the day saw them as Impressionist, particularly Guy Pène du Bois, whose articles objectively contrasted the Pennsylvania and Boston schools.[35] For du Bois, the Boston artists, interested in the figure and urban life, were aristocratic, concerned with beauty, but more timid and implicitly "feminine." The Pennsylvanians were rugged, virile, and therefore "masculine"; they were also more "democratic," but totally lacking in sentiment. Du Bois commended the latter most for their Americanness, for having nationalized French Impressionism.

Edward Redfield recalled that even as a student in Paris he had been less interested in the Old Masters than in modern artists such as Monet, Pissarro, and Fritz Thaulow.[36] Thaulow was at that time considered the leading Norwegian Impressionist. His vigorous paintings of snowy landscapes and broad, flowing streams—the principal subjects taken up by Redfield and others of the Pennsylvania School—were often exhibited in America in the late nineteenth century. Thaulow was a friend of Walter Elmer Schofield, another Pennsylvania School artist, who had studied at the Academy before going on to Paris. Schofield then went to England and settled in the Saint Ives art colony in Cornwall in 1903.[37] Although he became an expatriate, Schofield was recognized by the critics not only as an American but as part of the Pennsylvania Impressionist tradition; he continued to exhibit in this country, to belong to American art organizations, and to receive prizes here. Schofield painted sun-filled landscapes in extremely bright colors but became best known for his snowscapes and his onrushing streams, painted in extremely broad, fluid strokes, the action of the paint echoing the movement of the water, often along an extended diagonal axis. Thaulow's water was relatively placid, Redfield's more vigorous, and Schofield's the most dynamic of all.

Vigorous depictions of rugged American landscapes—usually joyous, never threatening—were much appreciated in the early years of the century, and many

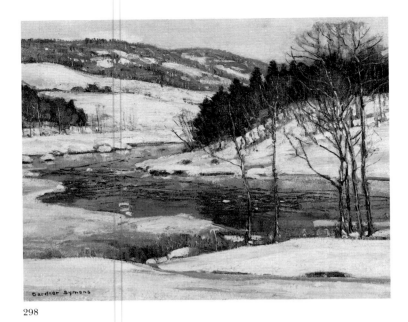
298

were painted by Pennsylvania School artists and others, such as Charles Rosen during his association with Redfield and George Gardner Symons, who was regularly identified with the Pennsylvania artists. Symons was an esteemed Chicago painter who also worked at Saint Ives with Schofield and painted in Laguna Beach, California, with William Wendt.[38] Symons was considered a realist in his training but an Impressionist in his mode of expression, painting colorful canvases with great areas of white covered with shimmering shadows. The appeal of such paintings was doubly nationalistic: critics recognized the winter landscape as a traditional American subject and applauded the transformation of a foreign aesthetic into a true expression of this native heritage. As one writer said about Schofield, "He is as near to the vigorous banner of Winslow Homer as he is far from the tenderly tinctured oriflamme of Twachtman."[39]

Winter landscapes were only one aspect of Pennsylvania School painting. Schofield painted village and port scenes, and several of Redfield's finest, subtlest works were evening views of New York painted about 1909, which merge the sensibilities of Whistler's Nocturnes with the vital urbanism of the Ashcan School. Several of the Pennsylvania group worked in even more original ways. One of these was Robert Spencer, whose art dealt primarily with the life and environment of the working classes, the only major Impressionist to concentrate on this subject matter.[40] One might view this as Spencer's legacy from his two teachers at the New York School of Art, William Merritt Chase and Robert Henri, where he studied from 1903 to 1905. From Chase, Spencer seems to have absorbed a concern for painterly surfaces and pictorial effects; from Henri an interest in social themes. Spencer began to paint along the Delaware River Valley and ultimately settled in New Hope, where he painted such subjects as his *Grey Mills* (plate 300) of about 1915, a view of the William Maris Cotton Mill. Workers are grouped in the foreground, but the mill building is the primary focus, and it looms over the small figures below. Factories, tenements, and the backyards and backsides of apartment buildings are Spencer's special themes—as in his best-known work, *White Tenements* of 1913 (plate 299)—though his Impressionist colorism and scintillating brushwork mitigate their sobriety.

While some of Spencer's work is technically the most orthodox Impressionism

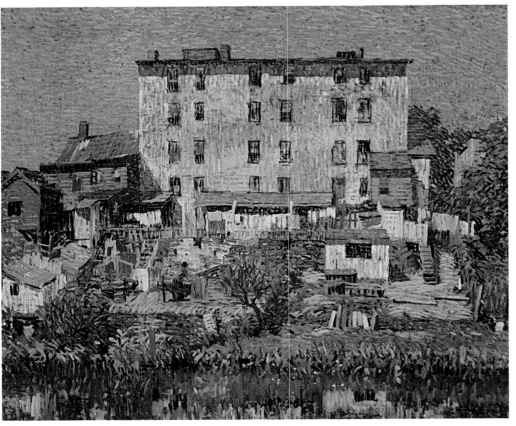
299

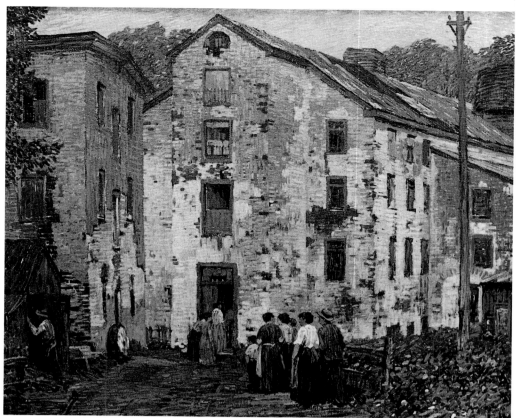

300

298. GEORGE GARDNER SYMONS (1863–1930). *Winter*, n.d. Oil on canvas, 20 x 25 in. Scripps College, Claremont, California; Gift of General and Mrs. Edward Clinton Young, 1946.

299. ROBERT SPENCER (1879–1931). *White Tenements*, 1913. Oil on canvas, 30 x 36³⁄₁₆ in. The Brooklyn Museum; John B. Woodward Memorial Fund.

300. ROBERT SPENCER. *Grey Mills*, c. 1915. Oil on canvas, 30 x 36 in. Widener University Art Collection, Chester, Pennsylvania.

of the Pennsylvania School, the most original of that group and the most concerned with sunlight and color was Daniel Garber; he is also the one who has recently attracted the greatest attention.[41] Born in North Manchester, Indiana, Garber studied at the Art Academy of Cincinnati and seems not to have had any contact with the Hoosier School of Impressionists; his serious impulses toward the style may have been fostered at Hugh Breckenridge's Darby Summer School, which he attended in 1899 and 1900. At the same time Garber began to study at the Pennsylvania Academy; in 1905 the Academy awarded him the Cresson fellowship, and he immediately went abroad. His English paintings of that year may be the most strictly Impressionist work of his career, though whether or not he actually saw any French Impressionist paintings in London is not known. He went on to Italy and then to Paris, then returned to Philadelphia in 1907 to teach and moved into a summer studio in Lumberville, New Jersey, across the Delaware from New Hope.

A few years later Garber began to gain national prominence after receiving the Hallgarten Prize from the National Academy. During the next decade he had great success and established several Impressionist-related manners. Garber's landscapes are conceived in two quite different, overlapping modes that seem to have evolved simultaneously. *The Quarry* of 1917 (plate 301) is the finest of the first mode: the great rock formation is tightly painted with a concern for subtle nuances of shape and detail and illuminated in a radiant "glow aesthetic" that shimmers in the water below. These are quite realistic paintings, permeated with evidence of man's invasion and exploitation of the land. They differ from Garber's other mode, his more decorative landscapes in which trees painted in stitchlike patterns of bright colors weave sinuously through the composition, often contrasting with small blocks of buildings. *The Hawk's Nest* (plate 302) is representative of this much more Post-Impressionist, less realistic style. Both modes utilize a classical spatial approach with parallel planes in clear progression from background to foreground. Garber's work exemplifies two of the primary directions of American Post-Impressionist landscape painting in the second decade of this century, and his position is significant. The more decorative style became dominant in his work; it also characterizes some of Garber's figure painting, including the 1915 *Tanis* (plate

301

302

304). His young daughter stands in the doorway of their Delaware Valley house, shadowed and backlit against a brilliantly decorative landscape; sunlight pours through her sheer frock and she glows in reflected light. In other pictures members of his family are shown indoors, silhouetted against windows in a manner strongly suggesting some of Hassam's New York Window paintings.

Perhaps the most unlikely artist to be considered Impressionist is Newell Convers Wyeth, the famous illustrator, of Chadds Ford, Pennsylvania.[42] Though his illustrations provided N. C. Wyeth fame and fortune, he was in conflict over his ambitions toward easel painting. As early as 1903 Wyeth pursued painting independently, and he was directed toward a Tonalist interpretation of landscape by the work of Henry Ward Ranger and J. Francis Murphy. By the end of the decade Wyeth's admiration turned toward Hassam and Weir, and on meeting William Paxton in 1913 he expressed a wish to study with Tarbell and Benson. Broken Impressionist color began to appear in his rural landscapes by 1909, and Wyeth became more involved in Impressionism as he grew closer to the New Hope group and particularly to Daniel Garber. Perhaps most influential in Wyeth's short-lived Impressionist period (from about 1915 to 1920) was the art of the Swiss-Italian painter Giovanni Segantini; Wyeth had admired his work since his early study with Howard Pyle, and a reproduction of Segantini's *Springtime in the Alps* hung in Wyeth's studio. Segantini's successful Impressionist translation of the theme of rural labor attracted Wyeth, who applied it to the farmland around Chadds Ford in works such as his *Pyle's Barn* (plate 303) and *September Afternoon* (1918), complete with the brilliant palette of Impressionism and the texture of the "Segantini stitch" brushwork.

301. DANIEL GARBER (1880–1958). *The Quarry*, 1917. Oil on canvas, 50 x 60 in. Pennsylvania Academy of the Fine Arts, Philadelphia; Temple Fund Purchase.

302. DANIEL GARBER. *The Hawk's Nest*, n.d. Oil on canvas, 52 x 56 in. Cincinnati Art Museum; Mary Dexter Fund.

303. N. C. WYETH (1882–1945). *Pyle's Barn*, 1921. Oil on canvas, 25 x 30 in. Private collection.

304. DANIEL GARBER. *Tanis*, 1915. Oil on canvas, 60 x 46¼ in. The Warner Collection of Gulf State Paper Corporation, Tuscaloosa, Alabama.

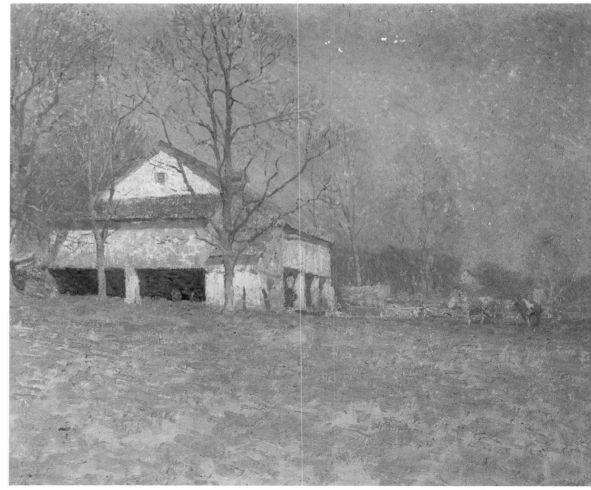

303

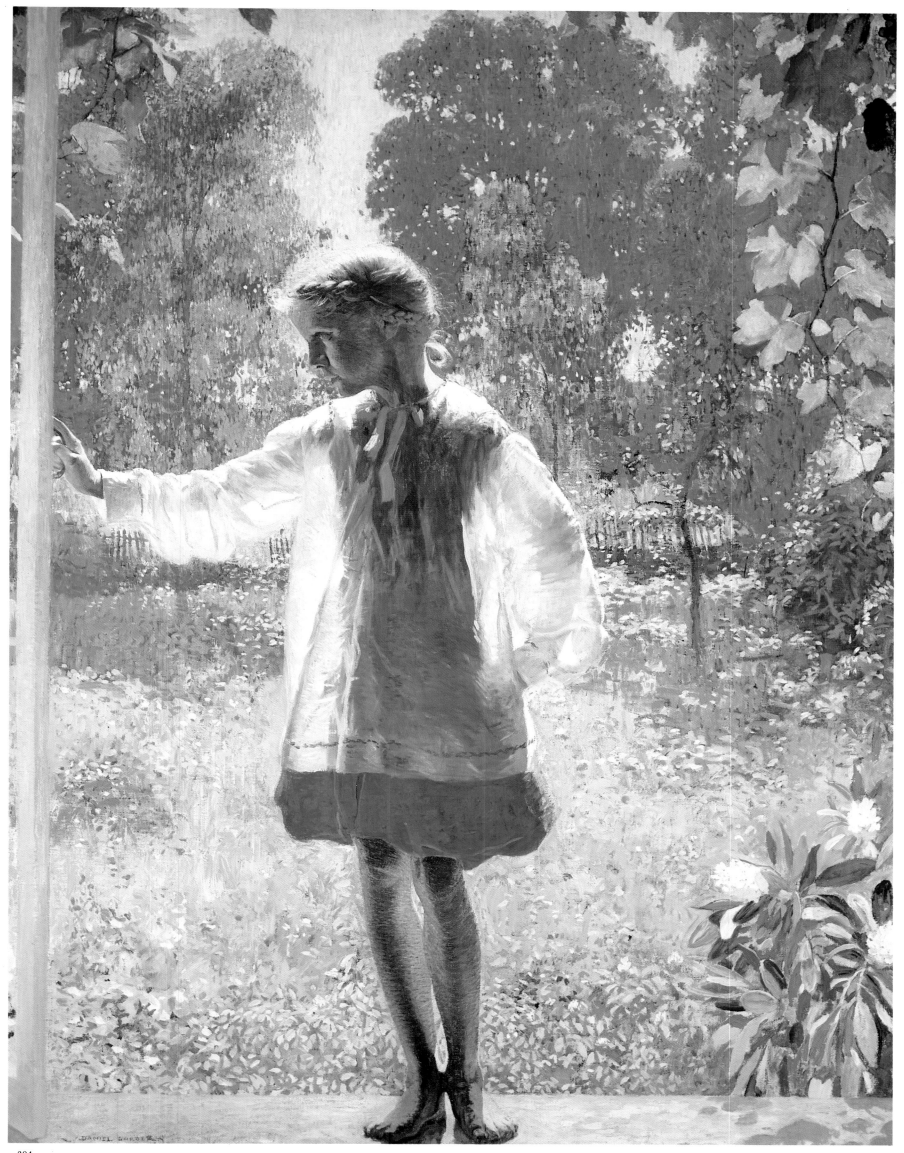

305. AUGUST ROLLE (1875–1941). *Early Spring, Good Hope Hill*, c. 1925. Oil on canvas, 22 x 24 in. Robert Fastov.

306. BENSON MOORE (1882–1974). *On the Upper Potomac*, 1924. Oil on canvas, 23½ x 23½ in. Gary L. Johnson Collection.

307. GARI MELCHERS (1860–1932). *Unpretentious Garden*, 1906–10. Oil on canvas, 33½ x 40¼ in. Telfair Academy of Arts and Sciences, Savannah, Georgia.

306

305

The South

South of Philadelphia and the Delaware River Valley, Impressionism took a far weaker hold, and almost no important masters seem to have emerged in the early twentieth century. In Baltimore some Impressionist features can be found in the work of Clark Summers Marshall, who otherwise worked in a Tonalist manner, and in that of R. McGill Mackali, a local rural painter. Perhaps the artist most closely associated with the movement was S. Edwin Whiteman, who was instructor of drawing at Johns Hopkins University from 1890 to 1922 and who achieved a reputation for Impressionist landscapes.[43]

Nor did Impressionism make much headway in Washington, D.C. Landscape painting there at the turn of the century was dominated by the Barbizon-oriented May Weyl, whose Tonalist views along the Potomac and in the neighboring Virginia and Maryland countryside are reminiscent of the paintings of the Hague School in Holland and of such Americans as Henry Ward Ranger.[44] In 1913 the Landscape Club was founded to promote regional work, and this seems to have led to some tentative results in the Impressionist manner by members such as Benson Moore and August Rolle. Rolle's *Brunswick, Maryland* is painted in a fairly orthodox Impressionist style, while Moore's winter view *On the Upper Potomac* of 1924 (plate 306) is more related to the broader, less-divisionist effects of Redfield and the New Hope group.

For reasons that are not yet clear, Southern artists seldom experimented with Impressionism, nor were collectors in the area attracted to it; and Northern artists who worked in the South rarely were of an Impressionist persuasion. The two most significant exceptions were artists who painted in Virginia. One of them, Gari Melchers, was also the most famous American artist working in the South in the early 1900s.[45] He had come to prominence in the 1880s and '90s, painting

monumental peasant imagery in Paris and in Egmond-aan-den-Hoef in Holland, where he lived for many years; gradually his work became more intense in color and more decorative as a result of his modernist investigations. His involvement with Impressionism was seen first in his more personal work, such as his *Unpretentious Garden* (plate 307), produced during his last years in Holland, about 1906–10. Painted in a flecked, Impressionist manner, it is a domestic scene of great tranquility, reinforced by the bathing sunlight. In 1909 Melchers became an instructor at the Ducal Academy in Weimar, Germany; with the approach of World War I he returned briefly to Egmond and then in 1915 to America. In 1916 he purchased "Belmont" in Fredericksburg, Virginia, and there his involvement with Impressionism developed, both in land- and cityscapes, usually with buildings, such as his view of *St. George's Church* (plate 310) in Fredericksburg, and in domestic figural pieces at Belmont. His *Young Woman Sewing* (plate 308) is a classic example of domesticated American Impressionism: in a subdued interior, painted in broken brushwork, the figure of his wife is silhouetted against a window, and beyond her is an inviting garden in blazing sunlight. Although Melchers was a

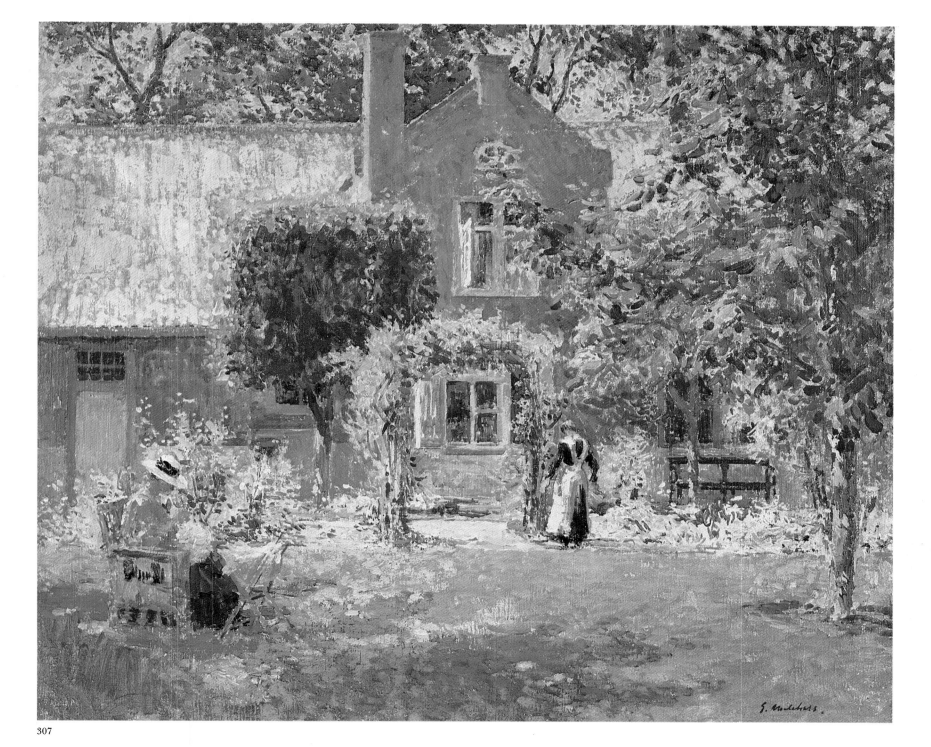

307

308

309

310

relative latecomer to Impressionism, his achievements in that aesthetic were of high quality.

The other significant Southern painter was Eliot Clark, who moved to Albemarle County, Virginia, in 1932.[46] A landscapist and a major writer on art, he worked in both a Tonalist and an Impressionist manner. His Impressionist sympathies were undoubtedly stimulated early, not only by the work of his father, Walter Clark, but by his association with Twachtman and other painters of that persuasion in Gloucester in 1900. He later wrote an important book on Twachtman and articles on Robinson, Hassam, Weir, and Vonnoh.

Elsewhere in the South, Impressionism seems to have been almost completely nonexistent. New Orleans was the most important art center in the South at the end of the century, but except for the broadly rendered forms and decorative effects sometimes favored by the brothers William and Ellsworth Woodward in their paintings, there seems to have been no evocation of Impressionism there.[47] Kate Freeman Clark of Holly Springs, Mississippi, produced some lovely Impressionist landscapes in the early twentieth century, but in the North under the tutelage of William Merritt Chase; his death in 1916 and her increasing family responsibilities drove Clark to abandon painting and ultimately to return to Holly Springs.[48] Though she is celebrated throughout the state as Mississippi's most important painter, she never painted there.

One Southern contribution to Impressionism can be found in Julian Onderdonk's paintings of flowering fields done in the 1910s around San Antonio, Texas.[49] Onderdonk was a Texas artist who had studied in New York at the Art Students League and with Chase at Shinnecock and at his New York School of Art. He later developed a routine of spending the summers in New York and the rest of the year in Texas. Onderdonk's Texas landscapes were painted in a free, vigorous

308. GARI MELCHERS. *Young Woman Sewing*, c. 1923. Oil on canvas, 34¼ x 29¼ in. Belmont, The Gari Melchers Memorial Gallery, Fredericksburg, Virginia.

309. KATE FREEMAN CLARK (1874–1957). *Shinnecock Hills*, c. 1902. Watercolor on paper, 38 x 34 in. Marshall County Historical Society, Holly Springs, Mississippi.

310. GARI MELCHERS. *St. George's Church*, c. 1920. Oil on canvas, 33 x 32¼ in. Belmont, The Gari Melchers Memorial Gallery, Fredericksburg, Virginia.

311. GRANVILLE REDMOND (1871–1935). *California Landscape with Poppies*, c. 1925. Oil on canvas, 30⅛ x 40 in. Bancroft Library, University of California, Berkeley; Gift of Mr. J. G. Redmond.

312. JULIAN ONDERDONK (1882–1922). *Bluebonnet Field*, 1912. Oil on canvas, 20 x 30 in. San Antonio Museum of Art; Gift of Mrs. Grace Irvin Gosling.

312

311

manner, but not in an Impressionist technique. Rather, when he chose to depict the flower-carpeted sweep of the land, in the rich yellows of the cactus flowers or the deep azures of the bluebonnets, he painted in small strokes to simulate the effects of the myriad blooms, achieving a style akin to Impressionism and using a favorite Impressionist theme. Onderdonk earned, and hated, the appellation of "The Bluebonnet Painter" and inspired a whole school of followers who still are turning out endless landscapes of the state's official flower. A somewhat more delicate approach to a similar theme was practiced by Granville Redmond, who painted the golden poppy fields of California in the same period. Mention should also be made of the Impressionist-related oils and pastels of Texas and the Texan Longhorns painted by Dallas-based Frank Reaugh, which were exhibited in Chicago in one of the first exhibitions of the Central Art Association in 1895.

The Midwest

If the South did not "take to" Impressionism, it found greater favor in the Midwest. Almost surely this resulted from the attention it received at the 1893 Columbian Exposition in Chicago and from the reputation of the Hoosier School in Indiana. In Frankfort, Kentucky, Paul Sawyier practiced a modified form of Impressionism, at its best in his scintillating watercolors of the city and the surrounding countryside.[50] In Louisville in the first two decades of this century, Paul Plaschke and his friend Bruno Alberts painted outdoor landscapes in a light-filled, modified Impressionist manner. Both Sawyier and Alberts had studied in Cincinnati, the early art center of the region. Impressionism, however, did not establish itself strongly in Cincinnati, primarily because Cincinnati artists who involved themselves with it went elsewhere.[51] Like artists from other Midwestern centers, they tended to follow Frank Duveneck's lead and go to Munich, where Impressionism was not promoted. Some of them did move on to Paris or come under Impressionist influences from other sources, but they rarely found a favorable reception back home. Louis Ritter, a Cincinnati artist who became one of the Duveneck Boys in Munich, left the Midwest again after unfavorable reviews about 1884; he returned to work with Duveneck in Italy, where he developed a modified Impressionist manner. He then joined the early Impressionist landscape contingent in Boston before his untimely death there in 1892.[52]

313

314

315

The Cincinnati painter Edward Henry Potthast studied first at the McMicken School there and then in 1882 traveled to Antwerp and Munich. He went to Europe again in 1887, to Munich and then Paris, and was in Grèz by 1889 or 1890. In Munich he had concentrated upon the figure, but in Grèz he fell under the influence of Robert Vonnoh and Roderick O'Conor and turned to landscape painting.[53] His *Sunshine* of 1889 (plate 315), exhibited at the Paris Salon that year, employs the variegated color of Impressionism and the broad, scrubby, impastoed brushwork of O'Conor. The picture was shown again in Cincinnati, in Potthast's first one-man exhibition there at Barton's Art Store in 1892; Potthast was noted as being the first Cincinnati artist to embrace Impressionism.[54] He is best known today for his scenes of beaches in New York, where he moved in 1896.[55] These may be later pictures, though they tend to be undated. Potthast maintained an Impressionist commitment from his days at Grèz, but his adoption of carefree bathers as subjects may have developed in the 1910s. (The catalog of Potthast's one-man show at the J. W. S. Young gallery in Chicago in March 1920 noted that the artist had begun to exhibit a series of beach scenes only recently.) These paintings are often of children playing on the sand or in the water, rendered in generalized form and with emphasis on flat patterns of beach umbrellas, balloons, and bathing caps. Painted in both thickly impastoed oils and free-flowing washes, they seem inspired, at least in part, by the work of the Spanish artist linked to Impressionism, Joaquín Sorolla,[56] while also recalling similar subjects by William Glackens and, particularly, by Maurice Prendergast.

Munich-trained Joseph De Camp also left Cincinnati after unfavorable reviews in the mid-1880s and settled in Boston, while his friend John Twachtman had more or less severed his ties with Cincinnati by 1882. Despite the association of all these painters with Frank Duveneck, in Cincinnati and in Europe, Duveneck himself resisted Impressionist facture and fragmentation. In some of his late landscapes created in Gloucester where he painted with Twachtman and De Camp, he did adopt some of the bright Impressionist colorism.[57] Charles Kaelin, who returned to Cincinnati after studying with Twachtman at the Art Students

313. LOUIS RITTER (1854–1892). *Villa Castellani, near Florence*, c. 1888. Oil on canvas, 26⁷⁄₁₆ x 35⁹⁄₁₆ in. Cincinnati Museum of Art; Gift of Frank Duveneck.

314. EDWARD POTTHAST (1857–1927). *The Balloon Vendor*, c. 1910. Oil on canvas, 30 x 40 in. Mr. and Mrs. Merrill J. Gross.

315. EDWARD POTTHAST. *Sunshine*, 1889. Oil on canvas, 31¹⁄₁₆ x 25⅝ in. Cincinnati Art Museum; Gift of Larz Anderson.

316. EDWARD POTTHAST. *At the Beach*, n.d. Oil on board, 5 x 7 in. The Warner Collection of Gulf State Paper Corporation, Tuscaloosa, Alabama.

League, spent his summers in Gloucester; and in 1916 he moved permanently to nearby Rockport, where he worked in a modified Impressionist manner.

Before leaving the Midwest permanently to settle in Boston, Joseph De Camp spent part of 1883 in Cleveland. He and Otto Bacher planned the Cleveland Room for the great loan exhibition in Detroit that year; both taught a sketch class in Richfield, Ohio, that summer and organized the Cleveland Academy that September. Bacher was engaged in a major work, *Ella's Hotel, Richfield Center*, completed in 1885; it depicts country people in a casual rural setting, dramatically illuminated in glaring summer sunlight.[58] In 1885 he returned to Europe and was back in Cleveland in 1887. He soon moved to New York, where he developed the Impressionism so evident in his 1893 *Nude Outdoors* (plate 317). While it may be the most fully Impressionist treatment of the nude in American art, Bacher's Munich and Parisian academic training is evident in the firm structure of the figure. This was the nude that Theodore Robinson had found "too photographic."[59] Bacher was an able and distinctive painter in both oil and pastel, but his activity in these media has been overshadowed by his brilliant printmaking. It developed under Whistler's tutelage in Venice in 1880, and Bacher's book on the relationship was published in 1908.[60] Frederick Gottwald, Bacher's boyhood friend and fellow Munich art student, remained in Cleveland and became one of the principal teachers there; he later painted sun-filled landscapes of Italy in a decorative, Post-Impressionist manner.

A mild form of Impressionism was practiced in Pittsburgh by the landscapist Christian Walter, and it even informed the later paintings of Joseph Woodwell, one of the Scalp Level group of artists who made that rural Somerset County site

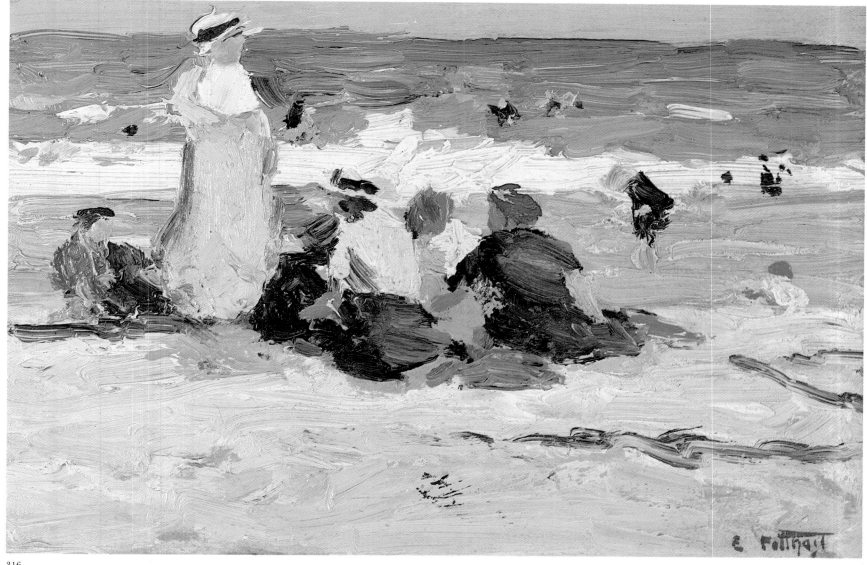

316

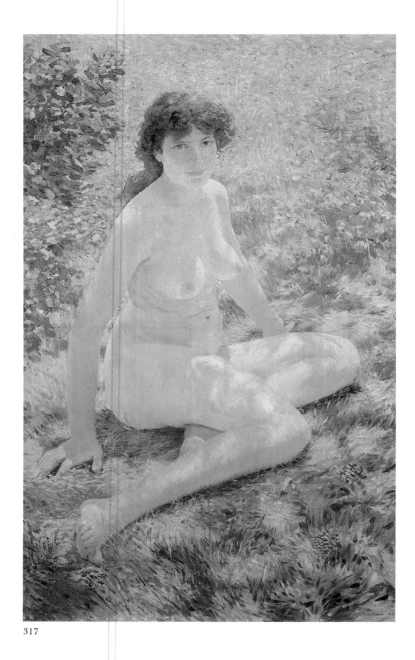

317

into a local Barbizon about 1870. But in Pittsburgh, Arthur Watson Sparks, the first head of the painting department at the Carnegie Institute of Technology, was the person most sympathetic to Impressionism and an admirer of Monet's work. A landscape and figure painter, Sparks was a close friend of Edward Redfield and spent his last months painting with him in the New Hope area.[61]

In Chicago, Impressionism had been sparked by the Columbian Exposition and the activity of major collectors of French Impressionist art such as the Potter Palmers, who would ultimately own as many as thirty-two canvases by Monet.[62] Although Chicago had made an amazing comeback from the disastrous fire of 1871, the Exposition was viewed as the real birth of a mature artistic tradition in the city. The seeds, however, had already been planted: in the collecting activities of the Palmers, Ryersons, Yerkes, and others; in the establishment of the Inter-State Industrial Expositions in 1873; and above all in the activities of the Art Institute of Chicago and its school. Among its noted teachers were John Vanderpoel, a figure painter; the sculptor Lorado Taft; and William Merritt Chase, who was a visiting instructor in 1893.

Turn-of-the-century Chicago was rife with professional art organizations. One of the earliest of importance was the Chicago Society of Artists, formed in 1888.[63] But professionalism did not always encourage modernity, and for the spring 1892 exhibition of the Society two prizes were offered for the best paintings by local artists *not* in the new style—specifically defined as that of "Monet, Pissarro and Sisley, and their followers and works in which a summary treatment and eccentricities in drawing and color take the place of intelligent selection or arrangement and conscientious study."[64]

This conservative spirit may have stimulated the formation of another, more adventurous society that year, the Cosmopolitan Art-Club. The Exposition the following year gave rise to discussions on the merits of Impressionism, and its championing by Hamlin Garland led to the formation of the Central Art Association in 1894. Its specific goal was to promote Impressionist painting throughout the Midwest and to inspire a native form of it, soon recognized by Garland in the work of the Hoosier School. The artists of that group also showed at the Cosmopolitan Art-Club, and they formed the Indiana contingent of the Society of Western Artists, founded in 1896, which circulated exhibitions of painting by Midwesterners to six major cities: Chicago, Indianapolis, Cincinnati, Detroit, Saint Louis, and Cleveland.

Despite the impact of the Exposition and the prominence of the Hoosier Impressionists in Chicago exhibitions, there seems to have been little immediate engagement with the aesthetic by Chicago painters. For almost a decade after the Society began its annual exhibitions, the Hoosiers were practically alone in their adherence to Impressionism. This almost surely resulted, at least in part, from the strong, inherent conservatism of the Chicago art establishment. Charles Francis Browne, a leading landscape painter, was a Barbizon-inspired Tonalist and "The Conservative Painter" of Garland's "Critical Triumvirate" (see chapter 8); the dominant teacher at the School of the Art Institute was John Vanderpoel, a champion of the academic tradition who taught and published a book on figure drawing.[65] And unique to Chicago was the fact that its major artist of national reputation, Lorado Taft, was *not* a painter but a sculptor, and that in the 1890s the city was known for its sculptors, including some who stayed because of the sculptural program of the Exposition and others who came to study with Taft.

By the early 1900s, however, Chicago began to produce able Impressionist artists, both landscape and figure painters, many of whom had begun their training with Vanderpoel at the Art Institute. This development began about 1892 when Vanderpoel decided to emulate Chase's Shinnecock Summer Art School, which encouraged outdoor landscape painting, though not necessarily Impressionism. For many years the students of the Art Institute summered in nearby Delavan, Wisconsin, where Vanderpoel and his classes received further

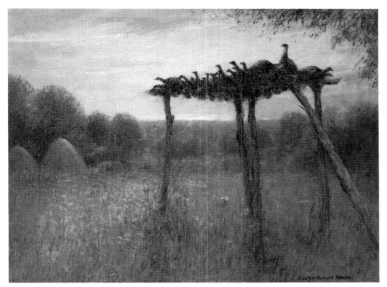

318

encouragement from an earlier student at the school, Adolph Shulz, who was a Delavan native. In 1900 Shulz discovered the rural beauty of Brown County, Indiana, and he persuaded a host of fellow Delavan-Chicago landscape painters to establish that area as a new summer art colony in 1907–8, just at the time when the leading Hoosier landscapist, Theodore Steele, had settled there permanently.[66] By then Shulz had abandoned his earlier Tonalism for a coloristic Impressionism similar to that of Steele and the first Hoosier School. The initial group that explored Brown County with him in 1907 consisted of Louis Griffith, Harry Engle, and Wilson Irvine, all landscapists who were developing an Impressionist aesthetic. Irvine later transferred his maturing Impressionism to the Old Lyme colony, where he would reside from 1919 on. Other Chicago landscape painters who regularly visited Brown County from 1908 were Lucie Hartrath, the earliest of the Chicago Impressionists to show with the Society of Western Artists, and Carl Krafft. Hartrath preferred the variegated autumnal tones so pertinent to Impressionism; Krafft developed Post-Impressionist landscapes of decorative forms in brilliant colors, inspired in part by the work of Lawrence Mazzanovich, an artist with Chicago ties who showed there often at the Thurber Gallery in the early 'teens. And Krafft, inspired by the activities of the Brown County colony, discovered another new painting ground, founding in 1913 the Society of Ozark Painters and becoming its president.[67] This was a group of Chicago and Saint Louis artists who established summer studios in the rural Ozarks, on the Gasconade and White rivers in Missouri. Rudolph Ingerle was a Chicago member of the Ozark group who by 1930 had gone on to still another unspoiled region, the

317. OTTO BACHER (1856–1909). *Nude Outdoors*, 1893. Oil on canvas, 35½ x 22⅝ in. The Cleveland Museum of Art; Gift of Will Low Bacher.

318. ADOLPH SHULZ (1869–1963). *Turkey Roost*, 1918. Oil on canvas, 34⅛ x 44 in. Indianapolis Museum of Art; Gift of Mrs. Adolph Robert Shulz.

319. LUCIE HARTRATH (1868–1962). *Autumn Pageant*, n.d. Oil on canvas, 42 x 42 in. Union League Club of Chicago.

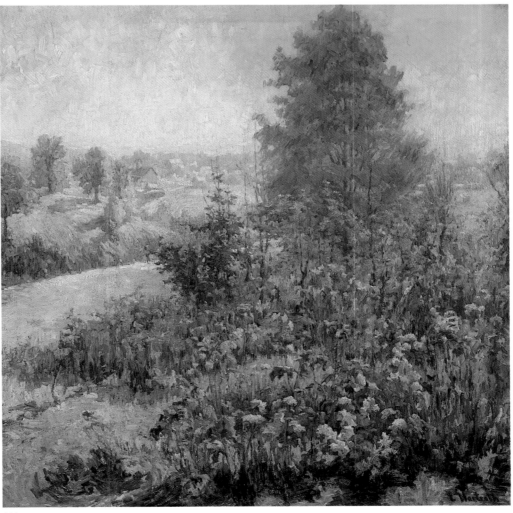

319

320

320. CARL KRAFFT (1884–1938). *The Mystic Spell*, c. 1915. Oil on canvas, 46 x 43 in. Barbara Millhouse.

321. LAWRENCE MAZZANOVICH (c. 1872–1959). *New Hampshire, Opus I*, c. 1910. Oil on canvas, 30 x 30 in. Glensheen, University of Minnesota, Duluth.

322. GEORGE AMES ALDRICH (1872–1941). *The Millstream in Summer*, n.d. Oil on board, 36 x 36 in. Warren Snyder Collection.

323. ALSON CLARK (1876–1949). *Giverny*, 1910. Oil on canvas, 26 x 32 in. Alce Ann Cole.

321

322

Smokies in western North Carolina and eastern Tennessee.[68] The Ozark group utilized the chromaticism and free brushwork of Impressionism, but they preferred stylized and generalized form, patterning of foliage and vines, and a more spiritual interpretation of nature; yet, like the Hoosiers, they wanted to express qualities specific to the region.

Another group of Chicago landscape painters created paintings more closely related to the Impressionism of Redfield and his Pennsylvania group; they were specialists in winter effects who owed a debt to the Norwegian Impressionist Fritz Thaulow. Thaulow had been represented in the Columbian Exposition with three oils, and the Norwegian contingent of modernists at the fair were praised most by Garland in his essay on Impressionism.[69] Svend Svendsen had studied with Thaulow before he moved to Chicago, where he began to exhibit his work shortly after the Exposition. George Ames Aldrich also had had contact with Thaulow in Paris and was a leading Chicago painter, primarily of winter scenes of Brittany villages along flowing streams. Two other Chicago landscapists involved with Impressionism were William Wendt and Alson Clark; both were to transmit the tradition to Southern California. Wendt made a trip to the West Coast as early as 1894, returning two years later with George Gardner Symons, another landscapist associated with both Chicago and the Pennsylvania School. Though Wendt continued to live and exhibit in Chicago, California obviously beckoned, and in 1906 he made the commitment to settle in Los Angeles. In 1912 he built a studio at Laguna Beach, which soon became the major art colony in Southern California. Wendt's bold, broadly brushed California painting is well known in that state, and it fits into the context of Impressionism there; but his Chicago work has not been studied.[70] Alson Clark settled in Los Angeles in 1919, after a peripatetic life based in Chicago, where he exhibited colorful Impressionist works based on his far-flung travels—notably a stay in Giverny in 1910 with his colleagues Frederick Frieseke and Guy Rose.

While there were more Impressionist landscapists than figure painters in

"Looking back upon it, it hardly seems possible that such an uproar could be created because a small group of men, banded together by a common creed, saw vibrations in sunlight and blue and purple in shadows. But to those of us painting in Paris at the time, it seemed almost a matter of life and death to prove, or disprove, the contentions of the Impressionists. The Cafes seethed and boiled with loud arguments in the midst of overturned tables and some broken heads. A disbeliever would ask, how could a cow possibly be purple? And a believer, thought by the other side to be entirely mad, would answer, 'How could a red cow, in the distance, be anything but purple, since each degree of distance contains a strata of blue, until in the extreme distance only blue exists? Therefore since red and blue combined form purple, how could a red cow, in the distance, be anything but purple?'"

Frederic Clay Bartlett, *Sortofa Kindofa Journal of My Own*, p. 25.

323

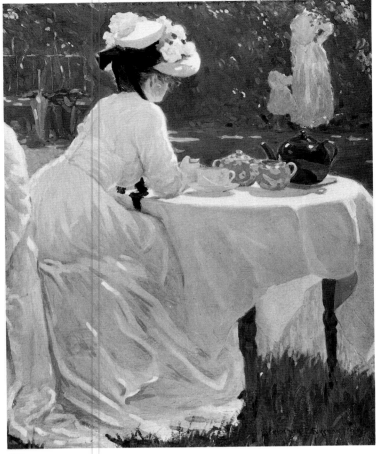

324

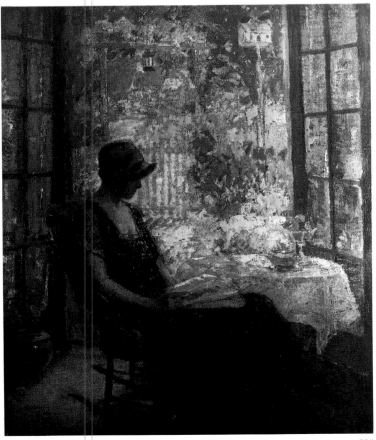

325

Chicago, the latter are better known today. One of the figure painters, Frederic Clay Bartlett, first arrived in Paris in 1896 after training in Munich. His mature style tended toward Post-Impressionism, a predilection evident in his great painting collection, which he gave to the Art Institute in 1926. Another figure painter among the Chicago artists was Frederick Fursman, who had studied at the School of the Art Institute before going to Paris; he joined the Chicago faculty in 1910 and remained for three decades. *In the Garden* of 1909 (plate 324) is a typical Impressionist subject, but Fursman remains more interested in form than dissolution. Sunlight is important, but it is used for clarification, and he avoids the most obvious feature of the popular garden theme, the multitude of flowers. His painting style seems more inspired by Chase than by the more orthodox Impressionists, and he also emulated Chase by founding the Saugatuck Summer School in Michigan, a school of outdoor painting that served the Art Institute. Many of the Chicago figural Impressionists—Frederick Frieseke, Lawton Parker, Louis Ritman, and others—tended to gravitate to Giverny, becoming part of the second generation of American expatriate painters who settled there in the first decade of this century (see chapter 13). Pauline Palmer was a Chicago artist who had an early success in the Paris Salon of 1903, a time when she was studying with Richard Miller in France.[71] Her *From My Studio Window* of 1907 (plate 325), the year after her return to Chicago, is a rather elegant but still casual sun-filled interior similar to Miller's own figure painting, though Palmer did still lifes and landscapes as well. The silhouetted woman in tones more subdued than the brilliantly colored garden outside is a motif favored by American Impressionists; though Palmer avoided the monumentality of Miller's figures and the strong patterns that he favored, she insured an underlying sense of structure by emphasizing architectural elements in the room and the garden.

Artistic activity in Minneapolis in the late nineteenth century was stimulated by the founding of the Minneapolis School of Art in 1886 under the direction of Douglas Volk.[72] Volk left in 1893, and Robert Koehler took over, abandoning the social themes of his early years for rather elegant figure paintings of scenes in Minneapolis homes or on its fashionable streets. These were done in a Whistlerian Tonalist manner but with gentle coloristic harmonies not unlike J. Alden Weir's several Nocturnes of the same period.

The most famous Impressionist painting by a Minneapolis artist is unquestionably Alexander Grinager's *Boys Bathing* of 1894 (plate 327), an extremely popular theme in American art of the late nineteenth century. The boys in Grinager's painting are neither generalized nor idealized; they are poor neighborhood boys in an identifiable Minneapolis locale, and they are dressed (or undressed) and posed with natural awkwardness. Placed in bright but transient light, they are caught in a specific moment of time and interpreted in a high, varied color range. Grinager returned to Minneapolis from study abroad with a sound academic technique, as well as a knowledge and understanding of modernist style, applied here to an almost Eakins-like subject. The impact of this interesting combination in Minneapolis must have been negligible, because he left to settle in Ossining, New York, in 1896.

Alexis Fournier was a major Impressionist landscape painter who was born in Saint Paul, grew up in Milwaukee, and worked in Minneapolis from 1883 to 1893. His depictions of the growing city are some of the finest ever created, done in a direct, naturalistic vein. After he left to study in Paris in 1893, Fournier's associations were far greater with Chicago, Buffalo, and Indiana than with Minneapolis. In Minneapolis, Edwin Dawes painted industrial views in an Impressionist vein early in the twentieth century. By and large the movement was not strong in Minnesota, which may explain why the Society of Western Artists did not reach out to include Minneapolis painters.[73]

By the turn of the century Chicago and Saint Louis had become the major progressive art centers of the Midwest, usurping the role that Cincinnati had

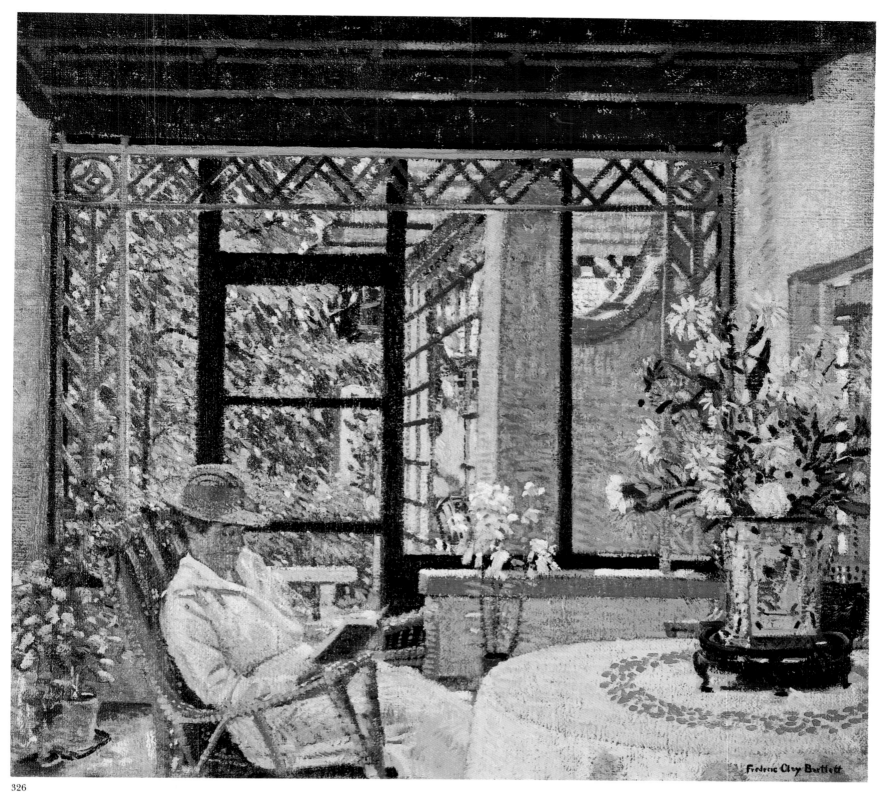

326

324. FREDERICK FURSMAN (1874–1943). *In the Garden*, 1909. Oil on canvas, 31⅞ x 25¾ in. The Toledo Museum of Art; Gift of Cora Baird Lacey, in memory of Henry Allen Lacey.

325. PAULINE PALMER (1865–1938). *From My Studio Window*, 1907. Oil on canvas, 30 x 25 in. Union League Club of Chicago.

326. FREDERIC CLAY BARTLETT (1873–1953). *Blue Rafters*, 1919. Oil on canvas, 28 x 30½ in. The Art Institute of Chicago; Friends of American Art Collection.

327. ALEXANDER GRINAGER (1864–1949). *Boys Bathing*, 1894. Oil on canvas, 34 x 59 in. The Minneapolis Institute of Arts.

327

328

329

330

served for several earlier generations. In Saint Louis this prominence was largely due to the efforts of Halsey C. Ives, director of the School of Fine Arts from 1879; the school also assumed the museum functions of collecting and exhibiting art until the founding of the City Art Museum in 1909.[74] During the 1890s Ives guided one of the most active exhibition programs in the nation: works by Monet and his colleagues were shown in 1890, alongside paintings by Hassam, and works by the Hoosier School were exhibited annually.

Despite the receptivity of Saint Louis to Impressionism, local artists were very little affected by it. A concept of spiritual ideality, particularly in Saint Louis landscape painting of the late 1800s, was promoted by the city's leading art writer, William M. Bryant, head of the Saint Louis Art Society and author of *The Philosophy of Landscape Painting.*[75] There was a dominant trend in Saint Louis landscape toward gentle, lyrical views, painted by artists such as Edmund Wuerpel and Frederick Oakes Sylvester. One artist, however, Dawson Dawson-Watson, was a direct link to the earliest American involvement with Impressionism in France. In April 1888 Dawson-Watson had been induced to visit Giverny by John Leslie Breck; he went for two weeks and stayed for five years. In January 1894 Dawson-Watson showed a group of Giverny paintings at the St. Botolph Club in Boston, joining his Giverny compatriots Wendel, Hale, and Perry, along with Tarbell, Benson, and De Camp. Settling in Saint Louis, Dawson-Watson became a member of the Society of Western Artists. His work is little known today, but the introduction to a 1906 exhibition of his painting at the Saint Louis Museum of Fine Arts praised him as "a painter of light; one always feels in studying one of his compositions that the whole field is flooded with the light of out-of-doors; there is no suggestion in his work of the sombre gloom of the studio."[76] Saint Louis's most famous Impressionist painter was Richard Miller, but although he produced a series of murals for the State Capitol in Jefferson City, his contribution to the development of American Impressionism occurred from his bases in Paris and Giverny. Among Miller's pupils was the Saint Louis artist and teacher Fred Green Carpenter.

The Saint Louis members of the Society of Ozark Painters included Carl Waldeck, Oscar Berninghaus, and Frank Nuderscher. Waldeck's work is very little known today, while Berninghaus is known best for his later work as a member of the Taos art colony. Nuderscher has only begun to emerge from obscurity. He and Frederick Oakes Sylvester were two of Saint Louis's best-known landscape painters, though the latter may be more familiar today; Nuderscher concentrated on Ozark scenes and views of Saint Louis.[77] His Ozark landscapes are sun filled and broadly painted, though more prosaic than those of his fellow Ozark Society artist, Carl Krafft; both had studios in Arcadia in the Ozarks, and Nuderscher at one time was mayor of the town. His city pictures tend to be livelier and more dramatic, although less concerned with Impressionism. His best-known work, *Red Cross Drive* of 1918 (plate 329), with its emphasis on the exuberant display of unfurled flags, is a paraphrase of Hassam's great Flag series of 1917–18.

The West

Impressionist involvement seems meager indeed in the vast terrain between the Mississippi Valley and the Pacific Coast. Though Adeline Adams writes about a group of pastels presented for exhibition by Hassam in Denver in 1890, no present trace of the show can be located, and Adams is unclear about whether Hassam visited the city.[78] The Broadmoor Art Academy in Colorado Springs certainly evinced an interest in Impressionism by inviting Robert Reid to serve as instructor in 1920; he was succeeded in 1927 by Ernest Lawson, who remained for several years.[79] In Salt Lake City, John Hafen's Barbizon-type landscapes gradually absorbed richer coloration; Hafen lived in abject poverty until 1908, when he joined the Brown County art colony in Indiana for three seasons until his death in 1910. Myra Sawyer had worked in Giverny and produced Impressionist garden scenes.

328. ALEXIS FOURNIER (1865–1948). *Autumn in Brown County*, n.d. Oil on Masonite, 28 x 29 in. The Snite Museum of Art, University of Notre Dame, Notre Dame, Indiana; Gift of Mr. and Mrs. Judd Leighton.

329. FRANK NUDERSCHER (1880–1959). *Red Cross Drive*, 1918. Oil on canvas, 31 x 27 in. Boatman's National Bank of St. Louis.

330. ERNEST BLUMENSCHEIN (1874–1960). *Sangre de Cristo Mountains*, 1925. Oil on canvas, 50 x 60 in. The Anschutz Corporation, Denver, Colorado.

331. OSCAR BERNINGHAUS (1874–1950). *Apache Visitors*, n.d. Oil on canvas, 35 1/16 x 40 in. Harrison Eiteljorg Collection.

John Henri Moser migrated to Utah from Switzerland; he studied with Richard Miller in France for a time in 1908 and subsequently developed a colorful, Impressionist-based landscape manner (he is not to be confused with the Washington painter, James Henry Moser).[80]

The most active art colonies to emerge outside of California in the early twentieth century, and even before, were those in New Mexico—at Santa Fe and especially Taos.[81] Developments in New Mexico are usually described as relatively isolated from artistic currents elsewhere in America and abroad, and historians have only recently begun to place the origins of the Taos colony within the mainstream of Western tradition. This is not to suggest that the art created in New Mexico was just one more regional offshoot of Impressionism, for certainly both the light of the Southwest and the land itself—its terrain and its people—stimulated a very special response from the artists who first settled in Taos. Yet while Impressionist fragmentation played almost no part in Taos painting, which tended to concentrate on large formal masses, Taos art was very much an art of color and

331

332

333

334

light; and while this was a response to the inherent qualities of New Mexico itself, surely the joyous abandon of that response was intensified by the coloristic achievements of the Impressionists. A comparison of the few views of New Mexico done by Worthington Whittredge in 1865, for example, with those of the early Taos artists—Ernest Blumenschein, Oscar Berninghaus, Joseph Sharp, Walter Ufer, Victor Higgins, and others—makes this clear: the sun had shone no less brightly for Whittredge, but his response was certainly more muted than that of his successors.

Many of the Taos artists underwent the same formal training in Munich and Paris as professional artists from elsewhere in this country and undoubtedly also became aware of contemporary artistic developments. This would seem to have been particularly true of Blumenschein, who studied first at the Art Students League and then at the Académie Julian, and whose later work, so suffused with color and light, evokes both the concerns of Impressionism and the stylization of form characteristic of a number of Post-Impressionist landscapists.[82] Berninghaus, who divided his time between Saint Louis and Taos until his permanent move to New Mexico in 1925, has been identified with Impressionism in his early years in Taos by recent historians. This is not surprising, because he was an active member of both the Society of Western Artists and the Society of Ozark Painters, both of which had strong Impressionist ties. Berninghaus even adopted the Monet-inspired procedure of interpreting the same New Mexico subjects at different times of day and in different qualities of light.[83]

The best-known artists of Santa Fe are more associated with other, later styles: the vigorous realism of the Ashcan School transferred to the Southwest in the paintings of Robert Henri, John Sloan, and George Bellows, or modified reflections of European modernism in the art of Andrew Dasburg, Marsden Hartley, and others. An exception was Alfred Morang, a relative latecomer to Santa Fe, who arrived for reasons of health in 1938; he brought an Impressionist-inspired palette and the thick impastoes associated with Ernest Lawson to his interpretations of the landscape in and around Santa Fe.[84]

Art centers in the Pacific Northwest were still too recent for Impressionism to have made a serious imprint by the early twentieth century. A few pictures by Hassam and other Eastern Impressionists were shown in the Western Washington Industrial Exposition held in Tacoma in 1892. Paintings by the ubiquitous Hassam, along with those by Weir, Monet, and Pissarro, appeared in the Fine Arts Palace of the Seattle World's Fair of 1909, in the wake of Puget Sound's economic boom after the discovery of gold in Alaska. In Alaska, Sydney Laurence's repeated images of Mount McKinley and other snow-covered peaks in a high-keyed colorism with glowing sunlight effects are not directly Impressionist, but the distinction between his vision and the older aesthetic of artists such as Albert Bierstadt must be attributed to Impressionism. Portland's leading collector, Colonel Charles Erskine Scott Wood, was a friend and patron of a number of important American painters and sculptors, including Weir and Hassam; Wood was responsible for Hassam's two journeys to Oregon in 1904 and 1908, though Hassam had known Portland patronage earlier. The 1904 trip was made to install murals Hassam painted for Wood's library; the 1908 sojourn resulted in about twenty-five canvases of the Harney and Malheur deserts. Even though the Portland Art Association held a show of these canvases the next year, leading to further local patronage, his presence and his art seem not to have inspired any instant emulation.

The story of Impressionism in California is another matter, one that has begun to receive much serious attention in recent years.[85] A distinction must be made between developments in the northern and the southern parts of the state—around San Francisco and Los Angeles—despite the inevitable movement and communication between the two. As artists began to arrive from the East, Impressionism spread in both of these areas. San Francisco had a much older, more established culture, and as early as 1894, at the California Midwinter Exposition, works by Pissarro, Renoir, Sisley, and especially Monet were on view. One critic called Monet's *Field at Giverny* "a simple canvas, but so full of atmosphere and color that it really dazzles you, and makes you catch your breath. This work may not be appreciated or understood by the masses...."[86] Understood or not, it certainly did not yield immediate enthusiasm for Impressionism among either collectors or artists. This was true at least in part because of the dominance of Arthur Mathew's flat, decorative style; despite the conservatism of his patrons, his work was

332. JOSEPH RAPHAEL (1872–1950). *Tulip Field, Holland*, 1913. Oil on canvas, 30½ x 30 in. Stanford University Museum of Art; Gift of Morgan Gunst.

333. JOSEPH RAPHAEL. *The Garden*, c. 1913–15. Oil on canvas, 28¼ x 30¼ in. John Garzoli.

334. EUPHEMIA CHARLTON FORTUNE (1885–1969). *Summertime*, 1914. Oil on canvas, 22 x 26 in. The Fine Arts Museums of San Francisco; Skae Fund.

335. SELDEN GILE (1877–1947). *Boat and Yellow Hills*, n.d. Oil on canvas, 30½ x 36 in. The Oakland Museum; Gift of Dr. and Mrs. Frederick Novy.

335

336

modernist—partially Symbolist—related to Art Nouveau and the mural style of Puvis de Chavannes. As an Académie Julian gold medalist, a frequent exhibitor at the Paris Salon, and then director of the California School of Design from 1890, Mathews was the most prominent and most cosmopolitan artist in San Francisco, a position he maintained well into the twentieth century.

Joseph Raphael studied with Mathews at the School of Design but moved on to Paris in 1903;[87] soon he began to divide his time between Paris and the art colony in Laren, Holland. His paintings of the next several years seem to be primarily figural, but after a visit home in connection with an exhibition at the San Francisco Institute of Art in 1910, Raphael began to ease toward landscape and outdoor painting, a direction intensified when he abandoned Laren for Uccle, a suburb of Brussels, in 1912. Raphael then developed his own very modern synthesis of Impressionism and Post-Impressionism: a full-colored, large-patterned division-ism, particularly evident in his many bright garden scenes with or without figures. The paint is applied so forcefully that his canvases approach the intense pictorial drama of Expressionism. Raphael continued to live in Belgium until war broke out in 1939, but he periodically sent work to San Francisco for exhibition, maintaining his identification as a California artist. He may be the finest and most original of the state's Impressionists.

The Panama-Pacific International Exposition of 1915 occurred late in the history of American Impressionism, but it was the first large-scale, sustained introduction of the movement to San Francisco (see chapter 15). Works by Monet and his associates were shown, and whole rooms were devoted to the works of Hassam, Weir, Tarbell, Chase, and Redfield, as well as deceased Impressionist masters such as Robinson and Twachtman. Raphael also showed; Reid and Simmons executed murals; and Weir, Chase, and Tarbell served on the Jury of Awards.

Chase had taught the previous summer at the Carmel Summer School of Art, at the urging of a former New York student, Euphemia Charlton Fortune. One of the first artists to arrive, in 1912, she helped develop the Carmel-Monterey area into an art colony.[88] Like Raphael's Dutch and Belgian garden pictures, Fortune's Impressionist works, such as her *Summertime* (plate 334), use large, blocky strokes, laid on more like patches than commas, that give her pictures a structural emphasis unlike the normal Impressionist fragmentation. Fortune, too, had begun to investigate Impressionism before the 1915 Exposition, but for many artists in the San Francisco area the fair proved a revelation. This seems to have been true of Selden Gile, the dominant figure in the Society of Six, the group of Oakland-San Francisco artists who developed the most avant-garde aesthetic among the Bay Area artists during the next generation.[89] Impressionism was a transient phase of Gile's painting, which became increasingly Fauvist or Expressionist, more reflective of personal interpretation than of the naturalistic color and light of Impressionism. Yet Gile, in works like *Boat and Yellow Hills* (plate 335), and some of his colleagues in the Society, such as William Henry Clapp, in *Bird-Nesting* (plate 336), did investigate Impressionist tenets. Clapp was the only member of the Society who had studied abroad and thus had first-hand experience with European Impressionism and Post-Impressionism. That experience and his academic training in Paris may account for his conservatism as the group moved on to more Expressionist concerns, but as curator of the Oakland Art Gallery, where the Society exhibited frequently during the 1920s, he was essential to their success.

Another Northern California artist whose work falls at times into the Impressionist camp is Theodore Wores, a Munich-trained artist who became one of the first to investigate pictorially life in San Francisco's Chinatown. Having been successful in his choice of exotic subject matter and eager to visit Japan after meeting Whistler in Venice, Wores made his first journey to the Orient in 1885. The paintings that resulted from his two-year stay were shown in America and then in London, where the bright colorism and increasing fluidity of his work led

337

some London critics to refer to him as an Impressionist.[90] In 1892 he went first to Hawaii and then back to Japan, creating works that evinced an even greater interest in light and brighter color, along with a preference for floral motifs. His most sensitive sorties into Impressionism, however, may be the limpid scenes he did in and around Granada, Spain, in 1903: sparkling views of gardens and crumbling architecture that owe a debt to his friendship with the Boston Impressionist Philip Hale.

In contrast to San Francisco, Los Angeles and the surrounding area were almost virgin territory for artists when Impressionism was first seen in America.[91] Professional artists only began to arrive in the 1890s, and one of these was the Paris-trained Saint Louis artist Benjamin Brown. Brown's landscapes and etchings were often used by writers such as Mabel Seares and William Howe Downes to popularize the beauty of California for artists, and he himself wrote on the history of painting in Southern California.[92] Brown's interpretation of the land, at least in works such as his c. 1923 *Jewelled Cove* (plate 338), displays an orthodox Impressionism not unlike that of Childe Hassam. Several of Hassam's dated paintings seem to indicate that artist's presence in California in 1914 and again in 1927.

Brown's work took on a higher key when a group of mainly Impressionist pictures shown at the Panama-Pacific Exposition was brought to Los Angeles and exhibited at the Museum of History, Science, and Art in October 1916. Exhibitions such as this and the arrival of artists from the Midwest, the East, and some returning from abroad led the local art critic Antony Anderson to affirm the preeminence of Impressionism in reviewing the spring exhibition of the California Art Club in 1917.[93]

Among the Chicago artists, including George Gardner Symons, William

336. WILLIAM HENRY CLAPP (1879–1954). *Bird-Nesting*, n.d. Oil on canvas, 36½ x 28¾ in. The Oakland Museum; Gift of Don Schroder.

337. THEODORE WORES (1860–1939). *Ancient Moorish Mill, Spain*, 1903. Oil on canvas, 29 x 36 in. Saint Francis Memorial Hospital, San Francisco.

338. BENJAMIN BROWN (n.d.). *Jewelled Cove*, c. 1923. Oil on canvas, 34 x 36 in. Martin and Brigitte Medak.

338

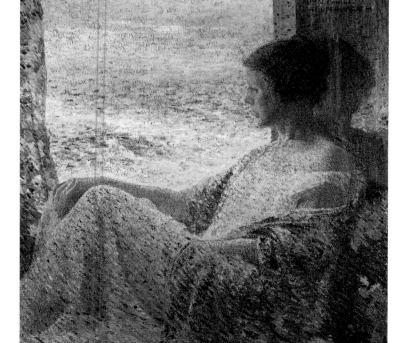

Wendt, and Alson Clark, who infused Southern California landscape painting with a vigorous colorism, Wendt was the most renowned. He shared with Benjamin Brown the position of "Dean of Landscape Painting" in the area, but Wendt developed a very aggressive, broad-stroked manner of interpreting the land in deep greens and earth tones, and seems to have practiced a more scintillating Impressionism for only a short period.[94] Guy Rose was one of the American painters who studied and practiced his art abroad before returning to this country in 1912 and to his native California in 1914. His finest works, however, seem to be those he painted in Giverny as part of the second generation of Americans there (see chapter 13). His later California landscapes, while higher in tonality, tended to be softer and less structural as he investigated the effects of coastal fog in subtle, poetic terms.[95]

Donna Schuster had been a pupil of Tarbell and Benson at the Boston Museum School and then studied with Chase on a painting tour to Belgium in 1912 and again in Carmel, in 1914.[96] She settled in Southern California in 1913; influenced by her teachers, but even more by the art of the Panama-Pacific Exposition, Schuster's paintings became ever more luminous. Her outdoor pictures especially —of figures in domestic landscape, porch, and garden settings, often with a particularly vivid color range of yellow-greens and bluish purples—are all aglow in warm noontime sun. Another former student of Tarbell and Benson, William Cahill, came out a year after Schuster, settling in Los Angeles in 1914. His *Thoughts of the Sea* (plate 340), painted in 1919 at Laguna Beach, depicts Cahill's wife in that common profile pose of contemplation, silhouetted against the great outdoors. It is imbued with a radiance that unites the gently rendered figure and the broad expanse of empty sea. Although more monumental and closer to the picture plane than most such depictions, it is nevertheless rather softly, lyrically painted, in keeping with its mood of reverie.[97]

Cahill's stay in Los Angeles and then in Laguna Beach was a relatively short one, and his work is not well known today. In its reflective mood *Thoughts of the Sea* suggests some contact with the art of Richard Miller, nationally the best-known Impressionist to settle for a time in Southern California. Miller had been in France for many years, painting and teaching in the summers at Giverny. In 1916, during World War I, he came to Pasadena to teach at the Stickney Memorial School of Art, joining his former fellow-Givernois Guy Rose and specializing in highly decorative garden scenes. One critic wrote: "Though few of his canvases remain,

his influence at a critical moment in California's art was potent and widespread. His methods were the best for an interpretation of our dappling sunlight, his brilliant color and fine draughtsmanship a vital force in the work of local painters."[98]

Laguna Beach was to attract numerous artists of the Impressionist persuasion, and by the late 1920s many of them were focusing on the eucalyptus groves transplanted from Australia to Southern California in the late nineteenth century. Stylized landscapes—painted by a multitude of professionals and amateurs alike from about 1915—that tend toward the decorative and generalized have caused these artists to be grouped as "The Eucalyptus School." The term now has a very negative connotation, but it represents a late flourishing of a Post-Impressionist landscape form indigenous to Southern California. Though undeniably monotonous in the repetition of a single motif, these paintings, individually, can assume real beauty and decorative majesty, as in some examples by Jean Mannheim, Edgar Payne, and Elmer and Marion Wachtel.

A more personal approach to painting decorative Impressionist landscapes informs the work of Maurice Braun, not only the finest Impressionist of the San Diego area, but arguably the most brilliant landscape artist of his generation working in California.[99] Having studied in New York at the National Academy and then with Chase, Braun went to Europe for further training; he settled in San Diego in 1909. Braun exploited the short brushstrokes, sparkling light, and prismatic coloration of Impressionism, but he was attracted to patterned landscapes that repeated similar shapes on different spatial planes and emphasized contrasting rhythms. In his *California Valley Farm* (plate 342) this can be seen in the spongelike tree shapes, rolling hills, and tall, sinuous tree trunks. Braun's finest landscapes seem imbued with a gentle mysticism and may reflect beliefs derived from his strong affiliation with the Theosophical Society at Point Loma. Theosophy could well appeal to artists involved with Impressionism, for it taught that the universe was a continuous medium of energy that was manifested as vibrations. The vibratory motion that activates the surface in Impressionist painting could be related to the vibrations that were the keynote of theosophical dogma, and this casts a spiritual, or at least a meditative, air upon the lyrically scintillating landscapes of Maurice Braun.

339. DONNA SCHUSTER (1883–1953). *The Fountain*, 1917. Oil on canvas, 35 x 34 in. Mr. and Mrs. Robert Hunt.

340. WILLIAM CAHILL (?–1924). *Thoughts of the Sea*, 1919. Oil on canvas, 40 x 40½ in. Gerald D. Gallop.

341. WILLIAM WENDT (1865–1946). *Emerald Bay, Laguna Beach*, 1901. Oil on canvas, 30 x 40 in. Kenneth Lux Gallery, New York.

342. MAURICE BRAUN (1877–1941). *California Valley Farm*, c. 1920. Oil on canvas, 40 x 50 in. Joseph L. Moure.

342

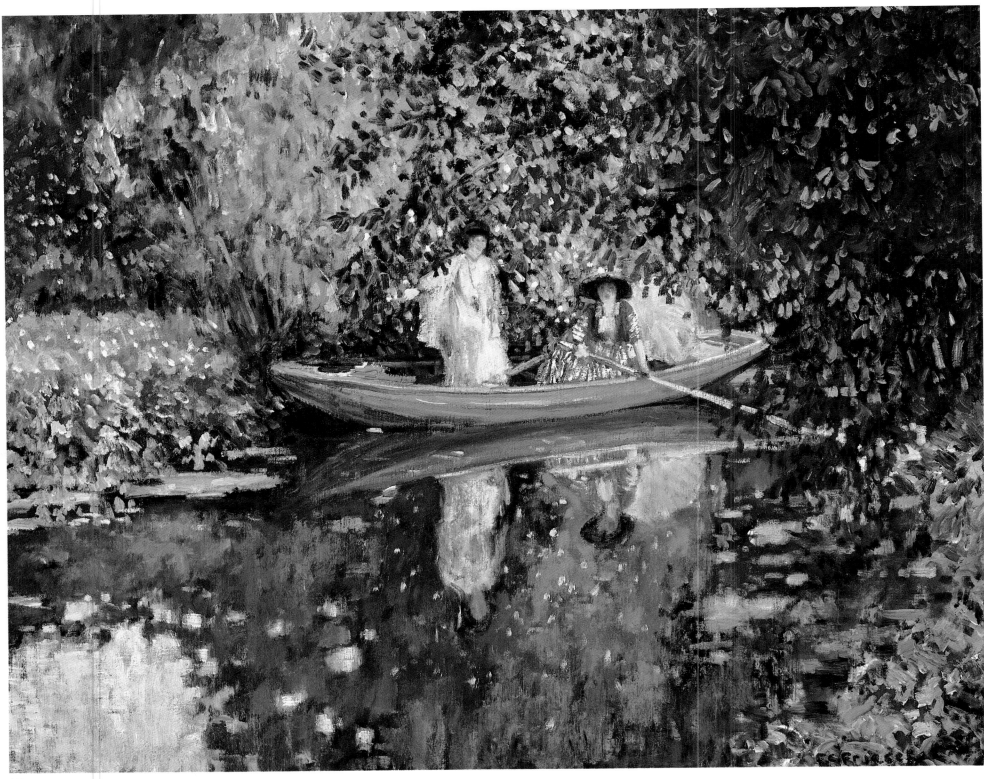

13 Giverny: The Second Generation

WILLARD METCALF AND THEODORE WENDEL returned to America from Giverny in 1889, and John Leslie Breck went back the following year. Theodore Robinson left the village for good late in 1892, and Philip Hale returned to Boston to teach in 1893. Yet they were hardly the last American artists in Monet's village. The painter William Howard Hart, almost totally forgotten today, remained there until 1895; Lilla Cabot Perry spent ten summers there between 1889 and 1909; and Theodore Butler, who married Monet's stepdaughter in 1892, was a permanent resident.

New artists also began to arrive in the 1890s. The sculptor Frederick MacMonnies married the painter Mary Fairchild in 1888; they began visiting Giverny and became regulars by 1890, first renting and then purchasing a house. In the ensuing decade MacMonnies began to paint more or less regularly, though sculpture remained his primary vocation. The muralist Will Low visited Robinson in Giverny in 1892; he later visited the MacMonnies and eventually became Mary Fairchild's second husband. And the mural and easel painter William De Leftwich Dodge went to Giverny between 1898 and 1900; invited for a visit by the MacMonnies, he then took up residency. None of these artists was an Impressionist, though vivacious brushwork, rich color, and sunlight interested all of them. They are transitional from the early Impressionists to the second generation of Americans. This group, moreover, introduced the primary themes that became standard for the younger artists: the figure in the garden and the nude, sometimes one and the same.[1]

The garden theme, of course, was not new. As Monet developed his own extravagant garden, other artists did the same, using those gardens as primary subjects or figural settings, as Monet did. This does not imply a free exchange of ideas between Monet and the ever-increasing numbers of artists at Giverny. In fact, more and more he came to resent the intrusion of the hordes of artists, professional and amateur. While the garden is clearly linked with Monet, the attraction of the nude was more traditional and universal, and thus more obvious. It was stimulated by the freedom that France allowed artists working with this theme, compared with the restraints they encountered in America. Americans in Paris had first emulated the French tradition of painting the nude in idyllic outdoor settings when Alexander Harrison exhibited *In Arcadia* to great acclaim at

343. FREDERICK FRIESEKE (1874–1939). *Two Ladies in a Boat*, c. 1905. Oil on canvas, 41 x 73⅞ in. Private collection.

261

the Paris Salon in 1886; it was later purchased by the French government. Shortly afterward, American muralists began to paint partially or completely nude figures for commissions from America. Dodge, for instance, incorporated the nude in his Columbian Exposition murals and depicted the subject in easel paintings in his Giverny garden, as Frederick and Mary Fairchild MacMonnies did in theirs.[2]

Dodge's garden images of women, whether nude or clothed, were painted between 1898 and 1900. Will Low's Giverny paintings of 1901 were exhibited in 1902 as *A Painter's Garden of Pictures* at the Avery Art Galleries in New York. That year he also published a story, "In an Old French Garden," in *Scribner's Magazine*, illustrated with his paintings. The works of these two artists follow the precepts of academic training, and, in Low's case, some utilize classical formulas associated with the American Renaissance. Immediately thereafter, however, the academic classicist interpretation of the theme gave way to the new generation of Impressionists. Perhaps the first artist of this group in Giverny was Frederick Frieseke, who also became the dominant American there and most representative of the aesthetic that developed.[3] Born in Michigan, he studied at the Art Institute of

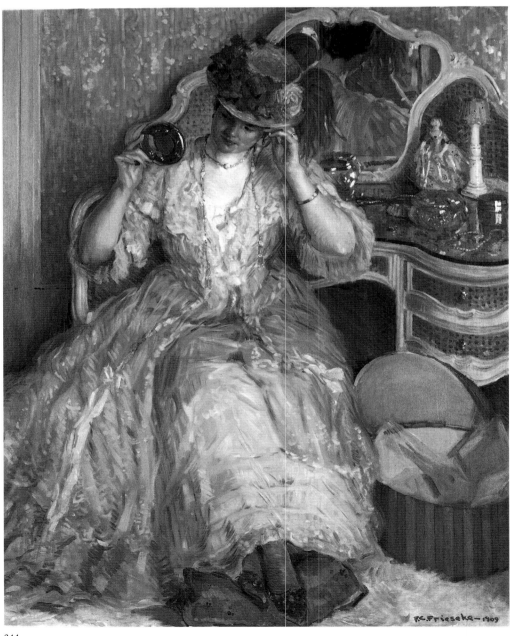

344

345

Chicago and at the Art Students League in New York before going to the Académie Julian in 1898. He is also said to have received some instruction in Paris from Whistler, whose Tonalist concerns affected Frieseke's paintings of women in interiors for a short time. Frieseke moved on rather quickly, however, to Impressionism and Post-Impressionism. He was also quick to discover Giverny: he began to summer there in 1900 and to rent Theodore Robinson's former house next door to Monet beginning in 1906. Despite the proximity, Frieseke seems not to have associated much with Monet nor patterned his art after that of the French master. Frieseke acknowledged the influence of Auguste Renoir, the contemporary whose work he admired most, and of Henri Fantin-Latour's flower painting.[4] Indeed, Frieseke's large, rounded figures resemble those of Renoir, and this emulation also signifies the shift from landscape to emphasis on a figure within the landscape, which characterizes Frieseke's work and those of the artists around him.

But light and sunshine were Frieseke's principal concerns; by his own admis-

346

sion this had begun to occur by 1904, before he moved permanently to Giverny. In 1912 he said, "It is sunshine, flowers in sunshine, girls in sunshine, the nude in sunshine, which I have been principally interested in for eight years...."[5] The Frieseke garden was the setting for many of his finest works, providing the brilliant color. His wife was the gardener, not he. He acknowledged: "I know nothing about the different kinds of gardens, nor do I ever make studies of flowers. My one idea is to reproduce flowers in sunlight...to produce the effect of vibration, completing as I go.... If you are looking at a mass of flowers in the sunlight out of doors you see a sparkle of spots of different colors; then paint them in that way."[6] Frieseke's flower-filled *Hollyhocks* of about 1914 (plate 346) and his beautiful *Woman in a Garden* (frontispiece) of about 1912 are superb examples of his aesthetic. He often introduced parasols not only as sunlight-enhancing parapher-

nalia but also as added color patterns, their geometry contrasting with the more broken color areas of the flowers.

Frieseke strongly defended his continued foreign residency, saying, "I am more free and there are not the Puritanical restrictions which prevail in America. Not only can I paint a nude here out of doors, but I can have a greater choice of subjects."[7] His work was particularly well known in Italy: *Autumn* was acquired by the Museo de Arte Moderna in Venice; a room was devoted to his work at the 1909 Venice Biennale; he was represented in the International Exposition in Rome in 1911; and several Italian journals published articles on him. Still later, he was acknowledged as the most internationally renowned American artist.[8]

Not all of Frieseke's paintings are outdoor scenes; but even in the paintings of women indoors done on gray or rainy days he preferred a heightened colorism. The Friesekes remodeled the house they lived in, painting it bright yellow with green shutters; the living room walls were lemon yellow, the kitchen a deep blue. The bright, flat tones of architectural planes in his works take on the colors of Frieseke's reality. Some of his most sensitive paintings are his interiors with elegant ladies engaged in private, sometimes intimate domestic situations: in reverie, at a dressing table, mending lingerie. At times, as in his monumental *Les Perroquets*, these are painted in more subtle, muted colors, utilizing large patterns of form and a more radical distortion of flattened space. After Frieseke left Giverny and his inspirational garden in 1919 for Normandy, he painted less bright and patterned works, concentrating on more solidly rendered forms in domestic interiors.[9]

Frieseke designated himself an Impressionist and expressed a strong distaste

"I cannot scrape down or repaint a canvas. I must take a new one. I usually make my first notes and impressions with dashes of tempera, then I paint over this with small [strokes] as I have to keep it as pure as possible or the effect of brilliancy will be lost. . . . Nor do I believe in constructing a picture from manifold studies which have been made in 'plein air.' One is in a nervous tension then, and falls into no studied methods or mannerisms. . . . One should never forget that seeing and producing an effect of nature is not a matter of intellect, but of feeling. . . . I avoid being conventional as much as possible. . . . The effect of impressionism in general has been to open the eyes of the public to see not only sun and light, but the realization that there are new truths in nature."

Frederick Frieseke, quoted in Clara T. MacChesney, "Frieseke Tells Some of the Secrets of His Art," *New York Times*, June 7, 1914.

346. FREDERICK FRIESEKE. *Hollyhocks*, c. 1914. Oil on canvas, 25½ x 32 in. National Academy of Design, New York.

347. FREDERICK FRIESEKE. *Memories*, 1915. Oil on canvas, 51¾ x 51¼ in. National Gallery of Art, Washington, D.C.; Gift of Frances Frieseke Kilmer, 1969.

347

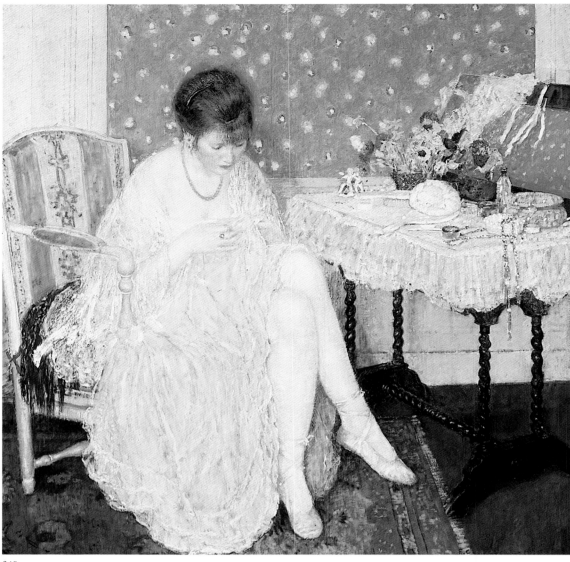
349

348

for much avant-garde art, especially that of Matisse.[10] Yet his own painting, and that of his colleagues in Giverny, seems to represent the more decorative direction that Impressionism was to take in the twentieth century, almost as close to Bonnard and Vuillard as to Renoir. Repeated patterns of figural shapes, patterns on costumes, patterns on the curtains and coverings of furnishings, patterns of flowers and dappled sunlight were integral to his art. Decoration was primary even in Frieseke's early work, above all his murals for the Hotel Shelbourne in Atlantic City, completed about 1905.[11] Most of the figures are women and children at the beach; their forms are more solidly rendered than in his later French garden paintings, but the sinuous outlines of windblown skirts and veils and the emphatic patterns of beach umbrellas and dressing tents already testify to Frieseke's participation in Post-Impressionist aesthetics.

Frieseke's art and that of most of the second-generation Giverny painters were committed to the feminine subject. Not only were the subjects primarily women but their activities also were associated with women and the tradition of women in art. The maternal theme was not uncommon in Frieseke's painting, and many of his interior scenes are set in boudoirs. This is even more true of work by Frieseke's Giverny colleague Richard Miller from Saint Louis.[12] Miller and Frieseke were often associated by critics in this period; they both worked in Giverny, painted similar scenes, and frequently exhibited together (Miller, too, had a room of work

348. FREDERICK FRIESEKE.

349. FREDERICK FRIESEKE. *Torn Lingerie*, 1915. Oil on canvas, 51¼ x 51¾ in. The St. Louis Art Museum.

350. FREDERICK FRIESEKE. *Summer*, 1914. Oil on canvas, 45 x 57¾ in. The Metropolitan Museum of Art, New York; George A. Hearn Fund, 1966.

on view in the 1909 Venice Biennale [13]). Miller entered the Académie Julian in 1898 when Frieseke did and later became an important teacher at the Académie Colarossi in Paris; each summer he taught classes in Giverny for the students of Mary Wheeler's Providence, Rhode Island, school.[14]

The precise chronological development of these artists—Frieseke, Miller, and their colleagues—has not been thoroughly studied, but early critics imply that Miller's transition to Impressionism was slower than Frieseke's. Miller's early works were muted in tonality; following his successes at the Paris Salon in 1901 and 1904, he painted a series of night scenes along the city's boulevards—paintings

350

351

like his *Café de Nuit* (plate 353), exhibited in 1906, or *Le Marchand de Jouets*, acquired by the French nation. But about this time, almost surely in association with Frieseke, whose portrait he painted, Miller turned to an aesthetic similar to that of his colleague.[15] Miller, however, painted outdoors less consistently than Frieseke; when he did, as in his *Sylvan Dell*, c. 1916–18 (plate 352), he produced scintillating visions, integrating his lovely women with their sun-flecked environment in full Impressionist chromaticism. The finest of these outdoor pictures, including *Sylvan Dell*, were painted in the gardens of Mrs. Adelbert Fenyes in Pasadena, California, after Miller left Giverny.[16] Miller often used the picture's alternate title, *Reverie*, which describes the most common mood of his figures—less active, more pensive than Frieseke's.

Again, as in so many American Impressionist figure paintings, the woman in *Sylvan Dell* is not fragmented the way the surrounding landscape is, and in his more common interior scenes, Miller's figural renderings are quite firm, the academic tenets still strongly maintained, especially in his nudes. Most of his models are shown in voluptuous finery, seated in bedrooms or on porches with bright sunlight streaming through slatted blinds; Miller enjoyed the patterning made by the strong, repeated diagonals. Color contrasts are more powerful in his work than in Frieseke's, compositions more dramatic, and figures and furniture often diagonal to the picture plane, contributing a dynamism to otherwise introspective scenes. Strongly geometric linearity characterizes Miller's art, while Frieseke's is more

352

353

351. FREDERICK FRIESEKE. *Woman in a Sunlit Landscape*, n.d.
Oil on canvas, 31¾ x 25½ in. Robin C. Duke.

352. RICHARD MILLER (1875–1943). *Sylvan Dell*, or *Reverie*,
c. 1916–18. Oil on canvas, 36 x 34 in. Museum of Art,
Rhode Island School of Design, Providence, Rhode Island.

353. RICHARD MILLER. *L'Heure de l'Apéritif (Café de Nuit)*,
1906. Oil on canvas, 48½ x 67⅜ in. Dr. and Mrs. Henry C.
Landon, III.

354. RICHARD MILLER. *Reverie*, 1913. Oil on canvas, 45 x
58 in. The St. Louis Art Museum.

354

355

curvilinear. Among Miller's favorite color combinations are juxtapositions of greens and purples, as in his indoor *Reverie* (plate 354).

Frieseke remained the expatriate he always denied he had become and died in France. Miller came back to America in 1916, during World War I, and spent some time in Pasadena, where he was associated with the Stickney Memorial School of Art; his impact on the development of California Impressionism is in need of evaluation. Eventually he purchased a house in Provincetown, Massachusetts, and became part of the art colony there.

Another American in the second generation at Giverny was the Chicago painter, Lawton Parker. At fourteen he won a prize in Chicago for a drawing of the nude; later he entered the School of the Art Institute, went to France to study, and was there off and on for several decades.[17] Parker fully absorbed academic training, which enabled him to create award-winning figure paintings and to become one of the most sought-after portraitists of his generation. But on moving to Giverny in 1903 he began to undertake very different themes, the same ones that his good friend and next-door neighbor Frederick Frieseke had begun to paint: figures, nude or clothed, in flowering gardens and under intense sunlight; in fact, Parker used these themes before Miller and possibly even before Frieseke. As one biographer has written: "Up to now he was a studio painter. All the outdoor work he had done was the more or less desultory sketching with which one occupies a holiday. Now he tackled *plein air* in earnest. He went on painting portraits. That was his profession. But in his water garden in Giverny he began studying the full outdoor light on things: how foliage and dresses and naked human flesh look against the light, down the light, across the light."[18]

The native California painter Guy Rose had been in Giverny as early as 1890, during his three years as a student at the Académie Julian; he returned to America in 1891. On a summer trip to Greece in 1894 Rose contracted lead poisoning and

gave up painting until 1899, when he went back to Paris; from 1904 until 1912 he was in Giverny, and two years later he was again in California. Rose's painting remained closer to the earlier tradition of Giverny, more like that of Theodore Robinson than of Frieseke. His figures tend to be integrated with the willow-filled landscapes, rather than dominate their environment, and he painted lovely, misty scenes along the Epte, rather than figures in blazing sunlight or bright garden scenes. Rose seems to have become known to Monet and received artistic criticism from him, an acquaintance perhaps fostered by their mutual early friendship with Robinson. But while in Giverny, Rose was also close to Frieseke, Miller, Parker, and the other Americans there. After returning to California, he became instructor and then director of the Stickney Memorial School of Art.

In 1907 Edmund Greacen, a student of William Merritt Chase who had settled in Paris, rented a house in Giverny after falling more and more under the influence of Monet and Renoir.[19] Greacen remained there for two years, painting river scenes along the Epte and garden pictures that often included his wife, Ethol. He joined the Old Lyme colony in 1910 but continued to paint garden scenes,

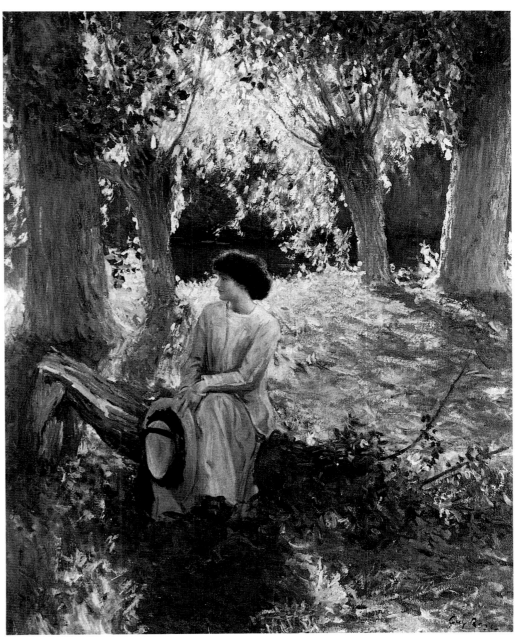

355. LAWTON PARKER (1868–1954). *Laurel*, n.d. Oil on canvas, 10 x 11⅞ in. Lyme Historical Society, Florence Griswold Museum; Gift of the artist.

356. GUY ROSE (1867–1925). *Warm Afternoon*, n.d. Oil on canvas, 38 x 32 in. The Oakland Museum.

356

including "portraits" of formal gardens of the wealthy. Karl Anderson, brother of the playwright Sherwood Anderson, was in Giverny by 1909; he had been a student with Frieseke at the Art Institute of Chicago.[20] His 1910 portrait of Frieseke painting a nude in a garden setting is a summation of the aesthetic and the subject matter of the second generation of Americans in Giverny. Though Anderson continued to favor garden pictures after he settled in Westport, Connecticut, in 1912, he moved away from Impressionist fragmentation of light and form and toward a mystical, poetic interpretation of the figure, at odds with the basically realist precepts of Impressionist subject matter.[21]

Because of Frieseke, many Chicago-trained artists settled in Giverny. These included not only Parker, Anderson, and Louis Ritman, who worked partially in Frieseke's manner, but also Henry Salem Hubbell and Karl Buehr. Ritman grew up in Chicago and studied with John Vanderpoel at the Art Institute before going to France in 1909.[22] He studied in Paris until about 1911 or 1912, then took a house in Giverny, where he spent most of the next two decades. Frieseke comes to mind when one sees Ritman's paintings of both clothed women and nudes, in domestic interiors and outdoors, often in garden settings. Evelyn Marie Stuart was certainly thinking of Frieseke in 1915 when she complained that Ritman's "spotty sunlit flower gardens...while clever, are similar in style to the works of some of his contemporaries."[23] One writer even stated that Ritman had studied with Frieseke. That same biographer, however, perceived the most serious distinction between the work of the two men: "Frieseke knows his Monet, but seems totally unaware of Cézanne. Ritman is always plastic.... He has learnt that the painting of light and atmosphere need not imply the annihilation of form."[24] Ritman often laid on his

357

358

357. EDMUND GREACEN (1877–1949). *The Old Garden*, c. 1912. Oil on canvas, 30¼ x 30¼ in. Lyme Historical Society, Florence Griswold Museum; Gift of Mrs. Edmund Greacen, Jr.

358. LOUIS RITMAN (1889–1963). *Nude, Study No. 1*, 1915. Oil on canvas, 36½ x 36½ in. Des Moines Art Center; Gift of Mrs. Florence Carpenter, 1941.

paint in blocks of pure color; the figures are precisely rendered, the floral environment described in splotches, and often watery backgrounds worked in "bricks" of paint.

Frieseke, Miller, Parker, Rose, Greacen, and Anderson called themselves "The Giverny Group," while critics referred to them as "Luminists" when they showed together in 1909 or early 1910. In December 1910, Frieseke, Miller, Parker, and Rose exhibited in New York at Henry Fitch Taylor's Madison Gallery, established in 1908. Taylor, a first-generation Giverny Impressionist, may well have known Rose there and, in any case, would have been sympathetic to the continuing Impressionist tradition there. Ironically, it was at Taylor's 1911 exhibition of the work of Walt Kuhn, Elmer MacRae, and Jerome Myers that the idea for the Armory Show of 1913 was born. New York critics noted the absence of Greacen and Anderson from the Madison Gallery show of 1910 and also that Rose's painting was mellower, less strong than that of his colleagues.[25] Radiant gardens, parasols, and the nude were the identifying features of the works, all depicted in the brilliant warmth of summer sunlight. While the writer for the *New York Telegraph* found them intensely modern, the critic of the *Times* thought them unrelated to the latest movements; but all acknowledged these artists as "impressionist painters of the very best sort...strong and optimistic."[26]

359

14 Impressionism and the New Generation

The New Artists

BY THE EARLY TWENTIETH CENTURY Impressionism had proved itself and, inevitably, newer movements challenged it as outmoded. Historians have singled out two primary new directions that art took during this period: a reinvigorated realism concentrated on city life and a formalist modernism related to such European movements as Post-Impressionism, Fauvism, and Cubism. Though Impressionism may have been part of the training or practice of these American artists and the European progenitors of modernism as well, it often was abandoned for more radical strategies.

The urban realists, whom critics and historians have dubbed "the Ashcan School," coalesced around "the Eight," a group of painters whose historic exhibition was held at the Macbeth Galleries in New York in February 1908, a decade after the Ten had their first show. Just as all members of the Ten were not truly Impressionists, at least not in 1898, so not all of the Eight painted in a similar mode. The "hard-core" urban realists were Everett Shinn, John Sloan, George Luks, William Glackens, and their leader, Robert Henri. Glackens soon left the dramatic approach of his colleagues for a more colorful, lyrical one already favored by two other members of the group, Ernest Lawson and Maurice Prendergast, while Arthur B. Davies's gentle mysticism relates more to European and American Symbolism. Henri, an early admirer of French Impressionism, had practiced it during summers on the New Jersey coast in 1892–93. Back in France by the mid-'90s, he turned to dark, dramatic cityscapes of Paris, still with the vigorous brushwork of Impressionism; the fragmentation of form and varied colorism would reappear only in the pastels he made on Monhegan Island, Maine, in 1918.[1] But for Henri, Impressionism had become academicized too quickly—too easily seized as a method for demonstrating mere virtuosity. Henri championed "Art for Life's Sake" rather than "Art for Art's Sake."[2]

Among the Eight it was the Canadian-born Lawson who maintained the closest contact with mainstream American Impressionists through his study with Twachtman and Weir. In 1891 Lawson began to study at the Art Students League with Twachtman and then, more productively, with Twachtman and Weir at Cos Cob in the summer of 1892.[3] Lawson recalled Weir's first criticism of his work: "This is the worst landscape I have ever seen."[4] He admired both of his American teachers, but he revered Twachtman, and their association was recalled by every critic of Lawson's work, although he developed a mature style far stronger and

359. WILLIAM GLACKENS (1870–1938). *Mahone Bay*, 1911. Oil on canvas, 26¼ x 31¾ in. University of Nebraska Art Galleries, Lincoln.

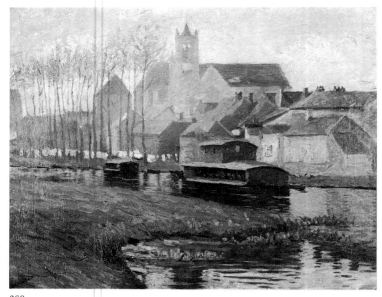

360

361

more colorful than his mentor's. Throughout this century Twachtman has been
the most admired of the first-generation American Impressionists, and the rela-
tionship of the two artists has been seen as a mutual tribute.

Ironically, Theodore Robinson had encountered Lawson and his painting
during visits to Twachtman in Cos Cob and found the work neither personal nor
delicate, though he later amended his judgment and came to admire its primitive
rudeness. Robinson's negative reaction was to Lawson's plein-air work done
earlier at Moret-sur-Loing in France;[5] Lawson had gone to Paris in 1893 to
continue his studies at the Académie Julian. In Moret, he met the French Impres-
sionist Alfred Sisley, and his landscapes of that time have a subtle but glowing
coloration, though they are somewhat thinly painted and rather linear. Back in
America briefly in 1894, Lawson returned again from two more years in Paris in
1896 and settled in Washington Heights in New York City in 1898. During the
ensuing years he developed his mature interpretation of that area, still rather
rugged, with only an occasional shanty. Lawson was the landscape painter of the
Eight and shared their ideas in expressing the beauty of the nominally unpictur-
esque urban landscape along the Hudson, Harlem, and East rivers, and in nearby
Hoboken, New Jersey. He developed thick impastoes applied in broken strokes of
rich, dramatic colors that the critics James Huneker, Albert Gallatin, and Frederic
Newlin Price wrote about as "crushed jewels."[6] By 1910, Lawson's scenes exem-
plified modernism in American landscape, and it was an act of faith that the
Newark Museum bought his *Harlem River* (plate 362) that year, one of their first
three painting acquisitions.

Lawson's landscapes are more urban and more panoramic than those of
Twachtman, but they share a lyricism. From his teacher Lawson also derived a
special fondness for the poetry of the snowscape, and many of his finest canvases,
such as his 1916 *Boathouse, Winter, Hudson River* (plate 361), are winter scenes. A
poetic mood also infuses his 1913 *Spring Night, Harlem River* (plate 363), one of his
most beautiful and glowing works. Nighttime pictures are uncommon in his
oeuvre and recall the recent New York nocturnes of an earlier teacher, J. Alden
Weir. Works such as *Spring Night, Harlem River* and *Harlem River* feature the
prosaic High and Washington bridges, which Lawson transformed into dramatic

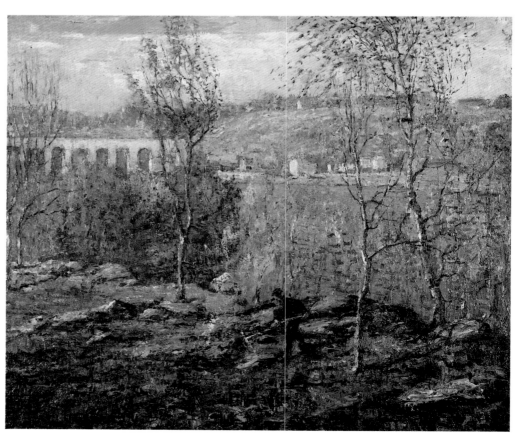

362

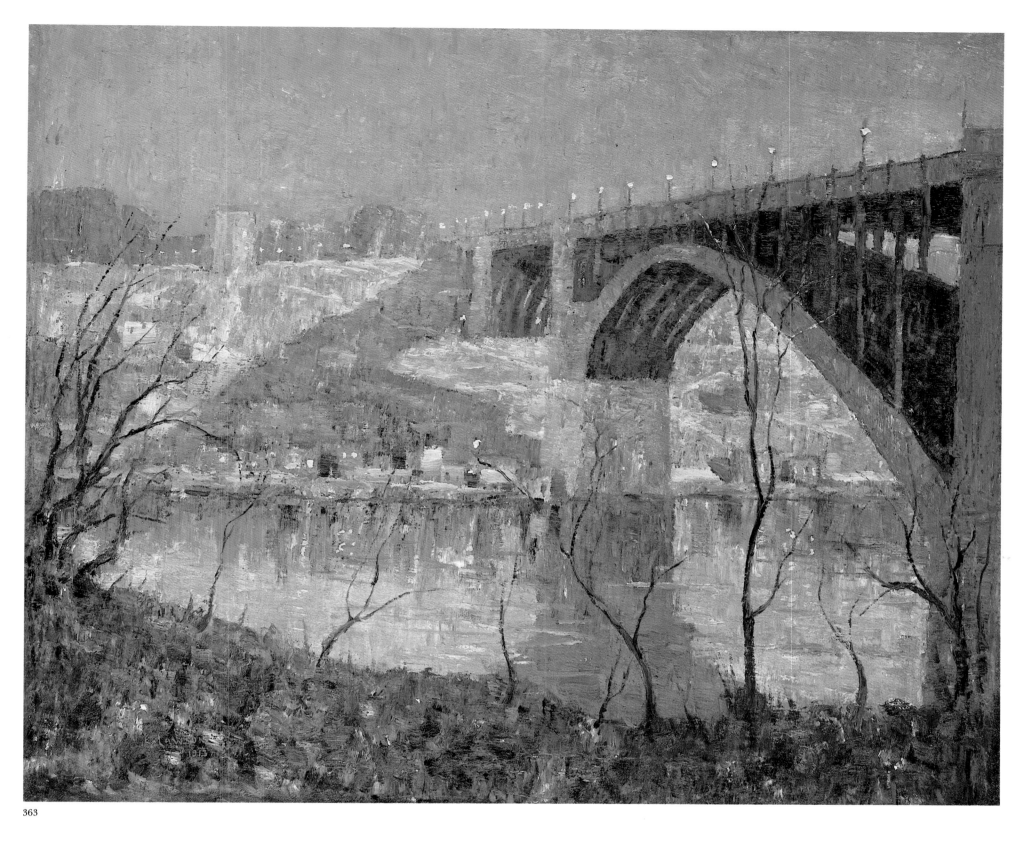

363

evocations of modernity and which form strong diagonal axes that open up the compositions through the cadences of their structure.

Lawson's technique remained constant throughout his career, but during the 1910s there were changes in his style. Some of the paintings of this period were done away from New York. In his most publicized trip, to Spain in 1916, his views of Segovia and Toledo took on a more dramatic chiaroscuro and yet became more geometric than his other works, hinting at Cézannesque structure.[7] The less naturalistic directions of American Post-Impressionist landscape painting, with emphasis on repeated rhythmic form, appear in some of his works painted at the end of the decade and later, such as his *Vanishing Mist* (plate 365), pure landscapes painted perhaps as he traveled through New England in 1919 and 1920 and

277

366

364

365

summered in the art colony at Cornish, New Hampshire. In such works the gritty
speed of New York was replaced by rural serenity. Lawson transmitted his vigor-
ous brand of late Impressionism to other parts of the country. He taught at the
Broadmoor Academy in Colorado Springs for several years, beginning in 1927; he
then began to visit Florida annually in 1931, painting very expressionistic views of
tropical scenery. He died there in 1939.

Lawson was particularly close to William Glackens, who painted his portrait for
the National Academy when Lawson became an Associate in 1908. The two
maintained a basic allegiance to the Impressionist aesthetic, even during their long
leadership of the realist movement. But Glackens's art underwent a profound
transformation to arrive at its full Impressionist expression, and critics have been
divided on the merits of the change. He began his career in Philadelphia as a
newspaper illustrator for the *Record*, the *Press*, and the *Ledger*. At the Pennsylvania
Academy he formed a strong bond with fellow illustrators Luks, Sloan, and Shinn,
all of whom enjoyed Henri's leadership.[8] After a year in Paris, Glackens worked as
a newspaper illustrator in New York and as an illustrator-reporter during the
Spanish-American War in 1898.

About this time Glackens began to be recognized as a powerful draftsman of
skill unequaled in this country, whose art was likened to that of Manet and
Raffaëlli.[9] At the same time he was moving more and more toward easel painting;
he had exhibited a painting of the Brooklyn Bridge at the Pennsylvania Academy
as early as 1894, responding to the call of modern life represented by that
monument of modernity. For over a decade Glackens's paintings, primarily scenes
of Paris and New York but often figures in parks and public gardens, were
dramatically painted in broad brushstrokes with strong tonal contrasts—blacks and
whites and dark greens prevail, related to the monochrome of illustrative art but
also to Manet's earlier painting, which he greatly admired. Glackens's 1905
Maypole, Central Park (plate 368) is such a representation. His rarer indoor scenes

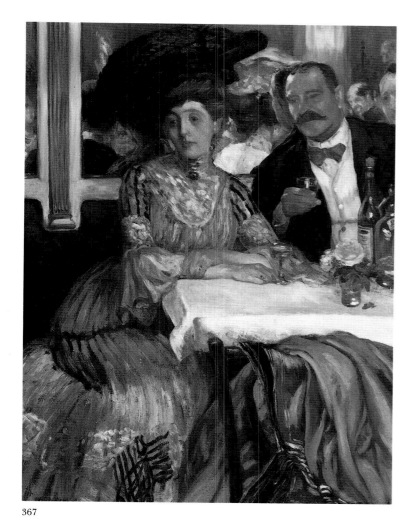

367

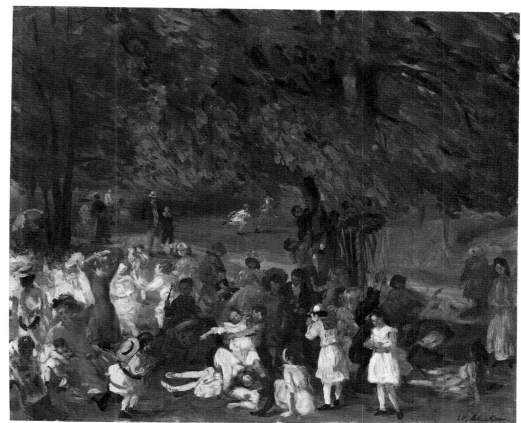

368

364. ERNEST LAWSON. *Hudson River at Inwood*, n.d. Oil on canvas, 30 x 40 in. Columbus Museum of Art; Gift of Ferdinand Howald.

365. ERNEST LAWSON. *Vanishing Mist*, 1919. Oil on canvas, 40 x 50 in. Museum of Art, Carnegie Institute, Pittsburgh; Purchase from the artist, 1921.

366. ERNEST LAWSON. *Segovia*, 1916. Oil on canvas, 25 x 30 in. The Minneapolis Institute of Arts.

367. WILLIAM GLACKENS. *Chez Mouquin*, 1905. Oil on canvas, 48 x 39 in. The Art Institute of Chicago; Friends of American Art Collection.

368. WILLIAM GLACKENS. *Maypole, Central Park*, 1905. Oil on canvas, 25⅛ x 30¼ in. Fine Arts Museums of San Francisco; Gift of Charles E. Merrill Trust with matching funds from De Young Memorial Society.

of the period are more allied to Degas's work, above all his great *Chez Mouquin* (plate 367) of the same year. Set in one of the most famous restaurant hangouts of New York artists, this is a monumental rendition, deep and sonorous, though the woman's blue dress and the touches of red throughout offer more color than most works by Glackens of the period. The setting is very much after Degas and Manet, both of whom used the mirror reflection for spatial and coloristic complexities.

The shift in Glackens's allegiances within European modernism is tellingly demonstrated in two articles on his art by Albert Gallatin. The first, of 1910, begins: "Degas had many cohorts behind him. . . . He had also a vast multitude of followers, and uncounted legions of artists have learned invaluable lessons from his masterly pastels and paintings. William J. Glackens, a young American painter and illustrator, although from Manet, it is true, he has also derived many of his inspirations, is one of these latter artists." And Gallatin went on to present Glackens as a lineal descendant of the two French artists in his subjects, his realism, his compositions, and his powerful draftsmanship. He admired Glackens for the gaiety and humor of his subject matter, as opposed to Degas who, in his opinion, preferred the prosaic, the sordid, the ugly, and the repulsive.[10] Six years later Gallatin wrote, "In many of [Glackens's] recent portraits and figure compositions the influence Renoir has exerted on his technique and on his palette is quite apparent." It is this relationship to Renoir that has been the primary issue in critical discussions of Glackens's work. Many writers have preferred the earlier pictures, which are far fewer in number than the more Renoir-related ones; other critics have tended to explain that connection in terms of a similarity of spirit, implicitly denying derivation. There is some disagreement, too, about when the Renoir phase began: a date of about 1912 has been suggested, which Gallatin's two articles would support, although this "conversion," may have begun as early as 1906, during Glackens's second European trip. All agree that it relates strongly to the preferences of Glackens's close friend Albert Barnes, whom he advised on

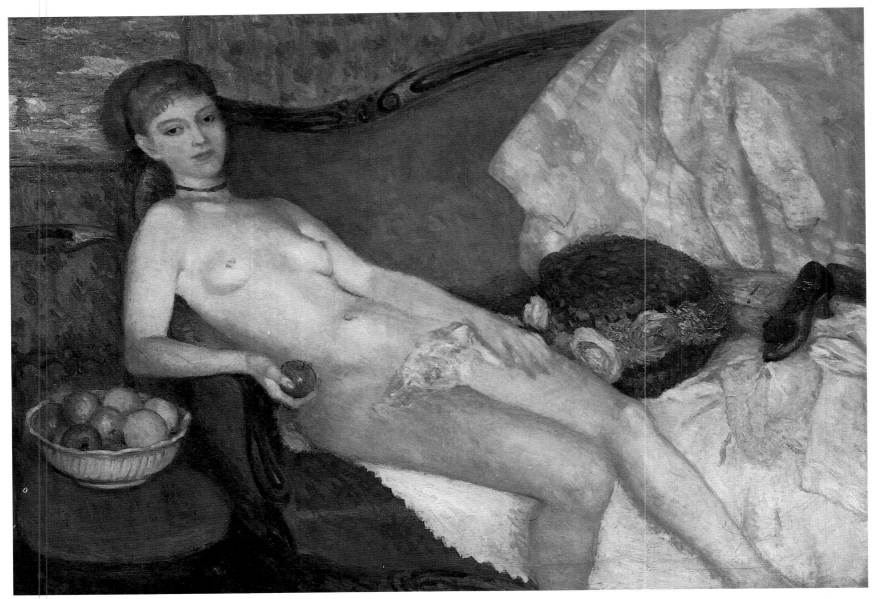

369

370

"*Glackens is strictly American. His painting tradition is French, but his point of view is American. His sense of humor is American. . . . It's hard to say why exactly they appear so American, and of course, it is not merely the scene itself. The whole attitude is American. The subject is seen through American eyes.*"

Forbes Watson, "William Glackens," *Arts*, April 1923, p. 256.

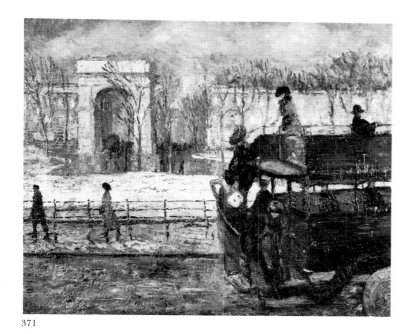

371

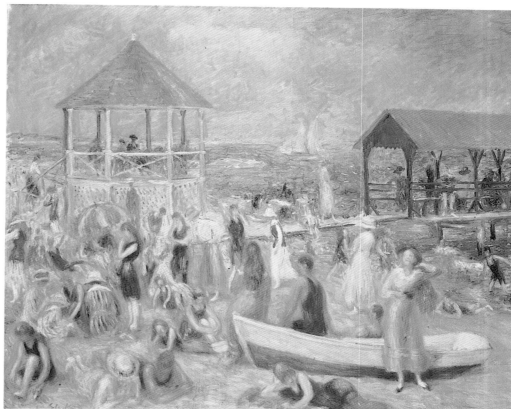

372

369. WILLIAM GLACKENS. *Nude with Apple*, 1910. Oil on canvas, 40⅝ x 57½ in. The Brooklyn Museum; Dick S. Ramsay Fund.

370. WILLIAM GLACKENS. *Still Life, Flowers in a Vase*, n.d. Oil on canvas, 20 x 15 in. Private collection.

371. WILLIAM GLACKENS. *Descending from the Bus*, c. 1912. Oil on canvas, 25 x 30 in. IBM Corporation, Armonk, New York.

372. WILLIAM GLACKENS. *Beach Scene, near New London*, 1918. Oil on canvas, 26 x 31⅞ in. Columbus Museum of Art; Gift of Ferdinand Howald.

collecting and whose first acquisition was a painting by Renoir.[11] Glackens's paintings of the Renoir phase, whenever it began, feature the soft, feathery brushwork and rich, variegated colorism, with emphasis on soft pinks, yellows, and greens, that are associated with Renoir. Glackens did maintain stronger color and structure in his New York views, such as *Descending from the Bus* (plate 371), and used more melting form and color in his beach scenes and still lifes. Although some of the still lifes display a formless insubstantiality, they may be the most consistently appealing of his themes. Their color-shape patterns are sometimes almost Oriental in richness and complexity, particularly when combined with patterns of flower containers, table coverings, and wall hangings.

Glackens's figures, particularly in the more monumental indoor pieces but also in the beach scenes, are the most inconsistent of all his work; some appear rather wan and deflated, lacking the robustness of Renoir's more classical forms. In general, there seems to have been a progressive *de*structuring in Glackens's chronology, but in an earlier coloristic work such as his 1910 *Nude with Apple* (plate 369) the firm modeling supports the frank sensuality of the image, a very modern-day Eve, in contrast to the more coy and bashful nudes of earlier Impressionists such as Tarbell and De Camp.

The Renoir connection did not bother earlier writers on Glackens's artistic development as much as it has more recent ones. Gallatin viewed it as natural, and Forbes Watson, who wrote four articles and a book on Glackens, concluded that "Glackens' gifts did not flower fully until he came into contact with the art of Renoir.... Renoir for him is part of the beauty of the world. He gladly acknowledges his obligations to Renoir."[12] It would seem that the critics of the 1910s, '20s, and '30s were not bothered by similarities to a French master because they could profitably emphasize another distinction, not stylistic but philosophic—an artist's Americanness. Nationalism became a significant issue in distinguishing the native artist from his European forebears and colleagues.

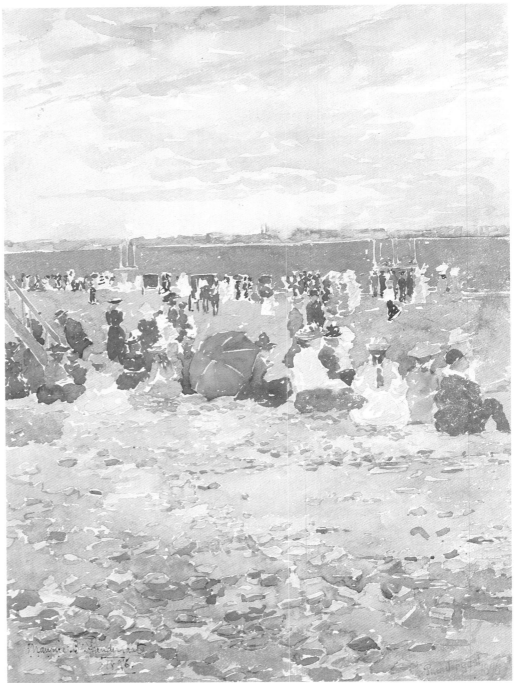

373

373. MAURICE PRENDERGAST (1861–1924). *Revere Beach*, 1896. Watercolor and pencil on paper, 13 9/16 x 9 7/8 in. The St. Louis Art Museum.

374. MAURICE PRENDERGAST. *Dieppe*, 1892. Oil on canvas, 13 x 9 1/2 in. Whitney Museum of American Art, New York; Purchase.

The most original among the Impressionist-related artists of the Eight was Maurice Prendergast. He was born in Saint John's, Newfoundland (as in the case of Lawson, born in Halifax, Nova Scotia, this Canadian background had little effect on his art[13]). Prendergast grew up in Boston, and it may be that the Impressionist elements in the work of Tarbell, Breck, and Wendel had some influence on his future coloristic concerns. Very little is known of his life before he went to the Académie Julian in the winter of 1890–91, but he seems to have taken to Post-Impressionism more readily than almost any other American. His associates were English-speaking foreigners: he was closest to the Australian Charles Conder and the Canadian James Wilson Morrice, who appear to have influenced both his technique and style. Prendergast painted vivacious little pictures of women along the Paris boulevards and along the coastal beaches on his visits to Le Treport, Dieppe, Saint Mâlo, and Dinard. The reduction to flat colored shapes,

282

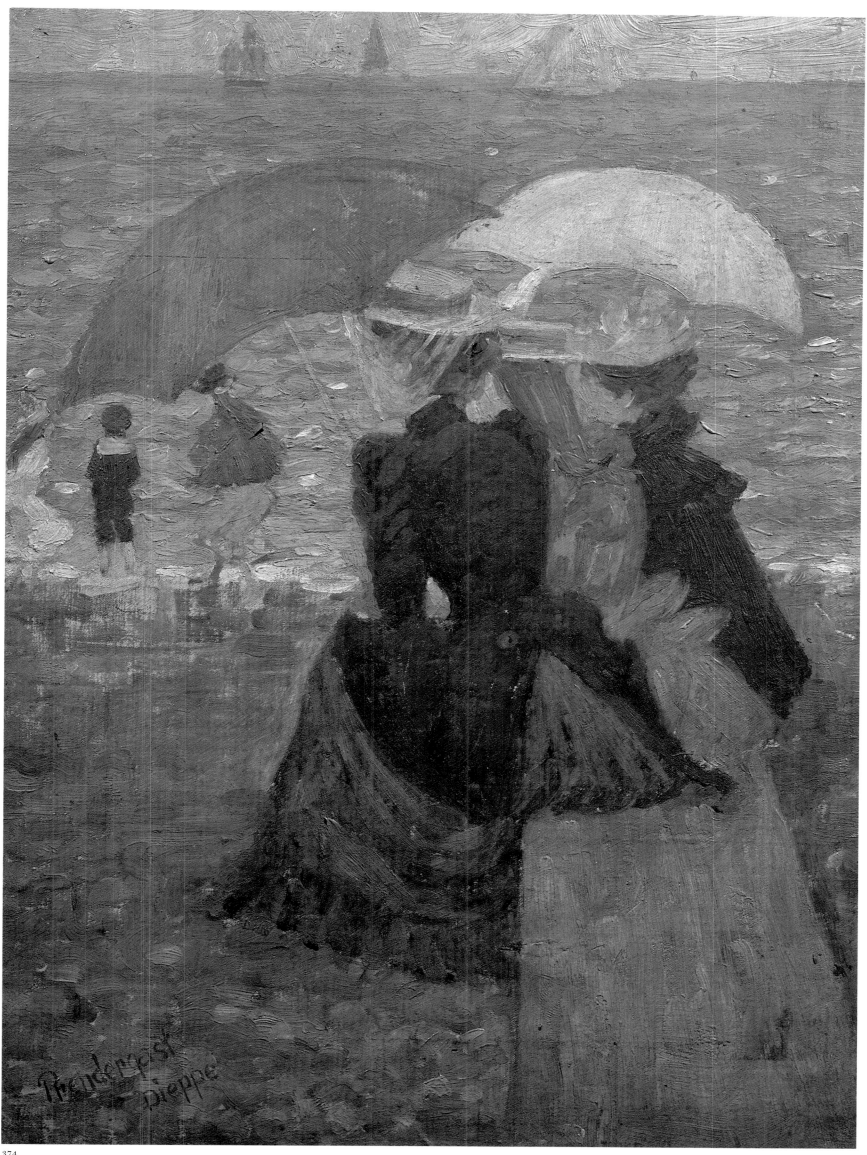

283

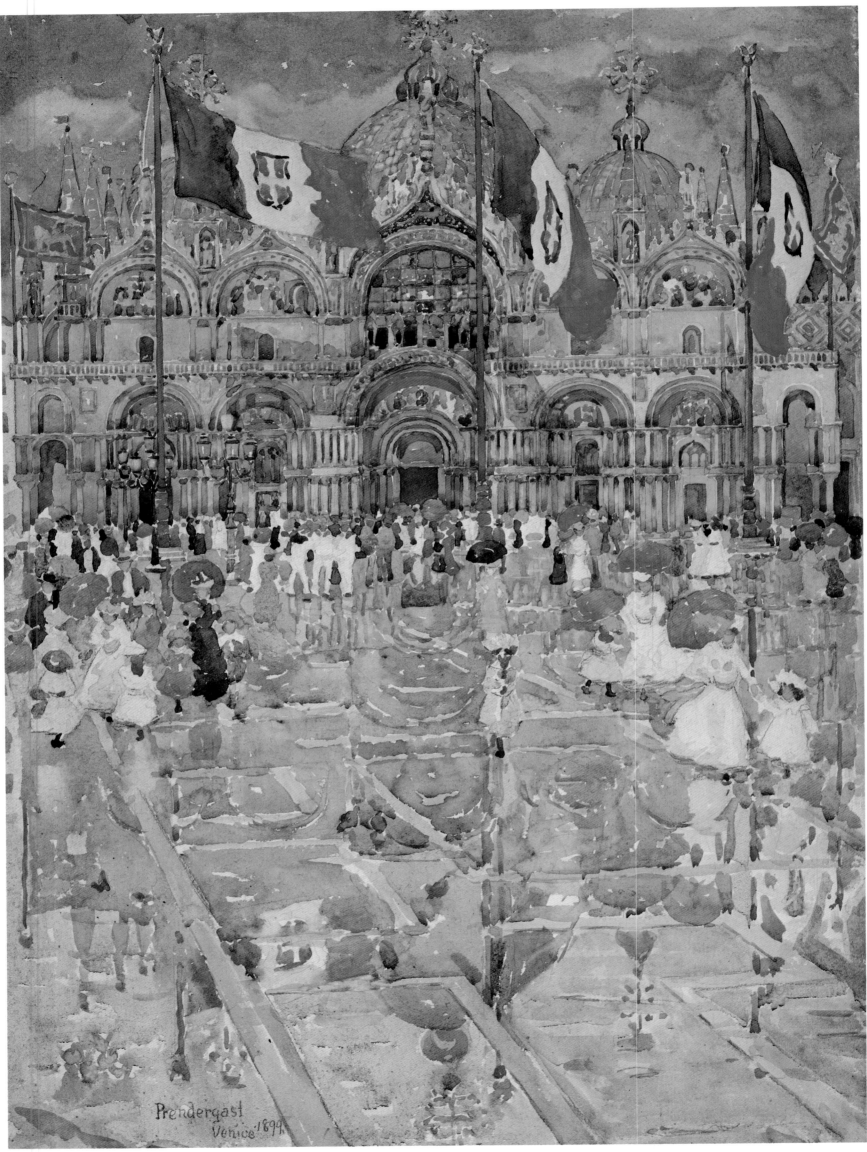

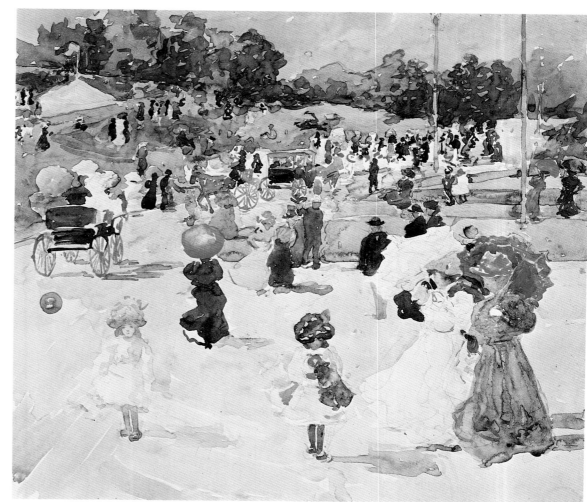

376

"As for the world's obsession that objects have fixed colors, it was always incomprehensible to this unworldly artist. [Prendergast] was not poking fun at the human race in general nor at the license clerk in particular when he once answered that young man's question as to the color of his dog by stating that he was purple and yellow. I am sure the license clerk looked alarmed or angry, but there was no need for his concern or for his indignation. Prendergast was giving his serious and sincere opinion as to the appearance of his own dog, and it was the answer of as great an authority on this question of color as could be found in all the world."

Duncan Phillips, "Maurice Prendergast," *Arts*, March 1924, p. 128.

375. MAURICE PRENDERGAST. *Square of San Marco, Venice*, 1899. Watercolor and pencil on paper, 19¾ x 14¼ in. Mrs. Alice M. Kaplan.

376. MAURICE PRENDERGAST. *Carnival (Franklin Park, Boston)*, c. 1900. Pencil and watercolor on paper, 13 x 14½ in. Museum of Fine Arts, Boston; Gift of the Estate of Nellie P. Carter.

such as the simplified figures and bright parasols in his 1892 *Dieppe* (plate 374) suggests similarities to the work of Vuillard and other French Nabis; the high horizon line, with its concomitant flattening of the picture plane, is typical of avant-garde antinaturalism of the time.

Prendergast returned to Boston in late 1894 or early 1895 and began to paint watercolors of the beaches near Boston at holiday time. These sparkling conceptions, such as *Revere Beach* of 1896 (plate 373), are more diverse in color and more truly Impressionist than his French paintings. They are joyous works full of sunlight and, while extremely original, still very much a part of the most modern developments in American art. Prendergast's work was being shown widely in exhibitions not only in Boston but also in New York (at the Society of American Artists and the New York Water-Color Club), Philadelphia (at the Pennsylvania Academy), and as far away as Chicago; he participated in a four-artist exhibition and sale at the C. O. Elliett Gallery in Malden, Massachusetts, in April 1897, where he showed French and American beach scenes and views of Paris. His works began to attract critical attention, though they were found decorative and impressionistically suggestive rather than specific; their simplifications of form and flat areas of color were likened to posters, which had just become a popular art form.[14] Prendergast also began to attract wealthy Boston collectors, such as Mrs. Montgomery Sears. The Elliett catalog spoke of him as the "rage of the town...unable to keep pace with the demand."

With this early success Prendergast was able to return to Europe in 1898. He revisited France and spent an extended time in Italy, painting watercolors in Rome, Capri, Siena, and especially Venice, where his response to the color and light of the city and to the work of the Renaissance artist Carpaccio led to the most brilliant and joyous of all Prendergast's paintings. His sparkling canal scenes and his views of Saint Mark's Square and other architectural features are enlivened

377. MAURICE PRENDERGAST. *West Church at Cambridge and Lynde Streets*, c. 1909. Watercolor on paper, 10�5/16 x 14¾ in. Museum of Fine Arts, Boston; Charles Henry Hayden Fund.

378. MAURICE PRENDERGAST. *Stony Beach, Ogunquit*, c. 1900–1901. Watercolor on paper, 20⅞ x 13¹⁵/16 in. Mr. and Mrs. Arthur G. Altschul.

379. MAURICE PRENDERGAST. *The Mall, Central Park*, 1901. Watercolor on paper, 15¼ x 22½ in. The Art Institute of Chicago; Olivia Shaler Swan Memorial Collection.

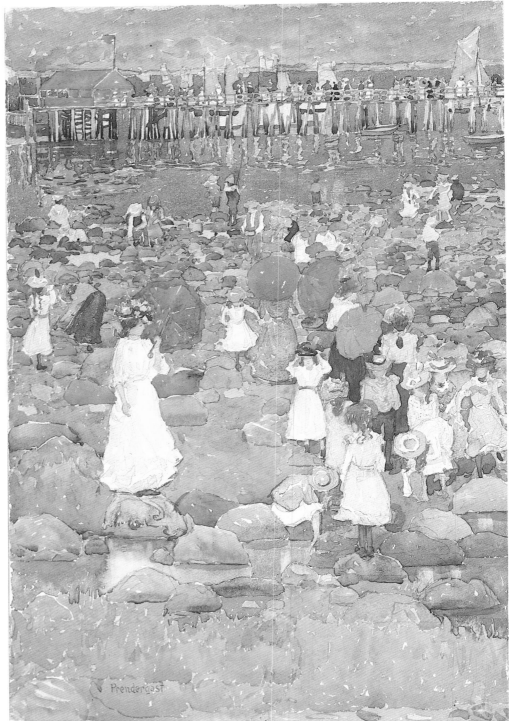

378

377

with glistening reflections, breezy flags, and colorful parasols. Prendergast often chose a high vantage point from which he established a deep recession into space, as in *Venetian Canal Scene* and *Square of San Marco, Venice* (plate 375). While space is naturalistically delineated and forms diminish in size, light and color remain as intense in the distance as in the foreground, which reinforces the posterlike quality that critics had noticed. While in Italy, Prendergast continued to generalize the shapes of his figures to conform to the repeated curves and circles of his beloved parasols.

Prendergast returned from Europe in late 1899 and transferred the scintillating qualities of his Venetian pictures to American beach and park scenes, such as

Stony Beach, Ogunquit (plate 378), which won a bronze medal at the Pan-American Exposition in Buffalo in 1901. During the same period he spent more and more time in New York and became better acquainted with future members of the Eight through his friendship with Glackens. Arthur B. Davies introduced him to the Macbeth Galleries, where he had a show of watercolors and monotypes in 1900; a similar exhibition was held the next year in the Cincinnati and Detroit museums. In 1904 Prendergast joined the future members of the Eight (except Shinn and Lawson) in an exhibition at the National Arts Club in New York. The New York and Boston park and garden scenes that Prendergast painted in this decade, primarily in watercolor, are modern life subjects somewhat like the oils of Glackens. They are always bright, colorful, joyous works, unlike the more socially oriented subjects of Sloan, Luks, and Shinn, who continued to reflect their reportorial origins.

Prendergast's Post-Impressionist tendencies were reinforced by the Cézanne exhibitions he saw in Paris in 1907: he was most struck by Cézanne's color. His own art was developing increasingly in terms of two-dimensional patterns of simplified shapes, and he painted in oils with increasing frequency, putting the paint on more and more thickly. Figures in seaside parks were integrated with surrounding foliage, all laid out on a single plane; these works were allied to those

379

381

"Usually when we speak of the youthfulness of America it is with a thought of those qualities that we want to see outgrown; but in Mr. Prendergast's art we have a phase of that youthfulness that is precious, passing as he has done from an art of sheer delicacy to an art whose stimulating thrill brings us into the clear atmosphere of the greater moderns."

Walter Pach, *The Freeman*, March 9, 1921, p. 617.

of his early friend Charles Conder or to the decorative Post-Impressionism of Ker-Xavier Roussel. Prendergast's late, mature oils often project a tapestrylike effect with "empty" spaces of distant sky on the same plane as solid forms and just as thickly painted.

Prendergast was one of the first Americans to appreciate Cézanne and to communicate that enthusiasm to his colleagues; his ardor only increased with the Armory Show in 1913. About this time a new sense of structure entered Prendergast's painting. It can be seen by comparing several works entitled *Promenade*, a nonspecific title he chose to identify an increasingly nonspecific type of scene (titles signified specific locales far less often in his later work). The *Promenade* in the Columbus Museum (plate 383) seems to be an earlier work than the *Promenade* in Detroit (plate 381), which adopts the mosaic of bricklike color blocks that Prendergast used for a few years, from about the time of the Armory Show. About 1913 he also seems to have done a group of still lifes, a theme he seldom painted. These paintings of fruit and flowers in pots resemble in subject those of Cézanne and investigate similar structural problems.[15] *La Rouge* of 1913 (plate 380), a rare portrait by Prendergast, depicts Miss Edith King; it also suggests Cézanne, as do a number of paintings of bathers from those years. The figures in Prendergast's oils of the last half of the 'teens tend to be larger and the compositions more studied and measured. These triumphs of his old age were painted in his Washington Square studio in New York; he moved there in 1914, feeling that Boston was unappreciative of his art and of modern painting in general; the move proved a good choice, given the ferment in New York following the Armory Show. Prendergast's own painting was immediately successful in an exhibition at the Carroll Gallery in early 1915. He found his critical champions, too, perhaps none more eloquent than Walter Pach, who wrote in 1921, "... to-day after so many years, his painting becomes ever more vigorous in mood; the tone is fuller, the design more inevitable; it is the art of a radiantly young spirit strengthened by untiring work."[16]

There were other artists of the early twentieth century who depicted the dynamics of modern life but did not necessarily fall under the rubric of "The Ashcan School," and some of them either evolved through an Impressionist phase or maintained a partial allegiance to that aesthetic. One of the finest of these artists was Gifford Beal, who about 1910 began to establish a reputation for his dramatic Tonalist images of the sea. About 1915 he began to turn toward more joyous

380

288

382

380. MAURICE PRENDERGAST. *La Rouge: Portrait of Miss Edith King*, 1913. Oil on canvas, 27¾ x 30½ in. Lehigh University Art Galleries, Bethlehem, Pennsylvania.

381. MAURICE PRENDERGAST. *Promenade*, 1915. Oil on canvas, 83¾ x 134 in. Detroit Institute of Arts; City of Detroit purchase.

382. MAURICE PRENDERGAST. *Landscape with Figures*, c. 1912. Oil on canvas, 29¾ x 42¹³⁄₁₆ in. Munson-Williams-Proctor Institute, Utica, New York.

383. MAURICE PRENDERGAST. *Promenade*, n.d. Oil on canvas, 28 x 40⅛ in. Columbus Museum of Art; Gift of Ferdinand Howald.

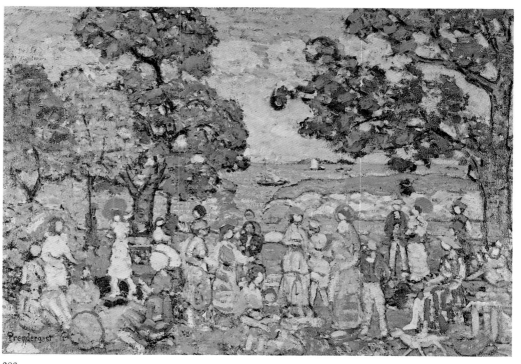

383

themes and adopted a glittering Impressionist colorism in pictures like his 1915 *Albany Boat* (plate 389). Circus scenes, lawn fêtes, and riders in the parks were among his favorite subjects, but he concentrated most on the pleasurable aspects of life along the Hudson River.[17]

Impressionism in the early twentieth century found its way into the depiction of industry. We have come to associate the industrial landscape in American art with the painting of the Precisionists: Charles Sheeler, Niles Spencer, Louis Lozowick, and others, who were unrelated to Impressionism. But a slightly earlier group of painters had celebrated the industrial scene more traditionally. A modified Impressionism was used by two of the most significant, the Norwegian Jonas Lie and the Swede Henry Reuterdahl. Both came to America about the time of the 1893 Columbian Exposition; Lie was only a boy at the time, while Reuterdahl was sent to illustrate the Exposition for a Swedish weekly.[18] He decided to remain and centered his art on maritime subjects, many of them derived from the United States Navy and some of them commissioned by the Navy. His 1912 *Blast Furnaces* (plate 392) was one of his most famous nonofficial works, a paean to modern industry. In a harbor setting, watery reflections and factory smoke shimmer with the broken colors of Impressionism. Lie, renowned for his paintings of the Panama Canal, painted harbor scenes and winter landscapes more related to the work of Fritz Thaulow and the Pennsylvania Impressionists.[19]

While one group of the younger artists primarily investigated urban realism, another involved itself with European modernism, with the aesthetics of Post-Impressionism, Fauvism, and Cubism. Gauguin and van Gogh had relatively little impact on American art, though there have been some suggestions of contact in the early 1890s between Gauguin and his Pont-Aven followers and some of the Americans who visited there; and, while Cézanne was to exert a strong influence on some American artists, it was a late, posthumous development.

Van Gogh was discussed at length in an American journal as early as 1892 by the very astute Cecilia Waern, but his first follower was Allen Tucker—an article on him is even entitled "Vincent in America."[20] By 1911 Tucker was depicting poplar trees in a manner reminiscent of van Gogh. Tucker had studied with Twachtman at the Art Students League, and like many Twachtman students he continued to revere his teacher, later publishing a monograph on him.[21] From 1895 to 1905 Tucker was a partner in an architectural firm. When he returned to painting he adopted a full Impressionist aesthetic, seen at its best and most typical in his several depictions of corn shocks (plate 390) of 1909 and 1910, native equivalents of Monet's Haystacks. Tucker's Impressionist phase was short-lived, though probably more sensitive than his emulation of van Gogh, which immediately followed.

Most early twentieth-century American modernists—such as Arthur Dove, Joseph Stella, Alfred Maurer, and others—went through a brief, early stage of involvement with Impressionism, at least tangentially. But while Impressionism may have liberated them from academic restraints and inculcated or reinforced an awareness of color and expressive brushwork, their mature art is only tenuously linked with the movement. Some of the early moderns made their way to Europe or to European training via study with William Merritt Chase at the New York School of Art. Joseph Stella was one of these, Marsden Hartley was another.

From Chase, Hartley gained the ability to manipulate paint in broad, active strokes and a sense of the physicality of painting; but he rejected Chase's emphasis on technical virtuosity and moved on to the National Academy schools.[22] His native Maine beckoned, as it would throughout his career, and he spent each summer and fall there from 1907 to 1911. During this period he developed his first mature style, interpreting transient aspects of nature in a Neo-Impressionist technique derived from reproductions of work by Giovanni Segantini.[23] He applied the "Segantini stitch" and the high colorism of Segantini's late works to scenes of the Maine woods and mountains, particularly those of 1908 and early

384

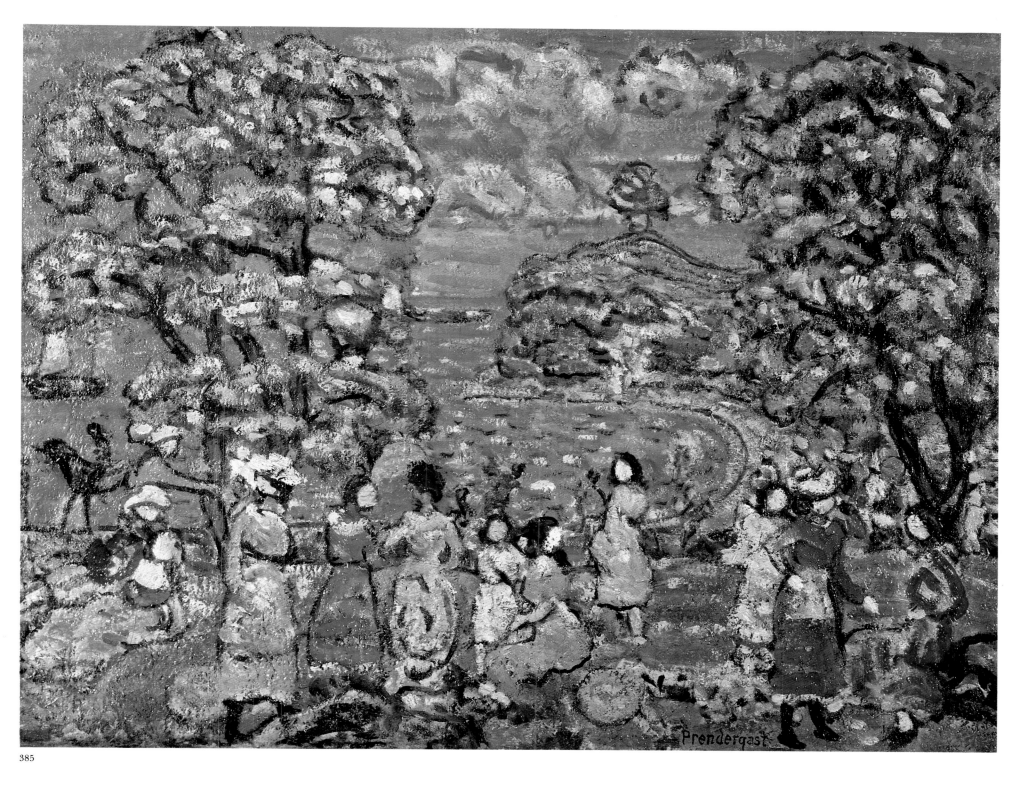

1909 such as *Carnival of Autumn* (plate 393) and *The Mountains* (plate 394). The colored "stitch," however, was an overlay on massive landscape forms and cloud shapes that retained their solidity. Hartley's distinctive concern with monumental shape would remain in his art throughout his career. These landscapes were exhibited in Boston in March 1909 and were much admired by Prendergast, who arranged for them to be shown to the other members of the Eight in New York. In May, Alfred Stieglitz gave Hartley his first one-man show at his 291 Fifth Avenue gallery. This elicited Hartley's first serious critical review, written by Sadakichi Hartmann, in Stieglitz's *Camera Work*. Hartmann recognized "a version of the famous Segantini 'stitch'" and "an extreme and up-to-date impressionism."[24] Yet even as the show heralded an emerging modernist who evolved through Impressionism, Hartley was discovering Ryder, Matisse, and then Cézanne at the modernist galleries in New York. His Dark Landscapes, done in Maine only slightly later, in 1909 and in 1910, are Ryderesque works in which color is expunged and

386

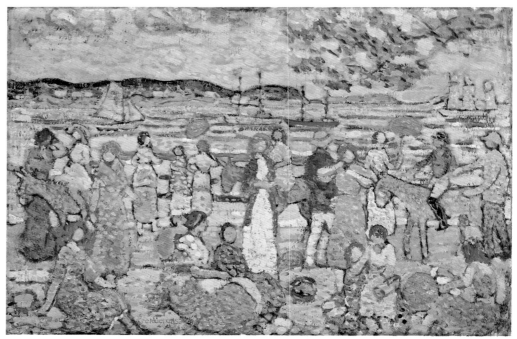

387

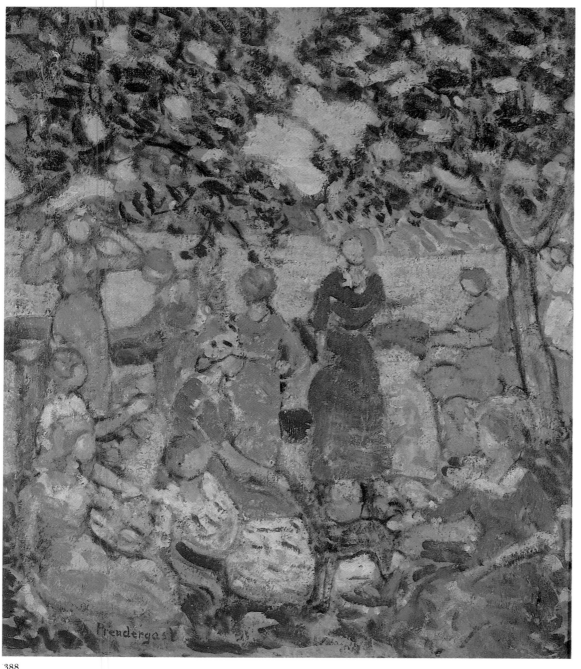

388

386. MAURICE PRENDERGAST. *The Swans*, 1916–18. Oil on canvas, 30⅛ x 43 in. Addison Gallery of American Art, Phillips Academy, Andover, Massachusetts; Bequest of Miss L. P. Bliss.

387. MAURICE PRENDERGAST. *Along the Shore*, c. 1916. Oil on canvas, 23¼ x 34 in. Columbus Museum of Art; Gift of Ferdinand Howald.

388. MAURICE PRENDERGAST. *Picnic by the Inlet*, 1916. Oil on canvas, 28¼ x 24⅝ in. Mr. and Mrs. Raymond J. Horowitz.

389. GIFFORD BEAL (1879–1956). *The Albany Boat*, 1915. Oil on canvas, 36⅜ x 60¼ in. The Metropolitan Museum of Art, New York; George A. Hearn Fund, 1917.

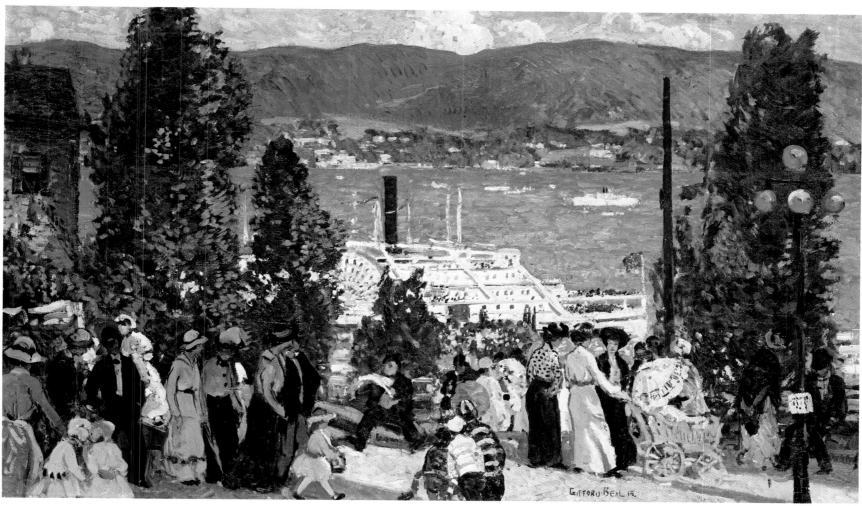

389

*"Over the wall comes a beating of tom-toms and in rushes
a new herd and new shepherds. They say the choicest
grass in Arcadia grows near the cliffs, so they dash up
to this precipice of French Impressionism run mad and
misnamed. . . . I paint ballet girls, says Degas—ballet girls
are all legs or should be—calls out this able painter,
bitten by this new craze. Hurrah! here goes—off come
their bodies and heads with a slice, and ten pink fish worms
dangling from the pole of the drop curtain, are expected
to give you the impression of the close of the first act at La
Scala! Another throws a tomato salad at a canvas and
calls it 'Poppies in bloom.' Then he picks out the tomatoes
and leaving the yellow Mayonnaise, calls it a 'wheat-
field,' or perhaps only a few sprigs of lettuce and an olive
remain and lo! we have an 'Early spring.'"*

F. Hopkinson Smith, *Between the Extremes*, pp. 22–23.

forms are reduced to heavy, somber, elemental shapes. Though Hartley moved
farther and farther away from the joyous fragmentation of Impressionism, as a
serious critic of the arts he wrote sensitive, sympathetic essays on Theodore
Robinson and John Twachtman.[25]

The New Criticism

Even after Impressionism had achieved primacy in the mainstream of American
art by the mid-1890s, it continued to generate a great deal of critical discussion.
Much of this had to do with establishing a tradition for its innovations rather than
with giving it validity. Another shift in the nature of criticism was in its authorship.
Most earlier criticism had been written by professional art writers, critics, or
editors of art journals; much of the later writing was by the artists themselves, some
of them Impressionists and others not.

Some of the artist writers felt free to proselytize or decry. Inness, as we have
seen, was an early detractor. Another unsympathetic voice was that of the water-
colorist F. Hopkinson Smith, a prolific writer and speaker as well as a widely
exhibited painter. His earliest speech, which seems to have been preserved in full,
was "Between the Extremes," presented to the Rembrandt Club of Brooklyn in
February 1888 and published later that year.[26] In it Smith advocated an art that
balanced Pre-Raphaelite detail and Impressionist blurring of form: "Extreme
realism is when we say too much; extreme impression is when we say too little." He
basically espoused a Barbizon-inspired mode: "I often think the coming landscape
painter will be an out door painter. He will be a realistic impressionist. He will be

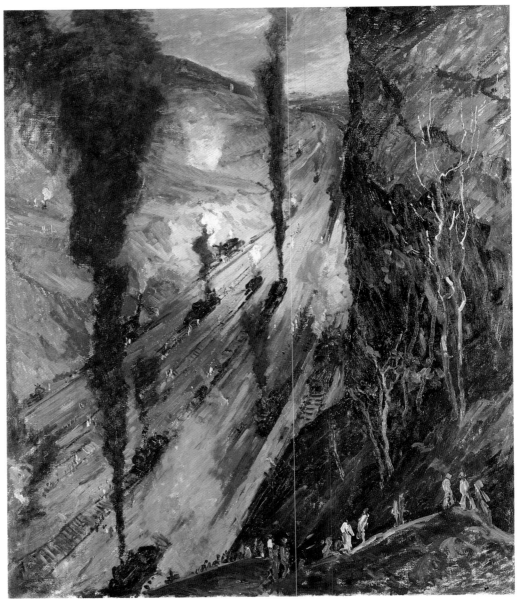

391

390

between the extremes."[27] A talk entitled "Impressionism and Realism in Art," given in 1903 at the Philadelphia Art Club and subsequently published, suggests that Smith became only more vehement in time: "The impressionist is the short-hand student of Nature. His canvases—not even those of Monet, his great master—and all others are in the awkward squad compared to him—convey no thought. They are simply a wilderness and riot of the primary colors."[28]

Smith's diatribes against Impressionism were not unopposed. A week after he spoke against French Impressionism at the Art Institute of Chicago in early 1896, the Hoosier Impressionist Theodore Steele presented a rebuttal, "The Trend of Modern Art."[29] Steele became one of the major spokesmen on modernism throughout the Midwest, continuing to lecture until 1925, the year before his death. Midwestern art magazines were very receptive to writing on Impressionism, beginning with Steele's essay "Impressionalism," in *Modern Art* in 1893. The Central Art Association, begun by Hamlin Garland, was particularly favorable to Impressionism; its literary organ based in Chicago, the *Arts* (later *Arts for America*), published numerous articles on Impressionism. Several of them emphasized its origins in the work of Manet, including one by the young artist and future color theorist Hardesty Maratta.[30]

By the early years of this century a historical approach to Impressionism dominated much art writing. An example is Henry G. Stephens's summation, "Impressionism: The Nineteenth Century's Distinctive Contribution to Art," which appeared in 1903 in *Brush and Pencil*, the leading Midwestern periodical to succeed *Arts for America*.[31] Most of the critical literature of the time was quite balanced: it recognized the limitations of the style, decried imitation and extremism, and, as Stephens's article did, considered French and American painters on equal terms, pairing Monet and Hassam in texts and illustrations. A last gasp of

invective appeared in W. P. Lockington's "The Limited Range of the Luminist," in the *Art Interchange* of May 1902, in which the author hopefully predicted that "the fire and smoke of the Impressionist" would soon be stamped out. His ire had been aroused by new converts to the movement, in particular the Philadelphia painter Carl Newman, whose recent exhibition offered "woman, sunshine and flowers...turned into an unpalatable salad."[32]

Lockington was a proponent of Barbizon landscape, which "gave us atmosphere such as might be applied to the seasons, without distortion or hard cajolery —sweet, simple and seductive." Although some of the late Barbizon and Tonalist painters were among the more prolific art writers of the period, they strove for a balanced point of view on Impressionism. A perceptive historical survey of the early years of French Impressionism was presented by Arthur Hoeber in 1896, whose own reductive landscapes of marshlands on Long Island and Cape Cod are only slightly tinged with Impressionist color.[33] While Hoeber was more at ease with tradition than with innovation, he was one of the first Americans to write an appreciation of Mary Cassatt's work.[34] A colleague of Hoeber's was Birge Harrison, one of the finest Tonalist artists and an important teacher who ran the Art Students League summer school at Woodstock, New York.[35] Harrison was also the leading writer in America on contemporary landscape painting and produced a book on the subject in 1909. One chapter entitled "The True Impressionism in Art" appeared that year in *Scribner's Magazine*.[36] Harrison stressed, as did others of the period, the universality of Impressionism: "Anyone who honestly and sincerely records his impressions of nature *is* in the truest sense an impressionist... Velásquez and Titian and Rembrandt were as truly impressionist as were Manet or Monet or Sisley.... To tell the truth, the so-called French impressionists were far more accurately termed luminarists, or painters of light."[37] Harrison denigrated the achievements of the Impressionists as "a purely technical triumph—the discovery that by the use of broken color in its prismatic simplicity the pulsating, vibrating effect of light could be transferred to the surface of a canvas" and also found the artists "somewhat deficient in the quality of personal vision...."[38] At the same time, in a section of the book called "Vibration," which was published separately in *Palette and Bench* that year, Harrison emphatically acknowledged Impressionism. Recalling one of the revolutionary early Impressionist exhibitions in Paris and the scorn it met from critics and older painters, he acknowledged that "no future painter certainly can afford to ignore their message."[39]

Similar sentiments were expressed in 1914 by Henry Ward Ranger, the leading spokesman for Tonalism. In *Art-Talks with Ranger* he said, "The influence of the Luminists will be felt, consciously or unconsciously in every 'landscape' of the future...."[40] But he also criticized: "As might have been expected, the followers of this school got into trouble. With them it became the thing to paint every picture in the highest possible key."[41] Ranger noted that Impressionism, an art movement in defiance of conventions, soon created its own conventions, notably that works be painted outdoors and that shadows be purple. He appreciated the airiness and suggestiveness of Impressionism but regretted the loss of subtle line and color. Yet he too acknowledged its universality.

While Tonalist artists disparaged Impressionism because of its materiality, seeing it as an art concerned primarily with technique, Robert Henri, whose painting was factually oriented, decried its aestheticism, warning the art student: "Do not be interested in light for light's sake or in color for color's sake, but in each as a medium of expression....Colors are beautiful when they are significant."[42] By the time Henri and Ranger wrote, Impressionism had become established. Ranger said, "In the eighties it was thought that iconoclasm had, with Monet and Manet, gone to the limit; but to-day the 'ultra advanced' call Monet and Manet 'old-hats'; and the extreme swing is marked by the 'Cubists' and 'Futurists.'"[43] Another artist who depicted aspects of modern life and also wrote voluminously was Guy Pène du Bois, a contemporary of Henri and the Eight. He wrote a historical perspective on

"The object of painting a picture is not to make a picture— however unreasonable this may sound. The picture, if a picture results, is a by-product and may be useful, valuable, interesting as a sign of what has passed. The object, which is back of every true work of art, is the attainment of a state of being, a state of high functioning, a more than ordinary moment of existence."

Robert Henri, quoted in Robert Goldwater and Marco Treves, *Artists on Art* (New York: Pantheon, 1945), p. 401.

393. MARSDEN HARTLEY (1878–1943). *Carnival of Autumn*, 1908–9. Oil on canvas, 30¼ x 30⅛ in. Museum of Fine Arts, Boston; Charles Henry Hayden Fund.

393

394

Impressionism, published in *Arts and Decoration* in 1914. A year later in the same magazine, du Bois did several articles on the Boston and Pennsylvania Impressionists that initiated the attempt to define regional schools, a further indication that Impressionism was being consigned to history.

The American Impressionists themselves were not especially given to writing about art. There are a few exceptions, of course, notably the substantial body of material by Philip Leslie Hale; the contributions of Robinson and Weir, along with many of their non-Impressionist colleagues, to *Modern French Masters*, edited by John Van Dyke; and some writing by the Hoosier School in the Midwest. There are isolated essays of considerable interest by Hassam and Lilla Cabot Perry, and occasional memorials to departed colleagues, but the Impressionists seem not to have been involved in criticism as much as the Tonalist landscape painters or the urban realists.

Critics from about 1905 into the 1930s emphasized the Americanness of Impressionism, however much of it had originated abroad. Royal Cortissoz,

394. MARSDEN HARTLEY. *The Mountains*, 1909. Oil on canvas, 30 x 30⅛ in. Columbus Museum of Art, Ohio; Gift of Ferdinand Howald.

Christian Brinton, Bernard Teevan, and Catherine Beach Ely, for example, all stressed the American qualities of Willard Metcalf's work. While Metcalf may have been the artist who seemed to have nationalized Impressionism most, critics did not credit him alone. Albert Gallatin wrote in 1907 that Hassam "only went to France to learn the technique of his art. Above all he is typically American...." and Bayard Boyesen wrote of Hassam the following year that "the charm, the grace, the poignantly sweet lyricism of his pictures is apt to blind one to his Americanism."[44] Eliot Clark wrote of Robinson in 1918 that "he was not only a modern, but an American," amplifying this in 1921 by stating that "his pictures have the unaffected and uncultivated simplicity of American landscape." In 1919 Duncan Phillips said of Twachtman that "the man was thoroughly American and in his paintings we find at times a typical New England reserve," while a year later he stressed the Americanness of Weir in "his combination of certain traits which we like to think of as characteristic, not of what is common but what is best in the American. His themes were American, his mind was American, his method was American, he was American heart and soul."[45] In 1922 Frederic Newlin Price described Redfield's "devotion to American art," and as early as 1910 J. Nilsen Laurvik had placed him among those "who have done most to infuse an authentic note of nationalism into contemporary American art." This was the core of du Bois's analysis of the Pennsylvania Impressionists when he wrote: "The Pennsylvania school of landscape painters, whose leader is Edward W. Redfield, is our first truly national expression...."[46] The Americanness of the Boston Impressionists was less often stressed, though du Bois observed that they depicted a side of the national character, and in 1921 Anna Seaton-Schmidt described Frank Benson's paintings as "typically American," with a "spirit of optimism, of daring, of a surety of happiness."[47]

This issue also dominated Royal Cortissoz's writing on the American Impressionists. Cortissoz was one of the finest critics at the turn of the century, though his conservatism has led art historians to ignore his sensitive insights into the more traditional art of his time. He was especially sympathetic to the work of the American Impressionists, even though he accurately assessed their limitations. Cortissoz had begun to recognize the Americanness of Metcalf's art as early as 1905; thirty years later he spoke of Hassam as "the robust champion of American art." In a letter of May 31, 1943, Benson wrote to Cortissoz, "I am the last of the Ten and it is good to have a word from you for you were all but a member, yourself, and nearer than any outsider."[48]

In his article "Current Impressionism" of 1915, Louis Weinberg defined the technical aspects of Impressionist painting—"broken color tones," a "purer palette," an "interest in values, in luminous shadows, and in vibrating light"—but he saw these as manifestations of the kaleidoscopic nature of "an age of impressionistic living. All is atmosphere and movement.... Most things are enveloped in the vibrating atmosphere of doubt—light, the rationalists call it. In our social life, in our industrial life, in our political and in our very religious life, all is change."[49] Thus Impressionism was not only enshrined as a historical phase of American art but it was also recognized as a principle of primary energies implicit in contemporary life, at a time when Albert Einstein had begun to enunciate the principles of relativity and civilization was enduring the upheaval of World War I.

We are a new people in a new country. Watch the crowds along the Piccadilly or the Champs Elysees—you spot the Americans among them almost as easily as if they wore our flag in their buttonholes. It means that already a new type has appeared, the offspring as we know of European stock, but which no longer resembles it. . . . And just as his look and character are different, so his art must be different.

William Merritt Chase, "The Import of Art: An Interview with Walter Pach," *Outlook*, June 25, 1910.

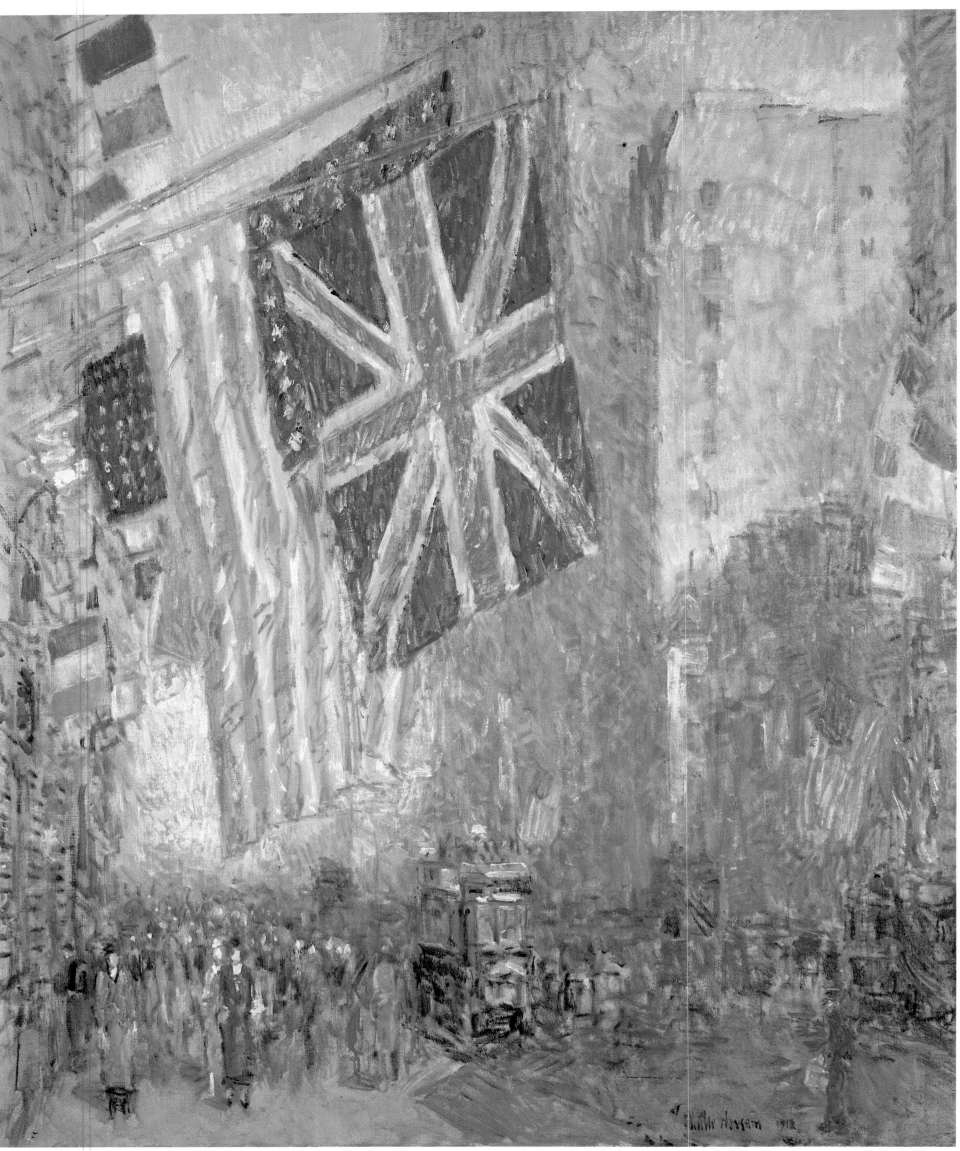

15 Triumph and Closure

THE ASCENSION OF IMPRESSIONISM IN AMERICA can be charted through the series of international expositions held in this country between the Philadelphia Centennial in 1876—which included no Impressionist works—and the great Pan-Pacific Exposition in San Francisco in 1915. That is roughly the time span of this study, though Impressionism continued to be popular and much practiced even after 1915. The Impressionist work shown in Chicago in 1893 has been discussed at length (see chapter 8), and Impressionism was a major feature of both the Pan-American Exposition in Buffalo in 1901 and the Louisiana Purchase Exposition in Saint Louis in 1904.

But it was at the Panama-Pacific Exposition in San Francisco that Impressionism, and especially American Impressionism, enjoyed its most complete triumph. Impressionist works dominated the show, Impressionist artists painted many of the murals, and the public and critics acclaimed the style. Impressionists were everywhere and en masse: there was an entire wall of paintings by Monet. But the foreign Impressionists were not limited to the French—the ever-popular Swedish artists were also seen in force. In the American section the roll call of artists read like a *Who's Who* of American Impressionists, and most of the painters discussed in this book were represented there. Some were given whole rooms to themselves: thirty-two paintings by Chase, thirty-eight by Hassam, twenty-one by Melchers, twenty-one by Redfield, twenty by Tarbell, and twenty-six by Twachtman. Nor was such representation limited to the major figures of the movement. A host of regional artists were present: many of the Old Lyme painters, including Charles Ebert, Will Howe Foote, and Edward Rook; Charles Curran and Helen Turner from Cragsmoor, New York; John Ottis Adams, William Forsyth, Theodore Steele, and Otto Stark from Indiana; Arthur Watson Sparks from Pittsburgh; many of the Chicago painters; and even Kate Freeman Clark (listed as Freeman Clark), identified as being from Mississippi but working with Chase in New York. California painters also were prevalent—many, though not all of them, Impressionists—such as Joseph Raphael and Euphemia Charlton Fortune from the San Francisco area; Benjamin Brown, Donna Schuster, Guy Rose, and others from Los Angeles; and Maurice Braun of San Diego, with three Southern California hillside scenes. The expatriate contingent was there, too—Frederick Frieseke, Richard Miller, Louis Ritman, and many of the group who, like Lawton Parker, had since returned home. Finally, there was a smattering of work by the Post-Impressionists,

395. CHILDE HASSAM (1859–1935). *The Union Jack, New York, April Morn*, 1918. Oil on canvas, 36 x 30⅛ in. Hirshhorn Museum and Sculpture Garden, Smithsonian Institution, Washington, D.C.

such as Lawrence Mazzanovich, whose art was based primarily on Impressionist techniques and principles.

Critical reaction to the art at the Panama-Pacific Exposition was extremely enthusiastic—and plentiful—if not always totally unqualified, but the nature of the criticism, and of the critics, reflects the changed position and estimation of Impressionism in America by 1915. The two most perceptive and respected writers on the Exposition were J. Nilsen Laurvik and Christian Brinton. Laurvik was an international figure: a writer on many of the contemporary American painters; a specialist on Scandinavian painting; the commissioner of fine arts and member of the International Jury of Awards for Norway; and author of publications on Anders Zorn and on Henrik Ibsen. Brinton's interests were even more international: in addition to a volume called *Modern Artists*, he had written painting catalogs on the Spaniard Ignacio Zuloaga, the Englishman Walter Greaves, the Belgian Constantin Meunier, and studies on Goya and Manet. He engineered the great American painting show in Berlin in 1910, the Scandinavian exhibition brought to America in 1912, the Swedish exhibition seen here in 1916, and wrote a study on American art published in French in 1913. Such commentators saw beyond the narrow, nationalistic limits applied by so many critics to American Impressionism and viewed the movement in international perspective. Laurvik wrote a very thoughtful article in *Century* magazine.[1] In Brinton's book, *Impressions of the Art at the Panama-Pacific Exposition*, he placed American developments within a broader context than any previous writer had done.[2] Comparisons and contrasts with the French Impressionists had not been infrequent, of course, and usually concluded that each American was "his own man." But Brinton went much, much farther, and because he viewed American Impressionism from a perspective that has not yet been adopted even by recent critics and historians, his summation of the international development of Impressionism deserves to be quoted in full:

Paris of course proved the spot from whence radiated this new gospel, just as, a generation later, it was from Paris that was launched the propaganda of the Expressionists, who today represent the inevitable reaction against Impressionism. Simultaneously there sprang up over the face of Europe, and also America, countless acquisitive apostles of light who soon changed the complexion of modern painting from black and brown to blonde, mauve, and violet. The movement seemed spontaneous. In Spain it was Sorolla and Rusiñol who popularized the prismatic palette among the vineyards of Valencia, along the plage of Cabanal, or in the gardens of Andalucia. Far up among the peaks of the Engadine, Giovanni Segantini, the solitary, heroic-souled Italian-Swiss painter perished in endeavouring to apply the principles of Divisionism, as he termed it, to simple and austere mountain scenes. Darkness was everywhere dissipated. Under the direct inspiration of Degas, Max Liebermann undertook the task of injecting purity of tone and swiftness of touch into the Gothic obscurity and linear severity of Teutonic painting. Claus and Van Rysselberghe in Belgium, Thaulow in Norway, Kroyer in Denmark, and a dozen or more talented Swedes witness the widening acceptance of the Impressionist programme. Apart from George Clausen, Bertram Priestman, Wilson Steer, and a scant handful of the younger men, it cannot be claimed that Impressionism has made commensurate headway in England. The Scotchmen, to the contrary, have proved more sensitive and open-minded, and, in modified form, the feeling for atmospheric clarity has become one of the characteristic features of the Glasgow School. In America conditions were favourable owing to the efforts of certain of our abler men who lived and studied in Paris during the early 'eighties of the last century. The pioneers in this particular field were Theodore Robinson and Alexander Harrison. Still, it must not be assumed that American Impressionism and French Impressionism are identical. The American painter accepted the spirit, not the letter of the new doctrine. He adapted the division of tones to local taste and conditions and ultimately evolved a species of compromise technique. Only one American artist, Hassam, went as far as Monet, yet he has managed to individualize his brilliant, vibrant colour appositions.[3]

And Hassam continued to maintain a surprising creativity in his interpretation of Impressionism, as few of his early colleagues did. Some were already dead, and the year after the Exposition in San Francisco, William Merritt Chase died. Of the other master Impressionists, J. Alden Weir was still active in the late 1910s, but more effective as an official than as a painter. In 1915 he became president of both the National Academy and the Metropolitan Museum of Art and shortly before he died in 1919 joined the New Society of American Painters, Sculptors, and Gravers. Critical tributes to his painting and printmaking continued unabated during his last years and increased after 1919, culminating in the memorial show of his work at the Metropolitan Museum of Art in 1924.

The Boston master Impressionists gradually withdrew from Impressionism to concentrate on more somber interior genre pictures and increasingly on portraiture. Frank Benson had ventured into the new field of wildlife depiction in painting and prints, and in the early 1920s he began to add to his repertory an interest in lush, monumental still lifes done in sparkling, silvery tones and heavily factured brushwork. These opulent still lifes are a counterpart to his upper-class portraiture, thematically reviving the Grand Manner. Benson's colleague Philip Leslie Hale in his posthumously published essay on the history of Boston painting and etching wrote: "In the matter of still life Mr. Benson has invented what amounts to a new genre. His paintings, through choice of original subjects, a new way of presenting things, effective and brilliant technique, have struck a new note. The Benson still lifes are bigger, brighter and in many instances better than those that have gone before."[4]

Willard Metcalf, a relatively late-blooming Impressionist, maintained a high creative level until his death in 1925. But of all the original group of American Impressionists, the Ten, and the other early converts to the aesthetic, it was Childe Hassam who remained the most dynamic for at least a decade and a half after the Panama-Pacific Exposition. In the 1930s, the last few years of his life, there was a recognized falling off of activity; but in the 1920s much of his vital recent work was presented in a series of major exhibitions throughout the country. The most comprehensive, with important catalogs, were the show of 182 pictures held in

396. FRANK BENSON (1862–1951). *Still Life Decoration*, 1922. Oil on canvas, 45 x 60 in. The Art Institute of Chicago.

396

397

New York at the American Academy of Arts and Letters and the retrospective of 136 works at the Buffalo Fine Arts Academy in 1929.

Hassam's major innovation was his well-known Flag series, which was begun soon after the Exposition, though its genesis can be traced to a picture painted in Paris in 1910, at the beginning of his last trip to Europe.[5] On Bastille Day, July 14, he painted a long view of the street celebration from on high, reviving the format of his New York views begun twenty years earlier; but he combined the vivid animation of myriad dark figures and carriages with the larger, brightly colored patterns of unfurled French flags (see plate 398). The general format and the specific urban locale have their ultimate source in the Paris views by Monet and Pissarro. Hassam transferred his fascination with this motif to New York in 1916. After the sinking of the Lusitania, New Yorkers brandishing American flags marched in "preparedness parades" down Fifth Avenue. Hassam utilized these strikingly repeated and instantly recognized color patterns to establish an aesthetic innovation with patriotic overtones.

Once the United States entered World War I, Hassam enlarged his repertory, both artistically and patriotically. Fifth Avenue was decked with flags both of the United States and of the Allies, beginning in 1917 and culminating in 1918 with the Allied victory celebrations. The varied flag patterns create a coloristic display of great richness, and these become even more exuberant in the paintings of 1918—in terms of both the vitality of the crowds in the streets and the magnificence of the flags flying above them. Though sparkling in the animated Impressionist brushwork and bright prismatic colors, the flags maintain their basic geometric form and appear massive above the swarms of tiny figures below. They act as unifying elements in the composition as well as symbols of national and international solidarity.

Hassam first exhibited these works in November 1918, fittingly enough in New York at Durand-Ruel, the dealer who introduced Impressionism in America. Included were four Flag pictures of 1916, six of 1917, and ten of 1918. In his introduction to the catalog the artist ánd writer William A. Coffin briefly traced the evolution of the Flag pictures and their commemoration of successive parades, drives, and celebrations.[6] The patriotic note was seized by Hassam's critics and admirers alike. In one article, "Painting America: Childe Hassam's Way," concerned primarily with the series and illustrated with examples from it, the author declared: "Never has there been a more marvellous street decoration and never a more brilliant recording of it in picture form.... Such was our Fifth Avenue and such again are the great canvases painted by Childe Hassam in honor of this historical emblematic gathering together of friendly nations. America speaks in these canvases...."[7] The article appeared in July 1919, when most of the pictures were exhibited at the Milch Galleries in New York, having been shown again at Durand-Ruel earlier in the summer. Though the attempt that year to raise one hundred thousand dollars to purchase the series as a war memorial for the city was unsuccessful, the Flag paintings were on view again at the Corcoran Gallery in Washington, D.C., in 1922.

Hassam continued to produce additions to his New York Window series into the early 1920s, but though he and his wife remained in the city during the winter, they spent more and more time each year in the house they bought in August 1919 on Egypt Lane in East Hampton, Long Island. Hassam also continued to travel in the 1920s: in 1925 he wintered in Savannah, Georgia, with stops in Baltimore, Richmond, and Charleston, and in 1927 he passed through New Orleans, Texas, and New Mexico, to reach Southern California, creating pictures of the areas he visited on both trips. But most of his paintings of the 1920s were done in East Hampton: formal still lifes, local landscapes, scenes on the golf course, and idyllic paintings of nudes on the local beaches, all in an increasingly loose Impressionist technique, bright colors, and often very large scale, almost muralsized, recalling his 1904 decorations for Colonel Wood's Portland library. Has-

sam's late works became increasingly decorative as he adopted a Post-Impressionist, nonnaturalistic aesthetic, though his technique remained quite orthodox. These paintings of his old age have not stood the test of time well, though we may not be distanced enough yet for proper appreciation. Perhaps his most attractive late pictures are his more modest ones, the close-up views of the shingled dwellings in East Hampton, in which Hassam made effective use of the repeated geometric forms of the shingles and the purple-gray tones of their weathered surfaces against the bright greens of foliage.[8]

Though Hassam in later years showed his work rather frequently at Durand-Ruel, the two dealers closest to him and to many of his Impressionist colleagues were Albert Milch and Robert Macbeth. In 1936, the year after Hassam's death,

"Paris is a huge Coney Island—noisy, dirty. The streets are ankle deep in advertizing cards and bills and when it rains the whole thing becomes a pulp. The town is all torn up like New York. Much building is going on. They out American the Americans! . . . I made a 14th July from the balcony here."

Childe Hassam to J. Alden Weir, July 21, 1910. Childe Hassam Papers, Archives of American Art.

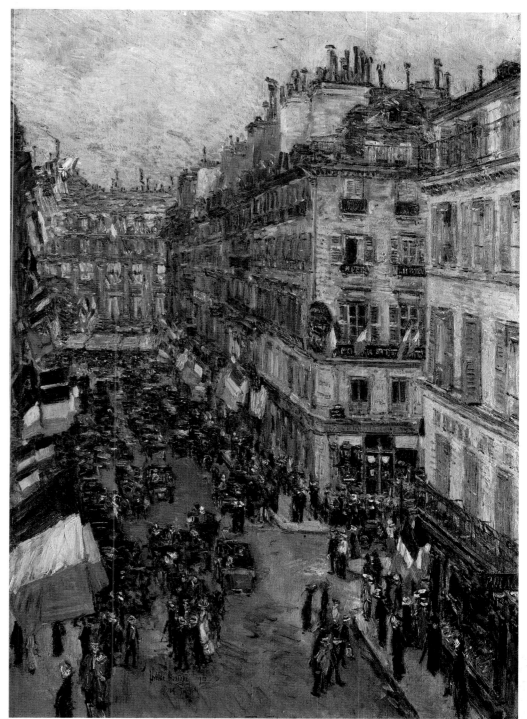

397. WILLARD METCALF (1858–1925). *Indian Summer, Vermont*, 1922. Oil on canvas, 50¼ x 60⅛ in. Dallas Museum of Fine Arts; Gift of the Jonsson Foundation.

398. CHILDE HASSAM. *July Fourteenth, Rue Daunou*, 1910. Oil on canvas, 29⅛ x 19⅞ in. The Metropolitan Museum of Art, New York; George A. Hearn Fund, 1929.

398

the two men were made supervisors of his estate of almost five hundred works, which he had left to the American Academy of Arts and Letters. Several pictures were to be sold annually for the support of younger American painters, a legacy bespeaking the generosity of spirit that Hassam's exuberant art so engagingly demonstrates.

The Panama-Pacific Exposition established the preeminence of American Impressionism. The nation, and indeed the Western world, had witnessed its development over the preceding thirty years, but the Exposition enshrined it. Impressionism had become not only domesticated but historicized in America. At the Exposition a number of the "Old Master" Impressionists were especially honored, and one of the newer ones, Frederick Frieseke, won the grand prize; Metcalf received a medal of honor; Lawson, Vonnoh, and Reid won gold medals; and Glackens and Perry, silver ones. But already to be seen, not in a Salon des Refusés but on the walls of the Exposition exciting much critical attention, were adherents to the Ashcan School aesthetic, such as John Sloan, Robert Henri, and George Bellows. And even more radical painters were there: Arthur B. Carles, Stuart Davis, Samuel Halpert, Alfred Maurer, and both William and Marguerite Zorach, among others, many of whom reflected the most avant-garde artistic tendencies from Europe.

In his extremely perceptive book on the art at the Exposition, Christian Brinton recognized the prevailing winds of changes:

> While there resulted from this scrupulous study of the optics of art much that was fresh and invigorating, the personal equation was nevertheless lacking, or was reduced to a minimum. You cannot open the window to nature and close it upon the human soul, and even before the conclusive triumph of Impressionism there were signs of a reaction. Analysis was bound to give place to synthesis, and hence Impressionism, which ignores the individual, was supplemented by Expressionism, which exalts the individual.... We hear, with increasing perturbation, of Post-Impressionism, Cubism, Futurism, Orphism, Synchromism, and a bewildering succession of isms all more or less closely associated in aim and idea.[9]

Perhaps the most succinct and penetrating observation on the state of the arts at this crucial juncture was made by Brinton's colleague Laurvik.[10] He noted the cycle of change that the Exposition illuminated and even endorsed, pointing out that "If one considers what occurred in the interval between the painting of *Niagara Falls* by F. E. Church and the same subject some forty years later by John H. Twachtman, one will perhaps be ready to admit that work such as this *Interior* by Halpert may perhaps carry forward into a new sphere of expression the ideas admirably expressed in Tarbell's *Girl Crocheting*."[11] Laurvik would have agreed with Brinton that "the various movements overlap one another, and in each will be found that vital potency which proves the formative impulse of the next."[12] The vital potency of the Impressionist movement in American art is celebrated not only in its aesthetic legacy but in the richness, beauty, and diversity of its own pictorial achievements.

399. CHILDE HASSAM. *Allies Day, May 1917*, 1917. Oil on canvas, 36¾ x 30¼ in. National Gallery of Art, Washington, D.C.; Gift of Ethelyn McKinney in memory of her brother, Glenn Ford McKinney, 1943.

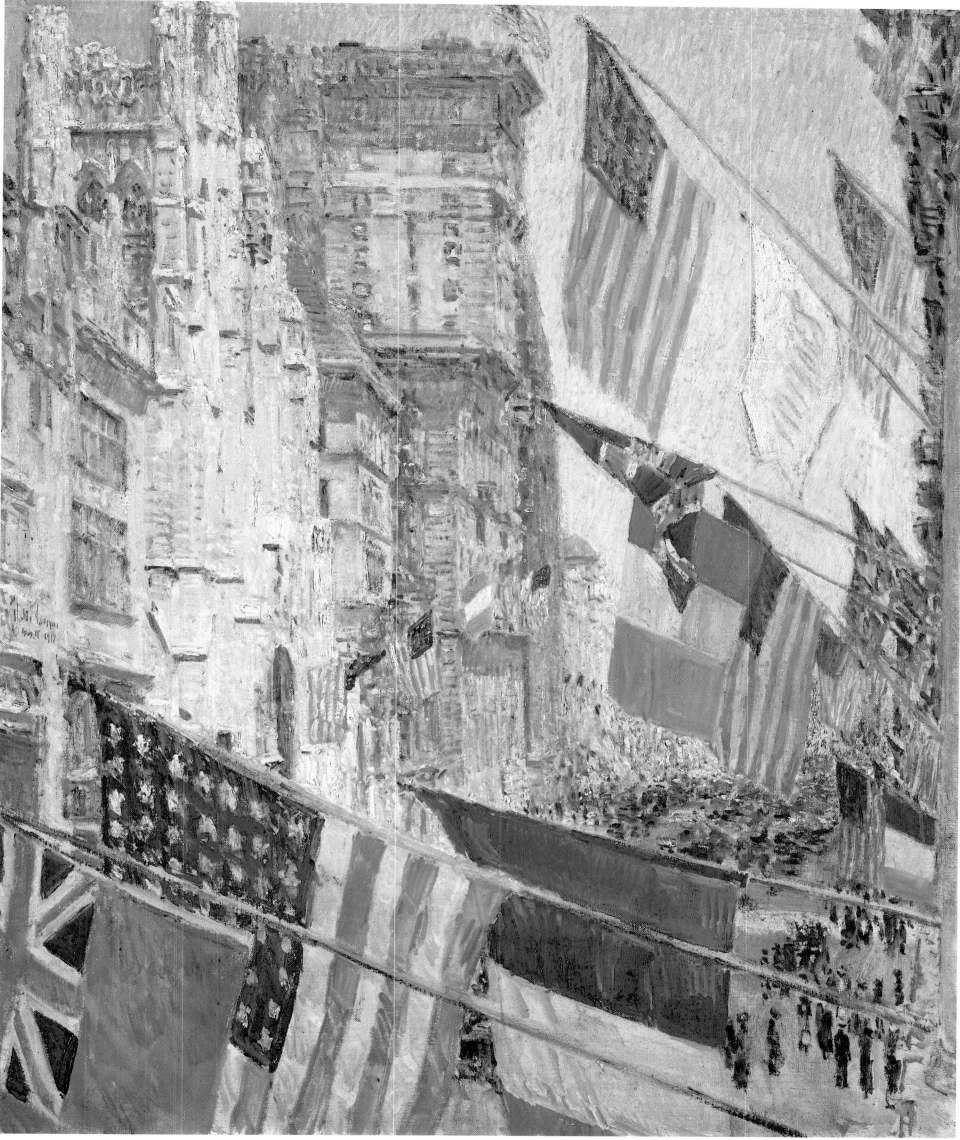

16 Impressionist Themes

MENTION HAS BEEN MADE earlier of the two collections of French Impressionist painting sent over to this country by Paul Durand-Ruel in 1883 and 1886, the seventeen works included in the Foreign Exhibition Association show of 1883 held in Boston, and then the huge display in New York in April 1886, held at the galleries of the American Art Association, which, the following month, was enlarged and moved to the National Academy of Design. While the Impressionist section of the Foreign Exhibition was only a fraction of the whole show, it garnered tremendous publicity of wildly divergent views from critics of both cities.[1] The artist who fared best was Auguste Renoir, whose *Breakfast at Bougival* (*Luncheon of the Boating Party*) (plate 401) was particularly commented upon favorably by a number of writers.[2]

The works of Claude Monet, on the other hand, were greeted especially badly, a situation curiously reversed in the large exhibition held in New York three years later, though in fact some of the same pictures that had been shown in Boston reappeared in that exhibit. The reasons for the about-face have never been examined, and though they cannot be investigated here, they would seem to lie in factors more complex than the contrasting arenas in which the two exhibitions appeared, the disparity in the scale of the shows, or the short time that had elapsed between the two. We have seen that, out of the gigantic display in New York, Monet emerged as not only the critical star but also the recipient of ever more patronage from American collectors. The critical reaction to this display has recently been addressed brilliantly by Michael Leja, focusing upon Helen Abbott Michael's published analytical pamphlet about the show, but I want to take a somewhat different spin on the voluminous criticism of the exhibit.[3] One of the most interesting aspects here was the differentiation offered by a number of writers concerning the figure pictures by Gustave Caillebotte, Edgar Degas, Edouard Manet, Jean-Louis Forain, and Renoir, and the landscapes, especially by Monet. Thus, the writer for the *Critic* noted, "The tenderness and grace of impressionism are reserved for its landscapes; for humanity there is only the harsh brutality of the naked truth. . . . One might say that the feminine principle of impressionistic art is embodied in its landscape and the masculine in its figures."[4] In *Art Age* one read, "The

400. CHILDE HASSAM, *Descending the Steps, Central Park*, 1895. Oil on canvas, 35 x 34⅝ in. Virginia Museum of Fine Arts, Richmond; Gift of the Estate of Hildegarde Graham van Roijen. Photo: Ann Hutchinson. © Virginia Museum of Fine Arts.

figure subjects and the landscapes have in common their truth, their magnificent handling, their strength of color, and, in some cases, their intentional neglect of tone. But here the analogy ends. The complex problems of human life which make the figure subjects so terrible in their pessimism and seem to fill the air with cries of uneasy souls, have no part in the landscapes. These are wholly lovely, with the loveliness of repose and the tenderness of charity. They are full of heavenly calm."[5] And from the writer in the *Mail and Express* came the following commentary:

> The exasperating subjects of Renoir—his flabby, ugly "Bathers"; the brutal realism of Forain; and the coarse color contrasts of Caillebotte, discredit the principles of the school and illustrate the curious anomaly of artists perversely choosing the vile and saying to deformity, "Be thou my ideal!" In landscape, the inadequacies of their presentation in drawing are frequently atoned for by fulness and accuracy of observation in other respects, and compensated by felicitous purity of local tints. . . . One finds a joyous self-abandonment to the charm of sunshine.[6]

Such critical reaction to the work of the French Impressionists may well have impacted upon those American painters who were soon to investigate this new and challenging aesthetic. When Americans adopted the strategies of Impressionism, they most often chose to paint the landscape, and when they portrayed the figure, it was usually lovely young women, often of the upper classes and garbed in virginal white, or equally comely children, rather than the working-class subjects, derelicts, or prostitutes of Renoir, Degas, and Manet. And in these pictures, women were far more often grouped together, or shown with children, than in the company of members the opposite sex. This is not cynically to suggest that these artists compromised their ideals either to attain critical acclaim or to win patronage, though these are components that must be factored into the aesthetic and thematic choices made by artists throughout the ages, and which art historians often ignore.[7] Rather, the artists who avoided the subject matter condemned in 1886 most often shared the cultural values of their critics and patrons, imbued as they were with traditional American moral beliefs and with an optimism that contrasted with European pessimism, alienation, and skepticism.[8]

Having said that, it should be emphasized that a search for qualities specifically American must be approached with caution. American artists undertook many of the same themes that their French colleagues, and indeed painters from all nations, investigated. Rather, there are at times disparities in emphases, modified by American purposes, values, and traditions as well as by the temperaments of the individual artists. Thus, when American painters working in France undertook to paint the landscape, whether in art colonies such as Giverny and Grez, or on the coasts, they often chose scenic attractions similar to those painted by Monet and Renoir, or alternatively chose more restricted, more private vistas such as Lilla Cabot Perry's *Giverny Hillside* (plate 90), very similar to Monet's own landscapes. Yet the preference for the panoramic, as archetypically defined in Theodore Robinson's series on the *Valley of the Seine* (plates 63, 64, 66), may in fact bespeak the heritage of the depiction of the vast spaces of the American continent that can be traced all the way back to Thomas Cole, and is perhaps preeminently defined in the painting of Albert Bierstadt, however much the latter's work might have seemed anathema to these young modernists of the late nineteenth century.

In their paintings of the American landscape, the Impressionists, at least in the Northeast, usually avoided the panoramic; the frontier, after all, had been declared closed in 1892, and few of the later artists chose to paint the

401

401. AUGUSTE RENOIR, *Luncheon of the Boating Party (Breakfast at Bougival)*, 1880–81. Oil on canvas, 51 1/4 x 69 1/8 in. The Phillips Collection, Washington, D.C.

sublimity of the wilderness, such works as Marsden Hartley's *Carnival of Autumn* (plate 393) excepted. Rather, American Impressionists concentrated upon either the urban landscape or the rural and domestic. In this context, "urban landscape" refers here not to street activities later featured in the work of the Ashcan School Realists but to the fascination among these earlier painters with the nature preserves of New York—especially Prospect Park in Brooklyn and, even more, Central Park in Manhattan, along with the green-space squares there: Washington, Union, and Madison.[9] William Merritt Chase was the pioneer in exploring these subjects, first in Brooklyn (plates 137–39) and then in Manhattan (plate 142),[10] though eventually almost all the major American Impressionists undertook to depict these parks and squares. Since Chase abandoned this theme in 1891, it was Childe Hassam who became most associated with the urban landscape, and it was he who painted all the major natural vistas in Manhattan (plates 102, 104). But while the parks were created to serve and uplift the populace, they were depicted by these artists as leisure retreats for the middle and upper classes. The complexity of urban social and economic identification is never on view in the park scenes of Chase and Hassam (plate 400) as one finds, for instance, in George Seurat's *Sunday Afternoon on the Island of La Grande Jatte*, which, as we have seen, may have partly inspired the investigation of this theme. Several painters—Willard Metcalf in his *Early Spring Afternoon Central Park* (1911; Brooklyn Museum), and Ernest Lawson (plate 361) throughout his career—were attracted to painting the urban complex as viewed above and beyond

402

the natural setting, almost surely unconsciously reflecting the compositional and ideological preferences of some of the earliest American landscape painters of a century earlier.

It was the Impressionists who introduced the urban street scene into the repertory of American art. Isolated examples existed earlier, of course, and commentary was generally directed at their distinction, but it was only during the 1880s that Fernand Lungren in New York and Childe Hassam in Boston (plate 97) began to concentrate upon the urban landscape, though both were then painting in a dark, Tonalist manner.[11] It was Hassam who, after "converting" to Impressionism during his three years in Paris, 1886–89, returned and settled in New York to become celebrated for his Impressionist views of the city (plate 49).[12] Hassam's paintings of the last decade of the nineteenth century celebrated the city's livability, portraying (usually elegant) pedestrians and working cabdrivers in juxtaposition to (equally ele-

gant) homes, hotels, commercial establishments, and houses of worship. But in the early twentieth century he came more and more to emphasize the new skyscraper city, either observed directly as in his quintessential *Lower Manhattan* (1907; Herbert F. Johnson Museum of Art, Cornell University, Ithaca, New York), or viewed through transparently curtained windows in his famous Window series of the 1910s (plate 213). In these works, the soaring city buildings became symbols of modernity, an assessment equally projected by the urban landscapes of his contemporary, Colin Campbell Cooper. Beginning in 1902, Cooper concentrated upon the skyscrapers and dynamics of New York, even writing about their paintability,[13] though he also essayed views of many other American cities. Cooper's *Broad Street, New York* of 1904 (plate 402), depicting almost exactly the same subject that Hassam essayed three years later in *Lower Manhattan*, became perhaps the most celebrated of all such urban imagery in America, reproduced in 1906 by A. W. Elson and Company in a facsimile edition of 250 impressions after it had been acquired by the Cincinnati Art Museum.[14] Indeed, the urban architecture of almost every American city found its interpreter in the early twentieth century, but there were few specialists outside New York; even the pioneering role of Chicago in the development of modern architecture went little noticed by artists.[15]

The concentration upon the soaring buildings of New York, and the canyons between—the simile of Western landscape grandeur appears over and over again in the literature[16]—necessitated a different format from the primarily horizontal landscapes, both urban and natural, that had predominated in the nineteenth century. Impressionist artists extended themselves, even literally, to encompass most or all of the tremendously tall buildings in their more often vertical canvases, such as Cooper's *Lower Broadway in Wartime* (1917; Pennsylvania Academy of the Fine Arts, Philadelphia), where both the older Renaissance revival structures such as the squat City Hall Post Office at the left, and even the newer skyscrapers such as the 1908 Singer Building, are dwarfed by the 1913 "Cathedral of Commerce," the Woolworth Building.[17] The great majority of Hassam's Flag series paintings are vertical, most done on Fifth Avenue and commemorating America's efforts and participation in World War I. These are celebrations of urban growth and grandeur, seen against the brilliant coloristic national banners of the United States and its allies. But the paintings also reflect the artist's devout, patriotic beliefs, with a number of the finest of these pictures centering upon the great churches of Manhattan (plate 399).[18] The dedicated spiritual component in Hassam's paintings may be unique, but a tremendous number of other American painters, working not only in New York but elsewhere, and perhaps inspired by Hassam, utilized similar artistic strategies to convey their patriotic fervor. Though French artists such as Monet and Raoul Dufy also utilized the flag motif, this appears to be especially a significant, if temporary, addition to the range of American Impressionist themes.[19]

Impressionist landscapes were painted throughout the United States, but three or four areas stand out especially as attracting the attention of painters of the movement. A great many gravitated to Long Island, New York, and throughout New England, settling for all or part of the year in the many art colonies in those regions, especially along the Connecticut coast. There, their subject matter was the rural and domestic landscape, the artists concentrating upon the gentle rolling hills and usually shunning, for instance, the more rugged scenery of Maine and the White Mountains of New Hampshire that had so attracted earlier painters. They chose rather to paint the scenery with which the art-loving layman, and their own patrons, could empathize.

402. COLIN CAMPBELL COOPER, *Broad Street, New York*, 1904. Oil on canvas, 35 1/2 x 53 in. George G. Daly.

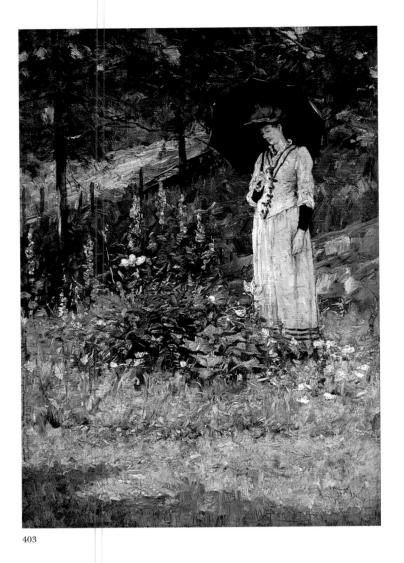

403

Perhaps even more than their European contemporaries, artists who resided in the Northeast painted their own personal environment, concentrating upon the suburban, rather than upon wild or uninhabited nature.[20] Despite their commitment to glorifying urban modernity, especially the "New New York," many artists sought refuge from urban sprawl and crowding in the pleasures of simple rural life and the scenery of the familiar, often depicting their own homes and the surrounding landscape, especially when transportation to both the suburbs and the communities on Long Island and along the Connecticut coast became more efficient. Twachtman, living in Greenwich and teaching in Cos Cob, painted his house and the surrounding landscape with its brook, pool, and waterfall over and over again (plates 119, 120, 121, 168, 169, 174),[21] while his friend and colleague J. Alden Weir devoted himself to rendering his two Connecticut estates at Branchville and Windham (plates 175, 176, 178, 182).[22] Many of the Old Lyme colonists such as Clark Voorhees (plate 273) painted their homes, not baronial estates but rather modest, agreeable dwellings, projecting the enjoyment of rural existence and the preservation of a traditional lifestyle. Tradition was an important element in the art of the New England and Long Island Impressionists, who gravitated to monuments dotting the landscape that were both old and familiar.[23] The bow bridge at Old Lyme appears repeatedly (plate 283), as do venerable houses such as the Florence Griswold home in that town (plate 223). Especially appealing were the gray-shingled houses that appear so often in East Hampton paintings of Hassam (plate 167), as well as the old houses painted throughout New England by Willard Metcalf, such as the Captain Lord House in Kennebunkport, Maine (plate 226) and the Leete House in Guilford, Connecticut, the subject of *October* (Museum of Fine Arts, Springfield, Massachusetts). Not surprisingly, an abundance of old churches

403. WILLIAM FORSYTH, *Alice with Parasol*, 1900. Oil on canvas, 20 x 14 in. Mr. and Mrs. Wade Harrison.

404. EDGAR PAYNE, *Lake Sabrina (Rugged Slopes of Tamarak)*, c. 1919. Oil on canvas, 45 x 45 in. Barbara and Thomas Stiles.

405. ALSON CLARK, *Desert Verbena, Palm Springs*, not dated. Oil on canvas, 26 x 32 in. Paul and Kathleen Bagley.

406. GUY ROSE, *Laguna Coast*, 1916. Oil on canvas, 24 x 29 in. Rose Family Collection.

407. BRUCE NELSON, *Pacific Grove Shoreline*, c. 1915. Oil on canvas, 24 x 30 in. John and Patricia Dilks.

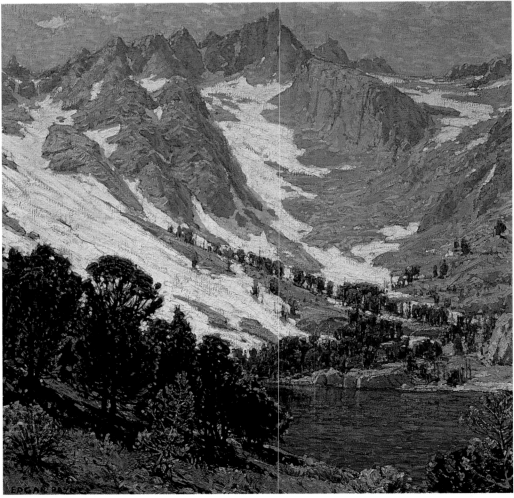

404

405

406

407

appear in these pictures. In some cases, as in the series of pictures of the Congregational Church in Old Lyme by Childe Hassam (plate 207), the structure is the subject of the painting. At other times, again especially with Hassam, the artist painted old and venerable New England towns such as Newport, Gloucester, and Provincetown, where the spires of the church or churches soar upward toward the heavens as a link with the earthbound community (plate 206). In both formats, Hassam sought to express both religious and traditional convictions in a modern aesthetic.[24]

For the landscape painters of the Midwest, especially Theodore Steele and his fellow Hoosiers of Indiana (plates 152–58), the application of Impressionism to the interpretation of the American landscape had other connotations. Instead of affirming traditional values through modernist strategies, these artists were attempting to create an art that was at once distinctly modern and distinctly American, one that would, perhaps necessarily, arise from the indigenous native heartland. The Midwest as a region that had retained its inherent values and was less contaminated by European mores received confirmation in the 1893 Columbian Exposition held in Chicago. It was in the immediate aftermath of that event that the essayist, novelist, and cultural spokesman Hamlin Garland not only recognized Impressionism as *the* modernist art form, calling upon Midwestern artists to utilize its artistic devices to create a distinctively American art, but also identified the Hoosiers as having begun to do just that.[25] Nor was this nationalistic mission imposed upon the Hoosiers from outside. One of the group, William Forsyth, acknowledged their aim when he wrote that, while studying abroad, and having viewed Dutch and Scandinavian art, "the Hoosiers were strongly attracted toward this national expression," and that, once they came home, "a singleness of purpose has been the animating principle of this group of painters and their pupils: To paint their pictures here at home, to express themselves each in his own way and yet hold closely to that local truth characteristic of our particular spot on earth. . . . there is a family likeness, indefinite perhaps, but yet a likeness, binding them together into perhaps as near a school of painting as has been developed in this country—certainly in the West."[26] And that they did. The casual and colorful interpretations of the Indiana landscape, painted by Forsyth (plate 403) and his fellow Hoosiers, with their meandering streams, rural homesteads and fences, and provincial folk traversing village streets and country roads, are distinctive to the American Impressionist canon.

The landscape of Long Island, New England, and the Midwest was being interpreted with Impressionist strategies by the early 1890s. That of California, especially in the south but also on the Monterey Peninsula, was not similarly rendered until the early twentieth century, but it was then that Impressionism found its most diverse scenic application in this country.[27] With brilliant color and vigorous brushwork, the California Impressionists such as Paul Lauritz, Edgar Payne (plate 404), and Jack Wilkinson Smith reinterpreted the grandeur of the Hudson River School in their delineation of the mountain scenery of the Sierra Nevada, while others, such as Alson Clark (plate 405) and John Frost, pictorially marveled at the hot and flat desert interior. Equally compelling was the attraction of the broad beaches and brilliant blue water of the Pacific for artists such as Guy Rose (plate 406) and William Wendt, painting especially in and around Laguna Beach, the principal art colony on the West Coast.[28] And while the scenes depicted there tended toward the sweeping and sometimes placid, the artists working in Monterey—those residing there such as Paul Dougherty, Bruce Nelson (plate 407), and William Ritschel, visitors from the South such as Rose, and even from the East Coast such as Childe Hassam, who was sojourning in the state

in connection with his mural painting at the Panama-Pacific International Exposition, were drawn to the rugged, rocky scenery at Pacific Grove and Point Lobos.

Probably the theme most distinctive to the California Impressionists was the celebration of the floral landscape—not cultivated gardens but rather masses of wildflowers, referred to as "The Carpet of God's Country"— poppies, lupine, pink buckeye, wild lilac, wild mustard, wild buckwheat, and other blooms that carpeted both the valleys and coast of the state.[29] Poppies especially were ubiquitous in the landscape; the poppy is also the state flower, and was referred to as the "Queen flower of them all."[30] While this wildflower theme was explored elsewhere—poppy fields, after all, were painted in Giverny by both Claude Monet and American colonists, including the Californian Guy Rose, and in the United States, where the bluebonnets and cactus flowers of Texas became a specialization of such artists as Julian Onderdonk (plate 312) and Dawson Dawson-Watson—it was investigated by scores of painters in both Northern and Southern California. Granville Redmond (plate 311), who began rendering this theme at least by 1912, is probably the best known of these specialists, but William Wendt had painted

409

410

408. THEODORE WORES, *Tree Blossoms*, 1920. Oil on canvas, 36 x 48 in. City of Santa Clara in care of the Triton Museum of Art, Santa Clara, California.

409. ALSON CLARK, *Ruins of San Juan Capistrano*, 1919. Oil on board, 31 x 25 in. Joan Irvine Smith Fine Arts, Newport Beach, California.

410. MARY MACMONNIES, *Blossoming Time*, 1901. Oil on canvas, 33 1/2 x 63 5/8 in. Collection of the Union League Club of Chicago.

fields of scarlet poppies by 1897,[31] and John Gamble, first in San Francisco and then in Santa Barbara, and William Jackson in Sacramento devoted the greater part of their artistry to this theme, while John Frost painted even the desert in flowering pink verbena, and Theodore Wores painted poppies and lupines along the San Francisco coast.

Wores was also the principal master of a variation on the carpeted floral landscape, painting a series of colorful vistas featuring blossoming fruit and almond trees in the Santa Clara Valley (plate 408). This theme was not solely his of course, nor even limited to California. Theodore Robinson had painted flowering orchards in Giverny, but there, for all their decorative appearance, they functioned as elements in the subsistence economy of the local peasantry. And a number of New England painters also specialized in blossom pictures. Indeed, J. Appleton Brown earned the sobriquet of "Appleblossom Brown" for the profusion of such imagery, and among the most impressionist of the paintings of John Joseph Enneking were those that engaged this theme (plate 150), as was true also of Old Lyme's William Chadwick (plate 279). In California, there were other painters of blossoming orchards such as Elmer Wachtel (*Blossom Time*; formerly, Witherspoon Art Gallery, Lafayette, California), but it was Wores who adopted this as his specialty. He had painted this theme much earlier, during several prolonged visits to Japan in 1885 and 1891, and reinterpreted the subject in his native region around Los Gatos, Los Altos, and the Santa Clara Valley. He appears to have begun these about 1918, and exhibited his series of Spring Blossom Trees of California in a show held at San Francisco's Bohemian Club in October 1920.[32] In 1926 the artist wrote that he "did not appreciate the beauty and possibilities for his art in the Santa Clara Valley blossom season until he went to Japan and saw there the use made of this natural attraction by Oriental artists."[33]

California painters of the Impressionist movement celebrated the breadth and beauty of their landscape, distinct from other regions of the nation. And they also recognized and extolled the uniqueness of California Light, warmer, more glowing, and more constant than elsewhere in the nation.[34] This is implicit not only in their pure scenic work but perhaps even more in their interpretation of the California missions, a theme unique to the state and the equivalent there of the Eastern emphasis on old homes and churches as symbols of an historic heritage, interpreted in a modern aesthetic.[35] Almost all the California Impressionists painted the missions, especially that at San Juan Capistrano, and in almost all of these paintings the buildings bask in the rich warm California sunlight, in such works as Alson Clark's 1919 *Ruins of San Juan Capistrano* (plate 409), enriching the picturesqueness of the crumbling architecture.

Many other images of this subject include the mission gardens, adding sparkling color notations to the glowing beige walls, and these constitute the major essays in California garden representations, which are otherwise infrequent among the Impressionists there, though such artists as Anne Bremer, Benjamin Brown, and Donna Schuster painted more traditional if informal garden pictures, Wores painted his own garden at Saratoga, California, while Colin Campbell Cooper painted the rich, extensive gardens of the resort hotels in and around Santa Barbara.[36] Among the Eastern Impressionists, private gardens provided a naturally colorful environment for Impressionist painters.[37] This was true for Hugh Breckenridge at his home, "Phloxdale," in Fort Washington, Pennsylvania (plate 293), and even more for many of the artists living and working in the art colonies along the Connecticut coast. John Twachtman depicted the garden at his Greenwich, Connecticut, home numerous times, as did many of the Old Lyme painters such as Edmund Greacen (plate 357), painting a series of views of Florence Griswold's garden

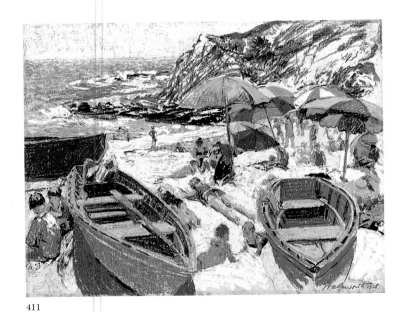

411

between 1910 and 1913, George Burr (plate 284), and Clark Voorhees (plate 273). For his *Poppy Garden* (plate 222), Willard Metcalf may have utilized Voorhees's garden, which attracted other Old Lyme artists such as Matilda Browne (*In Voorhees' Garden*; 1914; Fine Arts Collection of the Hartford Steam Boiler Inspection and Insurance Company, Connecticut). All of these are casual scenes; formal estate gardens figure far less prominently among the American Impressionists, though Greacen did essay these also. Among the most celebrated of the American painters of garden scenes was Hassam, best known, of course, for the series he painted of Celia Thaxter's garden on Appledore (plate 105–8), but this was a deliberately wild flower garden, closer in spirit to the fields of wildflowers favored by the Californians, though of course far more contained.[38] This "old-time flower garden," though innovative in contemporary garden design, yet bespoke the tradition of the old-time cottage garden, a horticultural interest sparked by the 1876 Philadelphia Centennial in things colonial.[39]

Of all the American Impressionists, Hassam was probably the artist most drawn toward the garden theme, a natural motif for painters exploring chromatic variety and splendor, but also a personal attraction. His involvement began during his second visit to France, 1886–89, spending his summers in the Blumenthal home in Villiers-le-Bel, outside Paris, and recording the garden there and probably in Paris also (plate 93), an appeal also reflected in his many images of Parisian flower sellers. Coincidentally, San Francisco's Theodore Wores began his lifelong involvement with the floral motif in Japan at exactly the same time, painting gardens and flowering trees there, and he too depicted flower sellers, in his case, in Tokyo. Only a few of the Giverny colonists—notably John Leslie Breck, working in Claude Monet's own garden, and Mariquita Gill, cultivating her own flower garden—followed Monet's lead in selecting the garden motif. But by the end of the century, Mary MacMonnies had developed an extensive garden with her sculptor husband, Frederick, at their three-acre estate, Le Prieure (The Priory), in the village, where both she, as in her 1901 *Blossoming Time* (plate 410), along with a number of artist-visitors—Mary Hubbard Foote, William De Leftwich Dodge, and Will Hickok Low (whom she would later marry)—drew upon the garden motif. And while the next group of Americans in Giverny, the Frieseke generation, were almost all consistently figure painters, the flower garden offered an invariable background for their imagery (plates 345, 346).[40]

The perceptive French writer, S. C. de Soissons, commenting in 1894 upon the state of the arts in Boston, noted, "The landscape painters are more successful, for the reason that the pictures are more modern, and the treatment of light and atmosphere introduced by Monet is more conspicuous, and even if the results are not so large as they should be, the new tendency to artistic individuality is more tangible."[41] Nevertheless, figure painting also occupied the attention of many of the American Impressionists. What is conspicuous here is that in these works the figures are principally lovely, usually quite young women, healthy, spirited, and "pure." They may, as in the works of Frank Benson, appear composed and detached, but if they are presented for the masculine gaze, they are for the most part nevertheless devoid of overt sensuality. Often these women appear in a bright, sunlit landscape, where, as Bailey Van Hook has written in the primary study of female imagery of this period, the figures could be "beautiful, decorative, and poetic but it [the painting] could also be ostensibly a study of light at midday in June on the human figure." Van Hook further noted that "The Americans' Impressionist vision was as sunny and bourgeois as the French one had been, representing the pleasures of middle-class life, leisure, boating, picnicking, and endless summer. But it is far more usual for Americans to see any of

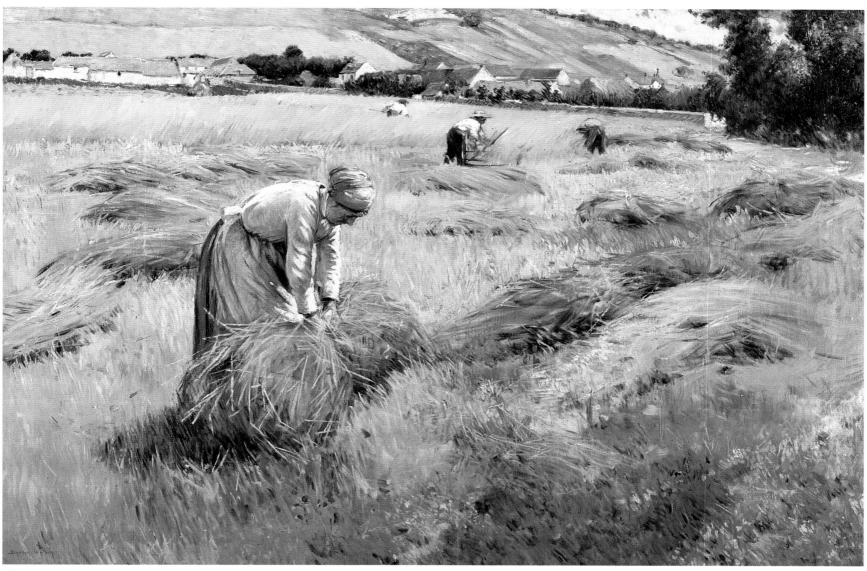

412

those pleasures personified in young women. . . . women were the leisure of introspection, of aesthetic pleasure, of sensual delight, which the American male worked to give them."[42] And she notes that they appear, especially when placed in interiors, as

> signifiers of culture or culture's consumers . . . and as signifiers of leisure; they have pastimes not occupations. They are shown performing nonessential functions, sewing [plates 231, 243, 349], reading [plates 128, 161, 246, 247, 249], enjoying the sun [plates 135, 236, 257], or even passively engaged in "reverie" [plates 347, 354] . . . compatible with their powerless status . . . [where] women often function simply as one more object amid the display of other precious objects [plate 344]. . . . In addition, objects that women wear, hold, or accompany in these paintings—kimonos [plate 203], tanagra statuettes [plate 213], blue and white vases—were associated with the taste and decoration of the home.[43]

411. WILLIAM GRIFFITH, *Diver's Cove*, 1928. Pastel on linen, 16 x 20 in. Wilson Burrows.

412. DAWSON DAWSON-WATSON, Harvest Time, ca 1891. Oil on canvas, 34 x 50¼ in. Formerly, Pfeil Collection.

One could add the abundance of parasols held by so many young women, not only shielding them from the intense sunlight but also emphasizing their essentially decorative role (plates 77, 202).[44]

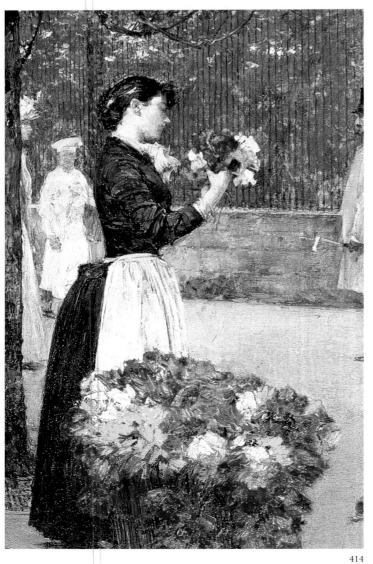

The lovely, well-bred young women of American Impressionism, often garbed in virginal white and holding or surrounded by flowers (plates 202)—symbols of both beauty and springtime—appear singly or in groups (plates 123, 127, 258, 288),[45] and sometimes with equally lovely children, but rarely sullied by the presence of males; and if men *are* present (plate 124), the scene remains noticeably decorous—no suggestion of Edouard Manet's *Luncheon on the Grass* here on American shores. At times these women hover between the shadowy interior and the out-of-doors (plates 308, 325, 340)—a recognition, perhaps, of their hermetic confine and an unconscious yearning for the freedom of the sunlit landscape beyond. Golden-haired children are also quite common (plates 252, 256), especially in the work of Frank Benson, seldom exhibiting the nascent sexuality conveyed in Daniel Garber's 1915 *Tanis* (plate 304), but older women are fairly rare. The exception here is the recognition of their maternal identity (plates 125, 179, 290), especially in the work of Cassatt (plates 27–30)—a reflection of woman's one "essential" function. Alternatively, the nude—again only the *female* nude—was not a common feature among the painters on these shores, and when she appears in American Impressionist art, she is often artfully turned away from the spectator (plates 190, 233, 250), assuming a modicum of modesty antithetical, for instance, to Manet's *Olympia* (Paris, Musée D'Orsay).[46] Even Childe Hassam's fairly numerous outdoor nudes, including those that appear along the New England coast in the murals painted in 1904 for the Portland, Oregon, home of his friend and patron Charles Erskine Scott Wood, seem rather to be responding to the tenets of healthy enjoyment of the out-of-doors promoted by proponents of the modern physical culture movement, spearheaded by Bernarr Macfadden at the end of the nineteenth century, rather than offering sensual provocation.[47] The principal exceptions here are the nudes of Frederick Frieseke (plates 350, 351) and some of his Giverny colleagues (plates 355, 358), Frieseke acknowledging that in France he was free to paint the nude outdoors, as he would not have been under the puritanical restrictions in America.[48]

The American Impressionists depicted their figures involved in activities of both recreation and work. Unlike their French contemporaries, however, there were relatively few depictions of urban enjoyment, Mary Cassatt's magnificent series of theater delineations aside (plate 22), and even these appeared over the short five-year period from 1878–1882 and were, of course, Parisian subjects.[49] In the United States, it would be the later, Ashcan School artists who chose to depict the various pleasure grounds and activities of the city—shopping, restaurants, taverns, the cinema, prizefighting, and prostitutes; instead, the Impressionists concentrated upon the enjoyment of activities in a natural environment. These were especially pictures of life at the shore, women and children bathing and boating[50] or just relaxing among the dunes at Southampton in the paintings of Chase (plates 136, 144, 145);[51] enjoying the seashore outside New York in the pictures of Edward Potthast (plates 314, 316)[52] and William Glackens (plate 372);[53] outside Boston in those of Maurice Prendergast (plate 373); by William Chadwick at Griswold Beach at Old Lyme;[54] at Gloucester;[55] in Benson's paintings of his children boating at North Haven on the Maine coast (plate 255);[56] and at Laguna Beach, as in the pastels of William Griffith such as *Diver's Cove* (plate 411).[57]

It is the Impressionists' attraction to forms of labor and allusions to commerce and industry that may give the Americans their greatest distinction. This may seem surprising for an art form so traditionally identified with sparkling landscapes, summer girls, and golden-haired children, especially since toil had traditionally been only a minor concern in American artistry—understandably not a priority subject in attracting private patronage.[58]

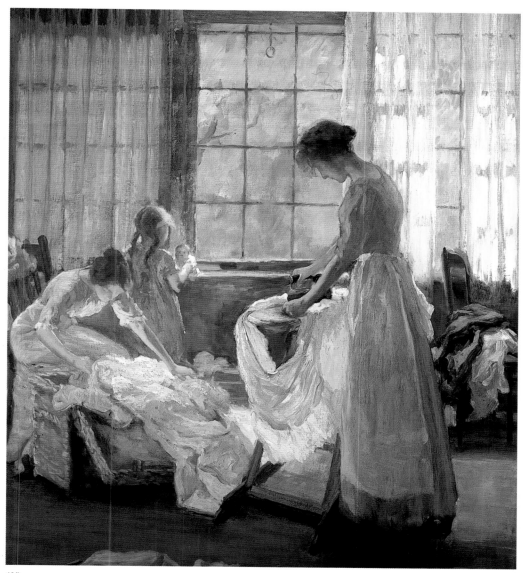

415

413. THEODORE ROBINSON, *Road by the Mill*, 1892. Oil on canvas, 20 x 25 in. Cincinnati Art Museum. Gift of Alfred T. and Eugenie I. Goshorn.

414. CHILDE HASSAM, *Flower Girl*, c. 1887–89. Oil on canvas, 14¼ x 8⅝ in. Senator and Mrs. John D. Rockefeller IV.

415. JEAN MANNHEIM, *Ironing Day*, 1910. Oil on canvas, 39 x 34 in. Peter and Gail Ochs.

In fact, however, images of working-class subjects probably figure at least as often if not more in Impressionist painting than in those of their successors among the Ashcan School.

In rural France, the first generation of painters in the Giverny art colony, such as Theodore Robinson, John Leslie Breck, and Dawson Dawson-Watson, concentrated upon the agricultural activities of the local peasantry. These Americans emphasized the caring of farm animals (plate 55) and the cultivation of grain fields, orchards, and vegetable gardens (plates 56, 412), while their favored structures in the village were the mills which processed the harvest (plates 56, 413). In other colonies such as Grez, Willard Metcalf and Robert Vonnoh also gave emphasis to peasant toil (plates 16, 42, 43). These concerns actually align these American painters more with Camille Pissarro than with Monet himself, who all but ignored the image and presence of his peasant-neighbors in Giverny; Pissarro visited Monet's in Giverny, and Robinson, who admired Pissarro, met him there at least once.[59] And it also positions them with the traditional concern with rural labor stretching back to the mid-nineteenth century and the Barbizon figure painters such as Jean François Millet.[60]

But urban workers also figure in the paintings of the American Impressionists in France. The women who accompany the children in Mary

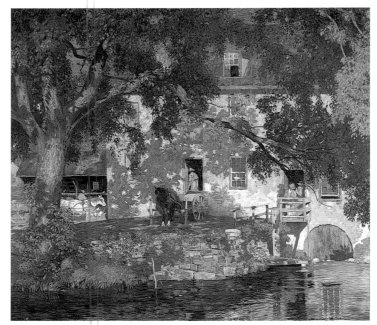

416

Cassatt's maternal themes are often, certainly, mothers, but in many cases may equally be hired nurses, or at least models meant to suggest a nurse or nanny (plate 28), and this occupation appears occasionally also in park scenes done back in the United States by other Impressionists such as Childe Hassam. In the Parisian paintings of Hassam, the most important and most active among the American Impressionists painting there, two forms of labor are abundantly present. One is the succession of lovely young flower vendors (plate 414), chosen as subjects, certainly, both for their beauty and for their association with the gorgeous blooms they market, but also working women in their own right.[61] And their male equivalent can be found in the ubiquitous Parisian cab and carriage drivers (plates 98, 100), who were present in Hassam's earlier Tonalist Boston imagery (plate 97), and would continue to figure prominently when he settled in New York City late in 1889 (plates 102, 104).[62]

Once settled in New York, other forms of work and toil also appeared in Hassam's paintings, among the noticeable being the street cleaners (102), symbols of municipal improvement and urban regeneration. In the early twentieth century Hassam produced a series of small paintings of working-men involved in construction—bricklayers and hod carriers—as well as images of skyscraper-building itself, such as his celebrated 1904 *The Hovel and the Skyscraper* (plate 208). Indeed, Hassam's Window series of the 1910s, implicitly, celebrates modern building and construction, contrasting the hermetic world of women in confined interiors with the male preserve of the great city. In his 1918 *Tanagra* (plate 213), skyscrapers soar in the view out the partly curtained window, while workingmen can be seen actively engaged in the construction of the girdered framework of a new building. Beyond genteel endeavors such as sewing and crocheting (plates 231, 243, 308, 349),[63] indoor domestic labor (always by women) figures only occasionally in Impressionist paintings, principally in those of Julian Alden Weir and of several of the Boston Impressionists such as Edmund Tarbell, Joseph DeCamp (plate 244) and William Paxton (plate 249), though surfacing in 1910 in the unusual rendering of *Ironing Day* (plate 415) by the California Impressionist Jean Mannheim. But Mannheim projects earnest but casual communal labor, while the Boston artists firmly fix the class and cultural status of the maidservants vis-à-vis their mistresses, perhaps a distinction between the less structured life in Southern California and traditional Boston Brahmanism.[64]

In Old Lyme, Edward Rook painted a series of images of Bradbury's Mill and the adjoining dam between 1905 and 1917, while Robert Spencer, painting the cotton and silk mills and mill workers of New Hope, Pennsylvania (plate 300), may be the only American Impressionist whose career was primarily devoted to labor. The mills in this region were the subject of paintings by other Pennsylvania Impressionists, notably Daniel Garber in his stunning 1921 canvas *The Old Mill* (plate 416), painted from an old bridge in New Hope, the mill subsequently altered and now the Bucks County Playhouse. Garber's landscapes of the Delaware River quarries (plate 301) are equally suggestive of the artist's consciousness of the impact of industry on the landscape; the quarries were also painted by his colleague Edward Redfield. There is an intriguing factor here, since the deep and raw depressions in the landscape enhance both the beauty and the topography of the scene, basically negating any implied admonishment of environmental exploitation. The same may be said of Julian Alden Weir's most renowned Impressionist work, *The Red Bridge* (plate 183), of a bridge that spanned the Shetucket River near his summer home in Windham, Connecticut. Much has been made of Weir's regret that this modern structure had replaced a venerable covered bridge,[65] but here he certainly revels in the brilliant vermilion metalwork and

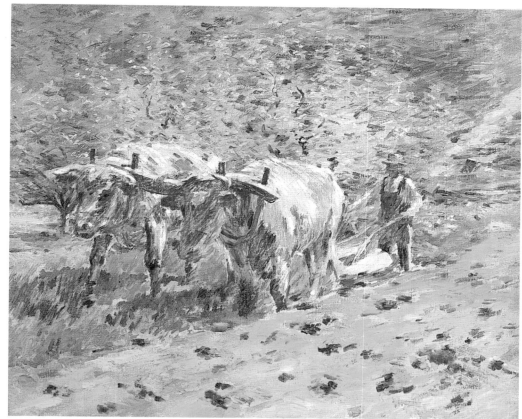

417

its rigorous geometry, reflected in the stream and played against the soft green-and-buff tones of the natural world—the picture's original title was *Iron Bridge at Windham*. Weir, after all, does not appear to have found the earlier bridge a worthy motif! And the same attraction to modern industry may be found in the series of pictures he painted of the mills at nearby Willamantic, which ignore the tensions of labor conditions that prevailed there in favor of a harmonizing of natural and industrial forms.[66]

The industrialized countryside as well as country labor figure in a number of Weir's finest and most important Connecticut paintings (plates 180, 219), and he was hardly alone among the Impressionists. Theodore Robinson's series of paintings of the canals painted in the summer of 1893 at Port Ben, New York, for all their celebration of light, air, and color, are images of a working landscape. And in his final summer of 1895, spent in Townshend, Vermont, Robinson painted his cousin's neighbors hard at work farming with their teams of oxen (plate 417).[67] Childe Hassam's involvement with work and laborers was not limited to his urban scenes. He painted woodcutters in Connecticut and especially shipbuilders in Gloucester (plate 209) and Provincetown, more involved there with the town's traditional work ethos than most of his colleagues, and underscoring both his respect for manual labor and his recognition of the industry that had made these communities economically viable. As one writer has noted, Hassam offered "a respectful glance at the local craftsmen who build boats—a trade with nostalgic, even noble, overtones, recalling his cabbies and flower sellers."[68] Adeline Adams, in the earliest biography of Hassam, recognized that "all this passion for whatever is lovely and fleeting does not prevent him from painting with zest men shingling the Baptist Church at Gloucester, or building a schooner at Provincetown."[69]

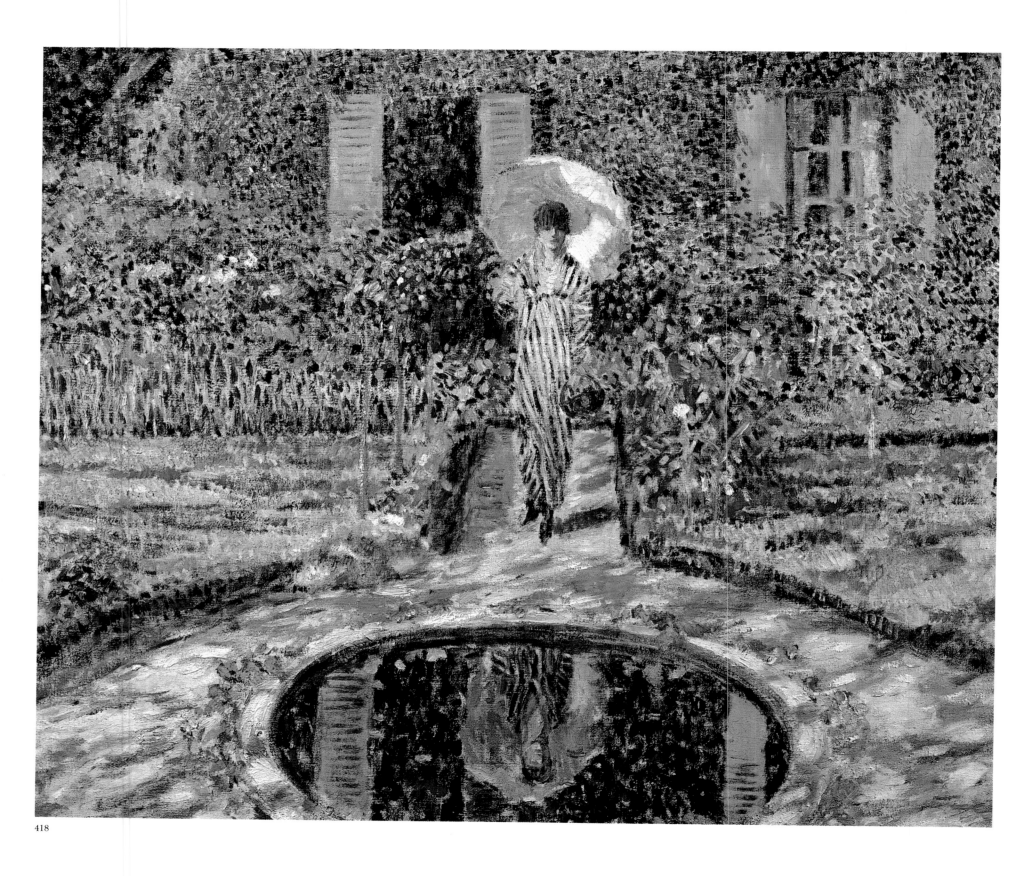

Afterword

IN THE AFTERMATH OF THE GREAT EXHIBITION held in New York in 1886, American collectors of French Impressionist painting increased both in numbers and in the scope of their collecting. This is in marked contrast to the dearth of collectors of *American* Impressionism in the late nineteenth and early twentieth centuries. In order to support themselves, many of the American masters, such as John Twachtman and Theodore Robinson, were forced to rely, at least in part, on teaching; others, such as J. Alden Weir, were independently comfortable. And some, like Childe Hassam and Mary Cassatt, were quite well patronized. Hassam, for instance, had the support of Colonel Wood in Portland, who not only commissioned murals for his home but also encouraged his wealthy friends to acquire Hassam's paintings. And Mary Cassatt enjoyed extensive lifetime patronage, some French and more American, with Louisine and Henry O. Havemeyer owning at least seventeen of her works; Cyrus Lawrence, at least nine; Alfred Atmore Pope, four or five; Sarah Choate Sears, at least seven; and various members of the Whittemore family, at least nine; while James Stillman owned at least twenty-six; and Payson Thompson, at least twenty-nine examples of her work.[1]

Still, few patrons were drawn to collecting works by the American Impressionists as a group—few seized specifically upon this aesthetic as the primary focus of their collecting, in contrast, for instance, to the championing of the contemporaneous Tonalist painters by collectors such as George Hearn and Charles Lang Freer. Hearn's contemporaries William T. Evans, John Gellatly, and H. Wood Sullivan certainly had substantial holdings of works by the Impressionists but were basically major collectors of contemporary late-nineteenth and early-twentieth-century painting in general, including the Tonalist artists, as was the less well known William J. Johnson of Uniontown, Pennsylvania.[2] In Boston, patronage for the Impressionists often came from well-to-do colleagues such as Dwight Blaney, Lilla Perry, Sears, and Ross Turner, while Weir owned works by his close friend Twachtman; for the most part, though, this patronage was fairly limited. Likewise, institutional support for the American Impressionists was quite sparse until the second decade of the twentieth century, with the exception of the Pennsylvania Academy of the Fine Arts.

418. FREDERICK FRIESEKE, *The Garden*, c. 1915. Oil on canvas, 25 1/2 x 32 in. Private collection.

New York's Samuel T. Shaw established the Shaw Fund in 1892 at the Society of American Artists, with awards often made for Impressionist work; this was a purchase prize, the pictures entering Shaw's own collection, enhanced by direct purchases of other paintings by William Merritt Chase and Willard Metcalf, as well as the acquisition of seven pictures from Theodore Robinson's estate sale. This last, of course, did not benefit the painter directly. Shaw provided a showcase for these painters, for he hung them on the walls of the Grand Union Hotel on Forty-second Street, of which he was the coproprietor. Two other collectors, the New York merchant Hugo Reisinger and Charles Van Cise Wheeler of Washington, D.C., were probably the other major collectors of American Impressionist work. Reisinger's artistic support here has been overshadowed by his championing of the art of his native Germany—the Busch-Reisinger Museum at Harvard University bears his name along with that of his father-in-law—but Reisinger purchased Impressionist work from the artists themselves, as well as the dealers William Macbeth and N. E. Montross and owned examples by Frederick Frieseke, Hassam, Ernest Lawson, Metcalf, Richard Miller, Edward Redfield, Robert Reid, Robinson, Twachtman, and Weir. The heart of Wheeler's collection consisted of Impressionist pictures, both French works by Renoir, Monet, and Degas and American pictures by Frank Benson, Cassatt, Chase, DeCamp, William McGregor, Edward Henry Potthast, and Twachtman, while he also owned no less than ten examples by Hassam, and was a close friend of Redfield and Edmund C. Tarbell. Included in his collection were three figure paintings by the former, and two landscapes by Redfield, about whom he also published several articles and a monograph.[3]

But beginning in 1960, collectors such as Rita and Dan Fraad and Margaret and Ray Horowitz began to devote their attention specifically to the achievements of the American Impressionists. The Fraad and Horowitz collections, which have continued to evolve and have been on public view in recent years, continue to set the standards for those collectors who have emerged in subsequent decades.[4] Collectors such as Marie and Hugh Halff Jr. have continued to successfully pursue that qualitative level, while the late Daniel Terra established museums in both Chicago and Giverny, built around his passion for the works of the American Impressionists. As of the year 2000, the demand for the works of artists such as Cassatt, Hassam, Twachtman, and many of their contemporaries has grown to such proportions that the market has seen prices rise to levels unthinkable forty years ago, sometimes 1,000 percent or more over what the same pictures brought back in 1960.

This has had broad repercussions. Quality paintings, and graphics too by such artists as Cassatt, have become tremendously sought after and consequently sufficiently scarce that the market is seriously depleted; the problem today lies in locating such works, not in selling them. Even lesser works by major artists find a ready market, while fine examples by painters once considered minor figures are eagerly sought after by both private collectors and public institutions. Furthermore, works by Impressionist painters whose reputations have remained confined primarily to local or regional audiences find an ever-increasing audience: in California, for instance, dozens—seemingly hundreds—of commercial establishments are devoted almost totally to the state's Impressionists, while pictures by certain California painters such as Guy Rose can now bring prices up in the millions, and those by painters such as Granville Redmond edge well up into six figures. In addition, the "I" word is so powerful a draw that many artists whose formal concerns fall into quite different categories—Tonalism, Naturalism, and others—are advertised and offered to the art-buying public as Impressionists to cash in on the movement's popularity.[5]

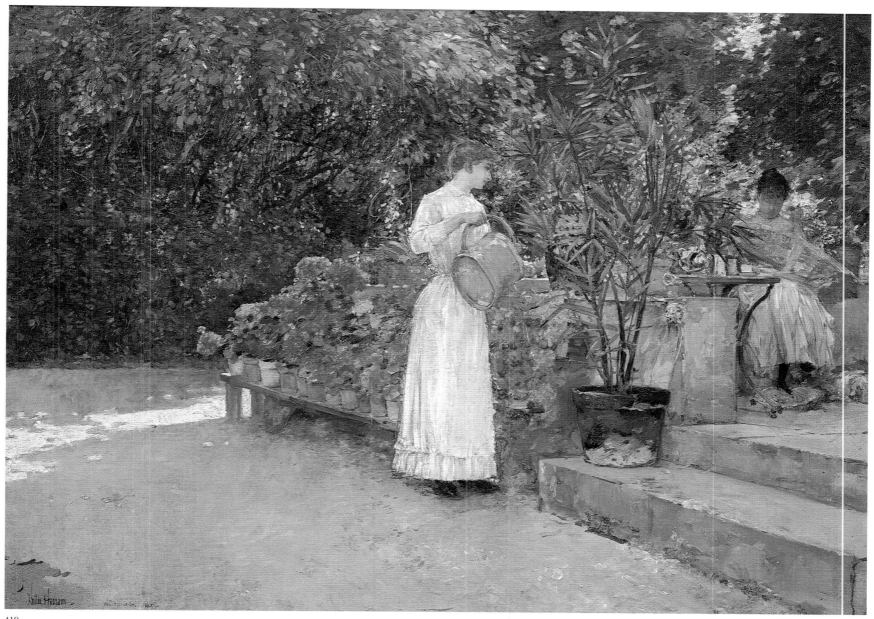

419

Beyond the active marketplace and its attendant publicity, the tremendous growth of interest in Impressionism has been fueled both by scholarly exhibitions and by publications involving this phase of American art. Such displays have taken a number of forms. These have included institutional shows devoted to single private collections or to regional selections.[6] A good many museums have also held shows devoted to their own Impressionist holdings, sometimes bolstered by key loans to fill important lacunae.[7] These also, of course, identify their deficiencies in this field, though spiraling market prices have made significant acquisitions increasingly difficult without special private financial infusion.

A number of museum exhibitions stand out for their quality, comprehensiveness, and/or innovation. The present author was privileged to be invited to curate a show of American Impressionism that took place in 1990 at the Villa Favorita in Lugano, Switzerland, the Thyssen-Bornemisza Foundation, in which were assembled some of the masterworks covering the entire range of the American Impressionist movement. Though not the first

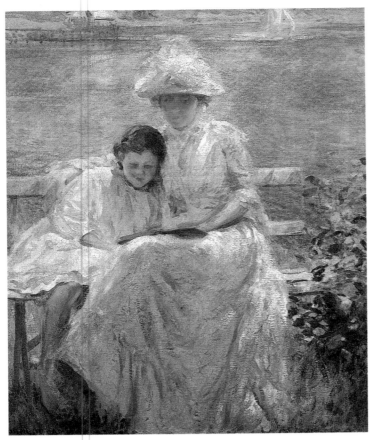

display of such material to appear abroad, this display achieved an exceptional level of quality, thanks to the generosity of American institutions and private collectors.[8] In 1994 the Metropolitan Museum of Art in New York presented an outstanding show, *American Impressionism and Realism: The Painting of Modern Life, 1885–1915*, which compared and contrasted the work of the American Impressionists and the slightly later realists of the Ashcan School, a comprehensive analysis of both their formal and thematic concerns under the broad rubric of modernity.[9] In 1997 the Fleischer Museum, in Scottsdale, Arizona, presented *East Meets West: American Impressionism,* a rare look at American Impressionism across the nation, and in 1999 the Laguna Art Museum in Laguna Beach, California, mounted *Colonies of American Impressionism,* correlating the paintings created in the art colonies of Cos Cob and Old Lyme, Connecticut; Shinnecock, Long Island; and Laguna Beach, California. This exhibit not only addressed the creativity associated with the summer art colonies that had developed in this country at the turn of the century but offered a display of cross-regional artistic phenomena. Such shows as these investigated analogies otherwise seldom on view in the identification of American Impressionism.[10]

Actually, however, scholarship in the form both of exhibitions and attendant publications have increasingly become the purview of commercial galleries even more than public institutions. These include, especially, three exhibitions in New York City: *Impressionism and Post-Impressionism: Transformations in the Modern American Mode, 1885–1945,* mounted by Grand Central Art Galleries in 1988; *Ten American Painters* at the Spanierman Gallery in 1990; and *The Giverny Luminists: Frieseke, Miller and Their Circle* at the Berry-Hill Galleries in 1996 (plate 418).[11]

It is in the realm of regional investigations of Impressionism that the greatest proliferation of exhibitions has appeared in both public and commercial venues in the last fifteen years. To a degree, this naturally mirrors the commitment to the aesthetic that took place in the late nineteenth and early twentieth centuries, far greater in certain states and regions than others, and even ignored in some locales. The achievements of the Pennsylvania Impressionists—meaning, actually, the artists working in New Hope and Bucks County—and the California Impressionists—painters in Southern California as well as on the Monterey Peninsula—have been celebrated by far the most copiously. But there have also been exhibitions of the work of the Impressionists on Cape Cod; on the Connecticut coast; those in Ohio, Indiana, and Utah; and generally in the South.[12]

A number of major publications have appeared concerning regional Impressionism, unassociated with exhibitions. This includes Rena Coen's study of Minnesota Impressionism and Judith Newton's masterful treatise on the Hoosier group, the most significant of the Indiana Impressionists.[13] Especially numerous are independent studies of California painting. This last has been fostered especially by scholarship emanating from the Fleischer Museum under the initiative of Mort and Donna Fleischer, and even more by the Irvine Museum in Irvine, California.[14] This institution, developed by the collector Joan Irvine Smith and overseen by its director, Jean Stern, has been producing a series of publications devoted to California Impressionism.[15]

The standard literature on American Impressionism, generally, has been enriched during the last fifteen years by studies by Ulrich Hiesinger and Lisa N. Peters.[16] Also, the place of American art within the international context of Impressionism has been further investigated. This has taken two forms. First, there have been treatises on the activities of American artists in several of the major French art colonies where the aesthetic developed, in

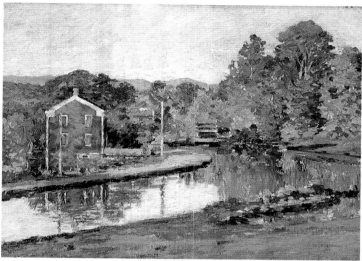

421

both Giverny and Grez, though others, such as Etaples, await significant investigation.[17] Second, a number of major publications, some related to exhibitions, have introduced American Impressionism within an international context, exploring not only the American variations of its French prototype but also the aesthetic contrasts within Impressionist practice, from Latin America to Japan and Australia.[18] Each nation studied produced not only distinctive work, some more committed to both Impressionist strategies and themes than others, but also demonstrated varied dependency upon French precedent. Thus, while Monet's work provided a major catalyst for much American painting, German Impressionists (and, partly due to national rivalry, far fewer painters were involved in the movement) looked more to Manet, while a number of Japanese artists drew upon the art of Renoir.

Another development of tremendous importance has been the prodigious number of monographic publications devoted to both major and minor American Impressionists, some related to exhibitions, others as independent monographs. Space does not allow discussion of all of these, which are found in the updated bibliography in this volume. Some of the significant figures in the movement have engendered multiple studies, Mary Cassatt especially, with four publications by Nancy Mowll Mathews, a leading Cassatt scholar, an extensive exhibition catalog for a major Cassatt exhibition held at the Art Institute of Chicago in 1998, and most recently, an important study of Cassatt's graphic work.[19]

Another American expatriate, John Singer Sargent, is the other American artist to have received such extensive scholarly treatment in the last fifteen years, but in Sargent's case, his Impressionist work has often been subsumed in more general studies of his vast output of portraits, figure studies, genre subjects, interiors, landscapes, and nature studies in a variety of media.[20] This is true also of William Merritt Chase, though in addition to several biographies and comprehensive treatises of his art, several studies have concentrated especially on his Impressionist works, painted first in the parks of Brooklyn and New York, and then out at Shinnecock, Long Island.[21] In his own time, Childe Hassam was probably the most popular of all the artists identified with the Impressionist movement, and he has been the subject of a number of recent scholarly treatises, one by Ulrich Hiesinger and the second by Warren Adelson, Jay Cantor, and the present author, sponsored respectively by the Vance Jordan Gallery and the Adelson Gallery, both in New York City (plate 419). These two volumes have covered his career in broad but thorough terms, but in addition there have been specialized publications devoted to his paintings created on Appledore on the Isles of Shoals (105–9), to his paintings of New York City (plates 102, 104, 401), and to his celebrated Flag series, painted during World War I (plate 399).[22]

In addition to Chase and Hassam, the other members of the Ten who have received the most individual scholarly attention have been John Twachtman and Frank Benson. Lisa N. Peters's study of the former is one of the finest and most comprehensive treatments of an American Impressionist, while individual aspects of Twachtman's art have inspired more concentrated essays: the pictures he painted in Connecticut and in Gloucester, and, departing from his primary concern with landscape, his floral and figurative works.[23] An important exhibition of Benson's Impressionist paintings was mounted in New York in 1988, and Faith Andrews Bedford has produced a series of important and substantial scholarly studies concerning her grandfather and his art.[24] And the third Boston master among the Ten, Joseph DeCamp (plate 420), has been examined in a major monograph by Laurene Buckley.[25]

Among the later artists whose work has been identified with Impressionism, Maurice Prendergast has been the subject of two major

420. JOSEPH DECAMP, *June Sunshine*, 1902. Oil on canvas, 30 x 25 in. Private collection.

421. THEODORE ROBINSON, *Lock 27 Autumn*, 1893. Oil on canvas, 16 x 22 1/4 in. Private collection.

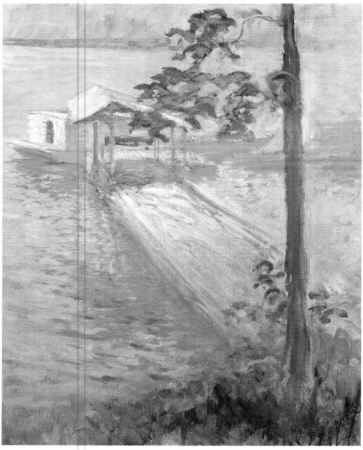

monographs.[26] And the growing preoccupation with regional investigations has led not only to a great many general surveys but also to a number of major monographs, especially of the leading California Impressionists, particularly Guy Rose and William Wendt, the most admired and sought after among them.[27] The most significant American Impressionists still lacking in extended scholarly treatment in recent years are probably Frederick Frieseke, Robert Reid, Edmund Tarbell, and among the regional masters, the San Diego painter Maurice Braun. But two projects concerned with Tarbell's artistic achievement are presently under way,[28] while the Telfair Academy of Arts and Sciences is planning a major exhibition of Frieseke's paintings, with a substantial catalog.

In terms of scholarship, the most significant development regarding American Impressionism has been the large number of catalogues raisonnés—comprehensive records of all relevant information and commentary on all authentic works by an individual artist—devoted to many of the more noteworthy painters of the movement. The determination of authenticity demands that connoisseurship be brought to bear to separate dubious examples from those unquestionably by the master. Such enterprises inevitably take a great deal of time, so that few such projects have come to completion so far. The major exception here is that devoted to Maurice Prendergast and his brother, Charles, undertaken by the Williams College Museum of Art, the major recipient of the Prendergast estate.[29]

But the great majority of catalogues raisonnés devoted to American Impressionist artists, as to European ones, have been sponsored by commercial galleries. Under way at this time are those devoted to Willard Metcalf, Theodore Robinson (plate 421), and John Twachtman (plate 422), sponsored by the Spanierman Gallery; to Mary Cassatt (plate 423) and John Singer Sargent, by the Adelson Gallery; and to Childe Hassam by Hirschl & Adler Galleries, all of these establishments in New York, and that to Frank Benson by Vose Galleries of Boston. Such projects, of course, are not limited to Impressionists. Current catalogue raisonné projects are dedicated to many other American artists, such as the Winslow Homer catalogue raisonné, also promoted by the Spanierman Gallery, and that devoted to Frederic Edwin Church under the Berry-Hill Galleries, while especially numerous are those under way and under consideration concerning leading painters of the American West—like Impressionism, an field of heightened interest to collectors, both private and public.

Each such catalog, both time-consuming and expensive, requires enormous investment—thus the correlation with the demands of the marketplace and the involvement of commercial sponsorship, although each catalog has been under the direction of recognized academicians. This in turn has not been without its critics among more purist scholars, who have feared conflict of interest on the one hand, and market manipulation on the other. In fact, neither of these are substantial issues; the one serious inhibition to the catalog process is the general but understandable unwillingness of commercial galleries to share information concerning collectors and locations with their competitors. But without such sponsorship, these catalogs would not be viable at all.

Significant emphasis has been paid in recent years to thematic interpretations of American Impressionism, following the groundbreaking study of French Impressionism in 1988 by Robert L. Herbert.[30] The substantial catalog by H. Barbara Weinberg and others, *American Impressionism and Realism: The Painting of Modern Life, 1885–1915*, previously mentioned, is especially pertinent here, as are the several specialized studies of Childe Hassam's art by David Park Curry and Ilene Fort. Fort's discourses on

Hassam's New York scenes and his Flag series informed the present author's *Impressionist New York*, which dissects the metropolis through the lenses of the Impressionists vis-à-vis contemporary writings.[31] Alternative concerns with suburban and country living were effectively elucidated in Lisa N. Peters's 1997 *Visions of Home*, which identified the powerful magnet that rural comfort and the attachment to home and property had for the Impressionists (plates 118–22, 168–70 for Twachtman; 176, 178, 182 for Weir).[32] A major theme of that study, in an essay by May Brawley Hill, was the cultivation of the suburban garden, especially the old-fashioned garden, and the implications there of both tradition and nationalism. This had been previously examined at great length and with regional connotations in Hill's 1995 *Grandmother's Garden*, in which Impressionist artists figured strongly.[33]

Another theme that has generated considerable thematic interpretation has been the identification of New England with authentic, i.e., "traditional," American values. This investigation and celebration of our early heritage

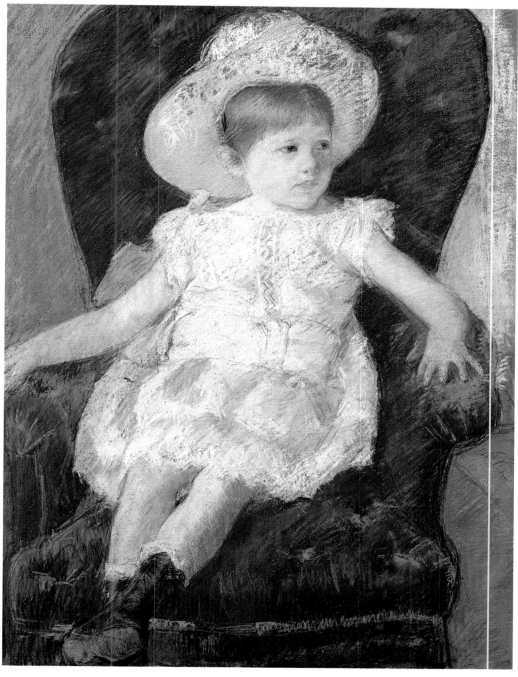

423

422. JOHN HENRY TWACHTMAN, *River Scene with Pier*, c. 1893. Oil on canvas. 30 x 24 in. Private collection.

423. MARY CASSATT, *Elsie in a Blue Chair*, 1880. Pastel on paper, 35 x 25 1/4 in. Private collection.

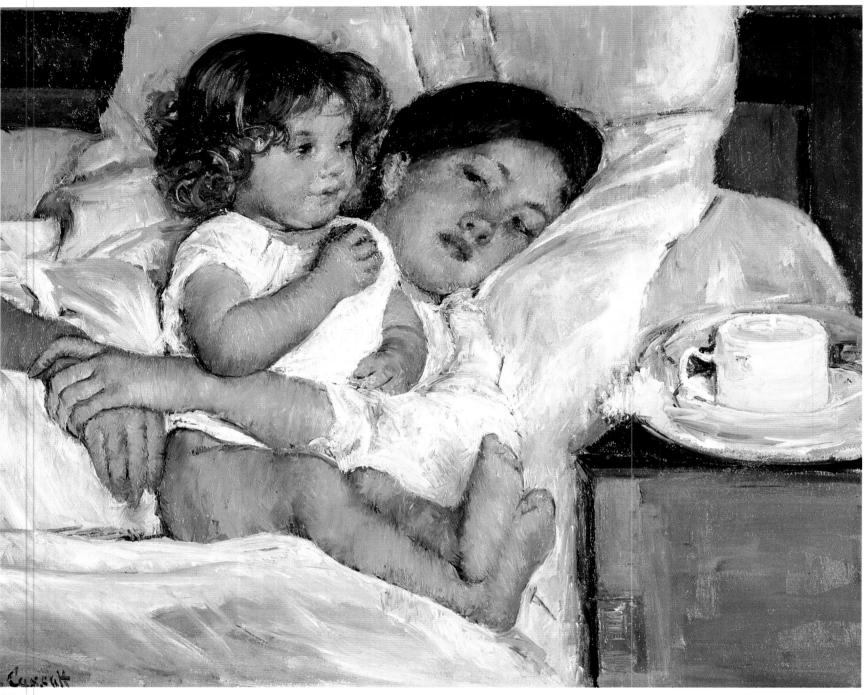

424

started to develop even earlier than the advent of Impressionism in American art, beginning with the Philadelphia Centennial in 1876. But the Impressionists drew upon this ideology, in part perhaps for the satisfaction offered in presenting in a modern pictorial idiom an archetypically native, often colonial patrimony—representations of towns of Puritan heritage, Congregational churches, and old shingled and clapboarded houses (plates 95, 167, 206, 207, 226).[34]

Of all the themes that the American Impressionists addressed, that which has most been the subject of recent scholarship has been the imagery of women. Following the groundbreaking dissertation by Bernice Kramer Leader,[35] numerous writers have emphasized both the hermetic implications of female identity in the face of the rise of the "New Woman," feminism, and the question of woman suffrage. Kathleen Pyne, especially, identified the

imagery of the American Impressionists with the preservation of conservative elitism in defining a traditional social hierarchy through peaceful, contemplative, nostalgic figures of women in spare interiors or idyllic landscapes.[36] As pointed out earlier, Marion Wardle has recently defined sewing and related activity in Impressionistic imagery, one aspect of woman's "proper" domestic sphere, though she has provided more ambitious interpretations of this activity within the Arts and Crafts movement of the period.[37] The identification of such Impressionist representation of women with a concern for the evolutionary order and function of the female (and implicitly of the absent male) had earlier been discussed by Bram Dijkstra, with particular attention paid to the Giverny Luminists.[38]

These and other interpretive modes of critical analysis have broadened the understanding of American Impressionism, though they have also, at times, taken a moral high ground, embedded in contemporary values.[39] Only occasionally have the American Impressionists been subjected to psychosexual extremism, a burden laid, perhaps not surprisingly, especially upon Mary Cassatt, as the most renowned of the women Impressionists, unmarried and yet devoted to maternal imagery. In Kathryn Zerbe's 1987 account of Cassatt, the author concluded that Cassatt's art originated from "developmental arrest" and that her "paintings represent her unconscious wishes to give birth to Degas' child as well as her own symbolic child."[40] A different approach to Cassatt's images of mothers and children was presented in 1993 by Harriet Scott Chessman, who views the child's body in such a work as *Mother About to Wash Her Sleepy Child* (plate 27), as the site of maternal sexuality.[41] Chessman is on firmer ground when analyzing Cassatt's 1878 *Little Girl in a Blue Armchair* (plate 21) as positioned in a tradition of representations of female sexuality, but defeats herself when she declares that "the only way in to the curved empty space in the middle of the room is literally through the child's body."[42] And in an even more outré critique, Chessman interprets the child in Cassatt's cozy, comfortable *Breakfast in Bed* (plate 424) as "compact of libidinal energy," figuring "the mother's sexuality" and "palpable eroticism."[43]

Such outlandish excursions into left-field pop psychology—which often expose far more about their authors' subjective and emotional state than they do about the motivations of Cassatt and her contemporaries—aside, the enrichment of art history generally, and specifically the integration of American Impressionist art within its social, economic, and cultural landscape, has only enhanced our perceptions and enjoyment of this art. And these developments, added to the now long-perceived beauty, refinement, and serenity of these images, however much they revisionists may interpret them as reactionary and hierarchical, can only further their appreciation among art lovers, collectors, and the general public, who flock to their exhibitions and pore over the ever-increasing publications devoted to the American Impressionists.

424. MARY CASSATT, *Breakfast in Bed*, c. 1897. Oil on canvas, 23 x 29 in. Virginia Steel Scott Collection, courtesy of Huntington Library, Art Collections, and Botanical Gardens, San Marino, California.

Notes

1. Nature and American Art

1. Although the landscape theme in American painting has attracted more scholars in the last three decades than any other subject, there is still no definitive history of American landscape. Barbara Novak's *Nature and Culture: American Landscape and Painting 1825–1875*, which provides a useful conceptual approach to a rich period of landscape painting, is a compilation of essays largely from periodicals and exhibition catalogs. Wolfgang Born's *American Landscape Painting* (New Haven: Yale University Press, 1948) is extremely outdated but comprehensive.

2. The basic source on Luminism is John Wilmerding, et al., *American Light: The Luminist Movement 1850–1875*, published to accompany an exhibition at the National Gallery of Art, Washington, D.C. Gifford's involvement with what are now considered Luminist concepts was mentioned invidiously by James Jackson Jarves in *The Art-Idea* (New York, 1864), p. 193; more positively by Henry T. Tuckerman in the *Book of the Artists* (New York, 1867), pp. 525–27; and first discussed at length by John Ferguson Weir in "American Landscape Painters," *New Englander* 32 (January 1873): 145–48.

3. "On Landscape Painting," *New-York Weekly Magazine* 2 (August 17, 1796): 1.

4. Inness's complex relationship to Impressionism is further complicated by his vehement hostility to the aesthetic, which will be discussed later. The problem is that Inness's coloristic interests and the canvases of his last several decades are related to Impressionism, while the ideological bases of his art are diametrically opposite. This is well discussed by Nicolai Cikovsky, Jr., in *George Inness* (New York: Praeger Publishers, 1971), pp. 44–45, 62–63.

2. Glare: An Alternative Aesthetic

1. A discussion of the glare aesthetic first appeared in my previous study, *American Impressionism*, chap. 2, "An Alternate Aesthetic of Light," pp. 17–19. It is my pleasure to acknowledge again my indebtedness to Michael Quick for our discussion in 1973 in formulating this concept. The literature of the period offers tantalizing acknowledgment but little direct discussion of the phenomenon; see, for instance, "Color and Distance," *Art Amateur* 15 (October 1886): 96. An earlier English response to the glare aesthetic can be found in R.T., "Sunshine," *Fine Arts Quarterly Review*, n.s. 2 (June 1867), pp. 362–78.

2. One of the greatest practitioners of the glare aesthetic was the Berlin architectural specialist Eduard Gaertner; in his compositions strong, flat planes of light and dark imparted a sense of order and solidity to the Prussian capital and reinforced an aura of majesty. Luminist concerns were particularly apparent in Danish art. The work of Christian Købke developed from architectural painting of seventeenth-century Holland; his 1830 *View of the Arhus Domkirke*, for example, is a clear descendant.

3. Extracts from thirty French journals on Picknell's paintings, the most eloquent devoted to the *Road to Concarneau*, were published in *Art Criticisms from the French, English and American Newspapers upon Paintings in the Paris Salon, Royal Academy and Other Exhibitions by William L. Picknell* (New York: S. P. Avery, Jr., 1890).

4. This subject is addressed in relationship to Caillebotte by J. Kirk T. Varnedoe and Peter Galassi in the exhibition catalog *Gustave Caillebotte: A Retrospective Exhibition* (Houston: Museum of Fine Arts, 1976), pp. 60–73.

5. "Art Hints and Notes," *Art Amateur* 15 (October 1886): 96.

6. Otto Stark, "The Evolution of Impressionism," pp. 53–56.

3. Americans Abroad after the Civil War

1. The standard study of Post-Civil War cosmopolitanism in American art is the catalog *The American Renaissance: 1876–1917* (Brooklyn: Brooklyn Museum, 1979). See also H. Wayne Morgan, *New Muses: Art in American Culture, 1865–1920* (Norman: University of Oklahoma Press, 1978).

2. William Cullen Bryant, "To Cole, the Painter, Departing for Europe," *Talisman for 1830*, p. 336.

3. The Düsseldorf Gallery displays, the British exhibitions of 1857–58, and the Gambart and Cadart displays are known through the catalogs published to accompany the shows. The Düsseldorf Gallery issued a catalog almost annually between 1849 and 1862; a catalog was published for each of the three showings of the British exhibition, which differed substantially in each city; Gambart held five exhibitions in New York between 1857 and the 1866–67 season; and Cadart held two of the French Etching Club in 1866 (which were not actually graphic exhibitions). See Raymond L. Stehle, "The Dusseldorf Gallery of New York," *New-York Historical Society Quarterly* 58 (October 1974): 304–14; David Howard Dickason, *The Daring Young Men: The Story of the American Pre-Raphaelites* (Bloomington: Indiana University Press, 1953), chap. 6, "British Pre-Raphaelite Art in America: 1857 Exhibition," pp. 65–70; Elizabeth C. Evans, "Commercial Gallery Exhibitions in America 1848–1866: Content and Criticism" (paper prepared at the Graduate School of the City University of New York in 1982); and Lois Marie Fink, "French Art in the United States, 1850–1870: Three Dealers and Collectors," *Gazette des Beaux-Arts* 92 (September 1978): 87–100.

4. Contemporary literature on American artists and their activities in France is almost endless, including discussions of study in Parisian écoles and ateliers, exhibition of paintings in the annual Salons, and activities of American artists' clubs. Dr. H. Barbara Weinberg is currently studying French training of Americans in the nineteenth century; see her "Nineteenth-Century American Painters at the Ecole des Beaux-Arts," pp. 66–84, and her "The Lure of Paris: Late-Nineteenth-Century American Painters and Their French Training," pp. 16–32.

5. *Boston Herald* correspondent quoted in "The Monthly Record of American Art," *Magazine of Art* 6 (December 1883): xlviii.

4. Americans and Impressionism, at Home and Abroad

1. The literature on French Impressionism is enormous. See such standard works as John Rewald, *The History of Impressionism*; Phoebe Pool, *Impressionism*; and Diane M. Kelder, *The Great Book of French Impressionism*.

2. "Mr. Inness on Art-Matters," *Art Journal* (New York) 5 (1879): 374–77.

3. Inness to Hitchcock, March 23, 1884, collection of the Montclair Art Museum; reproduced in the catalog *George Inness of Montclair* (Montclair, N.J., 1964), unpaginated.

4. In a letter to the editor of the Tarpon Springs *Ledger* (undated), he wrote: "When people tell me that the painter sees nature in the way the Impressionists paint it, I say 'Humbug!' from the lie of the intent to the lie of ignorance. . . . In fact, give me the same impression that did the first Monet it was my luck to see. He had a little more white in it, but the style was about the same. Now, however, Monet decorated an impressionless plane with a dab of paint apparently in childlike imitation of trees, house and so forth without substance." In George Inness, Jr., *Life, Art, and Letters of George Inness* (New York, 1917), pp. 168–69.

5. Henry James, "Parisian Festivity," *New York Tribune*, May 13, 1876.

6. Henry James, "The Grosvenor Gallery and the Royal Academy," *Nation* 24 (May 31, 1877): 320–21.

7. William Crary Brownell, "Whistler in Painting and Etching," *Scribner's Monthly* 18 (August 1879): 481–95.

8. Lucy H. Hooper, "Art Notes from Paris," pp. 188–90.

9. Mariana Griswold van Rensselaer, "The New York Water Color Exhibition," *Lippincott's Magazine*, n.s. 1 (April

1881): 417; I am grateful to Bruce Weber for this reference from his dissertation on Robert Blum, in preparation.

10. Archibald Gordon, "The Impressionist Pictures," *Studio and Musical Review* 1 (April 9, 1881): 162–63; and "The Impressionists" (April 16, 1881): 178–79.

11. Charles M. Kurtz, ed., *Illustrated Art Notes from the Fifty-Eighth Annual Exhibition of the National Academy of Design, New York* (New York, 1883), p. 28.

12. The earliest monographs on Cassatt were French: Achille Segard, *Mary Cassatt: Un Peintre des enfants et des mères*, and Edith Valerio, *Mary Cassatt*. There has since been a host of American studies; the standard study of Cassatt's life is Frederick A. Sweet, *Miss Mary Cassatt*. See also those by Margaret Breuning, E. John Bullard, Julia M. Carson, Frank Getlein, Nancy Hale, Richard H. Love, Nancy Mowll Mathews, and Forbes Watson. The most important monographs on her art are the two catalogues raisonnés by Adelyn Dohme Breeskin: *Mary Cassatt: A Catalogue Raisonné of the Oils, Pastels, Water-Colors and Drawings*, and *The Graphic Work of Mary Cassatt, a Catalogue Raisonné*.

13. For Cassatt's early French training see Nancy Mowll Mathews, "Mary Cassatt and the 'Modern Madonna' of the Nineteenth Century" (Ph. D. diss., New York University, 1980), pp. 19–23. For Cassatt and her tutelage under Couture see Cynthia H. Sanford, "Edouard Frère, the Ecouen School and the Americans" (paper prepared in Spring 1983, at the Graduate School of the City University of New York). Cassatt was specifically listed as a pupil of Couture and Gérôme in the *Catalogue of the Art Collection* (Cincinnati Industrial Exposition, 1873).

14. "Fine Arts. The National Academy Exhibition. II," *Nation* 18 (March 14, 1874): 321.

15. Susan N. Carter, "Exhibition of the Society of American Artists," *Art Journal* (New York) (1879), p. 157.

16. William Crary Brownell, "The Younger Painters of America. III," *Scribner's Monthly* 22 (July 1881): 333.

17. Louisine W. Havemeyer, "The Cassatt Exhibition," p. 377.

18. "Art in Paris," *New York Times*, April 27, 1879, p. 2.

19. Achille Segard, *Mary Cassatt: Un Peintre des enfants et des mères* (Paris: Ollendorff, 1913).

20. Early writers on Cassatt often denied the religious implications or analogies with traditional imagery and allegory; see Camille Mauclair, "Un Peintre de l'enfance," pp. 176–85, and Clara MacChesney, "Mary Cassatt and Her Work," pp. 265–67. For interpretations allying Cassatt's art to traditional religious imagery, see Mathews, "Cassatt and the 'Modern Madonna,'" and Richard H. Love, *Cassatt: The Independent*. For a very different, feminist-directed interpretation of Cassatt, see Griselda Pollock, *Mary Cassatt*, wherein Pollock sums up the purpose of Cassatt's career on p. 27: ". . . to produce a body of works about women, an *oeuvre* which was both feminine in its fidelity to the social realities of the life of a middle-class woman and thoroughly feminist in the way it questioned, transformed and subverted the traditional images of Women, Madonna, Venus, Vanity and Eve, in accordance with the aspirations of the movement of women to be *someone and not something*.'"

21. See Vittorio Pica, "Artisti Contemporanei: Berthe Morisot—Mary Cassatt," pp. 3–16, and Francis E. Hyslop, Jr., "Berthe Morisot and Mary Cassatt," pp. 179–84.

22. "Exhibitions at New York Galleries," *Studio* 6 (November 7, 1891): 394.

23. "De Omnibus Rebus," *Collector* 5 (December 15, 1893): 55.

24. Mariana van Rensselaer, "Current Questions of Art," *New York World*, December 18, 1892, p. 24.

25. "May-Day Facts and Fancies," *Collector* 6 (May 1, 1895): 208.

26. William Walton, "Miss Mary Cassatt," pp. 354–55.

27. See George Biddle, "Some Memories of Mary Cassatt," pp. 107–11.

28. "Editor's Table," *Appleton's Journal*, n.s. 5 (August 1878): 185–86.

29. "Fine Arts. The Lessons of a Late Exhibition," *Nation* 26 (April 11, 1878): 251; "Society of American Artists," *Aldine* 9, no. 9 (1879): 275.

30. Brownell, "Younger Painters," p. 1.

31. Charles De Kay, "Munich as an Art Centre," *Cosmopolitan* 13 (October 1892): 648.

32. Charles De Kay, "Whistler, the Head of the Impressionists," pp. 1–3.

33. Otto H. Bacher, *With Whistler in Venice* (New York,

1908); Harper Pennington, "The Whistler I Knew," *International Quarterly* 10 (October 1904): 156–64; and a quite separate article by Pennington under the same title in *Metropolitan Magazine* 31 (March 1910): 769–76. Bacher had previously published two pieces on Whistler in *Century*: "With Whistler in Venice 1880–1886" 73 (December 1906): 207–18, and "Stories of Whistler" 74 (May 1907): 100–11.

34. Articles on pastel paintings can be found particularly in *Art Amateur* 7 (July 1882): 28, 30; (August 1882): 49, 52; (October 1882): 97; the earliest in that magazine was "Some Hints about Pastel Painting," 1 (October 1879): 100. See also Philip Gilbert Hamerton, "Class Room. Pastel," *Art Interchange* 11 (August 2, 1883): 29.

35. The history of the Society of Painters in Pastel is admirably detailed in Dianne H. Pilgrim, "The Revival of Pastels in Nineteenth-Century America: The Society of Painters in Pastel," pp. 43–62.

36. Mariana Griswold van Rensselaer, "American Painters in Pastel," pp. 204–10, was the most important article on pastel painting written in this country during the crucial decade of the 1880s.

37. "Monthly Record of American Art," *Magazine of Art* 7 (June 1884): xxi.

38. *Art Interchange* 12 (March 27, 1884): n.p.

39. "Monthly Record of American Art," *Magazine of Art* 11 (August 1888): xxxii.

40. "The Pastel Exhibition," *Art Amateur* 21 (June 1889): 4.

41. "The Pastel Exhibition," *Art Amateur* 23 (June 1890): 4.

42. The specific circumstances surrounding its demise are not recorded and, indeed, the pastelists were expected to join the Society of American Artists, the Architectural League, and the New York Guild in finding a permanent home in the American Fine Arts Society building on West Fifty-seventh Street. The building was proposed in summer 1890 and the land acquired by January of the next year; but by the time the building was completed, in December 1892, the Pastel Club was no more.

43. Lucy H. Hooper, "The Salon of 1875. First Paper," *Art Journal* (New York) 1 (1875): 190.

44. "French Writers and Artists. III. Edouard Manet," *Appleton's Journal*, n.s. 5 (September 1878): 277–79.

45. "Manet and Zola," *Art Interchange* 3 (December 10, 1879): 100–101.

46. William Howe Downes, "Impressionism in Painting," *New England Magazine* 6 (July 1892): 600, recalling Manet's *Entombment* shown in Boston a decade earlier.

47. Theodore Child, "Paris Notes," *Art Amateur* 10 (March 1884): 89.

48. John Moran, "The American Water-Colour Society's Exhibition," *Art Journal* (New York) 4 (1878): 92.

49. "The Old Cabinet," *Century* 15 (April 1878): 888–89.

50. L. Lejeune, "The Impressionist School of Painting," *Lippincott's Magazine* 24 (December 1879): 720–27.

51. "Boston Notes," *Art Interchange* 11 (September 27, 1883): 80; "Monthly Record of American Art," *Magazine of Art* 6 (December 1883): xlv.

52. "The Bartholdi Loan Exhibition.—First Notice. —The Painters," *Art Interchange* 11 (December 20, 1883): 160; Mariana G. van Rensselaer, "The Recent New York Loan Exhibition," *American Architect and Building News* 15 (January 19, 1884): 29–30; "The Pedestal Fund Loan Exhibition," *Art Amateur* 10 (January 1884): 42.

53. "Monthly Record of American Art," *Magazine of Art* 9 (July 1886): xxvi–xxvii; "The Impressionists," *Art Age* 3 (April 1886): 165–66.

54. "The Impressionists' Exhibition at the American Art Galleries," *Art Interchange* 16 (April 24, 1886): 130–31; Roger Riordan, "The Impressionist Exhibition," *Art Amateur* 14 (May 1886): 121; 15 (June 1886): 4.

55. Clarence Cook, "The Impressionist Pictures," pp. 245–54.

56. "Fine Arts. Exhibition of the 'Plein-Airistes,'" *Nation* 42 (April 15, 1886): 328; Edward Rudolf Garczynski, "Jugglery in Art," pp. 592–602; "The Fine Arts. The French Impressionists," *Critic*, n.s. 5 (April 17, 1886): 195–96; Luther Hamilton, "The Work of the Paris Impressionists in New York," *Cosmopolitan* 1 (June 1886): 240ff.

57. Mrs. Schuyler (Mariana G.) van Rensselaer, "Fine Arts. The French Impressionists," *Independent* 38 (April 22, 1886): 491–92 and (April 29, 1886): 523–24.

5. *Giverny: The First Generation*

1. My two major sources are the essay by Daniel Wildenstein, "Monet's Giverny," in *Monet's Years at Giverny: Beyond Impressionism* (New York: Metropolitan Museum of Art, 1978); and Claire Joyes, *Monet at Giverny*. See also Stephen Gwynn, *Claude Monet and His Garden*. Also important for this discussion is the exhibition catalog *Claude Monet and the Giverny Artists* (New York: Charles E. Slatkin Galleries, 1960).

2. There are two additional studies on Americans at Giverny by Pierre Toulgouat: "Skylights in Normandy," pp. 66–70, and "Peintres américains à Giverny," pp. 65–73. Monet's own presence in Giverny was reported early and at length in America in two articles by Polly King, "Paris Letter," p. 65, and "Paris Letter. Claude Monet," pp. 131–32. Writers continued to discuss the American presence in Giverny well into the twentieth century. The best of these later discussions is by Mildred Giddings Burrage, "Arts and Artists at Giverny," pp. 344–51; see also Charles Henry Meltzer, "American Artist Colonies Abroad," *Hearst's Magazine* 24 (October 1913): 629. Most recent is the essay by David Sellin on Giverny in *Americans in Brittany and Normandy 1860–1910*, pp. 65–82.

3. Elizabeth de Veer, the current authority on Metcalf, has been most helpful in sharing information on the artist, including his letter of June 27, 1982, quoted in part in the auction catalog, William Doyle Galleries, April 20, 1983, item no. 110. For Metcalf, generally, see Ms. de Veer's essay in *Willard LeRoy Metcalf: A Retrospective*. De Veer also has a full-length manuscript study on Metcalf, and she generously excerpted for me the section on Metcalf and Robinson, including ms. pp. 149–50, discussing the early visits to Giverny by Metcalf and Robinson.

4. Toulgouat, "Skylights," p. 67.

5. Edward Breck, "Something More of Giverny," p. 13.

6. "Greta," "Boston Art and Artists," *Art Amateur* 17 (October 1887): 93.

7. Dawson Dawson-Watson, "The Real Story of Giverny," appendix to Eliot C. Clark, *Theodore Robinson: His Life and Art*, pp. 65–67.

8. "Monthly Record of American Art," *Magazine of Art* 12 (July 1889): xxv.

9. "Monthly Record of American Art," *Magazine of Art* 12 (August 1889): xxix.

10. Joan Murray, ed., *Letters Home: 1859–1906 The Letters of William Blair Bruce* (Moonbeam: Ontario, Canada, 1982), pp. 123–26, for Bruce's letters from Giverny; see also Murray's introduction, pp. 19–21.

11. In Metcalf's case, too, there are pictures of Giverny dated 1886, whether he had been there earlier or not, thus at least predating the recorded group stay the following year.

12. For a discussion of this picture see de Veer, "Metcalf's 'The Ten Cent Breakfast,'" pp. 51–53, and Sellin, *Americans in Brittany*, p. 198.

13. See the articles of 1889 in the *Boston Daily Advertiser*, March 19, p. 4, and March 21, p. 4, and the *Boston Evening Transcript*, February 11, p. 4, for discussion of Metcalf's and Wendel's early Boston exhibitions. These reviews and the art of these painters are perceptively discussed by Laura L. Meixner in *An International Episode*; seven of the Americans at Giverny are discussed on pp. 123–61.

14. "Monthly Record of American Art," *Magazine of Art* 14 (May 1891): xx. For Wendel, generally, see John I. H. Baur, "Introducing Theodore Wendel," pp. 102–12; and the brief exhibition catalog of the Wendel show held in 1976 at the Whitney Museum of American Art in New York.

15. Wendel married into a well-to-do family in Ipswich in 1897 and lived there until his death, although he continued to keep a studio in Boston for a number of years.

16. There is no monograph or modern study of Breck. See the essay by Benjamin Kimball in the two catalogs for the *Memorial Exhibition of Paintings by John Leslie Breck*. Kimball's authorship is acknowledged in the latter. Breck is treated at length in Meixner, *International Episode*, pp. 124–32, and in Sellin, *Americans in Brittany*; Sellin mentions the Breck-Blanche Hoschedé involvement, p. 71.

17. Garland, *Roadside Meetings*, pp. 30–31.

18. St. Botolph Club, *Paintings by John Leslie Breck* (Boston, 1890); "Fine Art Notes," *Boston Morning Journal*, November 22, 1890, p. 2, supplement; "The Fine Arts," *Boston Evening Transcript*, November 22, 1890, p. 12; "The

Fine Arts," *Boston Sunday Herald*, November 23, 1890, p. 12; "The Fine Arts," *Boston Daily Advertiser*, November 27, 1890, p. 4.

19. The three primary studies of Robinson are by John I. H. Baur, *Theodore Robinson, 1852–1896*; Sona Johnston, *Theodore Robinson, 1852–1896*; and Eliot C. Clark, *Theodore Robinson: His Life and Art*. See also the articles by Clark in the bibliography, as well as those by Hamlin Garland, Pearl H. Campbell, Florence Lewison, and Baur's "Photographic Studies by an Impressionist," *Gazette des Beaux-Arts*, s. 6, 30 (October–November 1946): 319–30.

20. Robinson's later work was likened by several writers to that of Bastien-Lepage, the French master regarded as the torchbearer of this *juste milieu* aesthetic; but Bastien-Lepage was never a member of the colony, and his direct or indirect contact with American artists associated with Grèz is a development of the early 1880s.

21. See, for instance, "The Society of American Artists," *Art Amateur* 21 (July 1889): 28; "The Fine Arts. The Society of American Artists," *Critic*, May 18, 1889, p. 249; "Monthly Record of American Art," *Magazine of Art* 12 (August 1889): xxx.

22. See "Fine Arts. Society of American Artists," *Nation* 50 (May 8, 1890): 382.

23. See Baur, "Photographic Studies."

24. Documented in the Theodore Robinson Diaries, in the collection of the Frick Art Reference Library, New York. They begin in March 1892 and end with the artist's death in 1896. Sona Johnston of the Baltimore Museum of Art is presently editing these diaries, an invaluable source for Robinson's last years. They document only his last stay in Giverny, from late May to early December 1892.

25. "The Fine Arts. The Society of American Artists' 15th Exhibition," *Critic* 19 (April 22, 1893): 262.

26. The published sources on Theodore Butler include two exhibition catalogs: *Theodore Earl Butler (1860–1936): American Impressionist*, Maxwell Galleries Ltd.; and *Theodore Earl Butler (1860–1936)*, Signature Galleries. The most important study of Butler is Sally Gross, "Theodore Earl Butler (1860–1936): His Life and Work." Ms. Gross has been extremely helpful in regard to Butler and his art, as has Richard H. Love of the R. H. Love Galleries, Chicago.

27. The finest study of Sargent's artistic development to date is Richard Ormond, *John Singer Sargent: Paintings, Drawings, Watercolors*; for Sargent's Impressionist painting see pp. 33–42. Also extremely valuable is Donelson F. Hoopes, "John S. Sargent," pp. 74–89.

28. Ormond, *Sargent: Paintings*, p. 242, discusses the relationship of the *Vickers Children* and *Carnation, Lily, Lily, Rose* and juxtaposes reproductions of them in plates 45 and 46.

29. See Hoopes, *John S. Sargent*. For the colony at Broadway see Henry James, "Our Artists in Europe," pp. 50–66; Alice Van Sittart Carr, *Mrs. J. Comyns Carr's Reminiscences* (London, 1926), pp. 172–79; Jeannette L. Gilder, "Broadway—in Worcestershire," *Book Buyer* 15 (November 1897): 315–19. Millet's residence at Broadway is discussed in "The Abbot Grange, and Russell House, Broadway, Worcestershire, the Residence of Mr. F. D. Millet," *Country Life* 29 (January 14, 1911): 54–61. For recollections of Sargent's painting of *Carnation, Lily, Lily, Rose* see Edwin Howland Blashfield, "John Singer Sargent—Recollections," *North American Review* 221 (June 1925): 643–44.

30. *Art Journal* 49 (1887): 248.

31. Sargent's small group of paintings of other artists at work are fascinating studies in themselves, for they have a degree of ease and informality very different from the studied brilliance of his portraiture. All of them, quite naturally, depict close colleagues, and they document the shared interest in painting outdoors as well as the friendships themselves. Sargent's depiction of Monet at Giverny assures us that Sargent himself was there when that first group of Americans—Robinson and the others—first descended on the little Norman town.

32. For Bunker see R. H. Ives Gammell, *Dennis Miller Bunker*, and Charles F. Ferguson, *Dennis Miller Bunker (1861–1890) Rediscovered*. Gammell wrote short introductions to the two Bunker exhibitions at the Museum of Fine Arts, Boston, in 1943 and 1945.

33. "The Fine Arts. The Society of American Artists," *Critic* 13 (May 3, 1890): 225.

34. Garland, *Roadside Meetings*, p. 31.

35. For Perry, see Carolyn Hilman and Jean Nutting Oliver, "Lilla Cabot Perry—Painter and Poet," pp. 601–4; Stuart P. Feld, *Lilla Cabot Perry: A Retrospective Exhibition*; and Santa Fe East, *Lilla Cabot Perry: Days to Remember*. Perry's study abroad is documented in Virginia Harlow, *Thomas Sergeant Perry: A Biography*, pp. 108–13 and throughout. See also Perry, "Reminiscences of Claude Monet: From 1889 to 1909," pp. 119–25.

36. Celin Sabbrin [Helen Cecilia De Silver Michael] *Science and Philosophy in Art*, pp. 17–18. I am tremendously grateful to Dr. Frances Weitzenhoffer for bringing this important publication to my attention and pointing out its significance for American understanding of Monet's art and Impressionism.

37. Ibid.

38. Ibid.

39. Theodore Robinson, "Claude Monet," pp. 696–701.

40. Anna Seaton-Schmidt, "An Afternoon with Claude Monet," pp. 32–35.

41. Walter Pach, "At the Studio of Claude Monet," pp. 765–68.

6. The Early Masters

1. Albert E. Gallatin, "Childe Hassam: A Note," p. 102. The major studies of Hassam and his art are Adeline Adams, *Childe Hassam*, and Donelson F. Hoopes, *Childe Hassam*. Stuart Feld and Kathleen M. Burnside are currently at work on a catalogue raisonné.

2. Gallatin, "Childe Hassam."

3. See, in particular, the following discussion of Hassam's *Grand Prix Day*. During his French years, in the late 1880s, Hassam seems to have alternated between Impressionist explorations and Tonalist retention.

4. Probably the finest of Hassam's illustrations, however, are those he prepared in the Impressionist manner. In addition to the illustrations for Celia Thaxter's *An Island Garden*, published in 1894, his contributions to William Dean Howells's *Venetian Life* in 1892 should be especially noted; the other artists whose work was reproduced in this book were Rhoda Holmes Nicholls, F. Hopkinson Smith, and Hassam's close friend Ross Turner.

5. Gaugengigl, like several other Munich-trained artists, was ironically referred to as "the American Meissonier"; he became a primary Boston exponent of the small, meticulous genre composition derived from seventeenth-century Dutch prototypes, popular in Munich during the late 1870s. Interest in Gaugengigl's art has begun to surface recently. Among the contemporary notices of the painter, see "Greta," "A Successful Bavarian Artist," *Art Amateur* 19 (July 1888): 28, and William Henry Howe and George Torrey, "I.M. Gaugengigl," *Art Interchange* 35 (July 1895): 11.

6. "Studio Notes," *Studio* 2 (July 1, 1883): 33.

7. "Boston Art Notes," *Art Interchange* 16 (February 27, 1886): 69.

8. Hassam was advised by the critic of the *Boston Transcript* to "come in out of the rain," in his review of a Hassam exhibition in 1887; clipping preserved at the American Academy of Arts and Letters, which holds a great deal of Hassam archival material. The reference is understandable on reviewing the picture titles of the exhibition at Noyes, Cobb & Co., *Catalogue of Oil Paintings and Water Colors by Mr. Childe Hassam*.

9. "The Fine Arts," *Boston Daily Advertiser*, March 19, 1889, p. 4.

10. See n. 8.

11. William Henry Howe and George Torrey, "Childe Hassam," p. 133.

12. A. E. Ives, "Talks with Artists. Mr. Childe Hassam on Painting Street Scenes," pp. 116–17.

13. In 1899 he also did a book called *Three Cities* about Paris, London, and New York.

14. "The Academy of Design," *Art Amateur* 24 (January 1891): 31.

15. For Thaxter see Celia Thaxter, *The Heavenly Guest* (Andover, Mass., 1935); Rosamond Thaxter, *Sandpiper: The Life of Celia Thaxter* (Sanbornville, New Hampshire, 1962); and *A Stern and Lovely Scene: A Visual History of the Isles of Shoals* (Durham: University of New Hampshire Art Galleries, 1978).

16. "The Fine Arts," *Critic* 17 (May 14, 1892): 281.

17. Celia Thaxter, *An Island Garden* (Boston and New York, 1894).

18. Quoted in Adams, *Childe Hassam*, p. 83.

19. Thaxter, *Heavenly Guest*, p. 126.

20. Candace Wheeler, *Content in a Garden* (Boston and New York, 1901), pp. 56–57.

21. Until recently the two major studies of Weir have been Duncan Phillips et al., *Julian Alden Weir: An Appreciation of His Life and Works*, a series of informative essays, and an excellent biography by his daughter, Dorothy Weir Young, *The Life and Letters of J. Alden Weir*. The recent study by Doreen Burke, *J. Alden Weir, An American Impressionist*, is now the definitive monograph on the artist.

22. Young, *J. Alden Weir*, p. 123.

23. Quoted ibid., p. 171.

24. Silver and gold utensils, for instance, were sometimes surrounded by Renaissance religious reliefs that cast a spiritual solemnity over the combination of manmade and natural beauty. This traditional concept related to the beautiful still lifes of the French School of Lyon. For these artists, and the Lyon still-life school see Elisabeth Hardouin-Fugier and Etienne Grafe, *The Lyon School of Flower Painters* (Leigh-on-Sea, Great Britain, 1978); the exhibition catalog *Fleurs de Lyon 1807–1917* (Lyon: Musée des Beaux-Arts, 1982); and especially the inclusion of these still lifes in the exhibition *Les Peintres de l'âme* (Lyon: Musée des Beaux-Arts, 1981).

25. See the short but perceptive notice of the exhibition in "Art Notes," *Art Interchange* 22 (February 16, 1889): 49; the reference to Courbet occurs in "The Weir and Twachtman Exhibition," *Art Amateur* 20 (March 1889): 75. Weir presented an unrecorded talk on Bastien-Lepage at the Art Students League on January 17, 1885; later, he went over this material orally, presumably with Clarence Cook, editor of *Studio*, who then prepared the article on "Jules Bastien-Lepage," *Studio*, n.s. no. 13 (January 31, 1885): 145–51. Weir's article on Bastien-Lepage is in John C. Van Dyke, ed., *Modern French Masters*, pp. 227–34; his fellow Impressionist Theodore Robinson contributed a study on Camille Corot and one on Claude Monet to this volume.

26. "Three Special Exhibitions," *Collector* 2 (February 1, 1891): 78; "Paintings by Mr. J. Alden Weir," *Art Amateur* 24 (February 1891): 56.

27. See, for instance, "Monthly Review of American Art," *Magazine of Art* 6 (October 1893): xl; "French and American Impressionists," *Art Amateur* 29 (June 1893): 4.

28. "Impressionism and Impressions," *Collector* 4 (May 15, 1893): 213.

29. The primary studies of Twachtman and his art are John Douglass Hale, "The Life and Creative Development of John H. Twachtman," 2 vols. (Ph. D. diss., Ohio State University, 1957), and Richard J. Boyle, *John Twachtman*.

30. Marsden Hartley, *Adventures in the Arts*, p. 76.

31. Although Twachtman had studied in Munich and Weir in Paris, the work of both men was associated in the critical mind with the dark, generalized forms of Munich, reinforcing the estimation of the Society in its early years as more Munich oriented. Even this early, critics tended to link Weir and Twachtman, and indeed the friendship between them was fast developing—in 1882 Twachtman named his first son J. Alden Twachtman.

32. Quoted in Boyle, *John Twachtman*, p. 16.

33. For those writers likening Twachtman's art with that of the Orient, see Hartley, *Adventures*, p. 75; Christian Brinton, *Impressions of the Art at the Panama-Pacific Exhibition . . .* , p. 95; John E. D. Trask and John Nilsen Laurvik, *Catalogue De Luxe of the Department of Fine Arts, Panama-Pacific International Exposition*, pp. 44–46; Sheldon Cheney, *The Story of Modern Art*, p. 432; John Cournos, "John H. Twachtman," p. 245.

34. When he exhibited with Weir at the Fifth Avenue Art Galleries early in 1889 he must not have included these new works, for the critics spoke of the Dutch inspiration of his art and admired its "few grays, greens, and subdued tints of earth or sand, with peculiarly tender blues and pearly grays in the sky"—a description that characterizes his art of the mid-1880s. "The Weir and Twachtman Exhibition," *Art Amateur* 20 (March 1889): 75.

35. "The Fine Arts. Oil-Paintings and Pastels by Mr. Twachtman," *Critic* 15 (March 14, 1891): 146–47.

36. *Art Amateur* 24 (April 1891): 116.

37. "Paintings in Oil and Pastel by J. H. Twachtman," *Studio* 6 (March 28, 1891): 162.

38. Monthly Record of American Art," *Magazine of Art* 14 (July 1891): xxvii.

39. Quoted in Adams, *Childe Hassam*, p. 93. On this art movement see Charles Eldredge, "Connecticut Impressionists: The Spirit of Place," *Art in America* 62 (September–October 1974): 84–90, and more recently, Susan G.

Larkin, "The Cos Cob Clapboard School," in *Connecticut and American Impressionism* (Storrs: University of Connecticut, William Benton Museum of Art, 1980), pp. 82–113.

40. Meixner, *International Episode*, suggests that Boston exposure to Impressionism in landscape was concurrent with or even preceded the emergence of the better-known Boston group of Impressionist figure painters. The two groups of avant-garde artists were certainly well acquainted and exhibited at the same galleries and at the St. Botolph Club; whether they enjoyed the same patronage is unclear.

41. Sadakichi Hartmann, "The Tarbellites," pp. 3–4; Hartmann expanded on this subject in *A History of American Art*, pp. 237–42. This group has been studied by Bernice Kramer Leader, "The Boston Lady as a Work of Art: Paintings by the Boston School at the Turn of the Century," and their work published by her in two specialized articles: "The Boston School and Vermeer," pp. 172–76, and "Antifeminism in the Paintings of the Boston School," pp. 112–19. See also Elizabeth Szancer, "The Proper Bostonians: Tarbell, Benson, Decamp" (Master's thesis, Queens College of the City University of New York, 1975). Hartmann's characterization of the Tarbellites is amplified in Guy Pène du Bois, "The Boston Group of Painters," pp. 457–60. See also Patricia Jobe Pierce, *Edmund C. Tarbell and The Boston School of Painting: 1889–1980*. Pierce glorifies the "Tarbellites" rather than condescends, as did Hartmann. A more balanced but basically favorable presentation of the Boston School appeared in William Howe Downes, "Boston Art and Artists," pp. 265–80; and, more recently, in R. H. Ives Gammell, "A Reintroduction to Boston Painters," pp. 94–104.

42. There is a tribute to Grundmann by R. H. Ives Gammell in the introduction to Bartlett Hayes, *Art in Transition: A Century of the Museum School* (Boston: Museum of Fine Arts, 1977), p. 9. See also "Greta," "Art in Boston," *Art Amateur* 13 (October 1890): 83.

43. Theodore Robinson Diaries, March 31, 1892.

44. "The Sixty-Seventh Annual Exhibition of the National Academy of Design in New York," *Studio* 7 (April 2, 1892): 163; "The National Academy Exhibition," *Art Amateur* 26 (May 1892): 141; Royal Cortissoz, "Art in New York," *Arcadia* 1 (May 2, 1892): 13.

45. George Torrey and William Henry Howe, "Edmund C. Tarbell, A.N.A.," *Art Interchange* 32 (June 1894): 167.

46. Hartmann, "The Tarbellites," p. 3.

47. "Art Notes," *Art Interchange* 33 (July 1894): 12.

48. Hale's life, writings, and art have been studied and discussed even less than the careers of his Boston colleagues. Frederick W. Coburn wrote a number of pieces on Hale cited in the bibliography. In addition, there is the catalog by Franklin P. Folts, *Paintings and Drawings by Philip Leslie Hale (1865–1931) from the Folts Collection*. Hale's daughter, Nancy Hale, wrote *The Life in the Studio*; but its concern is more personal than artistic and historical, and it does not deal at all with Hale's early artistic activities and achievements. The Hale papers at the Archives of American Art are especially useful here.

49. Hale to William Howard Hart, July 29, 1895, Philip Hale Papers, Archives of American Art.

50. See Philip Hale, "On Certain Pictures by Raffaelli," *Modern Art* 3 (Spring 1895): 36–46; "Degas," *Collector and Art Critic* 5 (November 1906): 11–17. Also pertinent to Hale's involvement with Impressionism and modern art in France and America are his columns in the short-lived (1892–93) but very professional Montreal-based magazine, *Arcadia*, where Hale conducted the weekly "Art in Paris" section. Hale's last writing was "Painting and Etching," pp. 353–64, with useful information on the Boston School.

51. Grèz is described numerous times in accounts of artists working there and in descriptions of French art colonies. For the most important articles see "Grèz, par Nemours," pp. 15–18; Birge L. Harrison, "In Search of Paradise with Camera and Palette," *Outing*, January 1893, pp. 310–16; R. A. M. Stevenson, "Grèz," pp. 27–32; Birge Harrison, "With Stevenson at Grèz," pp. 302–14. A full listing of artists at Grèz from all nations can be found in Fernande Sadler, *L'Hôtel Chevillon et les artistes de Grès-sur-Loing*. May Brawley Hill prepared an excellent study of "Grèz-sur-Loing as an Artists' Colony 1875–1890" for a course at the Graduate School of the City University of New York in 1983.

52. May Brawley Hill prepared a study of Vonnoh and his career for a course at the Graduate School of the City University of New York in 1981; published material on

him and his art is confined to periodical articles, including those by Susan Ketcham, Eliot Clark, and Harold Eberlein (see bibliography).

53. Jonathan Benington, "Roderic O'Conor (1860–1940), the Development of His Art up to 1913" (Master's thesis, Courtauld Institute of Art, London University, 1982), pp. 3, 7, 8.

54. *National Cyclopedia of American Biography*, vol. 7, 1897, p. 462.

55. *Paintings by Robt. W. Vonnoh* (Boston: Williams & Everett, 1891), n.p.

56. Vonnoh exhibited at the Academy in 1892; at the World's Columbian Exposition in 1893, where he showed more paintings than any other American artist; at O'Brien's Galleries in Chicago, in March 1894; and in a one-man show at Durand-Ruel in New York, in February 1896.

57. Lucy Monroe, "Chicago Letter," *Critic* 24 (March 17, 1894): 190.

58. Susan M. Ketcham, "Robert W. Vonnoh's Pictures," pp. 115–16.

59. Jesse Jones, "Where the Bayberry Grows," p. 112, quoted in Hill, "Grèz sur Loing," p. 20.

60. "Philadelphia Art Schools' Exhibit," *Art Amateur* 28 (May 1893): 156.

61. William Innes Homer, *Robert Henri and His Circle*, p. 69.

62. *Art News* 1 (April 1897): 4.

7. Widening Exposure

1. Theodore Child, "A Note on Impressionist Painting," pp. 313–15.

2. Trumble eulogized Inness in *Collector* 5 (1894) and took great notice of the Inness sale at the Fifth Avenue Art Galleries the following year. His tribute was combined with those of other authorities in Alfred Trumble, *George Inness, N. A.: A Memorial of the Student, the Artist, and the Man* (New York, 1895).

3. Trumble, "Impressionists and Imitators," p. 11.

4. Trumble, "Things of the Time," *Collector* 3 (December 15, 1891): 50.

5. William Howe Downes, "Impressionism in Painting," p. 601.

6. Ibid., p. 603.

7. Cecilia Waern, "Some Notes on French Impressionism," pp. 535–41.

8. Ibid., pp. 539–40.

9. W.H.W., "What Is Impressionism?" pp. 140–41; "Part II," *Art Amateur* 28 (December 1892): 5.

10. "R.R." [Roger Riordan], "From Another Point of View," p. 5.

11. "Impressionism and Impressions," *Collector* 4 (May 15, 1893): 213–14.

12. The standard work on the theme of nineteenth-century European academic instruction is Albert Boime, *The Academy and French Painting in the Nineteenth Century* (London, 1971).

13. The best study of American nineteenth-century art education is Doreen Bolger, "The Education of the American Artist."

14. Picknell, H. Bolton Jones, and his brother, Francis Jones, had a joint exhibition at the Williams & Everett Gallery in Boston of *Pictures at Annisquam*; the catalog unfortunately does not designate the year.

15. Helen M. Knowlton, "A Home-Colony of Artists," pp. 326–27.

16. Allen Tucker, *John H. Twachtman*, p. 8.

17. For instance, he pointed out: "In the schools we insist, if a number of pupils are drawing from a cast at different distances from it, that the drawings shall be made the size of the original. That is academic. Really, the one who sits the third row back sees the object much smaller than those in the front row. That is what we must attempt to render here. . . . After working all winter indoors, when you go out of doors to paint you are apt to get your color too cold. Try a gray subject on a yellow canvas and it should come out warmer than this study in sunlight."

18. Holger Cahill and Alfred H. Barr, Jr., eds., *Art in America: A Complete Survey* (New York, 1939), p. 87.

19. "An Art School at Cos Cob," pp. 56–57.

20. Ernest Knaufft, "Paragraphs," *Art Student* 1 (March 1893): 82.

21. "Monthly Record of American Art," *Magazine of Art* 15 (September 1892): xxxiii.

22. "Summer Study," *Art Student* 4 (May 1894): 11.

23. "Women and Their Interests. Artists Afield," p. 11.

24. Robinson taught at Princeton for one month; he arrived there on July 10 and rendered his accounts on August 20, leaving two days later. On July 20 he noted in his diary that he was doing canal pictures but that they were not as interesting as those he had painted the summer before. Robinson Diaries, July–August 1894.

25. "Monthly Record of American Art," *Magazine of Art* 15 (September 1892): xxxiii.

26. "Summer Study," p. 11.

27. "Our Summer Art Schools," *Art Interchange* 33 (July 1894): 21.

28. The Chase bibliography is voluminous. The standard older study of Chase is by his pupil, Katherine Metcalf Roof, *The Life and Art of William Merritt Chase* (New York, 1917). In recent years Ronald G. Pisano has published numerous studies on Chase and his art, culminating in *A Leading Spirit in American Art: William Merritt Chase, 1849–1916*, which includes an extensive bibliography on earlier Chase material.

29. "Address of Mr. William M. Chase, before the Buffalo Fine Arts Academy, January 28th, 1890," *Studio*, n.s. 5 (March 1, 1890): 124.

30. Kenyon Cox, "William M. Chase, Painter," p. 556.

31. Charles De Kay, "Mr. Chase and Central Park," pp. 327–28.

32. John Gilmer Speed, "An Artist's Summer Vacation," pp. 3–14; Rosina H. Emmet, "The Shinnecock Hills Art School," pp. 89–90; Lillian Baynes, "Summer School at Shinnecock Hills," pp. 91–92; Elizabeth W. Champney, *Witch Winnie at Shinnecock*; Jessie B. Jones, "Where the Bay-Berry Grows," pp. 109–14; Mary Clara Sherwood, "Shinnecock Hills School of Art," pp. 171–73. Related to the Shinnecock experience is "Out-of-Door Sketching; A Talk by William M. Chase," pp. 8–9.

33. "Art Notes," *Critic* 21 (April 21, 1894): 278.

34. Speed, "Artist's Summer Vacation," p. 3.

35. Ibid., p. 8.

8. The World's Columbian Exposition of 1893

1. The literature on the World's Columbian Exposition, as well as its art and architecture, is enormous. Especially pertinent to the present study is Elizabeth Broun, "American Paintings and Sculpture in the Fine Arts Building of the World's Columbian Exposition, Chicago, 1893" (Ph.D. diss., University of Kansas, 1976). For a bibliography on the art and architecture of the great international expositions of the second half of the nineteenth century see Julia Finette Davis, "International Expositions 1851–1900," in William B. O'Neal, ed., vol. 4 of *The American Association of Architectural Bibliographers, Papers* (Charlottesville, Va., 1967).

2. See especially Francis Davis Millet, "The Decoration of the Exposition," *Scribner's* 12 (December 1892): 692–709; reprint in Millet et al., *Some Artists at the Fair* (New York, 1893).

3. Maud Howe Elliott, ed., *Art and Handicraft in the Woman's Building of the World's Columbian Exposition* (Chicago, Paris, and New York, 1893). Particularly significant here is John D. Kysela, S. J., "Mary Cassatt's Mystery Mural and the World's Fair of 1893," pp. 129–45.

4. Impressionist influence was not particularly evident in these murals, which seemed indebted to the much-admired decoration by Paul Baudry in the Paris Opera. The Exposition murals, however, were the immediate inspiration for the whole mural movement in America, and some American Impressionists, such as Robert Reid, were to become successfully engaged in mural painting for much of their careers.

5. Raffaëlli later in the decade became one of the most popular continental French artists and made several triumphant visits to this country to accompany exhibitions of his work.

6. Roger Riordan, "The World's Fair Loan Collection. Contemporary Painting (concluded)," *Art Amateur* 30 (April 1894): 130.

7. John C. Van Dyke, "Painting at the Fair," *Century* 48 (June 1894): 444.

8. Hamlin Garland, *Roadside Meetings*, pp. 30–31.

9. Hamlin Garland, *Crumbling Idols: 12 Essays on Art*; John Rewald, *The History of Impressionism*, p. 447.

10. Garland, "Impressionism," *Crumbling Idols*, pp. 97, 101.

11. Ibid., p. 109.

12. For the activities of the Central Art Association see Harriet Monroe, "Chicago Letter," *Critic* 22 (December 29, 1894): 449–50; Hamlin Garland, "Successful Efforts to Teach Art to the Masses. Work of an Art Association in Western Towns," pp. 606–9. For a contemporary recounting of those activities, see Russell Lynes, *The Tastemakers*, pp. 151–56.

13. "A Critical Triumvirate" [Charles Francis Browne, Hamlin Garland, Lorado Taft], *Impressions on Impressionism* (Chicago, 1894).

14. Theodore Robinson Diaries, December 18, 1894.

15. I have touched upon some of these regional art colonies in my "Post-Impressionist Landscape Painting in America," pp. 60–67.

16. There is much uncertainty about the nature of Currier's instruction; Michael Quick has conveyed his opinion to the author that Currier may have offered general advice, but he believes that there was no formal instruction given, and he noted that Nelson C. White, in his keenly perceptive book, *The Life and Art of J. Frank Currier* (New York, 1936), stated on p. 46 that Currier "had no regular classes." Nevertheless, White quotes Ross Turner, the friend and colleague of Currier and Hassam, as writing in the memorial notice in the *Boston Evening Transcript* that Currier "was an excellent teacher always" (White, *J. Frank Currier*, p. 48). Mary E. Steele, the wife of Theodore Steele, wrote about the Hoosier artists in Munich in her *Impressions* (Indianapolis, 1893), n.p., noting that Schleissheim's nearness to Munich made it "a desireable suburban residence, and many artists spent their summers there, while a few lived there the year round. Mr. Currier had his school of landscape at Schleissheim."

17. Joseph Moore Bowles, "Messrs. Steele and Forsyth," *Modern Art* 1 (Spring 1893): n.p.

18. All in *Modern Art*: Theodore C. Steele, "Impressionalism," 1 (Winter 1893): unpaginated; William Forsyth, "Some Impressions of the Art Exhibit at the Fair—III," 1 (Summer 1893): unpaginated; Otto Stark, "The Evolution of Impressionism," 3 (Spring 1895): 53–56. For a brilliant analysis of *Modern Art* see Eleanor Phillips Brackbill, "Modern Art: An American Magazine of the 1890s" (paper prepared for a seminar on early American art criticism, Graduate School of the City University of New York, 1981).

19. "A Critical Triumvirate" [Charles F. Browne, Hamlin Garland, Lorado Taft], *Five Hoosier Painters*, passim.

20. Harriet Monroe, "Chicago Letter," *Critic* 22 (December 29, 1894): 450.

21. *Art Amateur* 32 (March 1895): 107.

22. Hamlin Garland, "Art Conditions in Chicago," n.p.

23. W.W.P., "Pictures at the St. Louis Exposition," *Art Amateur* 31 (October 1894): 90.

24. J. A. Stanton, "Impressions of the Art Display," *Overland Monthly* 23 (April 1894): 404.

25. The Central Art Association toured exhibitions of the Hoosier School and subsequently a show of work by the pastelist Frank Reaugh, one of the first Texas artists with Impressionist affinities. But a stronger and more lasting initiative for contemporary regional shows was effected in 1896 with the organization of the Society of Western Artists, which was grounded in modernism with some emphasis on Impressionism. Centered in Chicago, it comprised artists from that city, Cleveland, Cincinnati, Detroit, Indianapolis, and Saint Louis; exhibitions of work by members and nonmembers circulated among the six Midwestern centers. Frank Duveneck was president, and Steele, Adams, and Forsyth were its Indianapolis representatives the first year; Stark was added by 1897.

26. By that time Steele and Adams were located in the Whitewater Valley and had purchased a house in Brookville, Indiana, which they named "The Hermitage," in 1898. In 1907 Steele sold his share of the property to Adams and moved outside of Nashville, Indiana, in Brown County.

27. For the Brown County colony see especially Adolph Robert Shulz, "The Story of the Brown County Art Colony," pp. 282–89; and Josephine A. Graf, "The Brown County Art Colony," pp. 365–70.

28. Quoted in Selma N. Steele, Theodore L. Steele, and Wilbur D. Peat, *The House of the Singing Winds: The Life and Work of T. C. Steele*, p. 136.

9. *The Master Impressionists*

1. "Women and Their Interests," p. 11.

2. W. Lewis Fraser, "Theodore Robinson's Picture 'The Canal,'" *Art Collector* 9 (February 15, 1899): 117–18.

3. While New York remained Robinson's winter base, in spring 1894 he did the well-known painting of the Columbian Exposition, perhaps the grandest of the many commemorative pictures of the fair painted by artists from Hassam to Moran. Despite its intense coloration, Robinson's oil has a formal definition that suggests its function in the publication *World's Columbian Exposition: The Book of the Builders* (Chicago, 1894). He was commissioned to work on the publication by Frank Millet, who was involved in the project with the architect Daniel Burnham. Only a few separate numbers of the "book" appeared. Millet commissioned the first of two works from Robinson on March 12, 1894, and the artist was involved with the project through May, according to his diaries at the Frick Art Reference Library.

4. Baur's groundbreaking study of Robinson portrays him basically "rooted in the American realist tradition" and cites the diary entries to support his contention that Robinson consciously wanted to infuse his work with firmer draftsmanship and a greater sense of design; see pp. 50–52. But surely these are equally French characteristics, and their significance was impressed on Robinson during his student years in Paris.

5. Hamlin Garland, "Theodore Robinson," p. 285. Robinson was more successful this last summer with his figure paintings, such as *Making Pumpkin Pies*, a rare square canvas. But after he returned to New York in October and sent the picture to exhibition in Boston, he again had grave doubts: he judged his work not well enough drawn, noting that a Dutchman would have made a charming picture of the scene, with sobriety and a love of homely detail; and he indicated that he had Vermeer as his unrealized model. This is an early example of the emulation that would inform the art of many of his Boston colleagues.

6. Robinson Diaries, August 25, 1894, and February 7, 1896; Robinson to Philip Hale, commenting upon the current exhibition of Hassam's work in New York, in a letter of January 4, 1896; Philip Hale Papers, Archives of American Art.

7. Hassam's exploration of Post-Impressionist currents in Pont-Aven is discussed in Sellin, *Americans in Brittany*, pp. 63–64, 172.

8. "Paintings by Mr. Hassam," *Art Interchange* 36 (March 1896): 66.

9. December 16, 1891, quoted in Young, *J. Alden Weir*, p. 190.

10. Cheney, *Story of Modern Art*, p. 432.

11. Another very unusual picture is *The Cabbage Patch*. Twachtman painted numerous flower gardens, but the vegetable garden seems unique in his work and unusual for an American artist of the time painting in this country. By contrast, the vegetable garden—particularly the growing of the staple cabbage—was a prime subject among European painters of peasant life and landscapes, and it also was essayed by Robinson and others when they painted peasant gardens abroad.

12. Charles De Kay, "John H. Twachtman," p. 76.

13. Clark first wrote about the Niagaras in "John Henry Twachtman (1853–1902)," *Art in America* 7 (April 1919): 131; he expanded on the theme, as quoted here, in "The Art of John Twachtman," p. 82, repeated in his book, *John Twachtman* (New York), p. 51.

14. Clark, "Art of John Twachtman," p. 81.

15. Quoted in Young, *J. Alden Weir*, p. 177.

16. "The Exhibition of the Society of American Artists," *Art Amateur* 30 (April 1894): 127; "The Fine Arts. The Exhibition of the Society of American Artists," *Critic* 21 (March 17, 1894): 187.

17. Robinson Diaries, February 27, 1894.

18. Burke, *J. Alden Weir*, discusses Weir's indebtedness to Japanese art and aesthetics at length and with great perception, pp. 202–16.

19. "The National Academy of Design," *Art Amateur* 38 (May 1898): 131.

10. *The Ten American Painters*

1. The reference to the Ten as "a kind of academy of American Impressionism" is in Edgar P. Richardson, *Painting in America: The Story of 450 Years*, p. 306. To date the Ten have been the subject of two full-length studies: Kenneth Coy Haley, "The Ten American Painters: Definition and Reassessment," and Patricia Jobe Pierce, *The Ten*.

2. Agreement signed December 17, 1897; on file at the American Academy of Arts and Letters; on microfilm at the Archives of American Art.

3. Ibid.

4. Weir stated these views, as reported in "Eleven Painters Secede," *New York Times*, January 9, 1898, p. 12, and reiterated in Young, *J. Alden Weir*, p. 199.

5. Edward Emerson Simmons, *From Seven to Seventy: Memories of a Painter and a Yankee*, p. 222.

6. "The Eighth Exhibition of The Society of American Artists," *Art Interchange* 16 (May 8, 1886): 145; "Society of American Artists," *Art Interchange* 20 (April 21, 1888): 130.

7. "Art Gossip," *Art Interchange* 26 (May 9, 1891): 146; Malcolm Bell, "The Society of American Artists," *Art Amateur* 25 (June 1891): 4, speaks of "a curious epidemic of moonlight and twilight effects" in the exhibition.

8. "The Society of American Artists," *Art Amateur* 32 (May 1895): 157.

9. "The Society of American Artists," *Art Amateur* 34 (May 1896): 129; "The Fine Arts. Exhibition of the Society of American Artists (First Notice)" *Critic* 25 (April 4, 1896): 242.

10. "News and Views," *Collector* 8 (April 1, 1897): 163; "Society of American Artists' Exhibition," *Art Interchange* 38 (May 1897): 119.

11. "The Fine Arts. The Society of American Artists' Exhibition," *Critic* 29 (March 26, 1898): 220; "Society of American Artists' Exhibition," *Art Interchange* 40 (May 1898): 116.

12. "The Society of American Artists," *Art Amateur* 40 (May 1899): 117.

13. See article cited in n. 4.

14. Cox is quoted in "The Observer," *Art Interchange* 40 (February 1898): 40.

15. Ibid., pp. 40–41.

16. "Ten American Painters," pp. 133–34.

17. Childe Hassam, "Twenty-five Years of American Painting," *Art News* 26 (April 14, 1928): p. 22.

18. In the review in the *Art Amateur*, cited in n. 12, the critic noted, "There were few works of a decorative character," referring in part to the depiction of the nude in the Society's exhibition.

19. Simmons, *From Seven to Seventy*, p. 222.

20. "Current Art, Native and Foreign. II. The Ten," *International Studio* 49 (May 1913): 52–53.

21. "The Ten American Painters," *Art World* 2 (June 1917): 239.

22. Quoted in Young, *J. Alden Weir*, p. 258.

23. There is no contemporaneous or recent monograph on De Camp. Rose Berry, William Howe Downes, and Arthur Hoeber have written useful articles on the artist (see bibliography). See also Lee W. Court, *Joseph De Camp: An Appreciation*; George R. Agassiz's short essay therein was published separately as a pamphlet: *Joseph De Camp: An Appreciation* (Boston, 1923). A descendant of the artist, Donald Moffat, prepared an unpublished study and catalog which is on file at the Archives of American Art, the Donald Moffat Papers.

24. The most complete listing of De Camp's work can be found in the Donald Moffat Papers, Archives of American Art. There are fewer than two dozen De Camp paintings listed that were done prior to the disastrous fire of 1904. Almost none is located of those painted in the decade prior to his association with the Ten, beginning in 1898; thus De Camp's development in this crucial period is, at present, undecipherable.

25. Though Gloucester artists have been studied to some extent (see the exhibition catalog *Portrait of a Place*), the interaction among artists both working and teaching there and in nearby communities such as Annisquam, Swampscott, and Ipswich in the 1890s is in great need of investigation. The area at that time was a major center for the development of outdoor painting and its propagation through summer classes, a legacy that continued well into the twentieth century.

26. There is no full-length monograph on Dewing, though many of the most prominent art writers of the early twentieth century wrote articles about him, including Charles H. Caffin, Royal Cortissoz, Catherine Beach Ely, Sadakichi Hartmann, Homer Saint-Gaudens, Ezra Tharp, and, later, Nelson C. White (see bibliography).

More recently, studies by Susan Hobbs, Judith Elizabeth Lyczko, and Kathleen Pyne have been published in several art periodicals. The fullest and most perceptive treatment of Dewing's art is to be found in Sarah Lea Burns, "The Poetic Mode in American Painting: George Fuller and Thomas Dewing" (Ph.D. diss., University of Illinois at Urbana-Champaign, 1979).

27. On Freer as a collector see Aline Saarinen, *The Proud Possessors* (New York, 1958), pp. 118–43; Susan Hobbs, "A Connoisseur's Vision: The American Collection of Charles Lang Freer," *American Art Review* 4 (August 1977): 76–101; and H. Nichols B. Clark, "Charles Lang Freer: An American Aesthete in the Gilded Era," *American Art Review* 11 (October 1979): 53–68.

28. For Tonalism see Wanda M. Corn, *The Color of Mood: American Tonalism 1880–1910*, and William H. Gerdts, Diana Dimodica Sweet, and Robert R. Preato, *Tonalism: An American Experience*. See also Mary Margaret Morgan Muir, "'Tonal Painting,' 'Tonalism,' and 'Tonal Impressionism'" (Master's thesis, University of Utah, 1978). Key publications during the course of the Tonalist movement include Clara Ruge, "The Tonal School of America," *International Studio*, pp. 57–66, and Ralcy Husted Bell, *Art-Talks with Ranger* (New York and London, 1914).

29. Tonalism is sometimes defined as the dominance of a single hue throughout a painting, and Dewing's art partakes of this quality. Though his women have an air of lethargic mystery, rather than the outgoing enthusiasm of Tarbell and Benson's subjects, Dewing shared with his fellow Bostonians a concentration on the female figure—sometimes indoors, sometimes in a landscape, sometimes singly, sometimes in groups. He shared with them, too, an interest in Vermeer, just then rediscovered, and Dewing may have been the first of the Ten to succumb to that influence. Given Vermeer's subtle refinement, it would seem natural that Dewing was drawn to his work, and he echoed Vermeer's art in his own, not only compositionally and in the treatment of light and atmosphere but even in the props and "occupations" of his female subjects, who play the spinet or harpsichord or are actively engaged in putting on beads. Dewing's women are usually inactive and passive—they may hold books, but they seldom read; they usually sit, and when they stand they do not walk. Elegance is paramount—they are tall and bony, dressed aristocratically in long, elegant gowns and placed in sparsely furnished interiors, but with a few objects of utmost refinement—Oriental porcelains, antique furniture, rare musical instruments. See Judith Elizabeth Lyczko, "Thomas Wilmer Dewing's Sources: Women in Interiors," pp. 152–7.

30. For an excellent analysis of Dewing's "decorations," see Burns, "The Poetic Mode," pp. 229–37 and passim. For the most part, contemporary writers on Dewing tended to concentrate on his depictions of women indoors, rather than on the figures in the landscape.

31. [Sadakichi Hartmann], "Thomas W. Dewing," pp. 34–35.

32. The Saint Ives experience is described by Simmons in his delightful autobiography, *From Seven to Seventy: Memories of a Painter and a Yankee*, pp. 162–83. Saint Ives as an art colony for British and/or American artists is a subject still in need of in-depth study. *Studio* magazine took notice of the artistic activities there a number of times in the late 1880s.

33. "The Society of American Artists of New York. Fourteenth Exhibition," *Studio* 7 (May 28, 1892): 235.

34. William Henry Howe and George Torrey, "Edward E. Simmons," p. 121. These works extended the aesthetic of marine coastal painting developed by Simmons's close associate in Brittany, Alexander Harrison, but they substituted a more poetic spirit for the incredibly panoramic sweep of Harrison's scenes.

35. As with many of the Ten, Reid's art received numerous contemporary articles but no monographs (see bibliography for studies by Christian Brinton, Royal Cortissoz, Henry W. Goodrich, Charles Henry Hart, Arthur Hoeber, James William Pattison, Irene Sargent, and Evelyn Marie Stuart). Cortissoz's *In Summertime: Paintings by Robert Reid* is really a picture monograph; Stanley Stoner's *Some Recollections of Robert Reid* is a short, chatty personal memoir of Reid's last years. Helene Barbara Weinberg's "Robert Reid, Academic Impressionist," *Archives of American Art Journal*, pp. 2–11, is a serious, modern scholarly study but is concerned with Reid's pre-Impressionist work and his experience as a student overseas.

36. See Weinberg, "Robert Reid." For Etaples as a subject for artists see Birge Harrison, "In Search of Paradise," pp. 313–16; Jane Quigley, "Picardy: A Quiet Simple Land of Dreamy Beauty Where Artists Find Much to Paint," *Craftsman* 12 (June 1907): 255–62; Meltzer, "American Artist Colonies Abroad," p. 629.

37. Weinberg, "Robert Reid," pp. 9–10.

38. "The Pictures at the Union League Club in New York—Second Notice," *Studio* 6 (January 17, 1891): 57; "The Fine Arts. The Society of American Artists' Exhibition—Second Notice," *Critic* 17 (May 14, 1892): 280–81.

39. *Art Interchange* 33 (August 1894): 45.

40. Several of these were compared to work by the French painter Albert Besnard: "The Fine Arts. The Exhibition of the Society of American Artists," *Critic* 21 (March 17, 1894): 187, and "The Exhibition of the Society of American Artists," *Art Amateur* 30 (April 1894): 128.

41. "The Society of American Artists' Exhibition," *Art Interchange* 34 (May 1895): 136.

42. "The Society of American Artists," *Art Amateur* 34 (May 1896): 129.

43. All the critics referred to Reid's work as "decorative" and to the painter as a "decorative artist." For a typical reaction to *Trio* see "Ten American Painters," *Art Amateur*, p. 134.

44. "Ten American Painters," *Artist* 25 (May–June 1899): ix. The *Artist*, like the *Magazine of Art*, was an English art periodical that for a time published an American edition with a supplementary section on American art activities. This review in 1899 was one of the most perceptive that appeared.

45. Durand-Ruel held a one-man show of thirty-seven of Reid's works in April 1898, immediately after the first exhibition of the Ten; the artist had a one-man show in his large studio in the Gibson Building the week before the second exhibition of the Ten in 1899. He continued to exhibit with the new group and in 1901 showed six works, three figure pieces and three landscapes, though his pure landscapes are scarce and little known.

46. That same year, however, he became seriously involved in creating murals for the Boston State House and in designing stained glass windows for the H. H. Rogers Memorial Church in Fairhaven, Massachusetts.

47. See Christian Brinton, "Robert Reid: Decorative Impressionist," pp. 13–15, 34.

48. In the latter part of the first decade of this century, screens themselves began to appear in Reid's painting, one of a number of Oriental motifs that began to take a prominent place in his decorative repertory. Even the specific flower of his 1908 *Peonies* is associated with the Orient. But Oriental screens appear as flattening backdrops to his figures in *The Mirror* of about that same year, the *Golden Screen*, and the *Japanese Screen*. Still another Japanese motif, the kimono, is favored in such paintings as *The Violet Kimono* of about 1910, *The Blue Kimono* of 1911, and the *Flowered Kimono* of 1919. In such paintings the garment itself not only provides the major color accent but allows for soft, billowing areas of broken and striated color. *The Violet Kimono*, especially, utilizing the hue so dear to the Impressionists, offers repetitions of the color in the draperies, flowers, and reflected images in the mirror—another motif often found in Impressionist figure painting.

49. [Sadakichi Hartmann], "Robert Reid," pp. 14–15.

50. Evelyn Marie Stuart, "Finished Impressions of a Portrait Painter," pp. 32–40; the term, "portrait impressions," is discussed on pp. 36–38.

11. The Master Impressionists

1. Childe Hassam, *Three Cities* (New York, 1899).

2. This extended to the titles of some of the articles published on Hassam: Israel L. White, "Childe Hassam—A Puritan," pp. 29–36; and Frederic Newlin Price, "Childe Hassam—Puritan," pp. 3–7.

3. One may regard these pictures as affirmations of the values of simple village life, but they also seem to have become for Hassam icons of tradition and faith.

4. Royal Cortissoz, *American Artists*, pp. 140–41.

5. J. Alden Weir and Colonel Wood discussed Hassam and his decorations for Wood; correspondence is excerpted in Young, *J. Alden Weir*, pp. 222–23.

6. Priscilla C. Colt, "Childe Hassam in Oregon," n.p.; this was published in relation to an exhibition of Hassam's

Oregon work at the museum, for which there was a checklist but no catalog.

7. See William H. Gerdts, "Post-Impressionist Landscape Painting in America." However, the interaction during the decade 1900–10 between the work of the older men, Hassam and Weir, and the emerging landscape painting of artists such as Garber, Krafft, and Mazzanovich is in need of exploration.

8. Young, *J. Alden Weir*, p. 255.

9. The earliest of Hassam's Window series dates from 1910, although there are some precursors; one is his *June Morning* of c. 1904, in which the figure stands before a mirror, with an open window to the left contrasting indoors and outdoors on a ground level with a garden view.

10. Richard Watson Gilder, for instance, is quoted as stating that he believed that Hassam's *Bowl of Nasturtiums*, one of the Window series, would become one of the artist's most famous pictures; see *A Catalogue of an Exhibition of the Works of Childe Hassam*, p. 26.

11. He was not only active in its first four exhibitions but energetic in its formation and sustenance, and his own work was particularly well received in the exhibition of 1902. Twachtman also was very active in other exhibitions during these years. In 1900 he and his son, J. Alden Twachtman, had several two-artist shows: one at the St. Botolph Club in Boston, where the father showed only oils, and another at the Cincinnati Art Museum, where he exhibited only two oils and a sizeable selection of pastels.

12. For a historical survey of art in Gloucester see *Portrait of a Place. Some American Landscape Painters in Gloucester*.

13. Although Segantini was little known in America before the end of the century, the always perceptive Clarence Cook presented in his magazine an essay by Esme Stuart, "Segantini, an Italian Artist," *Studio* 5 (June 7, 1890): 265–67. A number of periodicals featured Segantini's work in 1897 and 1898, and his paintings were seen for the first time at the second Carnegie International Exhibition in Pittsburgh in 1897. That Weir would have seen this work seems extremely likely, for he won a medal there for his *Reflections in a Mirror*. Segantini had considerable influence on American artists as diverse as William Singer, N. C. Wyeth, and Marsden Hartley, for the most part after his death in 1899. Early articles on Segantini appeared in the American editions of English art periodicals or were written by Italians: Alfredo Melani, "Giuseppe [sic] Segantini," *Scribner's Magazine* 21 (February 1897): 212–19; Burnley Bibb, "The Work of G. Segantini," *International Studio* 2 (September 1897): 144–49, 151–53, 155–56; W. Fred, "Giovanni Segantini and His Work," *Artist* 23 (November 1898): 121–31. The earliest article I have located on Segantini by an American author is, characteristically, by that most cosmopolitan of our art writers, Christian Brinton, "Giovanni Segantini," *Critic* 41 (December 1902): 490–509.

14. An article on the appeal of such urban scenes appeared just a few years before Weir undertook his own exploration of the subject; see "The Picturesqueness of New York Scenes: Illustrated in the Paintings of Birge Harrison," *Craftsman*, January 1908, pp. 397–99.

15. Elizabeth de Veer's *Willard Leroy Metcalf, A Retrospective* is the most recent study of the artist's life and work; Ms. de Veer is presently completing a full-length study of the artist. Earlier writers on Metcalf include Christian Brinton, Royal Cortissoz, Catherine Beach Ely, and Bernard Teevan. In Metcalf's scrapbook of newspaper notices about his art, the first page deals with the paintings made in Maine in 1903, and on the flyleaf he wrote: "A partial history of the Renaissance." See the introduction by Theodore Bolton in *Memorial Exhibition of Paintings by the Late Willard L. Metcalf* (New York: Century Association, 1928).

16. *New York Herald*, February 4, 1905, p. 10.

17. Elizabeth de Veer to the author, April 25 and July 29, 1983. Ms. de Veer has been most generous in sharing information from her forthcoming book.

18. Royal Cortissoz, "Willard Leroy Metcalf," in *Commemorative Tributes of the American Academy of Arts and Letters, 1905–1941* (New York, 1942), p. 181; Cortissoz's *Tribute* was originally published in 1927. Cortissoz wrote glowingly of Metcalf's work as early as his article, "Willard L. Metcalf: An American Landscape Painter," pp. 509–11.

19. Christian Brinton, "Willard L. Metcalf," p. 155.

20. Cortissoz, *Commemorative Tributes*, p. 511.

21. Bernard Teevan, "A Painter's Renaissance," p. 10. Catherine Beach Ely, "Willard L. Metcalf," pp. 332, 335.

12. Regional Schools

1. Homer Saint-Gaudens immediately produced an article, "Edmund Tarbell," pp. 136–37, reproducing *A Girl Crocheting* and stating that the painter had reached his highest level with this work. Frederick Coburn also reproduced the picture later that year in "Edmund C. Tarbell, Painter," *World Today* 11 (October 1906): 1077–85, with the caption: "Considered one of the most important pictures of the American Art Season of 1905." In 1909 Kenyon Cox, reviewing Tarbell's career, wrote: "Then, almost suddenly, came the *Girl Crocheting*, which, in its quiet perfection, seemed to eclipse his previous works, as it did those of others, making them look like mere paint while it alone looked like nature." "Recent Works by Edmund C. Tarbell," p. 259.

2. See the dissertation and several published articles by Bernice Kramer Leader, cited in the bibliography.

3. For the history of the Vermeer rediscovery see Stanley Meltzoff, "The Rediscovery of Vermeer," *Marsyas* 2 (1942): 145–66.

4. Hale claimed in 1913 "that to other painters Vermeer seems very great, perhaps the greatest painter *per se* who has lived." Hale, *Jan Vermeer of Delft*, p. 4. Hale acknowledged here the importance and quality of the work of Velázquez but judged that Velázquez did not have Vermeer's sense of values or color relations. Hale also allied Vermeer with modern tendencies by describing his *pointilliste* touch, see pp. 6, 13. This phenomenon is studied by Leader, "The Boston School and Vermeer."

5. The Academy also purchased a landscape by another Boston Impressionist, Theodore Wendel, from the 1909 annual. See "Philadelphia," *American Art News* 7 (February 20, 1909): 2.

6. The Roosevelt portrait is discussed at length in Michael Quick et al., *American Portraiture in the Grand Manner, 1720–1920* (Los Angeles: Los Angeles County Museum of Art, 1981), pp. 72, 204–5.

7. For articles about Paxton by his fellow Boston artist, Philip Hale, and by Frederick Coburn and Gardner Teall see the bibliography. Paxton's pupil, R. H. Ives Gammell, kept alive the traditions of the Boston School in general and the veneration of Paxton's art and aesthetic principles in particular; Gammell wrote the essay for the Paxton memorial show at the Museum of Fine Arts, Boston, in 1941, and for both the major exhibition catalog and the book published by the Indianapolis Museum of Art in 1978.

8. Bernice Kramer Leader, "Antifeminism in the Paintings of the Boston School," pp. 112–19.

9. The many lesser Boston Impressionists, such as Hamilton and Churchill, seem to have elicited relatively little attention in their own time and have garnered equally little to date, though this seems to be changing. For Hamilton see the auction catalog of *Paintings by E. W. D. Hamilton* (Boston: Leonard and Co., March 1–3, 1900), with extracts from articles that appeared in the *Springfield Republican* and the *Boston Herald*.

10. *Catalogue of Paintings by Edward W. D. Hamilton* (Boston: Gallery of J. Eastman Chase, 1892).

11. *Art Amateur* 40 (May 1899): 114.

12. "The Ten Landscape Painters," *Art Interchange* 46 (May 1901): 106; the picture was recalled in the same magazine in 48 (May 1902): 111.

13. Some of these pictures were oils, but Benson increasingly used watercolor; he also became an extremely active printmaker. More illustrative than his earlier works, these pictures tend to be abstract and Orientalized in design; Impressionism is seen primarily in their clarity of light. Probably more has been written about Benson's sporting prints than about his paintings, beginning with William Howe Downes, "Mr. Benson's Etchings," pp. 309–16. Benson was the first American to be included in the *Modern Masters of Etching* series, a book published in London in 1925 with an introduction by Malcolm C. Salaman. The first catalog volume of an eventual five-volume compilation of his prints appeared by 1917.

14. A signal honor came to Tarbell in 1919 when he was chosen by the National Committee as one of the portraitists to create a pictorial record of Allied leaders of World War II. Tarbell's likeness of Marshall Foch, painted in 1920, reveals the coloristic heritage of Impressionism.

15. Arlo Bates, writing in the *Memorial Exhibition of the Works of Frederic Porter Vinton*, p. 14, noted that "during his stay in Europe in 1889–90, he came in contact with Impressionism . . . he embraced the new gospel of sunlight and open air. . . ." See also L. E. Rowe, "Boudin, Vinton and Sargent," pp. 1–5.

16. *Arthur Clifton Goodwin, A Selective Exhibition* was held at the Addison Gallery of American Art, Phillips Academy, Andover, Massachusetts, in 1946. The catalog has a brief introduction by Bartlett H. Hayes, Jr., and an essay by Lionello Venturi. Venturi's essay was reproduced almost intact in *An Exhibition of Oils and Pastels*, a catalog for an exhibition held at the end of that year at Wildenstein in New York, with an additional essay by L. Denis Peterkin and with different examples included and illustrated. More recent is Sandra Emerson, Lucretia H. Giese, and Laura C. Luckey, *A. C. Goodwin, 1864–1929*.

17. See the artist's foreword to the *Catalogue of Works by Mr. L. H. Meakin* (Saint Louis: Saint Louis Museum of Fine Arts, 1899). A group of Meakin's forewords were reprinted in *Lewis Henry Meakin 1850–1917* (Cincinnati: Cincinnati Art Museum Association: 1918). See also Maude I. G. Oliver, "A Painter of the Middle West, L. H. Meakin," pp. 3–12.

18. See chap. 6, n. 39. The primary source for Connecticut Impressionism is the superb catalog of an exhibition presented jointly by the William Benton Museum of Art in Storrs, the Hurlbutt Library in Greenwich, and the Lyme Historical Society in Old Lyme, *Connecticut and American Impressionism* (1980), with a general essay by Harold Spencer, Susan G. Larkin on "The Cos Cob Clapboard School," and Jeffrey W. Andersen on "The Art Colony at Old Lyme."

19. See *Charles H. Ebert 1873–1959* (New London, Conn.: 1979).

20. The primary study here is Arthur Heming, *Miss Florence and the Artists of Old Lyme*. In addition to Jeffrey Andersen's essay, cited above, see the exhibition catalogs: *The Art Colony at Old Lyme 1900–1935* and *Memories of Old Lyme Art Colony 1900–1935*. See also "Some Painters from Lyme," p. 6; Lillian Baynes Griffin, "With the Old Lyme Art Colony"; "Lyme—A Country Life Community," pp. 47–50, 82, 94; "A New Gallery and a Summer Exhibition at Old Lyme," pp. 18–20; "Griswold House at Lyme," pp. 20–21; Grace L. Slocum, "Old Lyme," pp. 635–42.

21. For the earlier aesthetic manifestations at Old Lyme see Grace L. Slocum, "An American Barbizon: Old Lyme and Its Artist Colony," pp. 563–71; and more recently, Jeffrey Andersen's excellent essay in *Old Lyme: The American Barbizon* (Lyme Historical Society: Old Lyme, Conn., 1982).

22. Discussed by a writer for the *Grand Rapids Press*; quoted in J. Gray Sweeney, *The Artists of Grand Rapids 1840–1980*, p. 16.

23. See *A Memorial Exhibition of Paintings by Frank Vincent DuMond, N. A. Sponsored by the Art Students League of N.Y.* DuMond's teaching has been emphasized to the detriment of his artistry. See also Herbert E. Abrams, "The Teaching of Frank Vincent DuMond: Penetrating Light," pp. 36–45, 65–67, and DuMond's own description of "The Lyme Summer School and Its Theory of Art," pp. 7–18.

24. Davis's early tonal works were much commented upon and admired in the press in the late 1880s and the 1890s, but he became the subject of in-depth studies after he turned to the more colorful palette of Impressionism. See "Landscape Paintings by Charles H. Davis at Pratt Institute, Brooklyn," pp. lxxxi–lxxxii; William Howe Downes, "Charles H. Davis's Landscapes," pp. 423–37; "Charles H. Davis—Landscapist," *International Studio* 75 (June 1922): 177–83; Louis Bliss Gillet, "Charles H. Davis," pp. 105–12. More recently, there is Thomas L. Colville, *Charles Harold Davis N. A. 1856–1933*.

25. Downes, "Davis's Landscapes," pp. 429–30.

26. "Landscape Paintings by Charles H. Davis at Pratt Institute, Brooklyn," p. lxxxii.

27. Charles H. Davis, "A Study of Clouds," pp. 261–62.

28. Much of the writing concerning Carlsen's art has centered on his involvement with still-life painting. For his more Impressionist landscape work, see the articles by Eliot Clark, Duncan Phillips, Frederic Newlin Price, and John Steele reprinted in *The Art of Emil Carlsen, 1853–1932*. See also Gertrude Sill, "Emil Carlsen: Lyrical Impressionist," pp. 88–95.

29. For the history of the Cragsmoor colony see particularly the first two of an ongoing series of annual exhibitions sponsored by the Cragsmoor Free Library, under the direction of Maureen Radl and Kaycee Benton, *An Exhibition of Paintings by Cragsmoor Artists 1870's to 1830's* (1976), and *The Cragsmoor Artist's Vision of Nature* (1977).

30. See the recent exhibition catalog by Lewis Hoyer Rabbage, *Helen M. Turner, NA (1858–1958): A Retrospective Exhibition*.

31. "Interpreters of Nature . . . I. Cullen Yates II. Willard L. Metcalf III. Edward W. Redfield IV. Edward Dufner," p. 41.

32. *The Paintings of Hugh H. Breckenridge (1870–1937)* is the principal study of the artist and his work. See also Gerald L. Carr, "Hugh Henry Breckenridge: A Philadelphia Modernist," pp. 92–99, 119–22. For a contemporary discussion of his early work see Arthur Hoeber, "Hugh H. Breckenridge," pp. 24–26.

33. "The Breckenridge Pictures at the Albright Art Gallery," *Academy Notes* 3 (February 1908): 150.

34. Charles V. Wheeler was the principal writer on Redfield in the artist's lifetime; see also the articles on him by B. O. Flower and John Nilsen Laurvik. More recently Thomas Folk has been investigating the work of almost all the Pennsylvania School Impressionists, starting with Redfield, and will soon be the curator of a major exhibition of the school as a whole. See Thomas Folk, *Edward Redfield (1869–1965)*.

35. See Guy Pène du Bois, "The Pennsylvania Group of Landscape Painters," pp. 351–54; du Bois followed this with a contrasting article, "The Boston Group of Painters: An Essay on Nationalism in Art," in the October *Arts and Decoration*, pp. 457–60. For another interesting article in *Arts and Decoration* on the Pennsylvania School as a whole see Harvey M. Watts, "Nature Invites and Art Responds: The Haunts of the Painters of the Delaware Valley School," pp. 152–55, 196, 198.

36. Charles V. Wheeler, *Redfield*, n.p.

37. Thomas Folk, *Walter Elmer Schofield: Bold Impressionist*. See the bibliography for articles by C. Lewis Hind and Arthur Hoeber.

38. See the article on Symons by Thomas Shrewsbury Parkhurst. More recent is the important book by Ruth Lilly Westphal, *Plein Air Painters of California: The Southland*, pp. 164–69.

39. C. Lewis Hind, "An American Landscape Painter: W. Elmer Schofield," p. 282.

40. Thomas Folk, *Robert Spencer: Impressionist of Working Class Life*. See the article cited by F. Newlin Price.

41. See the fine catalog by Kathleen A. Foster, *Daniel Garber 1880–1958*; see also the articles by the artist's contemporaries Gardner Teall, Bayard Breck, and Henry Pitz.

42. While a great deal has been written about N. C. Wyeth, most of these accounts have dealt with his role as an illustrator. See James H. Duff, *Not for Publication: Landscapes, Still Lifes, and Portraits by N. C. Wyeth*; Impressionist-related works are discussed on pp. 20–24.

43. I am most grateful to Sona Johnston, associate curator of painting and sculpture at the Baltimore Museum of Art, for her help and interest in regard to Baltimore artists and Impressionism.

44. In Washington, D.C., Linda C. Simmons, associate curator of prints and drawings, Corcoran Gallery of Art, and Andrew Cosentino, who organized the exhibition of Washington artists for the National Museum of American Art, have been most helpful in regard to local painters.

45. Rick Stewart, one of the organizers of the *Painting in the South* exhibition presently touring the country, was most helpful in regard to southern Impressionists. Richard S. Reid, director of Belmont, The Gari Melchers Memorial Gallery in Fredericksburg, Virginia, offered much advice in regard to Melchers. There is extensive published material on Melchers, but most of it has concentrated on his earlier work and much of it was written before he moved to Virginia. See Henriette Lewis-Hind, *Gari Melchers: Painter* (New York, 1928). For the Virginia career of Melchers see Richard S. Reid, "Gari Melchers: An American Artist in Virginia," pp. 154–73.

46. See Love, *Walter Clark and Eliot Clark*; *Eliot Clark, N. A.: Retrospective Exhibition*; and *Eliot Clark: American Impressionist, 1883–1980*.

47. One might also cite the work of Alexander Drysdale, working in New Orleans, whose misty atmospheric evocations are at least tangential to Impressionism.

48. Cynthia Grant Tucker, *Kate Freeman Clark: A Painter Rediscovered.*

49. Cecilia Steinfeldt, *The Onderdonks: A Family of Texas Painters.* Julian Onderdonk is treated on pp. 89–168.

50. Arthur F. Jones, *The Art of Paul Sawyier* (Lexington, 1975); Arthur F. Jones and Bruce Weber, *The Kentucky Painter from the Frontier Era to the Great War.*

51. The best study of Cincinnati art of this period is *The Golden Age: Cincinnati Painters of the Nineteenth Century Represented in the Cincinnati Art Museum.*

52. Ibid., pp. 97–98.

53. "In Studio and Gallery," unidentified Cincinnati newspaper clipping, Archives of American Art, roll no. N738, frame 249.

54. Ibid.

55. For Potthast see Arlene Jacobowitz, "Edward Henry Potthast," pp. 113–28.

56. Sorolla began to investigate this subject matter about 1904; the work received tremendous acclaim and was seen in London, Hamburg, and Paris between 1906 and 1908, culminating in his great show of 356 works at the New York Hispanic Society in 1909. Sorolla's emphasis on such beach scenes would, at least, have confirmed Potthast's commitment to the subject, but it may actually have been responsible for it.

57. These late works were first featured in the exhibition at the Chapellier Gallery, and many are illustrated in color in the catalog *Frank Duveneck* (New York, 1972). See also Josephine W. Duveneck, *Frank Duveneck: Painter-Teacher* (San Francisco, 1970), pp. 160–62.

58. Bacher's activities as a printmaker have almost totally overshadowed his role as an easel painter. See William W. Andrew, *Otto H. Bacher.* Bacher and De Camp taught one of the earliest outdoor painting classes at Richfield during the summer of 1883.

59. Robinson saw Bacher's *Nude Outdoors* in November 1893 in New York, according to his diaries. The picture was painted by Bacher in East Hampton, Long Island.

60. Otto H. Bacher, *With Whistler in Venice* (New York, 1908).

61. See *Arthur Watson Sparks: American Impressionist* (Greensburg, Penn.: Westmoreland County Museum of Art, 1963).

62. Modernism in the Midwest, and particularly in Chicago, is a major theme of John D. Kysela, S. J., "The Critical and Literary Background for a Study of the Development of Taste for 'Modern Art' in America, from 1880 to 1900," especially chap. 3. See also Leslie S. Goldstein, "Art in Chicago and the World's Columbian Exposition of 1893."

63. See Esther Sparks, "List of Art Societies," in "A Biographical Dictionary of Painters and Sculptors in Illinois 1808–1945," pp. 691–706; also, Lucy B. Monroe, "Art in Chicago," *New England Magazine* 6 (June 1892): 418–19.

64. *Chicago Tribune*, March 27, 1892, p. 40.

65. John H. Vanderpoel, *The Human Figure* (Chicago, 1907). Despite his significance in the art development of turn-of-the-century Chicago, there is very little published about the artist; see Thomas Wood Stevens, "John H. Vanderpoel and His Work," *Inland Printer* 47 (August 1911): 589–93, and *A Memorial Collection of Works by John H. Vanderpoel* (Chicago: Art Institute of Chicago, 1912).

66. See John H. Vanderpoel, "Delavan and Its Environments," *Delavan Enterprise*, August 10, 1899. For Shulz see Marian A. White, "A Landscape Painter of the Middle West," pp. 332–33, and *A Retrospective Exhibition of Paintings and Drawings by Adolph Robert Shulz.* On the origins of the Brown County School see Shulz, "Story of the Brown County Art Colony," and Graf, "Brown County Art Colony"; Harry L. Engle, "'Hoosier Salon' Recalls Old Days to Club Members," *Palette and Chisel* 1 (March 1925): 1–2; and Psi Iota Xi Sorority, *Brown County Art and Artists.*

67. For Krafft and the Society of Ozark Painters see Lena McCauley, "A Painter Poet of the Ozarks," pp. 465–72, and V. E. Carr, "Carl R. Krafft," pp. 474–80.

68. Rudolph F. Ingerle, "A Painters' Paradise and Its Lure," *Palette and Chisel* 8 (May 1931): 1–2.

69. Garland, *Crumbling Idols*, especially pp. 103 and 109. In addition to artists who had contact with Thaulow in Paris and the general impact of his art on Americans working at home, Thaulow's painting was shown here often, particularly in the 1890s.

70. For Wendt see Nancy Dustin Wall Moure, *William Wendt 1865–1946.* Moure discusses Wendt's activities in Chicago on pp. 9–11; the rest of her essay, and almost all other writing on Wendt, is concerned only with his California years. This is true also for Alson Clark; see two articles in *California Southland*: Elizabeth Whiting, "Painting in the Far West: Alson Clark, Artist," pp. 8–9, and "Alson Skinner Clark, Artist," 9 (March 1927): 28–29. See also Westphal, *Plein Air Painters of California*, pp. 52–57, for Clark, and pp. 170–75 for Wendt. For Clark see also the 1983 full-length study by Jean Stern, *Alson S. Clark.*

71. For Palmer see Sparks, "Painters and Sculptors in Illinois," pp. 543–44, and Judith A. Barter and Lynn E. Springer, *Currents of Expansion: Painting in the Midwest, 1820–1940*, p. 129. Not surprisingly, artists from the Midwest, Chicago and Saint Louis particularly, seemed especially drawn to study with their Midwestern compatriot, Miller, when in France.

72. See Rena Neumann Coen, *Painting and Sculpture in Minnesota 1820–1914.* For Volk and the Minneapolis School of Art, see pp. 106–8.

73. Ibid., p. 119, for Dawes; pp. 112–14 for Fournier in Minnesota; pp. 110–12 for Grinager. See also "Alexander Grinager: An Appreciation," *International Studio* 52 (May 1914): 24–25.

74. Ives generated great understanding for contemporary art during his many years in Saint Louis; indeed, his impact was nationwide, for he headed the Fine Arts Committee of the World's Columbian Exposition in Chicago and performed a similar task in 1904 for Saint Louis's own Louisiana Purchase Exposition. Under the guidance of Ives and Charles Kurtz, the director for annual art exhibitions of the Saint Louis Exposition and Music Hall Association from 1894 to 1899, modern art was shown in that city in more varied forms than almost anywhere else in the country during that crucial decade. In 1895, for instance, the first exhibition of the Glasgow School appeared at the Saint Louis Exposition, and the following year works by the Munich "Secession" were shown. Nor were the Impressionists ignored, for works by Monet and his colleagues were exhibited in 1890, beside paintings by Childe Hassam. Annual shows of work by the Hoosier School at the Saint Louis Museum of Fine Arts followed the founding of the Society of Western Artists in 1896.

75. The art movement in Saint Louis in the late nineteenth and early twentieth centuries has not been studied yet, though there are signs that local interest is beginning. There was a strong Hegelian philosophic movement in Saint Louis, and the interaction of this with Bryant and the idealistic aesthetic needs investigation, as does the reaction of local artists to the innovative, cosmopolitan exhibitions brought in by Ives and Kurtz.

76. *A Collection of the Works of Mr. Dawson-Watson*, quoted from the *Exhibition of Selected Paintings by Western Artists* (Saint Louis: City Art Museum, 1906).

77. See two articles from the *St. Louis Post Dispatch* on Nudercher, December 14, 1948, and September 16, 1956.

78. Adams, *Childe Hassam*, p. 76.

79. See Robert L. Shalkop, *A Show of Color: 100 Years of Painting in the Pike's Peak Region* (Colorado Springs: Colorado Springs Fine Arts Center, 1971).

80. James L. Haseltine, *100 Years of Utah Painting.*

81. The literature on the Taos and Santa Fe schools is enormous, but none of the many writers has dealt directly with the impact of Impressionism on the painters of the region. Most, however, have accurately acknowledged its effect, particularly on Oscar Berninghaus and Ernest Blumenschein.

82. Laura M. Bickerstaff, *Pioneer Artists of Taos*, p. 30, noted that Blumenschein was a staunch defender of both Impressionism and Post-Impressionism early in the century. Ms. Bickerstaff quotes Blumenschein as stating that the two major influences in his art were the works he saw in the Louvre and the art of the Paris Impressionists.

83. Patricia Janis Broder, *Taos: A Painter's Dream*, p. 125.

84. See Walt Wiggins, *Alfred Morang: A Neglected Master.*

85. The primary study is *Impressionism: The California View.* See also Sonia Bryan, "Impressionism in California: The Impact of French Nineteenth Century Art," in Joseph Armstrong Baird, Jr., ed., *Theodore Wores and the Beginnings of Internationalism in Northern California Painting: 1874–1915.* For Southern California see Westphal, *Plein Air Painters*; *Southern California, 1890–1940*; Nancy Dustin Wall Moure, *Los Angeles Painters of the Nineteen-Twenties*; and Moure, *Painting and Sculpture in Los Angeles, 1900–1945.*

86. J. A. Stanton, "Impressions of the Art Display," *Overland Monthly* 23 (April 1894): 404.

87. The Stanford University Museum of Art presented a Joseph Raphael exhibition in 1980, but no catalog was published; Anita Ventura Mozley's label information on the show is extremely enlightening. See also *The Creative Frontier: A Joint Exhibition of Five California Jewish Artists 1850–1928* (Berkeley: Judah L. Magnes Museum, 1975).

88. Fortune's work awaits study and publication. See Helen Spangenberg, *Yesterday's Artists on the Monterey Peninsula*, and *Monterey: The Artist's View, 1925–1945.*

89. For Gile see *Paintings by Selden Connor Gile 1877–1947: An Exhibition of Paintings in Oil and Water Color from the Collection of James L. Coran and Walter A. Nelson-Rees*, and vol. 2, *A Feast for the Eyes: The Paintings of Selden Connor Gile.* For the Society see Terry St. John, *Society of Six.*

90. The literature on Wores is extensive. In addition to Baird, ed., *Theodore Wores*, see Lewis Ferbrache, *Theodore Wores: Artist in Search of the Picturesque*; Gary A. Reynolds, "A San Francisco Painter, Theodore Wores," pp. 101–17; *Theodore Wores: The Japanese Years*; and Michael Preble, *Theodore Wores 1859–1939.*

91. See the several catalogs of art in Los Angeles and Southern California cited in note 85. For earlier considerations see Henry W. Splitter, "Art in Los Angeles before 1900," *Historical Society of Southern California Quarterly* 41 (March 1959): 38–57; (June): 117–38; (September): 247–56.

92. For Brown see Edna Gearhart, "Benjamin Brown of Pasadena," pp. 314–16; Rose V. S. Berry, "A Patriarch of Pasadena," pp. 123–27; and Gearhart, "The Brothers Brown—California Painters and Etchers," pp. 283–89. For the artist's own historical survey see Benjamin Chambers Brown, "The Beginnings of Art in Los Angeles," *California Southland*, pp. 7–8. Brown's landscapes were used several times to illustrate the attractions of the state for painters; see Mabel Urmy Seares, "California as a Sketching Ground. Illustrated by the Paintings of Benjamin Chambers Brown," pp. 121–32; and William Howe Downes, "California for the Landscape Painter. Illustrated by Paintings by Benjamin C. Brown," pp. 491–502.

93. *Los Angeles Times*, April 8, 1917, sec. 3, p. 4, quoted by Nancy Dustin Wall Moure in "Impressionism, Post-Impressionism and the Eucalyptus School in Southern California," in Westphal, *Plein Air Painters*, p. 7. There was a great deal of recognition in California of the achievements of her Impressionists; see Everett Carroll Maxwell, "Development of Landscape Painting in California," pp. 138–42; and especially in the periodical articles written by Mabel Urmy Seares. See her "Modern Art and Southern California," pp. 58–64; "A California School of Painters," pp. 10–11; and "California as Presented by Her Artists," pp. 7–13.

94. For Wendt see especially Nancy Dustin Wall Moure, *William Wendt 1865–1946.* For earlier discussion see the articles by Charles Francis Browne, Mabel Urmy Seares, and the 1926 Stendahl Art Galleries catalog.

95. For Guy Rose see Rose V. S. Berry, "A Painter of California," pp. 332–34, 336–37, and the two exhibition catalogs of the Stendahl Art Galleries with extensive essays and reproductions of the artist's work: *Guy Rose: Paintings of France and America* and *Guy Rose: Memorial Exhibition.*

96. *Donna Norine Schuster (1883–1953)* (California: Downey Museum of Art, 1977).

97. Cahill is one of the least studied of the California Impressionists; see *Impressionism: The California View*, pp. 84–85. He was a commercial artist in San Francisco from 1920 to 1922; he died in Chicago in 1934.

98. On Miller in Southern California see Mabel Urmy Seares, "Richard Miller in a California Garden," pp. 10–11.

99. The basic study of Braun and his art is Martin E. Petersen, "Maurice Braun: Master Painter of the California Landscape," pp. 20–40. Petersen's footnotes are extensive; his full bibliography on Braun was not published but is available from the author at the Fine Arts Gallery of San Diego. San Diego had a far less active art scene than either Los Angeles or San Francisco, but also working in San Diego were Charles Reiffel—who, with Alexis Fournier, had also been a leading luminary in the Buffalo art scene—and the able Cincinnati landscapist Charles Fries.

100. See the artist's own discussion in Maurice Braun,

"Theosophy and the Artist," pp. 7–17. See also the theosophical writings of Madame Helena Blavatsky, *The Secret Doctrine* (Los Angeles, 1952), and Annie Besant, *Thought Power* (Los Angeles, 1918), discussed and quoted by Sherrye Cohn in "The Image and the Imagination of Space in the Art of Arthur Dove; Part 1: Dove's 'Force Lines, Growth Lines' as Emblems of Energy," *Arts Magazine* 58 (December 1983): 93. For the artistic concerns of the Theosophist community at Point Loma, or Lomaland, as it became known, see Bruce Kamerling, "Theosophy and Symbolist Art: The Point Loma Art School," *Journal of San Diego History* 26 (Fall 1980): 231–55.

13. Giverny: The Second Generation

1. For the transitional group of Americans in Giverny in the 1890s, see Sellin, *Americans in Brittany*, pp. 76–77; Will H. Low, *A Chronicle of Friendships*, pp. 446ff; and Sara Dodge Kimbrough, *Drawn from Life*, pp. 60–71.

2. Kimbrough, *Drawn from Life*, pp. 66–71.

3. Frieseke was discussed in his own time by E. A. Taylor, Albert Gallatin, William Walton, and E. V. Lucas, and more recently by Allen S. Weller; he was the subject of articles in both French and Italian publications by Tristan Leclere in 1906, Pier Occhini in 1911, and Vittorio Pica in 1913, testifying to the international nature of his reputation (see bibliography). The fullest monograph on the artist is the catalog essay for the 1982 Frieseke exhibition at the Maxwell Galleries in San Francisco.

4. See the very important interview with Frieseke recorded by Clara T. MacChesney, "Frieseke Tells Some of the Secrets of His Art," p. 7. MacChesney had published some of this material earlier in "Frederick Carl Frieseke—His Work and Suggestions for Painting from Nature," pp. 13–15.

5. Ibid.

6. Ibid.

7. Ibid.

8. *Art Digest* 6 (March 15, 1932): 12.

9. The recognition and appreciation of Frieseke's late work is a recent phenomenon; see *A Retrospective Exhibition of the Work of F. C. Frieseke*, pp. 28–36.

10. MacChesney, "Frieseke Tells." Sellin, in *Americans in Brittany*, p. 79, notes that Frieseke's daughter reported to him that the artist did not disparage Matisse's work and that MacChesney simply invented that section of the interview; her words, however, sound very convincing and this recent report may simply be an attempt to align Frieseke with more avant-garde sympathies.

11. Tristan Leclere, "La Décoration d'un hôtel américain," pp. 195–200. In 1914 Frieseke stated that he disliked painting murals, because after the first sketch the work was all mechanical.

12. The principal published study on Miller is Robert Ball and Max Gottschalk, *Richard E. Miller, N. A.: An Impression and Appreciation*. In the artist's own time see Wallace Thompson, "Richard Miller—A Parisian-American Artist," pp. 709–14. Miller and Frieseke were frequently paired; see especially E. A. Taylor, "The American Colony of Artists in Paris (first article)," pp. 263–75.

13. As with Frieseke, this Italian exposure led to recognition in an article in an Italian art magazine by Vittorio Pica, "Artisti contemporanei: Richard Emile Miller," pp. 162–77.

14. That Miller was the art instructor for Miss Wheeler's pupils is confirmed in Mildred Giddings Burrage, "Arts and Artists at Giverny," p. 351. This article is an important source for material on the later American art colony in Giverny, including an excellent discussion of Miller.

15. See Taylor, "The American Colony," pp. 270ff.

16. Seares, "Miller in a California Garden."

17. Parker attracted a great deal of attention at the beginning of the second decade of the century. See James William Pattison, "Many Sorts of Realism," pp. 545–49; Henry Kitchell Webster, "Lawton Parker," p. 23; Rowland Sheldon, "Two American Artists Distinguished Abroad: Lawton Parker and C. Arnold Slade," pp. 240–51; and George Breed Zug, "The Art of Lawton Parker," pp. 37–43.

18. Webster, *Lawton Parker*, p. 23.

19. On Greacen see Elizabeth Greacen Knudsen, *Edmund W. Greacen, N.A., American Impressionist, 1876–1949*.

20. See Burrage, *Arts and Artists at Giverny*, pp. 349–51, for the Americans in Giverny around 1910.

21. For Karl Anderson see Robert R. Preato, "Karl Anderson: American Painter of Youth, Sunshine and Beauty," *Illuminator*, pp. 8–16. In Anderson's own time, see F. Newlin Price, "Karl Anderson, American," *International Studio*, pp. 132–39. Anderson's own reminiscences are recorded in Karl Anderson, "European Reminiscences," *Bellman*, pp. 202–4.

22. See *The Paintings of Louis Ritman (1889–1963)* for the fullest account of the artist and his work.

23. Evelyn Marie Stuart, "Annual Exhibition of Local Artists," *Fine Arts Journal* 32 (April 1915): 173–79.

24. C. H. Waterman, "Louis Ritman," p. 64.

25. Extensive reviews of the 1910 New York show of "The Giverny Group" were reprinted in *Paintings by Lawton Parker*. The differentiation of Rose's work from that of his colleagues was noted by the writer in the *New York Telegraph*, December 21, 1910.

26. *New York Telegraph*, December 21, 1910, n.p.

14. Impressionism and the New Generation

1. The basic study on Henri is William Innes Homer, *Robert Henri and His Circle*. Henri's early work—his Impressionist phase in particular—has received very little attention beyond Homer's book.

2. See ibid., p. 162; Henri is quoted on his teaching: "I only want to see the things that bring to my mind the fact of life and that point a certain interest in life. . . ." And in Robert Henri, *The Art Spirit* (Philadelphia and London, 1923), p. 201: "After all, the goal is not making art. It is living a life. Those who live their lives will leave the stuff that is really art. Art is a result."

3. For Lawson, see the book by Henry and Sidney Berry-Hill, *Ernest Lawson, American Impressionist, 1873–1939*. The fullest bibliography on Lawson is to be found in the exhibition catalog, Adeline Lee Karpiscak, *Ernest Lawson 1873–1939*. Lawson had first studied at the Kansas City Art League School in 1888 and later in Mexico City for a month in the night classes at the Academia de San Carlos. Writers on Lawson have differed on exactly when he began studying with Twachtman, both at the League and in Cos Cob. However, Weir's participation in the class affirms an 1892 date for Cos Cob.

4. Quoted in almost all the Lawson literature; see F. Newlin Price, "Lawson, of the 'Crushed Jewels,'" p. 367.

5. Robinson Diaries, August 25, 1894, and December 22, 1894.

6. Price, "Lawson," p. 369; Karpiscak, *Ernest Lawson*, p. 33.

7. Lawson's Spanish paintings were discussed particularly in "Ernest Lawson's Spanish Pictures," pp. 225–27, and Ameen Rihani, "Landscape Painting in America. Ernest Lawson," pp. 94–97.

8. "Artists of the Philadelphia Press," *Philadelphia Museum Bulletin* 41 (November 1945): 6–15, with essays by John Sloan and Everett Shinn. The primary general works on Glackens are Vincent John De Gregorio, "The Life and Art of William J. Glackens"; Ira Glackens, *William Glackens and the Ashcan Group: The Emergence of Realism in American Art*; and Leslie Katz, *William Glackens in Retrospect*.

9. Regina Armstrong, "Representative Young Illustrators," p. 109.

10. Albert E. Gallatin, "The Art of William J. Glackens: A Note," p. 68.

11. See Barnes's own study, Albert C. Barnes, *The Art in Painting* (New York, 1925). In the 2d ed., 1928, p. 361, Barnes states, "Of the American impressionists, Prendergast, Glackens and Lawson are the most important"; he discusses Glackens on pp. 362–63, recognizing the relationship to Renoir.

12. Forbes Watson, "William Glackens," pp. 252–53.

13. The primary studies of Prendergast are Hedley Howell Rhys, *Maurice Prendergast, 1859–1924*, and Eleanor Green, *Maurice Prendergast*. The chronology in Green is the best published survey to date of the artist's life.

14. See the comments of Dora M. Morell in *Brush and Pencil* 3 (December 1898): 178, and "Art Notes," *Art Interchange* 40 (April 1898): 88.

15. See Patterson Sims, *Maurice B. Prendergast*, pp. 24–25, and Shelly Dinhofer, "Cézanne's Conception of Still-Life Painting and Its Influence on the Still-Life Painting of Maurice Prendergast" (term paper prepared at the Graduate School of the City University of New York).

16. Walter Pach in *Freeman* 2 (March 9, 1921): 617. Pach not only discussed Prendergast's work often in that

periodical, but contributed the section "Maurice B. Prendergast" to the compendium of essays for *American Art Portfolios* (New York, 1936).

17. There is no modern study of Beal, and a number of the early essays on his work feature the dark, dramatic pictures he painted before his work became more Impressionistic. See Helen Comstock, "Gifford Beal's Versatility," pp. 236–42.

18. Jonas Lie's art inspired a good many studies; among the most complete are F. Newlin Price, "Jonas Lie, Painter of Light," pp. 102–7; and Rose V. S. Berry, "Jonas Lie: The Man and His Art," pp. 59–66. For Reuterdahl see *The Art of Henry Reuterdahl*.

19. For the comparison of Lie and Thaulow see "Jonas Lie of Norway and America: A Painter Who Has Found the Secret of Suggesting on Canvas Nature's Manifold Moods," *Craftsman* 13 (November 1907): 137.

20. Waern, "Some Notes on French Impressionism," pp. 540–41; James W. Lane, "Vincent in America: Allen Tucker," *Art News* 38 (December 16, 1939): 13, 17, 18.

21. Allen Tucker, *John H. Twachtman*. Walter Pach, particularly, recalled Tucker's reverence for his teacher: ". . . the name of John H. Twachtman remains in Mr. Tucker's memory not only as that of a painter to be ranked with the very best that his country has produced, but as a man who gave inspiration and ideas to his pupils." See Walter Pach, "Allen Tucker," *Shadowland*, p. 78.

22. The standard work on Hartley is Barbara Haskell, *Marsden Hartley*.

23. The magazine was *Jugend*, January 1903, devoted entirely to Segantini with reproductions in both black and white and color; see Haskell, *Marsden Hartley*, p. 13. Samuel Kootz quoted Hartley: "Segantini, Swiss impressionistic realist, through a reproduction in *Jugend*, showed me how to begin painting my own Maine mountains, at Center Lovell and North Lovell, Maine. Therefore, Segantini was my first direct influence. . . ." *Modern American Painters* (New York, 1930): p. 40.

24. [Sadakichi Hartmann], "Unphotographic Paint: —The Texture of Impressionism," *Camera Work*, no. 28 (October 1909), pp. 20–23.

25. See the chapter "Our Impressionists" in Marsden Hartley, *Adventures in the Arts*, pp. 74–79.

26. F. Hopkinson Smith, *Between the Extremes*.

27. Ibid., p. 18.

28. "Impressionism and Realism in Art," *Art Interchange* 50 (March 1903): 58. Francis Hopkinson Smith, *At Close Range*, pp. 167–92. See also Theodore Hornberger, "Painters and Painting in the Writings of F. Hopkinson Smith," *American Literature* 16 (1944–45): 1–10. Smith's most inventive denunciation was published in 1905 in his short story "Old Sunshine." The title refers to an elderly artist in the "Studio Building," who had discovered a palette that would make viewers use tinted glasses to observe his masterwork: "He's crazy over a color scheme; gone daft on purples and yellows." Old Sunshine's masterwork "was a landscape showing the sun setting behind a mountain, the sky reflected in a lake; in the foreground was a stretch of meadow. The sky was yellow and the mountain purple; the meadow reddish brown. In the centre of the canvas was a white spot the size of a pill box. This was the sun, and the centre of the color scheme. Radiating from this pat of white were thousands of little pats of chrome yellow and vermillion, divided by smaller pats of blue. The exact gradations of these tones were to produce the vibrations of light." A young artist, whom Old Sunshine had befriended, is finally allowed to view the mysterious picture: "For a moment he did not and could not speak. The thousands of little patches of paint radiating from the centre spot were but so many blurs on a flat canvas. The failure was pathetic, but it was complete." *At Close Range*, p. 183.

29. Steele, *House of the Singing Winds*, pp. 43–44, 196–97.

30. Hardesty G. Maratta, "Impressionism as Interpreted through the Works of Manet," pp. 169–71; Martha C. Thurber, "Impressionism in Art," *Arts for America*, pp. 181–84; W. L. Everett Knowles, "Art and Its Mission," p. 73.

31. Henry G. Stephens, "Impressionism: The Nineteenth Century's Distinctive Contribution to Art," pp. 279–97.

32. W. P. Lockington, "The Limited Range of the Luminist," pp. 120–21.

33. Arthur Hoeber, "Plain Talks on Art—Impressionism," pp. 5–7.

34. Arthur Hoeber, "Mary Cassatt," pp. 740–41.

35. Harrison was already settled in Woodstock when John Carlson persuaded the Art Students League to move there because of the mounting costs and the hostility to the students in Old Lyme. Harrison accepted the invitation to run the summer school, which opened in Woodstock in June 1906. See Karal Ann Marling, *Woodstock: An American Art Colony 1902–1977* (Poughkeepsie, N.Y.: Vassar College Art Gallery, 1977). Also Birge Harrison, "The Woodstock School of Landscape Painting," *Art and Progress* 1 (September 1910): 316–22, and Harrison, "Painting at Woodstock," *Arts and Decoration* 2 (May 1912): 245–48.

36. Birge Harrison, *Landscape Painting*, and Harrison, "The True Impressionism in Art," pp.491–95.

37. Harrison, "The True Impressionism," 495.

38. Harrison, *Landscape Painting*, pp. 232–33.

39. Harrison, *Landscape Painting*, p. 270.

40. Ralcy Husted Bell, *Art-Talks with Ranger*, p. 92.

41. Ibid., p. 93.

42. Robert Henri, *Art Spirit*, p. 51.

43. Bell, *Art-Talks*, p. 96.

44. Albert E. Gallatin, *Whistler: Notes and Footnotes*, p. 93; this appeared also as "Childe Hassam: A Note," p. 103; Bayard Boyesen, "The National Note in American Art," *Putnam's Monthly and The Reader* 4 (May 1908): 134–35.

45. Eliot Clark, "Theodore Robinson," p. 293; Clark, "Theodore Robinson: A Pioneer American Impressionist," p. 768; Duncan Phillips, "Twachtman—An Appreciation," p. 106; Phillips, "J. Alden Weir," pp. 192–94.

46. F. Newlin Price, "Redfield, Painter of Days," p. 410; J. Nilsen Laurvik, "Edward W. Redfield—Landscape Painter," p. 29; Guy Pène du Bois, "The Pennsylvania Group of Landscape Painters," p. 353.

47. Guy Pène du Bois, "The Boston Group of Painters," p. 458, and Anna Seaton-Schmidt, "Frank W. Benson," pp. 365–66.

48. Royal Cortissoz Collection, Beinecke Rare Book and Manuscript Library, Yale University, New Haven, Conn.

49. Louis Weinberg, "Current Impressionism," pp. 124–25.

15. Triumph and Closure

1. J. Nilsen Laurvik, "Evolution of American Painting," p. 772.

2. Christian Brinton, *Impressions of the Art at the Panama-Pacific Exposition.*

3. Ibid., pp. 15–16.

4. Philip L. Hale, "Painting and Etching," p. 357.

5. See *Exhibition of a Series of Paintings of the Avenue of the Allies by Childe Hassam* and *Childe Hassam: An Exhibition of His "Flag Series" Commemorating the Fiftieth Anniversary of Armistice Day.*

6. William A. Coffin, "The Flag Pictures of Childe Hassam, N.A.," in *Exhibition of a Series of Paintings of the Avenue of the Allies by Childe Hassam*, n.p.

7. "Painting America: Childe Hassam's Way," pp. 272–74. Hassam enjoyed East Hampton tremendously, and a sense of hominess is revealed in the simple charms of these unpretentious dwellings.

8. See Judith Wolfe, "Childe Hassam in East Hampton—A Note," in *Childe Hassam 1859–1935*, pp. 13–18, and *"Montauk" by Childe Hassam*, introduction by Duncan Phillips.

9. Brinton, *Impressions*, p. 17.

10. Laurvik, "Evolution of American Painting," p. 786.

11. Ibid.

12. Brinton, *Impressions*, p. 17.

16. Impressionist Themes

1. The full name of the show was the "American Exhibition of Foreign Products, Arts & Manufactures." The Boston Public Library holds the 467-page volume by Charles Benjamin Norton, *Newspaper Clippings, etc., collected by Charles Benjamin Norton, Secretary of the Foreign Exhibition Association* (Boston, 1884).

2. "One may object to the glaring flesh-tints of the 'Boatman's Breakfast,' the impossible red on the cheeks of the 'Fisherman's Children,' or the purple hair of the girl in 'The Opera Box'; but all the same, there is a freshness and a piquancy and a certain charm about the pictures that the surrounding canvases do not have." And the writer went on at length about the "indescribable mastery" of the *Boatman's Breakfast* ("Exhibition Art," *Boston Daily Globe*, September 16, 1883, p. 10). "Renoir is a painter who seems at times to have ideas, and at others to be a hopeless lunatic . . . yet occasionally, and as it were in spite of all the laws of art, he comes very near to attaining the quality of tone, incredible as such a feat may appear when one studies his palette" ("The Fine Arts," *Boston Morning Journal*, September 8, 1883, supplement, p. 1). The *Traveller* quoted the local artist Horace Burdick, that this was the "school of the future" and that Renoir's *Opera Box*, *Boatman's Breakfast at Bougival*, and *Fisherman's Children* "have a freshness and light and a vitality that makes work of the old school look dull," and that the *Boatman's Breakfast* was "intrinsic with life, with motion, with light and color." ("Fine Arts," *Daily Evening Traveller* [Boston] August 30, 1883, p. 4).

3. Michael Leja, "Monet's Modernity in New York in 1886," *American Art* 14 (spring 2000): 50–79. The work Leja focuses upon is Celen Sabbrin [Helen Abbott Michael], *Science and Philosophy in Art* (Philadelphia: William F. Fell, 1886).

4. "The Fine Arts: the French Impressionists," *Critic* 5 (April 17, 1886): 195–96.

5. "The Impressionists," *Art Age* 3 (April 1886): 165–66.

6. "The Impressionists, No. III," *Mail and Express*, April 24, 1886, p. 5.

7. Though I wish to avoid the specific, I have just read an article by a distinguished art historian pointing out that the artist about whom he was writing must have considered a specific work as especially important because he sent it to three successive major exhibitions in one year. In actually, he sent it to the second and third show precisely *because* it had not sold previously!

8. "Euphemism and optimism distinguishes the work of the American artists from those of their French mentors and counterparts." H. Barbara Weinberg, Doreen Bolger, and David Park Curry, *American Impressionism and Realism: The Painting of Modern Life, 1885–1915* (New York: Metropolitan Museum of Art, 1994), p. 8. This extensive survey is the most significant to address thematic and contextual issues in the work of the American Impressionists, but its search for specific "Americanisms," amplified through aligning the sometimes opposing aesthetics of the Impressionists and the Realists, mars the interpretation of the very satisfying achievement of the show that this publication accompanied. Here, see Trevor Fairbrother, "American Impressionism and Realism: The Painting of Modern Life, 1885–1915," *Archives of American Art Journal* 33, no. 4 (1993): 15–21.

9. William H. Gerdts, *Impressionist New York* (New York: Abbeville Press, 1994), chaps. 4, 7, and 9.

10. Chase's Brooklyn and New York park scenes have recently been definitively explored in Barbara Dayer Galati, *William Merritt Chase: Modern American Landscapes, 1886–1890* (New York: Brooklyn Museum of Art, 1999). See also Weinberg, Bolger, and Curry, *American Impressionism*, pp. 138–52.

11. The early work of the two painters was in fact linked in their own time. See "Art Notes," *Daily Evening Transcript* [Boston], January 27, 1886, p. 6 [courtesy of Merl M. Moore Jr.]. Lungren's New York pictures have been ignored in recent literature on the artist.

12. Ilene Susan Fort, *Childe Hassam's New York* (San Francisco: Pomegranate Artbooks, 1993); William H. Gerdts, "Three Themes: The City," in Warren Adelson, Jay E. Cantor, and William H. Gerdts, *Childe Hassam, Impressionist* (New York: Abbeville Press, 1999), pp. 122–70.

13. Colin Campbell Cooper, "Skyscrapers and How to Build Them in Paint," *Palette and Bench* 1, (January–February 1909): 90–92, 106–8. Though he was much celebrated in his own time, contemporary writing on Cooper is very limited. See *An Exhibition of Paintings by Colin Campbell Cooper* (Santa Barbara, Calif.: James M. Hansen, 1981); Tina Goolsby, "Colin Campbell Cooper," *Art and Antiques*, January/February 1983, pp. 56–63; Gerdts, *Impressionist New York*, passim.

14. The painting was reproduced in the one of the first articles to celebrate Cooper's turn to modern urban landscapes: Albert W. Barker, "A Painter of Modern Industrialism," [Appleton's] *Booklover's Magazine* 5 (March, 1905): 326. See also Cooper in "What Is the Most Beautiful Spot in New York?" *New York Times*, June 18, 1911, magazine sec., pt. 5, p. 4; "The Picture That First Helped Me to Success," *New York Times*, January 28, 1912, sec. 5, p. 5.

15. The best-known Chicago urban scene of the period is Alson Skinner Clark's dramatic *Coffee House* (before 1906; Art Institute of Chicago), but the painting was done before Clark's turn to the Impressionist aesthetic, and its modernity lies in its emphasis upon the gritty reality of the warehouse district and the State Street Bridge, not in celebrating architectural splendor. This was rather the province of Albert Fleury, the most eminent delineator of the city itself, but he achieved only limited fame and is totally forgotten today. See Maude I. G. Oliver, "A Chicago Painter: The Work of Albert F. Fleury," *International Studio* 22 (March 1904): 21–23. Likewise, within the tremendous activity of hundreds of Impressionist painters in Southern California, only one, Frank Coburn, specialized in urban scenes. See Bradley J. Delaney, *Frank Coburn (1862–1938): An Early Los Angeles Painter* (San Diego, Calif.: Orr's Gallery, 1991).

16. The classic identification here actually referenced Chicago's skyscrapers, likening these structures to mountains, and the spaces between to canyons or plateaus. See Henry Blake Fuller, *The Cliff Dwellers* (New York: Harper and Brothers, 1893).

17. Edwin A. Cochran, *The Cathedral of Commerce* (New York: Broadway Park Place Co., 1916).

18. The definitive study of this series is Ilene Susan Fort, *The Flag Paintings of Childe Hassam* (Los Angeles: Los Angeles County Museum of Art, 1988). See also Gerdts, *Impressionist New York*, pp. 53–57; Gerdts, *Childe Hassam, Impressionist*, pp. 214–23.

19. Fort, *The Flag Paintings*, cites and reproduces wartime flag pictures by Gifford Beal, Theresa Bernstein, Theodore Butler, Hayley Lever, George Luks, and William Meyerowitz. Other artists who undertook this theme include Jane Peterson, Boston's Arthur Clifton Goodwin, and Saint Louis's Frank Nuderscher (plate 329).

20. The major study here is Lisa N. Peters, *Visions of Home: American Impressionist Images of Suburban Leisure and Country Comfort* (Carlisle, Pa.: Trout Gallery, Dickinson College, 1997).

21. Lisa N. Peters, "The Frontier within the Terrain of the Familiar: The Art of the Greenwich Years (1889–1900)," in her *John Henry Twachtman: An American Impressionist* (Atlanta: High Museum of Art, 1999). See also Kathleen A. Pyne, "John Twachtman and the Therapeutic Landscape," in Deborah Chotner, Lisa N. Peters, and Kathleen A. Pyne, *John Twachtman: Connecticut Landscapes* (Washington, D.C.: National Gallery of Art, 1989).

22. Nicolai Cikovsky Jr. et al., *A Connecticut Place: Weir Farm An American Painter's Rural Retreat* (Wilton, Conn.: Weir Farm Trust, 2000).

23. These issues are discussed in William H. Truettner and Thomas Andrew Denenberg, "The Discreet Charm of the Colonial," in ed. William H. Truettner and Roger Stein *Picturing Old New England: Image and Memory* (Washington, D.C.: Smithsonian Institution, National Museum of American Art, 1999), pp. 78–109.

24. Gerdts, "For God and Country," in *Childe Hassam, Impressionist*, esp. pp. 204–13. For Hassam's treatment of churches, and more especially *The Church at Gloucester* (1918; Metropolitan Museum of Art, New York), see Weinberg, Bolger, and Curry, *American Impressionism*, pp. 131–33.

25. See pp. 143–49 in the present volume.

26. William Forsyth, *Art in Indiana* (Indianapolis: H.

Lieber Co., 1916), p. 16. Forsyth's publication offers a strong endorsement of nationalistic artistic goals.

27. The literature on California Impressionism has grown exponentially in the last decade. The most extensive treatment is William H. Gerdts and Will South, *California Impressionism* (New York: Abbeville Press, 1998). See also Patricia Trenton and William H. Gerdts, *California Light, 1900–1930* (Laguna Beach, Calif.: Laguna Art Museum, 1990); Susan Landauer et al, *California Impressionists* (Atlanta: Atlanta Committee for the Olympic Games, 1996); Jean Stern et al., *Impressions of California: Early Currents in Art, 1850–1930* (Irvine, Calif.: Irvine Museum, 1996); William H. Gerdts et al., *All Things Bright and Beautiful: California Impressionist Paintings from the Irvine Museum* (Irvine, Calif., Irvine Museum, 1998).

28. For the latest study of this art colony, see Jack Becker and William Gerdts, *The California Impressionists at Laguna* (Old Lyme, Conn.: Florence Griswold Museum, 2000).

29. At the turn of the century, just at the time painters were beginning to investigate this theme, it also began to receive attention in California literature. A classic study, with illustrations by Margaret Warriner Buck, is: Mary Elizabeth Parsons, *The Wild Flowers of California* (San Francisco: Cunningham, Curtis & Welch, 1897). See also Bertha F. Herrick, "California Wild Flowers," *Californian* 3 (December 1892): 3–15; Charles F. Lummis, "The Carpet of God's Country," *Out West* 22 (May 1905): 306–17. A later article, "California in Bloom," appeared in the *California Magazine of Pacific Business* 27 (March 1937): 18–19.

30. Grace Hortense Tower, "California's State Flower," *Overland Monthly* 39 (May 1902): 882–89.

31. Wendt exhibited a *Poppy Field, California* at the Art Institute of Chicago in 1897, lent by Dr. A. J. Ochsner.

32. For Wores and the history of American renditions of the blossoming tree motif, see William H. Gerdts, "Theodore Wores—Flowers and Blossoms," in *Theodore Wores: Works from the California and Japan Years*, ed. Gerdts and Susan Hillings (Santa Clara, Calif.: Triton Museum of Art, 2000), pp. 7–12. Interestingly, blossoming fruit trees figure in a biography of Mary Day Brown, John Brown's widow, who had earlier settled in Saratoga, where Wores was later to summer and paint. See M. H. F., "A Brave Life," *Overland Monthly* 6 (February 1885): 360–67.

33. *Call and Post* [San Francisco], March 25, 1926, Artist's Scrapbook, Wores Archives, Stanford University, Gift of Drs. Ben and A. Jess Shenson.

34. This phenomenon was the subject of two essays in Trenton and Gerdts, *California Light*: Michael P. McManus, "A Focus on Light," pp. 13–18; and Joachim Smith, "The Splendid, Silent Sun: Reflections on the Light and Color of Southern California," pp. 61–90. Smith here refers to the "sheer excess of light" in Southern California, p. 61.

35. Jean Stern et al, *Romance of the Bells the California Missions in Art* (Irvine, Calif.: Irvine Museum, 1995).

36. There is fairly extensive literature on California gardens, but for their pictorial representation, see Nancy Moure, "California Garden Scenes," *Art of California* 4 (September 1991): 52–57.

37. For the study of American garden imagery, see William H. Gerdts, *Down Garden Paths: The Floral Environment in American Art* (Montclair, N.J.: Montclair Art Museum, 1983).

38. The definitive study here is David Park Curry, *Childe Hassam: An Island Garden Revisited* (New York: Denver Art Museum, 1990).

39. For this approach to gardening, see Alice Morse Earle, *Old Time Gardens* (New York: Macmillan, 1901). The definitive study here is May Brawley Hill, *Grandmother's Garden: The Old-Fashioned American Garden, 1865–1915* (New York: Harry N. Abrams, 1995).

40. William H. Gerdts, *Monet's Giverny: An Impressionist Colony* (New York: Abbeville Press, 1993), pp. 82–84, 87–88, 132–37, 144–54, 171–75.

41. S. C. de Soissons, *Boston Artists: A Parisian Critic's Notes* (Boston: n.p., 1894), pp. 41–42.

42. Bailey Van Hook, *Angels of Art: Women and Art in American Society, 1876–1914* (University Park: Pennsylvania State University Press, 1996), pp. 109–10.

43. Ibid, pp. 147, 181–82.

44. See here Bram Dijkstra, "The High Cost of Parasols: Images of Women in Impressionist Art," in Trenton and Gerdts, *California Light*, pp. 33–52, in which the symbolic significance of the parasol as an emblem of woman's subordination is carried a bit far: "It proclaims the modesty of her wishes in the sun-drenched world of creative masculinity. It announces her desire to exist only as a satellite to the masculine will" (p. 42).

45. See here Annette Stott, "Floral Femininity A Pictorial Definition," *American Art* 6 (Spring 1992): 61–77.

46. The explicit nakedness of Otto Bacher's *Nude Outdoors* (plate 317), painted in this country in 1893, is therefore a remarkable exception for its time.

47. A good many of the leading American Impressionists were involved with mural painting before and after the turn of the century, but in most of this work they utilized more traditional, sometimes academic strategies to depict their chosen allegorical and historical subjects. The nude figures strongly in Hassam's murals painted for the Court of Palms at San Francisco's Panama-Pacific International Exposition held in 1915, where the most overt use of Impressionist light, color, and broken brushwork appears in Edward Simmons's panels for the Triumphal Arch, wherein the figure of *Truth and Beauty* was a full frontal nude. For color illustrations of these now-lost murals, see *California's Magazine*, 2 vols. (San Francisco: California's Magazine Company, 1916), vol. 2, plates 284, 285, 287.

48. Clara T. McChesney, "Frieseke Tells Some of the Secrets of His Art," *New York Sunday Times*, June 7, 1914, sec. 6, p. 7.

49. Surprisingly, given the wealth of written material on Cassatt, there is no study isolating er theater pictures. See Judith A. Barter, "Mary Cassatt: 'The Fashionable Spectacle," in her essay "Themes, Sources, and the Modern Woman" in *Mary Cassatt: Modern Woman* (Chicago: Art Institute of Chicago, 1998), pp. 44–55. One notes that, unlike the theater pictures of her mentor, Degas, Cassatt's pictures never delineate the theatrical or operatic performers but concentrate solely upon the viewers; there is no interaction between them and the entertainers.

50. This theme is discussed in Valerie Ann Leeds et al., *At the Water's Edge: Nineteenth- and Twentieth-Century American Beach Scenes* (Tampa, Fla.: Tampa Museum of Art, 1989). See also "At the Seaside: the New Country Retreat by the Shore," in Bolger, Weinberg, and Curry, *American Impressionism*, pp. 98–116. The Impressionist period coincided with vast discussion of recreational bathing in the periodical press. See, for instance, Duffield Osborne, "Surf and Surf-Bathing," *Scribner's Magazine* 8 (July 1890): 100–12; J. Howe Adams, "Bathing at the American Sea-Shore Resorts," *Cosmopolitan* 19 (May 1895): 316–28; Francis H. Hardy, "Seaside Life in America," *Cornhill Magazine* 74 (November 1896): 605–10; "Summer on the Sands," *Munsey's Magazine* 17 (August 1897): 651–56; Sylvester Baxter, "Seaside Pleasure-Grounds for Cities," *Scribner's Magazine* 23 (June 1898): 676–87; W. H. Page, "The People at Play," *World's Work* 4 (August 1902): 2373–77; Ralph D. Paine, "The Bathers of the City," *Outing* 46 (August 1905): 558–69.

51. D. Scott Atkinson and Nicolai Cikovsky Jr., *William Merritt Chase: Summers at Shinnecock, 1891–1902* (Washington, D.C.: National Gallery of Art, Smithsonian Institution, 1987); Ronald G. Pisano, *Summer Afternoons: Landscape Paintings of William Merritt Chase* (Boston: Little, Brown, 1993).

52. The latest study of Potthast is John Wilson, *Edward Henry Potthast: American Impressionist* (New York: Gerald Peters Gallery, 1998).

53. For Glackens's beach scenes painted at Bellport and Blue Point, Long Island, see Richard J. Wattenmaker, "William Glackens's Beach Scenes at Bellport," *Smithsonian Studies in American Art* 2 (spring 1988): 75–94; William H. Gerdts and H. Santis Jorge, *William*

Glackens (New York: Abbeville Press, 1996), pp. 111–13. See also Stephanie S. Bigelow, *Bellport and Brookhaven: A Saga of the Sibling Hamlets at Old Purchase South* (Bellport, N.Y.: Bellport-Brookhaven Historical Society, 1968). Glackens had previously painted beach scenes at Cape Cod in 1908, and at Wickford, Rhode Island, in 1909. In 1918 he painted in Pequot, near New London, Connecticut, and in 1919 at Gloucester, Massachusetts.

54. See Chadwick's *Griswold Beach, Old Lyme* (Florence Griswold Museum, Old Lyme). The Old Lyme Impressionists paid surprisingly little attention to their nearby coast, whether in landscape or in beach scenes.

55. There is considerable literature on Gloucester and its pictorial attraction, but the Impressionists concentrated primarily upon the town itself and its important shipbuilding and fishing industries. Beach scenes were more often painted by slightly later artists utilizing Post-Impressionist strategies, such as Maurice Prendergast along with William Meyerowitz and his wife, Theresa Bernstein, as well as other very able women artists, including Alice Schille, Martha Walter, and Jane Peterson. The subject was addressed by Rebecca Redell, *On the Beach* (Gloucester, Mass.: Cape Ann Historical Association, 1981).

56. See "North Haven Sunlight," in the recent study by Faith Andrews Bedford, *Frank W. Benson: American Impressionist* (New York: Rizzoli, 1994), pp. 97–119.

57. Given the coastal activity among the artists of the Laguna Beach art colony, there was surprisingly little attention given to bathing and bathers. Griffith, who moved to Laguna Beach in 1920 and was president of the local art association for a number of years during that decade, appears to have been the only specialist. Joseph Kleitsch and Clarence Hinkle also painted occasional bathing scenes there, beginning in the late 1920s, while in 1924 Alson Clark worked farther down at Mission Beach, between La Jolla and San Diego.

58. Most studies of images of labor in American art have concentrated on the decades following the ascendancy of the Impressionists, and those that deal with the earlier periods tend to ignore Impressionist imagery. See Abigail Booth Gerdts and Patricia Hills, *The Working American* (Washington, D.C.: Smithsonian Institution, 1979); and Patricia Hills, "The Fine Arts in America: Images of Labor from 1800 to 1950," in *Essays from the Lowell Conference on Industrial History 1982 and 1983: The Arts and Industrialism: The Industrial City*, ed. Robert Weible (North Andover, Mass.: Museum of American Textile History, 1985), pp. 120–64.

59. For the similarities between Robinson's and Pissarro's artistic concerns, see William Kloss's introduction to *The Figural Images of Theodore Robinson, American Impressionist* (Oshkosh, Wisc.: Paine Art Center and Arboretum, 1987), pp. 26–27.

60. For the American concern for peasant labor in Giverny, see Gerdts, *Monet's Giverny*, pp. 71–87. The basic study here is Julia Rowland Myers, "The American Expatriate Painters of the French Peasantry, 1863–1893" (Ph.D. diss., University of Maryland, 1989). Myers does discuss the American Impressionists in Grez (pp. 246–80) but not those in Giverny.

61. For contemporary reference and admiration for the Parisian flower vendors, see B. Archdekan-Cody, "The Parisian Working-Classes," *Catholic World* 46 (October 1887): 86.

62. For a different, unromanticized view of the cabdrivers of Paris, focusing upon their mistreatment of their animals and the great cab strike of 1889, held at the time of the Exposition Universelle, see Amy Beth Scott, "Academic Art and Animal Cruelty: The Legacy of John Douglas Patrick, 1863–1937" (M.A. thesis, University of Kansas, 1993). My thanks to Ms. Scott for sharing with me a wealth of newspaper clippings relating to Parisian cabdrivers.

63. This is the theme of the recent dissertation by Marian Eastwood Wardle, "Genteel Production: Art and Labor in the Images of Women Sewing by Tarbell and Weir" (Ph.D. diss, University of Maryland, 2000).

64. See "Bridget in the Service of the Boston School, 1892–1923," chap. 6 of Elizabeth L. O'Leary, *At Beck*

and Call: The Representation of Domestic Servants in Nine-teenth-Century American Painting (Washington, D.C.: Smithsonian Institution Press, 1996), pp. 210–61. Unexplained is the omission of domestic labor from the paintings of most other Impressionist figure artists in New York and elsewhere. The California Impressionists were much less involved with the themes of labor and industry than their Eastern counterparts, though Sam Hyde Harris sometimes stressed the unpicturesque industrialization of the Los Angeles area harbors, and in 1913 Alson Clark painted a series of rugged images of the building of the Panama Canal. Jean Stern, Alson S. Clark (Los Angeles: Petersen Publishing Company, 1983), pp. 25–27. The major exceptions here are the paintings of the salmon and sardine fishermen of Monterey, which was a recurring theme for Armin Hansen. See the essay by Charlotte Berney, "Steering a Course: The Art of Armin Carl Hansen," in Armin Hansen: The Jane and Justin Dart Collection (Monterey, Calif.: Monterey Peninsula Museum of Art, 1993).

65. See, for instance, Weinberg, Bolger, Curry, American Impressionism, p. 83, which claims that "to twentieth-century eyes this painting seems an endorsement of progress, but in reality this was not Weir's response." The authors suggest, without foundation, that "he must have been shocked by the clear functional construction of the bridge; its skeletal support system is in full view, with no outer shell and no ameliorating decorations." And they quote his daughter's report of her father's dismay that "he missed the old landmark and regretted the necessary march of progress until one day he suddenly saw in the ugly modern bridge a picture that I am sure no one but he had ever seen." Dorothy Weir Young, Life and Letters of J. Alden Weir (New Haven, Conn.: Yale University Press, 1960), p. 187. But this is exactly the point here.

66. The basic study here remains unpublished: Margaret Ellen Fein, "J. Alden Weir: Paintings of the Willamantic Linen Company, 1893–1897," seminar paper, Graduate School and University Center, City University of New York, 1990.

67. On May 10, 1895, Robinson was working on his Oxen Ploughing, based on a snapshot of a local farmer, Elliott Morse. Theodore Robinson Diaries, Frick Art Reference Library, New York.

68. Warren Adelson, "Childe Hassam: Cosmopolitan and Patriot," in Adelson, Cantor, Gerdts, Childe Hassam, p. 41.

69. Adeline Adams, Childe Hassam (New York: American Academy of Arts and Letters, 1938), p. 121.

Afterword

1. My thanks to Pamela Ivinski, of the Mary Cassatt Catalogue Raisonné committee, for information on these and other of Cassatt's patrons.

2. As an example, Sullivan owned nine works by Childe Hassam, far more than by any other Impressionist, but he also had eleven examples by the Tonalist J. Francis Murphy. See Catalogue of the Modern Paintings Principally by American Artists, Collected by the Late H. Wood Sullivan, Brooklyn (New York: American Art Association, 1903).

3. For Charles V. Wheeler see his Sketches (Washington, D.C.: privately printed, 1927). For a more detailed discussion of the early history of collecting American Impressionist painting, see my essay "Collectors of American Impressionism," in William H. Gerdts, Masterworks of American Impressionism from the Pfeil Collection (Alexandria, Va.: Art Services International, 1992), pp. 31–38. This was drawn, in part, from a study on this subject by Teresa A. Carbone, prepared in a seminar on American Impressionism at the City University Graduate School in New York in 1985. This subject is also discussed in H. Barbara Weinberg, Doreen Bolger, and David Park Curry, American Impressionism and Realism: The Painting of Modern Life, 1885–1915 (New York: Metropolitan Museum of Art, 1994), pp. 22–24.

4. For the more recent exhibitions of the Fraad and Horowitz collections, see Linda Ayres and Jane Myers, American Paintings, Watercolors, and Drawings from the Collection of Rita and Daniel Fraad (Fort Worth, Tex.: Amon Carter Museum, 1985); Nicolai Cikovsky Jr. et al., American Impressionism and Realism: The Margaret and Raymond Horowitz Collection (Washington, D.C.: National Gallery of Art, 1999).

5. Nor is this misrepresentation limited to categorization of American Impressionism. Gabriel P. Weisberg's definitive study of the Naturalist movement is entitled Beyond Impressionism: The Naturalist Impulse (New York: Harry N. Abrams, 1992). Not only does Naturalism, the actual theme of this marvellous study, appear merely in the subtitle, following Impressionism, but the title suggests that Naturalism is a further development of, or out of, Impressionism, while actually the reverse is true in formal, aesthetic terms. Of the painters generally regarded as involved with the Impressionist movement, this book reproduces only seven works—a Manet, three Degases, and three by Gustave Caillebotte, these last arguably not Impressionist paintings.

6. Jean Stern, ed., Masterworks of California Impressionism: The FFCA, Morton H. Fleischer Collection (Phoenix, Ariz.: Franchise Finance Corporation of America, 1986). Three years later a selection from this collection was combined with that of Paul and Kathleen Bagley, and shown as American Impressionism: California School (Scottsdale, Ariz.: Fleischer Museum, 1989). For a regional selection, see Donald D. Keyes, American Impressionism in Georgia Collections (Athens, Ga.: Georgia Museum of Art, 1993).

7. Marie Louise Kane, American Impressionist Paintings (Saint Louis: Saint Louis Art Museum, 1984); Painters of Light and Color: American Impressionists from the Lyman Allyn Art Museum and Private Collections (New London, Conn.: Lyman Allyn Art Museum, 1989); Susan Danley, Light, Air, and Color: American Impressionist Paintings from the Collection of the Pennsylvania Academy of the Fine Arts (Philadelphia: Pennsylvania Academy of the Fine Arts, 1990); Dorothy Deeds, American Impressionism from the Sheldon Memorial Art Gallery (Lincoln, Nebr.: Sheldon Memorial Art Gallery, 1991); Emily Ballew Neff and George T. M. Shackelford, American Painters in the Age of Impressionism (Houston: Museum of Fine Arts, 1994); David R. Brigham, American Impressionism: Paintings of Promise (Worcester, Mass.: Worcester Art Museum; San Francisco: Pomegranate, 1997); Elizabeth Prelinger, American Impressionism: Treasures from the Smithsonian American Art Museum (New York: Watson-Guptill, 2000). Some of these shows were traveling exhibitions, and in some cases works from other sources were added to the core museum collections. See also Jean C. Harris, Steven Kern, and Bill Stern, Lasting Impressions: French and American Impressionism from New England Collections (Springfield, Mass.: Museum of Fine Arts, 1988).

8. William H. Gerdts, American Impressionism: Masterworks from Public and Private Collections in the United States (Lugano-Castagnola, Switzerland: Thyssen-Bornemisza Foundation, in association with Eidolon/Benziger, Einsiedeln, Switzerland, 1990). This publication also appeared in German and Italian.

9. Weinberg, Bolger, and Curry, American Impressionism and Realism.

10. William A. Coles, East Meets West: American Impressionism (Scottsdale, Ariz., Fleischer Museum, 1997); Deborah Epstein Solon and Will South, Colonies of American Impressionism: Cos Cob, Old Lyne, Shinnecock abd Laguna Beach (Laguna Beach, Calif.: Laguna Art Museum, 1999).

11. Robert R. Preato, Impressionism and Post-Impressionism: Transformations in the Modern American Mode, 1885–1945 (New York: Grand Central Art Galleries, 1988); William H. Gerdts et al., Ten American Painters (New York: Spanierman Gallery, 1990); Bruce Weber, The Giverny Luminists: Frieseke, Miller and Their Circle (New York: Berry-Hill Galleries, 1996).

12. For the Pennsylvania Impressionists, see Thomas Folk, The Pennsylvania School of Landscape Painting (Allentown, Pa.: Allentown Art Museum, 1984); Sam Hunter, American Impressionism: The New Hope Circle (Fort Lauderdale, Fla.: Fort Lauderdale Museum of Art, 1985); Landscape Painting of Bucks County (Doylestown, Pa.: James A. Michener Arts Center, 1988); Lauren Rabb, The Pennsylvania Impressionists: Painters of the New Hope School (Washington, D.C.: Taggart & Jorgensen Gallery, 1990); An American Tradition: The Pennsylvania Impressionists New York: Beacon Hill Fine Art, 1995); Thomas C. Folk, The Pennsylvania Impressionists (Cranbury, N.J.: Associated University Presses, 1997). For California Impressionism, see American Impressionism: California School; Patricia Trenton and William H. Gerdts, California Light, 1900–1930 (Laguna Beach, Calif.: Laguna Art Museum, 1990); Jean Stern, American Impressionism: A California Collage (Tulsa, Okla.: Thomas Gilcrease Institute of American History and Art, 1991); Janet Blake Dominik, Harvey L. Jones, and Jean Stern, Selections from the Irvine Museum (Irvine, Calif.: Irvine Museum, 1992); Jean Stern et al., Reflections of California: The Athalie Richardson Irvine Clarke Memorial Exhibition (Irvine, Calif.: Irvine Museum, 1994); Palette of Light: California Paintings from The Irvine Museum (Irvine, Calif.: Irvine Museum, 1995); Susan Landauer, Donald D. Keyes, and Jean Stern, California Impressionists (Atlanta: Atlanta Committee for the Olympic Games, 1996); William H. Gerdts et al., All Things Bright and Beautiful: California Impressionist Paintings from the Irvine Museum (Irvine, Calif.: Irvine Museum, 1998); Jack Becker and William H. Gerdts, The California Impressionists at Laguna (Old Lyme, Conn.: Florence Griswold Museum, 2000); Sarah Vure, Kevin Starr, and Nancy Dustin Wall Moure, Circles of Influence: Impressionism to Modernism in Southern California Art, 1910–1930 (Newport Beach, Calif.: Orange County Museum of Art, 2000). For other regional investigations, see A Century of Impressionism on Cape Cod (Dennis, Mass.: Cape Museum of Fine Arts, 1999); Susan G. Larkin, The Cos Cob Art Colony: Impressionism on the Connecticut Shore (New York: National Academy of Design; New Haven, Conn.: Yale University Press, 2001); James M. Keny and Nannette V. Maciejunes, Triumph of Color and Light: Ohio Impressionists and Post-Impressionists (Columbus, Ohio: Columbus Museum of Art in association with Keny Galleries, 1994); Martin Krause, The Passage: Return of Indiana Painters from Germany, 1880–1905 (Indianapolis, Ind.: Indianapolis Museum of Art; Cologne, Germany: Wallraf-Richartz-Museum, 1990); Linda Jones Gibbs, Harvesting the Light: The Paris Art Mission and Beginnings of Utah Impressionism (Salt Lake City: Church of Jesus Christ of Latter-day Saints, 1987); Donald D. Keyes, Impressionism and the South (Greenville, S.C.: Greenville Museum of Art, 1988).

13. Rena Neumann Coen, Minnesota Impressionists (Afton, Minn.: Afton Historical Society, 1996); William H. Gerdts and Judith Vale Newton, The Hoosier Group: Five American Painters. (Indianapolis: Eckert Publications, 1985).

14. The Fleischer Collection was published in Gerdts, Masterworks of California Impressionism. Mort and Donna Fleischer and the Fleischer Museum supported the publication of the major study of California Impressionism to date, William H. Gerdts and Will South, California Impressionism (New York: Abbeville Press, 1998).

15. In addition to the copious exhibition catalogs cited above, the Irvine Museum published Jean Stern et al. Impressions of California: Early Currents in Art, 1850–1930 (Irvine, Calif.: Irvine Museum, 1996), dealing with a broader range of California painting but concentrating upon the Impressionists. This was also true of the important study by Jean Stern, Gerald J. Miller, Pamela Hallan-Gibson, and Norman Neuerburg, Romance of the Bells: The California Missions in Art (Irvine, Calif.: Irvine Museum, 1995).

16. Ulrich W. Hiesinger, Impressionism in America: The Ten American Painters (Munich: Prestel, 1991); Lisa N. Peters, American Impressionist Masterpieces (New York: Hugh Lauter Levin, 1991).

17. On American artists in France and the Giverny and Grez colonies, all by William H. Gerdts, see Lasting Impressions: American Painters in France, 1865–1915

(Giverny, France: Musée Américain, 1992); *Monet's Giverny: An Impressionist Colony* (New York: Abbeville Press, 1993); "The American Artists in Grez," in Toru Arayashiki et al., *The Painters in Grez-sur-Loing* (Jamanashi, Fuchu, Otani, Nariwa, Sakura, Japan: Yomiuri Shimbun/Japan Association of Art Museums, 2000), pp. 267–77.

18. Norma Broude, ed., *World Impressionism: The International Movement, 1860–1920* (New York: Harry N. Abrams, 1990); Götz Czymmek, *Landschaft im Licht: Impressionistische Malerei in Europa und Nordamerika* (Cologne: Wallraf-Richartz-Museum, 1990); Richard J. Boyle and Herwig Todts, *World Impressionism and Pleinairism* (Nagoya, Japan: Chunichi Shimbun/Matsuzakaya Art Museum, 1991). The present author wrote the essays on American Impressionism for the first two of these publications; Richard J. Boyle wrote the essay for the Japanese publication.

19. Nancy Mowll Mathews, ed., *Cassatt and Her Circle: Selected Letters* (New York: Abbeville Press, 1984); Mathews, *Mary Cassatt* (New York, Harry N. Abrams, 1987) Mathews, *Mary Cassatt: A Life* (New York: Villard Books, 1994); Mathews, *Cassatt: A Retrospective* (New York: Hugh Lauter Levin Associates, 1996); Judith A. Barter et al., *Mary Cassatt: Modern Woman* (Chicago: Art Institute of Chicago, 1998); Marc Rosen et al., *Mary Cassatt: Prints and Drawings from the Artist's Studio* (Princeton, N.J.: Princeton University Press, 2000). In addition, a great number of more cursory studies of Cassatt, primarily picture books, have been published in the last decade and a half.

20. Sargent's Impressionism has been addressed particularly in *Sargent at Broadway: The Impressionist Years* (New York: Coe Kerr Gallery, 1986). In a broader context, it is a major feature of: Warren Adelson et al., *Sargent Abroad: Figures and Landscapes* (New York: Abbeville Press, 1997). See also the extensive discussion of Sargent in the brilliant dissertation by Marc Alfred Simpson, "Reconstructing the Golden Age. American Artists in Broadway, Worcestershire, 1885 to 1889" (Yale University Press, 1993).

21. Two recent treatments of Chase's life and career are: Keith L. Bryant Jr., *William Merritt Chase: A Genteel Bohemian* (Columbia, Mo.: University of Missouri Press, 1991); Barbara Dayer Gallati, *William Merritt Chase* (New York: Harry N. Abrams, 1995). For studies concentrating on Chase's Impressionist work, see D. Scott Atkinson and Nicolai Cikovsky Jr., *William Merritt Chase: Summers at Shinnecock, 1891–1902* (Washington, D.C.: National Gallery of Art, 1987); Ronald G. Pisano, *Summer Afternoons: Landscape Paintings of William Merritt Chase* (Boston: Little, Brown, 1993); Barbara Gallati, *William Merritt Chase: Modern American Landscapes, 1886–1890* (New York: Brooklyn Museum of Art, 2000).

22. Ulrich W. Hiesinger, *Childe Hassam: American Impressionist* (New York: Prestel, 1994); Warren Adelson, Jay E. Cantor, and William H. Gerdts, *Childe Hassam, Impressionist* (New York: Abbeville Press, 1999); David Park Curry, *Childe Hassam: An Island Garden Revisited* (New York: Denver Art Museum, 1990); Ilene Susan Fort, *Childe Hassam's New York* (San Francisco: Pomegranate Artbooks, 1993); Fort, *The Flag Paintings of Childe Hassam* (Los Angeles, Los Angeles County Museum of Art, 1988).

23. Lisa N. Peters, *John Henry Twachtman: An American Impressionist* (Atlanta: High Museum of Art, 1999); Deborah Chotner, Lisa N. Peters, Kathleen A. Pyne, *John Twachtman: Connecticut Landscapes* (Washington, D.C.: National Gallery of Art, 1989); John Douglass Hale, Richard J. Boyle, and William H. Gerdts, *Twachtman in Gloucester: His Last Years, 1900–1902* (New York: Ira Spanierman Gallery, 1987); Lisa N. Peters et al., *In the Sunlight: The Floral and Figurative Art of J. H. Twachtman* (New York: Spanierman Gallery, 1989).

24. John Wilmerding, Sheila Dugan, and William H. Gerdts, *Frank W. Benson: The Impressionist Years* (New York: Spanierman Gallery, 1988); Faith Andrews Bedford, Susan C. Faxon, and Bruce W. Chambers, *Frank W. Benson: A Retrospective* (New York: Berry-Hill Galleries, 1989); Bedford, *Frank W. Benson: American Impressionist* (New York: Rizzoli, 1994); Bedford et al., *The Art of Frank W. Benson, American Impressionist* (Salem, Mass.: Peabody Essex Museum, 2000); Bedford, *The Sporting Art of Frank W. Benson* (Boston: David R. Godine, 2000).

25. Laurene Buckley, *Joseph DeCamp: Master Painter of the Boston School* (New York: Prestel, 1995).

26. Nancy Mowll Mathews, *Maurice Prendergast* (Munich: Prestel, 1990); Richard J. Wattenmaker, *Maurice Prendergast* (New York: Harry N. Abrams, 1994).

27. Will South, *Guy Rose: American Impressionist* (Oakland, Calif.: Oakland Museum; Irvine, Calif.: Irvine Museum, 1995), is the most significant study of a regional Impressionist to date. The most substantial publication on Wendt is John Alan Walker, *Documents on the Life and Art of William Wendt, 1865–1946: California's Painter Laureate of the Paysage Moralisé* (Big Pine, Calif.: John Alan Walker, 1992). But see also *In Praise of Nature: The Landscapes of William Wendt* (Long Beach, Calif.: University Art Museum, California State University, 1989).

28. Laurene Buckley, already the author of a major monograph on Joseph DeCamp, is currently writing a biography of DeCamp's close colleague Tarbell, while the Currier Gallery of Art, Manchester, New Hampshire, is preparing a major Tarbell exhibition and catalog.

29. Carol Clark, Nancy Mowll Mathews, and Gwendolyn Owens, *Maurice Brazil Prendergast; Charles Prendergast* (Williamstown, Mass.: Williams College Museum of Art; Munich: Prestel, 1990).

30. Robert L. Herbert, *Impressionism: Art, Leisure, and Parisian Society* (New Haven: Yale University Press, 1988).

31. William H. Gerdts, *Impressionist New York* (New York: Abbeville Press, 1994).

32. Lisa N. Peters, David Schuyler, and May Brawley Hill, *Visions of Home: American Impressionist Images of Suburban Leisure and Country Comfort* (Carlisle, Penn.: Trout Gallery, Dickinson College, 1997).

33. May Brawley Hill, *Grandmother's Garden: The Old-Fashioned American Garden, 1865–1915* (New York: Harry N. Abrams, 1995).

34. Julia Beth Rosenbaum, "Local Views, National Visions: Art, New England, and American Identity, 1890–1920" (Ph.D. diss., University of Pennsylvania, 1998); William H. Truettner and Thomas Andrew Denenberg, "The Discreet Charm of the Colonial," in *Picturing Old New England: Image and Memory*, ed. William H. Truettner and Roger B. Stein (Washington, D.C.: National Museum of American Art, Smithsonian Institution, 1999), pp. 79–110. See also Kathleen Pyne, *Art and the Higher Life: Painting and Evolutionary Thought in Late Nineteenth-Century America* (Austin: University of Texas Press, 1996), pp. 267–75. For the literary equivalent here, see Van Wyck Brooks, *New England: Indian Summer, 1865–1915* (New York: E. P. Dutton, 1940).

35. Bernice Kramer Leader, "The Boston Lady as Work of Art: Paintings by the Boston School at the Turn of the Century" (Ph.D. diss., Columbia University, 1980).

36. Pyne, *Art and the Higher Life*, chap. 5, "The Ideologies of American Impressionism," pp. 220–90.

37. Marian Eastwood Wardle, "Genteel Production: Art and Labor in the Images of Women Sewing by Tarbell and Weir" (Ph.D. diss., University of Maryland, 2000).

38. Bram Dijkstra, "The High Cost of Parasols: Images of Women in Impressionist Art," in Trenton and Gerdts, *California Light*, pp. 33–52.

39. Pyne, for instance, refers to Robinson's 1895 painting *[Making] Pumpkin Pies* (1895; private collection) as an "insipid subject," though she was unfamiliar with the picture; one wonders if the author would equally so relegate Velasquez's *bodegones* and Chardin's household interiors. Pyne, *Art and the Higher Life*, p. 251.

40. Kathryn J. Zerbe, "Mother and Child: A Psychobiographical Portrait of Mary Cassatt," *Psychoanalytic Review* 74 (spring 1987): 51. Zerbe states that her "study aims at psychoanalytic validity, not historical truth" (46).

41. Harriet Scott Chessman, "Mary Cassatt and the Maternal Body," in *American Iconology*, ed. David C. Miller (New Haven, Conn.: Yale University Press, 1993), p. 247.

42. Ibid., p. 250.

43. Ibid., p. 252.

Acknowledgments

I AM EXTREMELY GRATEFUL to Abbeville Press for offering me the chance to write a second study of this subject, which allows me many opportunities that had not been available in my *American Impressionism* published in 1981 by the Henry Art Gallery in Seattle. Beyond the obviously enlarged and enriched format, there is the chance to reconsider my own earlier analysis of the material and to expand and distill my previous considerations. Also important is the fact that the present volume is an independent study, complete unto itself, while the previous essay was related to a traveling exhibition: the works in that earlier book were those included in the show, while here I have been able to illustrate the most pertinent, historic, and beautiful examples, regardless of their availability for exhibition.

Finally, the present study has taken advantage of the expanding scholarship and the recent discoveries of hitherto unknown or unlocated works of art, of neglected American Impressionists, or even whole schools of artists. This particularly applies to the increasing awareness of regional developments in Impressionism during the first decades of this century. My previous study was the first to suggest the pervasiveness of the Impressionist aesthetic, and since its publication the areas that I discussed briefly—Impressionism in Connecticut, Indiana, and California—have been the subject of expanded study by devoted scholars in those regions, and their efforts are reflected here. It has also been possible for me to glean a great deal of new information about Impressionism throughout the Midwest, in isolated centers in the South, and in other regions. Thus, I hope to make a contribution to the current understanding of this aspect of American art and to stimulate future art historical research.

Such geographic catholicity is evident in the following expressions of gratitude to my colleagues, to other scholars, and to collectors, dealers, and other private individuals scattered across the country for their valuable responses to my search for information about Impressionism throughout America. While many have been extremely generous over the years with information and advice regarding the development of American Impressionism, the following were especially helpful in the preparation of this volume: Ann B. Abid, former librarian, Saint Louis Art Museum; Jeffrey W. Andersen, director, Lyme Historical Society, Old Lyme, Connecticut; Mrs. Martha Andrews, former coordinator, Inventory of American Painting, Smithsonian Institution, Washington, D.C.; Martha Blocker, librarian, Indianapolis Museum of Art; Jeffrey Brown; Theresa Cederholm, curator of fine arts, Boston Public Library; Dr. Rena A. Coen, Minneapolis; Dr. Andrew J. Cosentino, formerly Franklin and Marshall College, Lancaster, Pennsylvania; Elizabeth de Veer; James H. Dunn, director, Brandywine River Museum, Chadds Ford, Pennsylvania; Stephen Edidin, curator, the Dahesh Museum, New York; Stuart Feld; Thomas Folk; Sally Gross; May Hill; Daniel Hodgson; Sona Johnston, associate curator of painting and sculpture, Baltimore Museum of Art; Mason Klein; Richard H. Love; the late Edgar deN. Mayhew, former director, Lyman Allyn Museum, New London, Connecticut; Chad Mandeles; Nancy Moure, formerly assistant curator of American art, Los Angeles County Museum of Art; the late Ron Pisano; Michael Quick, former curator of American art, Los Angeles County Museum of Art; Richard S. Reid, former director, Belmont, The Gari Melchers Memorial Gallery, Fredericksburg, Virginia; Terry Saint John, former assistant curator, Oakland Museum; Linda C. Simmons, assistant curator of prints and drawings, Corcoran Gallery of Art, Washington, D.C.; Rick Stewart, director, Amon Carter Museum, Fort Worth, Texas; Catherine Stover, former archivist, Pennsylvania Academy of the Fine Arts; Jean-Marie and Claire Joyes Tougouat; Catherine Hoover Voorsanger; the late Robert C. Vose, Jr.; Bruce Weber; the late Dr. Francis Weitzenhoffer; Dr. James Yarnall, former coordinator, American Art Exhibition Catalogue Index, Smithsonian Institution, Washington, D.C.; Denny Young, former curator of painting, Cincinnati Art Museum. I would also like to thank Jeanne D'Andrea for her skillful editing and my associates at Abbeville Press—Mark Magowan, Nancy Grubb, Amelia Jones, Howard Morris, and Dana Cole—for their gratifying cooperation and sensitivity in producing this book. And finally, my everlasting gratitude goes to my wife, Abigail, for her assistance, her support, her advice, and her enthusiasm—yet again.

Bibliography

by William H. Gerdts, Chad Mandeles, & Carol Lowrey

GENERAL BOOKS

America and Impressionism, exhibition catalog. Dayton, Ohio: Dayton Art Institute, 1951.

American Impressionism and Related Works of Art from the Phillips Collection, Washington, D.C., exhibition catalog. Nashville, Tenn.: Fine Arts Center, Cheekwood, 1982.

American Impressionist Painting, exhibition catalog. Washington, D.C.: National Gallery of Art, 1973.

The American Impressionists, exhibition catalog. New York: Hirschl and Adler Galleries, 1968.

American Impressionists and Others, 1880–1900, exhibition catalog. Brooklyn: Brooklyn Museum, 1932.

American Painters on the French Scene, 1874–1914, exhibition catalog. New York: Beacon Hill Fine Art, 1996.

American Painters of the Impressionist Period Rediscovered, exhibition catalog. Waterville, Maine: Colby College, 1975.

The American Renaissance 1876–1917, exhibition catalog. Brooklyn: Brooklyn Museum, 1979.

An American Tradition: The Pennsylvania Impressionists, exhibition catalog. New York: Beacon Hill Fine Art, 1995.

Anderson, Margaret Steele. *The Study of Modern Painting*. New York: Century Co., 1914.

The Art Colony at Old Lyme 1900–1935, exhibition catalog. New London, Conn.: Lyman Allyn Museum, 1966.

Ayres, Linda, and Jane Myers. *American Paintings, Watercolors and Drawings from the Collection of Rita and Daniel Fraad*, exhibition catalog. Fort Worth, Tex.: Amon Carter Museum, 1985.

Bagley, Paul and Kathleen Bagley. *American Impressionism: California School*, exhibition catalog. Scottsdale, Ariz.: Fleischer Museum, 1989.

Barnes, Albert C. *The Art in Painting*. New York, 1925; 2d ed., 1928.

Barter, Judith A., and Lynn E Spring. *Currents of Expansion: Painting in the Midwest, 1820–1940*, exhibition catalog. St. Louis: Saint Louis Art Museum, 1977.

Bartolo, Christine. *The Ten: Works on Paper*, exhibition catalog. Williamstown, Mass.: Sterling and Francine Clark Art Institute, 1980.

Becker, Jack, and William H. Gerdts. *The California Impressionists at Laguna*, exhibition catalog. Old Lyme, Conn.: Florence Griswold Museum, 2000.

Bell, Ralcy Husted. *Art-Talks with Ranger*. New York: G. P. Putnam's Sons, 1914.

Benjamin, Samuel. *Art in America*. New York: Harper and Brothers, 1880.

Bickerstaff, Laura M. *Pioneer Artists of Taos*. Denver: Sage Books, 1955.

Bizardel, Yvon. *American Painters in Paris*. New York: Macmillan Co., 1960.

Blume, Peter F. "The Pennsylvania School of Landscape Painting." In *Inaugural Exhibition of Twentieth-Century American Art*, exhibition catalog. Doylestown, Pa.: James A. Michener Art Center, 1988.

Bolger, Doreen. "The Education of the American Artist." In *In This Academy*, exhibition catalog. Philadelphia: Pennsylvania Academy of the Fine Arts, 1976.

Boyle, Richard J. *American Impressionism*. Boston: New York Graphic Society, 1974.

Boyle, Richard J., and Herwig Todts. *World Impressionism and Pleinairism*, exhibition catalog. Nagoya, Japan: Chunichi Shimbun/Matsuzakaya Art Museum, 1991.

Brigham, David R. *American Impressionism*, exhibition catalog. Worcester, Mass.: Worcester Art Museum; San Francisco: Pomegranate, 1997.

Brinton, Christian. *Modern Artists*. New York: Baker and Taylor Co., 1908.

———. *Impressions of the Art at the Panama-Pacific Exposition, with a Chapter on the San Diego Exposition and an Introductory Essay on the Modern Spirit in Contemporary Painting*. New York: John Lane Co., 1916.

Broder, Patricia Janis. *Taos: A Painter's Dream*. Boston: Little, Brown, 1980.

Brooks, Van Wyck. *New England: Indian Summer, 1865–1915*. New York: E. P. Dutton, 1940.

Broude, Norma, ed. *World Impressionism: The International Movement, 1860–1920*. New York: Harry N. Abrams, 1990.

Brown County Art and Artists. Nashville, Ind.: Psi Iota Xi, 1971.

Brownell, William Crary. *French Art: Classic and Contemporary Painting and Sculpture*. New York: Charles Scribner's Sons, 1892.

Bryant, Lorinda Munson. *American Pictures and Their Painters*. New York: John Lane Co., 1917.

Burke, Doreen Bolger. *A Catalogue of Works by Artists Born between 1846 and 1864*. American Paintings in The Metropolitan Museum of Art, vol. 3. New York: The Metropolitan Museum of Art, 1980.

Burnet, Mary Quick. *Art and Artists of Indiana*. New York: Century Co., 1921.

Caffin, Charles H. *The Story of American Painting*. New York: Frederick A. Stokes Co., 1907.

———. *The Story of French Painting*. New York: Century Co., 1911.

———. *How to Study Pictures*. New York and London: D. Appleton-Century Co., 1941.

Calo, Carole Gold, et al. *Impressionism and Post-Impressionism: The Collector's Passion*, exhibition catalog. Portland, Maine: Portland Museum of Art, 1991.

Carr, Carolyn Kinder, and George Gurney. *Revisiting the White City: American Art at the 1893 World's Fair*, exhibition catalog. Washington, D.C.: National Museum of American Art and National Portrait Gallery, Smithsonian Institution, 1993.

Cartwright, Derrick R. *The City and the Country: American Perspectives, 1870–1920*, exhibition catalog. Chicago: Terra Foundation for the Arts, 1999.

A Century of Impressionism on Cape Cod, exhibition catalog. Dennis, Mass.: The Cape Museum of Fine Arts, 1999.

Champney, Elizabeth W. *Witch Winnie at Shinnecock*. New York, 1894.

Cheney, Sheldon. *An Art-Lover's Guide to the Exposition*. Berkeley: At the Sign of the Berkeley Oak, 1915.

———. *The Story of Modern Art*. New York: Viking Press, 1941.

Cikovsky, Nicolai, Jr., et al. *American Impressionism and Realism: The Margaret and Raymond Horowitz Collection*, exhibition catalog. Washington, D.C.: National Gallery of Art, 1999.

Clark, Carol. *American Impressionist and Realist Paintings and Drawings from the William Marshall Fuller Collection*, exhibition catalog. Fort Worth, Tex.: Amon Carter Museum of Western Art, 1978.

Coen, Rena Neumann. *Painting and Sculpture in Minnesota 1820–1914*. Minneapolis, 1976.

———. *Minnesota Impressionists*. Afton, Minn.: Afton Historical Society, 1996.

Coles, William A. *East Meets West: American Impressionism*, exhibition catalog. Scottsdale, Ariz.: Fleischer Museum, 1997.

Corn, Wanda M. *The Color of Mood, American Tonalism 1880–1910*, exhibition catalog. San Francisco: M. H. de Young Museum, 1972.

Cortissoz, Royal. *American Artists*. New York: Charles Scribner's Sons, 1923.

———. *Personalities in Art*. New York and London: Charles Scribner's Sons, 1925.

"A Critical Triumvirate" [Charles F. Browne, Hamlin Garland, Lorado Taft]. *Five Hoosier Painters*. Chicago: Central Art Association, 1894.

———. *Impressions on Impressionism*. Chicago: Central Art Association, 1894.

Czymmek, Gotz. *Landschaft im licht: Impressionistische malerei in Europa und Nordamerika*, exhibition catalog. Cologne: Wallraf-Richartz-Museum, 1990.

Damigella, Anna Maria. *L'Impressionismo fuori di Francia*. Milan: Fratelli Fabbri, 1967.

Danley, Susan. *Light, Air, and Color: American Impressionist Paintings from the Collection of the Pennsylvania Academy of the Fine Arts*. Philadelphia: Pennsylvania Academy of the Fine Arts, 1990.

Deeds, Daphne. *American Impressionism from the Sheldon Memorial Art Gallery*, exhibition catalog. Introduction by William H. Gerdts. Lincoln, Neb.: Sheldon Memorial Art Gallery, 1992.

Dewhurst, Wynford. *Impressionist Painting: Its Genesis and Development*. London: G. Newnes, 1904.

Dominik, Janet. *Early Artists in Laguna Beach: The Impressionists*, exhibition catalog. Laguna Beach, Calif.: Laguna Art Museum, 1986.

Downes, William Howe. "Boston Art and Artists." In *Essays on Art and Artists*, by F. Hopkinson Smith, Alfred Trumble, Frank Fowler, et al. Chicago: American Art League, 1896.

Eiland, William U., Donald Keyes, and Janice Simon, eds. *Crosscurrents in American Impressionism at the Turn of the Century*. Athens, Ga.: Georgia Museum of Art, University of Georgia, 1996.

Ely, Catherine Beach. *The Modern Tendency in American Painting*. New York: F. F. Sherman, 1925.

An Exhibition of Paintings by American Impressionists, exhibition catalog. Santa Fe: Santa Fe East, 1982.

Exhibition of Paintings by Ten American Painters, exhibition catalog. Philadelphia: Pennsylvania Academy of the Fine Arts, 1908.

Exhibition of a Series of Paintings of the Avenue of the Allies by Childe Hassam, exhibition catalog. New York: Durand-Ruel Galleries, 1918.

Fairbrother, Trevor J., et al. *The Bostonians: Painters of an Elegant Age, 1870–1930*, exhibition catalog. Boston: Museum of Fine Arts, 1986.

Faxon, Susan, Alice Downey, and Peter Bermingham. *A Stern and Lovely Scene: A Visual History of the Isles of Shoals*. Durham, N.H.: University of New Hampshire Art Galleries, 1978.

Fink, Lois Marie. *American Art at the Nineteenth-Century Paris Salons*. Washington, D.C.: National Museum of American Art, Smithsonian Institution, 1990.

Five American Women Impressionists, exhibition catalog. Santa Fe: Santa Fe East, 1982.

Folk, Thomas C. *The Pennsylvania School of Landscape Painting*. Allentown, Pa.: Allentown Art Museum, 1984.

———. *The Pennsylvania Impressionists*. Cranbury, N.J.: Associated University Presses, 1997.

Forsyth, William. *Art in Indiana*. Indianapolis: H. Lieber Co., 1916.

French and American Impressionism, exhibition catalog. South Hadley, Mass.: Mount Holyoke College, 1956.

French Impressionists Influence American Artists, exhibition catalog. Coral Gables, Fla.: University of Miami, Lowe Art Museum, 1971.

Gallatin, Albert E. *Certain Contemporaries: A Set of Notes in Art Criticism*. New York: John Lane Co., 1916.

———. *American Water-colourists*. New York: E. P. Dutton and Co., 1922.

Gammell, R. H. Ives. *Twilight of Painting: An Analysis of Recent Trends to Serve in a Period of Reconstruction*. New York: G. P. Putnam's Sons, 1946.

Garland, Hamlin. *Crumbling Idols: Twelve Essays on Art*. 1894. Revised edition, Cambridge, Mass.: Harvard University Press, Belknap Press, 1960.

———. "Art Conditions in Chicago." In *United Annual Exhibition of the Palette-Club and the Cosmopolitan Art-Club*, exhibition catalog. Chicago: Art Institute of Chicago, 1895.

———. *Roadside Meetings*. New York: Macmillan Press, 1930.

Gerdts, William H. *American Impressionism*, exhibition catalog. Seattle: University of Washington, Henry Art Gallery, 1980.

———. *Down Garden Paths*, exhibition catalog. Montclair, N.J.: Montclair Art Museum, 1983.

———. *The Hoosier Group: Five American Painters*, exhibition catalog. Indianapolis: Eckert Publications, 1985.

———. *Artistic Transitions: From the Academy to Impressionism*, exhibition catalog. Jacksonville, Fla.: Cummer Gallery of Art, 1986.

———. *American Impressionism: Masterworks from Public and Private Collections in the United States*, exhibition catalog. Lugano-Castagnola: Thyssen-Bornemisza Foundation, Einsiedeln, Switzerland, in association with Eidolon/Benziger, Einsiedeln, Switzerland, 1990.

———. *Art across America: Two Centuries of Regional Painting, 1710–1920*. 3 vols. New York: Abbeville Press, 1990.

———. *Lasting Impressions: American Painters in France, 1865–1915*, exhibition catalog. Giverny, France: Musée Américain, 1992.

———. *Masterworks of American Impressionism from the Pfeil Collection*. Alexandria, Va.: Art Services International, 1992.

———. *Monet's Giverny: An Impressionist Colony*. New York: Abbeville Press, 1993.

———. *Impressionist New York*. New York: Abbeville Press, 1994.

Gerdts, William H., et al. *Ten American Painters*, exhibition catalog. New York: Spanierman Gallery, 1990.

Gerdts, William H., et al. *All Things Bright and Beautiful: California Impressionist Paintings from the Irvine Museum*, exhibition catalog. Irvine, Calif.: Irvine Museum, 1998.

Gerdts, William H., and Will South. *California Impressionism*. New York: Abbeville Press, 1998.

Gerdts, William H., Diana Dimodica Sweet, and Robert R. Preato. *Tonalism: An American Experience*, exhibition catalog. Phoenix: Phoenix Art Museum, 1982.

Gibbs, Linda Jones. *Harvesting the Light: The Paris Art Mission and Beginnings of Utah Impressionism*, exhibition catalog. Salt Lake City: Church of Jesus Christ Latter-day Saints, 1987.

The Golden Age, Cincinnati Painters of the Nineteenth Century Represented in the Cincinnati Art Museum, exhibition catalog. Cincinnati: Cincinnati Art Museum, 1979.

Goldstein, Leslie S. "Art in Chicago and the World's Columbian Exposition of 1893." Master's thesis, University of Iowa, 1970.

Hale, Philip Leslie. "Painting and Etching." In *Fifty Years of Boston*. Boston: Boston Tercentenary Committee, c. 1932, pp. 353–64.

———. *Jan Vermeer of Delft*, Boston, 1913. Rev. ed. completed by Frederick W. Coburn and Ralph T. Hale and published as *Vermeer*. Boston and New York, 1937.

Haley, Kenneth. "The Ten American Painters: Definition and Reassessment." Ph.D. dissertation, State University of New York at Binghamton, 1975.

Hardin, Jennifer, and Valerie Ann Leeds. *In the American Spirit: Realism and Impressionism from the Lawrence Collection*, exhibition catalog. St. Petersburg, Fla.: St. Petersburg Museum of Fine Arts, 1999.

Harris, Jean C., Steven Kern, and Bill Stern. *Lasting Impressions: French and American Impressionism from New England Collections*, exhibition catalog. Springfield, Mass.: Springfield Museum of Fine Arts, 1988.

Harrison, Birge. *Landscape Painting*. New York: Charles Scribner's Sons, 1909.

Hartmann, Sadakichi. *A History of American Art*. 2 vols. Boston: L. C. Page and Co., 1902.

Haseltine, James L. *100 Years of Utah Painting*, exhibition catalog. Salt Lake City: Salt Lake Art Center, 1965.

Havemeyer, Louisine W. *Sixteen to Sixty, Memoirs of a Collector*. New York: Privately printed for the family of Mrs. H. O. Havemeyer and The Metropolitan Museum of Art, 1961.

Heming, Arthur H. H. *Miss Florence and the Artists of Old Lyme*. Essex, Conn.: Pequot Press, 1971.

Herbert, Robert L. *Impressionism: Art, Leisure, and Parisian Society*. New Haven, Conn.: Yale University Press, 1988.

Hiesinger, Ulrich W. *Impressionism in America: The Ten American Painters*. Munich: Prestel Verlag, 1991.

Hill, May Brawley. *Grandmother's Garden: The Old-Fashioned American Garden, 1865–1915*. New York: Harry N. Abrams, 1995.

Hills, Patricia. *Turn of the Century America*, exhibition catalog. New York: Whitney Museum of American Art, 1977.

Hoopes, Donelson F. *The American Impressionists*. New York: Watson-Guptill Publications, 1972.

Howells, William Dean. *Venetian Life*. 2 vols. Cambridge, Mass.: Riverside Press, 1892.

Hunter, Sam. *American Impressionism: The New Hope Circle*, exhibition catalog. Fort Lauderdale, Fla.: Fort Lauderdale Museum of Art, 1985.

Impressionism in America, exhibition catalog. Albuquerque: University of New Mexico, 1965.

Impressionism: An American View, exhibition catalog. Canton, Ohio: Canton Art Institute, 1983.

Impressionism: The California View, exhibition catalog. Oakland, Calif.: Oakland Museum, 1981.

Impressionism and Its Influence in American Art, exhibition catalog. Santa Barbara, Calif.: Santa Barbara Museum of Art, 1954.

Impressionism and Its Roots, exhibition catalog. Iowa City: University of Iowa, 1964.

Impressionist Mood in American Painting, exhibition catalog. New York: American Academy of Arts and Letters, 1959.

Inness, George, Jr. *Life, Art, and Letters of George Inness*. New York: Century Co., 1917.

Isham, Samuel. *The History of American Painting*. New York: Macmillan Co., 1905.

Jackman, Rilla Evelyn. *American Arts*. Chicago and New York: Rand, McNally and Co., 1928.

Jacobs, Michael. *The Good and Simple Life: Artist Colonies in Europe and America*. Oxford, England: Phaidon Press, 1985.

Jones, Arthur F., and Bruce Weber. *The Kentucky Painter from the Frontier Era to the Great War*, exhibition catalog. Lexington: University of Kentucky Art Museum, 1981.

Jones, Harvey L., John Caldwell, and Terry St. John. *Impressionism: The California View*, exhibition catalog. Oakland, Calif.: Oakland Museum, 1981.

Jones, Harvey L., Janet Blake Dominik, and Jean Stern. *Selections from the Irvine Museum*. Irvine, Calif.: Irvine Museum, 1992.

Kelder, Diane. *The Great Book of French Impressionism*. New York: Abbeville Press, 1980.

Keny, James M., and Nanette V. Maciejunes. *Triumph of Color and Light: Ohio Impressionists and Post-Impressionists*, exhibition catalog. Introduction by William H. Gerdts. Columbus, Ohio: Columbus Museum of Art in association with Keny Galleries, 1994.

Keyes, Donald D. *Impressionism and the South*, exhibition catalog. Greenville, S.C.: Greenville County Museum of Art, 1988.

———. *American Impressionism in Georgia Collections*, exhibition catalog. Athens, Ga.: Georgia Museum of Art, University of Georgia, 1993.

Kimbrough, Sara Dodge. *Drawn from Life*. Jackson, Miss.: University Press of Mississippi, 1976.

King, Pauline. *American Mural Painting*. Boston: Noyes, Platt and Co., 1902.

Krause, Martin. *The Passage: Return of Indiana Painters from Germany, 1880–1905*. Indianapolis, Ind.: Indianapolis Museum of Art; Cologne, Germany: Wallraf-Richartz-Museum, 1990.

Kysela, John D., S.J. "The Critical and Literary Background for a Study of the Development of Taste for 'Modern Art' in America, from 1880–1900." Master's thesis, Loyola University, 1964.

La Farge, John. *The Higher Life in Art*. New York: McClure Co., 1908.

LaFollette, Suzanne. *Art in America*. New York: Harper, 1929.

Landauer, Susan, Donald D. Keyes, and Jean Stern. *California Impressionists*, exhibition catalog. Atlanta: Atlanta Committee for the Olympic Games, 1996.

Landscape Painting of Bucks County. Doylestown, Pa.: James A. Michener Arts Center, 1988.

Langdale, Cecily. *Charles Conder, Robert Henri, James Morrice, Maurice Prendergast: The Formative Years, Paris 1890s*, exhibition catalog. New York: Davis and Long Co., 1975.

Larkin, Oliver W. *Art and Life in America*. New York: Rinehart, 1949.

Larkin, Susan G. *American Paintings from Connecticut Collections: Impressionists of the Connecticut Shore, 1890–1915*, exhibition catalog. Brockton, Conn.: Brockton Art Museum, 1987.

———. *The Cos Cob Art Colony: Impressionism on the Connecticut Shore*. New York: National Academy of Design; New Haven, Conn.: Yale University Press, 2001.

Leader, Bernice Kramer. "The Boston Lady as a Work of Art: Paintings by the Boston School at the Turn of the Century." Ph.D. dissertation, Columbia University, 1980.

Leaders of American Impressionism, exhibition catalog. Brooklyn: Brooklyn Museum, 1937.

Lynes, Russell. *The Tastemakers*. New York: Harper, 1954.

Masters of American Impressionism, exhibition catalog. New York: Coe Kerr Gallery, 1976.

Mather, Frank Jewett, Jr. *Modern Painting*. New York: H. Holt and Co., 1927.

McSpadden, Joseph Walker. *Famous Painters of America*. New York, 1916.

Meixner, Laura L. *An International Episode: Millet, Monet and Their North American Counterparts*, exhibition catalog. Memphis, Tenn.: Dixon Gallery and Gardens, 1982.

Memories of Old Lyme Art Colony 1900–1935, exhibition catalog. New York: Grand Central Art Galleries, 1967.

Monterey: The Artist's View, 1925–1945, exhibition catalog. Monterey, Calif.: Monterey Peninsula Museum of Art, 1982.

Moore, George. *Modern Painting*. London: W. Scott, 1900.

Morice, John H. *The First Out-of-Door Art School in the United States*. Privately published, n.d.

Morris, Harrison Smith. *Confessions in Art*. New York: Sears Publishing Co., 1930.

Moure, Nancy Dustin Wall. *Los Angeles Painters of the Nineteen-Twenties*, exhibition catalog. Claremont, Calif.: Pomona College, 1972.

———. *Painting and Sculpture in Los Angeles, 1900–1945*, exhibition catalog. Los Angeles: Los Angeles County Museum of Art, 1980.

Nash, Steven A., et al. *Facing Eden: 100 Years of Landscape Art in the Bay Area*, exhibition catalog. San Francisco: Fine Arts Museum of San Francisco, 1995.

Neff, Emily Ballew, and George T. M. Shackelford. *American Painters in the Age of Impressionism*, exhibition catalog. Houston: Museum of Fine Arts, 1994.

Neuhaus, Eugene. *The Galleries of the Exposition: A Critical Review of the Paintings, Statuary, and the Graphic Arts in the Palace of Fine Arts at the Panama-Pacific International Exposition*. San Francisco: P. Elder and Co., 1915.

———. *The History and Ideals of American Art*. Stanford, Calif.: Stanford University Press; London: H. Milford, Oxford University Press, 1931.

Novak, Barbara. *American Painting of the Nineteenth Century*. New York: Praeger, 1969.

———. *Nature and Culture: American Landscape and Painting 1825–1875*. New York: Oxford University Press, 1980.

———. *Impressionistes américains*. Washington, D.C.: Smithsonian Institution Travelling Exhibition Service, 1982.

Painters of Light and Color: American Impressionists from the Lyman Allyn Art Museum and Private Collections, exhibition catalog. New London, Conn.: Lyman Allyn Art Museum, 1989.

Palette of Light: California Paintings from The Irvine Museum. Irvine, Calif.: Irvine Museum, 1995.

Peat, Wilbur David. *Pioneer Painters of Indiana*. Indianapolis: Indianapolis Art Association, 1954.

Perlman, Bennard B. *The Immortal Eight: American Painting from Eakins to the Armory Show (1870–1913)*. New York: Exposition Press, 1962.

Peters, Lisa N. *American Impressionist Masterpieces*. New York: Hugh Lauter Levin, 1991.

Peters, Lisa N., et al. *Visions of Home: American Impressionist Images of Suburban Leisure and Country Comfort*, exhibition catalog. Carlisle, Pa.: Trout Gallery, Dickinson College, 1997.

Phillips, Duncan. *A Collection in the Making*. New York: E. Weyhe; Washington, D.C.: Phillips Memorial Gallery, 1926.

Pierce, Patricia Jobe. *The Ten*. Concord, N.H.: Rumford Press; North Abington, Mass.: Pierce Galleries, 1976.

Pilgrim, Dianne H. *American Impressionist and Realist Paintings and Drawings from the Collection of Mr. and Mrs. Raymond J. Horowitz*, exhibition catalog. New York: The Metropolitan Museum of Art, 1973.

Pisano, Ronald G. *American Realist and Impressionist Paintings from the Collection of Mr. and Mrs. Haig Tashjian*, exhibition catalog. Southampton, N.Y.: Parrish Art Museum, 1982.

———. *Long Island Landscape Painting, 1865–1914*. Boston: Little, Brown, 1985.

———. *Idle Hours: Americans at Leisure, 1865–1914*. Boston: Little, Brown, 1988.

Pizer, Donald. *Hamlin Garland's Early Work and Career*. New York: Russell & Russell, 1969.

Pool, Phoebe. *Impressionism*. New York: Praeger, 1967.

Portrait of a Place: Some American Landscape Painters in Gloucester, exhibition catalog. Gloucester, Mass.: Gloucester 350th Anniversary Celebration, 1973.

Poulet, Anne L., and Alexandra R. Murphy. *Corot to Braque*, exhibition catalog. Boston: Museum of Fine Arts, 1979.

Preato, Robert R. *Impressionist Moods: An American Interpretation; American Painters Rediscovered 1880–1930*, exhibition catalog. New York: Grand Central Art Galleries, 1979.

———. *Impressionism and Post-Impressionism: Transformations in the Modern American Mode, 1885–1945*, exhibition catalog. New York: Grand Central Art Galleries, 1988.

Prelinger, Elizabeth. *American Impressionism: Treasures from the Smithsonian American Art Museum*. New York: Watson-Guptill, 2000.

Pyne, Kathleen. *Art and the Higher Life: Paintings and Evolutionary Thought in Late Nineteenth-Century America*. Austin: University of Texas Press, 1996.

Quietist Moments in American Painting 1870–1920, exhibition catalog. New York: Wickersham Gallery, n.d.

Rabb, Lauren. *The Pennsylvania Impressionists: Painters of the New Hope School*, exhibition catalog. Washington, D.C.: Taggart & Jorgensen Gallery, 1990.

Rathbone, Perry T. *Boston Painters*, exhibition catalog. Boston: Museum of Fine Arts, 1971.

Rewald, John. *The History of Impressionism*. New York: The Museum of Modern Art, 1946.

———. *Postimpressionism from van Gogh to Gauguin*. New York: The Museum of Modern Art, 1956.

Richardson, Edgar P. *Painting in America from 1502 to the Present*. New York: T. Y. Crowell, 1956.

Robinson, Frank Torrey. *Living New England Artists*. Boston: S. E. Cassino, 1888.

Rothenstein, William. *Men and Memories, Recollections of William Rothenstein, 1872–1900*. 3 vols. London: Faber and Faber, 1931.

Rummell, John, and E. M. Berlin. *Aims and Ideals of Representative American Painters*. Buffalo, N.Y., 1901.

Sabbrin, Celin [Helen Cecilia De Silver Michael]. *Science and Philosophy in Art*. Philadelphia: Wm. F. Fell, 1886.

Sadler, Fernande. *L'Hôtel Chevillon et les artistes de Grèz-sur-Loing*. Fontainebleau, France, 1938.

St. Gaudens, Homer. *The American Artist and His Times*. New York: Dodd, Mead and Co., 1941.

St. John, Terry. *Society of Six*, exhibition catalog. Oakland, Calif.: Oakland Museum, 1972.

———. *Plein Air Paintings: Landscapes and Seascapes from Santa Cruz to the Carmel Highlands, 1898–1940*, exhibition catalog. Santa Cruz, Calif.: Mary Porter Sesnon Art Gallery, University of California, 1985.

Seavey, Kent L. *A Century of California Paintings 1870–1970*, exhibition catalog. Los Angeles: Crocker-Citizens National Bank, 1970.

Sellin, David. *Americans in Brittany and Normandy 1860–1910*, exhibition catalog. Phoenix: Phoenix Art Museum, 1982.

Sherman, Frederic Fairchild. *Landscape and Figure Painters of America*. New York: Privately printed, 1917.

———. *American Painters of Yesterday and Today*. New York: Privately printed, 1919.

Siegfried, Joan C. *Some Quietist Painters: A Trend toward Minimalism in Late Nineteenth-Century American Painting*. Saratoga Springs, N.Y.: Skidmore College, 1970.

Singleton, Esther, comp. and ed. *Modern Paintings, as Seen and Described by Great Writers*. New York: Dodd, Mead and Co., 1911.

Smith, F. Hopkinson. *Between the Extremes, A Paper Read before the Rembrandt Club by Francis Hopkinson Smith*. Brooklyn: Rembrandt Club, 1898.

———. "Old Sunshine." In *Art at Close Range*. New York: Charles Scribner's Sons, 1905.

de Soissons, S. C. *Boston Artists—A Parisian Critic's Notes*. Boston, 1894.

Solon, Deborah Epstein, and Will South. *Colonies of American Impressionism: Cos Cob, Old Lyme, Shinnecock and Laguna Beach*, exhibition catalog. Laguna Beach, Calif.: Laguna Art Museum, 1999.

Southern California Artists, 1890–1940, exhibition catalog. Laguna Beach, Calif.: Laguna Beach Museum of Art, 1979.

Spangenberg, Helen. *Yesterday's Artists on the Monterey Peninsula*, exhibition catalog. Monterey, Calif.: Monterey Peninsula Museum of Art, 1976.

Sparks, Esther. "A Biographical Dictionary of Painters and Sculptors in Illinois 1808–1945." Ph.D. dissertation, Northwestern University, 1971.

Spencer, Harold, Susan G. Larkin, and Jeffrey W. Andersen. *Connecticut and American Impressionism*, exhibition catalog. Storrs, Conn.: William Benton Museum of Art; Greenwich: Greenwich Library; Old Lyme: Lyme Historical Society, 1980.

Stebbins, Theodore E., Jr. *American Master Drawings and Watercolors*. New York: Harper and Row, 1976.

Stern, Jean. *American Impressionism: A California Collage*, exhibition catalog. Scottsdale, Ariz.: Fleischer Museum, 1991.

———. *American Impressionism: A California Collage*. Tulsa, Okla.: Thomas Gilcrease Institute of American History and Art, 1991.

———, ed. *Masterworks of California Impressionism: The FFCA, Morton H. Fleischer Collection*. Phoenix, Ariz.: Franchise Finance Corporation of America, 1986.

Stern Jean et al. *Reflections of California: The Athalie Richardson Irvine Clarke Memorial Exhibition*. Irvine, Calif.: Irvine Museum, 1994.

———. *Impressions of California: Early Currents in Art, 1850–1930*. Irvine, Calif.: Irvine Museum, 1996.

Stern, Jean, Gerald J. Miller, Pamela Hallan-Gibson, and Norman Neuerburg. *Romance of the Bells: The California Missions in Art*. Irvine, Calif.: Irvine Museum, 1995.

Stranahan, Mrs. C. H. *A History of French Painting*. New York: Charles Scribner's Sons, 1888.

"Studio Notes. Impressionism." *Arion* 1 (September 1881): 89–90.

Sweeney, J. Gray. *The Artists of Grand Rapids 1840–1980*, exhibition catalog. Grand Rapids, Mich.: Grand Rapids Art Museum and Grand Rapids Public Museum, 1981.

Sweet, Frederick A. *Sargent, Whistler and Mary Cassatt*, exhibition catalog. Chicago: Art Institute of Chicago, 1954.

Szancer, Elizabeth. "The Proper Bostonians: Tarbell, Benson, DeCamp." Master's thesis, Queens College of the City University of New York, 1975.

Taber, Edward Martin. *Stowe Notes, Letters, and Verses*. Boston and New York: Houghton Mifflin Co., 1913.

Taft, Lorado. *Painting and Sculpture in Our Time: Syllabus of a Course of Six Lecture Studies.* Chicago: University of Chicago Press, 1896.

Tarrant, Dorothy, and John Tarrant. *A Community of Artists: Westport-Weston, 1900–1985.* Westport, Conn.: Westport-Weston Arts Council, 1985.

Thaxter, Celia. *An Island Garden.* Boston and New York: Houghton, Mifflin and Co., 1894.

Three Centuries of American Art, exhibition catalog. Philadelphia: Philadelphia Museum of Art, 1976.

Toru, Arayashiki, et al. *The Painters in Grèz-sur-Loing,* exhibition catalog. Jamanashi, Fuchu, Otani, Nariwa, Sakura, Japan: Yomiuri Shimbun/The Japan Association of Art Museums, 2000.

Trask, John E. D., and John Nilsen Laurvik. *Catalog De Luxe of the Department of Fine Arts, Panama-Pacific International Exposition.* 2 vols. San Francisco, 1915.

Trenton, Patricia, and William H. Gerdts. *California Light, 1900–1930,* exhibition catalog. Laguna Beach, Calif.: Laguna Art Museum, 1990.

Truettner, William H., and Roger Stein, eds. *Picturing Old New England: Image and Memory.* Washington, D.C.: Smithsonian Institution, National Museum of American Art, 1999.

The United States and the Impressionist Era, exhibition catalog. San Jose, Calif.: San Jose Museum of Art, 1979–80.

Van Dyke, John Charles. *Art for Art's Sake.* New York: Charles Scribner's Sons, 1898.

———. *American Painting and Its Tradition.* New York: Charles Scribner's Sons, 1919.

———, ed. *Modern French Masters.* New York: Century Co., 1896.

Von Mach, Edmund. *The Art of Painting in the Nineteenth Century.* Boston and London: Ginn and Co., 1908.

Vure, Sarah, Kevin Starr, and Nancy Dustin Wall Moure. *Circles of Influence: Impressionism to Modernism in Southern California Art, 1910–1930,* exhibition catalog. Newport Beach, Calif.: Orange County Museum of Art, 2000.

Weber, Bruce. *The Giverny Luminists: Frieseke, Miller and Their Circle,* exhibition catalog. New York: Berry-Hill Galleries, 1995.

Weber, Bruce, and William H. Gerdts. *In Nature's Ways: American Landscape Painting of the Late Nineteenth Century,* exhibition catalog. West Palm Beach, Fla.: Norton Gallery of Art, 1987.

Weinberg, H. Barbara. "The Lure of Paris: Late Nineteenth-Century American Painters and Their French Training." In *A New World: Masterpieces of American Painting, 1760–1910,* exhibition catalog. Boston: Museum of Fine Arts, 1983.

———. *The Lure of Paris: Nineteenth-Century American Painters and Their French Teachers.* New York: Abbeville Press, 1991.

Weinberg, H. Barbara, Doreen Bolger, and David Park Curry. *American Impressionism and Realism: The Painting of Modern Life, 1885–1915,* exhibition catalog. New York: The Metropolitan Museum of Art, 1994.

Weisberg, Gabriel P. *Beyond Impressionism: The Naturalist Impulse.* New York: Harry N. Abrams, 1992.

Weitenkampf, Frank. *American Graphic Art.* New York: Macmillan Co., 1924.

Weitzenhoffer, Frances. "The Creation of the Havemeyer Collection, 1875–1900." Ph.D. dissertation, City University of New York, 1982.

Westphal, Ruth Lilly. *Plein Air Painters of California. The Southland.* Irvine, Calif.: Westphal Publishing, 1982.

———. *Plein Air Painters of California: The North.* Irvine, Calif.: Westphal Publishing, 1986.

Wheeler, Charles V. *Sketches.* Washington, D.C.: privately printed, 1927.

Wilmerding, John, et al. *American Light: The Luminist Movement 1850–1875,* exhibition catalog. New York: Harper and Row, 1980.

Wood, Carolyn H. *American Impressionist Painters,* exhibition catalog. Huntsville, Ala.: Huntsville Museum of Art, 1978–79.

Young, Mahonri Sharp. *The Eight: The Realist Revolt in American Painting.* New York: Watson-Guptill Publications, 1973.

GENERAL PERIODICALS

Adams, H. S. "Lyme—A Country Life Community." *Country Life in America* 25 (April 1914): 47–50, 92, 94.

Armstrong, Regina. "Representative Young Illustrators." *Art Interchange* 43 (November 1899): 108–9.

"Art in Boston: The Wave of Impressionism." *Art Amateur* 24 (May 1891): 141.

Bacon, Henry. "Glimpses of Parisian Art." *Scribner's Monthly* 21 (December 1880): 169–81; 21 (January 1881): 423–31; 21 (March 1881): 734–43.

Bourdon, David. "Art: Painting of Gardens." *Architectural Digest* 37 (June 1980): 70–75.

Brinton, Christian. "The Conquest of Color." *Scribner's Magazine* 62 (October 1919): 513–16.

Brown, Benjamin Chambers. "The Beginnings of Art in Los Angeles." *California Southland* 6 (January 1924): 7–8.

Brownell, William C. "The Younger Painters of America." *Century* 20 (May 1880): 1–15; 20 (July 1880): 321–35; 22 (July 1881): 321–34.

———. "French Art—III. Realistic Painting." *Scribner's Magazine* 12 (November 1892): 604–27.

Burgess, Ida J. "Modern Flower-Painting." *Lotus* 11 (January 1920): 383–86.

Burrage, Mildred Giddings. "Arts and Artists at Giverny." *World To-day* 20 (March 1911): 344–51.

Bye, Arthur Edwin. "Artists of the Delaware Valley." *General Magazine and Historical Chronicle* 40 (January 1938): 145–51.

Caffin, Charles H. "Arthur Hoeber—An Appreciation." *New England Magazine* 28 (April 1903): 223–33.

———. "Some New American Painters in Paris." *Harper's New Monthly Magazine* 118 (January 1909): 284–93.

Chamberlain, Arthur. "Impressionism and Its Obstacles." *Art Interchange* 38 (November 1897): 101.

Child, Theodore. "The King of the Impressionists." *Art Amateur* 14 (April 1886): 101–2.

———. "A Note on Impressionist Painting." *Harper's New Monthly Magazine* 74 (January 1887): 313–15.

Clark, Eliot. "American Painters of Winter Landscape." *Scribner's Magazine* 72 (December 1922): 763–68.

"Colored Shadows." *Scribner's Magazine* 19 (April 1896): 522.

Cook, Clarence. "The Impressionist Pictures." *Studio* 1 (April 17, 1886): 245–54.

———. "Some Present Aspects of Art in America." *Chautauquan* 23 (August 1896): 595–601.

Corn, Wanda M. "The New New York." *Art in America* 61 (July–August 1973): 58–65.

Cortissoz, Royal. "Some Imaginative Types in American Art." *Harper's New Monthly Magazine* 91 (July 1895): 164–79.

———. "Personal Memories." *Arts* 1 (June–July 1921): 8–24.

Cox, Kenyon. "The American School of Painting." *Scribner's Magazine* 50 (December 1911): 265–68.

Curran, Charles C. "The Outdoor Painting of Flowers." *Palette and Bench* 1 (July 1909): 217–18.

Daingerfield, Elliott. "Color and Form—Their Relationship." *Art World* 3 (December 1917): 179–80.

Davidson, Carla. "Boston Painters, Boston Ladies." *American Heritage* 23 (April 1972): 4–17.

DeKay, Charles. "A Group of Colourists." *Magazine of Art* 9 (1886): 389–90.

———. "French and American Impressionists." *New York Times,* January 31, 1904, p. 23.

Downes, William Howe. "Impressionism in Painting." *New England Magazine* 6 (July 1892): 600–3.

du Bois, Guy Pène. "The French Impressionists and Their Place in Art." *Arts and Decoration* 4 (January 1914): 101–5.

———. "The Pennsylvania Group of Landscape Painters." *Arts and Decoration* 5 (July 1915): 351–54.

———. "The White House with the Green Blinds." *Arts and Decoration* 5 (September 1915): 429–31.

———. "The Boston Group of Painters: An Essay on Nationalism in Art." *Arts and Decoration* 5 (October 1915): 457–60.

DuMond, Frank Vincent. "The Lyme Summer School and Its Theory of Art." *Lamp* 27 (August 1903): 7–18.

Edgerton, Giles. "Is America Selling Her Birthright in Art for a Mess of Pottage?" *Craftsman* 11 (March 1907): 657–70.

———. "The Younger American Painters: Are They Creating a National Art?" *Craftsman* 13 (February 1908): 512–32.

———. "Pioneers of Modern American Art." *Craftsman* 14 (September 1908): 597–606.

Eldredge, Charles. "Connecticut Impressionists: The Spirit of Place." *Art in America* 62 (September–October 1974): 84–90.

Faulkner, Joseph W. "Painters at the Hall of Expositions, 1890." *Chicago History* 2 (spring 1972): 14–16.

Folk, Thomas, and Barbara J. Mitnick. "The Pennsylvania Impressionists." *Antiques* 128 (July 1985): 111–17.

Forgey, Benjamin. "American Impressionism from the Vital to the Academic." *Artnews* 72 (October 1973): 24–27.

Forsyth, William. "Some Impressions of the Art Exhibit at the Fair—III . . . Impressionism. . . ." *Modern Art* 1 (summer 1893): unpaginated.

Fowler, Frank. "The New Heritage of Painting of the Nineteenth Century." *Scribner's Magazine* 30 (August 1901): 253–56.

———. "The Value of Art Effort." *Scribner's Magazine* 44 (August 1908): 253–56.

"French and American Impressionists." *Art Amateur* 29 (June 1893): 4.

"The French Impressionists." *Critic* 5 (April 17, 1886): 195–96.

"French Impressionists." *New York Times,* May 28, 1886, p. 5.

Gammell, R. H. Ives. "A Reintroduction to Boston Painters." *Classical America* 3 (1973): 94–104.

Garczanski, Edward Rudolf. "Jugglery in Art." *Forum* 1 (August 1886): 592–602.

Garland, Hamlin. "Successful Efforts to Teach Art to the Masses. Work of an Art Association in Western Towns." *Forum* 19 (July 1895): 606–9.

Gerdts, William H. "The Square Format and Proto-Modernism in American Painting." *Arts Magazine* 50 (June 1976): 70–75.

———. "The Artist's Garden." *Portfolio* 4 (July–August 1982): 44–51.

———. "Post-Impressionist Landscape Painting in America." *Art and Antiques* 6 (July–August 1983): 60–67.

Gordon, Archibald. "The Impressionist Painters." *Studio and Musical Review* 1 (April 9, 1881): 162–63.

———. "The Impressionists." *Studio and Musical Review* 1 (April 16, 1881): 178–79.

Graf, Josephine A. "The Brown County Art Colony." *Indiana Magazine of History* 35 (December 1939): 365–70.

"Greta." "The Wave of Impressionism." *Art Amateur* 24 (May 1891): 141.

"Grèz, par Nemours." *Studio* 2 (July 1883): 27–30.

Griffin, Lillian Baynes. "With the Old Lyme Art Colony." *New Haven Morning Journal and Courier,* July 5, 1907.

"Griswold House at Lyme." *Arts* 1 (August–September 1921): 20–21.

Hamilton, Luther. "The Work of the Paris Impressionists in New York." *Cosmopolitan* 1 (June 1886): 240–42.

Harrison, Birge. "Vibration in Landscape Painting." *Palette and Bench* 1 (September 1909): 269–71; 2 (October 1909): 12–13.

———. "The True Impressionism in Art." *Scribner's Magazine* 46 (October 1909): 491–95.

———. "Appeal of the Winter Landscape." *Fine Arts Journal* 30 (March 1914): 191–96.

Hartmann, Sadakichi. "The Tarbellites." *Art News* 1 (March 1897): 3–4.

———. "Unphotographic Paint: The Texture of Impressionism." *Camera Work* 28 (October 1909): 20–23.

Henderson, Helen W. "Centenary Exhibition of the Pennsylvania Academy of the Fine Arts." *Brush and Pencil* 15 (March 1905): 145–55.

Hoeber, Arthur. "Plain Talks on Art—Impressionism." *Art Interchange* 37 (July 1896): 5–7.

———. "The Ten Americans." *International Studio* 35 (July 1908): xxiv–xxix.

Hooper, Lucy. "Art Notes from Paris." *Art Journal* (New York) 6 (1880): 188–90.

Huth, Hans. "Impressionism Comes to America." *Gazette des Beaux-Arts* 6, no. 29 (April 1946): 225–52.

"Impressionism and After." *Scribner's Magazine* 21 (March 1897): 391–92.

"Impressionism in France." *American Art Review* 1 (1880): 33–35.

"The Impressionist Exhibition." *Art Amateur* 14 (May 1886): 121.

"The Impressionists." *Art Age* 3 (April 1886): 165–66.

"The Impressionists." *Art Interchange* 29 (July 1892): 1–7.

"The Impressionists." *Art Amateur* 30 (March 1894): 99.

"The Impressionists." *Gallery and Studio* 1 (October 1897): 6–7.

"The Impressionists' Exhibition at the American Art Galleries." *Art Interchange* 16 (April 24, 1886): 130–31.

"Impressionists and Imitators." *Collector* 1 (November 1889): 11.

"The Impressionists at the National Academy of Design." *Art Interchange* 16 (June 19, 1886): 193.

"Interpreters of Nature — I. Cullen Yates, II. Willard L. Metcalf, III. Edward W. Redfield, IV. Edward Dufner." *Country Life in America* 38 (June 1920): 40–41.

James, Henry. "The Grosvenor Gallery and the Royal Academy." *Nation* 24 (May 31, 1877): 320–21.

———. "Our Artists in Europe." *Harper's New Monthly Magazine* 79 (June 1889): 50–66.

Johnson, Virginia C. "The School of Modern Impressionism." *Art Interchange* 42 (April 1899): 88.

"Jules Bastien-Lepage." Interview with J. Alden Weir in *Studio*, no. 13 (January 31, 1885): 145–51.

Kane, Marie Louise. "American Impressionist Paintings." *Saint Louis Art Museum Bulletin* 17 (fall 1984): 2–3.

Kelly, Florence Finch. "Painters of Sea and Shore." *Broadway Magazine* 18 (August 1907): 580–86.

Keyes, Donald D. "California Impressionists, From Giverny to Laguna Beach." *American Art Review* 8 (June–August 1996): 148–55.

Knowles, W. L. Everett. "Art and Its Mission." *Arts for America* 7 (October 1897): 70–73.

Knowlton, Helen M. "A Home-Colony of Artists." *Studio* 5 (July 19, 1890): 326–27.

Kysela, John D., S.J. "Sara Hallowell Brings 'Modern Art' to the Midwest." *Art Quarterly* 27, no. 2 (1964): 150–67.

Laughton, Bruce. "British and American Contributions to Les XX, 1884–93." *Apollo* 86 (November 1967): 372–79.

Laurvik, J. Nilsen. "Evolution of American Painting." *Century* 90 (September 1915): 772–86.

Leader, Bernice Kramer. "The Boston School and Vermeer." *Arts Magazine* 55 (November 1980): 172–76.

———. "Antifeminism in the Paintings of the Boston School." *Arts Magazine* 56 (January 1982): 112–19.

Lejeune, L. "The Impressionist School of Painting." *Lippincott's Magazine* 24 (December 1879): 720–27.

Lockington, Walter Percy. "The Limited Range of the Luminists." *Art Interchange* 48 (May 1902): 120–21.

Lowell, Amy. "Impressionist Picture of a Garden." *Trimmed Lamp* 5 (April 1916): 181.

Maratta, Hardesty G. "Impressionism as Interpreted through the Works of Manet." *Arts* 4 (December 1895): 169–71.

Mather, Frank Jewett, Jr. "The Luxembourg and American Painting." *Scribner's Magazine* 47 (March 1910): 381–84.

Maxwell, Everett Carroll. "Development of Landscape Painting in California." *Fine Arts Journal* 34 (March 1916): 138–42.

McLaughlin, George. "Cincinnati Artists of the Munich School." *American Art Review* 2, part 1 (1881): 1–4, 45–50.

Mechlin, L. "The Freer Collection of Art." *Century* 73 (January 1907): 357–70.

———. "Contemporary American Landscape Painting." *International Studio* 39 (November 1909): 3–14.

Meltzer, Charles Henry. "American Artist Colonies Abroad." *Hearst's Magazine* 24 (October 1913): 628–29.

Moore, Charles Herbert. "Modern Art of Painting in France." *Atlantic Monthly* 68 (December 1891): 805–16.

"Mr. Inness on Art-Matters." *Art Journal* 5 (1879): 374–77.

"The National Note in Our Art—A Distinctive American Quality Dominant at the Pennsylvania Academy." *Craftsman* 9 (March 1906): 753–73.

"A New Gallery and a Summer Exhibition at Old Lyme." *American Magazine of Art* 11 (November 1919): 18–20.

Novak, Barbara. "American Impressionism." *Portfolio* 4 (March–April 1982): 68–81.

Osborne, Carol. "Impressionists and the Salon." *Arts Magazine* 48 (June 1974): 36–39.

"Our Summer Art Schools." *Art Interchange* 33 (July 1894): 21.

T. S. P. [Thomas Sergeant Perry?]. "Edgar Degas." *Gallery and Studio* 1 (January 1899): 5.

"A Painter on Painting." *Harper's New Monthly Magazine* 56 (February 1878): 458–61.

"Painters' Motifs in New York City." *Scribner's Magazine* 20 (July 1896): 127–28.

Pecht, Frederick. "The Impressionists under Heavy Fire." *Studio and Musical Review* 1 (February 26, 1881): 82–83.

Phillips, Duncan. "The Impressionistic Point of View." *Art and Progress* 3 (March 1912): 505–11.

———. "What Is Impressionism?" *Art and Progress* 3 (September 1912): 702–7.

Pilgrim, Dianne. "The National Gallery's Impressionist Show." *American Art Review* 1 (January–February 1974): 76–80, 126–27.

———. "The Revival of Pastels in Nineteenth-Century America: The Society of Painters in Pastel." *American Art Journal* 10 (November 1978): 43–62.

"The Point of View." *Scribner's Magazine* 9 (May 1891): 657–58.

Pomeroy, Ralph. "Yankee Impressionists: Impressive, Impressionable." *Art News* 67 (November 1968): 51.

R. R. [Roger Riordan]. "From Another Point of View." *Art Amateur* 27 (December 1892): 5.

Rand, Harry. "American Impressionism." *Arts Magazine* 50 (May 1976): 13.

Reutersvard, Oscar. "The 'Violettomania' of the Impressionists." *Journal of Aesthetics and Art Criticism* 9 (December 1951): 106–10.

———. "The Accentuated Brush Stroke of the Impressionists." *Journal of Aesthetics and Art Criticism* 10 (March 1952): 273–78.

Rosenbaum, Julia Beth. "Local Views, National Visions: Art, New England, and American Identity, 1890–1920." Ph.D. diss., University of Pennsylvania, 1998.

Rowe, L. E. "Boudin, Vinton and Sargent." *Bulletin of the Rhode Island School of Design* 25 (January 1937): 2–5.

Ruge, Clara. "The Tonal School of America." *International Studio* 27 (January 1906): lvii–lxvi.

Seares, Mabel Urmy. "Modern Art and Southern California." *American Magazine of Art* 9 (December 1917): 58–64.

———. "A California School of Painters." *California Southland* 1–3 (February 1921): 10–11.

———. "California as Presented by Her Artists." *California Southland* 6 (June 1924): 7–13.

Shulz, Adolph Robert. "The Story of the Brown County Art Colony." *Indiana Magazine of History* 31 (December 1935): 282–89.

Slocum, Grace L. "An American Barbizon: Old Lyme and Its Artist Colony." *New England Magazine* 34 (July 1906).

———. "Old Lyme." *American Magazine of Art* 15 (December 1924): 635–42.

Smith, David Loeffler. "Observations on a Few Celebrated Women Artists." *American Artist* 26 (January 1962): 51–55.

Smith, F. Hopkinson. "Impressionism and Realism in Art. Talk before the Philadelphia Art Club." *Art Interchange* 50 (March 1903): 158.

"Some Painters from Lyme." *Art Bulletin* 4 (February 4, 1905): 6.

Stark, Otto. "The Evolution of Impressionism." *Modern Art* 3 (spring 1895): 53–56. Reprinted in Leslie G. Howard, *Otto Stark, 1859–1926*. Indianapolis, Ind.: Indianapolis Museum of Art, 1977, pp. 58–60.

Stephens, Henry G. "'Impressionism'—The Nineteenth Century's Distinctive Contribution to Art." *Brush and Pencil* 11 (January 1903): 279–97.

Stern, Jean. "The Laguna Beach School: California Impressionism, 1900–1930." *Western Art Digest* 13 (September–October 1986): 112–15.

Stevenson, R. A. M. "Grèz." *Magazine of Art* 17 (January 1894): 27–32.

Stevenson, Robert Louis. "Fontainebleau: Village Communities of Painters—IV." *Magazine of Art* 7 (1884): 340–45.

Tarrant, John J. "Florence Griswold, Old Lyme, and the Impressionists." *Smithsonian* 13 (January 1982): 104–11.

Taylor, E. A. "The American Colony of Artists in Paris (first article)." *International Studio* 52 (May 1911): 263–75.

"Ten American Painters." *Art Amateur* 38 (May 1898): 133–34.

Thurber, Martha C. "Impressionism in Art—Its Origin and Influence." *Arts for America* 5 (June 1896): 181–84.

Toulgouat, Pierre. "Skylights in Normandy." *Holiday* 4 (August 1948): 66–70.

———. "Peintres américains à Giverny." *Rapports: France—États-Unis*, no. 62 (May 1952), pp. 65–73.

Trumble, Alfred. "Impressionists and Imitators." *Collector* 1 (November 15, 1889): 11.

———. "Impressionism and Impressions." *Collector* 4 (May 15, 1893): 213–14.

Van Rensselaer, Mariana. "American Painters in Pastel." *Century* 29 (December 1884): 204–10.

Venturi, Lionello. "The Aesthetic Idea of Impressionism." *Journal of Aesthetics and Art Criticism* 1 (spring 1941): 34–45.

F. W. "Notes on a Young 'Impressionist.'" *Critic* 1 (July 30, 1881): 208–9.

W. H. W. "What Is Impressionism?" *Art Amateur* 27 (November 1892): 18.

———. "What Is Impressionism? Part II." *Art Amateur* 27 (December 1892): 5.

Waern, Cecilia. "Some Notes on French Impressionism." *Atlantic Monthly* 69 (April 1892): 535–41.

Watts, Harvey M. "Nature Invites and Art Responds: The Haunts of the Painters of the Delaware Valley School." *Arts and Decoration* 15 (July 1921): 152–55, 196, 198.

Weber, Nicholas Fox. "Rediscovered American Impressionists." *American Art Review* 3 (January–February 1976): 100–15.

Webster, J. Carson. "Technique of Impressionism: A Reappraisal." *College Art Journal* 4 (November 1944): 3–22.

Weinberg, H. Barbara. "American Impressionism in Cosmopolitan Context." *Arts Magazine* 55 (November 1980): 160–65.

————. "Nineteenth-Century American Painters at the École des Beaux-Arts." *American Art Journal* 13 (autumn 1981): 66–84.

Weinberg, Louis. "Current Impressionism." *New Republic* 2 (March 6, 1915): 124–25.

Weitzenhoffer, Frances. "Estampes impressionnistes de peintres américains." *Nouvelles de l'estampe,* no. 28 (July–August 1976): 7–15.

————. "First Manet Paintings to Enter an American Museum." *Gazette des Beaux-Arts* 97 (March 1981): 125–29.

Weller, A. S. "The Impressionists." *Art in America* 51 (June 1963): 86–91.

Winslow, W. Henry. "The Impressionists of 1877." *Boston Evening Transcript,* April 21, 1892, p. 6.

"Women and Their Interests. Artists Afield." *New York World,* August 8, 1893, p. 11.

Young, Mahonri Sharp. "Purple Shadows in the West." *Apollo* 98 (October 1973): 308–10.

Zug, George Breed. "The Story of American Painting—IX. Contemporary Landscape Painting." *Chautauquan* 50 (May 1908): 369–402.

ARTISTS

Karl Anderson

Anderson, Karl. "European Reminiscences." *Bellman* 8 (March 5, 1910): 202–4.

Preato, Robert R. "Karl Anderson: American Painter of Youth, Sunshine and Beauty." *Illuminator* (fall–winter 1979–80): 8–16.

Price, Frederic Newlin. "Karl Anderson, American." *International Studio* 76 (November 1922): 132–39.

Otto H. Bacher

Andrew, William W. *Otto H. Bacher,* Madison, Wisc.: Education Industries, 1973.

Frederic Clay Bartlett

Bartlett, Frederic Clay. *Sortofa Kindofa Journal of My Own.* Chicago: Privately printed, 1965.

Frueh, Erne R., and Florence Frueh. "Frederic Clay Bartlett: Chicago Painter and Patron of the Arts." *Chicago History* 8 (spring 1979): 16–19.

Granger, Alfred Hoyt. "Frederick [*sic*] Clay Bartlett—Painter." *Sketch Book* 5 (February 1906): 247–53.

Palumbo, Anne Cannon. *The Paintings of Frederic Clay Bartlett and Evelyn Fortune Bartlett,* exhibition catalog. Washington, D.C.: Smithsonian Institution Press, 1982.

Sweet, Frederick A. "Great Chicago Collectors." *Apollo* 84 (September 1966): 190–207.

Gifford Beal

Comstock, Helen. "Gifford Beal's Versatility." *International Studio* 77 (June 1923): 236–42.

Gifford Beal, 1879–1956: A Centennial Exhibition, exhibition catalog. New York: Kraushaar Galleries, 1979.

Gifford Beal: Paintings and Watercolors, exhibition catalog. Washington, D.C.: The Phillips Collection, 1971.

"Gifford Beal: Perennially Youthful Painter of the Good Life." *American Artist* 17 (October 1953): 24–27.

Pisano, Ronald G., and Ann C. Madonia. *Gifford Beal: Picture-Maker,* exhibition catalog. New York: Kraushaar Galleries, 1993.

Weschler, Jeffrey. *Gifford Beal: At the Water's Edge: Fishing Paintings from the 1920s and 1930s,* exhibition catalog. New York: Kraushaar Galleries, 1999.

Cecilia Beaux

Beaux, Cecilia. *Background with Figures: Autobiography of Cecilia Beaux.* Boston and New York: Houghton Mifflin Co., 1930.

Bell, Mrs. Arthur. "The Work of Cecilia Beaux." *International Studio* 8 (October 1899): 215–22.

"Cecilia Beaux: Philadelphia Artist." *Pennsylvania Magazine of History and Biography* 124 (July 2000): 245–418.

Drinker, Henry S. *The Paintings and Drawings of Cecilia Beaux.* Philadelphia: Pennsylvania Academy of the Fine Arts, 1955.

Fichera, Susanna J. *Cecilia Beaux,* exhibition catalog. Boston: Alfred J. Walker Fine Art, 1990.

Goodyear, Frank H., Jr. *Cecilia Beaux: Portrait of an Artist,* exhibition catalog. Philadelphia: Pennsylvania Academy of the Fine Arts, 1974–75.

Hill, Frederick D. "Cecilia Beaux, the Grande Dame of American Portraiture." *Antiques* 105 (January 1974): 160–68.

Mechlin, Leila. "The Art of Cecilia Beaux." *International Studio* 61 (July 1910): iii–x.

Oakley, Thornton. *Cecilia Beaux.* Philadelphia: Howard Biddle Printing Co., 1943.

Tappert, Tara Leigh. *Cecilia Beaux and the Art of Portraiture,* exhibition catalog. Washington, D.C.: Smithsonian Institution Press for the National Portrait Gallery, 1995.

Walton, William. "Cecilia Beaux." *Scribner's Magazine* 22 (October 1897): 477–85.

Frank W. Benson

Bedford, Faith Andrews. *Frank W. Benson: American Impressionist.* New York: Rizzoli, 1994.

————. *The Sporting Art of Frank W. Benson.* Boston: David R. Godine, 2000.

Bedford, Faith Andrews, et al. *The Art of Frank W. Benson: American Impressionist,* exhibition catalog. Salem, Mass.: Peabody Essex Museum, 2000.

Bedford, Faith Andrews, Susan C. Faxon, and Bruce W. Chambers. *Frank W. Benson: A Retrospective,* exhibition catalog. New York: Berry-Hill Galleries, 1989.

Caffin, Charles H. "The Art of Frank W. Benson." *Harper's New Monthly Magazine* 119 (June 1909): 105–14.

Chamberlain, Samuel. "Frank W. Benson the Etcher." *Print Collector's Quarterly* 25 (April 1938): 169–72.

Coburn, Frederick W. "Frank W. Benson's 'Portrait of My Daughters.'" *New England Magazine* 38 (May 1908): 328–29.

Dodge, Ernest S. *Frank W. Benson, 1862–1951,* exhibition catalog. Rockland, Maine: William A. Farnsworth Library and Art Museum, 1973.

Downes, William H. "Frank W. Benson and His Work." *Brush and Pencil* 6 (July 1900): 144–57.

————. "The Spontaneous Gaiety of Frank Benson's Work." *Arts and Decoration* 1 (March 1911): 195–97.

————. "Mr. Benson's Etchings." *American Magazine of Art* 9 (June 1918): 309–13.

Lucas, E. V. "Frank W. Benson." *Ladies' Home Journal* 44 (October 1927): 16–17.

Morgan, Charles Lemon. *Frank W. Benson, N.A.* New York: Crafton Collection; London: P. & D. Colnaghi and Co., 1931.

Olney, Susan Faxon. *Two American Impressionists: Frank W. Benson and Edmund C. Tarbell,* exhibition catalog. Durham, N.H.: University of New Hampshire Art Galleries, 1979.

Paff, Adam E. M. *Etchings and Drypoints by Frank W. Benson.* Boston and New York: Houghton Mifflin Co., 1917.

Price, Lucien. *Frank W. Benson, 1862–1951,* exhibition catalog. Salem, Mass.: Essex Institute and the Peabody Museum of Salem, 1956.

Price, Lucien, and Frederick W. Coburn. *Frank W. Benson, Edmund C. Tarbell,* exhibition catalog. Boston: Museum of Fine Arts, 1938.

Reece, Claude. "Frank W. Benson." *Prints* 4 (March 1934): 4–8.

Salaman, Malcolm C. "The Modern Adventure in Print Collecting—IV. The Etchings and Dry-Points of Frank W. Benson." *Bookman's Journal & Print Collector* 3 (March 18, 1921): 374–76.

————. *Frank W. Benson.* London: Studio, 1925.

Seaton-Schmidt, Anna. "Frank W. Benson." *American Magazine of Art* 12 (November 1921): 365–72.

Smith, Minna C. "The Work of Frank W. Benson." *International Studio* 35 (October 1908): xcix–cvi.

Wilmerding, John, Sheila Dugan, and William H. Gerdts. *Frank W. Benson: The Impressionist Years,* exhibition catalog. New York: Spanierman Gallery, 1988.

Wright, Helen. "Etchings by Frank W. Benson." *Art and Archeology* 15 (February 1923): 92–95.

Ernest Blumenschein

Blumenschein, Ernest L. "The Painting of To-morrow." *Century* 87 (April 1914): 844–50.

Blumenschein, Helen Greene. *Recuerdos: Early Days of the Blumenschein Family.* Silver City, N.M.: Tecolote Press, 1979.

The Blumenscheins of Taos, exhibition catalog. Flagstaff, Ariz.: Museum of Northern Arizona, 1979.

Brown, Sherry. "Ernest L. Blumenschein, 1874–1960." *Artists of the Rockies and the Golden West* 9 (spring 1982): 68–75.

Henning, William T., Jr. *Ernest L. Blumenschein Retrospective,* exhibition catalog. Colorado Springs, Colo.: Colorado Springs Fine Arts Center, 1978.

Maurice Braun

Braun, Maurice. "Theosophy and the Artist." *Theosophical Path* 14 (January 1918): 7–17.

Comstock, Helen. "Painter of East and West." *International Studio* 80 (March 1915): 485–88.

Petersen, Martin E. "Maurice Braun: Master Painter of the California Landscape." *Journal of San Diego History* 23 (summer 1977): 20–40.

Poland, Reginald. "The Divinity of Nature in the Art of Maurice Braun." *Theosophical Path* 34 (May 1928): 473–76.

John Leslie Breck

Breck, Edward. "Something More of Giverny." *Boston Evening Transcript,* March 9, 1895, p. 13.

Corbin, Kathryn. "John Leslie Breck, American Impressionist." *Antiques* 134 (November 1988): 142–49.

Kimball, Benjamin. *Memorial Exhibition of Paintings by John Leslie Breck,* exhibition catalog. Boston: St. Botolph Club; New York: National Arts Club, 1899.

Hugh Henry Breckenridge

Carr, Gerald L. "Hugh Henry Breckenridge, A Philadelphia Modernist." *American Art Review* 4 (May 1978): 92–99, 119–22.

Hoeber, Arthur. "Hugh H. Breckenridge." *International Studio* 37 (March 1909): 24–26.

Vogel, Margaret. *The Paintings of Hugh H. Breckenridge (1870–1937),* exhibition catalog. Dallas: Valley House Gallery, 1967.

Benjamin Brown

Berry, Rose V. S. "A Patriarch of Pasadena." *International Studio* 81 (May 1925): 123–27.

Downes, William Howe. "California for the Landscape Painters. Illustrated by Paintings by Benjamin C. Brown." *American Magazine of Art* 11 (December 1920): 491–502.

Gearhart, Edna. "Benjamin Brown of Pasadena." *Overland Monthly and Out West Magazine* 82 (July 1924): 314–16.

————. "The Brothers Brown—California Painters and Etchers." *American Magazine of Art* 20 (May 1929): 283–89.

Seares, Mabel Urmy. "California as a Sketching Ground. Illustrated by the Paintings of Benjamin Chambers Brown." *International Studio* 43 (April 1911): 121–32.

Walker, John Alan. *Benjamin Chambers Brown (1865–1942): A Chronological and Descriptive Bibliography.* Big Pine, Calif.: Privately printed, 1989.

William Blair Bruce

Bonds, Gunvor. "William Blair Bruce, Caroline Benedicks och Brucebo." Master's thesis, Stockholm Universitet Konstvetenskapliga Institutionen, 1977.

Bruce, William Blair. Art Gallery of Hamilton, Hamilton, Ontario. Unpublished papers.

Exposition rétrospective de l'oeuvre de W. Blair Bruce, exhibition catalog. Paris: Galeries Georges Petit, 1907.

Gehmacher, Arlene. *William Blair Bruce: Painting for Posterity*. Hamilton, Ontario: Art Gallery of Hamilton, 2000.

Minnesutställning W. Blair Bruce. Stockholm: Kunstakademien, 1907.

Murray, Joan, ed. *Letters Home: 1859–1906: The Letters of William Blair Bruce*. Moonbeam, Ontario: Penumbra Press, 1982.

———. *Preparatory Sketches for a Salon Painting: Bathers at Capri by William Blair Bruce*. Oshawa, Ontario: Robert McLaughlin Gallery, 1975.

———. "The Man Who Painted Ghosts." *MD* (December 1985): 30–32.

———. "William Blair Bruce: Poet of Paint." *Northward Journal*, no. 35 (1985): 34–39.

"Short Sketch of W. Blair Bruce, Artist, Paris." Typescript, circa 1901. W.B. Bruce Artist File, E.P. Taylor Reference Library, Art Gallery of Ontario, Toronto.

Wistow, David. "William Blair Bruce." *Dictionary of Canadian Biography*. Vol. 13, pp. 117–18. Toronto: University of Toronto Press, 1994.

Dennis Miller Bunker

Dennis Miller Bunker: A Supplementary Group of Paintings and Water Colors Including Some Early Works, exhibition catalog. Boston: Museum of Fine Arts, 1945.

Ferguson, Charles B. *Dennis Miller Bunker (1861–1890) Rediscovered*, exhibition catalog. New Britain, Conn.: New Britain Museum of American Art, 1978.

Gammell, R. H. Ives. *Dennis Miller Bunker*, exhibition catalog. Boston: Museum of Fine Arts, 1943.

———. *Dennis Miller Bunker*. New York: Coward McCann, 1953.

Hirshler, Erica E. *Dennis Miller Bunker: American Impressionist*, exhibition catalog. Boston: Museum of Fine Arts, 1994.

———. *Dennis Miller Bunker and His Circle*, exhibition catalog. Boston: Isabella Stewart Gardner Museum, 1995.

Theodore Earl Butler

Gross, Sally. "Theodore Earl Butler (1860–1936): His Life and Work." Master's thesis, Bryn Mawr College, 1982.

Love, Richard H. *Theodore Earl Butler: Emergence from Monet's Shadow*. Chicago: Haase-Mumm Publishing Co., 1985.

T. E. Butler, exhibition catalog. Paris: Bernheim Jeune and Co., 1912.

Theodore Earl Butler (1860–1936): American Impressionist, exhibition catalog. San Francisco: Maxwell Galleries, 1972.

Theodore Earl Butler (1860–1936), exhibition catalog. Chicago: Signature Galleries, 1976.

Emil Carlsen

The Art of Emil Carlsen, 1853–1932, exhibition catalog. San Francisco: Wortsman Rowe Galleries, 1975.

Clark, Eliot. "Emil Carlsen." *Scribner's Magazine* 66 (December 1919): 767–70.

Emil Carlsen, exhibition catalog. Tyler, Tex.: Tyler Museum of Art, 1973.

Hailey, Gene., ed. *California Art Research 4*. San Francisco: WPA Project 2874, 1937, pp. 27–63.

Hiesinger, Ulrich W. *Quiet Magic: The Still-Life Paintings of Emil Carlsen*, exhibition catalog. New York: Vance Jordan Fine Art, 1999.

Phillips, Duncan. "Emil Carlsen." *International Studio* 61 (June 1917): cv–cx.

Price, F. N. "Emil Carlsen—Painter, Teacher." *International Studio* 75 (July 1922): 300–8.

Sill, Gertrude. "Emil Carlsen Lyrical Impressionist." *Art and Antiques* 3 (March–April 1980): 88–95.

Steele, John. "The Lyricism of Emil Carlsen." *International Studio* 88 (October 1927): 53–60.

Stewart, Jeffrey. "Soren Emil Carlsen." *Southwest Art* 4 (April 1975): 34–37.

———. "Soren Emil Carlsen (1853–1932)." In Ruth Lilly Westphal, *Plein Air Painters of California: The North*. Irvine, Calif.: Westphal Publishing, 1986.

Tananbaum, Dorothy. *The Art of Emil Carlsen*, exhibition catalog. New York: Hammer Galleries, 1977.

Mary Cassatt

Alexandre, Arsene. "Miss Mary Cassatt, aquafortiste." *La Renaissance de l'art français et des industries de luxe* 7 (March 1924): 127–33.

———. "La Collection Havemeyer et Miss Cassatt." *La Renaissance* 13 (February 1930): 51–56.

Barter, Judith, et al. *Mary Cassatt: Modern Woman*, exhibition catalog. Chicago: Art Institute of Chicago; New York: Harry N. Abrams, 1998.

Beurdeley, Yveling Rambaud. "Miss Cassatt." *L'Art dans les deux mondes*, no. 1 (November 22, 1890): 7.

Biddle, George. "Some Memories of Mary Cassatt." *Arts* 10 (August 1926): 107–11.

Breeskin, Adelyn D. *The Graphic Work of Mary Cassatt, a Catalogue Raisonné*. New York: H. Bittner, 1948.

———. *The Paintings of Mary Cassatt*. New York: M. Knoedler and Co., 1966.

———. *Mary Cassatt, 1844–1926*, exhibition catalog. Washington, D.C.: National Gallery of Art, Smithsonian Institution, 1970.

———. *Mary Cassatt: A Catalogue Raisonné of the Oils, Pastels, Water-Colors, and Drawings*. Washington, D.C.: Smithsonian Institution Press, 1970.

———. *Mary Cassatt, Pastels and Color Prints*, exhibition catalog. Washington, D.C.: National Collection of Fine Arts, 1978.

Breuning, M. *Mary Cassatt*. New York: Hyperion Press, 1944.

Brinton, Christian. "Concerning Miss Cassatt and Certain Etchings." *International Studio* 27 (February 1906): i–vi.

Bullard, E. John. *Mary Cassatt, Oils and Pastels*. New York: Watson-Guptill Publications, 1972.

———. "An American in Paris: Mary Cassatt." *American Artist* 37 (March 1973): 40–47, 75–76.

Carson, Julia Margaret Hicks. *Mary Cassatt*. New York: D. McKay, 1966.

Cary, Elizabeth Luther. "The Art of Mary Cassatt." *Scrip* 1 (October 1905): 1–5.

Constantino, Maria. *Mary Cassatt*. New York: Barnes & Noble Books, 1995.

Denoinville, Georges. "Mary Cassatt, peintre des enfants et des mères." *Byblis* 7 (winter 1928): 121–23.

Fuller, Sue. "Mary Cassatt's Use of Soft-Ground Etching." *American Magazine of Art* 43 (February 1950): 54–57.

Geffroy, Gustave. *La Vie artistique*. Paris: E. Dentu Editeur, 1894.

———. "Femmes artistes: Un Peintre de l'enfance, Miss Mary Cassatt." *Les Modes* 4 (February 1940): 4–11.

Getlein, Frank. *Mary Cassatt: Paintings and Prints*. New York: Abbeville Press, 1980.

Grafly, Dorothy. "In Retrospect—Mary Cassatt." *American Magazine of Art* 18 (June 1927): 305–12.

Hale, Nancy. *Mary Cassatt, A Biography of the Great American Painter*. Garden City, N.Y.: Doubleday and Co., 1975.

Havemeyer, Louisine E. "The Cassatt Exhibition." *Pennsylvania Museum Bulletin* 22 (May 1927): 373–82.

Hess, Thomas B. "Degas-Cassatt Story." *Art News* 46 (November 1947): 18–20, 52–53.

Hoeber, Arthur. "Mary Cassatt." *Century* 57 (March 1899): 740–41.

Hyslop, Francis E., Jr. "Berthe Morisot and Mary Cassatt." *College Art Journal* 13 (spring 1954): 179–84.

Ivins, William M., Jr. "New Exhibition in the Print Galleries: Prints by Mary Cassatt." *Bulletin of The Metropolitan Museum of Art* 22 (January 1927): 8–10.

Johnson, Lincoln. *Paintings, Drawings and Graphic Works by Manet, Degas, Berthe Morisot and Mary Cassatt*, exhibition catalog. Baltimore: Baltimore Museum of Art, 1962.

Johnson, Una. "The Graphic Art of Mary Cassatt." *American Artist* 9 (November 1945): 18–21.

Kysela, John D. "Mary Cassatt's Mystery Mural and the World's Fair of 1893." *Art Quarterly* 29 (1966): 129–45.

Lecomte, Georges. *L'Art impressionniste*, Paris, 1892.

Leeper, John P. "Mary Cassatt and Her Parisian Friends." *Bulletin of the Pasadena Art Institute* 2 (October 1951): 1–9.

Love, Richard H. *Cassatt: The Independent*. Chicago: Richard H. Love, 1980.

Lowe, David. "Mary Cassatt." *American Heritage* 25 (December 1973): 10–21, 96–100.

Lucas, E. V. "Mary Cassatt." *Ladies' Home Journal* 44 (November 1927): 24, 161.

MacChesney, Clara T. "Mary Cassatt and Her Work." *Arts and Decoration* 3 (June 1913): 265–67.

Mancoff, Debra M. *Mary Cassatt: Reflections of Women's Lives*. New York: Stewart, Tabori & Chang, 1998.

Mary Cassatt: An American Observer, exhibition catalog. New York: Coe Kerr, 1984.

"Mary Cassatt's Achievement: Its Value to the World of Art." *Craftsman* 19 (March 1911): 540–46.

Mary Cassatt among the Impressionists, exhibition catalog. Omaha, Nebr.: Joslyn Art Museum, 1969.

Mathews, Nancy Mowll. *Cassatt and Her Circle: Selected Letters*. New York: Abbeville Press, 1984.

———. *Mary Cassatt*. New York: Harry N. Abrams, in association with the National Museum of American Art, Smithsonian Institution, Washington, D.C., 1987.

———. *Mary Cassatt: A Life*. New York: Villard Books, 1994.

———, ed. *Cassatt: A Retrospective*. [New York?]: Hugh Lauter Levin Associates, 1996.

Mathews, Nancy Mowll and Barbara Stein Shapiro. *Mary Cassatt: The Color Prints*, exhibition catalog. New York: Harry N. Abrams, in association with the Williams College Museum of Art, 1989.

Mauclair, Camille [Camille Faust]. "Un Peintre de l'enfance, Miss Mary Cassatt." *L'Art décoratif* 8 (August 1902): 177–85.

———. *The French Impressionist (1860–1900)*. Translated by P. G. Konody. London: Duckworth and Co., 1911.

———. *Les Maîtres de l'impressionnisme*. Paris: Librarie Ollendorff, 1923.

McKown, Robin. *The World of Mary Cassatt*. New York: T. Y. Crowell, 1972.

Mellerio, Andre. *L'Exposition des oeuvres de Mary Cassatt*, exhibition catalog. Paris: Galeries Durand-Ruel, 1893.

———. "Mary Cassatt." *L'Art et les artistes* 12 (November 1910): 69–75.

Merrick, Lula. "The Art of Mary Cassatt." *Delineator* 74 (August 1909): 121, 132.

Milkovich, Michael. *Mary Cassatt and the American Impressionists*, exhibition catalog. Memphis, Tenn.: Dixon Gallery and Gardens, 1976.

Myers, Elizabeth P. *Mary Cassatt, A Portrait*. Chicago: Reilly and Lee, 1971.

Newman, Gemma. "The Greatness of Mary Cassatt." *American Artist* 30 (February 1966): 42–49.

Pica, Vittorio. "Artisti Contemporanei: Berthe Morisot—Mary Cassatt." *Emporium* 26 (July 1907): 3–16.

Pollock, Griselda. *Mary Cassatt*. New York: Harper and Row, 1979.

Riordan, Roger. "Miss Mary Cassatt." *Art Amateur* 38 (May 1898): 130.

Rosen, Marc, et al. *Mary Cassatt: Prints and Drawings from the Artist's Studio*, exhibition catalog. Princeton, N.J.: Princeton University Press, 2000.

Segard, Achille. *Mary Cassatt, Un Peintre des enfants et des mères*. Paris: Ollendorff, 1913.

Shapiro, Barbara Stern. *Mary Cassatt at Home*, exhibition catalog. Boston: Museum of Fine Arts, 1978.

———. *Mary Cassatt: Impressionist at Home*. New York: Universe Publishing, 1998.

Sweet, Frederick A. "America's Greatest Woman Painter: Mary Cassatt." *Vogue* 123 (February 15, 1954): 102–3, 123.

———. "A Chateau in the Country." *Art Quarterly* 21 (summer 1958): 202–15.

———. *Miss Mary Cassatt: Impressionist from Pennsylvania.* Norman, Okla.: University of Oklahoma Press, 1966.

Tabarant, Adolphe. "Les Disparus—Miss Mary Cassatt." *Bulletin de la vie artistique* 7 (July 1926): 205–6.

Teall, Gardner. "Mother and Child, The Theme as Developed in the Art of Mary Cassatt." *Good Housekeeping* 50 (February 1910): 141.

———. "America's World-Famous Woman Artist." *Hearst's Magazine* 21 (January 1912): 1659–62.

Valerio, Edith. *Mary Cassatt.* Paris: Les Éditions G. Crès, 1930.

Walton, William. "Miss Mary Cassatt." *Scribner's Magazine* 19 (March 1896): 353–61.

Watson, Forbes. "Mary Cassatt." *Arts* 10 (July 1926): 3–4.

———. "Philadelphia Pays Tribute to Mary Cassatt." *Arts* 11 (June 1927): 289–97.

———. *Mary Cassatt.* American Artists Series. New York: Whitney Museum of American Art, 1932.

Webster, Sally. "Mary Cassatt's Allegory of Modern Woman." *Helicon Nine* 1 (fall–winter 1979): 38–47.

Weitenkampf, Frank. "Some Women Etchers." *Scribner's Magazine* 46 (December 1909): 731–39.

———. "The Drypoints of Mary Cassatt." *Print Collector's Quarterly* 6 (December 1916): 397–409.

Welch, M. L. "Mary Cassatt." *American Society of the Legion of Honor Magazine* 25 (summer 1954): 155–65.

Wilson, Ellen. *American Painter in Paris: A Life of Mary Cassatt.* New York: Farrar, Straus and Giroux, 1971.

Witzling, Mara R. *Mary Cassatt: A Private World: Illustrations from the National Gallery of Art.* New York: Universe Books, 1991.

Yeh, Susan Fillin. "Mary Cassatt's Images of Women." *Art Journal* 35 (summer 1976): 359–63.

Zerbe, Kathryn J. "Mother and Child: A Psychobiographical Portrait of Mary Cassatt." *Psychoanalytic Review* 74 (spring 1987): 51.

William Chadwick

Love, Richard H. *William Chadwick (1879–1962): An American Impressionist,* exhibition catalog. Old Lyme, Mass.: Lyme Historical Society, 1978.

William Merritt Chase

Atkinson, D. Scott, and Nicolai Cikovsky, Jr. *William Merritt Chase: Summers at Shinnecock, 1891–1902,* exhibition catalog. Washington, D.C.: National Gallery of Art, Smithsonian Institution, 1987.

Baer, William J. "Reformer and Iconoclast." *Quarterly Illustrator* 1 (1893): 135–41.

Baynes, Lillian. "Summer School at Shinnecock Hills." *Art Amateur* 31 (October 1894): 91–92.

Bryant, Keith L., Jr. *William Merritt Chase: A Genteel Bohemian.* Columbia, Mo.: University of Missouri Press, 1991.

Cox, Kenyon. "William M. Chase, Painter." *Harper's New Monthly Magazine* 78 (March 1889): 549–57.

De Kay, Charles. "Mr. Chase and Central Park." *Harper's Weekly* 35 (May 2, 1891): 327–28.

Emmet, Rosina H. "The Shinnecock Art School. *Art Interchange* 31 (October 1893): 89–90.

Gallati, Barbara Dayer. *William Merritt Chase.* New York: Harry N. Abrams, Inc. in association with the National Museum of American Art, Smithsonian Institution, Washington, D.C., 1995.

———. *William Merritt Chase: Modern American Landscapes, 1886–1980,* exhibition catalog. New York: Brooklyn Museum of Art in association with Harry N. Abrams, Inc., 2000.

Jones, Jessie B. "Where the Bay-Berry Grows: Sketches at Mr. Chase's Summer School." *Modern Art* 3 (autumn 1895): 109–14.

Lauderbach, Frances. "Notes from Talks by William M. Chase: Summer Class, Carmel-By-The-Sea, California—Memoranda from a Student's Note-Book." *American Magazine of Art* 8 (September 1917): 432–38.

Milgrome, Abraham David. "The Art of William Merritt Chase." Ph.D. dissertation, University of Pittsburgh, 1969.

"Out-of-Door Sketching: A Talk by William M. Chase." *Art Interchange* 39 (July 1897): 8–9.

Pisano, Ronald G. *The Students of William Merritt Chase,* exhibition catalog. Huntington, N.Y.: Heckscher Museum, 1973.

———. *William Merritt Chase (1849–1916),* exhibition catalog. New York: M. Knoedler and Co., 1976.

———. *William Merritt Chase.* New York: Watson-Guptill Publications, 1979.

———. *William Merritt Chase in the Company of Friends.* Southampton, N.Y.: Parrish Art Museum, 1979.

———. *A Leading Spirit in American Art: William Merritt Chase 1849–1916,* exhibition catalog. Seattle: University of Washington, Henry Art Gallery, 1983.

———. *Summer Afternoons: Landscape Paintings of William Merritt Chase.* Boston: Little, Brown, 1993.

Pisano, Ronald G., and Alicia Grant Longwell. *Photographs from the William Merritt Chase Archives at the Parrish Art Museum,* exhibition catalog. Southampton, N.Y.: Parrish Art Museum, 1992.

Roof, Katherine Metcalf. "William Merritt Chase: An American Master." *Craftsman* 18 (April 1910): 33–45.

———. *The Life and Art of William Merritt Chase.* New York: Charles Scribner's Sons, 1917.

Sherwood, May Clara. "Shinnecock Hills School of Art." *Arts* 4 (December 1895): 171–73.

Speed, John Gilmer. "An Artist's Summer Vacation." *Harper's New Monthly Magazine* 87 (June 1893): 3–14.

Alson Skinner Clark

"Alson Skinner Clark, Artist." *California Southland* 9 (March 1927): 28–29.

Stern, Jean. *Alson S. Clark.* Los Angeles: Petersen Publishing Co., 1983.

———. "Alson Clark: An American at Home and Abroad." In Patricia Trenton and William H. Gerdts, *California Light, 1900–1930,* exhibition catalog. Laguna Beach, Calif.: Laguna Beach Art Museum, 1990.

Whiting, Elizabeth. "Painting in the Far West: Alson Clark, Artist." *California Southland* 1–3 (February 1922): 8–9.

Eliot Clark

Eliot Clark: American Impressionist 1883–1980, exhibition catalog. New York: Hammer Galleries, 1981.

Eliot Clark, N.A. Retrospective Exhibition, exhibition catalog. Charlottesville, Va.: University of Virginia Art Museum, 1975.

Love, Richard H. *Walter Clark (1848–1917) and Eliot Clark (1883–1980): A Tradition in American Painting,* exhibition catalog. Chicago, 1980.

Kate Freeman Clark

Summers of '96: Shinnecock Revisited; The Inspiration of Kate Freeman Clark by William Merritt Chase, exhibition catalog. Laurel, Miss.: Lauren Rogers Museum of Art, 1996.

Tucker, Cynthia Grant. *Kate Freeman Clark, A Painter Rediscovered.* Jackson, Miss.: University Press of Mississippi, 1981.

Charles Courtney Curran

Cook, Clarence. "A Representative American Artist." *Monthly Illustrator* 11 (November 1895): 289–92.

Curran, Charles C. "Class in Oil Painting." *Palette and Bench* 1 (December 1908): 52–57; (July 1909): 216–19; 2 (December 1909): 68–71.

Dreiser, Theodore. "C.C. Curran." *Truth* 18 (September 1899): 227–31.

St. Gaudens, Homer. "Charles Courtney Curran." *Critic* 48 (January 1906): 38–39.

Charles Harold Davis

"Charles H. Davis—Landscapist." *International Studio* 75 (June 1922): 177–83.

Colville, Thomas L. *Charles Harold Davis N.A. 1856–1933,* exhibition catalog. Mystic, Conn.: Mystic Art Association, 1982.

Davis, Charles H. "A Study of Clouds." *Palette and Bench* 1 (September 1909): 261–62.

Downes, William Howe. "Charles H. Davis's Landscapes." *New England Magazine* 27 (December 1902): 423–37.

Gillet, Louis Bliss. "Charles H. Davis." *American Magazine of Art* 27 (March 1934): 105–12.

"Landscape Paintings by Charles H. Davis at Pratt Institute, Brooklyn." *Artist* 26 (January 1900): lxxxi–lxxxii.

Dawson Dawson-Watson

A Collection of the Works of Mr. Dawson-Watson, exhibition catalog. St. Louis: City Art Museum of Saint Louis, 1912.

Curley, F. E. A. "Dawson-Watson, Pinx." *Reedy's Mirror* 22 (December 5, 1913): 12–13.

Dawson-Watson, Dawson. "The Rolling-Pin in Art." *Literary Review* 1 (May 1897): 70.

———. "Impressionism." *Mirror* 17 (March 28, 1907): 33.

———. "The Real Story of Giverny." In Eliot Clark, *Theodore Robinson: His Life and Art.* Chicago: R. H. Love Galleries, 1979, pp. 65–67.

Fisk, Francis Battaile. *A History of Texas Artists and Sculptors.* Abilene, Tex.: Fisk Publishing Co., 1928, pp. 30–32.

"Glory of the Morning." *Pioneer Magazine* 7 (April 1927): 5–6, 12.

Hutchings, Emily Grant. "Art and Artists." *Globe Dispatch* (St. Louis), July 12, 1925.

"Kindly Caricatures, No. 99: Dawson-Watson." *Mirror* 17 (March 19, 1907): 7–8.

Joseph DeCamp

Agassiz, George R. *Joseph DeCamp: An Appreciation.* Boston, 1923.

Berry, Rose V. S. "Joseph DeCamp: Painter and Man." *American Magazine of Art* 14 (April 1923): 182–89.

Buckley, Laurene. *Joseph DeCamp: Master Painter of the Boston School.* New York: Prestel Verlag, 1995.

Coburn, Frederick W. "Joseph DeCamp's 'The Guitar Girl.'" *New England Magazine* 39 (October 1908): 238–39.

Court, Lee W., comp. and ed. *Joseph DeCamp, An Appreciation.* Boston: State Normal Art School, 1924.

Downes, William Howe. "Joseph DeCamp and His Work." *Art and Progress* 4 (April 1913): 918–25.

Hoeber, Arthur. "DeCamp, A Master of Technique." *Arts and Decoration* 1 (April 1911): 248–50.

Thomas Wilmer Dewing

Caffin, Charles H. "Exhibition of Works by Thomas W. Dewing." *Artist* 27 (April 1900): xxi–xxiii.

———. "The Art of Thomas W. Dewing." *Harper's New Monthly Magazine* 116 (April 1908): 714–24.

Cortissoz, Royal. "An American Artist Canonized in the Freer Gallery." *Scribner's Magazine* 74 (November 1923): 539–46.

Ely, Catherine Beach. "Thomas W. Dewing." *Art in America* 10 (August 1922): 224–29.

Hartmann, Sadakichi. "Thomas W. Dewing." *Art Critic* 1 (January 1894): 34–36.

Hobbs, Susan. "Thomas Dewing in Cornish, 1885–1905." *American Art Journal* 17 (spring 1985): 2–32.

———. "Thomas Wilmer Dewing: The Early Years, 1851–1885." *American Art Journal* 13 (spring 1981): 4–35.

———. *The Art of Thomas Wilmer Dewing: Beauty Reconfigured,* exhibition catalog. Brooklyn, N.Y.: Brooklyn Museum in association with Smithsonian Institution Press, Washington, D.C., 1996.

Hobbs, Susan, and Barbara Dayer Gallati. "Thomas Wilmer Dewing: An Artist Against the Grain." *Antiques* 149 (March 1996): 416–27.

Lyczko, Judith Elizabeth. "Thomas Wilmer Dewing's Sources: Women in Interiors." *Arts Magazine* 54 (November 1979): 152–57.

Pyne, Kathleen. "Classical Figures, a Folding Screen by Thomas Dewing." *Bulletin of the Detroit Institute of Arts* 59 (spring 1981): 4–15.

St. Gaudens, Homer. "Thomas W. Dewing." *Critic* 48 (May 1906): 418–19.

Tharp, Ezra. "T. W. Dewing." *Art and Progress* 5 (March 1914): 155–61.
———. "'Gloria' and 'The Musician' by Thomas W. Dewing." *Art World* 3 (December 1917): 187–89.
White, Nelson G. "The Art of Thomas W. Dewing." *Art and Archeology* 27 (June 1929): 253–61.
———. *Thomas W. Dewing*, exhibition catalog. New York: Durlacher Brothers, 1963.
Van Hook, Bailey. *Commerce and Agriculture: Bringing Wealth to Detroit: A Mural by Thomas Wilmer Dewing*. New York: Spanierman Gallery, 1998.

Frank Vincent DuMond
Abrams, Herbert E. "Our Heritage from Frank Vincent DuMond." *League* (spring 1951): 2–3, 23.
———. "The Teaching of Frank Vincent DuMond: Penetrating Light." *American Artist* 38 (March 1974): 36–45, 65–67.
Andersen, Jeffrey W., and Charles B. Ferguson. *The Harmony of Nature: The Art and Life of Frank Vincent DuMond, 1865–1951*, exhibition catalog. Old Lyme, Conn.: Florence Griswold Museum, 1990.
Frank Vincent DuMond, exhibition catalog. New York: Art Students League Gallery, 1949.
Gertsenhaber, Rachel. "The Early Works of Frank Vincent DuMond (1865–1952)." Senior essay, Yale University, 1987.
Mellin, Barbara Rizza. "Universal Truths and the Laws of Nature: The Life, Art and Teaching of Frank Vincent DuMond." Master's thesis, Harvard University, 1994.
A Memorial Exhibition of Paintings by Frank Vincent DuMond, N.A. Sponsored by the Art Students League of N.Y., exhibition catalog. New York: National Academy of Design, 1952.

Charles H. Ebert
Charles H. Ebert 1873–1959, exhibition catalog. New London, Conn.: Lyman Allyn Museum, 1979.

John J. Enneking
Closson, William Baxter. "The Art of John J. Enneking." *International Studio* 76 (October 1922): 3–6
Davol, Ralph. "The Work of John J. Enneking." *American Magazine of Art* 8 (June 1917): 320–23.
"John J. Enneking." *Photo Era* 38 (January 1917): 30.
John J. Enneking, American Impressionist, exhibition catalog. Brockton, Mass.: Brockton Art Center—Fuller Memorial, 1974.
Kristiansen, Rolf. "John J. Enneking: An Artist Rediscovered." *American Artist* 26 (October 1962): 45–47, 71–72.
Pierce, Patricia Jobe, and Rolf H. Kristiansen. *John Joseph Enneking: American Impressionist Painter*. Hingham, Mass.: Pierce Galleries, 1972.
Rittenhouse, Jessie B. "The Art of John J. Enneking." *Brush and Pencil* 10 (September 1902): 335–45.

Will Howe Foote
Sweeney, J. Gray. "Will Howe Foote (1874–1965)." In *Artists of Michigan from the Nineteenth Century*, exhibition catalog. Muskegon, Mich.: Muskegon Museum of Art, 1987, pp. 182–187.
Watson, Forbes. "Will Howe Foote." *Arts* 1 (August–September 1921): 4–9, 20–21.
Will Howe Foote American Impressionist, exhibition catalog. New York: SKT Galleries, 1978.

Frederick Carl Frieseke
The American Painter F. C. Frieseke: The Small Retrospective, exhibition catalog. New Bedford, Mass.: Swain School of Design, 1974.
Chambers, Bruce W. *Frederick C. Frieseke: Women in Repose*, exhibition catalog. New York: Berry-Hill Galleries, 1990.
Domit, Moussa M. *Frederick Frieseke, 1874–1939*, exhibition catalog. Savannah, Ga.: Telfair Academy of Arts and Sciences, 1974.
"Frieseke, at 68, Turns to Pure Landscape." *Art Digest* 6 (March 1932): 12.

Gallatin, Albert E. "The Paintings of Frederick C. Frieseke." *Art and Progress* 3 (October 1912): 747–49.
Kilmer, Nicholas. *A Place in Normandy*. New York: Henry Holt & Co., 1997.
———. *Chamber Works by Frederick C. Frieseke*, exhibition catalog. New York: Hollis Taggart Galleries, 2000.
———. *Uneventful Reminiscences: A Childhood in Florida; Frederick C. Frieseke*. New York: Hollis Taggart Galleries, 2000.
Kilmer, Nicholas, and Ben L. Summerford. *A Retrospective Exhibition of the Work of F. C. Frieseke*, exhibition catalog. San Francisco: Maxwell Galleries, 1982.
Kilmer, Nicholas, et al. *Frederick Carl Frieseke: The Evolution of an American Impressionist*, exhibition catalog. Savannah: Telfair Museum of Art in association with Princeton University Press, 2001.
The Last Expatriate: F. C. Frieseke, exhibition catalog. Fayetteville, N.C.: Museum of Art, 1980.
Leclere, Tristan. "La Décoration d'un hôtel américain." *L'Art décoratif* 8 (1906): 195–200.
Lucas, E. V. "John White Alexander and Frederick Carl Frieseke." *Ladies' Home Journal* 43 (July 1926): 16–17, 126.
MacChesney, Clara. "Frederick Carl Frieseke—His Work and Suggestions for Painting from Nature." *Arts and Decoration* 3 (November 1912): 13–15.
———. "Frieseke Tells Some of the Secrets of His Art." *New York Sunday Times*, June 7, 1914, sec. 6, p. 7.
Occhini, Pier Ludovico. "Karl Frédéric' Frieseke." *Vita d'arte* 7 (February 1911): 58–68.
Pancza, Arlene. "Frederick Carl Frieseke (1874–1939)." In J. Gray Sweeney, *Artists of Michigan from the Nineteenth Century*. Muskegon, Mich.: Muskegon Museum of Art, 1987, pp. 168–73.
Pica, Vittorio. "Artisti contemporanei: Frederick Carl Frieseke." *Emporium* 38 (November 1913): 323–37.
A Retrospective Exhibition of the Work of F. C. Frieseke, exhibition catalog. San Francisco: Maxwell Galleries, 1982.
Taylor, E. A. "The Paintings of F. C. Frieseke." *International Studio* 53 (October 1914): 259–67.
"Three Paintings of the Nude by Frederick Carl Frieseke." *International Studio* 76 (November 1922): 153–55.
Walton, William. "Two Schools of Art: Frank Duveneck, Frederick C. Frieseke." *Scribner's Magazine* 58 (November 1915): 643–46.
Weller, Allen S. *Frederick Frieseke, 1874–1939*. New York: Hirschl and Adler Galleries, 1966.
———. "Frederick Carl Frieseke: The Opinions of an American Impressionist." *Art Journal* 28 (winter 1968): 160–65.

Daniel Garber
Breck, Bayard. "Daniel Garber: A Modern American Master." *Art and Life* 11 (March 1920): 493–97.
Foster, Kathleen A. *Daniel Garber 1880–1958*, exhibition catalog. Philadelphia: Pennsylvania Academy of the Fine Arts, 1980.
Lucas, E. V. "Daniel Garber and Edward Redfield." *Ladies' Home Journal* 43 (May 1926): 20–21, 74.
Pitz, Henry. "Daniel Garber." *Creative Art* 2 (April 1928): 252–56.
Teall, Gardner. "Daniel Garber: Exponent of Nationalism in Art." *Hearst's International* 35 (January 1917): 11, 46.
———. "In True American Spirit, The Art of Daniel Garber." *Hearst's International* 39 (June 1921): 28, 77.

Selden Connor Gile
A Feast for the Eyes. The Paintings of Selden Connor Gile, exhibition catalog. Walnut Creek, Calif.: Civic Arts Gallery, 1983.
Paintings by Selden Connor Gile 1877–1947, An Exhibition of Paintings in Oil and Water Color from the Collection of James L. Coran and Walter A. Nelson-Rees, exhibition catalog. Oakland, Calif.: Sohlman Art Gallery, 1982.

William J. Glackens
At Home Abroad: William Glackens in France, 1925–1932, exhibition catalog. New York: Kraushaar Galleries, 1997.
Breuning, Margaret. "Comprehensive View of William Glackens." *Art Digest* 23 (January 1, 1949): 12.
De Gregorio, Vincent John. "The Life and Art of William J. Glackens." Ph.D. diss., Ohio State University, 1955.
De Mazia, Violette. "The Case of Glackens vs. Renoir." In *Journal of the Art Department* 2 (autumn 1971): 3–30. Merion Station, Pa.: Barnes Foundation.
Du Bois, Guy Pène. "William Glackens, Normal Man." *Arts and Decoration* 4 (September 1914): 404–6.
———. *William J. Glackens*, exhibition catalog. New York: Whitney Museum of American Art, 1931.
Flower Paintings by William Glackens and Alfred H. Maurer, exhibition catalog. New York: Kraushaar Galleries, 1997.
Gallatin, Albert E. "The Art of William J. Glackens: A Note." *International Studio* 40 (May 1910): 68–71.
———. "William Glackens." *American Magazine of Art* 7 (May 1916): 261–63.
Gerdts, William H., and H. Santis Jorge. *William Glackens*. New York: Abbeville Press, 1996.
Glackens, Ira. *William Glackens and the Ashcan Group: The Emergence of Realism in American Art*. New York: Crown Publishers, 1957.
Glackens, William J. "The American Section: The National Art." *Arts and Decoration* 3 (March 1913): 159–64.
Katz, Leslie. *William Glackens in Retrospect*, exhibition catalog. St. Louis: City Art Museum of Saint Louis, 1966.
Pach, Walter. "William J. Glackens." *Shadowland* 7 (October 1922): 10–11, 76.
Roberts, Mary Fanton. "Glackens' Walter Hampden." *Arts* 1 (December 4, 1920): 16–17.
Salpeter, Harry. "America's Sun Worshipper." *Esquire* 7 (May 1937): 87–88, 190–92.
Shinn, Everett. "William Glackens as an Illustrator." *American Artist* 9 (November 1945): 22–27, 37.
Watson, Forbes. "William Glackens—An Artist Who Seizes the Colorful and Interesting Aspects of Life." *Arts and Decoration* 14 (December 1920): 103, 152.
———. *William Glackens*. New York: Duffield and Co., 1923.
———. "William Glackens." *Arts* 3 (April 1923): 246–60.
———. "A Note on William Glackens." *American Magazine of Art* 30 (November 1937): 659, 700.
———. "Glackens." *Magazine of Art* 32 (January 1939): 4–11.
———. *William Glackens Memorial Exhibition*, exhibition catalog. San Francisco: San Francisco Museum of Art, 1939.
Wattenmaker, Richard J. *The Art of William Glackens*, exhibition catalog. New Brunswick, N.J.: Rutgers, the State University, 1967.
William Glackens, exhibition catalog. New York: Owen Gallery, 1995.
William Glackens: Portrait and Figure Painter, exhibition catalog. Fort Lauderdale, Fla.: Fort Lauderdale Museum of Art, 1994.
"W. J. Glackens: His Significance to the Art of His Day." *Touchstone* 7 (June 1920): 191–99.

Arthur Clifton Goodwin
Emerson, Sandra, Lucretia H. Giese, and Laura C. Luckey. *A. C. Goodwin, 1864–1929*, exhibition catalog. Boston: Museum of Fine Arts, 1974.
Venturi, Lionello. *Arthur Clifton Goodwin: A Selective Exhibition*, exhibition catalog. Andover, Mass.: Phillips Academy, Addison Gallery of American Art, 1946.

Edmund W. Greacen
Knudsen, Elizabeth Greacen. *Edmund W. Greacen, N.A., American Impressionist, 1876–1949*, exhibition catalog. Jacksonville, Fla.: Cummer Gallery of Art, 1972.

Walter Griffin

Cortissoz, Royal, and Frederic Newlin Price. *Walter Griffin.* New York: Ferargil, 1935.

Love, Richard H. *Works by Walter Griffin (1861–1935),* exhibition catalog. Chicago: Signature Galleries, 1975.

Lovejoy, Rupert. "The Life and Work of Walter Griffin, 1861–1935." *American Art Review* 2 (September–October 1975): 99–107.

Merrick, Lulu. "Walter Griffin, Artiste." *International Studio* 62 (August 1917): 45–48.

Walter Griffin 1861–1935: Maine Impressionist, exhibition catalog. Rockland, Maine: William A. Farnsworth Library and Museum, 1978.

Lillian Westcott Hale

Berry, Rose V. S. "Lillian Westcott Hale—Her Art." *American Magazine of Art* 18 (February 1927): 59–70.

Hardwicke, Greer, and Rob Leith. *Two Dedham Artists: Philip and Lillian Hale,* exhibition catalog. Dedham, Mass.: Dedham Historical Society, 1987.

Hirshler, Erica F. *Lillian Westcott Hale (1880–1963): A Woman Painter of the Boston School.* Ph.D. dissertation, Boston University, 1992. Published, Ann Arbor, Mich.: UMI Press, 1992.

———. *"Drawn with Butterfly's Wings": The Art of Lillian Westcott Hale,* exhibition catalog. Weston, Mass.: Regis College, 1999.

Philip Leslie Hale

Castano, John. *Oils and Drawings by Philip Leslie Hale, 1865–1931,* exhibition catalog. Boston: Castano Galleries, 1951.

Coburn, Frederick W. "Philip L. Hale, Artist and Critic." *World Today* 14 (January 1908): 59–67.

———. "Philip L. Hale's 'The Art Students.'" *New England Magazine* 38 (April 1908): 196–97.

———. "Philip L. Hale, An Appreciation." In Philip Leslie Hale, *Vermeer.* Completed by Frederick W. Coburn and Ralph T. Hale. Boston and New York, 1937. Revised edition of Philip Leslie Hale, *Jan Vermeer of Delft.* Boston, 1913.

Folts, Franklin P. *Paintings and Drawings by Philip Leslie Hale (1865–1931) from the Folts Collection,* exhibition catalog. Boston: Vose Galleries of Boston, 1966.

Hale, Nancy. *The Life in the Studio.* Boston: Little, Brown, 1969.

Hardwicke, Greer, and Rob Leith. *Two Dedham Artists: Philip and Lillian Hale,* exhibition catalog. Dedham, Mass.: Dedham Historical Society, 1987.

Lowrey, Carol. "The Art of Philip Leslie Hale." In *Philip Leslie Hale, A.N.A.,* exhibition catalog. Boston: Vose Galleries, 1988, pp. 3–11.

"The Philip L. Hale Memorial Exhibition." *Bulletin of the Museum of Fine Arts, Boston* 29 (December 1931): 113–16.

Marsden Hartley

Ferguson, Gerald, ed. *Marsden Hartley and Nova Scotia.* Halifax: Mount Saint Vincent University Art Gallery, in association with the Press of the Nova Scotia College of Art and Design and the Art Gallery of Ontario, Toronto, 1987.

Hartley, Marsden. *Adventures in the Arts.* New York: Boni and Liveright, 1921.

———. *Somehow a Past: The Autobiography of Marsden Hartley.* Edited, with an introduction, by Susan Elizabeth Ryan. Cambridge, Mass.: MIT Press, 1995.

Haskell, Barbara. *Marsden Hartley,* exhibition catalog. New York: Whitney Museum of American Art, 1980.

Hokin, Jeanne. *Pinnacle & Pyramids: The Art of Marsden Hartley.* Albuquerque: University of New Mexico Press, 1993.

Levin, Gail. *Marsden Hartley in Bavaria,* exhibition catalog. Clinton, N.Y.: Emerson Gallery, Hamilton College, 1989.

Ludington, Townsend. *Marsden Hartley: The Biography of an American Artist.* Boston: Little, Brown, 1992.

Marsden Hartley, exhibition catalog. New York: The Museum of Modern Art, 1944.

McCausland, Elizabeth. *Marsden Hartley.* Minneapolis: University of Minnesota Press, 1952.

McDonnell, Patricia. *Marsden Hartley: American Modern,* exhibition catalog. Minneapolis: Frederick R. Weisman Art Museum, University of Minnesota, 1997.

Robertson, Bruce. *Marsden Hartley.* New York: Harry N. Abrams, in association with the National Museum of American Art, Smithsonian Institution, 1994.

Scott, Gail R. *Marsden Hartley.* New York: Abbeville Press, 1988.

Childe Hassam

Adams, Adeline. *Childe Hassam.* New York: American Academy of Arts and Letters, 1938.

Adelson, Warren, Jay E. Cantor, and William H. Gerdts. *Childe Hassam, Impressionist.* New York: Abbeville Press, 1999.

"An Almost Complete Exhibition of Childe Hassam." *Arts and Decoration* 6 (January 1916): 136.

Arms, John Taylor. "Childe Hassam, Etcher of Light." *Prints* 4 (November 1933): 1–12.

"Art. The Etchings of Childe Hassam." *Nation* 101 (December 9, 1915): 698–99.

Beuf, Carlos. "The Etchings of Childe Hassam." *Scribner's Magazine* 84 (October 1928): 415–22.

Bienenstock, Jennifer A. Martin. "Childe Hassam's Early Boston Cityscapes." *Arts Magazine* 55 (November 1980): 168–71.

Buchanan, Charles L. "The Ambidextrous Childe Hassam." *International Studio* 67 (January 1916): lxxxiii–lxxxvi.

Buckley, Charles E. *Childe Hassam: A Retrospective Exhibition,* exhibition catalog. Washington, D.C.: Corcoran Gallery of Art, 1965.

Burke, Doreen Bolger, and David W. Kiehl. *Childe Hassam as Printmaker,* exhibition catalog. New York: The Metropolitan Museum of Art, 1977.

A Catalogue of an Exhibition of the Works of Childe Hassam. New York: American Academy of Arts and Letters, 1927.

Catalogue of Oil Paintings and Water Colors by Mr. Childe Hassam, exhibition catalog. Boston: Noyes, Cobb and Co., 1887.

Childe Hassam, exhibition catalog. Detroit: J. L. Hudson Gallery, 1968.

Childe Hassam, exhibition catalog. New York: Hammer Galleries, 1969.

Childe Hassam, exhibition catalog. New York: Hirschl and Adler Galleries, 1974.

Childe Hassam, exhibition catalog. New York: American Academy and Institute of Arts and Letters, 1981.

Childe Hassam, 1859–1935, exhibition catalog. New York: A C A Heritage Gallery, 1965.

Childe Hassam, 1859–1935, exhibition catalog. Tucson: University of Arizona Museum of Art, 1972.

Childe Hassam 1859–1935, exhibition catalog. East Hampton, N.Y.: Guild Hall Museum, 1981.

Childe Hassam: An Exhibition of His "Flag Series" Commemorating the Fiftieth Anniversary of Armistice Day, exhibition catalog. New York: Bernard Danenberg Galleries, 1968.

Childe Hassam in Indiana, exhibition catalog. Muncie, Ind.: Ball State University Art Gallery, 1985.

"Childe Hassam and His Prints." *Prints* 6 (October 1935): 2–14, 59.

Clark, Eliot. "Childe Hassam." *Art in America* 8 (June 1920): 172–80.

Colt, Priscilla C. "Childe Hassam in Oregon." *Portland Art Museum Bulletin* 14 (March 1953): n.p.

Cortissoz, Royal. Introduction to *The Etchings and Dry-Points of Childe Hassam, N.A.* New York: Charles Scribner's Sons, 1925.

Curry, David Park. *Childe Hassam: An Island Garden Revisited,* exhibition catalog. New York: Denver Art Museum, in association with W.W. Norton, 1990.

Czestochowski, Joseph S. *Childe Hassam Impressions,* exhibition catalog. Memphis, Tenn.: Brooks Memorial Art Gallery, n.d.

———. "Childe Hassam Paintings from 1880 to 1900." *American Art Review* 4 (January 1978): 40–51, 101.

Eliasoph, Paula. *Handbook of the Complete Set of Etchings and Drypoints of Childe Hassam, N.A.* New York: Leonard Clayton Gallery, 1933.

"The Etchings of Childe Hassam." *Nation* 101 (December 9, 1915): 698–99.

Exhibition of Paintings by Childe Hassam, exhibition catalog. New York: House of Durand-Ruel, 1926.

Fort, Ilene Susan. *Childe Hassam's New York.* San Francisco: Pomegranate Artbooks, 1993.

———. *The Flag Paintings of Childe Hassam,* exhibition catalog. Los Angeles: Los Angeles County Museum of Art, 1988.

Gallatin, Albert E. "Childe Hassam: A Note." *Collector and Art Critic* 5 (January 1907): 101–4.

Griffith, Fuller. *The Lithographs of Childe Hassam—A Catalog.* United States National Museum Bulletin Number 232. Washington, D.C.: Smithsonian Institution, 1962.

Haskell, Ernest. "Twenty-Five Years of American Painting." *Art News* 26 (April 14, 1928): 22–28.

———. *Exhibition of a Retrospective Group of Paintings Representative of the Life Work of Childe Hassam, N.A.,* exhibition catalog. Buffalo, N.Y.: Buffalo Fine Arts Academy, Albright Art Gallery, 1929.

Hassam, Childe. *Three Cities.* New York, 1899.

Hiesinger, Ulrich W. *Childe Hassam: American Impressionist.* New York: Prestel–Verlag, 1994.

Hoopes, Donelson. *Childe Hassam.* New York: Watson-Guptill Publications, 1979.

Howe, William Henry, and George Torrey. "Childe Hassam." *Art Interchange* 34 (May 1895): 133.

Ives, A. E. "Mr. Childe Hassam on Painting Street Scenes." *Art Amateur* 27 (October 1892): 116–17.

McGuire, James C. *Childe Hassam, N.A.* American Etchers, 3. New York: T. Spencer Hutson and Co., 1929.

Meyer, Annie Nathan. "A City Picture: Mr. Hassam's Latest Painting of New York." *Art and Progress* 2 (March 1911): 137–39.

"Montauk" by Childe Hassam, exhibition catalog. New York: William Macbeth Galleries, 1924.

Morton, Frederick W. "Childe Hassam, Impressionist." *Brush and Pencil* 8 (June 1901): 141–50.

"Painting America: Childe Hassam's Way." *Touchstone* 5 (July 1919): 272–80.

Pattison, James William. "The Art of Childe Hassam." *House Beautiful* 23 (January 1908): 19–20.

Pousette-Dart, Nathaniel, comp. *Childe Hassam.* Introduction by Ernest Haskell. New York: Frederick A. Stokes Co., 1922.

Price, Frederic Newlin. "Childe Hassam—Puritan." *International Studio* 77 (April 1923): 3–7.

Reynard, Grant. "The Prints of Childe Hassam, 1859–1935." *American Artist* 24 (November 1960): 42–47.

Smith, Jacob Getlar. "The Watercolors of Childe Hassam." *American Artist* 19 (November 1955): 50–53, 59–63.

Stavitsky, Gail. "Childe Hassam and the Carnegie Institute: A Correspondence." *Archives of American Art Journal* 22, no. 3 (1982): 2–7.

———. "Childe Hassam in the Collection of the Museum of Art, Carnegie Institute." *Carnegie Magazine* 56 (July–August 1982): 27–39.

Van Rensselaer, Mariana G. "Fifth Avenue with Pictures by Childe Hassam." *Century* 47 (November 1893): 5–18.

Weitenkampf, Frank. "Childe Hassam and Etching." *American Magazine of Art* 10 (December 1918): 49–51.

White, Israel L. "Childe Hassam—A Puritan." *International Studio* 45 (December 1911): xxix–xxxvi.

"Who's Who in American Art." [Childe Hassam] *Arts and Decoration* 5 (October 1915): 473.

Young, Mahonri Sharp. "A Quiet American." *Apollo* 79 (May 1964): 401–2.

Zigrosser, Carl. *Childe Hassam.* New York: Frederick Keppel and Co., 1916.

Robert Henri

Bouche, Louis, and William Yarrow, eds. *Robert Henri, His Life and Works.* New York: Privately printed by Boni and Liveright, 1921.

Henri, Robert. *The Art Spirit*, compiled by Margery Ryerson. Boulder, Colo.: Westview Press, 1984, reprint of Philadelphia: J.B. Lippincott, 1923.

Homer, William Innes. *Robert Henri and His Circle*. Ithaca, N.Y.: Cornell University Press, 1969.

Leeds, Valerie Ann. *My People: The Portraits of Robert Henri*, exhibition catalog. Orlando, Fla.: Orlando Museum of Art, 1994.

Perlman, Bernard B. *Robert Henri: His Life and Art*. New York: Dover Publications, 1991.

———, ed. *Revolutionaries of Realism: The Letters of John Sloan and Robert Henri*. Princeton, N.J.: Princeton University Press, 1997.

Perlman, Bernard B., and Valerie Ann Leeds. *Robert Henri: American Icon*, exhibition catalog. New York: Owen Gallery, 1998.

Valente, Alfredo. *Robert Henri, Painter—Teacher—Prophet*, exhibition catalog. New York: New York Cultural Center, 1969.

Carl R. Krafft

Bulliet, C[larence] J. "Artists of Chicago Past and Present, No. 38, Carl Rudolph Krafft." *Chicago Daily News*, November 9, 1935.

Carr, V. E. "Carl R. Krafft," *American Magazine of Art* 17 (September 1926): 474–80.

Davies, Lal [Gladys Krafft]. *Carl R. Krafft: An Artist's Life*. New York: Vantage Press, 1982.

McCauley, Lena. "A Painter Poet of the Ozarks." *Fine Arts Journal* 34 (October 1916): 465–72.

Ernest Lawson

Adeney, Jeanne. "Art Notes (Ernest Lawson)." *Canadian Bookman* 12 (February 1930): 39.

Anderson, Dennis R. *Ernest Lawson Exhibition*, exhibition catalog. New York: ACA Galleries, 1976.

Berry-Hill, Sidney, and Henry Berry-Hill. *Ernest Lawson, American Impressionist, 1873–1939*. Leigh-on-Sea, England: F. Lewis, 1968.

Cahill, Edgar Holger. "Ernest Lawson and His America." *Shadowland* 6 (March 1922): 22–23, 72.

Du Bois, Guy Pène. "Ernest Lawson, Optimist." *Arts and Decoration* 6 (September 1916): 505–7.

———. *Ernest Lawson*. New York: Whitney Museum of American Art, 1932.

———. *Ernest Lawson*, exhibition catalog. New York: Babcock Galleries, 1943.

Ely, Catherine Beach. "The Modern Tendency in Lawson, Lever, and Glackens." *Art in America* 10 (December 1921): 31–37.

"Ernest Lawson." *Arts and Decoration* 10 (March 1919): 257–59.

"Ernest Lawson's Spanish Pictures." *Fine Arts Journal* 35 (March 1917): 225–27.

Gallatin, Albert. "Ernest Lawson." *International Studio* 59 (July 1916): xiii–xv.

"Jerome Myers, Ernest Lawson." *Arts and Decoration* 10 (March 1919): 257–59.

Karpiscak, Adeline Lee. *Ernest Lawson, 1873–1939*, exhibition catalog. Tucson: University of Arizona Museum of Art, 1979.

Leeds, Valerie Ann. Ernest Lawson, exhibition catalog. New York: Gerald Peters Gallery, 2000.

O'Brien, Mern. *Ernest Lawson (1873–1939): From Nova Scotia Collections*, exhibition catalog. Halifax: Dalhousie Art Gallery, Dalhousie University, 1983.

O'Neal, Barbara. *Ernest Lawson, 1873–1939*, exhibition catalog. Ottawa: National Gallery of Canada, 1967.

Phillips, Duncan. "Ernest Lawson." *American Magazine of Art* 8 (May 1917): 257–63.

Price, Frederic Newlin. "Lawson, of the 'Crushed Jewels.'" *International Studio* 78 (February 1924): 367–70.

———. *Ernest Lawson, Canadian American*. New York: Ferargil, 1930.

Rihani, Ameen. "Landscape Painting in America—Ernest Lawson." *International Studio* 72 (February 1921): 114–17.

Sherman, Frederic Fairchild. "The Landscape of Ernest Lawson." *Art in America* 8 (January 1919): 32–39.

Strawn, Arthur. "Ernest Lawson." *Outlook* 157 (April 22, 1931): 573.

Jonas Lie

Berry, Rose V. S. "Jonas Lie: The Man and His Art." *American Magazine of Art* 16 (February 1925): 59–66.

Brinton, Christian. "Jonas Lie: A Study in Temperament." *The American-Scandinavian Review* 3 (July–August 1915): 197–207.

Exhibition of Paintings by Jonas Lie, exhibition catalog. New York: Macbeth Galleries, 1926.

Price, Frederic Newlin. "Jonas Lie, Painter of Light." *International Studio* 82 (November 1925): 102–7.

Will H. Low

Dreishspoon, Douglas S. "Will H. Low: American Muralist (1853–1932), with a Catalogue Listing of His Known Work." Master's thesis, Tufts University, 1979.

Low, Will H. "In an Old French Garden." *Scribner's Magazine* 32 (July 1902): 3–19.

———. *A Chronicle of Friendships*. New York, 1908.

———. *A Painter's Progress*. New York: Charles Scribner's Sons, 1910.

———. "The Primrose Way." McKinney Library, Albany Institute of History and Art, Albany, N.Y., Typescript, 1930.

Meixner, Laura L. "Will Hickok Low (1853–1932): His Early Career and Barbizon Experience." *American Art Journal* 17 (autumn 1985): 51–70.

A Painter's Garden of Pictures Painted from Early Spring until Late in the Autumn of 1901 at Giverny in France by Will H. Low. New York: Avery Art Galleries, 1902.

Harriet Randall Lumis

Love, Richard H. *Harriet Randall Lumis: 1870–1953*, exhibition catalog. Chicago, 1977.

Lewis Henry Meakin

Boyle, Richard J. *Lewis Henry Meakin, 1850–1917: An American Landscape Painter Rediscovered*, exhibition catalog. Cincinnati: Cincinnati Art Galleries, 1987.

Lewis Henry Meakin 1850–1917, exhibition catalog. Cincinnati: Cincinnati Museum Association, 1918.

Oliver, Maude I. G. "A Painter of the Middle West, L. H. Meakin." *International Studio* 33 (November 1907): 3–12.

Gari Melchers

Dreiss, Joseph G. *Gari Melchers: His Works in the Belmont Collection*. Charlottesville: University Press of Virginia, 1984.

Hoeber, Arthur. "Gari Melchers." *International Studio* 31 (March 1907): xi–xviii.

Lesko, Diana. *Gari Melchers: A Retrospective Exhibition*, exhibition catalog. St. Petersburg, Fla.: Museum of Fine Arts, 1990.

Lewis-Hind, Henriette. *Gari Melchers: Painter*. New York: W. E. Rudge. 1928.

Oresman, Janice. *Gari Melchers: American Painter*, exhibition catalog. New York Graham Gallery, 1978.

Reid, Richard S. "Gari Melchers: An American Artist in Virginia." *Virginia Cavalcade* 28 (spring 1979): 154–73.

Willard L. Metcalf

Bolton, Theodore. *Memorial Exhibition of Paintings by the Late Willard L. Metcalf*, exhibition catalog. New York: Century Association, 1928.

Boyle, Richard J. *Willard Leroy Metcalf: An American Impressionist*, exhibition catalog. New York: Spanierman Gallery, 1995.

Brinton, Christian. "Willard L. Metcalf." *Century* 77 (November 1908): 155.

Coburn, Frederick W. "Willard L. Metcalf's 'A May Pastoral.'" *New England Magazine* 45 (November 1908): 374–75.

Cortissoz, Royal. "Willard L. Metcalf, An American Landscape Painter." *Appleton's Booklovers Magazine* 6 (October 1905): 509–11.

———. "Willard L. Metcalf." American Academy of Arts and Letters, *Academy Publications*, no. 60 (1927): 1–8.

Cushing, Frank H. "My Adventures in Zuni." *Century* 25 (December 1882): 191–207; 25 (February 1883): 500–1.

De Veer, Elizabeth. *Willard Leroy Metcalf: A Retrospective*, exhibition catalog. Springfield, Mass.: Museum of Fine Arts, 1976.

———. "Willard Metcalf's 'The Ten Cent Breakfast.'" *Nineteenth Century* 3 (winter 1977): 51–53.

De Veer, Elizabeth, and Richard J. Boyle. *Sunlight and Shadow: The Life and Art of Willard L. Metcalf*. New York: Abbeville Press, 1987.

Duncan, Walter Jack. *Paintings by Willard L. Metcalf*, exhibition catalog. Washington, D.C.: Corcoran Gallery of Art, 1925.

Ely, Catherine Beach. "Willard L. Metcalf." *Art in America* 13 (October 1925): 332–36.

Hamerton, Philip Gilbert, Jr. "Book Illustrators. III. Willard L. Metcalf." *Book Buyer* 11 (April 1894): 120–22.

Hoeber, Arthur. "A Summer in Brittany. With Original Illustrations by Willard L. Metcalf." *Monthly Illustrator* 4 (April–June 1895): 74–80.

MacAdam, Barbara J. *Winter's Promise: Willard Metcalf in Cornish, New Hampshire, 1909–1920*, exhibition catalog. Hanover, N.H.: Hood Museum of Art, Dartmouth College, 1999.

Shepard, Lewis A. "Willard Metcalf." *American Art Review* 4 (August 1977): 66–75.

Steele, Henry Milford. "The Requirements of Black and .White. With Original Illustrations by Willard L. Metcalf." *Monthly Illustrator* 3 (January–March 1895): 93–96.

Teevan, Bernard. "A Painter's Renaissance." *International Studio* 82 (October 1925): 3–11.

Richard Emile Miller

Allan, Sidney [Sadakichi Hartmann]. "Masterpieces of American Portraiture (Richard E. Miller)." *Bulletin of Photography* 16 (June 2, 1915): 684–86.

Ball, Robert, and Max W. Gottschalk. *Richard E. Miller, N.A.: An Impression and Appreciation*. St. Louis: Longmire Fund, 1968.

Kane, Marie Louise. *A Bright Oasis: The Paintings of Richard E. Miller*. New York: Jordan-Volpe Gallery, 1997.

Pica, Vittorio. "Artisti contemporanei: Richard Emile Miller." *Emporium* 39 (March 1914): 162–77.

Richard Emil Miller (1875–1943). Bayeux, France: Hôtel des Ventes de Bayeux, 1991.

Seares, Mabel Urmy. "Richard Miller in a California Garden." *California Southland*, no. 38 (February 1923): 10–11.

Thompson, Wallace. "Richard Miller—A Parisian–American Artist." *Fine Arts Journal* 27 (November 1912): 709–14.

Claude Monet

"Claude Monet." *Scribner's Magazine* 19 (January 1896): 125.

"Claude Monet." *Gallery and Studio* 1 (October 1897): 3–4.

Claude Monet and the Giverny Artists, exhibition catalog. New York: Charles E. Slatkin Galleries, 1960.

Cortissoz, Royal. "Claude Monet." *Scribner's Magazine* 81 (April 1927): 329–36.

Elder, Marc [Marcel Tendron]. *A Giverny, chez Claude Monet*. Paris: Bernheim-Jeune, 1924.

An Exhibition of Paintings by Claude Monet, exhibition catalog. Boston: St. Botolph Club, 1892.

Fitzgerald, Desmond. *Claude Monet*, exhibition catalog. Boston: St. Botolph Club, 1892.

———. "Claude Monet—Master of Impressionism." *Brush and Pencil* 15 (March 1905): 181–95.

Fuller, William H. *Claude Monet*, exhibition catalog. New York: Union League Club, 1891.

———. *Claude Monet and His Paintings*, exhibition catalog. New York: Lotus Club, 1899.

Gwynn, Stephen. *Claude Monet and His Garden*. London: Country Life, 1934.

House, John. *Monet: Nature into Art*. New Haven, Conn.: Yale University Press, 1986.

Joyes, Claire. *Monet at Giverny*. London: Mathews Miller Dunbar, 1975.

———. *Claude Monet: Life at Giverny*. New York: Vendome Press, 1985.

King, Polly. "Paris Letter." *Art Interchange* 31 (September 1893): 65.

———. "Paris Letter. Claude Monet." *Art Interchange* 31 (November 1893): 131–32.

Mirbeau, Octave. *Catalogue: Marvelous Paintings of Cathedral Rouen by Claude Monet*, exhibition catalog. New York: American Art Galleries, 1896.

Monet's Years at Giverny: Beyond Impressionism, exhibition catalog. New York: The Metropolitan Museum of Art, 1978.

Pach, Walter. "At the Studio of Claude Monet." *Scribner's Magazine* 43 (June 1908): 765–68.

Perry, Lilla Cabot. "Reminiscences of Claude Monet from 1889 to 1909." *American Magazine of Art* 18 (March 1927): 119–25.

Robinson, Theodore. "Claude Monet." *Century* 44 (September 1892): 696–701.

Seaton-Schmidt, Anna. "An Afternoon with Claude Monet." *Modern Art* 5 (January 1, 1897): 32–35.

Spate, Virginia. *Claude Monet: Life and Work*. New York: Rizzoli, 1992.

Stuckey, Charles F., ed. *Claude Monet, 1840–1926*, exhibition catalog. Chicago: Art Institute of Chicago, 1995.

[Trumble, Alfred?]. "Claude Monet." *Collector* 2 (February 15, 1891): 91.

Tucker, Paul Hayes. *Monet in the 90s*. New Haven, Conn.: Yale University Press, 1989.

Julian Onderdonk

Steinfeldt, Cecilia. *Julian Onderdonk: A Texas Tradition*. Amarillo, Tex.: Amarillo Art Center, 1985.

———. *The Onderdonks, A Family of Texas Painters*. San Antonio: Trinity University Press, 1976.

Tonkin, L. "Julian Onderdonk: A Tribute by a Fellow Texan." *American Magazine of Art* 14 (October 1923): 556–59.

Lawton Parker

Lawton Parker, exhibition catalog. Chicago: Thurber Art Gallery, 1910.

Paintings by Lawton Parker, exhibition catalog. Chicago: Art Institute of Chicago, 1912.

Parker, Lawton S. "Another View of Art Study in Paris." *Brush and Pencil* 11 (November 1902): 11–15.

Pattison, James William. "Many Sorts of Realism." *Fine Arts Journal* 28–29 (September 1913): 545–49.

Sheldon, Rowland. "Two American Artists Distinguished Abroad: Lawton Parker and C. Arnold Slade." *Fine Arts Journal* 30 (May 1914): 240–51.

Tietjens, Eunice. "Lawton Parker." *The Little Review* 1 (May 1914): 34.

Webster, Henry Kitchell. "Lawton Parker." *Collier's* 52 (January 31, 1914): 23.

Zug, George Breed. "The Art of Lawton Parker." *International Studio* 57 (December 1915): 37–43.

William McGregor Paxton

Buckley, Charles E. "The Front Parlor by William McGregor Paxton." *Saint Louis Art Museum Bulletin*, 1 (November–December 1975): 105–7.

Buxton, Frank W., and R. H. Ives Gammell. *William McGregor Paxton*, exhibition catalog. Boston: Museum of Fine Arts, 1941.

Coburn, Frederick W. "Seeing Nature with Both Eyes." *World Today* 9 (November 1905): 1210–14.

———. "William M. Paxton's 'A String of Pearls.'" *New England Magazine* 39 (September 1908): 36–37.

Gammell, R. H. Ives. *William McGregor Paxton, N.A., 1869–1941*, exhibition catalog. Indianapolis: Indianapolis Museum of Art, 1978.

———. *William McGregor Paxton 1869–1941*. Exhibition organized by Ellen Wardwell Lee. Indianapolis, Ind.: Indianapolis Museum of Art, 1979.

Hale, Philip. "William McGregor Paxton." *International Studio* 39 (November 1909): xlvi–xlviii.

William McGregor Paxton, N.A. Memorial Exhibition of Paintings, exhibition catalog. Boston: Museum of Fine Arts, 1941.

Teall, Gardner. "Paxton: A Painter of Things Seen." *Hearst's Magazine* 31 (June 1917): 457–58, 525.

Young, Mahonri Sharp. "A Boston Painter." *Apollo* 108 (November 1978): 344–45.

Lilla Cabot Perry

Feld, Stuart P. *Lilla Cabot Perry: A Retrospective Exhibition*, exhibition catalog. New York: Hirschl and Adler Galleries, 1969.

Harlow, Virginia. *Thomas Sergeant Perry: A Biography*. Durham, N.C.: Duke University Press, 1950.

Hilman, Carolyn, and Jean Nutting Oliver. "Lilla Cabot Perry—Painter and Poet." *American Magazine of Art* 14 (November 1923): 601–4.

Lilla Cabot Perry, exhibition catalog. Chicago: Mongerson Galleries, 1984.

Lilla Cabot Perry: Days to Remember. Santa Fe: Santa Fe East, 1983.

Martindale, Meredith. *Lilla Cabot Perry: An American Impressionist*, exhibition catalog. Washington, D.C.: National Museum of Women in the Arts, 1990.

Perry, Lilla Cabot. "Reminiscences of Claude Monet from 1889 to 1909." *American Magazine of Art* 18 (March 1927): 119–25.

Ward, Lisa Michelle. "Lilla Cabot Perry and the Emergence of the Professional Woman Artist in America: 1885–1905." Master's thesis, University of Texas at Austin, 1985.

Edward Henry Potthast

Brown, E. *Edward Henry Potthast*, exhibition catalog. St. Petersburg, Fla.: St. Petersburg Museum of Art, 1991.

Edward Henry Potthast (1857–1927): An American Painter, exhibition catalog. Cincinnati: Art Academy of Cincinnati, 1994.

Edward Henry Potthast: American Painter of Summer and Surf, exhibition catalog. Louisville: J. B. Speed Art Museum, 1985.

Edward Potthast: American Impressionist, exhibition catalog. Marietta, Ga.: Marietta/Cobb Museum of Art, 1992.

Edward Henry Potthast from the Collection of Mr. and Mrs. Merrill Gross, exhibition catalog. Youngstown, Ohio: Butler Institute of American Art, 1965.

Findsen, Owen. *Paintings by Edward H. Potthast (1857–1927) from the Collection of Mr. and Mrs. Merrill Gross*, exhibition catalog. Cincinnati: Taft Museum, 1968.

———. *The Merrill J. Gross collection: Edward Potthast, 1857–1927*, exhibition catalog. Washington, D.C.: Corcoran Gallery of Art, 1973.

Hinkley, A. "Edward Henry Potthast: Cincinnati's First Impressionist." Master's thesis, University of Cincinnati, 1989.

Jacobowitz, Arlene. "Edward Henry Potthast." *Brooklyn Museum Annual* 9 (1967–68): 113–28.

———. *Edward Henry Potthast, 1857 to 1927*, exhibition catalog. New York: Chapellier Galleries, 1969.

Keny, James M. "Into the Light: The Art of Edward Potthast," *Timeline* 8 (April–May 1991): 18–29.

Moehl, Karl J. *Exhibition of Paintings: Edward Henry Potthast*, exhibition catalog. Peoria, Ill.: Peoria Guild of Lakeview Center, 1967.

Wilson, John. *Edward Henry Potthast: American Impressionist*, exhibition catalog. New York: Gerald Peters Gallery, 1998.

Maurice Prendergast

Breuning, Margaret. *Maurice Prendergast*. New York: Whitney Museum of American Art, 1931.

Brooks, Van Wyck. "Anecdotes of Maurice Prendergast." *American Magazine of Art* 31 (October 1938): 564–69, 604.

"The Brothers Prendergast in Review." *Art News* 37 (October 8, 1938): 14–15, 19.

Clark, Carol, Nancy Mowll Mathews, and Gwendolyn Owens. *Maurice Brazil Prendergast, Charles Prendergast: A Catalogue Raisonné*. Williamstown, Mass.: Williams College Museum of Art; Munich: Prestel–Verlag, 1990.

Four Boston Masters: Copley, Allston, Prendergast, Bloom, exhibition catalog. Wellesley, Mass.: Jewett Arts Center, Wellesley College, 1959.

Glavin, Ellen M. "Maurice Prendergast: The Boston Experience." *Art and Antiques* 6 (July–August 1982): 64–71.

Goldin, Amy. "The Brothers Prendergast." *Art in America* 64 (March–April 1976): 86–93.

———. "How Are the Prendergasts Modern?" *Art in America* 64 (September–October 1976): 60–67.

Green, Eleanor. *Maurice Prendergast*, exhibition catalog. College Park, Md.: University of Maryland Art Gallery, 1976.

Katz, Leslie. "The Centenary of Maurice Prendergast." *Arts Magazine* 35 (November 1960): 34–39.

Langdale, Cecily. *The Monotypes of Maurice Prendergast*, exhibition catalog. New York: Davis and Long Company, 1979.

Mathews, Nancy Mowll. *Maurice Prendergast*, exhibition catalog. Munich: Prestel–Verlag; Williamstown, Mass.: Williams College Museum of Art, 1990.

Maurice Prendergast Memorial Exhibition, exhibition catalog. Cleveland: Cleveland Museum of Art, 1926.

Milliken, William Mathewson. "Maurice Prendergast, American Artist." *Arts* 9 (April 1926): 181–92.

Owens, Gwendolyn. *Watercolors by Maurice Prendergast from New England Collections*, exhibition catalog. Williamstown, Mass.: Sterling and Francine Clark Art Institute, 1978.

Pach, Walter. *Maurice Prendergast Memorial Exhibition*, exhibition catalog. New York: Whitney Museum of American Art, 1934.

———. "Maurice B. Prendergast." In *American Art Portfolios*, New York: Raymond and Raymond, 1936.

Pepper, Charles Hovey. "Is Drawing to Disappear in Artistic Individuality?" *World Today* 19 (July 1910): 716–19.

Phillips, Duncan. "Maurice Prendergast." *Arts* 5 (March 1924): 125–31.

Prendergast, Maurice. *Large Boston Public Garden Sketchbook*. Introduction by George Szabo. New York: George Braziller in association with The Metropolitan Museum of Art, New York, 1987.

The Prendergasts: Retrospective Exhibition of the Work of Maurice and Charles Prendergast, exhibition catalog. Andover, Mass.: Phillips Academy, Addison Gallery of American Art, 1938.

Rhys, Hedley Howell. *Maurice Prendergast, 1859–1924*, exhibition catalog. Boston: Museum of Fine Arts, 1960.

Sawyer, Charles H. "The Prendergasts." *Parnassus* 10 (October 1939): 9–11.

———. *Maurice Prendergast*, exhibition catalog. New York: M. Knoedler and Co., 1966.

Scott, David W. *Maurice Prendergast*. Washington, D.C., 1980.

Sims, Patterson. *Maurice B. Prendergast*, exhibition catalog. New York: Whitney Museum of American Art, 1980.

Smith, Jacob Getlar. "The Watercolors of Maurice Prendergast." *American Artist* 20 (February 1956): 52–57, 68.

The Unknown Pastels: Maurice Brazil Prendergast. New York: Coe Kerr Gallery/Universe Books, 1987.

Wattenmaker, Richard J. *Maurice Prendergast*. New York: Harry N. Abrams in association with The National Museum of American Art, Smithsonian Institution, Washington, D.C., 1994.

Wick, Peter. *Maurice Prendergast Watercolor Sketchbook, 1899*. Boston and Cambridge, Mass.: Museum of Fine Arts and Harvard University Press, 1960.

Joseph Raphael

Lilienthal, Theodore M. *An Exhibition of Rediscovery: Joseph Raphael, 1872–1950*, exhibition catalog. Berkeley, Calif.: Judah L. Magnes Memorial Museum, 1975.

未能

Edward W. Redfield

An Exhibition of Paintings by Edward W. Redfield, exhibition catalog. Holicong, Pa.: Holicong Junior High School, 1975.

Fletcher, J. M. W. *Edward Willis Redfield (1869–1965): An American Impressionist—His Paintings and the Man Behind the Palette.* Lahaska, Pa.: J. M. W. Fletcher, 1996.

Flower, Benjamin Orange. "Edward W. Redfield: An Artist of Winter-Locked Nature." *Arena* 36 (July 1906): 20–26.

Folk, Thomas. "Edward Redfield." *Art & Antiques* 4 (March–April 1981): 56–63.

———. *Edward Redfield (1869–1965)*, exhibition catalog. New Brunswick, N.J.: Rutgers University Art Gallery, 1981.

———. *Edward Redfield: First Master of the Twentieth Century Landscape*, exhibition catalog. Allentown, Pa.: Allentown Art Museum, 1987.

Kirby, C. Valentine. *A Little Journey to the Home of Edward W. Redfield.* Doylestown, Pa.: Bucks County Series—Unit 3, 1947.

Laurvik, John Nilsen. "Edward Redfield." *International Studio* 41 (August 1910): xxix–xxxvi.

Pitz, Henry C. "Edward Redfield: Painter of a Place and a Time." *American Artist* 23 (April 1959): 28–33, 84, 86.

Price, Frederic Newlin. "Redfield, Painter of Days." *International Studio* 75 (August 1922): 402–10.

Trask, J[ohn] E. D. *Catalogue of the Exhibition of Landscape Paintings by Edward W. Redfield*, exhibition catalog. Philadelphia: Pennsylvania Academy of the Fine Arts, 1909.

Wheeler, Charles V. *Redfield.* Washington, D.C.: Privately printed, 1925.

———. "Redfield." *American Magazine of Art* 16 (January 1925): 3–8.

———. "Redfield's One-Man Show." *American Magazine of Art* 21 (March 1930): 139–42.

"Who's Who in American Art." *Arts and Decoration* 6 (January 1916): 135.

Winer, Donald A. *A Retrospective Exhibition of the Work of the Great American Impressionist Edward Willis Redfield of Pennsylvania*, exhibition catalog. Harrisburg, Pa.: William Penn Memorial Museum, 1973.

Robert Reid

Bowdoin, W. G. "In Summertime." *Artist* 28 (June 1900): 44–47.

Brinton, Christian. "Robert Reid, Decorative Impressionist." *Arts and Decoration* 2 (November 1911): 13–15, 34.

Coffin, William A. "Robert Reid's Decorations in the Congressional Library, Washington, D.C." *Harper's Weekly* 40 (October 17, 1896): 1028–29.

Cortissoz, Royal. *In Summertime: Paintings by Robert Reid.* New York: R. H. Russell, 1900.

———. "The Work of Robert Reid." *Appleton's Booklovers Magazine* 6 (December 1905): 738–48.

Crowninshield, Frank. *Exhibition of Paintings by Robert Reid, N.A., NIAC*, exhibition catalog. New York: Grand Central Art Galleries, 1927.

Goodrich, Henry W. "Robert Reid and His Work." *International Studio* 36 (February 1909): ciii–cxxi.

Hart, Charles Henry. "Robert Reid's Mural Decoration in the New State House at Boston." *Era* 9 (April 1902): 445–47.

[Hartmann, Sadakichi]. "Robert Reid." *Stylus* 1 (February 1910): 9–18.

Hoeber, Arthur. "Robert Reid." *Century* 77 (March 1909): 799.

Pattison, James William. "Robert Reid, Painter." *House Beautiful* 20 (July 1906): 18–20.

Sargent, Irene. "The Mural Paintings by Robert Reid in the Massachusetts State House." *Craftsman* 7 (March 1905): 699–712.

Stoner, Stanley. *Some Recollections of Robert Reid.* Colorado Springs: Dentan Printing Co., 1934.

Stuart, Evelyn Marie. "Finished Impressions of a Portrait Painter." *Fine Arts Journal* 36 (January 1918): 32–40.

Weinberg, Helene Barbara. "Robert Reid: Academic Impressionist." *Archives of American Art Journal* 15, no. 1 (1975): 2–11.

Henry Reuterdahl

The Art of Henry Reuterdahl, exhibition catalog. Annapolis, Md.: United States Naval Academy Museum, 1977.

Louis Ritman

De Fleur, Nicole. *Louis Ritman, 1892–1963: American Painter.* Random Lake, Wis.: Times Publishing Co., 1967.

Love, Richard H. *Louis Ritman: From Chicago to Giverny.* Chicago: Haase-Mumm Publishing Co., 1989.

The Paintings of Louis Ritman (1889–1963), exhibition catalog. Chicago: Signature Galleries, 1975.

Waterman, C. H. "Louis Ritman." *International Studio* 67 (April 1919): 63–65.

Theodore Robinson

Baur, John I. H. *Theodore Robinson, 1852–1896*, exhibition catalog. Brooklyn: Brooklyn Museum, 1946.

———. "Photographic Studies by an Impressionist." *Gazette des Beaux-Arts* 6, 30 (October–November 1946): 319–30.

Byrd, D. Gibson. *Paintings and Drawings by Theodore Robinson*, exhibition catalog. Madison, Wisc.: University of Wisconsin, 1964.

Campbell, Pearl H. "Theodore Robinson, A Brief Historical Sketch." *Brush and Pencil* 4 (September 1899): 287–89.

Clark, Eliot. "Theodore Robinson." *Art in America* 6 (October 1918): 286–94.

———. "Theodore Robinson, A Pioneer Impressionist." *Scribner's Magazine* 70 (December 1921): 763–68.

———. *Theodore Robinson: His Life and Art.* Chicago: R. H. Love Galleries, 1979.

The Figural Images of Theodore Robinson, American Impressionist, exhibition catalog. Edited by Bev Harrington, with an introduction by William Kloss. Oshkosh, Wis.: Paine Art Center and Arboretum, 1987.

Garland, Hamlin. "Theodore Robinson." *Brush and Pencil* 4 (September 1899): 285–86.

Harrison, Birge. "With Stevenson at Grèz." *Century* 93 (December 1916): 306–14.

Johnston, Sona. *Theodore Robinson, 1852–1896*, exhibition catalog. Baltimore: Baltimore Museum of Art, 1973.

Koeninger, Betty Kathryn. "Theodore Robinson's La Débâcle, 1892: An American Artist in France." Master's thesis, University of California at Riverside, 1992.

Levy, Florence N. "Theodore Robinson." *Bulletin of The Metropolitan Museum of Art* 1 (July 1906): 111–12.

Lewison, Florence. "Theodore Robinson America's First Impressionist." *American Artist* 27 (February 1963): 40–45, 72–73.

———. "Theodore Robinson and Claude Monet." *Apollo* 78 (September 1963): 208–11.

———. *Theodore Robinson, the 19th Century Vermont Impressionist*, exhibition catalog. Manchester, Vt.: Southern Vermont Artists, 1971.

Love, Richard H. *Theodore Robinson: Sketchbook Drawings*, exhibition catalog. Chicago: R. H. Love Galleries, 1991.

Mayer, Stephanie. *First Exposure: The Sketchbooks and Photographs of Theodore Robinson*, exhibition catalog. Giverny, France: Musée d'Art Américain, 2000.

Oil Paintings and Studies by the Late Theodore Robinson, exhibition catalog. New York: American Art Galleries, 1898.

Paintings in Oil and Pastel by Theodore Robinson and Theodore Wendel, exhibition catalog. Boston: Williams and Everett Gallery, 1892.

Robinson, Theodore. Unpublished diaries, March 1892–March 1896. New York: Frick Art Reference Library.

———. "A Normandy Pastoral." *Scribner's Magazine* 21 (June 1897): 757.

Sherman, Frederic Fairchild. "Theodore Robinson." New York: Frick Art Reference Library, c. 1928 unpublished article.

"Theodore Robinson." *Scribner's Magazine* 19 (June 1896): 784–85.

Theodore Robinson, exhibition catalog. New York: Florence Lewison Gallery, 1962.

Theodore Robinson, American Impressionist (1852–1896), exhibition catalog. New York: Kennedy Galleries, 1966.

Theodore Robinson, America's First Impressionist, exhibition catalog. New York: Florence Lewison Gallery, 1963.

Theodore Robinson: Exhibition of Paintings, exhibition catalog. New York: Owen Gallery, 2000.

"Theodore Robinson, Pioneer Impressionist." *Scribner's Magazine* 70 (December 1921): 763–68.

Guy Rose

Anderson, Anthony and Earl L. Stendhal. *Guy Rose: A Biographical Sketch and Appreciation, Paintings of France and America*, exhibition catalog. Los Angeles: Stendhal Galleries, 1922.

Berry, Rose V. S. "A Painter of California." *International Studio* 80 (January 1925): 332–34, 336–37.

Fort, Ilene Susan. "The Cosmopolitan Guy Rose." In Patricia Trenton and William H. Gerdts, *California Light, 1900–1930*, exhibition catalog, pp. 93–111. Laguna Beach, Calif.: Laguna Beach Art Museum, 1990.

———. "The Figure Paintings of Guy Rose," *Art of California* 4 (January 1991): 46–50.

Guy Rose: Memorial Exhibition, exhibition catalog. Los Angeles: Stendhal Art Galleries, 1926.

Guy Rose: Paintings of France and America, exhibition catalog. Los Angeles: Stendhal Art Galleries, 1922.

Paintings by Guy Rose, exhibition catalog. Los Angeles: Los Angeles Museum of History, Science and Art, 1916.

Rose, Guy. "At Giverny." *Pratt Institute Monthly* 6 (December 1897): 81.

South, Will. "The Painterly Pen." *Antiques and Fine Art* 9 (March–April 1992): 120.

———. *Guy Rose: American Impressionist*, exhibition catalog. Introduction by William H. Gerdts; essay by Jean Stern. Oakland, Calif.: Oakland Museum; Irvine, Calif.: Irvine Museum, 1995.

John Singer Sargent

Adelson, Warren, et al. *Sargent Abroad: Figures and Landscapes.* New York: Abbeville Press, 1997.

Blashfield, Edwin Howland. "John Singer Sargent—Recollections." *North American Review* 221 (June 1925): 641–53.

Charteris, Evan. *John Sargent.* New York: Charles Scribner's Sons, 1927.

Downes, William Howe. *John S. Sargent: His Life and Work.* Boston: Little, Brown, 1925.

Fairbrother, Trevor J. *John Singer Sargent.* New York: Harry N. Abrams, 1994.

———. *John Singer Sargent and America.* New York: Garland Publishing, 1986.

———. *John Singer Sargent: The Sensualist*, exhibition catalog. Seattle: Seattle Art Museum; New Haven, Conn.: Yale University Press, 2000.

Getscher, Robert H., and Paul G. Marks. *James McNeill Whistler and John Singer Sargent: Two Annotated Bibliographies.* New York: Garland Publishing, 1986.

Goldfarb, Hilliard T., Erica E. Hirshler, and T. J. Jackson Lears. *Sargent: The Late Landscapes*, exhibition catalog. Boston: Isabella Stewart Gardner Museum, 1999.

Herdrich, Stephanie L., H. Barbara Weinberg, and Marjorie Shelley. *John Singer Sargent: American Drawings and Watercolors in The Metropolitan Museum of Art*, exhibition catalog. New York: The Metropolitan Museum of Art, 2000.

Hills, Patricia, et al. *John Singer Sargent*, exhibition catalog. New York: Whitney Museum of American Art, 1986.

Hoopes, Donelson. "John S. Sargent: Worcestershire

Interlude, 1885–89." *Brooklyn Museum Annual* 7 (1965–66): 74–89.

John Singer Sargent and the Edwardian Age, exhibition catalog. Leeds, England: Leeds Art Galleries, 1979.

Kilmurray, Elaine, and Richard Ormand, eds. *John Singer Sargent*, exhibition catalog. London: Tate Gallery; Washington, D.C.: National Gallery of Art, 1998.

Mount, Charles Merrill. *John Singer Sargent: A Biography.* London: Cresset Press, 1957.

Olson, Stanley. *John Singer Sargent: His Portrait.* New York: St. Martin's Press, 1986.

Ormond, Richard. *John Singer Sargent.* New York and Evanston: Harper and Row, 1970.

Ratcliff, Carter. *John Singer Sargent.* New York: Abbeville Press, 1982.

Sargent at Broadway: The Impressionist Years, exhibition catalog. New York: Coe Kerr Gallery, 1986.

Simpson, Marc, Richard Ormond, and H. Barbara Weinberg. *Uncanny Spectacle: The Public Career of the Young John Singer Sargent*, exhibition catalog. New Haven, Conn.: Yale University Press; Williamstown, Mass.: Sterling and Francine Clark Art Institute, 1997.

Weinberg, H. Barbara. *John Singer Sargent.* New York: Rizzoli International, 1994.

Paul Sawyier

Hamel, Mary Michele. *A Kentucky Artist: Paul Sawyier (1865–1917)*, exhibition catalog. Richmond, Ky.: Frederick P. Giles Gallery, Eastern Kentucky University, 1975.

Jones, Arthur F. *The Art of Paul Sawyier.* Lexington, Ky.: University Press of Kentucky, 1975.

Walter Elmer Schofield

Folk, Thomas. *Walter Elmer Schofield: Bold Impressionist*, exhibition catalog. Chadds Ford, Pa.: Brandywine River Museum, 1983.

Hind, C. Lewis. "An American Landscape Painter, W. Elmer Schofield." *International Studio* 48 (February 1913): 280–89.

Hoeber, Arthur. "W. Elmer Schofield." *Arts and Decoration* 1 (October 1911): 473–75, 492.

Lever, J. "W. Elmer Schofield—Artist." *Vista*, August 1929, pp. 8, 27.

Livingston, Valerie. *W. Elmer Schofield: Proud Painter of Modest Lands*, exhibition catalog. Bethlehem, Pa.: Payne Gallery of Moravian College, 1988.

Donna Norine Schuster

Donna Norine Schuster (1883–1953), exhibition catalog. Downey, Calif.: Downey Museum of Art, 1977.

Adolph Robert Shulz

A Retrospective Exhibition of Paintings and Drawings by Adolph Robert Shulz, exhibition catalog. Indianapolis: Indiana State Museum, 1971.

White, Marian A. "A Landscape Painter of the Middle West." *Arts and Decoration* 2 (July 1912): 332–33.

Edward Emerson Simmons

Hoeber, Arthur. "Edward Emerson Simmons." *Brush and Pencil* 5 (March 1900): 241–49.

Howe, William Henry, and George Torrey. "Edward E. Simmons." *Art Interchange* 33 (December 1894): 121.

Simmons, Edward. *From Seven to Seventy: Memories of a Painter and a Yankee.* New York and London: Harper and Brothers, 1922.

Arthur Watson Sparks

Arthur Watson Sparks: American Impressionist, exhibition catalog. Greensburg, Pa.: Westmoreland County Museum of Art, 1963.

Robert Spencer

Folk, Thomas. *Robert Spencer: Impressionist of Working Class Life*, exhibition catalog. Trenton, N.J.: New Jersey State Museum, 1983.

Price, Frederic Newlin. "Spencer—and Romance." *International Studio* 76 (March 1923): 485–91.

Otto Stark

Howard, Leland G. *Otto Stark, 1859–1926*, exhibition catalog. Indianapolis: Indianapolis Museum of Art, 1977.

Theodore C. Steele

Bolles, J. M. "Messrs. Steele and Forsyth." *Modern Art* 1 (spring 1893): unpaginated.

Brooks, Alfred Mansfield. "The Art and Work of Theodore Steele." *American Magazine of Art* 8 (August 1917): 401–6.

———. "The House of the Singing Winds." *American Magazine of Art* 11 (February 1920): 139–41.

Burnet, Mary Q. "Indiana University and T. C. Steele." *American Magazine of Art* 15 (November 1924): 587–91.

Steele, Mary E. *Impressions.* Indianapolis, 1895.

Steele, Selma N., Theodore L. Steele, and Wilbur D. Peat. *The House of the Singing Winds: The Life and Work of T. C. Steele.* Indianapolis: Indiana Historical Society, 1966.

Steele, Theodore C. "Impressionalism." *Modern Art* 1 (winter 1893): unpaginated.

Gardner Symons

Handley, Marie Louise. "Gardner Symons—Optimist." *Outlook* 105 (December 27, 1913): 881–[87.]

Parkhurst, Thomas Shrewsbury. "Little Journeys to the Homes of Great Artists: Gardner Symons." *Fine Arts Journal* 33 (October 1915): 7–9, supplement.

———. "Gardner Symons, Painter and Philosopher." *Fine Arts Journal* 34 (November 1916): 556–65.

Edmund C. Tarbell

Caffin, Charles H. "The Art of Edmund C. Tarbell." *Harper's New Monthly Magazine* 117 (June 1908): 65–74.

Coburn, Frederick W. "Edmund C. Tarbell." *International Studio* 32 (September 1907): lxxv–lxxxvii.

———. "Mr. Tarbell's 'New England Interior.'" *New England Magazine* 38 (March 1908): 96–97.

Cox, Kenyon. "Recent Works by Edmund C. Tarbell." *Burlington Magazine* 14 (January 1909): 254–60.

"Edmund C. Tarbell." *Mentor* 8 (December 1920): 26–27.

Hale, Philip L. "Edmund C. Tarbell—Painter of Pictures." *Arts and Decoration* 2 (February 1912): 129–31, 156.

———. "'The Coral Necklace,' by Edmund C. Tarbell." *Harper's New Monthly Magazine* 129 (June 1914): 136–37.

Howard, W. Stanton. "A Portrait, by E. C. Tarbell." *Harper's New Monthly Magazine* 112 (April 1906): 702–3.

Howe, William Henry, and George Torrey. "Edmund C. Tarbell, A.N.A." *Art Interchange* 32 (June 1894): 167.

Mechlin, Leila. "A Painter of American Interiors." *Art and Progress* 2 (November 1910): 20–21.

Morrell, Dora M. "A Boston Artist and His Work." *Brush and Pencil* 3 (January 1899): 193–201.

"A Note on Tarbell." *Gallery and Studio* 1 (October 1897): 5.

Pierce, Patricia Jobe. *Edmund C. Tarbell and The Boston School of Painting 1889–1980.* Hingham, Mass., 1980.

St. Gaudens, Homer. "Edmund C. Tarbell." *Critic* 48 (February 1906): 137.

Trask, John E. D. "About Tarbell." *American Magazine of Art* 9 (April 1918): 218–28.

Wardle, Marian Eastwood. "Genteel Production: Art and Labor in the Images of Women Sewing by Tarbell and Weir." Ph.D. diss., Univsersity of Maryland, 2000.

Warren, William M. "Twenty-four Sittings with Tarbell." *Bostonia* 12 (1939): 9–11.

Allen Tucker

Allen Tucker, 1866–1939, Centennial Exhibition, exhibition catalog. New York: Milch Galleries, 1966.

Barker, Virgil. "The Painting of Allen Tucker." *Arts* 13 (February 1928): 75–88.

Pach, Walter. "Allen Tucker." *Shadowland* 5 (February 1922): 78.

Watson, Forbes. "Allen Tucker—A Painter with a Fresh Vision." *International Studio* 52 (March 1914): xix–xxi.

———. *Allen Tucker.* American Artists Series. New York: Whitney Museum of American Art, 1932.

———. "Allen Tucker." *Magazine of Art* 32 (December 1939): 698–703.

Helen M. Turner

Rabbage, Lewis Hoyer. *Helen M. Turner, NA (1858–1958): A Retrospective Exhibition*, exhibition catalog. Cragsmoor, N.Y.: Cragsmoor Free Library, 1983.

John Twachtman

"An Art School at Cos Cob." *Art Interchange* 43 (September 1899): 56–57.

Boyle, Richard J. *John Henry Twachtman, 1853–1902*, exhibition catalog. New York: Ira Spanierman, 1966.

———. *John Twachtman.* New York: Watson–Guptill Publications, 1979.

Boyle, Richard J., and Mary Welsh Baskett. *John Henry Twachtman*, exhibition catalog. Cincinnati: Cincinnati Art Museum, 1966.

Catalogue of Paintings in Oil and Pastel by J. Alden Weir and J. H. Twachtman, exhibition catalog. New York: Fifth Avenue Galleries, 1889.

Chotner, Deborah, Lisa N. Peters, and Kathleen A. Pyne. *John Twachtman: Connecticut Landscapes*, exhibition catalog. Washington, D.C.: National Gallery of Art, 1989.

Clark, Eliot. "John Henry Twachtman." *Art in America* 7 (April 1919): 129–37.

———. "The Art of John Twachtman." *International Studio* 72 (January 1921): lxxvii–lxxxvi.

———. *John H. Twachtman.* New York: Privately printed, 1924.

Cournos, John. "John H. Twachtman." *Forum* 52 (August 1914): 245–48.

Curran, Charles C. "The Art of John H. Twachtman." *Literary Miscellany* 3 (winter 1910): 72–78.

DeKay, Charles. "John H. Twachtman." *Arts and Decoration* 9 (June 1918): 73–76, 112, 114.

Dewing, Thomas W., Childe Hassam, Robert Reid, Edward Simmons, and J. Alden Weir. "John H. Twachtman: An Estimation." *North American Review* 176 (April 1903): 554–62.

Exhibition of Paintings by John H. Twachtman, exhibition catalog. New York: Macbeth Gallery, 1919.

Goodwin, Alfred Henry. "An Artist's Unspoiled Country House." *Country Life in America* 8 (October 1905): 625–30.

Hale, John Douglass. "The Life and Creative Development of John H. Twachtman." 2 vols. Ph.D. dissertation, Ohio State University, 1957.

Hale, John Douglass, Richard Boyle, and William H. Gerdts. *Twachtman in Gloucester: His Last Years, 1900–1902*, exhibition catalog. New York: Spanierman Gallery, 1987.

Larkin, Susan G. "On Home Ground: John Twachtman and the Familiar Landscape." *American Art Journal* 29 (1998): 52–85.

Mase, Carolyn C. "John H. Twachtman." *International Studio* 72 (January 1921): lxxi–lxxv.

O'Connor, John, Jr. "From Our Permanent Collection: 'River in Winter' by John H. Twachtman (1853–1902)." *Carnegie Magazine* 25 (April 1951): 136–38.

"Oil-Paintings and Pastels by Mr. Twachtman." *Critic* 18 (March 14, 1891): 146–47.

Peters, Lisa N. *John Henry Twachtman: An American Impressionist*, exhibition catalog. Atlanta: High Museum of Art, 1999.

———. *John Twachtman (1853–1902) and the American Scene in the Late Nineteenth Century: The Frontier within the Terrain of the Familiar.* Ph.D. dissertation, Graduate Center of the City University of New York, 1995. Ann Arbor, Mich.: UMI Press, 1995.

Peters, Lisa N., et al. *In the Sunlight: The Floral and Figurative Art of J. H. Twachtman,* exhibition catalog. New York: Spanierman Gallery, 1989.

Phillips, Duncan. "Twachtman—An Appreciation." *International Studio* 66 (February 1919): cvi–cvii.

Roof, Katherine Metcalf. "The Work of John H. Twachtman." *Brush and Pencil* 12 (July 1903): 243–46.

Ryerson, Margery Austen. "John H. Twachtman's Etchings." *Art in America* 8 (February 1920): 92–96.

Thorpe, Jonathan. "John H. Twachtman." *Arts* 2 (October 1921): 4–10.

Tucker, Allen. *John H. Twachtman.* American Artists Series. New York: Whitney Museum of American Art, 1931.

Watson, Forbes. "John H. Twachtman—A Painter Pure and Simple." *Arts and Decoration* 12 (April 25, 1920): 395, 434.

Wickenden, Robert J. *The Art and Etchings of John Henry Twachtman.* New York: Frederick Keppel and Co., 1921.

Yarnall, James L. "John H. Twachtman's 'Icebound.'" *Bulletin of the Art Institute of Chicago* 71 (January–February 1977): 2–5.

Frederic Porter Vinton

Bates, Arlo. *Memorial Exhibition of the Works of Frederic Porter Vinton,* exhibition catalog. Boston: Museum of Fine Arts, 1911.

Downes, William Howe. "The Vinton Memorial Exhibition." *Art and Progress* 3 (February 1912): 474–77.

Robert W. Vonnoh

Clark, Eliot. "The Art of Robert Vonnoh." *Art in America* 16 (August 1928): 223–32.

Eberlein, Harold Donaldson. "Robert W. Vonnoh: Painter of Men." *Arts and Decoration* 2 (September 1912): 381–83, 402, 404.

Hill, May Brawley. *Grez Days: Robert Vonnoh in France,* exhibition catalog. New York: Berry-Hill Galleries, 1987.

Ketcham, Susan M. "Robert W. Vonnoh's Pictures." *Modern Art* 4 (autumn 1896): 115–16.

Mechlin, Leila. "Robert Vonnoh." *Art and Progress* 4 (May 1913): 999–1002.

Vonnoh, Robert. "Increasing Values in American Paintings." *Arts and Decoration* 2 (May 1912): 254–56.

———. "The Relation of Art to Existence." *Arts and Decoration* 17 (September 1922): 328–29.

"The Vonnohs." *International Studio* 54 (December 1914): xlviii–lii.

"Vonnoh's Half Century." *International Studio* 77 (June 1923): 231–33.

Clark G. Voorhees

Gallatin, Albert E. "Landscapes by Clark G. Voorhees." In *Modern Art at Venice and Other Notes.* New York, 1910.

MacAdam, Barbara J. *Clark G. Voorhees 1871–1933,* exhibition catalog. Old Lyme, Conn.: Lyme Historical Society, 1981.

Julian Alden Weir

Baur, John I. H. "J. Alden Weir's Partition of 'In the Park.'" *Brooklyn Museum Quarterly* 25 (October 1938): 125–29.

Blashfield, Edwin Howland. *A Commemorative Tribute to J. Alden Weir.* New York: American Academy of Arts and Letters, 1922.

Brandegee, Robert B. "Living Artists No. 1: J. Alden Weir." *Art Review International* 1 (May 1919): 9–10.

Burke, Doreen Bolger. *J. Alden Weir, An American Impressionist.* Newark, Del.: University of Delaware Press, 1983.

Cary, Elizabeth Luther. "The Etched Work of J. Alden Weir." *Scribner's Magazine* 68 (October 1920): 507–12.

Catalogue of Paintings in Oil and Pastel by J. Alden Weir and J. H. Twachtman, exhibition catalog. New York: Fifth Avenue Galleries, 1889.

Cikovsky, Nicolai, Jr., et al. *A Connecticut Place: Weir Farm: An American Painter's Rural Retreat,* exhibition catalog. Wilton, Conn.: Weir Farm Trust, 2000.

Clark, Eliot. "J. Alden Weir." *Art in America* 8 (August 1920): 232–42.

Coffin, William A. *Memorial Exhibition of the Works of Julian Alden Weir,* exhibition catalog. New York: The Metropolitan Museum of Art, 1924.

Cox, Kenyon. "The Art of J. Alden Weir." *Burlington Magazine* 15 (May 1909): 131–32.

Cummings, Hildegarde, Helen K. Fusscas, and Susan G. Larkin. *J. Alden Weir: A Place of His Own,* exhibition catalog. Storrs, Conn.: William Benton Museum of Art, 1991.

Du Bois, Guy Pène. "The Idyllic Optimism of J. Alden Weir." *Arts and Decoration* 2 (December 1911): 55–57, 78.

Ely, Catherine Beach. "J. Alden Weir." *Art in America* 12 (April 1924): 112–21.

Ely, Catherine Weir. *Catalogue of an Exhibition by J. Alden Weir.* New York: Frederick Keppel and Co., 1927.

Field, Hamilton Easter. "Julian Alden Weir: An Optimist." *Arts and Decoration* 12 (January 1920): 200–2.

Flint, Janet A. *J. Alden Weir, An American Printmaker, 1852–1919,* exhibition catalog. Washington, D.C.: National Collection of Fine Arts, 1972.

J. Alden Weir (1852–1919), exhibition catalog. New York: Larcada Gallery, 1966.

King, Edward. "Straightforwardness Versus Mysticism." With original illustrations by John [*sic*] Alden Weir." *Monthly Illustrator* 5 (July 1895): 29–32.

Memorial Exhibition of the Works of Julian Alden Weir, exhibition catalog. New York: The Metropolitan Museum of Art, 1924.

Pach, Walter. "Peintres-graveurs contemporains M. J. Alden Weir." *Gazette des Beaux-Arts* 4, no. 6 (September 1911): 214–15.

Phillips, Duncan. "J. Alden Weir." *American Magazine of Art* 8 (April 1917): 213–20.

———. "J. Alden Weir." *Art Bulletin* 2 (June 1920): 189–212.

Phillips, Duncan Emil Carlsen, Royal Cortissoz, Childe Hassam, J. B. Millet, H. de Rassloff, Augustus Vincent Tack, and Charles Erskine S. Wood. *Julian Alden Weir: An Appreciation of His Life and Works.* New York: E. P. Dutton and Company, 1922.

Price, Frederic Newlin. "Weir—the Great Observer." *International Studio* 75 (April 1922): 127–31.

Ryerson, Margery Austen. "J. Alden Weir's Etchings." *Art in America* 8 (August 1920): 243–48.

Spence, Robert, and Jon Nelson. *The Etchings of J. Alden Weir,* exhibition catalog. Lincoln, Nebr.: University of Nebraska Art Galleries, 1967.

Thurlow, Fearn C. *J. Alden Weir,* exhibition catalog. Montclair, N.J.: Montclair Art Museum, 1972.

"Two Paintings by J. Alden Weir." *Brooklyn Museum Quarterly* 13 (October 1926): 124–25.

Wardle, Marian Eastwood. "Genteel Production: Art and Labor in the Images of Women Sewing by Tarbell and Weir." Ph.D. diss., University of Maryland, 2000.

Weitenkampf, Frank. "Weir's Excursion into Print-Land." *Arts and Decoration* 12 (January 20, 1920): 208–9.

Young, Dorothy Weir. *The Life and Letters of J. Alden Weir.* New Haven: Yale University Press, 1960.

Young, Mahonri Sharp. *J. Alden Weir, 1852–1919, Centennial Exhibition,* exhibition catalog. New York: American Academy of Arts and Letters, 1952.

———. *Paintings by Julian Alden Weir,* exhibition catalog. Washington, D.C.: The Phillips Collection, 1972.

Zimmerman, Agnes Saumarez. "An Essay toward a Catalog Raisonné of the Etchings, Drypoints and Lithographs of J. Alden Weir." *Metropolitan Museum of Art Papers,* 1, pt. 2, 1923.

———. "Julian Alden Weir—His Etchings." *Print Collector's Quarterly* 10 (October 1923): 288–308.

Theodore Wendel

Baur, John I. H. *Theodore Wendel, An American Impressionist, 1859–1932,* exhibition catalog. New York: Whitney Museum of American Art, 1976.

———. "Introducing Theodore Wendel." *Art in America* 64 (November–December 1976): 102–12.

William Wendt

Browne, Charles Francis. "Some Recent Landscapes by William Wendt." *Brush and Pencil* 6 (September 1900): 257–63.

Exhibition of Paintings by William Wendt and Sculpture by Julia Bracken Wendt, exhibition catalog. Los Angeles: Los Angeles Museum of History, Science and Art, 1918.

In Praise of Nature: The Landscapes of William Wendt, exhibition catalog. Long Beach, Calif.: University Art Museum, California State University, 1989.

Moure, Nancy Dustin Wall. *William Wendt 1865–1946,* exhibition catalog. Laguna Beach, Calif.: Laguna Beach Museum of Art, 1977.

Seares, Mabel Urmy. "William Wendt." *American Magazine of Art* 7 (April 1916): 232–35.

"Thinking About William Wendt." *Antiques & Fine Art* 7 (December 1989): 92–99.

Walker, John Alan. "William Wendt, 1865–1946." *Southwest Art* 4 (June 1974): 42–45.

———. *William Wendt's Pastoral Vision and Eternal Platonic Quests.* Big Pine, Calif.: Privately printed, 1988.

———. *Documents on the Life and Art of William Wendt (1865–1946), California's Laureate of the Paysage Moralisé.* Big Pine, Calif.: John Alan Walker, 1992.

———. "William Wendt: God's Green Acre." *Southwest Art* 22 (November 1992): 68–73, 153.

William Wendt and His Work, exhibition catalog. Los Angeles: Stendahl Art Galleries, 1926.

Guy Wiggins

Guy C. Wiggins, American Impressionist, exhibition catalog. Chicago: Campanile Galleries, 1970.

Paintings by Three Generations of Wiggins 1870's–1970's, exhibition catalog. Windsor and New Britain, Conn.: Loomis Chaffee School and the New Britain Museum of American Art, 1979.

Walt, Adrienne L. "Guy Wiggins: American Impressionist." *American Art Review* 4 (December 1977): 100–13.

Theodore Wores

The Art of Theodore Wores: Japan's Beauty Comes Home, exhibition catalog. Introduction by Joseph Armstrong Baird. Tokyo: Asahi Shimbun/Tokyo Honsha Kikaku Daiichibu, 1986.

Baird, Joseph Armstrong. *Theodore Wores: The Japanese Years,* exhibition catalog. Oakland, Calif.: Oakland Museum, 1976.

———, ed. *Theodore Wores and the Beginnings of Internationalism in Northern California Painting: 1874–1915,* exhibition catalog. Davis, Calif.: Library Associates, University Library, University of California, Davis, 1978.

Ferbraché, Lewis. *Theodore Wores, Artist in Search of the Picturesque.* San Francisco: David Printing Co., 1968.

Gerdts, William H. *Theodore Wores, 1859–1939,* exhibition catalog. New York: Wunderlich & Co., 1987.

Gerdts, William H., and Susan Hillhouse. *Theodore Wores: Works from the California and Japan Years,* exhibition catalog. Santa Clara, Calif.: Triton Museum of Art, 2000.

Gerdts, William H., and Claire Perry. *The World of Theodore Wores,* exhibition catalog. Stanford, Calif.: Iris and B. Gerald Cantor Center for Visual Arts, Stanford University, 1999.

Preble, Michael. *Theodore Wores 1859–1939,* Huntsville, Ala.: Huntsville Museum of Art, 1980.

Reynolds, Gary A. "A San Francisco Painter, Theodore Wores." *American Art Review* 3 (September–October 1976): 101–17.

Theodore Wores: An American Artist in Meiji, Japan, exhibition catalog. Pasadena, Calif.: Pacific Asia Museum, 1993.

Theodore Wores, 1859–1939: An American in Japan, exhibition catalog. London: Fine Arts Society, 1999.

Theodore Wores, 1858–1939: A Retrospective Exhibition, exhibition catalog. New York: Kennedy Galleries, 1973.

Theodore Wores: The Japanese Years: An Exhibition of Paintings from the Collection of Dr. Ben Shenson and Dr. A. Jess Shenson, exhibition catalog. Oakland, Calif.: Oakland Museum, 1976.

Thompson, Jan N. "Theodore Wores." *Art of California* 3 (May 1990): 17–24.

N. C. Wyeth

Allen, Douglas, and Douglas Allen Jr. *N. C. Wyeth: The Collected Paintings, Illustrations and Murals.* New York: Bonanza Books, 1984.

Duff, James A. *Not for Publication: Landscapes, Still Lifes, and Portraits by N. C. Wyeth,* exhibition catalog. Chadds Ford, Pa.: Brandywine River Museum, 1982.

Duff, James A., et al. *An American Vision: Three Generations of Wyeth Art: N. C. Wyeth, Andrew Wyeth, James Wyeth,* exhibition catalog. Boston: Little Brown in association with the Brandywine River Museum, 1987.

Jennings, Kate F. *N. C. Wyeth.* New York: Knickerbocker Press, 1998.

Michaelis, David. *N. C. Wyeth: A Biography.* New York: Alfred A. Knopf, 1998.

N. C. Wyeth: Precious Time, exhibition catalog. Portland, Maine: Portland Museum of Art, 2000.

Podmaniczky, Christine B. *N. C. Wyeth: Experiment and Invention, 1925–1935,* exhibition catalog. Chadds Ford, Pa.: Brandywine River Museum, 1995.

Visions of Adventure: N. C. Wyeth and the Brandywine Artists. New York: Watson-Guptill, 2000.

Photo Credits

All photographic material was obtained directly from the collection indicated in the caption, except for the following: Courtesy Adelson Galleries, Inc., New York: plates 419, 420, 423; Courtesy Archives of American Art, Smithsonian Institution, Washington, D.C.: plates 69, 115, 141, 143, 177, 186, 187, 210, 221, 236, 253, 384; Armen: plates 4, 362; Courtesy *Art and Antiques* magazine, New York: plate 309; William E. Barrett, Centreville, Virginia: plate 306; Courtesy Berry-Hill Galleries, New York: pages 2-3, plates 10, 50, 83, 91, 418; E. Irving Blomstram: plate 165; Courtesy Brandywine River Museum, Chadd's Ford, Pennsylvania: plate 303; Brenwasser Photographers, New York: plate 388; Courtesy Jeffrey Brown Fine Arts, Inc., North Amherst, Massachusetts: plate 150; Bo Ling Chen, New York: plates 198, 378; Geoffrey Clements, New York: plate 36; Courtesy Eckert Fine Art and Antiques, Westfield, Indiana: plate 155; Daniel Farber: plates 226, 274, 275, 281; Ron Forth: plates 190, 266; Courtesy Graham Galleries, New York: plates 240, 370; Helga Photo Studios, New York: plates 135, 353; Helga Photo Studios, New York, courtesy Hirschl and Adler Galleries, New York: plate 351; Ted Hendrickson: plates 284, 357; Courtesy Hirschl and Adler Galleries, New York: plate 320; Paulus Leeser: plate 111; Courtesy R.H. Love Galleries, Chicago: plates 89, 185, 265, 267, 278, 293, 322; Courtesy Lyme Historical Society, Old Lyme, Connecticut: plates 268, 273; Terrence McGuinness: plates 114, 178; Courtesy Metropolitan Museum of Art, New York: plate 176; Richard P. Meyer: plate 207; James O. Milmoe: plate 330; Johsel Namkung: plate 6; Courtesy Owen Gallery, New York: plate 417; Biagio Pinto, Philadelphia: plate 160; Quiriconi-Tropea Photographers, Chicago: plate 81; Clive Russ, Boston, courtesy Vose Galleries of Boston, Inc.: plate 229; Courtesy St. Louis Art Museum: plate 343; Schenck and Schenck Photography: plates 62, 298; Courtesy Sotheby Parke Bernet, Inc., New York: plate 119; Courtesy Spanierman Gallery, LLC, New York: plates 60, 146, 290, 416, 421, 422; John Tennant: plates 43, 395; Arthur Vitols, courtesy The Magazine *Antiques*, New York: plate 279; Herbert Vose: plate 45; Robert Wallace, Indianapolis: plates 131, 152, 257, 318; Robert Wallace, courtesy Indianapolis Museum of Art: plates 154, 156, 245; John Woolf, courtesy Jeffrey Brown Fine Arts, Inc., North Amherst, Massachusetts: plate 46; Steven J. Young: plates 149, 167.